LEICA MANUAL
The
Complete Book of 35mm Photography

Edited by
Douglas O. Morgan
David Vestal
William L. Broecker

15th Edition

MORGAN & MORGAN
Hastings-on-Hudson, New York
Fountain Press, London - Agents for Great Britain

An Introduction to Color Printing
©1971 by Bob Nadler

Designed by Bruce Blair and
 Rostislav Eismont

Typesetting: Morgan Press Incorporated
Printing: Murray Printing Company
Binding: A. Horowitz & Son

First Edition, 1935
Second Edition, 1935
Third Edition, 1936
Fourth Edition, 1936
Fifth Edition, 1937
Sixth Edition, 1938
Seventh Edition, 1939
Eighth Edition, 1942
Ninth Edition, 1943
Tenth Edition, 1944
Eleventh Edition, 1947
Twelfth Edition, 1951
Thirteenth Edition, 1955
Fourteenth Edition, 1961
Fifteenth Edition, 1973

Morgan & Morgan, Inc.
Publishers
400 Warburton Avenue
Hastings-on-Hudson, N.Y. 10706

International Standard Book Number 0-87100-003-2
Library of Congress Catalog Card Number 35-14997

Printed in the U.S.A.

Table of Contents

Cartier-Bresson • Dr. Paul Wolff • Alfred Eisenstaedt • Peter Stackpole • Arthur Rothstein • Ben Shahn • Willard Morgan • Barbara Morgan

Dedicated to the memory of Willard D. Morgan (1900-1967), in recognition of his pioneering work in the field of photography and his total belief in the capabilities of the small camera as a medium of expression and communication.

Acknowledgments

For advice, suggestions, assistance and
cooperation too varied to detail:

Gene Anderegg
Alfred Boch
Woodfin Camp
John Durniak
Susan Goldstein
Betty Hanke
Sam Holmes
Walter Heun
Robert Indorf
Dorothy Kaelin
James Lager
Rudolf Maschke
Walter Moffatt
Barbara Morgan
Gilbert Morgan
Liliane Morgan
Lloyd Morgan
Kenneth Poli
Bob Schwalberg
Michael Sullivan
William Summits
William Swan
Harvey Weber
Helen Wright
Richard Zakia

Regina Benedict, for editorial preparation of
manuscripts.

Ernest Pittaro, for checking
technical information.

Members of the staff of
Ernst Leitz, GmbH, Wetzlar, Germany and
E. Leitz, Inc., Rockleigh, N.J.

Foreword

THE LEICA MANUAL, *The Complete Book of 35mm Photography*—along with its supplementary loose-leaf volume, CURRENT 35mm PRACTICE—is an extensive information source describing what you can do in photography with the Leica and Leicaflex systems of cameras and accessory equipment.

The first edition of *The Leica Manual* appeared in 1935, and immediately became an indispensable book for users of the new 35mm camera. Since that time, 35mm photography has come of age, and each of the succeeding thirteen editions of *The Leica Manual* has been equally indispensable. Today, 35mm is the most widely-used photographic medium in the world. There are now more types of equipment, more films and related materials, and more special applications for 35mm than for any other format.

In this volume, we have included complete information on all of the latest Leitz cameras and accessories, and on previous models of the Leica as well. Several chapters cover in detail the application of 35mm photography to a wide variety of activities. Other chapters contain information on the newest materials and techniques available to the serious photographer. In addition to numerous illustrations within the chapters, there are three portfolios of outstanding pictures taken by master photographers around the world. Never has there been a *Leica Manual* so full of information or so lavishly illustrated.

Individual points of view and specialized ideas are incorporated in this Fifteenth Edition. Twenty-seven authors, many expert photographers, three editors, and those persons mentioned in the acknowledgments have contributed to this book. We have benefited greatly from their experience and suggestions. In editing, we have made every effort to maintain the personal style of each contributor, so that the book will be a rich and varied experience for the reader.

I wish to personally thank all of these individuals, and also the staff of Morgan & Morgan, who spent far more time and effort than we had ever anticipated to create this comprehensive edition of *The Leica Manual.*

In the future, 35mm photography will see more automated cameras, lighter-weight lenses, electronic controls and components, and a vast array of new products and materials. These, in turn, will generate new techniques and working methods for the studio and in the field. All these changes and every new Leica/Leicaflex development will be included in the companion volume, *Current 35mm Practice.*

We look forward to suggestions and questions from readers of this book. Your experiences and ideas will help in preparing the looseleaf supplements which will keep *Current 35mm Practice* up-to-date with specialized information in a ready-reference form.

In this way, *The Leica Manual* and *Current 35mm Practice* will always be the most authoritative and comprehensive source of 35mm information you can consult. Far more than books to read, they are books *to use.* We are proud to place them at your disposal.

Douglas O. Morgan
Publisher and Editor
Hastings-on-Hudson
January 1973

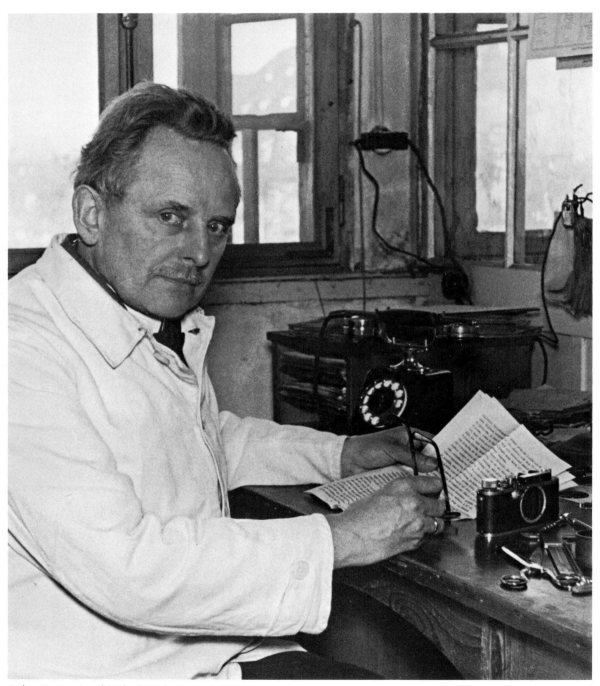

Oskar Barnack at his desk in the Leitz factory

Oskar Barnack and the Development of the Leica

Theo Kisselbach
translated by Rolf Fricke

Oskar Barnack, the inventor of the Leica, was born on November 1, 1879 in Lynow, a small town near Brandenburg, Germany. While he was still a small boy, his parents moved to Lichterfelde, a suburb of Berlin. His dream was to be a landscape painter, but a few words from his father, "You can't earn a living with that," squelched that dream. "Why don't you learn a sensible trade!", his father's next sentence, was the key for what was to come. Soon afterwards, young Oskar joined Julius Lampe as an apprentice mechanic. Lampe had only a modest machine shop, but he built fascinating things: small orreries and planetaria driven by clockwork, whose suns, moons, and stars changed their positions like the real ones we can observe in the skies. Barnack was fascinated by these devices, and his ambition changed in favor of becoming an astronomer.

Barnack was assiduous and industrious, and Lampe rewarded him by releasing him from his obligatory apprenticeship six months early.

After apprenticeship, every tradesman was expected to travel as a journeyman to broaden his knowledge. Barnack did that by going to Saxony, Vienna and the Tyrol.

He spent the next few years in the mechanical and optical industry of Jena. There he met Emil Mechau, a particularly talented designer, who conceived the idea of a shutterless motion-picture projector that would not flicker. The film would run continuously, not intermittently, from frame to frame. The pictures would remain steady on the screen, replacing each other smoothly by means of a mirror arrangement, much like today's lap dissolves. The idea found little support in Jena, so Mechau went to Wetzlar and approached the Leitz Company, and there he was able to begin construction of his device in 1910.

At Mechau's recommendation, Barnack was asked to head the experimental laboratory. Because of frail health, he hesitated, but Ernst Leitz II personally dispelled his reservations, and Barnack assumed his new post in January, 1911. One of his first assignments was to design diamond lathes for use in the polishing department. He also built a motion-picture camera made entirely of aluminum, a radical departure from the wooden models of that time. With this camera, he made several movies in his spare time. This led him to look for ways to determine correct exposure.

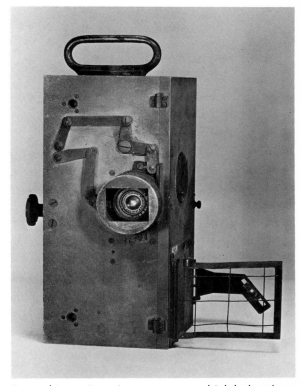

Barnack's motion-picture camera, which led to the construction of the Ur-Leica. Unfortunately, the motion-picture camera is no longer in working condition: it was exposed to intense heat during a fire-bomb air raid

It was then customary to compensate for minor over- or underexposures by small changes in development. This required test exposures, so Barnack built himself an aid in the form of a small camera with a fixed shutter speed of 1/40 second, which corresponded to the standard exposure in his motion-picture camera. He made various experiments, and was surprised and pleased by the quality of the small negatives produced by motion-picture films, which were used mostly for outdoor scenes. These films were slow, but they had finer grain than photographic plates. His experiments reminded Barnack of an idea that he had tested before, but without success.

Barnack became an avid amateur photographer at an early age. He knew that prints had to be of a certain size so that perspectives would appear

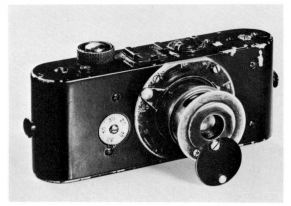

The Ur-Leica, begun in 1914 and ready for use in March of that year. Barnack first used a Kino-Tessar lens, not designed to cover the double-frame 24x36mm format. Later he tried a 64mm Leitz Mikro-Summar and, finally, a 50mm f/3.5 Leitz Anastigmat. The small black lens cover had to be swung over the lens after each exposure, because the focal-plane shutter was not yet self-capping

Barnack using his motion-picture camera at the spa, Bad Ems, on the River Lahn. Photographed with the Ur-Leica

natural at normal viewing distances. For that reason he used a 5x7-inch view camera instead of the popular 3½ x 4¾-inch format. But this heavy camera was quite a burden to lug on his hikes through the woods of Thuringia, along with six wooden double plate holders and a solid tripod.

Using a special indexing device, he exposed 15 to 20 photographs side-by-side on a 5x7-inch plate, but the results were disappointing. The grain of these negatives was too noticeable in the enlargements. That was in 1905. Barnack had already been intrigued by the concept, "small negative—large print."

When he looked at the small motion-picture frames, he was reminded of that idea. To make the best use of this film size, he chose a format made up of two standard motion-picture frames. Thus the now-classic 24x36mm format was born. Early in 1914, two prototype cameras, forerunners of the Leica,

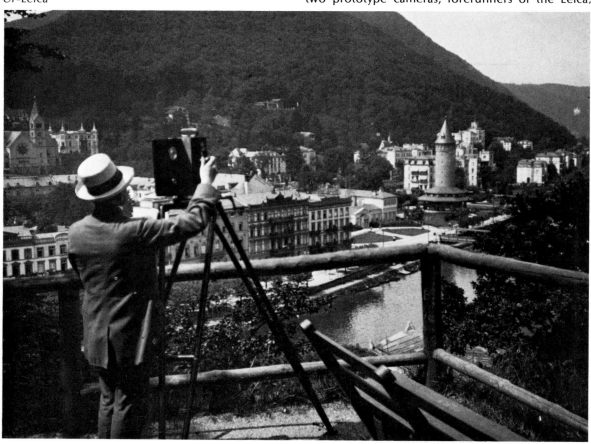

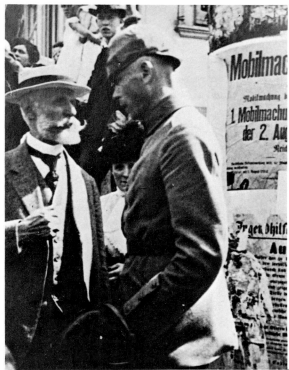

were built along these lines. Barnack himself made many photographs with one of them. The other was taken along by Ernst Leitz II on a trip to the United States that spring. In May 1914, a patent application was filed to cover the new camera's principal features. World War I began that August, preventing further development of its design. Barnack could not do much work during the war on the new camera, but he put it to good use; as food became scarcer in the latter half of the war, he visited farmers in nearby villages, taking pictures which he then bartered for precious food.

Mobilization Day, Wetzlar, 1914, photographed by Oskar Barnack with the Ur-Leica

Ernst Leitz, the founder, and Oskar Barnack on vacation in the Black Forest, 1917: taken with the Ur-Leica

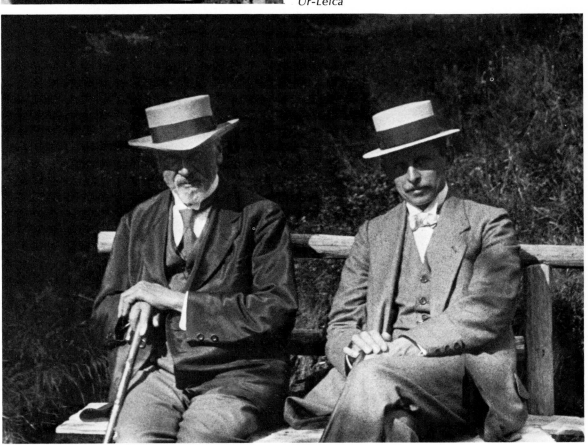

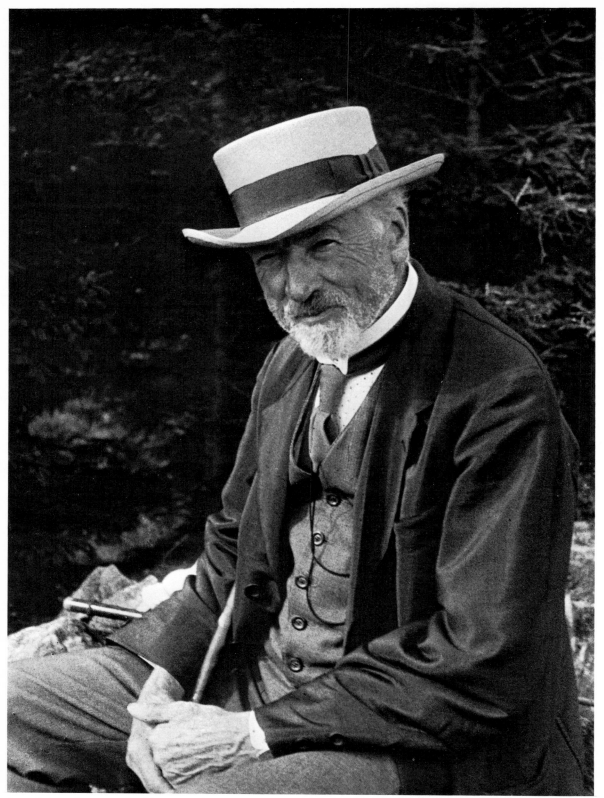

Ernst Leitz, photographed by Barnack

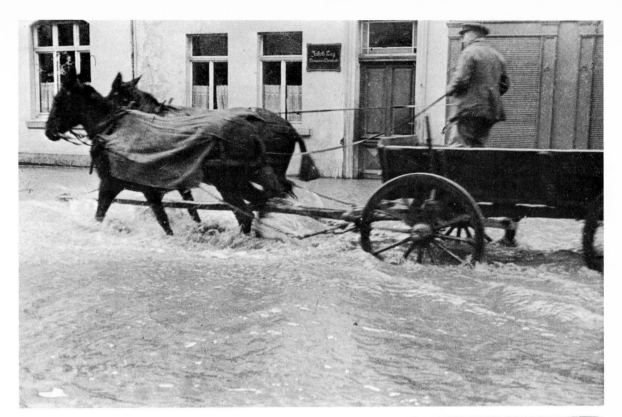

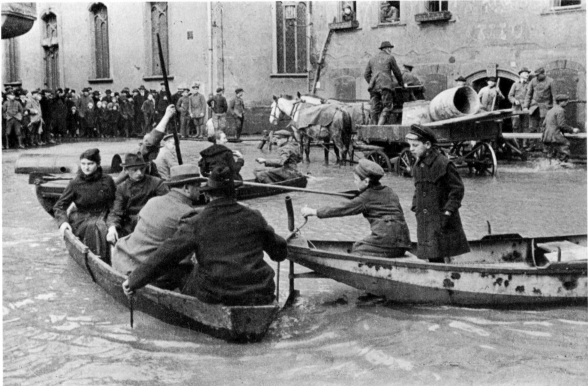

The 1920 flood in Wetzlar, photographed by Barnack

The Leitz archives contain a number of original negatives made by Oskar Barnack with his prototype camera. It is impossible to determine the exact date on which many were taken, but it is quite certain that some were exposed before 1920, because they show Ernst Leitz, the founder of the firm, who lived from 1843 to 1920. He was always concerned about Barnack's delicate health, so much so that he invited him along on a vacation in Sulzburg, his original home in the southern part of the Black Forest. During this holiday, Barnack made a series of excellent portraits of Leitz.

The origin of the prototype Leica and its development into a commercial product are best described by Oskar Barnack himself. In issue No. 1 of the magazine *Die Leica* (May 1931), he wrote: "Now the actual design of the Leica camera began. I gave complete freedom to my penchant for the unusual and for the novel. I was not restricted by a set assignment or by a specific direction, which are customary in a design department. It was more of a personal hobby. By blithely ignoring the conventional, and by using hardly any of the criteria which were considered essential to good photographic cameras until then, this novel type of camera came into being. Already then, the camera was basically what it still is today. The difference was that the first model did not have an adjustable focal-plane shutter. Instead, it had a fixed slit of 4cm width (just over 1½"), and exposure times were changed by varying the spring tension. The early camera also lacked daylight cassettes. But it already had everything else, especially the coupled shutter-cocking and film advance.

"I used this prototype for many years, and I still have many pictures taken during those days. However, further development of the camera was temporarily halted by the outbreak of war. Nevertheless, I gained extremely useful experience with the photographs I took during the war years, so that when the possibility of manufacture was later brought up, I was able to come up with a production version in a rather short time.

"Next , the following had to be designed: a rangefinder for closeup photography, an important requirement for a camera without groundglass focusing; then an absolutely dependable self-capping focal-plane shutter with adjustable slit width; and finally, the capability of loading film in daylight by means of cassettes. I also designed the viewfinder at

Barnack had a photographer's eye: this 1914 picture from Cologne shows true 35mm style

that time. Once these important problems had been solved to my satisfaction, only one major task remained: to find a suitable lens. It had to be of excellent quality, because a tenfold linear enlargement was a basic requirement; this became the task of Prof. Dr. Max Berek. He succeeded in designing a 50mm f/3.5 anastigmat lens that was at least equal to the very best lens of that type then in existence."

At first, the five-element Elmax lens was used, a relatively complex design whose rear group contained two cemented surfaces. With the advent of new types of optical glass with more favorable refractive properties, the number of elements could be reduced, and new calculations resulted in the famous four-element Elmar lens, introduced in 1926.

During 1923, a pre-production series of just over thirty cameras were built by hand, and given out for testing to principal distributors and to certain professional people. Their reactions were varied, and sometimes negative; the performance of this new camera was not immediately appreciated. Who, in those days, was familiar with processing techniques for such small negatives?

Nevertheless, the decision to begin series production of the Leica camera was made in 1924. Ernst

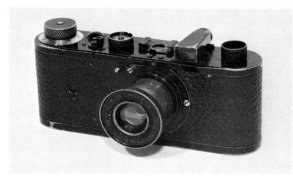

Leica No. 104 of the pilot run produced in 1923-24. It already had the principal Leica features, but the shutter-speed dial was not yet in its final form. The lens was engraved, "Leitz Anastigmat 1:3,5 F = 50mm"

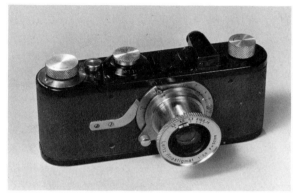

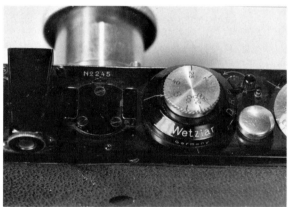

Leica No. 245, made in 1925. The lens was still engraved "Leitz Anastigmat 1:3,5." The shutter-speed sequence of 1/25, 1/40, 1/60 second, etc., was changed on later models

Leitz II called a meeting with his closest staff, and the discussion went on for hours. A whole new series of machines and fixtures would be needed for its manufacture. Finally, Ernst Leitz closed the session by saying: "Well, it is now twelve-thirty. We'll quit now, and I have decided that we'll take a chance on

it." A determining factor in his decision was the possibility, at a time when a depression was just beginning, that this new product would create work for his employees.

One of the first names considered was "Barnack-Camera"; then it was to be called "Leca"; but just before the official announcement, the better-sounding name, "Leica," was agreed upon. The Leica camera made its public debut at the 1925 Leipzig Spring Fair.

Meanwhile, a development that might have affected the Leica adversely took place in the motion picture field: movies began to be made more and more in studios, instead of outdoors. Working with tungsten illumination instead of daylight required faster films, with the drawbacks of larger grain and lower resolution. As a result of this demand for high speed, few films remained available that had the necessary quality to do justice to the capabilities of the Leica. One of them was Perutz Aerial Film, which had low sensitivity, very fine grain, and high contrast. To achieve good results, special care had to be taken in processing. Only a shortened development time would yield negatives with a gradation suitable for good enlargements. This led to the motto that guided many Leica photographers for a long time: "Overexpose and underdevelop."

Actual production of the Leica camera was supervised by Barnack himself from his office, located in the Hausertor plant, in a room partitioned off from the assembly line by a glass wall. He devoted all his efforts to further development of the camera and its accessories.

Camera manufacturing was a new and unfamiliar field for the Leitz Company, but the meticulous precision required for microscope production turned out to be a distinct advantage for the Leica camera. The demand was slow at first, but began to grow at an ever increasing rate.

A second model, introduced in 1926 and called the "Model B," was equipped with a Compur between-the-lens shutter in the 50mm f/3.5 Elmar lens. Its advantage was a wider choice of shutter speeds, which ranged from 1 to 1/300 second, but it did not have the convenience of coupled shutter cocking and film advance. The Compur Leica, as it was also called, was only slightly less expensive than the regular Leica (192 Marks instead of 220 Marks), and was only modestly successful. There were two versions;

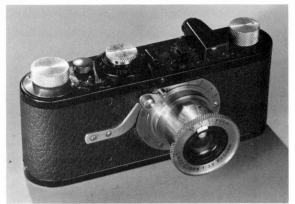

Leica No. 691, made in 1925. It was customary to replace the larger shutter-release button with the newer threaded release whenever such a camera came to the factory for repair; this camera was probably never sent in for service. Elmar lenses were supplied regularly on 1926 and 1927 Leicas, but some Elmax lenses were still used. When cameras with Elmax lenses were returned to the factory for repair or conversion, the Elmax name ring was automatically replaced by an Elmar name ring. The only difference is in the rear group of elements, where the Elmax has three elements, while the Elmar has two; it is difficult to tell them apart

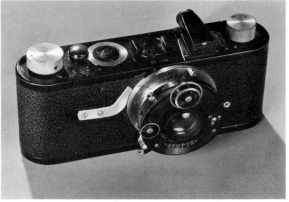

The Compur Leica, or Model B, was introduced in April, 1926. It used the collapsible 50mm f/3.5 Elmar lens. The first version had serial numbers from 5700 to 6278 and from 13100 to 13139

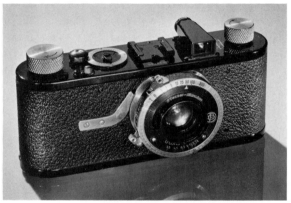

The second Model B Leica, introduced in 1929, had the "rim-set" Compur shutter. Small batches of this model were made until September, 1931, with groups of serial numbers between 13140 and 51715

the Compur shutter was redesigned in 1929. About 100 cameras were made with the early shutter, and just over 700 with the later shutter. The last batch, made in 1931, had serial numbers from 51612 to 51715. Since Compur Leicas could not be converted into later models, this version can still be found.

Minor improvements were introduced in February, 1929: the shutter-release button, which up until then had a spherical top, was replaced by a flat-top release with a threaded base, onto which a matching cable release could be fitted. The new release button was depressed automatically when the rewind lever was set on "R."

Two special versions of the Leica Model A (or I) were introduced in October, 1929: at a small extra charge, the camera could be ordered with a dyed calf covering in place of the conventional black vulcanized rubber one. This optional leather covering was available in a choice of four colors: green, blue, red, or brown. But customers did not seem to care for these refinements. The "Luxus Leica" camera, which appeared at the same time, also was more popular in exhibitions than in actual sales. All its exposed metal parts were plated with matte gold, and the camera was covered in colored lizard skin. Fewer than one hundred Luxus Leicas were produced. Collectors prize them today.

Barnack never tired of working on further refinements for his camera. Some of his designs became reality remarkably quickly, while others took years before going into production. Because he was ex-

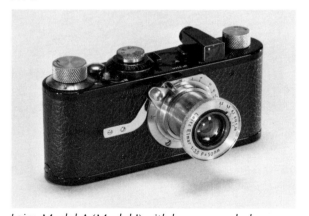

Leica Model A (Model I) with large, rounded shutter-release button. A bracket that slipped over the top of the camera from front to back made it possible to use a cable release. This model was also available with a small indentation in the top of the shutter-release button

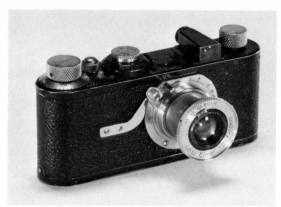

A later Leica A with threaded release button. The small knurled ring, to protect the thread from dirt, had to be removed before the cable release could be attached

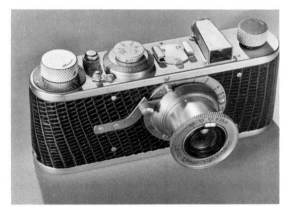

The gold-plated Luxus Leica of 1929

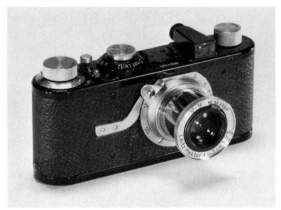

A rare Leica Model A (I) with a non-removable 50 mm f/2.5 Hektor lens. Interchangeable-lens cameras were already available when this camera was produced. About 1,200 were made, but many were later converted to other models, so probably only a few hundred of these cameras remain in their original form

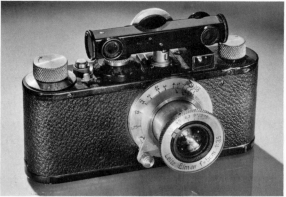

The Leica Model C (I), for interchangeable lenses, was introduced in May, 1930, but the Model A (I) with non-removable lens, remained available. At first, each lens had to be calibrated to a specific camera body: such lenses were then engraved with the last three digits of the camera's serial number. After the second version of the Leica C was introduced in 1931, with a standard distance from the front surface of the lens-mount flange to the film plane (28.8mm), most early cameras of this model were converted to the standard flange-to-film distance. For years thereafter, these cameras had an "O" marking on the flange

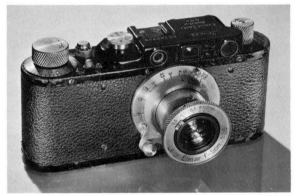

Barnack's most significant improvement of the Leica was the built-in rangefinder, which appeared with the Model D (II): the rotation of the lens for focusing was limited to 180 degrees. When older cameras were converted to the Model D, their lenses were automatically furnished with new mounts

tremely thorough, many parts had to undergo repeated changes before he was satisfied. He liked to have parts made in the machine shop from hand-made sketches so he could try them out right away.

Among his many improvements and innovations, two are especially significant: first, the Leica camera with interchangeable lens mount; second, the camera body with built-in rangefinder. Both played a major part in the success of the Leica.

The new model for interchangeable lenses was first shown at the Leipzig Spring Fair in 1930, accompanied by two new lenses: the 35mm f/3.5 Elmar

wide-angle lens, and the 135mm f/4.5 long-focus lens. In addition, a faster lens was introduced for the normal focal length: the 50mm f/2.5 Hektor. At first, every set of lenses had to be individually calibrated to a specific camera body, but in December, 1930, the distance from the film plane to the outer surface of the lens-mount flange was standardized at 28.8mm. After May 9, 1931, only cameras for interchangeable lenses were manufactured.

The second innovation resulted in the Model D (or II) with its built-in coupled rangefinder. Barnack discussed his thinking about this design in *Die Leica*, (Volume 2, No. 5, 1933, page 131):

"The Coupling of the Leica Camera Model D (or II)"

"The idea of coupling the lens with a focusing device is as old as the portable photographic camera itself. Patents to this effect were applied for as early as the nineties, but relatively few cameras of that type appeared on the market. Because of the slow lenses of the period, their practicality was very doubtful (with an aperture of f/18, one certainly does not need a rangefinder).

"The idea of such a coupling device, suggested over the years by numerous Leica fans, was therefore not really new to us. I myself considered this possibility for a long time. But it took five years for the coupling mechanism which we introduced on February 1st, 1932, to reach its current form. It is definitely a design problem, for which only a competent specialist who is familiar with the requirements is likely to find a satisfactory solution.

"We can generally say that a house does not necessarily become more beautiful if we build an addition to it. However, there are exceptions, and surely the Leica Model D (or II) can be counted among them. The following conditions had to be met:

1. The camera should not become larger (it should still fit in a pocket).
2. The camera must not become unsightly (which could certainly be caused by the addition of a coupling mechanism).
3. The camera must not become too expensive (at least not much more than the previous model plus a separate rangefinder).
4. The coupling mechanism must operate with the

utmost precision, and it must be usable with all interchangeable lenses of various focal lengths.
5. It should provide the greatest possible speed of operation.
6. The mechanism must be of original design, so that it can be patented and protected against copying.
7. The coupling must be constant, and it should not wear.
8. It should be possible to build the focusing mechanism into earlier models of the Leica.

"I believe that even the most demanding users of Leica cameras will be satisfied with our solutions for these eight requirements. By fitting the rangefinder into the open space between the shutter-speed dial and the rewind knob, the external appearance of the camera was definitely enhanced. It looked more uniform and compact. The fastest possible focusing of the lens was achieved by limiting its rotation to half a circle.

"At the same time, I re-introduced the infinity lock, in the form of a very easy-to-operate latch, in response to many requests from Leica users.

"Now let us discuss a few details of the rangefinder mechanism. We must take into account that the rotation of the lens and the deflection of the mirror in the rangefinder occur at a ratio of 200 to 1. You can imagine what a minute amount of mirror deflection is involved when you consider that an image displacement can already be noticed when the lens is turned by only two calibrations on its distance scale. In mathematical terms, only a few seconds of arc are involved. There is no play in its operation; in other words, the rangefinder will react immediately to even the smallest turning of the lens.

"An interesting test of the sensitivity of this rangefinder, which has a base of only 40mm, can be made by sticking two pins into a horizontal surface at a distance of about one meter (just over three feet) from the camera, separating them by 20mm (just over ¾") in distance from the camera, and viewing them against a white background. With careful focusing on the near pin, the far pin will already appear noticeably doubled, and by turning the lens just a little more, until the far pin is sharp, the near pin will appear decidedly doubled. Human vision has much coarser depth perception. Surely this is ample proof that the short-base rangefinder for miniature cam-

eras is not only adequate, but affords a considerable safety factor for accurate focusing. Why use cannon to shoot sparrows?''

The announcement of the Leica camera Model D (or II) came on February 1, 1932. This camera is really a masterpiece by Barnack—the first camera with a built-in coupled rangefinder and matching, freely-interchangeable lenses. It is especially commendable that this rangefinder can be added to earlier Leicas with focal-plane shutters.

The Leica Standard camera (Model E), evolved

The Leica Standard (Model E) appeared soon after the Model D. It was designed so that later conversion at the factory required substantially less work. The Leica E is easy to recognize: its rewind knob is slim like that of the Model D, and can be pulled up for easy rewinding

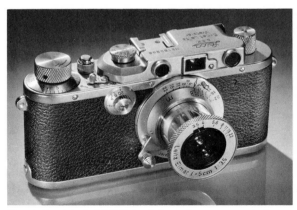

The Leica Model F (III) had slow shutter speeds from one second to ⅛ second, selected by turning a knob on the front of the camera

from the earlier Model C (I), was announced in the fall of 1932, at an attractive price. The price of the Model D (II) was approximately the same as the combined price of the earlier Model C (I) and a separate rangefinder. Against payment of the difference in price, the Leica Standard (Model E) could be factory-converted into the Model D (II)—a novel form of "time payment."

The Model F (Leica III) was introduced only a short time later, in May, 1933. Slow shutter speeds from ⅛ second to one second were added, the ease of using the rangefinder was increased by means of a 1.5x magnification, and the rangefinder eyepiece could be focused to accommodate the individual user's eye.

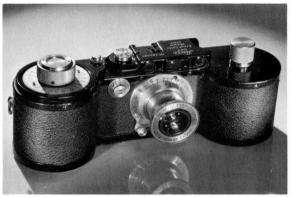

The Leica 250

In response to requests from camera users, Barnack designed the Leica 250 camera (the Model FF or Reporter), which could be loaded with thirty-three feet of film (10 meters), permitting just over 250 exposures. The camera had two identical cassettes, so the film did not have to be rewound. Otherwise the Leica 250 was the same as the Model F (III) and, starting in 1935, as the Model G (IIIa). For military purposes, a small series was built with a motor attached.

By adding a shutter speed of 1/1000 second to the Model F (III), the Model G (IIIa) was created. While previous models were offered in black as well as chrome finish, the Model G (IIIa) cameras were available officially only in chrome. However, the Leitz Conversion System resulted in the appearance of black Model G (IIIa) cameras. (As a rule, black cameras remained black when converted by the factory into later models.)

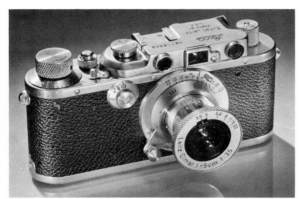

The Leica Model G, or IIIa, introduced in 1935

Barnack suffered much from asthma and from chronic colds; a haircut could result in a cold that would confine him to bed. But even then, he kept his mind occupied with design ideas; by the time he returned to work, he would always bring along sketches of new ideas.

He was unassuming and his private life was quiet. He was an avid and accomplished chess player. The great success of the Leica camera did not affect Barnack's character. He evaluated each suggestion for its practicality, and when customers suggested utterly impossible improvements, he would occasionally write his comments on the margins in appropriate photographic terms, such as "Totally underexposed."

Many of Barnack's ideas never became reality. For instance, in 1912 he designed a 35mm motion-picture camera entirely of metal, with many technical refinements over the current wooden models. Few persons know that he also built a very well conceived stereoscopic camera in prototype form.

In the summer of 1935, Barnack became seriously ill. After repeated examinations, pernicious anemia was diagnosed, and his recovery was very slow. On January 2nd, 1936, Barnack was able to celebrate his 25th anniversary with the company, but a few days later, pneumonia forced him back into bed. His resistance deteriorated rapidly, and in the early morning of January 16, 1936, Oskar Barnack closed his eyes forever. His achievements constitute a lasting memorial to this remarkable man.

Barnack's experimental Stereo Leica used two 35mm wide-angle lenses. Leitz had previously offered a stereo attachment designed by Dr. Lihotsky to be used on the Leica with a 50mm lens; it yielded two vertical 18x24mm pictures. Sales of this attachment were below expectations, however, so Leitz decided not to produce the stereo camera

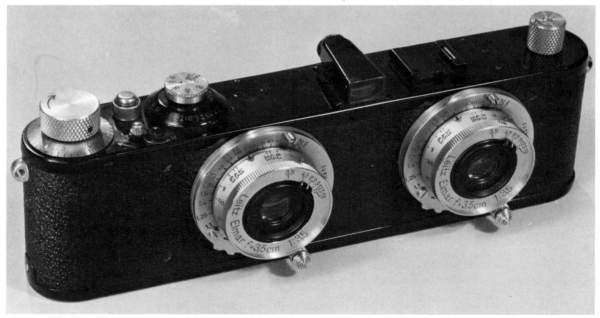

Leica or Leicaflex?

Harvey V. Fondiller

The fundamental difference between rangefinder cameras like the Leica M5 and single-lens reflexes like the Leicaflex SL is in their viewfinder images. To the Leica photographer, using the viewfinder is like looking through a window. What he sees is constant, unchanged by the lens he is using, except for the bright lines that show the field of the lens and the boundaries of the picture. The Leicaflex image is made by the lens that takes the picture, and depends on both focal length and diaphragm opening. The image in the Leicaflex viewing screen looks like the actual picture.

In the Leica, everything, near and far, is seen sharply: focusing does not change the sharpness of the viewfinder image. The Leica viewfinder is used for composition by placing objects within the rectangle, but does not provide the visual sense of space supplied by in-and-out-of-focus areas. When using long lenses, the Leica photographer sees a small image framed in the center of the viewfinder.

The Leicaflex SL photographer knows that he will get exactly what he sees in the viewfinder. He sees in terms of selective focus, and can see the color effects and the contrast effects of most filters in the finder. He shoots more slowly than he would with a rangefinder camera, and composes more carefully. Closeups and telephoto shots are framed more accurately and easily with the reflex than with the rangefinder camera.

But the viewing system is not the only difference between the Leica and the Leicaflex.

Lenses

The same range of focal lengths, from 21mm to 800mm, is available in lenses for both cameras; but reflex and rangefinder-camera lenses have different optical formulas. Lenses for the Leicaflex have longer back focus than those for the Leica. This increase in distance between the rear lens element and the focal plane permits adequate mirror clearance in the reflex camera. One ultra-fast lens, the 50mm f/1.2 Noctilux, is available for M Leica rangefinder cameras only. The fastest Leicaflex lens is an f/1.4.

The Leicaflex SL has a depth-of-field preview button that closes the lens diaphragm down to the preset stop, so the subject is seen approximately as it will appear in a photograph taken at that f-stop.

Only the Leicaflex can be used with the 45-to-90mm f/2.8 Angenieux-R zoom lens. This lens has click stops at half-stop intervals down to f/22, and can provide exposure information like a variable-angle light meter, at viewing angles from 4.5 to 8.5 degrees. Its focal length can be changed quickly to any point within a continuous range, with no need to reset focus or exposure.

Another special Leicaflex lens is the 35mm f/4 PA Curtagon-R, which permits up to 7mm of lateral, vertical or diagonal displacement of the lens axis in any direction through 360°. This provides a "rising-and-falling front" facility like that of a view camera, and is especially useful for preventing perspective distortions such as converging vertical lines in architectural photography.

Because the Leicaflex shows the photographer exactly what the lens is "seeing," and because of its extended focusing range, the reflex is the logical camera for telephoto and closeup work. In the macro range, Elpro attachments facilitate very close focusing, and provide optimum correction, each within a specific closeup focusing range.

The Leica is preferable for photomicrography and most scientific photography. Viewing is through the microscope itself, or on a groundglass focusing screen in the Visoflex attachment.

Lens interchangeability

Except for lenses designed for the Visoflex, M Leica lenses cannot be used on the Leicaflex SL. However, the Leica-to-Leicaflex Lens Adapter not only fits Visoflex lenses to the Leicaflex, but adapts the Leica Focusing Bellows II to the Leicaflex. Adapter No. 14,167 is for the Leicaflex SL; No. 14,127* (the asterisk is part of the catalog number) is usable on both the standard Leicaflex and the Leicaflex SL.

Focusing

Photographic subjects fall within four principal focusing ranges: closeup, medium, medium telephoto, and extreme telephoto. Most pictures are taken in the medium and medium-telephoto ranges, where Leica rangefinder cameras work best. For closeups and far-off subjects, the Leicaflex excels.

For easy and positive focusing, the Leica M5 is superior to the Leicaflex SL, especially in dim light. The M5's long-base (68.5mm) coupled rangefinder combines the split-image and coincidence methods of determining focus. The eye can judge when the ends of a broken line are brought together (as in the

Leica rangefinder) more easily than it can see when the image on a microprism screen is sharply focused (as in the Leicaflex SL). When the eye tires, it becomes relatively difficult to focus a single-lens reflex camera accurately, especially in dim light conditions.

Photographers with faulty eyesight will have more trouble focusing a reflex than a rangefinder camera; but corrective lenses, available for both Leica and Leicaflex viewfinder eyepieces, help solve this problem. They are available in strengths from -2.5 to +2.5 diopters. When they are attached, the photographer can use the camera without eyeglasses.

Framing in the viewfinder

When a 35mm, 50mm, 90mm or 135mm lens is used on the Leica M5, bright lines showing the picture area for that lens appear automatically in the viewfinder, and shift automatically to correct for parallax when the camera is focused.

A field-of-view selector permits pre-selection of focal length without first changing the lens.

For closeup and long-lens work, the Visoflex III attachment provides parallax-free viewing and focusing through the lens with the rangefinder Leica.

The all-microprism viewing screen of the Leicaflex SL has exactly the format (23x35mm) of a standard cardboard-mounted color slide, and is free from parallax. Focusing is done through the wide-open lens, so that the brightest image, with the minimum depth of field, is seen in the viewing screen.

Shutter speeds

The Leica M5 has shutter speeds from ½ second to 1/1000 second; the Leicaflex shutter ranges from 1 second to 1/2000. Both have a ''bulb'' (B) setting for time exposures. On the M5, this is calibrated, for metering purposes, for manually-controlled bulb exposures from 1 to 30 seconds.

Noise and vibration.

The Leicaflex is a notably quiet SLR, and the vibration caused by its shutter, mirror and auto-aperture complex is efficiently damped. The M Leica is even quieter—one of the most nearly silent cameras with a focal-plane shutter.

Self-timer

The Leica M5 self-timer has variable 8-to-10-second delay: the Leicaflex SL, a 6-to-10-second delay.

Metering

Both the Leicaflex SL and the Leica M5 have accurate through-the-lens CdS meters, coupled to their shutters. In the Leicaflex SL, the meter is also coupled to the automatic diaphragm. With both cameras, light readings can be made and exposure set without taking the eye from the viewfinder.

The M5 meter can be used either to find the correct shutter speed to match a preset f-stop, or to find the f-stop that matches a preset shutter speed. The M5 meter *cannot be used with the following lenses:* 21mm Super Angulon f/4 and f/3.4 lenses, and 28mm f/2.8 Elmarit lenses with serial numbers below 2,314,920. 28mm f/2.8 Elmarit lenses with serial numbers above 2,314,920 have been redesigned for the M5, and metering is normal. The Leica M5 meter is used at the taking aperture (a rangefinder camera needs no automatic diaphragm).

Leicaflex SL metering is done primarily at full aperture, though stopped-down metering is possible with non-automatic lenses. All Leicaflex SL lenses can be used with the SL meter; but earlier Leicaflex lenses should be factory modified for convenient SL metering. (For details, see the chapter, ''Handling the Leica and Leicaflex,'' by Rüdiger Krauth.)

Battery drain

The Leica M5 meter battery is switched off automatically after each exposure. Winding the film and shutter switches it on again. In the Leicaflex SL, the current is cut off when the film-advance lever is folded forward above the camera body, and turned on by pulling the lever back to its working position just behind the camera body.

Flash synchronization

The Leica M5 synchronizes with electronic flash at speeds up to 1/50 second (shown by a dot between ''30'' and ''60'' on the shutter dial), and with flashbulbs (except AG and class M bulbs) at all speeds up to 1/500 second.

The Leicaflex SL synchronizes with electronic flash at speeds up to 1/100 second (shown by a lightning-bolt symbol between ''60'' and ''125'' on the shutter dial). Flashbulb synchronization is up to 1/30 second with M2 bulbs; up to 1/60 with AG bulbs and flashcubes; up to 1/125 with XM and PF 1B and 5B bulbs; and up to 1/250 second with GE5, 25, and M3 bulbs, and PF60B bulbs.

Size and weight

Leica M5 with 50mm f/2 lens: weight, 955 grams (33.4 ounces); length, 154mm (6.06 inches); height, 88mm (3.46 inches); body thickness, 33mm (1.30 inches).

Leicaflex SL with comparable lens: weight, 1185 grams (41.5 ounces); length, 149mm (5.86 inches); height, 96mm (3.78 inches); body thickness, 56mm (2.19 inches).

Film loading and unloading

In the Leica M5 quick-loading system, the baseplate of the camera is removed and the film end is inserted in the prongs of a special takeup spool, which can be removed from the camera. Thus film that breaks free from its cartridge can be unloaded without difficulty in the darkroom, and the takeup spool can be re-positioned at any time for easy loading. A hinged section of the back permits inspection of the loading process.

The rewind crank is set into the camera baseplate, and is ratcheted to turn only in the rewind direction. The Leica M5 rewind-crank handle must be folded before the film can be advanced.

The Leicaflex SL has a conventional hinged back, which is swung open for loading and unloading. In loading, the film end is fitted into a multi-slotted takeup spool which is fixed permanently in place.

To rewind the Leicaflex SL, depress the button on the camera bottom to release the sprocket, and turn the rewind crank, located conventionally on top of the camera body.

Motorization

Neither the Leica M5 nor the standard Leicaflex SL can be motorized. However, a special model of the reflex camera, the Leicaflex SL-Mot, designed for use with its own specially-made motor drive, can be used either manually or in the motorized mode.

Cold-weather operation

Both the Leica M5 and the Leicaflex SL function well in moderately cold climates. For extended use in extreme cold, the camera should be "winterized" by having all lubrication removed. On returning to a normal climate, the unit must be relubricated. The Leica is somewhat preferable for arctic use because it has fewer moving parts than the Leicaflex.

The exposure automation systems of both the Leica M5 and the Leicaflex SL perform well in cold weather, but meter operation may be affected by decreased current supply at temperatures below 5°F.

Leica or Leicaflex?

The choice of a camera logically depends on the types of pictures the photographer intends to make.

If he prefers to compose carefully on a ground-glass, his choice will be the Leicaflex SL, which gives a fully accurate visual impression of the final photo-graph in its viewfinder. The momentary blackout of the viewfinder when the shutter is released is so brief that it is unimportant except during rapid shooting.

If the photographer needs a compact, lightweight, fast-focusing camera, the rangefinder Leica is pre-ferred (most photojournalists use rangefinder cameras, though many also carry a single-lens reflex).

Switching from one type of camera to the other is a vision-stretching experience for any photographer, for it extends his range, both of subjects and of their interpretation.

The rangefinder-camera photographer who looks through a Leicaflex SL viewfinder discovers that focusing and defocusing can make subject areas blend and overlap, and that changing the aperture produces a wide range of different effects. The range closer than three feet is virtually *terra incognita* to most rangefinder-camera users; but with a reflex camera and a macro lens or closeup accessories, a new closeup world opens, and the photographer finds subjects he never noticed before.

The reflex user who switches to a rangefinder camera learns that rapid and positive focusing and fast shooting enable him to snare subjects and situa-tions that were formerly beyond his scope. He devel-ops a sense of timing that helps him photograph seg-ments of life at which he had not previously aimed his lens as they flashed past.

There are specific advantages to using either the Leica rangefinder camera or the Leicaflex, but both cameras attain a standard of mechanical and optical precision that challenges any photographer's ability.

Rangefinder or reflex? Today's complete photo-grapher knows when to use each type of camera, and owns both.

Lens comparison chart

Focal length	Leica M5	Leicaflex SL
21mm	*Super Angulon f/3.4 (no metering)*	*Super Angulon-R f/4 (auto aperture)*
28mm	*Elmarit f/2.8 (above Serial No. 2,314,920, metering)*	*Elmarit-R f/2.8 (auto aperture)*
35mm	*Summicron f/2*	*Elmarit-R f/2.8 (auto aperture)*
	Summilux f/1.4	*Summicron-R f/2 (auto aperture)*
		PA Curtagon-R f/4 (manual aperture: 7mm shift of optical axis in any direction for perspective control)
45mm-90mm zoom		*Angenieux-R f/2.8 zoom*
50mm	*Elmar f/2.8*	*Summicron-R f/2 (auto aperture)*
	Summicron f/2	*Summilux-R f/1.4 (auto aperture)*
	Dual-Range Summicron F/2 (must be modified by Leitz for M5 use)	
	Summilux f/1.4	
	Noctilux f/1.2	
60mm		*Macro-Elmarit-R f/2.8 (auto aperture with and without use of extension tube supplied with lens)*
65mm	*Elmar f/3.5 lens head (Visoflex II or III)*	

Focal length	Leica M5	Leicaflex SL
90mm	Tele-Elmarit f/2.8 (short mount)	Elmarit-R f/2.8 (auto aperture)
	Elmarit f/2.8	Summicron-R f/2.8
	Summicron f/2	
100mm		Macro-Elmar f/4 (Focusing Bellows-R)
135mm	Tele-Elmar f/4	Elmarit-R f/2.8 (auto aperture)
	Elmarit f/2.8	
180mm		Elmarit-R f/2.8
200mm	Telyt f/4 (Visoflex II or III)	
250mm		Telyt-R f/4 (auto aperture)
280mm	Telyt f/4.8 (Visoflex II or III)	Telyt f/4.8 head only (Televit-R)
400mm	Telyt f/6.8 (Visoflex II or III)	Telyt-R f/6.8
	Telyt f/5.6 head only (Televit on Visoflex)	Telyt f/5.6 head only (Televit-R)
560mm	Telyt f/6.8 (Visoflex II or III)	Telyt-R f/6.8
	Telyt f/5.6 head only (Televit on Visoflex)	Telyt f/5.6 head only (Televit-R)
800mm	Telyt-S f/6.3 (with bayonet for Visoflex III)	Telyt-S "R" f/6.3

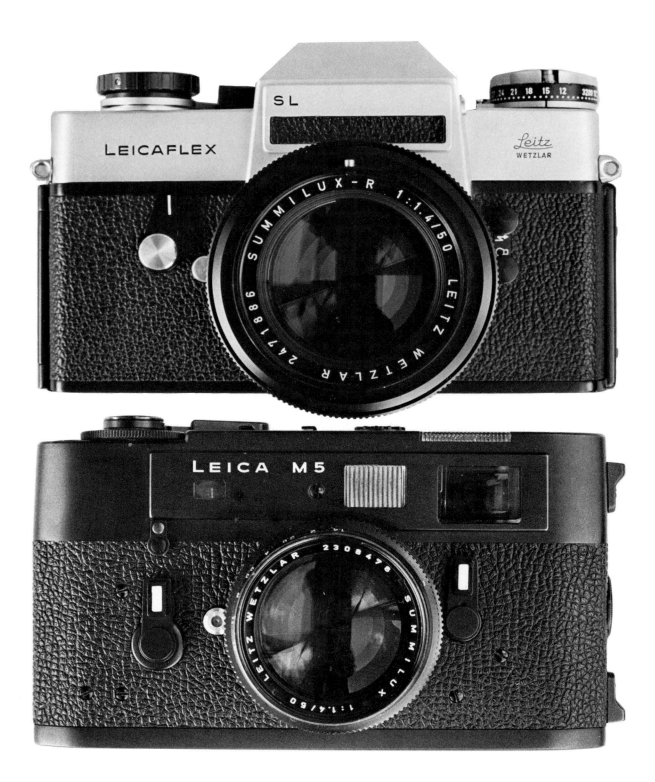

Handling the Leica and Leicaflex

Rüdiger Krauth

When you hold any Leitz camera in your hand, you admire its precision and craftsmanship. They are the same that go into Leitz microscopes and precision instruments. Made for professional use, these cameras stand up to the roughest treatment.

But buying a high-quality camera does not automatically make your pictures good. The Leica or Leicaflex can only give you the best results when you know how to handle it.

Begin by reading the instruction book: then your first roll of film won't come back blank because you loaded it wrong.

If you are new to photography, I suggest that you play with your new camera for ten minutes every day for a month, following the instruction book page by page. After this period of practice, you will be able to adjust the camera instantly to any setting. Then you are really ready to take pictures. As long as you have to worry about whether you've set the right f-stop, shutter speed, or focus, you can't concentrate on the picture. Even if you have done everything right, but aren't sure of it, nervousness can make you shoot unsteadily and get unsharp pictures. Therefore, practice with the empty camera until you have mastered it.

Basic camera controls

Once a camera can be aimed in the right direction and held at the distance from the subject that will produce the picture you want, the three other adjustments that control the picture are the same ones that were built into the first Leicas—*variable shutter speeds, variable-sized lens apertures,* and *variable focus.*

The shutter speeds control the time during which light from the lens strikes the film to form the image. Other things (light, aperture and film speed) being equal, the longer the shutter is open, and the slower the shutter speed, the more the film will be exposed.

The lens aperture controls the amount of light that can pass through the lens at one time. Other things (light, shutter speed and film speed) being equal, the larger the lens opening, the more light passes through it to the film, and the more the film is exposed.

Leica and Leicaflex lens apertures are calibrated in standard *f-stops,* marked on a ring around the lens barrel. Each f-number represents the diameter of the lens opening as a fraction of the lens-to-film dis-

tance; at f/8, the diameter is 1/8th the lens-to-film distance; at f/16, 1/16th, and so on. The larger the f-number, the smaller and "slower" the lens opening.

Each numbered f-stop admits twice as much light at a time as the next smaller stop, and half as much light as the next larger stop: f/8, for example, is twice as "fast" as f/11, but only half as fast as f/5.6.

Standard f-stops used on Leitz cameras currently appear in the following range, from "slow" to "fast":

f/32 (long lenses only)	f/5.6
f/22	f/4
f/16	f/2.8
f/11	f/2
f/8	f/1.4

Each of these apertures is twice as fast—lets in twice as much light at a given exposure time—as the one before it. Such numbers as f/3.4, f/4.8 and f/1.2 are not considered "full f-stops," but represent intermediate values.

To set the aperture on Leica and Leicaflex lenses, turn the aperture ring until the desired f-number is opposite the aperture-scale mark. If you look into the front of a Leica lens, you can see the leaves of the iris diaphragm move to open or close the aperture as you set it. (Leicaflex lenses remain fully open until the moment of exposure unless you press the Leicaflex SL preview button to close them manually.) Current Leitz lenses typically have a click stop for every marked f-number; some have additional half-stop values for 50% exposure adjustments.

The focusing scale or *distance scale* on Leica and Leicaflex lenses, calibrated in feet and meters, indicates the focusing range of the lens when it is mounted normally on the camera. The Leica is usually focused with the rangefinder, and the Leicaflex is usually focused by bringing the finder image to the greatest possible sharpness, but these cameras may also be focused using the distance scale on the lens, setting it to match a measured or estimated camera-to-subject distance.

The depth-of-field scale. Camera-mounted Leica and Leicaflex lenses have depth-of-field scales engraved on their mounts.

A lens focuses for maximum sharpness on only one distance at a time. Nearer and more distant objects are rendered less sharply in the picture.

However, a slight degree of unsharpness goes unnoticed in a normal-sized print, and the viewer accepts it as sharp. The distance range within which this happens is called the *depth of field.*

The depth-of-field scale shows the zone of acceptable sharpness at any lens aperture and any focused distance within the normal range of the lens. The larger the aperture and the closer the distance, the shallower the depth of field will be; that is, visible sharpness falls off more rapidly and drastically for objects nearer and farther away than the distance focused upon. Thus aperture is not only a speed control for exposure, but a visual control that lets you choose relative degrees of sharpness and unsharpness in different parts of the picture.

The depth-of-field scale is easy to use. An aperture scale is engraved on each side of the center mark that shows the point of sharpest focus. Large stops are near the center, and smaller stops are progressively farther from the center. With the lens focused at any point on the scale, you can read off the depth of field directly for any f-stop. The distance numbers opposite the chosen f-number on the near and far sides of the scale show the near and the far zones of acceptable sharpness at that stop and distance setting.

Because small apertures provide great depth of field with the relatively short lenses normally used in 35mm photography, the concept of *hyperfocal distance* is useful to the Leica or Leicaflex photographer.

The hyperfocal distance, at any f-stop, is that focusing distance which brings the infinity mark to the f-number of that stop on the depth-of-field scale. For example, when a 50mm lens is focused at 15 feet, the infinity mark reaches f/16 on the "far" side of the depth scale; and the distance opposite f/16 on the "near" side of the scale is 8 feet. Thus the scale tells us that everything farther away than eight feet will be rendered with acceptable sharpness when the lens is set at f/16 and focused at the hyperfocal distance for f/16, which is 15 feet. At f/8, as the scale shows, the depth of field is shallower. When infinity is set at f/8 on the scale, the near point opposite f/8 is about 15 feet, and the hyperfocal distance for a 50mm lens at f/8 is about 26 feet.

Within this range from 15 feet to infinity, with the 50mm lens, "everything is sharp" for most picture-taking purposes. There is no need to fine-focus with this distance range. The same principle applies to the hyperfocal distances of all conventional lenses at all their apertures, which is very convenient when you must shoot in a hurry or under difficult working conditions.

For detailed discussions of aperture, focus, and depth of field, see the chapter, "Photographic Optics," by Dr. Rudolf Kingslake.

Unlike earlier Leicas, the M5 hangs vertically from its strap

Handling the Leica and Leicaflex

Rüdiger Krauth

When you hold any Leitz camera in your hand, you admire its precision and craftsmanship. They are the same that go into Leitz microscopes and precision instruments. Made for professional use, these cameras stand up to the roughest treatment.

But buying a high-quality camera does not automatically make your pictures good. The Leica or Leicaflex can only give you the best results when you know how to handle it.

Begin by reading the instruction book: then your first roll of film won't come back blank because you loaded it wrong.

If you are new to photography, I suggest that you play with your new camera for ten minutes every day for a month, following the instruction book page by page. After this period of practice, you will be able to adjust the camera instantly to any setting. Then you are really ready to take pictures. As long as you have to worry about whether you've set the right f-stop, shutter speed, or focus, you can't concentrate on the picture. Even if you have done everything right, but aren't sure of it, nervousness can make you shoot unsteadily and get unsharp pictures. Therefore, practice with the empty camera until you have mastered it.

Basic camera controls

Once a camera can be aimed in the right direction and held at the distance from the subject that will produce the picture you want, the three other adjustments that control the picture are the same ones that were built into the first Leicas—*variable shutter speeds, variable-sized lens apertures,* and *variable focus.*

The shutter speeds control the time during which light from the lens strikes the film to form the image. Other things (light, aperture and film speed) being equal, the longer the shutter is open, and the slower the shutter speed, the more the film will be exposed.

The lens aperture controls the amount of light that can pass through the lens at one time. Other things (light, shutter speed and film speed) being equal, the larger the lens opening, the more light passes through it to the film, and the more the film is exposed.

Leica and Leicaflex lens apertures are calibrated in standard *f-stops*, marked on a ring around the lens barrel. Each f-number represents the diameter of the lens opening as a fraction of the lens-to-film dis-

tance; at f/8, the diameter is 1/8th the lens-to-film distance; at f/16, 1/16th, and so on. The larger the f-number, the smaller and "slower" the lens opening.

Each numbered f-stop admits twice as much light at a time as the next smaller stop, and half as much light as the next larger stop: f/8, for example, is twice as "fast" as f/11, but only half as fast as f/5.6.

Standard f-stops used on Leitz cameras currently appear in the following range, from "slow" to "fast":

f/32 (long lenses only)	f/5.6
f/22	f/4
f/16	f/2.8
f/11	f/2
f/8	f/1.4

Each of these apertures is twice as fast—lets in twice as much light at a given exposure time—as the one before it. Such numbers as f/3.4, f/4.8 and f/1.2 are not considered "full f-stops," but represent intermediate values.

To set the aperture on Leica and Leicaflex lenses, turn the aperture ring until the desired f-number is opposite the aperture-scale mark. If you look into the front of a Leica lens, you can see the leaves of the iris diaphragm move to open or close the aperture as you set it. (Leicaflex lenses remain fully open until the moment of exposure unless you press the Leicaflex SL preview button to close them manually.) Current Leitz lenses typically have a click stop for every marked f-number; some have additional half-stop values for 50% exposure adjustments.

The focusing scale or *distance scale* on Leica and Leicaflex lenses, calibrated in feet and meters, indicates the focusing range of the lens when it is mounted normally on the camera. The Leica is usually focused with the rangefinder, and the Leicaflex is usually focused by bringing the finder image to the greatest possible sharpness, but these cameras may also be focused using the distance scale on the lens, setting it to match a measured or estimated camera-to-subject distance.

The depth-of-field scale. Camera-mounted Leica and Leicaflex lenses have depth-of-field scales engraved on their mounts.

A lens focuses for maximum sharpness on only one distance at a time. Nearer and more distant objects are rendered less sharply in the picture.

However, a slight degree of unsharpness goes unnoticed in a normal-sized print, and the viewer accepts it as sharp. The distance range within which this happens is called the *depth of field*.

The depth-of-field scale shows the zone of acceptable sharpness at any lens aperture and any focused distance within the normal range of the lens. The larger the aperture and the closer the distance, the shallower the depth of field will be; that is, visible sharpness falls off more rapidly and drastically for objects nearer and farther away than the distance focused upon. Thus aperture is not only a speed control for exposure, but a visual control that lets you choose relative degrees of sharpness and unsharpness in different parts of the picture.

The depth-of-field scale is easy to use. An aperture scale is engraved on each side of the center mark that shows the point of sharpest focus. Large stops are near the center, and smaller stops are progressively farther from the center. With the lens focused at any point on the scale, you can read off the depth of field directly for any f-stop. The distance numbers opposite the chosen f-number on the near and far sides of the scale show the near and the far zones of acceptable sharpness at that stop and distance setting.

Because small apertures provide great depth of field with the relatively short lenses normally used in 35mm photography, the concept of *hyperfocal distance* is useful to the Leica or Leicaflex photographer.

The hyperfocal distance, at any f-stop, is that focusing distance which brings the infinity mark to the f-number of that stop on the depth-of-field scale. For example, when a 50mm lens is focused at 15 feet, the infinity mark reaches f/16 on the "far" side of the depth scale; and the distance opposite f/16 on the "near" side of the scale is 8 feet. Thus the scale tells us that everything farther away than eight feet will be rendered with acceptable sharpness when the lens is set at f/16 and focused at the hyperfocal distance for f/16, which is 15 feet. At f/8, as the scale shows, the depth of field is shallower. When infinity is set at f/8 on the scale, the near point opposite f/8 is about 15 feet, and the hyperfocal distance for a 50mm lens at f/8 is about 26 feet.

Within this range from 15 feet to infinity, with the 50mm lens, "everything is sharp" for most picture-taking purposes. There is no need to fine-focus with this distance range. The same principle applies to the hyperfocal distances of all conventional lenses at all their apertures, which is very convenient when you must shoot in a hurry or under difficult working conditions.

For detailed discussions of aperture, focus, and depth of field, see the chapter, "Photographic Optics," by Dr. Rudolf Kingslake.

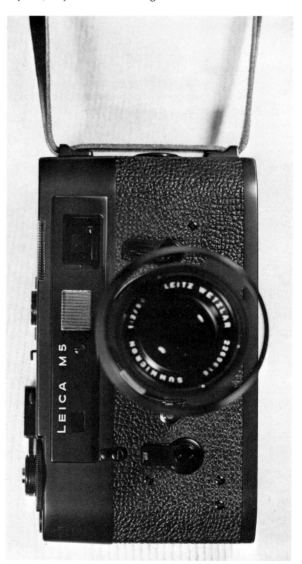

Unlike earlier Leicas, the M5 hangs vertically from its strap

The sturdy, simple strap fittings on the M5; the battery cover is under the strap

The meter cell of the M5 on its arm. Pressing the shutter release, or removing the lens from the camera, swings it out of sight. Some lens heads, such as the 50mm Summicron f/2, may be removed from their focusing mounts. When an empty lens mount, or a screw-to-bayonet adapter is in place—as here— the meter cell may be seen in its metering position. Do not touch!

THE LEICA M5

The Leica M5, introduced in 1971, is still what Leicas have been since 1932—a rangefinder camera that combines the highest optical and mechanical standards with the greatest ease of handling. It is the first rangefinder camera to combine interchange-lenses with a through-the-lens metering system.

The M5 has a rugged die-cast chassis like those of earlier M Leicas, redesigned and slightly enlarged to accommodate the metering system. It remains a compact and handy camera that can use most of the earlier M-Leica lenses and accessories.

With the 50mm f/2 Summicron lens in place, it weighs 955 grams (just over two pounds), measures 154mm (6.06 inches) long, 88mm (3.46 inches) high, with the standard M-Leica body thickness of 33mm (1.30 inches). It is available in black, chrome or white.

Among its design innovations is the new location of the carrying-strap lugs at the left end of the camera to leave the controls at the right end completely clear. This makes the camera hang vertically rather than horizontally when worn. The rapid-rewind crank has been moved to the left end of the camera baseplate. A less obvious change is that the finish of black M5s is now black chromium, far more durable than the black enamel used previously.

Features of the Leica M5

Interchangeable lenses. The M5 is part of the Leica system. All M5 lenses can be used on any M Leica, and most earlier M-Leica lenses can be used on the M5 without modification.

Bayonet-mount M5 lenses of 21mm to 135mm focal length mount directly on the camera. The Viso-flex III attachment adapts the camera for closeup work and accepts tele lenses up to 800mm in focal length.

The fastest M5 lens is the 50mm f/1.2 Noctilux.

All non-collapsible screw-mount Leica lenses of 35mm to 135mm focal length can be adapted to the M5 and permit normal focusing and metering.

M5 metering is not possible with 21mm lenses, nor with 28mm f/2.8 Elmarit lenses with serial numbers below 2,314,921. (These 28mm lenses must be modified before they can be used on the M5 at all, and at no time will they permit use of the M5 meter.) 28mm f/2.8 Elmarits with serial numbers above 2,314,920 have been redesigned for the M5 and permit normal metering.

The range-viewfinder. In rangefinder cameras, the magnification in the viewfinder remains constant regardless of the focal length of the lens being used (with a few exceptions in the cases of special tele and wide-angle auxiliary finders and certain lenses that have optical attachments built into their mounts).

The M5 range-viewfinder system is like that of the Leica M4, modified to incorporate coupled-light-meter data, the shutter speed, and the metering field of the lens in the viewfinder image, as well as the field of view of the lens and the central rangefinder spot.

Shutter speeds. The focal-plane shutter of the M5 has an almost uninterrupted continuous range of speeds from 1/2 second to 1/1000th. The only gap is between 1/30 and 1/60 second. Otherwise, intermediate speeds can be set at will. For time exposures longer then 1/2 second, the shutter is set at B ("bulb") and the time is controlled manually by first opening, then closing the shutter. The calibrated range from 1 second to 30 seconds in the B section of the shutter-speed selector ring is not linked to the shutter, but is purely for metering purposes.

The built-in light meter can be used with any lens, built for the M5, of longer than 21mm focal length. Film-speed settings on the meter comprise a ten-

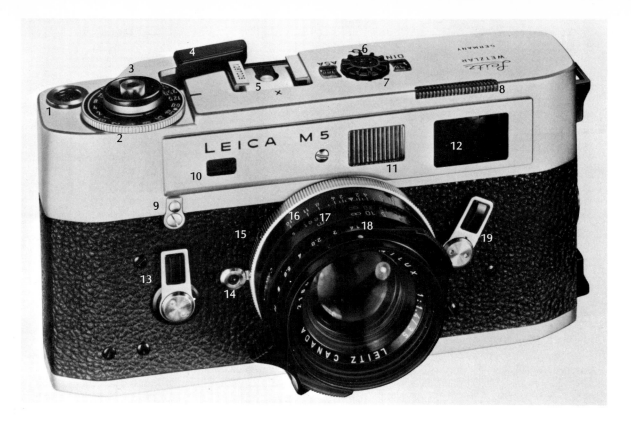

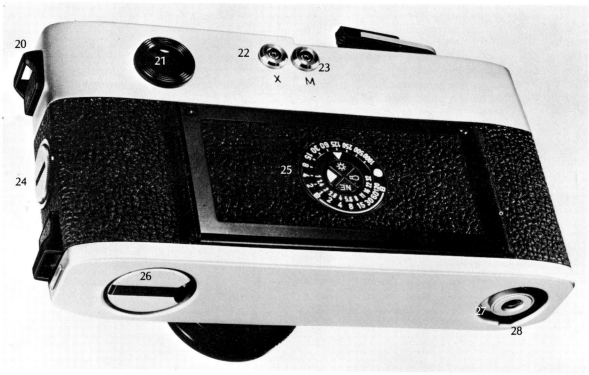

step range, in which each number represents twice or half the speed of the next number. The meter is coupled to the film-speed scale and to the shutter-speed selector. Readings are made through the camera lens at the working aperture.

This metering system is similar to that of the Leicaflex SL. An 8mm-diameter double cadmium-sulfide resistor is located on a carrier arm in the center of the lens field, 8mm in front of the film plane. When the shutter release is pressed, or when no lens or a non-metering lens is mounted on the camera, the CdS-cell carrier arm swings down parallel to the shutter curtain and "hides" in a recess below the shutter opening. (Never touch the carrier arm, which is extremely sensitive.)

Leica M5 parts and controls

1. Automatic frame counter
2. Shutter-speed selector ring
3. Shutter-release button
4. Rapid transport lever
5. Accessory shoe, with X flash contact
6. Film-plane indicator mark
7. Film-speed scales (ASA and DIN)
8. Illumination window for meter readout in viewfinder
9. Film rewind release lever
10. Rangefinder window
11. Illumination window for viewfinder frame lines
12. Viewfinder window
13. Self-timer lever
14. Lens-mount bayonet lock
15. Red locating protrusion for lens insertion
16. Depth-of-field scale
17. Focusing scale with distances in feet and meters
18. Lens aperture scale
19. Field-of-view preselector lever and battery-test lever
20. Strap fittings
21. Range-viewfinder eyepiece
22. X-synchronization contact for electronic-flash and short-peak flashlamps
23. M-sync contact for medium-peak flashbulbs
24. Battery cover plate
25. Film-type reminder and aperture/speed calculator dial
26. Folding film rewind crank
27. 1/4-inch tripod bushing
28. Baseplate lock

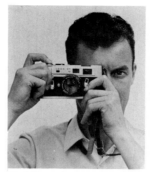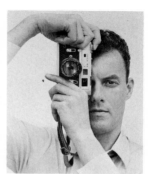

Holding the M5

Holding the M5

Horizontal position. Hold the camera in your right hand, with your thumb against the transport lever and your index finger touching, *but not pressing,* the shutter-release button (a light pressure is enough to swing the meter-cell carrier arm out of its central position, which would cause a false light reading). The right index finger moves forward to turn the milled edge of the shutter-speed selector dial during metering. The left hand holds the lens from below and controls the focusing ring and the aperture ring. Both hands press the camera against the forehead for steadiness, with the right eye at the finder window. Be careful not to cover the rangefinder window accidentally with the second finger of your right hand.

Vertical position. Without changing the placement of your hands on the camera controls, raise your right hand and move your left hand below it until the camera is vertical. Then it is quick and easy to change back and forth between horizontal and vertical shots.

Loading and unloading the Leica M5

The M5 uses only standard 35mm cartridges with a key at the bottom or long end of the film spool, which is engaged by the camera's rewind mechanism. (Leitz "N" cassettes cannot be used in the M5.)

With bulk-loaded film, there is no need to cut the leader of each roll into the standard tongue. The M5 takeup spool accepts the full width of the film.

Before loading, make sure the camera is empty by unfolding the *rewind crank* (26) on the baseplate and turning it in the direction of the pointer. Do not force it. If you feel resistance, there is film in the

The rewind crank is on the baseplate of the M5, and the rewind release lever is below the rangefinder window

Loading the M5

camera. This must be rewound and unloaded before you can put in fresh film.

To rewind, first turn the *film-rewind release lever* (9) downward. Unfold the rewind crank (26) and turn it until you feel a slight resistance; after one more turn, you will feel the film disengage from the take-up spool, which ends its resistance. To make sure the film is fully rewound, fold the rewind crank, then cock the camera with the *transport lever* (4) and release it by pressing the *shutter-release button* (3) once or twice, while you watch the rewind crank. If the crank turns, the film is not fully rewound. If it does not turn, you can open and unload the camera.

With the camera bottom up, unfold the *baseplate*

lock (28) and turn it to the left. Remove the baseplate. If there is rewound film in the camera, remove it.

Insert the new film cartridge in the empty chamber at the left and put the film leader into one of the three slots in the takeup spool, following the diagram on the bottom of the open camera.

Do not press the film too far down into the takeup spool, or it will jam. The baseplate will automatically push the film end into proper alignment.

Be sure to close the hinged back before you put the baseplate back on the camera.

To replace the baseplate, first engage it to the stud at the left end of the camera, near the strap fitting, then close the other end and lock it by turning the baseplate lock (28) to the right and folding it into its recess.

After you lock the baseplate, cock the camera once, then unfold the rewind crank (26) and turn it until you feel resistance. This takes up any slack in the film.

To make sure the film is loaded properly, fold the rewind crank flat into its recess, then release and cock the camera twice more. Watch the rewind crank, which will turn counterclockwise if the film is advancing as it should. (If it doesn't turn, open the camera and load it again.)

With the third stroke after the baseplate is locked on, the frame counter is at "1" and your M5 is ready for its first picture.

Caution: It is essential to fold the rewind crank before you cock the camera. When the crank is extended, the film spool is locked so it cannot turn, and cocking the camera will tear the perforations but the film will not advance.

The range-viewfinder system

The M5 range-viewfinder has the same 68.5mm base length (distance from viewing window to rangefinder window) and the same 0.72 magnification as that of the Leica M5. Objects are seen in the finder at about 3/4 the size they appear to the unaided eye.

Bright frame lines that compensate automatically for parallax when the camera is focused show the fields covered by 35mm, 50mm, 90mm and 135mm lenses. (Parallax is the discrepancy caused by the difference in viewing position between the taking lens of the camera and the viewfinder window.) Mounting a lens brings the correct bright frame lines

into the finder, as follows: 50mm lens, 50mm frame only; 90mm lens, 90mm frame only; 35mm or 135mm lens, a combined display of the small 135mm field corners inside the 35mm frame.

The primary purpose of the central rangefinder spot is for focusing, but it also indicates the metering field of lenses longer than 90mm.

When you look at the bottom of the finder, below the picture area, you can see the shutter speed that is set on the camera, displayed at the left of the bright meter-readout bar.

The *field-of-view preselector lever* (19), to the left of the lens on the front of the camera, serves as a built-in variable viewfinder. When you move the lever toward the lens mount, only the 90mm frame is seen, no matter what lens is mounted on the camera. When the lever is upright, only the 50mm frame is visible in the finder, and when the lever is moved away from the lens, the combined 35mm-135mm frames are seen. (Moved still farther away from the lens, this lever acts as a battery tester.) This variable frame selector lets you choose the focal length you want before you change lenses.

Focusing. Because the eye can distinguish lines and contours more quickly and easily than it can see the differences between degrees of sharpness and unsharpness, the rangefinder system provides more rapid and positive focusing than the reflex system. The rangefinder camera is the logical choice for action photography and for precise focusing with wide-angle lenses.

The measuring field of the M5 rangefinder is the round-ended bright oblong centered in the finder. When you cover the viewfinder window (12) and look into the eyepiece, you see the bright frame for the lens that is on the camera and a small, clear, single image of the subject in front of the camera, surrounded by darkness. The clear single image from the rangefinder window alone does not mean that the object is in focus. When you uncover the view-finder window, you will recognize a double image of the object unless the camera is focused on it.

When you see a double image in the rangefinder, the object seen there is out of focus. To bring it into focus, simply turn the focusing ring or lever on the lens until the two images merge into one. This is the *coincidence* system of rangefinder focusing.

You will not always see a double image of an out-of-focus subject in the rangefinder. For instance, if

The field-of-view preselector lever.
Top: lever nearly upright—50mm lens
Center: lever toward lens—90mm lens
Bottom: lever away from lens—35mm or 135mm lens
(both fields are seen together in the finder)

Double image: out of focus

Merged image: in focus

Focusing with the Leica M5 rangefinder: left, by coincidence; right, split-image focusing

the camera is focused at three feet and the subject requires infinity focus, the secondary rangefinder image may be outside the rangefinder field. Then when you turn the focusing ring, the double image will first come into view, and then, when focus is achieved, the two images will come together.

The meter and the finder. The measuring angle of the M5 meter varies with the focal length of the lens, and is shown in the finder. Wide-angle lenses meter larger areas than longer lenses. The marks that show the metering areas of the different lenses are:

Lens focal length	Metering area marks	Light-measuring coverage angle (approximate)
28mm	90mm lens frame	22.6°
35mm	135mm lens frame	16.9°
50mm	four arcs of circle inside 50mm lens frame	10.4°
90mm	focusing patch of rangefinder	5.6°
135mm	focusing patch of rangefinder	3.6°

For any lens longer than 135mm, use the focusing patch as your metering guide mark. The rule for identifying the metering area of the lens you are using is, "after the lens field, the next smaller area shown in the finder is the metering area."

Metering is done on a readout bar at the bottom of the finder image. You match a movable vertical crossbar (controlled by the light and by the lens aperture) to a movable diagonal crossbar (controlled by the shutter-speed dial) so they meet where they cross a horizontal centerline in the readout bar.

Basic controls of the Leica M5

The M5 shutter-speed selector ring (2) is new in design. It has click-stop settings from 1/2 second to 1/1000 second, and a bulb (B) setting for time exposures. The fractions of a second of exposure time are represented on the dial by whole numbers:

2 = 1/2 second		60 = 1/60 second	
4 = 1/4	"	125 = 1/125	"
8 = 1/8	"	250 = 1/250	"
15 = 1/15	"	500 = 1/500	"
30 = 1/30	"	1000 = 1/1000	"

Bright-line frame for 90mm lens; metering area is shown by rangefinder spot

M5 bright-line viewfinder frames for 35mm lens (larger outer frame) and 135mm lens (corners in center); the 135mm frame is the metering area for the 35mm lens, and the central rangefinder spot is the 135mm metering area

For lenses longer than 135mm, the metering area is either the rangefinder spot in the M5 finder, or the circle in the Visoflex groundglass. This is the rangefinder spot

Bright-line frame for 50mm lens and arcs of circle indicating metering area

One full second is available by setting the dial at B and tripping the shutter by using the self-timer, but 1/2 second is the slowest speed usable with the normal shutter-release button.

The above speeds are continuously variable on the Leica M5, except between 1/30, the dot that marks the flash-synchronization speed of 1/50 second, and 1/60. Except in this 1/30-1/60 zone, any intermediate setting between numbers can be used.

To set the shutter, use the index finger of the right hand to turn the milled edge of the ring until the desired shutter-speed number is opposite the mark at the left of the dial on top of the camera. The same number also appears in the viewfinder, at the left end of the meter readout bar. (The shutter in the illustration, next page, is set at 1/250 second.)

The "B" numbers, from B1 through B30, stand for whole seconds. They are for metering only. This part of the shutter-speed ring is not coupled to the shutter mechanism, and B exposures must be controlled manually. At any B setting, simply press the shutter-release button in the center of the speed dial to open the shutter; hold it down as long as you want the exposure to last. When you let the button go, the shutter will close. For long time exposures, a tripod and a cable release with a locking device are recommended.

To set the lens aperture, just turn the aperture ring (18) until the desired f-number is at the mark on top

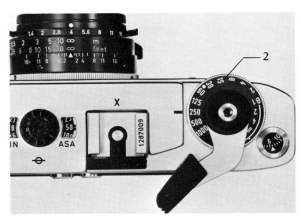

Basic camera controls: shutter speed, aperture, focus

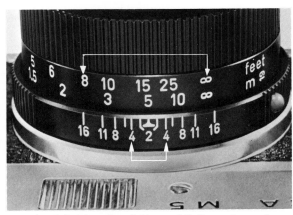

Depth-of-field scale of 50mm f/2 Summicron lens

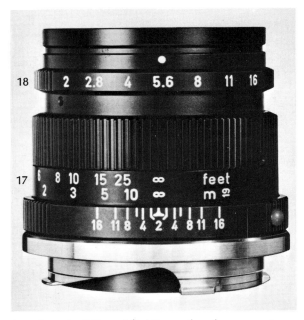

Lens barrel of 50mm f/1.4 Summilux shows aperture scale set at f/5.6, focusing scale set at infinity, depth-of-field scale

of the lens barrel. If you look into the front of the lens, you can see the iris diaphragm that controls the aperture size. (The lens in the illustration is set at f/5.6.)

The focusing scale (17) on the lens is calibrated in feet and meters, and indicates the normal focusing range of the lens. The Leica is normally focused with the rangefinder, but the focusing scale on the lens can be used by turning the focusing ring or lever until the measured or estimated camera-to-subject distance is at the pointer on top of the lens mount. (The lens illustrated is focused at "infinity" or "∞," for a distant subject.)

The depth-of-field scale. All Leica lenses that mount directly on the M5 have depth-of-field scales engraved on their mounts. This scale indicates the zone of generally acceptable sharpness (for normal-sized prints or projected slides) at any lens aperture and focusing distance. The larger the aperture and the closer the working distance, the shallower the depth of field.

The depth scale is easy to use. An f-stop scale reads outward, from large stops to small ones, from the focus point in the middle of the scale. With the lens focused at any point on the scale, you can read off the depth of field directly for any f-stop. The distance numbers opposite the f-numbers on the scale show the zone of acceptably-sharp focus for each f-stop of the lens, from the "near" side of the scale (at the left) to the "far" side (at the right). The 50mm Summicron lens in the illustration, set at f/4 and focused at 5 meters or about 16 feet, will be acceptably "in focus" from 4 meters (13 feet) to about 8 meters (25 feet). At f/16, the same point of focus will give apparent sharpness that extends from about 8 feet to infinity.

The concept of *hyperfocal distance,* as already noted, is useful to the Leica photographer. For any

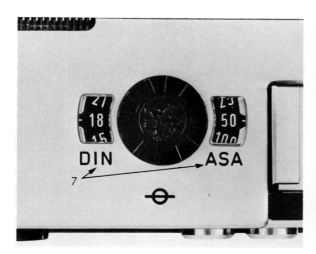

Leica M5 film-speed scale

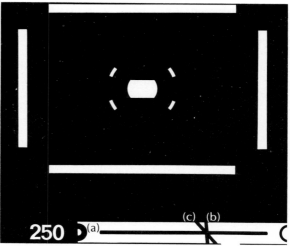

Meter readout for 50mm lens in Leica M5 viewfinder. The shaded circle shows the metering area of this lens

f-number of a lens, this is the focusing distance which brings the infinity mark to that f-number on the depth-of-field scale. At that f-stop-and-distance setting, everything from approximately half the distance focused upon to infinity will be rendered acceptably sharply in the picture. This is a great convenience for rapid shooting or work under difficult conditions.

Setting the film speed

The film-speed scale (7) on top of the Leica M5 must be set correctly for the film you are using, or the meter will not give correct exposures.

The film-speed dial has numbered click-stop settings over a ten-step range, from ASA 6 to ASA 3200, and the equivalent European speeds, DIN 9 to DIN 36, with unnumbered click stops for intermediate film speeds. For instance, if you are using a film rated at ASA 125, turn the film-speed dial one click up (counterclockwise) from the ASA 100 number. The unnumbered setting above 125 is 160, and the next speed is numbered, ASA 200. The click stops are definite, hold firmly, and are easy to set. The film-speed scale in the illustration is set at ASA 50/DIN 18.

Using the M5 light meter

Since the meter is switched off automatically after each exposure, you must cock the camera before you can take a light-meter reading. While you are using the camera, there is no harm in keeping it con-

stantly cocked. Very little current is drawn from the battery. But when you put the camera away, the shutter should be released, as there is no separate off-switch for the meter.

For metering, hold the camera in a horizontal position, with your left hand under the lens to operate the aperture ring. Your right hand controls the shutter-speed selector ring. Now look through the viewfinder, center the subject area you want to read in the metering area (marked with four arcs of a circle in the center of the 50mm frame, for example), then concentrate on the meter readout bar at the bottom of the finder image.

At the left end of the readout bar, you will see the shutter speed (in the illustration, 1/250 second). The "bulb" setting has numbers that represent times from 1 second to 30 seconds, which are not coupled to the shutter. These bulb numbers appear in the finder with the letter B, as follows: B1, B2, B4, B8, B15 and B30.

In the center of the readout bar is a horizontal cross-line (a). The vertical light-meter needle (b) responds to the intensity of the light and is therefore controlled by the aperture setting of the lens, while the diagonal follow-pointer (c) is moved by the ASA/DIN film-speed setting dial and by the shutter-speed dial.

To get the correct exposure for the metered area seen in the viewfinder, just align a, b, and c, as shown

in the illustration. You can either preset the f-stop and follow with the shutter speed, or preset the shutter speed and match the aperture setting to it on the readout bar.

The readout bar is easy to see in the finder when your eye is properly centered. If the tones of the subject tend to make the readout bar hard to see, cover the bottom of the viewfinder window with a finger, and the readout will stand out bright and clear.

Do not put any pressure on the shutter-release button while metering. A light touch on the button swings the meter arm down out of the light path, and the meter needle reacts to this movement. Exact light measurement is only assured when the meter re-sistors are in the correct position, centered on the optical axis of the lens.

It is best to read the light meter first, then disre-gard the readout bar while you release the shutter. To do this, concentrate on the readout bar for meter-ing, then raise or lower the camera slightly until the readout bar is hardly visible. Then focus and shoot. The movement of the needle will go unnoticed, and will not bother you.

The M5 meter is more sensitive in its low range than the one used in the Leicaflex SL: at the time of writing, it is the most sensitive through-the-lens meter made. This is an advantage, of course, for dim-light photography. The metering range covers 13 light values plus the f-stop settings of the lens in use. With the 50mm f/1.4 Summilux, the range is from 0.4 to 100,000 Apostilbs. One hundred thousand Apostilbs equal about 3,000 candelas per square foot —brighter than reflected sunlight anywhere on earth. With the f/1.2 Noctilux, the low reading limit extends to 0.3 Asb.

Leica lenses have no automatic diaphragms. Read-ings are made at the taking aperture, so, depending on the aperture range of the lens, 19 to 22 light values are available for metering.

The measuring range is influenced by film speed. With a film speed of ASA 400, exposure readout ranges from times of 1/000 second to 1/4 second; and with ASA 6, the range is from 1/250 second to 30 seconds, as shown in the table.

To simplify exposure, a calculator dial (25) has been placed on the back of the M5. For example, if you get a reading of 1/2 second at f/1.4, but you want to expose at f/11, just set the 1/2-second mark

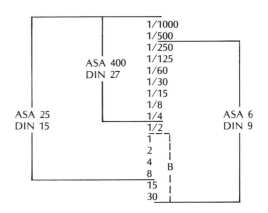

The shutter-speed range covered by the M5 meter varies with film speed, as shown in this table

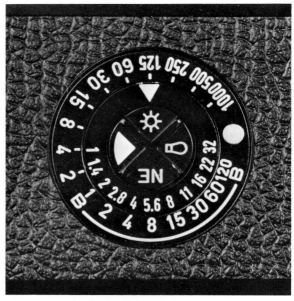

Exposure calculator dial on M5

at f/1.4, then read the exposure time opposite f/11, and you will see that it is 30 seconds.

The two semicircles at the ends of the meter read-out bar are aperture symbols. If the meter needle moves toward the semicircle with the smaller center, at the left, a smaller f-stop is set, and vice versa.

Remember that the metering field of the lens in use is always the next smaller area than the picture area that is shown in the finder.

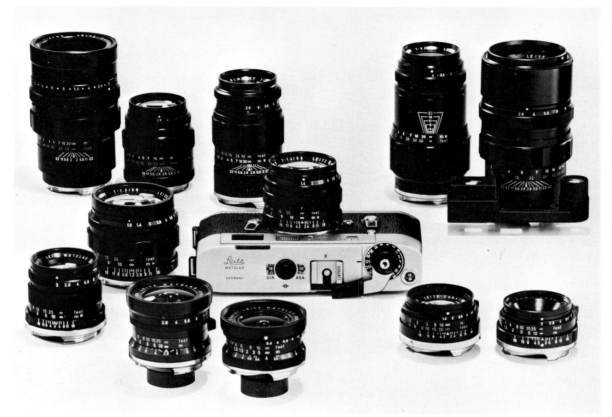

The Leica M5 and part of its family of lenses

Leica lenses and
the Leica system

The idea of a system camera is that it can be used with different lenses and accessories to take many different kinds of pictures under widely varying conditions and for many purposes. Flexibility is the key principle, and uniformly excellent performance in all modes of photography is the second, equally important requirement.

The Leica system includes lenses with focal lengths from 21mm (extreme wide-angle) to 800mm (extreme telephoto). 35mm to 135mm lenses couple directly to the Leica M5 and its range-viewfinder, and can be used normally without any auxiliary attachments.

Lenses longer than 135mm in focal length require the Visoflex III reflex housing on the M5, or the use of a Leicaflex camera, since the base length of the M-Leica rangefinder is too short to guarantee the extreme accuracy of focus needed with such lenses.

Lenses shorter than 35mm need auxiliary viewfinders.

Wide-angle lenses. The shortest lens made for the Leica M5 is the 21mm f/3.4 Super-Angulon, with a 92° angle of view, measured diagonally across the picture. The special 21mm viewfinder for this lens

fits in the accessory shoe on top of the camera. You focus normally with the rangefinder, then compose your picture in the 21mm finder. This lens focuses from infinity to 28 inches with the rangefinder, and can be focused as close as 16 inches from the film plane without the rangefinder. Use a ruler to measure the distance from the subject to the film-plane mark (6), behind the film-speed scale on the top of the camera, and focus by the distance scale engraved on the lens barrel.

Warning: All 21mm f/4 Super-Angulons, and 21mm f/3.4 Super-Angulon lenses with serial numbers below 2,437,251 must be modified by Leitz before being mounted on the Leica M5, or they will damage the meter mechanism, putting the camera out of action until major repairs are made.

After modification of their bayonet mounts by Leitz, all M-Leica 21mm lenses can be used freely on the M5.

Super-Angulon 21mm f/3.4 lenses with serial numbers above 2,437,250 have been redesigned for the M5 and can be used without modification.

In no case can the M5 meter be used with any 21mm Leica lens, since there is not enough clearance between the rear element of the lens and the shutter curtain for the M5 meter arm. Mounting a properly

designed or modified 21mm lens on the M5 automatically retracts the arm that carries the meter cell. A separate meter should be used with the 21mm lens.

The 28mm f/2.8 Elmarit, the next-to-shortest lens in the Leica system, is a slightly less extreme wide-angle lens. It is used like the 21mm lens—focusing in the rangefinder, composing in the 28mm auxiliary finder mounted on top of the camera. Its diagonal angle of view is 76°, and its focusing range is from infinity to 28 inches.

Warnings: 28mm f/2.8 Elmarit lenses with serial numbers below 2,314,921 must not be mounted on the Leica M5 before their bayonet mounts have been modified by Leitz, or meter damage will result and the camera will be made unusable.

After modification, these 28mm lenses can be used on the Leica M5, but without the possibility of using the M5 meter.

I recommend using instead 28mm f/2.8 Elmarits with serial numbers above 2,314,920. These lenses have been completely redesigned for the M5, and permit full use of the camera meter.

The combination of very wide viewing angle with high lens speed makes the 28mm f/2.8 Elmarit especially useful for available-light work and photojournalism.

The standard wide-angle focal length for the Leica M5 is 35mm. 35mm lenses take in a wider (64°) view than 50mm "normal" lenses, and offer greater depth of field with equal or nearly equal speed. The perspective of the 35mm lens appears normal and unforced, and many photographers regard it as their normal lens.

Two 35mm lenses are made for the M5; the 35mm f/2 Summicron and the 35mm f/1.4 Summilux, twice as fast as the Summicron. Their focusing range is from infinity to 28 inches. The difference in performance between these lenses is less than the price difference. The question of which one to buy is both a financial question and a question of the light conditions in which you will use the lens. If most of your pictures are taken at f/5.6 or f/8, there is no need to buy an f/1.4 Summilux. For my own work, I prefer the 35mm f/2 Summicron.

All but two 35mm lenses made for M Leicas can be used without alteration on the M5. They couple directly to the M5 range-viewfinder and permit full use of the camera-meter. No accessories are needed for normal picture-taking.

The two 35mm M-Leica lenses that *cannot* be used on the M5 are the 35mm "RF" Summicron f/2 with Optical Viewing Unit for the Leica M3, and the 35mm f/3.5 Summaron with removable M3 viewfinder attachment. The Summaron f/3.5 can be factory-modified for use on the M5.

All screw-mount 35mm Leica lenses can be used without modification on the Leica M5 with Bayonet Adapter No. 14,099, which actuates the 35mm-135mm finder frames in the M5 viewfinder.

Normal lenses. For the M5, as for all previous Leicas, the standard focal length is 50mm. The M5 can be ordered in black or chrome finish with the 50mm f/2 Summicron lens or the faster 50mm f/1.4 Summilux. If still higher speed is required, there is the fastest of all Leica lenses, the phenomenal 50mm f/1.2 Noctilux.

The 50mm lens has a 45° angle of view (diagonal), and its focusing range is from infinity to 28 inches.

For the average photographer, the 50mm Summicron, a superb lens, is fast enough. If you must do considerable shooting in dim light, the 50mm f/1.4 Summilux is an excellent standard lens.

For those who use photography as a hobby, I see no reason to buy the 50mm f/1.2 Noctilux. Such a lens is needed only if you do most of your work in dim light and at full aperture. Then the Noctilux comes into its own. This lens is designed especially for full-aperture photography by available light. Since you can use it wide open with slow films even in dim light, the high resolution of the lens can be augmented by high-resolution film. For maximum speed, of course, you use the fastest film you can get. (For more information, see Bill Pierce's chapter, "Available-Light Photography.")

Decisive factors in the high performance of the Noctilux f/1.2 lens are its unusually high contrast and the use of aspheric lens elements to eliminate virtually all coma and spherical aberration.

It is most difficult for a lens designer to arrive at the formula for a large-aperture lens that will produce high-resolution, highly-corrected photographs when used at full aperture. The manufacture of aspheric lens elements is likewise extremely complex. The Noctilux f/1.2 is the first lens with aspheric components to enter series production.

With one exception—the f/2 Dual-Range Summicron—all bayonet-mount 50mm M-Leica lenses can be used without modification on the M5.

Dymo-tape safety lock for the 50mm f/2.8 Elmar prevents the lens from being retracted so far as to damage the M5 meter

All screw-mount 50mm Leica lenses can be used on the M5, with full metering capability, but *special care must be taken not to retract collapsible Leica lenses when they are mounted on the M5.*

Leica authority Bob Schwalberg's technical report to the Leitz works about the M5 includes the following statement:

"If a collapsible Leica lens is retracted into the camera body with normal force, the meter (and in fact the whole camera!) geht Kaput! Achtung, Achtung, Achtung! . . . I will recommend (that you) never use a collapsible Leica lens on the Leica M5; trade it in on a modern Leica optic that's more worthy of this fine camera. . . "

However, for those who wish to use their collapsible Leica lenses safely on the M5, Leitz has issued directions for the use of Dymo tape to limit their retraction. The tape should be applied to the lens barrel, as illustrated, just behind the aperture ring. Leave a one-millimeter open space between the ends of the tape. Recommended Dymo tape widths for several collapsible Leica lenses are:

50mm f/2.8 Elmar	
50mm f/3.5 Elmar	3/4 inch tape (9.5mm wide)
50mm f/2 Summar	
50mm f/2 Summitar	
50mm f/2 Summicron	
90mm f/4 Elmar	
50mm f/2.5 Hektor	1/2 inch tape (12.7mm wide)

Long-focus lenses. Three 90mm lenses are made for the M Leica. The 90mm f/2.8 Tele-Elmarit, designed especially for the rangefinder camera, is extremely compact, due to its true telephoto design. If you will use only the 90mm lens directly on the camera, this is the lens I recommend. Its mount is only 60mm long.

The other two 90mm lenses, the 90mm f/2.8 Elmarit and the faster 90mm f/2 Summicron, offer greater flexibility, since they can also be used on the Visoflex reflex housing with the Leica, and, with the Leica Lens Adapter No. 14,127*, on the Leicaflex or the Leicaflex SL cameras. (The * is part of the code number.) All the 90mm lenses have a 27° diagonal angle of view.

Two 135mm lenses are made for M Leicas; the f/4 Tele-Elmar and the f/2.8 Elmarit. Both can be mounted directly on the M5 and focused with its rangefinder, or used on the Leica with the Visoflex housing or on either of the Leicaflexes.

The 135mm f/2.8 Elmarit has a special optical attachment for use with the range-viewfinder, since the f/2.8 aperture of this lens requires extremely accurate focusing. The attachment has a 1.5x magnification, bringing the ratio of the M5 finder image to approximately 1:1 ("life size"), for critical viewing and focusing.

Longer lenses are used with the Visoflex housing on the Leica. This housing, which converts the Leica into a single-lens reflex for long-lens and closeup work, is described, together with the lenses, later in this chapter and in Julius Behnke's chapter, "Telephotography."

Changing lenses

The procedure is quick and simple. Leitz recommends changing lenses in the shade, not in direct sunlight. (Illustrations, next page.)

To remove a lens from the M5, grasp the lens by the back ring (16), press the lens-mount release button (14), turn the lens slightly to the left until the red dot on the lens mount is aligned with the red dot in the lens-mount lock, then pull the lens free.

To mount a lens on the M5, line up the raised red dot (15) on the lens barrel with the red dot in the center of the lens-mount lock (14). Place the lens carefully in the mount, then turn it to the right (clockwise as you face the camera) until it locks with a distinct click. Always make sure the lens is locked rigidly in place before operating the camera.

Inserting the lens

Removing the lens

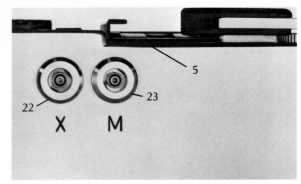

Flash contacts are the "hot shoe" in the accessory clip (5) and the two PC contacts on the back of the camera: X (22) and M (23)

Electronic flash		X	B━o (= 1/50)
Flash bulbs	AG 1 Flashcubes AG 3 M 2	X	B━1/30
	XM 1 PF 1 XM 5 PF 5	M	B━1/60
	M 3	M	B━1/125
	GE 5 25	M	B━1/500
X = Contact for electronic flash at the rear of the camera or built into the accessory shoe M = Contact for flashbulbs			

Flash synchronization

All flash units that have standard coaxial (PC) plugs or cordless "hot-shoe" contacts can be used on the Leica M5. The camera has two X contacts, one built into the accessory shoe (5), the other a standard PC contact on the back of the camera (22).

The X contacts are used to synchronize electronic flash units, fast-peak flashbulbs, and flashcubes. For proper X synchronization, set the shutter-speed dial (2) at the white dot (1/50 second).

The two X contacts have independent circuits, so two flash units can be used simultaneously.

The M contact (23) on the back of the camera is used with long-peak flashbulbs (necessary for all shutter speeds faster than 1/50 second, since the shutter curtains are not fully open across the entire picture area at these speeds. Instead, a moving slit travels across).

The covers should be kept on the PC contacts when they are not in use.

See the flash table for correct sync for different flashbulbs and for electronic flash. For more details on flash photography, see the chapter, "Artificial Light," by Bill Pierce.

The battery

The M5 meter uses so little current that temperatures down to 5°F (−15°C) will not affect metering accuracy as long as the right 1.35-volt mercury-oxide cell is used (Mallory PX 625 or Varta Pertrix 7002 or equivalent). These batteries have a life span of one or two years. Below 5°F, a chilled battery may cause inaccurate readings.

Testing the battery. To check the battery, move the frame-selector lever (19) as far away from the lens as it will go, while looking at the readout bar in the viewfinder. If the needle moves to the cut-out area at the lower right of the readout bar, your battery is all right. If the needle does not reach the cut-out section, it is time to change batteries.

Changing the battery. The battery-compartment cover (24) is between the strap lugs at the left end of the camera. It is coin-slotted for easy access. When you insert a new battery, be sure to place it in its receptacle with the engraved side up. Then put the cover back on.

Testing the battery: move the frame-selector lever away from the lens as far as it will go while watching the meter readout bar in the viewfinder

The M5 self-timer; its activating button hides behind the lever when it is not in use

Multiple-exposure technique

The M5 effectively prevents accidental double exposures, but it is also the first Leica that permits intentional double and multiple exposures on the same frame of film.

First shoot a "blank frame" with the lens cap on.

Then unfold the rewind crank (26) and put the film under tension by turning the crank in the arrow direction until you feel resistance.

Now take the lens cap off and turn the rewind release lever (9) downward. Hold this lever down while you cock the shutter (with the rewind crank still unfolded to prevent the film from advancing).

Take the first exposure.

Repeat the process: cock the shutter with the rewind release lever held down (it will spring up if you let go of it) and the rewind lever unfolded. This again cocks the shutter without advancing the film, and you can now take your second exposure.

This can be repeated as many times as you want.

Each shot admits light to the entire frame, and the exposures add together. You cannot give full exposure each time or the frame will be greatly overexposed. For subjects of generally similar brightness, meter the first scene to determine the proper exposure, then divide by the total number of shots you plan to superimpose. Give each shot that reduced exposure. For example, with a double-exposed negative or slide, give ½ the exposure that the meter indicates each time (½ x 2 = 1). This is easily done just by stopping down one f-stop (as from f/8 to f/11) or by increasing the shutter speed by one setting (as from 1/60 to 1/125 second).

When finished exposing the double- or multiply-exposed frame, resume normal shooting by folding the rewind crank and moving the rewind release lever to the upright position.

The self-timer

This delayed-action shutter release is set by the self-timer lever (13), on the front of the camera just below the rewind release lever. It releases the M5 shutter 8 to 10 seconds after being activated.

To set the self-timer for an 8-second delay, move the lever away from the lens and down to just past horizontal, until you hear the second of two faint clicks. To set the lever for full delay, move the lever all the way until it points straight down. In-between settings give intermediate delays.

To release the shutter using the self-timer, press the small button just above the pivot of the lever (it hides under the lever when not in use). After pressing the button, you will hear a whirring sound, and the lever will move slowly back to its upright position. Just before it stops, the shutter is tripped.

The self-timer functions at all shutter speeds, and the shutter can be cocked either before or after the timer is set. It has several uses: It allows the photographer to move in front of the camera for a self-portrait. It provides the steadiest method for shooting the hand-held camera without a cable release. Many photographers use the self-timer to get sharper pictures at shutter speeds slower than 1/30 second.

Perhaps the most useful aspect of the M5 self-timer is that it extends the shutter-speed range of the camera. Just set the shutter at B, release it with the self-timer, and you will get an accurately-timed one-second exposure.

The Visoflex III

The Visoflex III reflex housing is used for lenses longer than 135mm with the Leica M5, and for closeup work. Both the Visoflex III and the discontinued Visoflex I with bayonet mount can be used on the M5 without modification. They convert the range-finder Leica to a single-lens reflex, though not one as compact or handy as a Leicaflex.

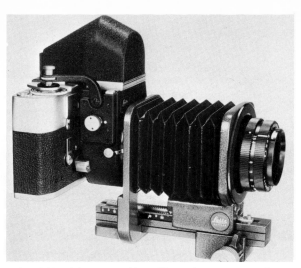

Leica M5 with Visoflex III reflex housing, 4x eye-level magnifier, and the shortest Visoflex lens; the 65mm f/3.5 Elmar on the Universal Focusing Mount No. 16,464

Leica M5 with 65mm f/3.5 Elmar lens mounted on Focusing Bellows II and Visoflex III. This combination is capable of extreme closeup and macro photography.

The Visoflex housing is attached to the camera just as you would attach a lens, and the lens is fitted to the Visoflex in the same way.

Viewing is through either a 4x eye-level magnifier, which uses a pentaprism to give an upright, laterally-correct viewing and focusing image, or through a 5x vertical magnifier, with an upright, but laterally-reversed image.

The adjustment screw on the arm of the Visoflex III should be adjusted to clear the shutter-release button on the camera by at least one millimeter.

The reflex mirror of the Visoflex III has three modes of operation, controlled by the setting knob on the side of the housing. Set to the yellow dot, the mirror has instant-return action, and springs back to the viewing position automatically after each exposure.

Set to the black dot, the mirror rises slowly and softly when released, for sharp pictures with long lenses and slow shutter speeds.

Set to the red dot, the mirror is raised and locked out of the light path for exposure or for metering.

For M5 metering through the Visoflex III, mount the camera and Visoflex on a tripod. Center the subject area on which you want to take your exposure reading in the small circle on the Visoflex III ground-glass. It represents the metering area. Then lock the mirror up (red dot) to take the reading and set the exposure on the camera. If further viewing or composing is necessary, unlock the mirror again before shooting.

The Visoflex III can be used without a magnifier, simply by looking down at the groundglass on top of the housing.

The use of the discontinued Visoflex II is not recommended and is possible on the M5 only when you use the 4x or 5x magnifier of the Visoflex III on it. The shutter-release arm of the Visoflex will not operate both the M5 shutter and the reflex mirror simultaneously; therefore you must raise the mirror for metering, bring it down to see the picture, and raise the mirror again before shooting.

A special lens designed for use on the Visoflex is the 65mm f/3.5 Elmar. It cannot be mounted on the Leica except with the Visoflex, on which it provides a continuous focusing range from infinity to 13 inches. It is the shortest lens for normal photography in the reflex part of the Leica system, and is used with Universal Focusing Mount No. 16,464. (This focusing mount is also used to adapt the lens heads of the 90mm f/2.8 Elmarit and the 135mm f/4 Tele-Elmar to the Visoflex, after unscrewing them from the long mount used directly on the rangefinder Leica.) Since three lenses of different focal lengths are used on the Universal Focusing Mount, no distance settings are engraved on it.

For information on longer Leica lenses used with the Visoflex, see the chapter, "Telephotography."

Focusing Bellows II

The Leitz Focusing Bellows II is used together with the Visoflex III housing to extend the focusing range of short Leica lenses, as well as longer lenses, into the macro range—large images shot from very close. 35mm and 50mm Leica lenses can produce high magnifications when used on the bellows, though they cannot be focused at infinity except when mounted directly on the camera.

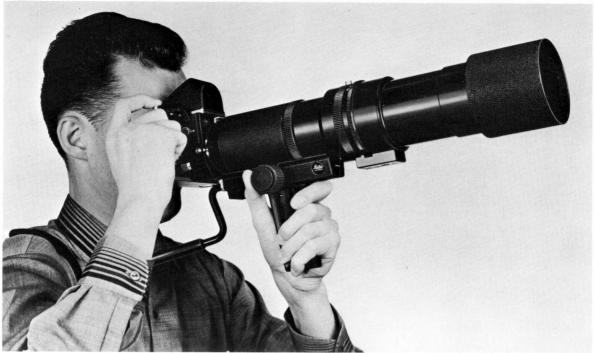

Televit with 400mm f/5.6 Telyt, Visoflex III and shoulder stock

With the Focusing Bellows II, 90mm lenses have a continuous focusing range from infinity to a 1:1 reproduction ratio, and 135mm lenses range from infinity to a 1.5x magnification. For a detailed discussion of the Focusing Bellows II, and a table of lens coverages, see the chapter, "Closeup Photography," by Norman Rothschild.

Tele-lenses for the M5

The Visoflex II accepts lenses ranging from 65mm to 800mm for work within a normal focusing range. As already mentioned, the Universal Focusing Mount No. 16,464 is used with the 65mm f/3.5 Elmar, the 90mm f/2.8 Elmarit, and the 135mm f/4 Tele-Elmar.

A different Universal Focusing Mount, No. 16,462, is used with the 90mm f/2 Summicron (lens head only, with preset diaphragm but no focusing mount), and with the 135mm f/2.8 lens head.

The 200mm f/4 Telyt short-mount lens, with preset diaphragm, built-in collapsible lens hood and lens hood cap, requires Adapter No. 16,466 for use on the Visoflex III.

The 280mm f/4.8 Telyt has a tripod socket built into its focusing mount, a preset diaphragm, built-in collapsible lens hood, and a retaining ring for a Series VIII filter. It is used directly on the Visoflex III.

The 400mm and 560mm f/6.8 Telyts have been designed for use directly on the Visoflex II and III. They feature rapid-slide, "trombone-style" focusing, with a push-button lock-and-release mechanism on the lens barrel. These lenses are light in weight and easy to use. A 60mm extension tube, No. 14,182, adapts these lenses for closer focusing.

The latest addition to the extreme-tele lenses for the Leica and the Visoflex III is the 800mm f/6.3 Telyt-S.

Televit Rapid Focusing Device

The Televit is usable with any rangefinder Leica equipped with the Visoflex II or III, and accepts the lens heads of the 180mm f/4.8 Telyt, and the 400mm and 560mm f/5.6 Telyts.

The left hand holds the pistol grip with the index finger on the focusing-release trigger and the thumb on the fine-focusing wheel. For rapid focusing, press the release trigger and move the camera back and forth with the right hand while watching the focusing screen of the Visoflex. Fine focusing, if needed, is done with the left thumb on the rubber-ribbed wheel after the left index finger lets go of the trigger. (The thumb wheel can be used for the entire focusing process, but that is the slow way.)

Apertures for the 400mm and 560mm f/5.6 Telyt lenses can be preselected on the lens mount. Depress the chromed locking button and set the desired f-stop on the preselecting ring. You focus at full aperture by turning the aperture control ring to f/5.6; then, before shooting, stop down by turning the preset ring until it stops at the chosen f-stop. Both rings are rotated to the left.

M5 on four-legged copying stand

Index finger on Televit focusing-release trigger, thumb on fine-focusing wheel

The narrow (upper) ring is used to open the lens, as shown, for focusing, then to stop down again before exposing. In this case, the dot would be turned back until it stopped at f/11, the preset aperture. The wider (lower) ring, released by pressing the chrome button, presets the diaphragm to any desired f-stop

On the left side of the Televit, just above the pistol grip, are two large locking knobs, used to preset near and far focusing limits as required by the pictures you want to take. First loosen the front knob, set the far-distance limit, and lock the knob. Then loosen the rear knob, focus on the near-distance limit, and lock the knob. You can focus freely within this range. This feature is especially useful for work such as sports photography, where the limits of the shooting distances are known in advance.

Four-legged copying stand
Leica fans know this stand under its old Leitz code name, BOOWUM (its present code number is 16,526). The stand uses three different extension tubes to obtain three fixed-focus reproduction ratios, 1:9, 1:6, and 1:4, covering subject fields of approximately 9x13.5 inches, 6x9 inches, and 4x6 inches respectively.

This stand can be used with either of two lenses: the collapsible 50mm f/2.8 Elmar, or the lens head of the 50mm f/2 Summicron, removed from its focusing mount and fitted with bayonet ring No. 16,508.

Either lens can be used with the optical near-focusing device No. 16,507 to obtain reproduction ratios from 1:5 to 1:7.5.

For more information on the practical use of this stand, also known as the Auxiliary Copying Stand and the Auxiliary Reproduction Unit, see the chapter, "Closeup Photography," by Norman Rothschild, and "The Scholar's Use of the Leica," by Beaumont Newhall.

Focusing-limit knobs on the Televit: far-limit knob is at left (toward front of lens); near-limit knob at right

Using your Leica M5
When you read the detailed instructions for using every feature of a camera, photography may seem difficult. That's why it is better to use a camera than to read about it. Then the real ease and simplicity of each operation become clear. Before you know it,

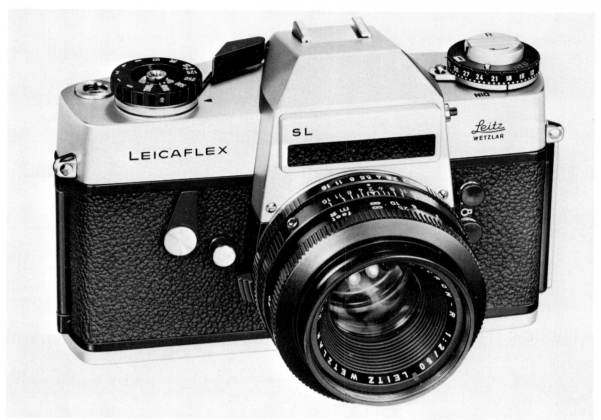

Leicaflex SL with standard 50mm f/2 Summicron lens

you can use the camera the way you use your hand—doing the right things without having to think about them.

Because it is a system camera, the M5's versatility is greater than most photographers will ever need or want. Most of our pictures are taken fairly simply, after all, and are not less worthwhile because of that.

The Leica is made for these pictures as well as for any of its many specialized capabilities. Essentially, the M5 is still the Leica of Oskar Barnack, an ingenious and practical design in which rapid and easy handling are balanced with precision, durability and versatility.

THE LEICAFLEX SL

The Leicaflex SL is the single-lens reflex member of the Leica family. Like the Leica M5, it is a system camera of immense versatility, designed for easy use, and built to the highest optical and mechanical standards. The "SL" stands for selective light measurement by the accurate through-the-lens meter built into the camera.

The Leicaflex SL, while compact, is somewhat larger and heavier than the Leica M5. With the standard 50mm f/2 Summicron-R lens in place, the camera weighs 1185 grams (41.5 ounces, or 2 pounds, 9½ ounces). It is 149mm (5.86 inches) long, 96mm (3.78 inches) high, and its maximum body thickness, from back to lens mount, is 56mm (2.19 inches). The Leicaflex SL is available in white or black chrome.

Viewing and focusing, as well as light measurement, are done through the lens that takes the

Top view of Leicaflex SL.
Shutter speed dial, shutter release and film advance lever are conveniently grouped at top right end of camera for right-hand operation. Left hand operates f-stop and focus controls on lens barrel. The film plane is indicated by the rear end of the accessory clip, just above the viewfinder eyepiece

picture. When you look in the Leicaflex SL view-finder you see the image projected upright and laterally correct on a large all-microprism screen of unusual brilliance. The picture is seen with all the in-and-out-of-focus qualities produced by the lens at full aperture, and focusing is by comparative sharpness in the screen. This is *photographic* seeing, which leaves less to the imagination than the image in a Leica range-viewfinder window, though reflex focusing is slightly slower and less positive. The Leicaflex SL is completely parallax-free. Partly because of this, Leicaflex lenses can normally be focused closer than rangefinder-Leica lenses of equivalent focal length.

Features of the Leicaflex SL

Interchangeable lenses. All R lenses in the current Leicaflex SL system can be used either on the Leicaflex SL or on the earlier standard Leicaflex without modification. Earlier R lenses made for the standard Leicaflex with external meter should be modified by Leitz for through-the-lens metering on the SL.

Leica-to-Leicaflex Adapter No. 14,127* adapts the Bellows II and all Leica lenses for the Visoflex II and III to both the standard Leicaflex and the Leicaflex SL. Adapter No. 14,167, without diaphragm simulator, does the same for the Leicaflex SL only.

All Leicaflex SL lenses, from 21mm (extreme wide-angle) to 800mm (extreme tele-lens), mount directly on the camera with a bayonet mount. All focal lengths permit through-the-lens metering.

The fastest lens for the Leicaflex SL is the 50mm f/1.4 Summilux-R.

The viewing-focusing system. The principal advantage of a reflex camera is that the large, focally-differentiated image in the viewscreen gives you a clearer, more photographic view of what you are getting than a rangefinder camera shows, making composition easier and more precise. No matter what focal length lens is used, the picture it produces fills the entire screen.

The Leicaflex SL viewing screen is unusually bright. The central 7mm-diameter spot that is used both for metering and for rapid focusing is made up of relatively coarse square micropisms, in which the image appears to "snap" in and out of focus. The rest of the screen, although it looks like groundglass, consists of much smaller microprisms. Focusing is possible over the whole picture area on the screen.

The Leicaflex SL viewscreen, with bright, clear image, shutter-speed scale, meter needle and follow-pointer; the circle in the center shows the area read by the meter

The light-meter needle and follow-pointer are seen in the finder at the right of the picture, with the camera held horizontally. A shutter-speed bar below the image shows what speeds are available and which one is set on the camera.

Shutter speeds on the Leicaflex SL range from one second to 1/2000 second and B, or "bulb," for manually-controlled time exposures longer than one second.

The speed range is continuous except between 1/4 and 1/8 second and 1/30 and 1/60. Any other intermediate value can be set and will function accurately. At B, the shutter opens when the shutter-release button is pressed, stays open as long as the button is held down, and closes when the button is let go.

The built-in light meter is similar to the meter in the Leica M5. It measures light through the lens at full aperture, however, and not at the taking aperture. The metering field, shown by the central spot in the finder, is one-sixth of the angle covered by the lens, measured diagonally across the finder. The meter is designed so that no scattered light can affect the reading; therefore, extremely bright highlights or dark shadows that would make generalized average-brightness readings inaccurate can be bypassed. You can read other areas of your subject selectively, without including them.

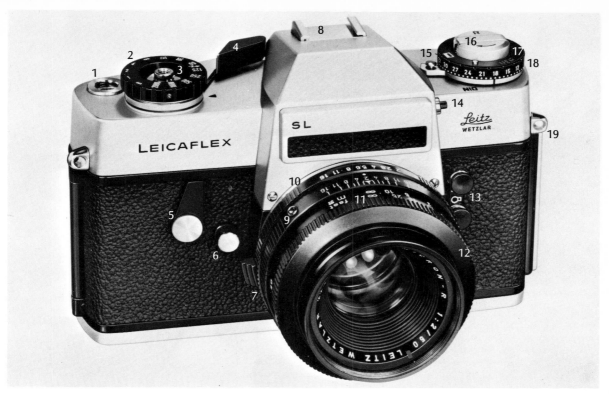

11. Depth-of-field scale
12. Focusing ring
13. Flash synchronization outlets
14. Battery-test button
15. Push-button lock for film-speed-setting dial
16. Folding film-rewind crank
17. Film-type reminder
18. Film-speed scale, DIN
19. Strap lugs
20. Locking bar for hinged camera back
21. Film-speed scale, ASA
22. Battery cover plate
23. Viewfinder eyepiece
24. 1/4-inch tripod bushing
25. Film-rewind release button

Leicaflex SL parts and controls

1. Frame counter
2. Shutter-speed dial
3. Shutter-release button with threaded cable-release socket
4. Rapid-winding lever (cocks shutter, advances film, acts as meter on-off switch)
5. Self-timer lever
6. Depth-of-field preview button
7. Lens-mount bayonet lock
8. Accessory shoe
9. Red dot mark for lens changing
10. Auto-aperture control ring

Basic Leicaflex SL controls

The basic controls of the Leicaflex SL are the same as those for any hand camera: shutter speeds, lens apertures, and focus.

The shutter speeds of the Leicaflex SL are in fractions of a second, expressed in whole numbers:

1 = 1 second	60 = 1/60 second
2 = 1/2 ''	125 = `1/125 ''
4 = 1/4 ''	250 = 1/250 ''
8 = 1/8 ''	500 = 1/500 ''
15 = 1/15''	1000 = 1/1000 ''
30 = 1/30''	2000 = 1/2000 ''

Except between 1/8 and 1/4 second and another gap between 1/30 and 1/60 second, these speeds

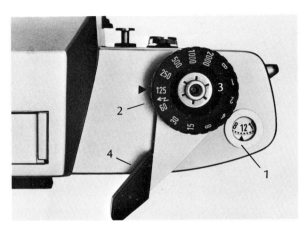

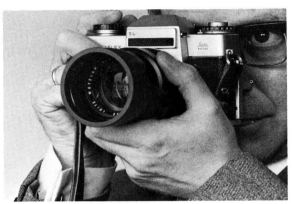

Camera held horizontal

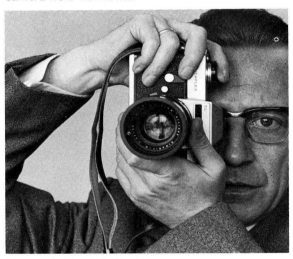

Camera held vertical

On top of the camera at the right are the shutter-speed knob (here set at 1/125 second); the shutter-release button, with cable-release socket, in the center of the knob; the rapid-advance lever; and, to the right, the exposure counter, which runs forward while you shoot, and backward to zero again when you rewind the exposed film

are continuously variable, and in-between settings may be used freely.

Shutter speeds are set by turning the shutter-speed dial until the desired speed number is at the pointer on top of the camera, or shown by the pointer on the shutter-speed scale below the view-screen in the finder.

For exposures longer than one second, set the shutter dial at B, and press the shutter-release button down to open the shutter. When you let the button go, the shutter will close. For long time exposures, a cable release with a locking device is useful.

Lens-aperture control. Leicaflex R lenses from 21mm to 250mm in focal length feature automatic diaphragms, set by using the auto-aperture ring on the lens barrel. These lenses remain fully open for metering and focusing, but stop down automatically to the preselected aperture when the shutter-release button is pressed. At the same time, the reflex mirror swings up out of the light path during the exposure; then the mirror returns instantly to viewing position and the lens reopens to full aperture.

There is one exception; the 35mm f/4 PA Curtagon-R has a manual click-stop diaphragm, not an automatic one.

The depth-of-field scale is used in the same way on the Leicaflex SL as it is with the rangefinder Leica.

Holding the Leicaflex SL

Horizontal. For steady three-point support, hold the camera with your left hand under the lens, supporting the camera and controlling the focusing ring and the auto-aperture ring on the lens barrel. Place your right index finger on the shutter-release button, and your right thumb against the rapid-winding lever. Use your forehead, your glasses or your nose as the third resting point.

Vertical. Keep your hands in the same position on the camera controls and turn the camera to the vertical position, right hand up. I do not recommed turning the camera the other way, as it is easy to press the rewind button accidentally when the camera is held

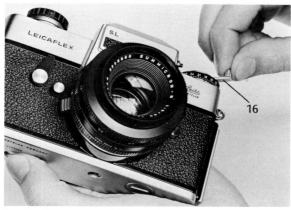

Rewinding exposed film. After pressing rewind release button on camera bottom, unfold and turn rewind crank

Loading film. First insert the end of the leader in the slots of the takeup spool, emulsion-side-out (the emulsion side is the less shiny side of the film)

To open the camera back, press the button on the locking bar and push the bar upward

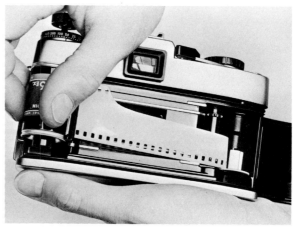

Once the leader is firmly held by the takeup spool, bring the cartridge over and place it in its chamber

vertically with the advance lever down. In that case, the film may not advance properly, and two frames are likely to overlap.

The meter is calibrated for reading in the horizontal camera position, not the vertical.

Loading and unloading the Leicaflex SL

First make sure there is no film in the camera by turning the *rewind crank* (17) in the arrow direction. If you feel any resistance, the camera is loaded, and the film must be rewound before the camera back is opened to insert a new film.

To rewind, press the rewind button (25), and unfold the rewind crank, but *do not pull the knob out.* Now turn the crank in the arrow direction until you feel resistance. Then give the crank one more turn and you will feel and hear the film end pull free from the takeup spool.

Caution: before you open the camera back, cock the camera once or twice while watching the rewind crank. If it turns, do not open the camera: the film is not fully rewound. If the rewind crank does not move when the camera is cocked, open the camera, pull up the crank and take out the exposed cartridge. The frame counter on the Leicaflex runs backward during rewinding.

The normal time to unload the camera, of course, is when you finish exposing a roll of film. At that point, the advance lever will no longer move. *Do not force the advance lever,* or you may either pull the

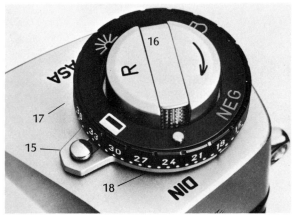

The film-speed dial must be set to the right ASA or DIN number for the film being used, or metering will not give accurate exposures; the film-type symbols (black-and-white, daylight or tungsten-type color-slide film, or color negative film) are secondary, but useful, reminders

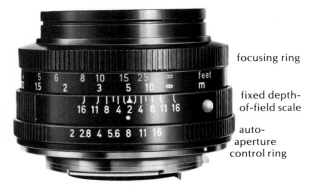

focusing ring

fixed depth-of-field scale

auto-aperture control ring

The dial (17) can be set to the following symbols to remind you of the type of film in the camera:	
▭	*black-and-white film*
☼	*daylight reversal color film*
♀	*tungsten-type reversal color film*
NEG	*color negative film*
Set the symbol you want opposite the lock button (15)	

film entirely out of its cartridge or tear the perforations.

To load the camera, open the back by pressing the safety button on the *locking bar* and pushing the bar upward.

There is a hard way and an easy way to load the camera. Either way, you must first pull up the *rewind crank* (16). The easy loading method is to begin by hooking the end of the film into one of the slots of the takeup spool. Make sure it is in firmly, then place the cartridge in its chamber and push the rewind crank down. The hard way is to start from the cartridge end and pull the film end over to the takeup spool—so don't.

Next, move the advance lever half a stroke with the camera back still open, and make sure the

sprocket teeth engage the film perforations.

Lock the camera back simply by closing it. Turn the rewind crank in the arrow direction, without forcing, until you feel a slight resistance. Then cock the shutter fully and press the release button. Since you must move the light-struck end of the film out of the way before you can take any pictures, cock and shoot twice more. Then you are ready for the first exposure.

Since the frame counter (1) resets automatically to two marks before zero when the camera is opened, you do not have to watch it. Instead, watch the rewind crank to be sure it turns as you advance the film.

If you need a reminder to tell you what kind of film is in the camera, and what its ASA or DIN film-speed rating is, set the film-speed index by pushing the chrome knob (15) and turning the setting ring (18). (I prefer to write the data on a gummed label which I stick on the camera.)

The viewing and focusing system

The principal advantage of a single-lens reflex camera is that the large, clear, parallax-free image in the viewscreen gives you a clearer, more photographic view of the picture you will get than is possible with a rangefinder camera, making composition easier and more precise.

The Leicaflex SL has an unusually bright viewing screen. The 7mm-diameter central spot used both for metering and for rapid focusing consists of precise square microprisms; the rest of the screen, although it looks like groundglass, is made up entirely of much smaller microprisms, both for brilliant viewing and for positive focusing.

*Leicaflex SL
focusing screen—
image out of focus*

*Sharp,
in-focus image*

Each Leicaflex lens mounted on the camera fills the entire screen with its image: no auxiliary finders are needed for normal photography with this camera.

Focusing. To focus on a subject, turn the *focusing ring* on the lens barrel until you see the subject's image become sharp on the viewscreen. When it is sharp, you can see the entire field of the finder without the disturbing spot that you would have with a split-image rangefinder. Focusing is possible over the whole area of the finder.

For *rapid focusing,* concentrate on the center spot. More or less as in the Leica rangefinder, when the subject is out of focus, you see a double image of lines and contours within the spot; also the incident light rays are scattered and give a shimmering effect when the image is out of focus.

The *depth-of-field preview button* (6) affords a

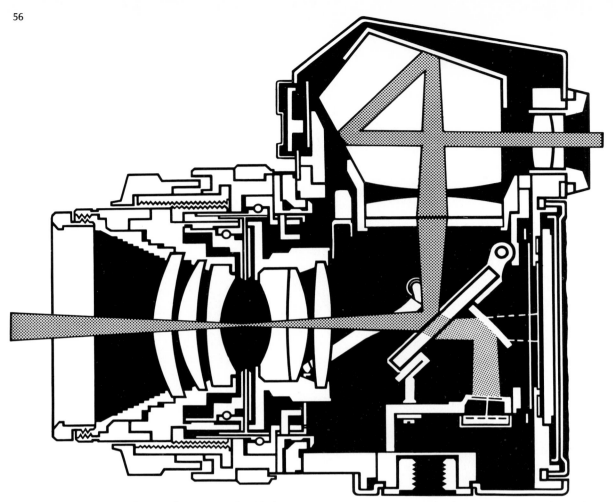

Cross section of Leicaflex SL, showing path of light to semitransparent mirror, viewing and focusing system, and (behind and below mirror) to the meter cells. Twenty percent of the light that strikes the mirror in the center of the image passes through it and is reflected by a small second mirror into the cells. During exposures, the smaller mirror folds and helps shield the camera interior against stray light

visual check of the depth of field you will get at the f-stop set on the automatic diaphragm. Pressing the button stops the lens down to that aperture.

When the preview button is pressed, less light enters the lens, causing the meter needle to move. Do not be tempted to "correct" for this change. The meter reads the light at full aperture and gives the correct stopped-down exposure automatically. (There is an exception: when an unmodified standard-Leicaflex lens is used on the Leicaflex SL, the meter is read with the lens stopped down. For details, see the section on SL metering which follows.)

Leicaflex SL metering
The Leicaflex SL measures light through the wide-open lens. The field measured by the meter, shown by the 7mm-diameter spot in the center of the finder, is one-sixth of the angle covered by the lens

The depth-of-field preview button

Closeup photograph of Leicaflex SL meter cells in the recess that helps to keep scattered light from reaching them. The black rectangle above the cells is the back of the secondary mirror

To set film speed for the SL meter, press the lock button, then turn the film-speed ring to the desired ASA or DIN number. The setting shown is DIN 18; on the other side of the ring, ASA 50, an equivalent film-speed number, is set

(measured diagonally across the screen). The meter is designed so that no scattered light can affect the readings; extremely bright highlights or dark shadows that would make average-brightness readings inaccurate can be bypassed. You can read other areas of your subject without including them.

The scenes we usually photograph consist of several areas of different brightness, often irregularly distributed. In very contrasty subjects, brightness may vary by ten or more exposure values. To get correct exposure for most scenes, read an area of average brightness, or measure the part of the scene in which you want maximum detail. Do *not* measure extreme areas such as dark shadows, bright clouds, light sources or reflections unless such an area is an important part of your picture.

Setting the film speed. Correct exposure depends on the right film-speed setting, so the first step toward metering is to adjust the *film-speed setting ring* (18 or 21) to the correct ASA or DIN value for the film you are using. To do this, press the lock button, then turn the ring to the desired film speed. The setting range is from ASA 8 to ASA 6400, and from DIN 10 to 39. The dots between the numbers stand for the following ASA values:

. = 8	ASA 50	ASA 400	. = 2500
. = 10	. = 64	. = 500	ASA 3200
ASA 12	. = 80	. = 640	. = 4000
. = 16	ASA 100	ASA 800	. = 5000
. = 20	. = 125	. = 1000	. = 6400
ASA 25	. = 160	. = 1250	
. = 32	ASA 200	ASA 1600	
. = 40	. = 320	. = 2000	

If you set the wrong film speed, the meter will give you wrong exposures.

Meter switch. The meter is switched off when the rapid-advance lever is folded against the camera body, and switched on by moving the lever out slightly. (This does not apply to early-production Leicaflex SLs or to late-production Leicaflex SL Mot cameras.)

Reading the meter. First aim the camera so the area you want to measure fills the center spot in the finder. The reading area is the same for lenses of all focal lengths.

In the viewfinder you see the shutter-speed scale, the meter needle, and its follow-pointer. Hold the camera horizontally while metering. To set correct exposure, line up the follow-pointer with the meter needle: either preset an f-stop and change shutter speeds, or preset a speed and move the lens' aperture ring. The pointer moves up, toward the large dot, when the auto aperture is being set for a larger f-stop; down, for a smaller stop.

SL metering with non-SL lenses. When using lenses made for the earlier standard Leicaflex, with one cam instead of two, keep the preview button depressed to close the diaphragm to the selected f-stop while you take the reading. Bring the follow-pointer into alignment as described before; then, for the exposure, either open the diaphragm by one f-stop or slow the shutter speed by one value. (Alternatively, you can simply set the film-speed scale at 1/2 the correct ASA value; e.g., 200 instead of 400.) Release the preview button before you make the exposure. (Better still, send the lens to the factory or to an authorized Leitz agency to have the second cam that converts a standard Leicaflex into an SL lens installed. Then you won't have to go through this.)

Leicaflex SL metering with Leica lenses. Leica lenses made for the Visoflex II and III and the Bellows II have no automatic aperture setting. When you use such lenses on the Leicaflex SL, read the meter with the lens stopped down to the aperture at

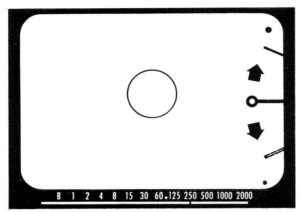

Turning the aperture ring on the lens moves the follow-pointer up or down at the right of the finder. As it moves up toward the larger dot, the diaphragm is being opened wider; toward the smaller dot, it is being stopped down to a smaller aperture

Follow-pointer has been moved up to match the meter needle. In this case, the adjustment is to a larger aperture. (The shutter-speed knob can also move the follow-pointer)

which you will take the picture. Move the follow-pointer of the meter with the shutter-speed knob until it is lined up with the meter needle.

If the light that reaches the meter cell at this f-stop is too dim to bring the needle into view in the finder, open up the lens until the needle comes into view and take your reading at that aperture. (This is apt to happen in closeup work, using the bellows and a small aperture.) If you are shooting at f/11 but must open the lens to f/5.6 for the reading, the next procedure is to stop the lens back down to f/11 and

slow the shutter accordingly. (To get the correct exposure, slow the shutter by one setting for each f-stop that you stop the lens down. From f/5.6 to f/11 is two stops; so slow the shutter by two settings. From a reading indicating 1/30 at f/5.6, the same exposure is obtained at f/11 by changing the shutter to 1/8 second.)

Leicaflex lenses and the SL system

Like the Leica, the Leicaflex SL is the heart of a photographic system of consistently superb quality and wide-ranging versatility.

Leicaflex SL R lenses range from 21mm to 800mm in focal length, and up to f/1.4 in lens speed.

By using Leica lens adapter No. 14,127*, Leica lenses made for the Visoflex II and III can be used on both the standard Leicaflex (discontinued) and the Leicaflex SL, as may the Focusing Bellows II. Or, adapter No. 14,167 can be used with the Leicaflex SL.

Earlier R lenses made for the standard Leicaflex lack the second cam which properly activates the follow-pointer of the Leicaflex SL light meter for full-aperture readings. Most such lenses can have the second cam installed by Leitz to adapt them for normal use on the Leicaflex SL.

In normal use, Leicaflex lenses do not require any auxiliary viewfinders, since each lens acts as the objective of its own finder system.

Wide-angle lenses characteristically form the images of objects in the foreground very large in comparison to the background, which is shown very small. The resolution of the eye is fairly poor where detail in small subjects is concerned, so at times small details on the reflex focusing screen are beyond the resolving power of the eye. Thus the image in the finder may look sharp to the eye when it is not sharp enough to produce satisfactory enlargements from a small negative. The eye, not the camera lens, is to blame. That is why microprisms are built into the Leicaflex SL to aid in focusing. But for rapid, positive, critically accurate focusing with extremely short lenses, no single-lens reflex camera can equal the rangefinder Leica.

My advice, when you use wide-angle lenses on the Leicaflex-SL at large aperture, is to check the distance setting on the lens mount and compare it to your estimate or measurement of the distance. A very quick method is to estimate the distance first, then set it on the lens.

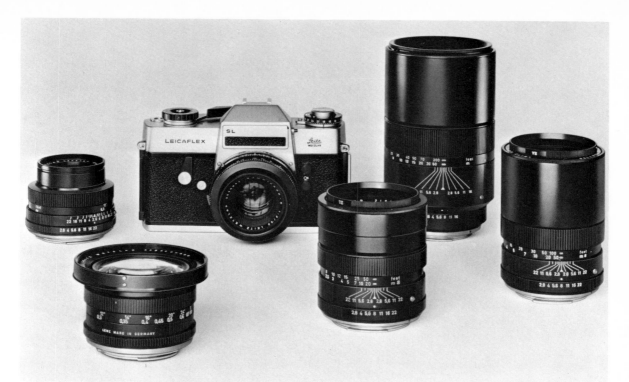

The Leicaflex SL and six of its family of R lenses.
From left to right: 35mm f/2.8 Elmarit-R; 21mm f/4
Super Angulon-R; 50mm f/2 Summicron-R (on
camera); 90mm f/2.8 ELmarit-R; 180mm f/2.8
Elmarit-R; and the 135mm f/2.8 Elmarit-R

The shortest-focal-length, widest-angle lens made
for the Leicaflex SL is the 21mm f/4 Super Angulon-
R, with auto aperture, which allows normal SL meter-
ing, viewing and focusing. (The discontinued 21mm
f/3.4 Super Angulon-R lens made for the standard
Leicaflex cannot be used on the Leicaflex SL, and
cannot be adapted to it. However, all SL lenses may
be used freely on the standard Leicaflex.) The 21mm
f/4 Super Angulon-R has a diagonal viewing angle of
92°, a minimum aperture of f/22, and focuses as
close as 8 inches (0.2 meter) from the film plane of
the camera. At f/22, the depth of field is from 16
inches to infinity.

The next-to-shortest SL lens is the 28mm f/2.8
Elmarit-R, with a diagonal angle of view of 76°. This
lens has an automatic diaphragm, a minimum aper-
ture of f/22, and comes supplied with a rectangular
lens hood with bayonet lock, which also serves as a
Series VII filter holder.

The average or "normal" wide-angle lenses for the
Leicaflex SL are the 35mm f/2 Summicron-R and the
35mm f/2.8 Elmarit-R. Both have a diagonal angle of
view of 64°. The 35mm f/2 lens stops down to f/16;
the f/2.8 lens, to f/22.

A special 35mm SL lens is the f/4 PA Curtagon-R.
Its optical axis can be shifted off-center by as much

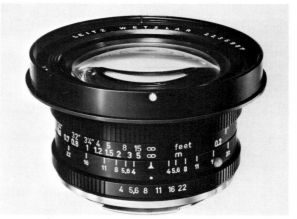

21mm f/4 Super-Angulon R

as 7mm in any direction—up, down, to either side
or diagonally, through 360°. It acts like a rising-,
falling-, sliding-front view-camera lens in miniature,
permitting the prevention of perspective distortion
in photographs made at moderately oblique angles.
This is especially valuable in such fields as archi-
tectural photography. This is the only short-focal-
length Leicaflex lens that lacks an automatic dia-
phragm; instead, it has a manual click-stop dia-
phragm.

The standard lens for the Leicaflex SL is the 50mm
f/2 Summicron-R, with a diagonal angle of view of
45°, a minimum aperture of f/16, and a close-focus-
ing limit of approximately 20 inches (0.5 meter). The

*Comparison between 21mm closeup portrait (left)
and 90mm portrait (right) shows why the author does
not think of the 21mm lens as a portrait lens.
Photographs by R. Berghoff*

fastest Leicaflex SL lens is the 50mm f/1.4 Summilux-R, which also stops down to f/16.

Another special Leicaflex lens is the f/2.8 Angenieux-R zoom with continuously-variable focal lengths, controlled by turning a zoom ring on the lens barrel, from 45mm to 90mm. The lens has a fully automatic diaphragm and permits normal viewing, focusing and Leicaflex SL metering. I consider it the best 1:2-ratio zoom lens now available. The diaphragm has click stops at half-stop intervals, and its smallest aperture is f/22. The closest focusing distance is one meter. The focus set on this lens remains constant when the lens is zoomed to change its focal length. At the 45mm focal length, its angle of view, measured diagonally, is 51°; at the 90mm focal length, the angle of view is 27°.

Another specialized lens is the 60mm f/2.8 Macro-Elmarit-R, which comes supplied with its own extension tube for closeup work.

Without the extension tube, its focusing range is from infinity to 27cm (10.6 inches), for a maximum reproduction ratio of 1:2. The extension tube permits reproduction ratios up to 1:1.

The focusing scale engraved in white shows dis-

28mm f/2.8 Elmarit-R

tances within the normal focusing range from infinity to 1 meter and to 3 feet-4 inches, and reproduction ratios from 1:10 to 1:2, representing the closeup range without the extension tube. The green focusing scale, for use with the extension tube, is engraved in reproduction ratios from 1:2 down to 1:1,

35mm f/2 Summicron-R

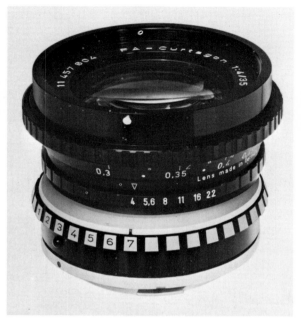

35mm f/4 PA Curtagon-R. To quote Leitz, "the optical 'secret' behind the PA Curtagon-R is that the lens has been corrected to cover a larger angle than. . . normal 35mm lenses"

35mm f/2.8 Elmarit-R

overlapping the white numbers.

To mount the lens on the extension tube, set the diaphragm at f/22, then align the two red dots on the lens with the red lever on the tube. Mount the lens on the tube bayonet by turning the lens clockwise until it locks in place with a click, just as you mount a lens on the camera.

To take the tube off the lens, pull down the red lever on the tube, then turn the lens counterclockwise and remove it.

The lens is fully automatic, and permits normal SL metering and shooting both with and without the extension tube.

For me, a reflex system really begins with the 90mm lens. I use this focal length more than any other on the Leicaflex. (This is, of course, a personal preference, not a dogma.) The 90mm lens, with its relatively narrow 27° angle, forces us to concentrate on the dominant detail of the picture. Focusing is very easy, since the viewfinder image is 1.5 times larger than the subject appears to the unaided eye.

There are two 90mm lenses for the Leicaflex SL; the f/2.8 Elmarit-R and the faster f/2 Summicron-R of this focal length. Both lenses are very compact, little larger in bulk than the 50mm lens, thanks to

50mm
f/2 Summiron-R

60mm
f/2.8 Macro-Elmarit-R
with extension tube attached

Cross section of 60mm f/2.8
Macro-Elmarit-R and its extension
tube, which is supplied with the lens

90mm
f/2.8 Elmarit-R

their telephoto design. Both are fully automatic. The 90mm f/2.8 Elmarit-R stops down to f/22, while the 90mm f/2 Summicron-R stops down to f/16. The 27° coverage of both lenses (diagonal) is the same as that of the meter on the standard Leicaflex. Both 90mm Leicaflex lenses focus as close as 0.7 meter (28 inches). Both have built-in lens hoods.

The 135mm f/2.8 Elmarit-R is another fully-automatic lens of telephoto design. Its field covers an angle of 18° diagonally, its smallest aperture is f/22, and its closest focusing distance is 1.5 meters (about five feet). When you can't get close enough to your subject to fill the frame with a 50mm or 90mm lens, the 135mm is the lens to use. It magnifies the subject 2.3 times on the viewscreen. A lens hood is built in.

The 180mm f/2.8 Elmarit-R telephoto is heavy enough so you know that you got what you paid for! But an f/2.8 aperture in this focal length requires a great deal of glass. This high-speed tele lens has a fully-automatic diaphragm. It covers 14° diagonally, and focuses as close as 2 meters, or about 6 1/2 feet. There is a built-in lens hood, and the minimum aperture is f/16.

The longest Leicaflex lens with a fully-automatic

diaphragm is the 250mm f/4 Telyt-R, relatively fast for its focal length. This lens produces high-quality images at full aperture, and its optimum performance is at f/5.6. For close work, it is advisable to stop down to f/5.6 or f/8. The diagonal angle of view is 10°, and the closest focusing distance is 4 meters (13 feet). The smallest aperture is f/22, and there is a built-in collapsible lens hood.

All Leicaflex SL lenses that mount directly on the camera, from 21mm to 250mm (except the 35mm f/4 PA Curtagon-R) have automatic diaphragms. The lens is fully open both before and after the exposure, so the finder image has maximum brightness. The auto diaphragm closes down to the preset f-stop just before the shutter opens (or when the depth-of-field

90mm
f/2 Summicron-R

135mm
f/2.8 Elmarit-R

250mm
f/4 Telyt-R

50mm
f/1.4 Summilux-R

preview button is pressed), and reopens immediately after the exposure (or when the preview button is released).

All auto-aperture Leicaflex lens mounts follow the same scheme. The auto-aperture ring, the fixed ring with the depth-of-field scale, and the focusing ring are always placed in the same order. Once your left hand is accustomed to operating one lens, the others can be handled in the same way, and you can make all lens settings without looking.

Two special long-focus lenses also mount directly on the Leicaflex. Both use a rapid-slide focusing movement with a push-button lock, rather than the conventional helical focusing mount. They have therefore been called "the trombones." They are the

400mm f/6.8 Telyt-R and the 560mm f/6.8 Telyt-R.

To focus these lenses, you push the lock button to release the lens, then simply push the lens head forward to focus closer, or pull it back to focus farther away. (See illustrations, next page.) Both lenses are light-weight adaptations from f/5.6 lenses of the same focal lengths, designed for use on the Televit (Leica) or the Televit-R (Leicaflex) Rapid Focusing Device. The f/6.8 400mm and 560mm Telyt-R lenses both have non-automatic click-stop diaphragms, a minimum aperture of f/32, and built-in collapsible lens hoods. They are supplied with lightweight shoulder stocks for steady hand-held use.

The 400mm f/6.8 Telyt-R has a diagonal angle of view of 6° and a near-focusing limit of 3.6 meters (12 feet).

The 560mm f/6.8 Telyt-R has a diagonal angle of 4.5° and its closest focusing distance is 6.4 meters (21 feet). It is, of course, longer and heavier than the 400mm lens.

A still longer focal-length Leica-and-Leicaflex lens has been developed, and was introduced in 1972—the 800mm f/6.3 Telyt-S "R." This is a three-element long-focus lens, not a mirror device, so it can be stopped down to control exposure and depth of

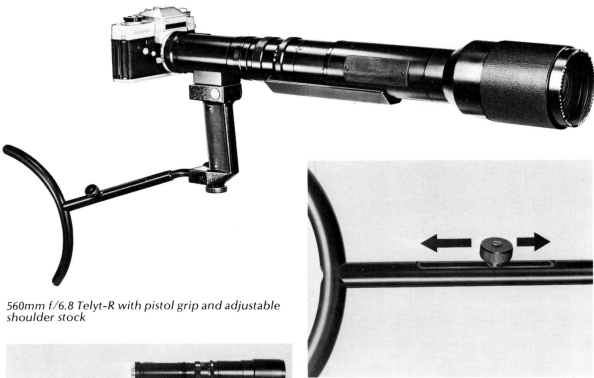

560mm f/6.8 Telyt-R with pistol grip and adjustable
shoulder stock

400mm f/6.8 Telyt-R on shoulder stock

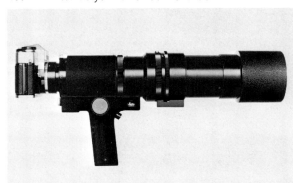

400mm f/5.6 Telyt lens head on Televit-R. This
rapid-focusing device accepts the same shoulder
stock used with the f/6.8 Telyt-R lenses

How the shoulder stock for the "trombones" and
the Televit-R is adjusted

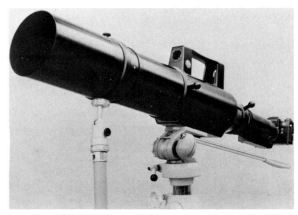

800mm f/6.3 Telyt-S "R" dismantles into three
sections, plus a lens hood and an intermediate collar
with a second tripod socket built in. Focusing is by a
knurled knob on the rear section of the tube, which
also contains the Series VII filter slot. A gunsight-
type aiming device is built into the handle on top of
the center section. The lens sections bayonet to-
gether, and the camera mount permits rotation for
horizontal or vertical pictures

field. The f/6.3 aperture is unusually fast for a lens of this focal length, and the optical quality of the lens is exceptional. Thanks to a new optical glass developed by Leitz, residual aberration and unsharpness are reduced to less than 1/3 the values for conventional optical glass. Contrast, resolution and color differentiation are all markedly improved.

The 800mm f/6.3 Telyt-S "R" weighs about fifteen pounds and is just over 31 inches long. Its smallest aperture is f/32, and its closest focusing distance is 12.5 meters (41 feet), at which distance a 13x19-inch subject area will fill the picture. The angle of view is 3°.

The 800mm lens is supplied together with a styrofoam-lined aluminum case, 22 inches long, which has compartments for three lens sections, for a Leicaflex camera body, and for an auxiliary tripod-socket ring, furnished for use when a second tripod is required.

Other Leicaflex lenses do not mount directly on the camera, but on the Focusing Bellows-R and on the Televit-R Rapid Focusing Device (similar to the Leica Televit already described, and used in the same way; for details, see the instructions for the Leica M5, earlier in this chapter).

Leicaflex lenses for use on the Focusing Bellows-R begin with a series of macro lenses, designed for specialized use in the closeup range. In order of increasing focal length, and with approximate reproduction-ratio ranges for each, they are:

```
 12.5mm  f/1.9  Photar   (15:1-30:1)
   25mm  f/2.5  Photar   (7:1-16:1)
   50mm  f/4    Photar   (3:1-8:1)
   50mm  f/2.8  Photar   (3:1-8:1)
   80mm  f/4.5  Photar   (1:1-4:1)
  120mm  f/5.6  Photar   (1:2-2:1).
```

The 100mm f/4 Macro-Elmar is also designed for use on the Leicaflex Focusing Bellows-R. Its focusing range is from infinity to a 1:1 reproduction ratio; the optical performance is excellent throughout this distance range. Series VII filters and the Elpro VIIa closeup lens can be used on the 100mm Macro-Elmar.

For detailed information on using the Focusing Bellows-R, the Leica Focusing Bellows II, the Photars, the Elpro lenses, and other Leitz closeup equipment, see the chapter, "Closeup Photography," by Norman Rothschild, and the chapter, "Photomacrography

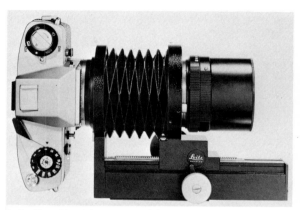

Leicaflex SL with 100 mm f/4 Macro-Elmar mounted on Bellows-R

and Photomicrography," by Renate Gieseler.

The Televit-R Rapid Focusing Device, similar to the Leica Televit, was designed to adapt the 400mm f/5.6 Telyt lens head and the 560mm f/5.6 Telyt lens head to the Leicaflex. These have already been described in the section of this chapter devoted to the Leica M5; they are easier to use with the Leicaflex SL than with the rangefinder Leica and the Visoflex reflex housing, since the Leicaflex automatically performs functions that must be done manually with the Visoflex.

The 280mm f/4.8 Telyt lens head made for use on the Visoflex can also be used on the Leicaflex Televit-R, with bayonet adapter No. 14,138; as may the discontinued 400mm f/5 Telyt lens head.

For more about using long lenses, see "Telephotography," by Julius Behnke.

Leica lenses in focusing mounts for the Visoflex can be used on the Leicaflex SL with the Leica-to-Leicaflex-SL adapter No. 14,167, or the Leica-to-Leicaflex adapter No. 14,127*. (The diaphragm simulator in adapter 14,127* is used only with the standard Leicaflex, and has no function when used with the Leicaflex SL. The discontinued adapter No. 14,127, without asterisk, is for the standard Leicaflex only, and does not activate the SL meter properly; however, this adapter can be modified for normal use with the Leicaflex SL.)

For long-lens metering instructions, see the section on SL metering with Leica lenses, earlier in this chapter.

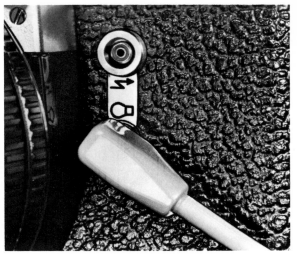

The flash contacts on the camera body next to the lens mount. In this case, a PC cord is plugged into the flashbulb contact

Removing the lens: depress bayonet lock, turn lens counterclockwise (moving the red dot down), then pull the lens straight out of the bayonet mount

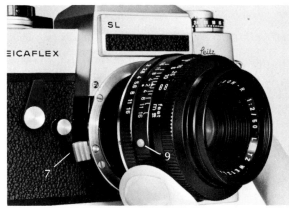

Mounting the lens: line up red dot on lens with red bayonet lock, insert lens and turn clockwise (moving the red dot upward) until it clicks home

Changing lenses

To remove a lens from the Leicaflex (standard or SL) hold the lens by the non-rotating ring of the lens barrel on which the depth-of-field scale is engraved. Push back the bayonet lock (7), turn the lens counter clockwise, and remove it from the camera.

To mount a lens on the Leicaflex, first line up the red dot (9) on the lens with the red bayonet lock on the Leicaflex SL (or the red dot on the standard Leicaflex). Then insert the lens in the bayonet mount of the camera and turn it clockwise until it locks with a click. Always turn the camera away from bright light sources while you change lenses.

Flash synchronization

Any flash unit with a standard PC flash plug can be used with the standard Leicaflex and the Leicaflex SL. The two flash outlets are on the front of the camera body. The upper contact, marked with a lightning-bolt symbol, is for electronic flash. The lower one, marked with a bulb symbol, is for flashbulbs. Both types of flash can be used simultaneously. The Leicaflex SL and the standard Leicaflex are synchronized for electronic flash at speeds up to 1/100 second, shown on the shutter-speed knob by a lightning symbol between 60 and 125. On the shutter-speed scale in the viewfinder, this speed is marked by a white dot. (For more about flash photography, see the chapter, "Artificial Light," by Bill Pierce.)

Flash table for Leicaflex (SL and Standard)

Type of flash	Shutter speed	Contact to use
Electronic flash	B to 1/100	upper (⚡)
Flashbulbs M2	1 to 1/30	upper (⚡)
AG 1 B AG 3 B Flashcubes	1 to 1/60	lower (⚲)
XM 1 B PF 1 B XM 5 B PF 5 B	1 to 1/125	lower (⚲)
GE 5 25 M3 PF 60 B	1 to 1/250	lower (⚲)

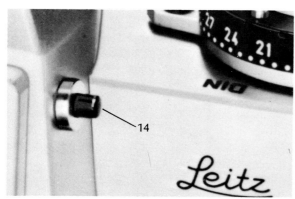

Battery-test button is on prism housing

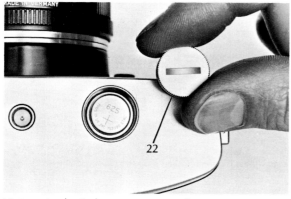

Note coin slot in battery cover and engraving ("625 +") on outer face of mercury cell

Self-timer lever in down (cocked) position. When the camera shutter release is pushed, the lever will travel slowly back to an upright position, triggering the shutter just before it reaches the top

The battery

The Leicaflex SL meter draws its current from a 1.35-volt mercury-oxide cell, located under a cover on the bottom of the camera. The recommended cell is the Mallory PX 625, or the Varta Pertrix 7002. The Mallory PX 13 may also be used. These cells have a normal life of one to two years.

To test the battery, press the button on the side of the prism housing near the rewind knob, while watching the meter needle in the viewfinder. If the needle moves down to or past the index point in the lower right corner of the screen, the battery is good. If the needle does not swing down fully, the battery needs replacement.

Mercury cells produce constant current until exhausted, then fall off rapidly, so a defective battery will usually not move the needle at all when the control button is pushed.

Changing the battery. Unscrew the cover with a small coin, remove the old cell and insert a fresh one; be sure the engraved side of the battery faces outward. Replace the cover, then go through the battery test procedure to confirm that the new cell is working correctly.

The self-timer

The delayed-action release can be used at any shutter speed. Wind it by turning the lever outward and down until it points straight down. To start the self-timer, press the shutter-release button. It makes no difference whether you cock the shutter first or the self-timer first; but the self-timer cannot be started on the Leicaflex and Leicaflex SL until the shutter is cocked.

The self-timer provides a delay of about ten seconds before releasing the shutter. During the delay, the lever returns slowly to its original upright position. The shutter is triggered just before it reaches the top of its travel.

If the lever is not moved down past the halfway point, the shutter release may be blocked, even if the lever is turned back by hand to the upright position. The solution is to turn the self-timer down all

the way and activate it normally with the shutter release.

The self-timer is used for pictures that include the photographer, or for slow exposures in the hand or on a tripod for which a cable release is not used.

With the shutter set at B, the self-timer gives an exposure of approximately two seconds.

Using filters on the Leicaflex SL

I recommend that you take a normal meter reading without a filter on the lens, then increase your exposure according to the factor of the filter you are using. (A factor of 2 requires twice the indicated exposure given by a filterless reading; a factor of 4 requires a 4x increase, and so on.)

It is not advisable to take meter readings through colored filters, since the color sensitivity of the CdS meter does not necessarily match that of the film you are using.

When any but the latest (1972) Series VII Leitz polarizing filter is used, the semitransparent viewing mirror of the Leicaflex SL influences the readings. With such old-type polarizing filters, there are two ways to determine the correct exposure.

One way is to take a normal reading without the filter, then insert the filter and increase the exposure according to the filter factor (3x), either by opening the lens 1 1/2 stops, or by slowing the shutter one speed and opening the lens 1/2 stop.

The other is to take the reading with the old-type polarizing filter in place. Rotate the filter until the maximum exposure time is indicated by the meter needle reaching the lowest position. Set the exposure accordingly, then turn the filter to obtain the visual effect of your choice, and shoot without further compensation.

The new Series VII polarizing filter for the Leicaflex SL makes this operation unnecessary. Simply place the filter in one of the new Leicaflex lens hoods (No. 12,508 or 12,509), so the yellow dot on the filter mount can be seen. The filter then permits normal SL metering at any angle of rotation. It can be used only with recent Leicaflex lenses and their bayonet-mount lens hoods that serve as filter holders. (These lenses have a small metal knob on top of the front of the lens barrel.)

Mounting filters on the lenses. Early Leicaflex lenses have built-in series-size filter-retaining rings, while newer lenses have bayonet-mount lens hoods

that hold the filters. The longest lenses have filter slots in the rear part of the lens tube, and thus accept smaller filters than would be required in front of the lens. The filter sizes and mounting methods for current Leicaflex SL lenses are as follows.

Leicaflex lens filter sizes

Lens and focal length	Filter size, series number	Mounting method
21mm f/4 Super Angulon-R	VIII½	bayonet lens hood
28mm f/2.8 Elmarit-R	VII	bayonet lens hood
35mm f/2 Summicron-R	VII and E48	bayonet lens hood
35mm f/2.8 Elmarit-R	VI	built-in retaining ring
35mm f/4 PA Curtagon-R	VIII	bayonet lens hood
45mm-90mm zoom Angenieux-R	VIII	lens hood
50mm f/1.4 Summilux-R	VII	bayonet lens hood
50mm f/2 Summicron-R	VI	built-in retaining ring
60mm f/2.8 Macro-Elmarit-R	VIII	bayonet lens hood
90mm f/2 Summicron-R	VII	built-in retaining ring
90mm f/2.8 Elmarit-R	VII	built-in retaining ring
100mm f/4 Macro-Elmar	VII	built-in retaining ring
135mm f/2.8 Elmarit-R	VII	built-in retaining ring
180mm f/2.8 Elmarit-R	VIII	built-in retaining ring
250mm f/4 Telyt-R	VIII	built-in retaining ring

400mm f/5.6 Telyt lens head	VII	filter slot in Televit-R mount
400mm f/6.8 Telyt	VII	filter slot in lens tube
560mm f/5.6 Telyt lens head	VII	filter slot in Televit-R mount
560 mm f/6.8 Telyt	VII	filter slot in lens tube
800mm f/6.3 Telyt-S "R"	VII	filter slot in lens tube

To put a filter on a new-type Leicaflex R lens (with small metal stud on top of the lens barrel), insert the filter in the lens hood; then align the white dot on the hood with the metal stud on the lens, fit the hood onto the lens, and turn the hood clockwise. To remove the hood, lift it slightly, turn counter-clockwise, and pull it free

To unscrew the filter-retaining ring on old-type Leicaflex R lenses, grip the ring by the inside, on one side only, and turn. Drop the filter into place and screw the ring back onto the lens

The filter will not come out of the lens hood (except in the case of the 21mm lens) until you lift the small knurled knob on the side of the hood. When the knob is lifted, the filter drops out

To put a filter on a retaining-ring-equipped lens, unscrew the ring by gripping it inside, on one side only, and turning. Then insert the filter and screw the ring back in place.

The filter-holding lens hoods for new Leicaflex lenses are used by inserting the filter in the lens hood, then mounting the bayonet of the hood on the front of the lens barrel. To attach the hood, align the white dot on the lens hood with the small metal knob on top of the lens barrel, and turn the hood clockwise.

To remove the hood, lift the hood slightly and turn it counterclockwise, then pull it free. With the hood for the 21mm lens, the filter simply drops out. With hoods for other lenses, the filter is held by the

With the new circular Series VII Leitz polarizing filter, you can rotate the filter inside the lens hood with the knurled knob on one side of the hood

hood until you lift the small knob on the side of the hood. The filter then drops out.

By moving the knob on the side of the lens hood, the new Leicaflex polarizing filter can be rotated inside the hood.

Corrective lenses for the viewfinder eyepiece.
With any 35mm reflex camera, the individual photographer's eyesight should be adjusted for maximum resolution. The viewing screen we look at is small—23x35mm—so we use a magnifier to see it better, usually a pentaprism with 4x magnification. The distance from the eyepiece to the focusing screen is based on the average eye, but not all eyes are average. To see all possible detail in the image on the screen, some people need corrections to adjust their eyes to the ocular screen distance of the camera. For this purpose, mounted corrective lenses are made to slip over the viewfinder eyepiece of the Leicaflex. For eyeglass wearers, these lenses are made according to their personal prescriptions. This is far more important with a reflex camera, where focusing depends on critically sharp eyesight, than with a rangefinder camera.

Camera care

Avoid pointing any camera toward the sun for any prolonged period. The lens acts as a burning glass, focusing heat as intensely as it focuses light, and severe damage can result. Protect your lens against dirt and your camera against heat by keeping the lens cap on whenever you are not shooting.

Never clean a photogaphic lens with colored or chemically-impregnated eyeglass-cleaning tissues; they may attack the lens surface chemically. Use a soft lens brush, or dab the surface carefully with a soft, clean, dry linen rag. Do not rub hard under any circumstanced. *It is better to keep a lens clean than to keep cleaning it.*

The clear Leitz UVa filter may be kept on the lens permanently to serve as a dust cover, and as protection against weather.

Dust and fluff on the reflex mirror should be removed carefully, using a soft lens brush which is rinsed repeatedly in alcohol before and during the cleaning process. (Accumulated dust on the brush can scratch the mirror.)

Dust on the underside of the viewing screen should not be removed unless it interferes seriously with the finder image. In that case, use an antistatic brush that is rinsed repeatedly in alcohol. Never allow wood or metal parts of the brush to touch the finder screen or the mirror surface. Do not blow into the mirror housing to remove dust. You are likely to force the dust into the interior of the camera, where it can cause damage.

For further tips on camera care, see the chapter, "Keeping Your Leica Out of the Repair Shop," by Norman Goldberg.

THE LEICAFLEX SL/MOT

This is a special model of the Leicaflex SL, designed for motorized use. It can also be used without the motor. If you plan to use a motor drive, now or later, get the Leicaflex SL/Mot. The regular Leicaflex SL cannot be modified to use the motor drive.

The Leicaflex SL/Mot has no self-timer, and cameras with serial numbers higher than 1,275,360 do not have a meter-battery off-on switch on the manual advance lever. The Leicaflex SL/Mot is available only in black finish.

Attaching the motor. Cock the camera and set the switch (11) on the side of the motor at M. Before connecting the motor to the camera, make sure that the lug (12) on the motor drive shaft is aligned with the red dot (13). Attach the motor to the camera and secure it with the screw (7).

The battery housing (5) is removed from the motor housing by depressing the lock (6). The battery case accepts ten 1.5-volt batteries, size AA (or R6). To insert the batteries, loosen the two screws and remove the cover from the container. Place the batteries in the housing according to the plus (+) and minus (−) marks, then replace the cover and tighten both screws. Leitz has tested the following batteries, which are recommended:

Bright Star	7524	(United States)
Burgess	AL-9	(" ")
Eveready	E-91	(" ")
Eveready	1015	(" ")
Mallory	MN-1500	(" ")
Ray-O-Vac	815	(" ")
Ray-O-Vac	7AA	(" ")
Sears 34-4666	Powermaster	(" ")
Berek	HP 7	(United Kingdom)
Ever Ready	HP 7	(" ")
Hellesens	738	(Denmark)
Daimon	298	(West Germany)
Pertrix	244	(" ")

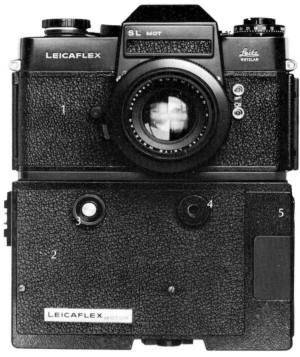

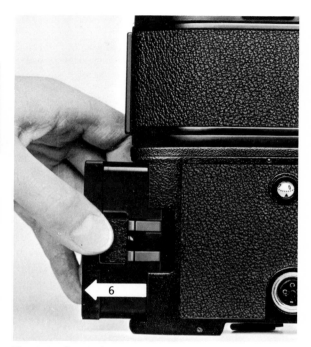

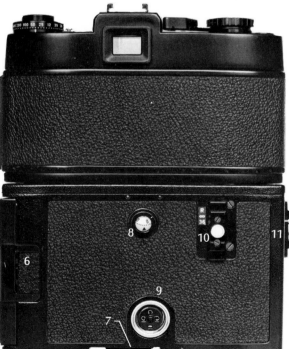

The Leicaflex SL/Mot, its parts and controls
1. Leicaflex SL/Mot camera
2. Leicaflex motor
3. Motor release button
4. Threads for tripod platform (Cat. No. 14,148)
5. Battery housing
6. Battery-housing lock
7. Screw connecting motor to camera
8. Motor frame counter
9. Three-pronged remote-control and remote-frame-counter socket
10. Switch for rewind position, 36-exposure cutoff, or continuous advance without cutoff (∞)
11. Manual operation (K) or motor drive (M) selector switch
12. Motor drive-shaft alignment lug
13. Drive-shaft alignment dot

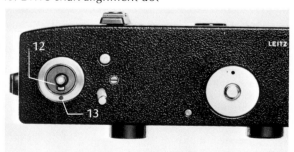

In cold weather, high-energy batteries should be used. At very low temperatures, a separate battery case equipped with a safety switch should be used with either a 12-volt storage battery or ten high-energy D-cell batteries.

Using the SL/Mot

Film loading is the same as with the Leicaflex SL. Before closing the camera back, advance the film one frame, using the motor release (3), to make sure that the film perforations engage the sprocket teeth. Set the desired number of exposures (36 or ∞) with the switch (10).

When set at 36, the motor will cut off automatically after 36 exposures. To set it for less than 36 exposures, advance the motor without film in the camera to two less than the difference between 36 and the desired number of frames. (This allows for two blank frames at the start, to avoid lightstruck exposures.) Thus you set the motor at 14 for a 20-exposure roll (36-20 = 16, and 16-2 = 14). This setting is marked on the motor's frame counter (8) by a black dot.

To operate the release button on the motor, the transport lever of the camera should be pushed against the camera body. (In cameras with serial numbers below 1,275,361, with a built-in meter switch on the advance lever, the motor can be used with the advance lever slightly moved out to the first metering position.) When fully extended, the lever switches the motor off.

All shutter speeds from 1 second to 1/2000 can be used for single exposures through the motor release. However, motorized sequence shooting can only be done at shutter speeds of 1/30 second and faster, because the motor cycles the camera at three to four frames per second.

The Leicaflex SL/Mot can be operated manually with the motor attached. To disengage the motor drive, set the switch (11) at K. Then expose by using the shutter-release button on the camera. For manual shooting, cock the camera by extending the advance lever fully, as you would without the motor.

To switch back from manual operation to motor drive, advance the film once with the advance lever, then set the switch (11) at M. Move the camera lever manually until you feel resistance, to assure correct mechanical coupling.

To rewind the exposed film, set the control switch (10) at R and wind the film back manually.

Remote-control photography with the SL/Mot. You can use any remote-control device that can close an electrical contact. Simply plug the remote-control unit into the three-pronged socket (9).

The Leitz remote-control cable has a built-in electric exposure counter. Remote Electronic Control Unit No. 22,226 uses the same type of battery case as the SL/Mot motor-drive unit, but draws less current, so you can prolong motorized remote-control shooting by exchanging the two cases when the motor batteries become weak.

Leicaflex SL/Mot trouble-shooting table

Motor does not work because	Remedy
camera shutter was not fully cocked when motor was attached	*immediately* pull out battery housing and put it back again
switch (11) is set at K	cock camera with lever and set (11) at M; then advance lever one stroke
switch (10) set at R	set switch (10) at 36 or ∞
advance lever extended from camera body	fold advance lever against camera body
motor counter has cut off at 36 while switch (10) is set at 36	change exposed film for fresh: set switch (10) at R, rewind, reload, then reset switch (10) to 36 or for further exposures
batteries weak or dead	change to fresh batteries
batteries inserted wrong	re-insert batteries according to plus (+) and minus (−) marks
felt mouth of film cartridge too tight to let film move	change to new film cartridge

In other respects, the Leicaflex SL/Mot is operated in exactly the same way as the regular Leicaflex SL.

The SL/Mot is ideal for all sports, fast-action, research, and remote-controlled photography.

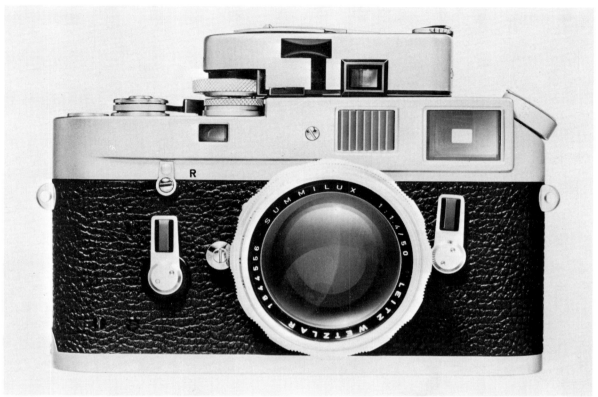

Leica M4 with Leica-Meter MR-4 attached. The M4 can be recognized easily by its tilted rewind crank

THE LEICA M4

Introduced in 1967, the Leica M4 was discontinued in 1972 to permit increased production of the M5, which had been introduced just the year before. It is a mark of Leitz' concern for quality that this change was made after so short a time.

The M4 is the last rangefinder Leica without a built-in meter, and the first with a rapid-rewind crank and a rapid-loading takeup spool. Otherwise, it closely resembles the M2 and the M3, which it replaced. Like them, it can use any M-Leica lens, and any screw-mount Leica lens can be adapted to it.

The focal-length range is therefore the same for all M Leicas, from 21mm to 800mm; and the fastest lens now available for the Leica fits them all—the 50mm f/1.2 Noctilux.

The M4 range-viewfinder was the first M-Leica finder to accommodate four focal lengths without accessories—35mm, 50mm, 90mm, and 135mm. The bright-line display is identical with the M5 viewfinder: 135mm field in the center of the 35mm field; separate line displays for the 50mm and 90mm fields. However the M4 does not have the meter-field and meter-readout features of the M5 range-viewfinder.

The M4 has shutter speeds from 1 to 1/1000 second and Bulb, and a self-timer actuated by a button on the front of the camera, as on the M5.

No meter is built into the M4, but the Leica-Meter MR-4, which fits the accessory shoe on top of the camera, couples to the shutter-speed knob. The use of the MR-4 is given in detail in the chapter, "Light Meters and Metering," by James Forney. The 90mm frame of the range-viewfinder represents the metering field of the MR-4, and the meter is aimed by aiming the camera.

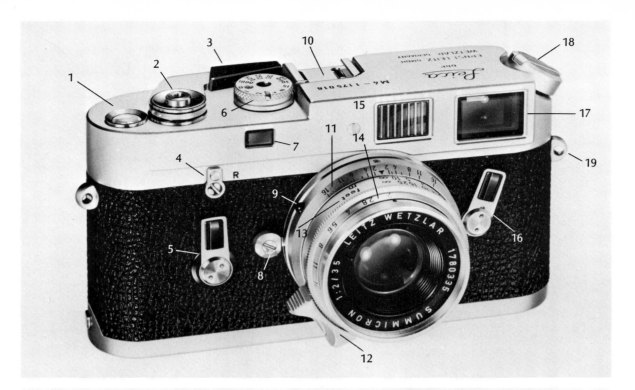

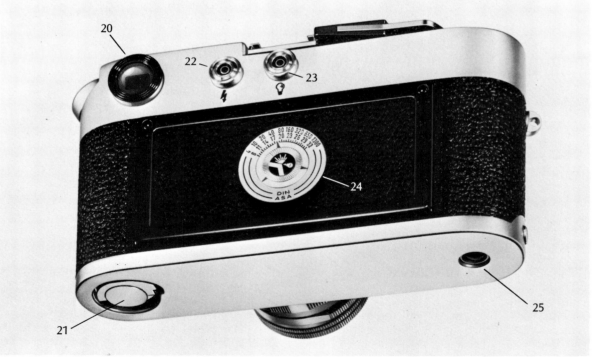

Leica M4 parts and controls

1. Automatic frame counter
2. Shutter-release button
3. Rapid-winding lever
4. Rewind-release button

5. Self-timer
6. Shutter-speed knob
7. Rangefinder window
8. Lens bayonet lock
9. Red locating knob for lens insertion

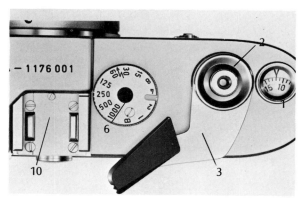

Left to right: M4 accessory shoe, shutter-speed dial with coupling groove for MR-4 meter, rapid-winding lever with shutter-release button and cable-release socket at its hub, and the automatic frame counter. The shutter is shown set at 1/250 second

Camera held horizontal

10. Accessory shoe
11. Depth-of-field scale
12. Focusing control
13. Distance scale
14. Aperture scale
15. Illumination window for viewfinder frame lines
16. Field-of-view preselector lever
17. Viewfinder window
18. Folding rewind crank
19. Eyelets for strap
20. Range-viewfinder eyepiece
21. Baseplate lock
22. Electronic-flash synchronization contact
23. Flashbulb synchronization contact
24. Film-type reminder
25. 1/4-inch tripod socket

Basic M4 controls

The shutter settings on the Leica M4 are as follows:

1 = 1 second	60 = 1/60 second
2 = 1/2 ''	125 = 1/125 ''
4 = 1/4 ''	250 = 1/250 ''
8 = 1/8 ''	500 = 1/500 ''
15 = 1/15 ''	1000 = 1/1000 ''
30 = 1/30 ''	B = bulb

When the shutter is set at B, it opens when the release button is pressed and closes when the button is let go. The fastest electronic-flash-synchronization speed on the M4 is 1/50 second, marked by a lightning-bolt symbol between 30 and 60 on the shutter knob. The knob is turned to set the desired speed at the index mark on the accessory shoe.

The shutter may be set to any speed either before or after the camera is cocked. Intermediate speeds may be set except between 1/8 and 1/15 second and between 1/30 and the lightning-bolt symbol.

The aperture scale, focusing scale and depth-of-field scale on M4 lenses are exactly the same as for all M Leicas. For details, see the instructions for the Leica M5.

Holding the Leica M4

Horizontal. As with the M5 and the Leicaflex, hold the camera with the left hand under the lens, to provide support and to operate the aperture and focusing controls. The right hand operates the shutter-speed dial, the shutter-release button and the rapid-winding lever. The shutter dial is placed farther back and inward than on the M5, and it is preferable to set the shutter before placing the camera in its shooting position at the eye. There is no shutter-speed indication in the viewfinder of any M Leica except the M5.

Vertical. As with the M5 and the Leicaflex, just move your right hand up, keeping your hands on the camera controls in the same positions, until the camera is vertical. The M4 can also be turned the

Vertical camera, right hand up *Vertical camera, left hand up*

other end down for vertical shots, but that is less convenient, as the hands must then be shifted on the controls.

Loading and unloading the Leica M4

Before you open the camera, make sure there is no film in it that has not been rewound into its cartridge. Unfold the *rewind crank* (18) and turn it gently in the arrow direction. If you feel resistance, there is film in the camera. Rewind it before proceeding.

To rewind the film in the camera, set the rewind-release lever (4) at R. Then unfold the rewind crank and turn it in the direction of the arrow. You will feel and hear the film moving through the camera into its cartridge. Rewind until you feel the film's resistance increase; after one more turn, the end of the film will pull free of the takeup spool and the crank will turn more freely.

Before opening the baseplate, cock and shoot the camera once or twice (with the lens cap on) and watch the rewind crank. If it does not turn when you cock the camera, the film is fully rewound and the camera can safely be opened.

To remove the rewound film, turn the camera bottom up, unfold and turn *the baseplate key* (21) and lift the baseplate off. The exposed cartridge can simply be dropped out of the camera into your hand.

To load the Leica M4, remove the baseplate, as above. Insert the cartridge of fresh film into its

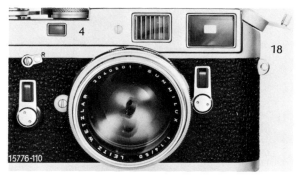

Rewind-release lever (left) at R, rewind crank (right) unfolded

chamber, then pull the tongue or leader of the film out far enough so you can push it between two of the three prongs of the quick-loading takeup spool. Thread the leader between the prongs so that its end touches the wall of the takeup-spool housing. *Do not* push the leader far down into the takeup spool, or you are likely to jam the camera. The baseplate automatically pushes the film into proper alignment in the spool.

Close the back-plate of the camera, then replace the baseplate and lock it by turning the key (21) to the right. Fold the key into its recess.

Cock the camera once, then turn the rewind crank gently in the arrow direction to take up any slack in the film. Then release the shutter and cock the

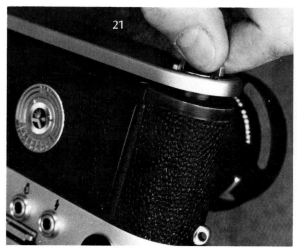

Removing the baseplate

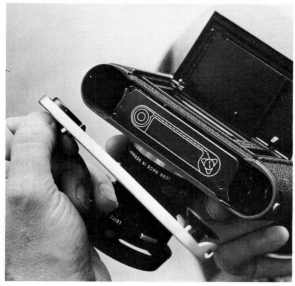

Baseplate off, back open, exposed cartridge removed

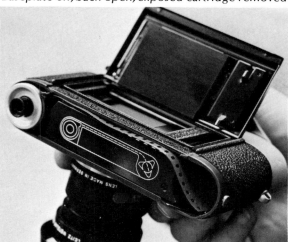

New film inserted in camera and takeup spool

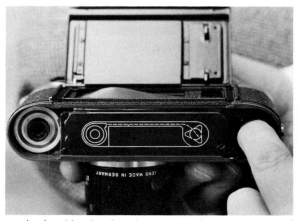

Push the film leader down into the takeup spool prongs, but not too far down

camera once more while watching the rewind crank. It the crank turns, the film is moving as it should. (If it does not run, something is wrong. Open the camera and begin loading again.) After the third stroke of the rapid-winding lever, the camera is ready for the first picture on the roll.

If you load your own cartridges with bulk film, you must trim the leader of each roll into a tongue for proper M4 loading. The tongue should be at least 1½ inches long and about ¾ inch wide. Use a factory-loaded roll as a guide. (The M1, M2, M3 and M5 do not require a leader tongue for loading. Square-cut film ends work as well in these cameras.)

When the winding lever (3) can no longer be moved, you have reached the end of a roll, and it is time to rewind and reload. Do not force the advance lever, or you may either tear the perforations in the film, or pull the film entirely out of its cartridge so it cannot be rewound in the camera. In that case, the camera must be opened and the film removed in total darkness (a changing bag, a darkroom, or even a coat or blanket held tightly over you and the camera).

To remove film that is wound this way around the takeup spool, take the camera into the dark, remove the baseplate, and hold the camera right-side-up. Cock and shoot several times, until the wound-up film emerges from the bottom of the camera by itself. If necessary, tap the camera lightly against your

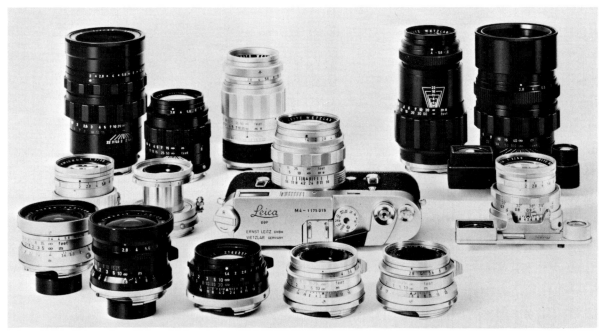

The Leica M4 and some of the lenses that can be used on it: wide-angle lenses in foreground, 50mm lenses in line with the camera, long lenses in background

hand to help. Put the film into a light-tight container or develop it at once.

The range-viewfinder system

Except for the absence of the meter and its view-finder guide marks, the M4 range-viewfinder dupli-cates that of the M5, and is used in the same way. The 35mm and 135mm frames appear together, and the 50mm and 90mm frames are each seen alone in the finder. The selector lever functions in the same way as that of the M5.

Lenses for the Leica M4

The Leica M4 uses all the lenses that are available for the M5, and also accepts one discontinued lens that cannot be used on the M5; the 21mm f/4 Super Angulon. This lens uses the same 21mm auxiliary viewfinder that is used with the 21mm f/3.4 Super Angulon. In all other respects, the use of lenses on the M4 is exactly the same as on the M5, though the M5 bayonet lock has been modified somewhat. All

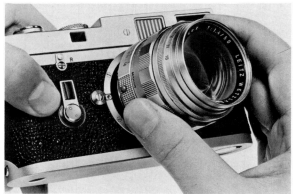

The bayonet on the M4 body accepts the same lenses and attachments in the same way as the M5 bayonet

collapsible Leica lenses may safely be retracted fully while mounted on the Leica M4.

Changing lenses

The procedure is the same as with the Leica M5.

Leica M4 flash synchronization

Any PC-cord equipped flash unit that can be used on the Leica M5 can be used with the M4. The sync con-

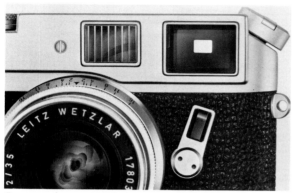

Frame-selector lever in position for 35mm and 135mm lenses

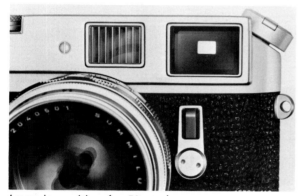

Lever in position for 50mm lens

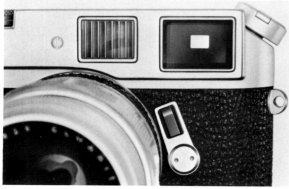

Lever in position for 90mm lens

tacts on the back of the M4 resemble those of the M5, but the electronic-flash contact is marked with a lightning-bolt symbol instead of an X, and the flash-

Flash contacts on the Leica M4; for electronic flash at left, for flashbulbs at right

bulb contact on the M4 is marked with a bulb symbol instead of an M, as on the M5.

Flash table for Leicaflex M4 and MDa

Type of flash	Shutter speed	Contact to use
Electronic flash	B to 1/50	left (⚡)
Ag 1 B Ag 3 B M2 Flashcubes	B to 1/30	left (⚡)
GE 5 25	B to 1/30	right (💡)
XM 1 B PF 1 B PF 5 B	B to 1/60	right (💡)
M3	B to 1/125	right (💡)
GE 6 26	B to 1/500	right (💡)

The self-timer

The delayed-action shutter release (5) can be used at all shutter speeds, and may be set either before or after the shutter is cocked.

When the self-timer lever is moved outward and down slightly past the horizontal, the delay is about five seconds; when it is turned so it points straight down, the delay is about ten seconds.

The self-timer is activated by pressing the small chrome button that is behind the lever when it is

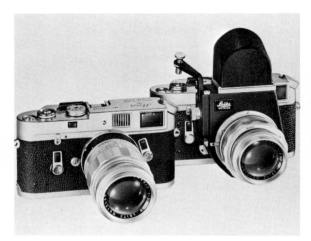

M4 with two versions of the 90mm f/2.8 Elmarit lens; in long focusing mount (left), and lens head for use with Visoflex III (right)

The self-timer is shown in its cocked position in this time exposure, and the arc to its left is its path of motion during the 10-second delay

upright. Do not use the shutter-release button on top of the camera for self-timer exposures; this release bypasses the self-timer and provides no delay.

Attachments and accessories

The attachments that can be used on the Leica M5 were mostly designed for use on earlier M Leicas, including the M4, which therefore accepts them freely. The Leica-meter MR-4 can be used on all rangefinder M Leicas except the M5.

To use the Leica-Meter MR-4, push the meter button with the index finger while you hold the frame-selector lever in the 90mm position with the second finger. The 90mm frame shows the metering field. To set exposure, turn the knurled wheel on the meter that is coupled to the camera's shutter-speed knob, and set the f-stop according to the meter reading

The Leica MDa

THE LEICA MDa

The Leica MDa, a special M Leica made for closeup and copy photography, is well suited to photomicrography and many other scientific applications. It differs from the Leica M4 mainly in having no viewfinder or rangefinder and no self-timer. It is normally used with such auxiliary viewing and focusing devices as the Visoflex reflex housing and the Micro-Ibso attachment.

The MDa camera is supplied without a lens. Its shutter has speeds from 1 second to 1/1000 and bulb, and is synchronized for flashbulbs and electronic flash.

The special baseplate. In addition to a standard baseplate, the special MDa baseplate No. 14,142 has a light-tight slit that allows translucent plastic negative-marking strips to be fed into the camera to imprint information on each frame as it is exposed. The film track in the Leica MDa has a 3.5mm-wide cutout into which these strips fit, and where they are held in direct contact with the film during the exposure. The negative marking strips themselves, Cat. No. 14,132, are supplied by Leitz in packages of 100.

Simply write on the strip with India ink

To use the marking strips with the special baseplate, simply write the data you want to record on the strip with India ink, let it dry, and insert the strip in the opening in the baseplate. Hold the strip so that it reads correctly when seen from behind the camera, and feed it in with the protruding tab at the lower end and at the left of the strip. The data should be written between the two pinholes on the long end of the strip.

The strip can accidentally jam against the bottom of the film, or even feed into the camera behind the film. Therefore it is a good idea to practice with the back of the camera open, the shutter set at bulb, and a length of unwanted film loaded in the camera. Then you can see exactly what is happening and learn the feel of the process, so you will be able to control it easily.

The special baseplate cannot be used with other M Leicas, since they have no film-track cutout to accept the marking strips.

In all other ways, the MDa is used exactly like a Leica M4; for more information, therefore, see the instructions for the M4.

Inserting the strip in the special baseplate

MDa negatives with imprinted information

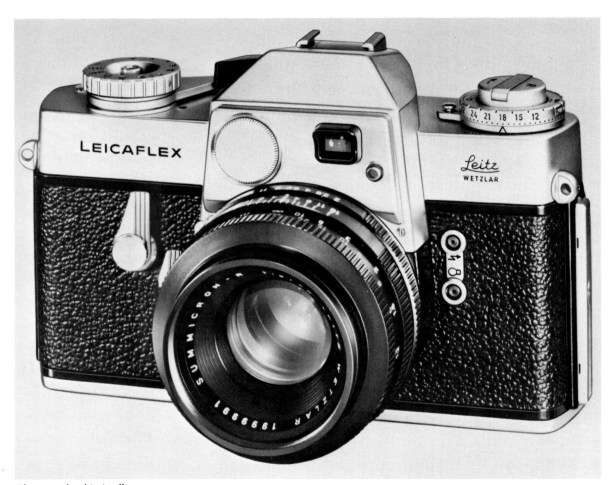

The standard Leicaflex

Handling Earlier Leitz Cameras

The standard Leicaflex

In most ways, the handling of the original Leicaflex is the same as that of the Leicaflex SL, so we refer you to the instructions for the Leicaflex SL for all procedures not given here.

This portion of the *Leica Manual* is devoted to the differences between the standard Leicaflex and the Leicaflex SL, and to the operating procedures for the standard Leicaflex.

Differences between the Leicaflex and the Leicaflex SL

	Standard Leicaflex	Leicaflex SL
Meter	*Coupled external CdS light meter with fixed 27° reading angle (equal to the angle of view of a 90mm lens). No on-off switch for meter.*	*Coupled through-the-lens CdS light meter with reading angle that varies with the focal length of the lens. Metering field shown accurately by central circle in viewscreen. Rapid-advance lever acts as on-off switch for meter.*
Viewfinder	*Non-focusing Fresnel viewscreen has central microprism spot which is used for all visual focusing. Central spot is aiming point for meter, but does not show its field. Focusing is not possible on other parts of the screen; only in the center spot.*	*All-microprism viewing-focusing screen permits focusing on any area of the screen. Coarse-microprism center spot for rapid focusing also shows metering field for the lens that is in use.*
Instant-return reflex mirror	*Leicaflex-standard instant-return mirror has control device to lock mirror in up position either before or after the shutter is released.* *This mirror lock permits use of the 21mm f/3.4 Super Angulon-R lens on the standard Leicaflex when the mirror is locked up against the bottom of the viewscreen.*	*Leicaflex SL instant-return mirror cannot be locked up. Mirror has a semi-transparent central area that transmits light to the internal CdS meter in the bottom of the camera, via a folding second mirror on the back of the main mirror. 21mm f/3.4 Super Angulon-R lens cannot be mounted or used on the Leicaflex SL.*
Depth-of field previewing	*No provision for previewing depth of field in finder.*	*Built-in preview button permits visual inspection of depth of field in viewfinder at any f-stop preset on a Leicaflex SL auto-aperture lens.*
Meter battery	*Meter battery is on front of camera body, above the lens mount. Battery-test button on front of prism housing.*	*Battery located in baseplate of camera. Battery-test button on side of prism housing, near rewind crank.*
Takeup spool	*Conventional takeup spool with single slot through shaft, which can be turned to bring slot into loading position. Film leader must be trimmed to width of about 3/4-inch to fit into spool slot.*	*Multi-slot rapid-loading takeup spool in Leicaflex SL accepts either tongue-trimmed standard film leaders or square-cut ends, simplifying bulk-film loading.*
Motor drive	*No provision for motor drive.*	*The Leicaflex SL/Mot can be used with or without its own motor drive attachment; regular Leicaflex SL cannot.*

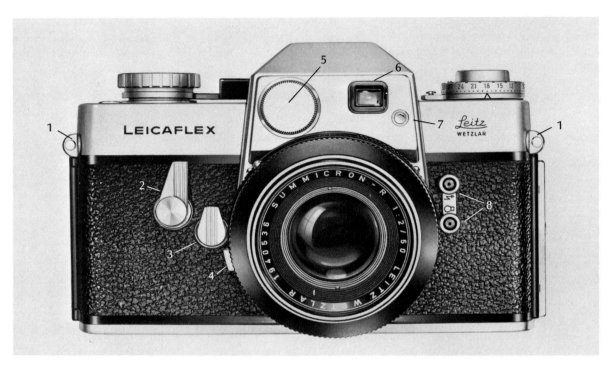

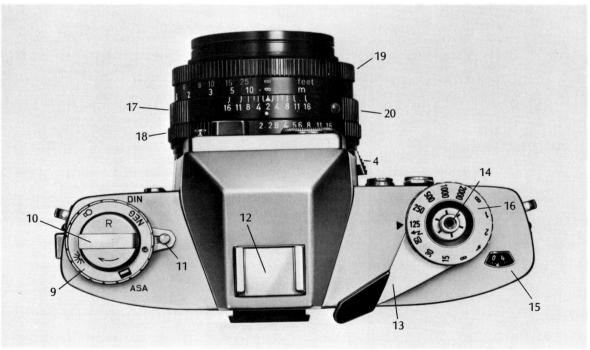

Leicaflex parts and controls

1. Carrying-strap lugs
2. Self-timer
3. Mirror-control lever
4. Lens-mount bayonet lock
5. Meter battery housing
6. Meter window
7. Battery-test button
8. Flash-synchronization contacts
9. Film type indicator and meter film-speed scale
10. Film-rewind crank
11. Film-speed scale lock
12. Accessory shoe
13. Rapid advance lever
14. Shutter-release button with cable-release socket
15. Frame counter
16. Shutter-speed dial
17. Depth-of-field scale
18. Auto-aperture selector ring
19. Focusing ring and distance scale
20. Raised red dot for lens changing

Loading the standard Leicaflex

As with the Leicaflex SL, first make sure that the camera is empty, or that film in it has been rewound.

Open the camera back by pressing the button on the locking bar at the left end of the camera and pushing the bar upward.

Pull up the unfolded rewind crank. If there is an exposed film cartridge in the camera, remove it.

Push the narrow leader of the new film into the slot in the takeup spool (which can be turned to place the slot where you want it). Make sure that the edge of the film lies straight against the flange of the spool. Then place the film cartridge in its chamber and push the rewind crank down. Before you close the camera, stroke the advance lever to wind the film one-half turn and make sure the sprockets engage the film perforations.

Close the camera back and press the locking bar downward.

Cock the camera fully and press the shutter-release button. Take up any slack in the film by turning the rewind crank gently in the arrow direction until you feel resistance, then fold the crank. Next, advance and shoot two more blank frames, watching the rewind crank as you do so, to make sure it turns.

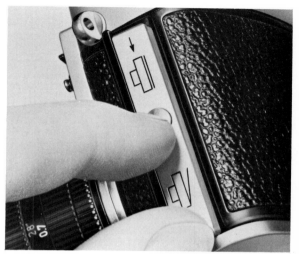

To open the camera, press the button on the locking bar, then push the bar upward

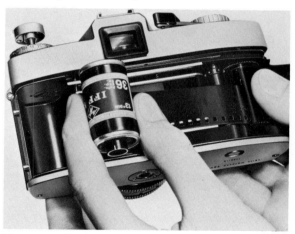

First insert the trimmed leader of the film in the slot in the takeup spool, then place the cartridge in its chamber and lock it in place by pushing the rewind crank down

Otherwise, loading and unloading the standard Leicaflex is the same as with the Leicaflex SL.

Standard Leicaflex viewing and focusing

Unlike the Leicaflex SL, the standard Leicaflex does not show in-and-out-of-focus differentiation over the whole viewfinder field. Except for the central

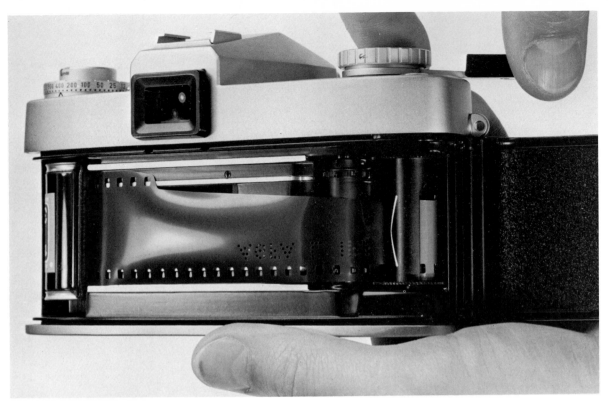

Before closing the camera, stroke the advance lever and make sure the sprocket teeth engage the film perforations

focusing spot, which consists of 13,000 triangular microprisms, the rest of the viewing screen is a Fresnel lens which has no focusing surface. The image in the screen appears sharp whether or not the lens is focused on the subject. Therefore, *focus only with the center spot.*

The microprisms deflect out-of-focus light rays, but do not affect sharply-focused images. When a subject seen within the focusing spot becomes sharp, the shimmering texture of the spot disappears.

The standard Leicaflex has no depth-of-field preview button. For depth-of-field information, users must consult the scale on the lens mount.

Lens coverage angles and the metering field

The viewfinder of the standard Leicaflex, like that of the Leicaflex SL, shows the field of the lens being used: the lens fills the screen with the picture it produces. However, the standard Leicaflex viewscreen does *not* show the metering field, except when a 90mm lens is being used. The metering field does *not* change when the focal length of the lens is changed, but is fixed at 27° (measured diagonally).

Therefore the central focusing spot in the screen can serve as an aiming point for the meter, but the metering field must be estimated. When in doubt, fill the entire viewscreen with the subject tone you want to measure, and you will get an accurate reading.

When the mirror of the standard Leicaflex is locked in the up position, no reading is visible in the screen; and when the Bellows-II attachment is adapted to and mounted on this camera, it blocks the meter window. It is simplest, in either case, to take light readings with a separate meter.

Otherwise, metering procedures are the same as those of the Leicaflex SL.

Leicaflex mirror-control lever

Another difference between the standard Leicaflex and the SL is that the reflex mirror of the earlier camera can be locked up against the underside of the viewscreen, while that of the Leicaflex SL cannot. (When the mirror is locked up, the screen is blacked out, which prevents normal reflex viewing and focusing and makes it impossible to read the meter.)

Using the mirror-control lever. Position 1 (lever upright) is the normal position for shooting with the standard Leicaflex. With the lever in this position, the instant-return mirror springs up when the shutter-release button is pressed, then returns immediately to the viewing position when the shutter closes.

The mirror-control lever
Position 1: instant return setting. Lever upright

Position 2: mirror locked up after shutter is released.
Lever horizontal

Position 3: mirror locked up before shutter is released; mirror rises when shutter is cocked. Lever points down

Position 2 (lever horizontal) causes the mirror to spring up *when the shutter is released,* and to stay locked up until the control lever is returned to position 1.

Position 3 (lever pointing down) locks the mirror up *before the shutter is released,* and holds it in the up position until the lever is returned to position 1.

If the camera is already cocked when position 3 is set, the mirror rises at once. Otherwise, cocking the camera by stroking the advance lever will raise it.

When you want to return to normal shooting after exposures have been made with the mirror locked up, and the lever in position 2 or 3, the lever should be returned to position 1 before the camera is cocked again. Otherwise the mirror will stay locked up until the shutter is released once more, and you will lose one frame.

Lenses for the standard Leicaflex

All standard-Leicaflex and Leicaflex-SL lenses can be used without modification on the standard Leicaflex. In addition, Leica lenses made for use on the Visoflex II and III can be used on the Leicaflex with Leica-to-Leicaflex Adapter No. 14,127*, as can the Focusing Bellows II. (If you want to use a standard-Leicaflex lens on the Leicaflex SL, a second cam should be added to the lens by Leitz.)

One standard-Leicaflex lens cannot be mounted or used on the Leicaflex SL—the (discontinued) 21mm f/3.4 Super Angulon-R. The mirror must be locked up before this lens can be mounted on the camera, so a separate 21mm viewfinder must be used in the accessory shoe on top of the camera.

To focus, estimate the camera-to-subject distance and set it on the distance scale of the lens. This works well at all distances from three feet to infinity, since this lens has great depth of field. To focus on closer objects, measure from the subject to the film plane (indicated by the rear edge of the accessory shoe) and set that distance on the lens scale.

Since the viewscreen is blacked out when this lens is in place, you cannot read the built-in light

meter. You can either take a reading with a different lens on the camera, then change lenses to take the picture, or—more convenient—you can read the light with a separate meter.

Mounting procedure

Mounting the 21mm f/3.4 Super Angulon-R on the standard Leicaflex. First set the mirror-control lever to position 3 (pointing straight down), and cock the camera to swing the mirror up and lock it.

If there is a lens on the camera, remove it.

Prepare the 21mm lens for mounting by sliding its curved locking knob against the direction of the red arrow on the knob and away from the raised red index mark on the lens mount. Center the knob opposite the white dot that is beyond the right end of the depth-of-field scale. When the knob reaches this position, you will feel a click, and the red dot in the center of the arrow on the locking knob will be directly under the white dot. (If you slide the knob past this point, you may have difficulty mounting the lens.)

Turn the camera so its lens-mount flange is up.

Hold the lens with the flat top of its rear extension parallel to the locked-up mirror in the camera body, and just below it.

Insert the lens with its red index mark aligned with the red dot on the camera lens-mount flange. The lens-locking pin of the camera will fit into a slot in the lens mount. Be sure the lens is flat against the flange.

Lock the lens in place by sliding the locking knob as far as it will go in the arrow direction. When correctly locked, the knob will be centered under the red index mark.

To remove the 21mm f/3.4 lens from the Leicaflex, slide the locking knob on the lens mount away from the raised red index mark and center its red dot under the white dot. *Do not press the bayonet-lock button on the camera body.* Lift the lens out of the camera, taking care that its rear protrusion does not touch the underside of the mirror as you do so.

Put the rear cover and the front lens cap on the lens at once, before putting the lens down on any surface, to prevent damage to the delicate glass lens surfaces.

The 21mm f/4 Super Angulon-R lens made for the Leicaflex SL can be used on the standard Leicaflex as well. This lens has a normal bayonet mount,

The auxiliary viewfinder used with the 21mm Super Angulon-R is the same as that used with 21mm lenses on Leica rangefinder cameras

21mm f/3.4 Super Angulon-R lens fits only the standard Leicaflex. The flat surface on its rear protrusion fits under the locked-up mirror of the camera

and its long back focus (the distance from the rear element to the film plane) leaves room for the mirror to function normally, permitting full viewing and focusing in the reflex viewscreen.

The built-in meter

The coupled CdS light meter on the standard Leicaflex is located on the front of the camera, above the lens. It is balanced to read correctly with the camera held horizontally. It does not measure the light that passes through the lens, but has a separate optical system of its own. Its fixed 27° acceptance angle is wider than that of the Leicaflex SL meter.

Preparing the lens for mounting: move the locking knob to the white dot

Removing the lens: first slide the locking knob to the white dot position, then pull the lens straight out, away from the camera. Do not press the bayonet-lock button on the camera when removing this lens

Insert the lens straight back into the camera, then lock it in place by moving the locking knob up to the red dot on the lens

Left to right: battery cover, battery in its compartment, light-meter window and battery-test button

Metering procedure is the same as with the Leicaflex SL, and film speeds are set on the ASA and DIN scales of the light meter in the same way.

The meter battery

Like the Leicaflex SL, the standard Leicaflex uses a Mallory PX 625 or PX 13 battery to power the meter.

To test the battery, press the button on the front of the prism housing above the lens, and watch the needle in the viewfinder, as in the Leicaflex SL.

To change batteries, unscrew the cover, turning it by its milled edge. Turn the camera down so the old battery drops out, then insert the new battery, with the inscribed side out, and replace the cover.

Other procedures

In all other respects, the standard Leicaflex is handled in the same way as the Leicaflex SL.

Earlier M-series Leicas

The cameras discussed here are the M1; the M2 and the related MD; the M3 and the related MP Leicas. All have bayonet-type lens mounts. Their features are described first, then their operation. The date indicates the year a model was introduced.

Leica M3 (1954)

Coupled range-viewfinder for single-window viewing and focusing, with both split-image and coincidence rangefinding.

Permanent bright line frame shows field of 50mm lens in viewfinder; other frames appear when 90mm or 135mm lens is mounted or a frame selector lever position is changed. (Early M3s had no selector.) Automatic parallax correction during close focusing.

Removable bottom plate and hinged back for loading. Film does not require notched or tongue-shaped leader. Film counter automatically resets on loading.

Thumb lever advances film and cocks shutter simultaneously. (Early M3s had two-stroke rather than one-stroke lever.) Shutter may not be tripped before film is completely advanced.

A-R selector lever is set at A to advance film, at R to rewind.

Shutter speeds, 1 sec. to 1/1000 sec. and B, on a single click-stop dial. Intermediate speeds between marked speeds above 1/60. Speeds may be changed before or after advancing film. Leicameter MR (and earlier MC) couples to shutter-speed dial.

Built-in self-timer delays shutter release from five to ten seconds. Shutter must be cocked first.

Two internal flash-synchronization circuits with separate contacts accept special M-model cable plug. Contact marked with lightning arrow is for electronic flash and fast-peak bulbs. Contact marked with bulb is for other bulbs. Electronic flash requires a shutter speed of 1/50 (marked by red arrow on some dials) or slower. Bulbs require speeds specified on cartons. Both circuits may be used simultaneously at 1/50 sec. and slower.

Leica M2 (1958)

Same features as M3, with the following exceptions.

Slightly smaller viewfinder image. Bright line frame showing 35mm field of view is changed to 50mm or 90mm frame by inserting lens in mount or moving frame selector lever.

Long-mount 135mm Elmar and Hektor lenses couple with rangefinder, but use separate viewfinder.

Film counter must be manually set after loading.

Early models have R button on front which must be depressed during rewinding. Later models have A-R lever, as M3.

Some early models, designated M2S or M2X, do not have self-timer.

Leica M1 (1959)

Same features as M2, except:

No rangefinder, only a viewfinder. Bright line frames for 35mm and 50mm fields are permanently visible in finder, cannot be changed.

No self-timer.

Leica MD (1965)

For scientific and technical photography, primarily with reflex viewing or microscope accessories. Same as M2, except:

No viewfinder or rangefinder.

Special baseplate for inserting celluloid strips with written data to print along one short side of frame during exposure. (See discussion of MDa in the chapter, "Handling the Leica and Leicaflex.")

Leica MP (1956)

A special press and news photography model of the M3.

Leicavit rapid advance device in baseplate.

No self-timer.

Film counter same as M2.

Loading M Leicas

Turn the camera upside down, lens pointing toward you. Unlock and remove baseplate; open hinged back. Remove takeup spool with right hand, knurled knob upward. Hold film cassette in left hand with film emerging to right, emulsion facing you. Engage end of film under clip on takeup spool with emulsion facing outward (film base against stem of spool). Perforated edge of film must be against upper flange of spool.

Pull out about four inches of film from the cassette so you can slip cassette and takeup spool into their camera positions with film running between them in the channel across the camera back, emulsion toward the shutter. Through the open back, make

sure the sprocket teeth at the right engage the film perforations. Slightly advance the thumb lever to turn the sprocket if necessary. Close the back; replace and lock the baseplate.

Turn the camera upright. Pull up the rewind knob and turn it slightly in the rewind direction (arrow on knob) to take up any slack in the film. Push down the rewind knob and alternately release the shutter and advance the film with the thumb lever. With M3 advance until film counter reads 0. With M1 and M2, advance two frames after loading; manually set film counter to 0. With all cameras, advance one more frame, to 1, to position film for first exposure. During initial advancing, observe the two red dots (red line on early M3s) in the center of the rewind knob. They must revolve as the film is advanced. If not, open the camera and check the loading.

M Leica shutter speeds
Turn the shutter-speed dial until the desired speed number clicks into place opposite the index line on the camera's accessory shoe. For intermediate speeds between 1/60 and 1/1000, turn the dial to the click-stop between any two numbers.

The slot between 2 and 4 on the dial is for coupling Leicameter MC or MR (see the chapter, "Meters and Metering").

Use the B setting for exposures longer than one second. Hold the shutter (or cable) release down for as long as you want the shutter open. Release it to close the shutter.

For double exposures: make the first exposure, then take up any film slack by turning the rewind knob slightly in the rewind direction, and hold it firmly. Set A-R selector to R (or hold R button depressed) to disengage the film-advance mechanism, and cock the shutter with the thumb lever. Set the selector at A again (or release the R button) and make the second exposure.

To use the self-timer, first set the desired shutter speed and cock the shutter. Turn the timer lever on the front of the camera halfway (90°) down for a five-second delay, all the way (180°) down for a ten-second delay. Press the flat button just above the timer lever to release the shutter, not the usual shutter release.

M Leica viewing and focusing
Bright line frames show the field of view for various lenses, as described above. Frames are changed by

a selector lever, or by inserting a lens in the lens mount.

A catch holds the lens focusing mount at the infinity position. Push it in to release it for focusing at closer distances. The distance focused on appears opposite the index mark (a triangle on most lenses) on the focusing scale.

Depth of field is indicated on the lens mount by pairs of index lines marked with f-numbers. The focusing-scale distances opposite each line marked with the same f-number indicate the near and far limits of acceptably sharp focus at that f-stop.

Out-of-focus objects have a double image in the rangefinder (the central rectangle in the viewfinder). As the lens is focused, the two images move together; when they coincide exactly, the lens is focused on that object. Out-of-focus objects are also split, or displaced as they cross the edges of the rangefinder field. When focused, a continuous object line or edge runs without a break across the rangefinder field edges.

M2 and M3 rangefinder fields have a square notch at the top and the bottom for quick depth-of-field judgments. When the separation between the two images of an object is no wider than the top notch, that object will be in focus at f/16. When the separation between the images is no wider than the bottom notch, it will be in focus at f/5.6.

Unloading M Leicas
When the last frame of film has been exposed, the thumb lever will not move to the right. Do not force it, or you will tear the film. To rewind, set the A-R selector to R, or hold the R button depressed. Pull up the rewind knob, and turn it in the direction of the engraved arrow to wind the film back into the cassette.

Open the bottom of the camera to remove the cassette. The hinged back permits opening the camera in a darkroom or changing bag to cut off an already-exposed portion of the film.

Non-bayonet-mount Leicas
The first two Leica models had non-interchangeable lenses. From 1930 onward, screw-thread mounts were used for interchangeable lenses until they were supplanted by the bayonet-mount M Leicas. Handling is basically the same for all screw-mount models, and is described following the list of models

and characteristics. The designations, "Model A," "Model B," etc., were used on export models, chiefly to the U.S.; they were dropped after "G." The date indicates the year a model was introduced.

Leica I; Model A (1925)
The first production-model Leica. Non-interchangeable 50mm Elmax (later Elmar) f/3.5 lens. In 1929 also supplied with 50mm Hektor f/2.5 lens. Focal plane shutter; speeds 1/20 to 1/500 sec. and B. Accessory vertical (later horizontal) rangefinder attached to shoe on top.

Compur Leica; Model B (1926)
Only non-focal-plane-shutter Leica. Non-interchangeable 50mm Elmar f/3.5 with Compur between-the-lens shutter; speeds 1 to 1/300 sec. Top right-hand knob only advanced film; shutter was cocked on lens first by dial, later by rim mechanism. Accessory rangefinder.

Leica I; Model C (1930)
First Leica with screw-thread mount for interchanging lenses; not standardized.
 Lens mount standardized with "0" ring from camera No. 60,500 (1931).
 Large rewind knob, did not pull up for use. Accessory rangefinder.

Leica II; Model D (1931)
First model with built-in coupled rangefinder; no rangefinder eyepiece adjustment. Shutter speeds 1/20-1/500; no slow speeds. From Serial No. 71,500.

Standard Leica; Model E (1932)
Like Model C, standardized screw-mount Leica I. Small-diameter, pull-up rewind knob. From Serial No. 100,000.

Leica III; Model F (1933)
Like Model D, Leica II, with front dial added for slow speeds 1 to 1/20 sec. Eyepiece adjustment for rangefinder, with 1.5x magnification. Eyelets for neckstrap. From Serial No. 109,000.

Leica 250 (1934)
Special Leica III with extra-large film and takeup compartments for 250-exposure (10 meter, 33 ft. long) film loads. Discontinued in 1942.

Leica IIIa; Model G (1935)
Like Model F, Leica III, with added speed of 1/1000 sec. From Serial No. 156,201.

Leica IIIb (1938)
Like Model G, Leica IIIa, but with rangefinder and viewfinder eyepieces closer together. Rangefinder eyepiece adjustment lever mounted under rewind knob. From Serial No. 240,017.

Leica Ic (1949)
No built-in rangefinder; separate viewfinder, rangefinder attachments. Speeds 1/30 to 1/500 sec. and B. From Serial No. 455,000.

Leica If (1952)
Like Model Ic, but fully synchronized with black numbers for setting synchronization contacts. Film type indicator in winding knob. From Serial No. 562,000.
 Leica If cameras from Serial No. 564,001 had international shutter speed series (1/25, 1/50, etc.) and red synch contact numbers.

Leica IIc (1948)
Like Model Ic, but with built-in coupled rangefinder. Speeds 1/30 to 1/500 sec., and Time (instead of B). From Serial No. 440,000.

Leica IIf (1951)
Like Model IIc, but with full synchronization, black contact numbers. Film type indicator in winding knob. From Serial No. 451,000.
 IIf cameras from Serial No. 574,401 (1952) had international speeds, 1/25 to 1/1000 and Time; red synchronization contact numbers.

Leica IIIc (1940)
Like Model IIc but with shutter speeds 1 to 1/1000 sec. and Time. From Serial No. 360,000.

Leica IIIf (1950)
Like Model IIIc, but with built-in synchronization using black contact numbers. Film type indicator in winding knob. No self-timer. From Serial No. 525,000.
 IIIf cameras from Serial No. 615,000 (1952) had international shutter speeds; red synch contact numbers; no self-timer.

IIIf cameras from Serial No. 685,000 (1954) had international shutter speeds; red synch contact numbers; self-timer with about 12 sec. delay.

Leica IIIg (1957)
Like Model IIIf, with bright line viewfinder with automatic parallax compensation. Fully automatic flash synchronization without separate contact number settings. Film type indicator on back. From Serial No. 825,001.

Leica Ig (1957)
Like Model IIIg without built-in rangefinder or viewfinder; no self-timer. From Serial No. 887,001.

Loading screw-mount Leicas
Set A-R selector to A; cock and release shutter. Turn camera upside down, lens pointing toward you. Unlock and remove baseplate. Hold film cassette in left hand, film emerging toward right, emulsion toward you. The film end must be trimmed to the usual tongue-like shape, and the sprocket holes in the tongue must be at the top as the film is pulled out to the right. Remove film takeup spool from camera in right hand, and push end of film under the clamp on the spool stem. Edge of film must be flush against top flange of spool, emulsion must face outward from stem.

Carefully insert cassette and takeup spool into camera with film running in channel across back. Make sure sprocket teeth engage the holes in the film; turn the advance knob slightly if necessary to line up holes and teeth. Replace and lock baseplate. Turn advance knob until it locks, then turn rewind knob in direction of arrow to take up any slack in the film. Release shutter, advance film; release shutter and advance film once again. Make sure the rewind knob turns as the film is advanced. Set film counter to 0 by turning the dial around the advance knob. Release shutter. When ready to make the first exposure, wind the film forward until the advance knob stops and the counter reads 1.

Shutter speeds, screw-mount Leicas
Advance film and cock shutter *before* setting the desired speed, because the speed dial turns during film advance and will change position. Raise and turn the high-speed dial to set the desired speed opposite the index line or arrow on the accessory shoe. The dial turns during exposure, so it must not be retarded by your finger on the shutter release.

For long time exposures, set high-speed dial to B (Z on some early models); shutter will remain open as long as the release is held down. Or use T setting on slow-speed dial; shutter release must be depressed once to open shutter, again to close it.

For slow speeds, set high-speed dial to 1/25 (1/20 or 1/30 on earlier models). Then push the slow-speed dial lock (at the top center of the dial) inward in order to turn the dial to the desired slow speed. Set the slow speed at the top of the dial, opposite the lock.

Viewing and focusing
The viewfinder and the rangefinder have separate eyepieces. Focus first with the rangefinder by turning the lens until the two images in the center spot coincide. Then shift your eye to the viewfinder to frame and compose the picture. White corner marks show the frame of one particular lens (varies with model). Accessory viewfinders are required for other lenses.

Rewinding, unloading screw-mount Leicas
After the last exposure, the advance knob will stop; do not force it or you risk tearing the film. Release shutter; set A-R selector to R. Pull up rewind knob and turn it in direction of arrow until film is completely rewound. There will be a release of tension and the rewind knob will turn freely when this occurs. Unlock baseplate and remove film.

Flash synch, Leica g Models
The Ig and IIIg are internally synchronized for class M and FP bulbs from 1/60 to 1/1000 sec.; simply set dial to desired speed. For electronic flash, set the dial to the black arrow (1/50 sec.) or the red arrow (1/30 sec.). For flash at slow speeds, set high-speed dial to red arrow, then set slow-speed dial.

Flash synch, Leica f Models and earlier
Synchronizing settings are made with a separately numbered dial. Black numbers were used on cameras with the early shutter-speed progression; red numbers on cameras with the international series of speeds. The following table shows shutter speed and dial settings for various flashbulbs.

Flash synch dial settings, screw-mount Leicas

LEICA

BULB	up to serial no. 360,000		from serial no. 360,001			
	Dial No.	Speed	Red Dial No.	Speed	Black Dial No.	Speed
XM	14 13	1/20 1/30	9 16	1/15-1/20 1/30	2 5 10	1/15 1/25 1/50
PF 5	14 11	1/20-1/30 1/40	16 11	1/15-1/20 1/40	2 14 11 5	1/15 1/25 1/50 1/75
AG 1	10 12 8 5	1/20 1/30 1/40 1/60	8 11 8 5	1/15-1/20 1/30 1/40 1/60	2 9 8 3	1/15 1/25 1/50 1/75
GE 5 25	14 11 9 7	1/20-1/30 1/40 1/60 1/100	16 11 8 5.5 4	1/15-1/30 1/40 1/60 1/100 1/200	2 14 11 6 4 2 1	1/15 1/25 1/50 1/75 1/100 1/200 1/500
M 3	14 13 12 10	1/20 1/30 1/40 1/60	9 15 11 8	1/15-1/20 1/30 1/40 1/60	2 7 10 6	1/15 1/25 1/50 1/75
All bulbs or elec-tronic flash	6 9 0 4 6.5	T, 1-1/8 B 1/30 T, 1-1/20 B	— 6 2 2 6	B, T 1-1/10 1/30 T, 1-1/20 B	— 2 20 0 2	B, T 1-1/10 1/50 T, 1-1/25 B

Light Meters and Metering

James Forney

Even a Leica or Leicaflex with a precisely-calibrated lens and shutter must be set correctly, or it will not give accurate exposure.

The problem is to balance the intensity of the light given off by the subject against the sensitivity of the film by matching one of the camera's f-stops with one of its shutter speeds in a combination that will let exactly the right amount of light reach the film.

Different films have different sensitivities, or speeds, and require different amounts of light to form good photographic images. Film speeds are given in exposure index numbers (in the United States, usually ASA numbers). When we know the film speed, we must still find out about the light.

To do this, we use various devices that collect and measure samplings of light. These are light meters. It is not accurate to call them exposure meters: they measure light to compute exposure.

Most meters read in numerical light values that are balanced against the film's exposure index to arrive at an "indicated exposure" that is given as a series of shutter speeds in fractions of a second, each paired with one of a series of lens f-stops.

The conventional light meter has two main components: the part that measures the light, and the calculator dial—a simple form of slide rule—that converts light values and film-speed values into exposure values and camera settings. The calculator dial can also be used to solve more complex problems, such as the exposure compensation needed in extreme closeup photography, as well as to give simple exposure readings.

To determine correct exposure under most circumstances, you point a reflected-light meter at the subject, read it, make a quick setting on the calculator dial, read the f-stop-and-shutter-speed combinations it displays, and set one of them on the camera. It's almost ridiculously simple.

Here are step-by-step procedures for a simple reading, using a reflected-light meter:

1. Set the correct film speed on the meter (for example, EI 200 on the "ASA" indicator).
2. Take a reading by holding the meter close to the subject tone you want to read, with the cell pointed directly at it: note where the meter needle points.
3. Set the pointer of the calculator dial to the same position as the needle on the light scale.
4. Choose one of the f-stop-and-shutter-speed

Weston Master V meter: logarithmic light value about 9.8. Indicated exposure at EI 200, f/11 at 1/30

Leica-Meter MR-4 coupled to M2 camera. Indicated exposure at EI 200 or DIN 24 is 1/30 at f/11. Shutter is set automatically together with meter dial: lens f-stop must be set separately

combinations shown on the calculator dial (for example, f/11 at 1/30 second).
5. Set the camera accordingly (shutter at 30, lens aperture at f/11): you are ready to shoot.

The meter used to illustrate the light scale and the calculator dial is the most recent of a classical line: the Weston Master V selenium-cell meter for reflected-light readings. It can be converted for incident-light readings by snapping an attachment over its cell. It was chosen here for its comprehensively informative calculator dial and its numbered light values, which make it a versatile professional instru-

ment, although the sensitivity of its selenium cell is limited.

Two meters available from Leitz are the Metrastar and the Leica-Meter MR-4, both cadmium-sulfide meters made by Metrawatt in Nürnberg, West Germany.

The Leica-Meter MR-4

This small CdS meter has the same angle of coverage as a 90mm lens, couples to M-Leica cameras, and reads the light on an unnumbered scale: the calculator dial sets a camera shutter speed and selects the correct f-stop to use at that exposure time. Its range of film speeds is from ASA 6 to ASA 3200, or DIN 3 to DIN 36. Its readings indicate times ranging from 1/1000 second to 120 seconds (two minutes), at apertures from f/1.4 to f/16.

To mount the MR-4 meter on an M Leica

1. Set the camera shutter to "B."

2. Turn the meter's knurled knob in the direction of the arrow on the end of the meter (counterclockwise) until it stops at the "B" on the meter.

3. Lift the meter knob toward the meter body and turn it as far as it will go in the arrow direction. The meter is now ready to mount on the camera.

4. Push the meter's accessory foot into the camera's accessory shoe, as far as it will go.

5. Couple the meter to the shutter by turning the meter knob back (against the arrow direction) to the "B" on the end of the meter, where it will slip down to engage the camera shutter dial.

6. Set your film speed on the meter by rotating the top part of the circular meter dial until the desired exposure index number is shown in one of the two "ASA" windows, or the desired DIN number is shown in the "DIN" window.

To read the MR-4 meter

1. Set the meter for the appropriate brightness range. The measuring-range selector is on top of the meter at the left front corner: for bright-light measurements, set its pointer at the black dot. For dim light, use the red dot. The red f-stop scale is for dim-light readings, and the black scale is for bright light: *always use the black dot for outdoor readings in bright daylight.*

2. Aim the meter by aiming the camera: push the frame-selector lever on the front of the camera

toward the lens to bring the 90mm frame into the viewfinder: the field within this frame is covered by the meter.

3. Activate the meter by pushing the needle-release button, on top of the meter at the left rear corner, in the arrow direction. Hold it for two seconds, then release it. The needle then locks in place, ready to be read.

4. Read the meter by noting the position of the needle on the light scale.

5. Set the calculator dial by turning the knurled meter knob. You can either select the desired shutter speed on the marker at the right of the meter, then find the f-stop number on the appropriate scale (red or black) that is opposite the needle on the light scale; or set the desired f-stop at the needle position and read off the shutter speed. The shutter is already set in either case: set the indicated f-stop on the camera lens and you are ready to shoot.

The dial of the Leica-Meter MR-4 does not give numbered light readings, but the coupling of the meter to the camera shutter eliminates one of the usual steps, making readings unusually quick and easy.

The MR-4 uses a Mallory PX 625 button battery. A Mallory PX 13 can be used if no readings are to be made at temperatures below 14°F or -10°C: other batteries may cause false readings, and should be tested for accuracy before use.

The Metrastar meter

The Metrastar is a hand-held CdS meter that reads either reflected light or incident light. Conversion to incident reading is made by sliding the white dome to cover the CdS cell at the right of the meter.

In reflected-light mode, the Metrastar has a narrow (18-degree) angle of coverage, shown in a viewfinder set into the meter dial. The meter does not read in numerical light values: like the Leica-Meter MR-4, it is read by noting where the needle points on a striped light scale, then placing the calculator-dial pointer opposite the needle.

The meter has two measuring ranges. For dim light, a black pointer is used, and exposure times are read off a black scale with white numbers. For bright light, the pointer and the scale are white, with black numerals. A fixed f-stop scale ranges from

3

Metrastar meter, reflected-light mode: indicated exposure at EI 200, f/11 at 1/30 second: other indications are for equal exposures

f/1 to f/45: exposure times shown on the Metrastar are from 1/1000 second to 8 hours; and the film speed range is from ASA 3 to ASA 12500, or DIN 6 to DIN 42.

The meter is switched from bright scale to dim scale, or vice versa, simply by turning the calculator dial by its outer edge. Like the MR-4 meter, the Metrastar uses one Mallory PX 625 button battery, which has an estimated life of about two years.

Reading the Metrastar
(reflected- light mode)

1. Set the film speed: turn the round meter dial by the plastic lugs until the film speed pointers indicate the desired ASA or DIN number.
2. Select the appropriate measuring range (white pointer and shutter-speed scale for bright light, black pointer and scale for dim light). *Always use the white pointer and scale in outdoor daylight.*
3. Aim the meter at the subject by filling the meter viewfinder with the area you want to measure.
4. Activate the meter by pulling back the sliding button on the left side. Hold it for about two seconds, until the needle steadies, then release to lock the needle in place for reading.
5. Turn the calculator-dial pointer until it is opposite the needle on the striped light scale.
6. Read the f-stop-shutter-speed combinations at the bottom of the meter dial.
7. Select an f-stop-and-shutter-speed combination and set it on the camera.

To read incident light with the Metrastar, slide the dome to the right to cover the CdS cell; then hold the meter at the subject position, aimed toward the camera (center the camera position in the meter viewfinder).

The Weston Master V meter

This meter can serve as a guide to the use of any conventional selenium-cell reflected-light meter. It can be converted to incident-light reading by placing an attachment over the cell. There are two reading ranges: for dim light, the meter cell is used uncovered; for bright light, a hinged baffle is closed over it, and another numerical scale slides into place on the light scale.

Light values are represented on the meter's light scale by numbers ranging from 2 to 16.

The calculator dial displays eleven full f-stops, from f/1.0 to f/32, with twenty intermediate f-numbers at 1/3-stop intervals, and exposure times from 1/1200 second to 90 seconds. Film speeds range from ASA 0.1 to ASA 16000 (equal to the meter's light-reading range), together with the equivalent DIN numbers, from DIN 1 to DIN 43.

The Master V generates its own current in response to light, and uses no batteries.

Using the Weston Master V meter

1. Select the sensitivity range. For bright light, close the hinged baffle over the selenium cell on the underside of the meter: for dim light, open it. The proper light-value numbers automatically slide into place on the light scale.
2. Hold the meter close to the subject area you want to read, with the cell surface toward the subject and parallel to it. Be careful not to read the meter's shadow, which would distort the reading.
3. Activate the meter by pressing the button on the right side of the meter. Releasing the button locks the needle.
4. Read the meter. With this meter, readings are shown in numbers; for example, the reading in Figure 1 is approximately 9.8 on the scale.
5. Set the pointer on the calculator dial to match the reading on the light scale (9.8).
6. Read the f-stop-and-shutter-speed combinations on the calculator dial.
7. Set the camera to the f-stop-and-shutter-speed combination you choose from the meter dial.

These instructions apply to most meters—selenium-cell or CdS type—with differences of detail. They represent the most elementary type of reflected-light reading.

This easy approach does not always give the best possible exposure. It may result in slight over- or underexposure; but with the forgiving films of today, ninety-nine of every hundred exposures should produce usable images.

Do not let the long odds against total failure tempt you to work carelessly. In 35mm photography, the accuracy of the exposure often makes the difference between an excellent photograph and a poor one. In enlarging, we often depend on the structure of the image within the film emulsion as much as on the presence of the image itself. Grain and sharpness take on increasing importance as the prints become larger.

Most negative films have considerable tolerance for overexposure (though reversal or transparency films do not), and even a greatly overexposed negative may record tonal differences distinctly. The most obvious difference is that, as overexposure increases, normally-processed negatives become denser overall, and require longer printing exposures in the darkroom. But exposure also affects grain. With overexposure, the size of grain clusters grows to a degree that can severely limit the maximum size of good-quality enlargements. (Overdevelopment of film causes a still greater increase in graininess; so underexposure plus overdevelopment will often produce coarser grain than normal exposure with normal processing.)

Underexposure can cause the loss of shadow-area detail and contrast, even in negatives that may look well-exposed. You may not know what you're missing until you see a side-by-side comparison of a print from an underexposed negative next to a print from a fully-exposed one.

You can get by with sloppy exposure; but accurate exposure will gain you more than the mere rescue from hopelessness of one or two percent of your pictures. Your negatives will become easy to print, and your prints and transparencies will have beautiful, rather than just passable, quality.

How films are rated for speed

Let's consider the inherent sensitivity of films. It is agreed internationally that the logical measure of a negative film's speed is the minimum exposure that will produce a usable density with normal processing.

The test exposures a manufacturer uses to determine a film's speed are made in a laboratory with a precisely-calibrated exposing instrument called a sensitometer, not with a camera aimed at a subject; but the minimum-density value measured in the lab corresponds to the thinnest printable density of a shadow area in a camera-made negative. Different film-speed systems use different symbols for the same information. The German DIN and British BSI logarithmic ratings use different film-speed numbers from each other, and from BSI and American ASA arithmetical exposure indexes (which are interchangeable); but all these systems are based on the same standard minimum density. The Russian GOST system uses a slightly higher standard minimum net density above fog level for negative films. (Positive films, such as color-slide materials, are rated for speed according to different testing methods.)

Table of equivalent film speeds

ASA BSI	BSI log*	DIN	ASA BSI	BSI log*	DIN
3	16°	6	125	32°	22
4	17°	7	160	33°	23
5	18°	8	200	34°	24
6	19°	9	250	35°	25
8	20°	10	320	36°	26
10	21°	11	400	37°	27
12	22°	12	500	38°	28
16	23°	13	640	39°	29
20	24°	14	800	40°	30
25	25°	15	1000	41°	31
32	26°	16	1250	42°	32
40	27°	17	1600	43°	33
50	28°	18	2000	44°	34
64	29°	19	2500	45°	35
80	30°	20	3200	46°	36
100	31°	21			

* BSI logarithmic ratings are always written with a degree sign (°), to distinguish them from BSI arithmetic numbers.

So far, we have considered only shadow values: what about middle tones and highlights? The rating systems for negative films tell us nothing about these. While the deep shadows on which film-speed

ratings are based are the most critical part of the exposure range, we must reconcile this one-sided information, the rating, with the whole range of measurable light intensities in our subjects, in order to convert these light intensities, by controlled exposure, into appropriate densities, first in our negatives, then in our prints.

For consistently good exposure, we must be able to measure either the light reflected by the subject (luminance) or the light that falls on the subject (incident light or illuminance), using either a reflected-light meter or an incident-light meter. We can seldom control the light reflected toward the camera by the subject, except in the studio or when using flash. Therefore we must evaluate the light as we find it, and relate it to film speed by means of f-stop-and-shutter-speed settings on the camera.

Light readings and exposure

Conventional reflected-light meters generally "see" and measure light over an acceptance angle of about 30 degrees to 50 degrees—about the angle of view of a normal lens. Thus, if you take your meter reading from the camera position, with the meter pointed in the same direction as the camera, it will usually measure light from everything that will be in the picture. Part of the reading will be from dark shadows, part from bright highlights, and the rest will be from everything in between.

Meters do not really see or think, of course. They just add up all the light that strikes their sensitive cells—highlights, shadows and mid-tones—and average it out for the whole area of the subject that is measured. This average reading is the basis for an average exposure which will generally give fairly good results on the film.

But this simple averaging system does not fill all of our exposure needs, because not all subjects have average distributions of light.

Let's take a hypothetical case, in which we divide a subject into ten equal areas, nine parts being dark shadow and the tenth being a bright highlight. Suppose that each dark area reflects one unit of light and the bright area reflects ten units: 9 shadow units plus 10 highlight units equal 19 in all. The meter that reads this subject will average it out to 1.9 light units per section.

If we reverse that, with nine highlight areas of ten light units each, and one shadow area of one unit,

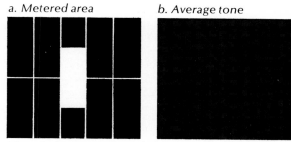

a. Metered area b. Average tone 4

Nine dark areas and one light one average out dark

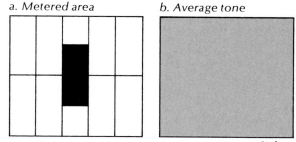

a. Metered area b. Average tone

Nine light areas and one dark one average out light

the total is 91 units, and the average reading will indicate 9.1 units.

Without changing at all the intensity of the light reflected from the shadow areas and from the highlight areas, we have changed the average luminance, and therefore also the meter reading, by more than four and one half times, or over two full stops—enough difference to introduce a considerable exposure error.

Which reading is correct? Neither one. If we expose according to the low reading from the dark subject, we will overexpose, tending to block up the highlights, while building up unnecessary density and graininess in the shadows.

If we expose according to the high reading from the light subject, we will underexpose the shadows, and the density of the highlights may be too thin to print with any brilliance. The meter is designed to give optimum exposure for negative densities that are to be printed as middle gray: highlights need more density than that.

A more practical exposure would result from splitting the difference between the shadow reading and the highlight reading. (This can be approximated by using an incident-light meter, which cannot be

fooled by the subject, since it ignores the subject and reads the light that falls on it instead.)

A more accurate method is to measure the shadow luminance and, separately, the highlight luminance, with a reflected-light meter. Then find the mid-point between the two readings on the meter's calculator dial. Set the pointer there and expose accordingly. The meter cannot interpret its readings; you must supply the observation and the intelligence.

It is especially important to interpret the meter accurately when you use reversal (slide or transparency) films. In printing negatives, you can easily make the prints lighter or darker; but the relative darkness of transparencies is established by the exposure in the camera. The film you shoot is the final picture.

Here's an experiment you can try. Take three cards, each about 8x10 inches in size—one white, one medium gray, and one black. Light them evenly. Take a reflected-light reading of each card in turn, and photograph each one on reversal film, giving exactly the exposure the meter indicates. There is no need to focus on the card, which has no details that need recording. Focus the camera at infinity and move it close enough so the out-of-focus card completely fills the picture area. If your reading and exposures are accurate, the result will be three middle-gray transparencies of matching density. You won't be able to tell which picture shows which card.

Why is this? It is because reflected-light meter calculator dials are designed to recommend an average, or middle-gray, exposure, regardless of the lightness or the darkness of the subject area measured.

The black card reflects little light, so it gives a low meter reading and a relatively great indicated exposure. The middle-gray card reflects more light, gives an intermediate reading and indicates a moderate exposure. The white card reflects most of the light that strikes it, gives a high reading, and calls for relatively little exposure. All three exposures meet in the middle: each lets the same amount of light reach the film.

This experiment is an extreme case, but it will show you why you should look critically at your subject as well as reading it with the meter before you decide how much exposure to give it. If you don't, the same problem may affect your everyday shooting.

If the subject is mostly light in tone, give one or two stops more exposure than the reflected-light meter indicates. If the subject has mostly dark tones, give less exposure than the meter indicates—the opposite of what logic would seem to dictate. Exactly how much to deviate from the meter reading depends on many factors, including your own taste. It can only be learned by experiment. The principle applies to color photography as well as to black-and-white; exposure error caused by misinterpreting an accurate meter reading could render deep scarlet as pale pink, or pink as red. (For a more detailed treatment that correlates photographic exposure and development with density and contrast, see the chapter, "Zone System for 35mm," by Ansel Adams.)

Meters work in terms of middle-gray average exposure and density; but film-speed ratings are not based on average exposure. On the contrary, as we have seen, they are based on the minimum exposure and the darkest recordable shadow values. If all films had the same exposure latitude, this would present no problem. Middle gray would always be the same number of stops more exposure than the minimum density value on which the speed rating is based, and simple addition or subtraction in laying out the meter's calculator dial would eliminate all discrepancies. Meter manufacturers do just that in practice. For lack of any better criterion, they typically base their calculator dials on the projected behavior of a theoretical film with "average" sensitivity characteristics. What real films, if any, actually fit this artificial norm is anybody's guess.

Processing also affects the performance of a film. Different developers can produce very different negatives from identical exposures on the same kind of film.

To get accurate exposure, we must reconcile the meter's arbitrary averaging of its middle-gray-centered readings with film-speed ratings based entirely on dark-shadow values. The two exposure levels do not affect all films in the same way, so we must consider metering technique and film speed separately before we can put them together.

Reading a reflected-light meter

The problem is to get specific information from the meter, not just pot-luck. One answer is to hold the meter close enough to the subject to read only one subject luminance—one tone—at a time.

Two especially valuable readings are measurements of the subject's brightest highlight and of the deepest dark tone that will be in the picture. For subjects of average luminance range (moderate contrast, neither all-light nor all-dark), the optimum exposure is about halfway between the extremes.

Once you know the maximum luminance range that a given film will record as a good transparency or an easy-to-print negative, the extreme highlight and shadow readings will tell you if the subject fits within that range. If not, you must decide whether a change in processing can make it possible, or whether you must sacrifice either some shadow detail or some highlight detail. In a photograph of a given subject, which will be more acceptable to you: solid black shadows or blank white highlights?

Gray cards and other stand-ins

Closeup readings of important subject tones are not always possible. A substitute reading that usually comes close to the middle tone of such a scene can be made by using a standard 18-percent-reflectance gray card (the Kodak Neutral Test Card, white on the back, is available from photo dealers). This is a middle gray, neither light nor dark.

Place the card where it receives the same light, as nearly as possible, that falls on the subject. Then take a simple reading on the card with the meter and give the indicated exposure.

If no card is within reach, take a reading on your hand instead, using the same method. Because Caucasian skin is normally about twice as light as the standard gray card, give twice the indicated exposure when you read the light from your hand.

In very dim light, you can get a more definite response from the meter by reading the white side of the card, which reflects about five times as much light as the gray side. Therefore, when you use a white-target reading, give five times the indicated exposure to get normal exposure of the subject.

Computing closeup exposure correction on the meter

When the camera is closer to the subject than eight times the focal length of the lens, the lens must move so far forward to focus that the effective f-number changes significantly, and more exposure must be given than a normal meter reading indicates.

There are several formulas for computing this

a: indicated exposure

b: corrected exposure

Weston meter dial used to calculate closeup exposure compensation for 50mm lens extended to 80mm (30mm forward from infinity focus) Indicated exposure at light value 9.8 is 1/30 second at f/11

To compute corrected exposure, move the f/5 (for "50mm") mark to the position of the f/8 (for "80mm") mark (at "1/70 sec.")

correction. Here is one that requires that the actual lens-to-film distance be known (measure it by measuring the extension beyond infinity focus in mm, and adding it to the focal length).

Where ce = corrected exposure, ie = indicated exposure, f = focal length, and d = lens-to-film distance,

$$ce = ie \times \frac{d^2}{f^2}$$

For those who would rather use a sliderule than calculate mentally or on paper, the meter dial makes it easy. Here is the procedure:

1. Take a reading in the normal way.
2. Measure the lens-to-film distance.
3. Among the indicated exposures on the meter dial, find f-stop numbers that can correspond to the focal length and to the lens-to-film distance. (In the example, p.101, focal length is 50mm, and lens-film distance is 50mm + 30mm = 80mm. The corresponding stops are f/5 and f/8.)
4. Note the position on the calculator dial of the f-number that stands for the measured lens-to-film distance (in this case, the f/8 mark is at the 1/70 second mark).
5. Reset the dial by moving the f-number that stands for focal length to the same point (in this case, move "f/5" to "1/70").
6. Read the corrected f-stop-and-shutter-speed combinations on the calculator dial, select one, and set it on the camera lens and shutter. You are now ready to shoot.

The Weston meter dial makes it very convenient, but this computation is also easy with other meters.

With the Leica-Meter MR-4, find the indicated exposure for a pre-selected f-stop in the normal way. Set that f-stop on the camera lens; then simply shift the "lens-to-film-distance" f-number on the meter to the position of the "focal-length" f-number. With the meter coupled to the camera, this sets the shutter to the corrected speed for the chosen f-stop, and you are ready to shoot. You can, of course, use any other camera setting that will give an equivalent amount of exposure.

With the Metrastar, first find the indicated exposure in the normal way; then move the shutter-speed that is under the "lens-to-film-distance" f-number

to the position of the "focal-length" f-number, and read the corrected exposures directly from the scale. Set one of them on the camera, and you are ready to shoot.

Incident-light metering
Incident light, or illuminance, is the light that falls on the subject. It is not affected by the subject's tones. Substitute-target readings, although made with reflected-light meters, are actually incident-light readings for all practical purposes.

There is an easier way: use an incident-light meter. Then you don't need a card. When you measure the light, not the subject, the subject's tones fall naturally into place on the overall exposure scale. Incident meters are calibrated to put mid-tones in the middle of the scale, so dark tones in the subject, which reflect less light, are automatically rendered dark, and bright tones in the subject are rendered pale in the pictures.

Over its sensitive cell, the incident-light meter has a three-dimensional translucent light receptor, typically dome-shaped, which acts as a stand-in for the subject in the way it receives the light. The meter is held as close as possible to the subject and in the same light, with the dome facing the camera. When the light falls unevenly on the subject, it falls the same way on the meter dome, and the meter averages it out.

Although the incident meter cannot read subject luminances at all, selective incident readings can be made by holding the meter in the full light for one reading, and in the shade for another, to measure the intensities of light that strike different parts of the subject. Exposure mid-way between the two readings is usually correct for subjects with average light-and-dark tones.

In photographing very light, very dark, or very contrasty subjects, incident metering could lead you to try to exceed the latitude of your film without knowing it. A rule-of-thumb suggestion: for dark subjects, give one stop more than the indicated exposure; for light or bright ones, expose one stop less. For accuracy, experiment.

The incident meter is especially useful in the studio, where it simplifies balancing lighting from two or more lamps.

From the subject position, read the light from each lamp separately, with the others switched off.

Move the lamps until you have the desired lighting ratio. If you want a 2:1 ratio, move one lamp until it gives half as high a reading (or twice as high) as the other. Then, to determine the final exposure, turn both lamps on and read the total illumination.

Many photographers prefer the incident meter to substitute-target readings with a reflected-light meter, because the incident meter is faster, easier to use, and just as accurate. No cards required.

The incident meter's strength is that subject tones cannot fool it. Its weakness is that it cannot measure them or determine a luminance range.

Film speed

Film speed is basic information that must be incorporated into the metering system to make specific exposure readings possible. ASA speeds and other ratings furnished by manufacturers are best used as preliminary guides, to be confirmed or corrected by trial.

No matter how accurately a rating is determined in the factory lab, important variations are usually introduced when you put the film in *your* camera, use *your* technique to determine exposure according to *your* preference, photograph *your* subjects, and process the film and print *your* way.

When you try out an unfamiliar film, begin by setting the recommended film speed on your meter. Shoot a roll or two of the new film at this rating, process it as recommended, and see what happens in pictures taken under various conditions—light, dark, and middle-toned subjects, and low-contrast, moderate-contrast, and high-contrast subjects.

If the trial exposures are consistently satisfactory, you have no problem. Just keep on using the manufacturer's recommended rating.

If most of your exposures at the recommended rating seem to be slight underexposures (dark transparencies, or negatives that print with poor shadow detail or a lack of contrast in shadow areas), try giving twice as much exposure.

If the manufacturer's rating gives you overexposure (washed-out, pale transparencies, or overdense negatives that require excessively long print exposures), try giving half the recommended exposure.

If you must give twice the recommended exposure, your revised exposure index will be half the ASA number: set your meter, for instance, at 200 instead of ASA 400. If an ASA 400 film turns out to be twice as fast as the rating, set the meter at 800. Use whatever speed number on your meter gives you the exposure you need.

Departures from ASA ratings are not ASA speeds. Those initials are reserved for one exposure index per film, the one determined by specific laboratory procedures established by the former American Standards Association (now ANSI). Other exposure indexes that use the same film-speed numbers to arrive at the same exposures are prefixed "EI" (for exposure index); as, "EI 800." These numbers are arithmetical. EI 400 is the same speed as ASA 400; at three times the ASA film speed, or one-third the exposure, the film is not ASA 1200, but EI 1200; at one-fourth the ASA speed, the rating is EI 100.

DIN speeds are not arithmetical, but logarithmic. When you double the film speed, add three to the DIN number; subtract three when you reduce speed by half. Thus DIN 27 is twice as fast as DIN 24, half as fast as DIN 30, and one-fourth as fast as DIN 33.

By using a revised exposure index for a film, you can adapt your meter to fit the film's actual behavior, including the purely personal variations introduced by your equipment, technique, choice of materials and your taste, as well as the film's built-in departures from the theoretical standard represented by the ASA rating.

More about meters

All light readings fall in two classes—incident and reflected—but the meters that are used to make them fall in several groups and sub-groups, and are not always limited to reflected-light or incident-light use. Not all meters are calibrated to the same standards, have the same sensitivity range, or the same degree of accuracy or consistency. It is nearly as important to know your meter's peculiarities as to know how to use it.

Photovoltaic meters

In the early 1930s, when photoelectric light meters were new, only one type was available: the photovoltaic reflected-light meter.

The light-sensing selenium cell or element of a photovoltaic meter absorbs light energy and converts it directly into electricity. Light goes in, current comes out. The meter's needle moves up and down a scale in proportion to the flow of electricity that

activates it. The conversion of the needle's position in a reading to the exposure needed in a camera is straightforward.

Photovoltaic meters are no longer the most popular type, but they have certain advantages. Self-generating selenium cells react almost instantaneously to changes in the amount of light that reaches them—even very slight changes. Because they generate their own current, they need no batteries, so battery failure is not a problem. The simplicity of a selenium meter minimizes the number of things that can go wrong with it. Many photographers still use meters that are twenty and thirty years old, some of which have never needed repairs.

Selenium cells are also used in some incident-light meters: the difference is in the light-gathering "window" and in the calibration. Some selenium meters (and some cadmium-sulfide meters) can be converted from the reflected-light mode of reading to the incident-light mode by putting an attachment over the sensitive cell.

The main limitation of the photovoltaic selenium-cell meter is its relatively low sensitivity. With recent increases in film and lens speed, and the growing popularity of photographing in dim "existing" or "available" light, this limitation has become increasingly important.

Photoconductive meters

A more recently developed kind of meter cell fills the new need for higher sensitivity—the photoconductive cell. The cadmium sulfide (CdS) cells used in many modern meters are far less limited in sensitivity range than the average selenium cell, and are usually much smaller.

Photoconductors, unlike self-generating photovoltaic cells, generate no electricity when they absorb light. Instead, they control the flow of current furnished by a battery or other source, at a rate that depends on the intensity of the light that strikes the cell. The more light, the lower the resistance, and the more current passes through the circuit, moving the needle farther up on the light scale and giving a higher reading.

Photoconductive cells not only extend the sensitivity of conventional light meters, but also make new, more specialized types possible, including spot meters and the behind-the-lens (BTL) meters that are built into modern cameras such as the Leicaflex

SL and the Leica M5, to read the light that passes through the picture-taking lens.

Using CdS cells, up to three consecutive ranges of light sensitivity can be achieved in one meter by varying the battery voltage. The color sensitivity of the meter can be made similar enough to those of the eye and of panchromatic and color films to make the CdS meter satisfactory throughout the visible spectrum.

Some CdS meters can be read through most of the contrast-enhancing filters used with black-and-white film (orange, red, green and so on), with more accurate results than you can get by taking white-light readings and applying mathematical filter factors. This is especially useful in BTL metering. (For a more detailed treatment, see the chapter, "Filters," by Leslie Stroebel.)

These advantages have their price. CdS meters need batteries. Recent developments in battery manufacture have brought better cold-weather performance, longer life, more rugged construction, better long-range voltage stability and smaller size; but we still have to remember when to replace the battery. Once-a-year replacement is a good rule of thumb, but does not guarantee that the battery won't fail sooner. Some metering applications use up batteries faster than others, some people use their meters more than others, and there is no telling how long the battery you buy has been on the shelf. Batteries start to age the day they are made, and their normal life expectancy is about one year. The dealer may put the battery you buy on a tester—which will show that it still has enough strength to move the tester's needle. It may or may not have the strength to operate your meter properly—or it may have only a short useful life left.

The only sure way to guard against battery failure is to put in a fresh battery whenever you start out on an important trip or assignment. Spare batteries in your camera case provide very cheap insurance.

Cadmium sulfide cells respond far less quickly than selenium cells to extreme changes in the intensity of the light. They are relatively sluggish, and have what is called "memory." When you take your meter from darkness into bright sunlight and try to take a reading, the cell may not respond to the change immediately, so the first reading may not tell you how bright it really is. The meter takes a few seconds to "wake up" before the needle will

settle on an accurate value. When you go from bright to dim light, the meter tends to "remember" the brightness, and may read high at first. Some CdS meters have less "memory" than others, but it is always a good idea to wait a few seconds to let the needle stop creeping.

Reciprocity-law failure

Some meter manufacturers seem carried away by the extreme light-sensitivity of CdS cells. At least one meter is calibrated to indicate exposures up to *eight hours.* You are not likely to work in such dim light as to get that reading, but when and if you do, an eight-hour exposure that conforms to the reading is more likely to produce blank film than to give you a normal negative.

Any indicated exposure longer than one or two seconds is likely to give exposure problems, not because the meter is wrong about the light, but because film does not behave the same way in very dim light as in normally bright light.

This discrepancy is called reciprocity-law failure ("reciprocity failure" for short). Its cause is not fully understood, but it is not hard to describe what happens in practice. As the brightness of the light that strikes the film diminishes, and the indicated exposure time becomes correspondingly longer, the film becomes, in effect, slower and less sensitive. The indicated exposure becomes underexposure in practice. (A related effect takes place, to some extent, with very intense light and extremely short exposure times—1/1000 second and shorter—but the problem is usually more serious with dim light and long exposures.)

Approximate reciprocity-failure compensation table for average black-and-white films

Indicated exposure (seconds)	multiply exposure time by	or open lens aperture
1	1-½x	1/2 stop
5	2x	1 stop
15	3x	1-½ stops
30	4x	2 stops
60	6x	2-½ stops
90	8x	3 stops

Not all films have average behavior, so this table is not final information, but a starting point for experimentation.

Some manufacturers will provide reciprocity-failure information on their films on request. Color films have much more complex reciprocity-failure characteristics than black-and-white materials, since each of the three emulsion layers responds differently, changing the film's color balance as well as its overall sensitivity at different light levels. Time compensation and filtration to correct for reciprocity failure are specified on the data sheets packed with some color films.

Behind-the-lens meters

One of the great contributions of the CdS cell is the behind-the-lens meter built into the camera. BTL metering was first patented in the 1920s by Eastman Kodak, but no practical BTL-metering camera emerged until about thirty years later, due to the large size and low sensitivity of pre-CdS meter cells.

Through-the-lens metering has two important advantages. It automatically restricts the meter reading to the area covered by the lens, or, in the Leitz cameras and some others, to a smaller area within it, minimizing the chance of exposure error due to non-picture bright or dark areas that might distort the meter reading (this is especially useful with telephoto lenses).

All optical anomalies of the lens that affect the amount of light reaching the film also affect the meter. Lens flare, for example, is automatically included in the reading. When readings are made with the lens stopped down to its working aperture, as in the Leica M5, intermediate settings between the marked f-stops remain as easy to read as full stops.

Backlighted subjects, dark subjects surrounded by bright tones, or very bright subjects in dark surroundings can cause false readings with BTL meters, however: a typical effect is serious underexposure of the dark tones. When in doubt, walk close to your subject and use the camera with its BTL meter like any reflected-light meter, filling the whole viewfinder with the subject you want to read.

Closeup readings of highlight and shadow values, and of the gray card, are as valid with a BTL meter as with any other reflected-light meter. The inclusion of lens behavior in the meter's performance helps to compensate for the absence of a full-information calculator dial.

The BTL meter cannot be used for incident-light readings except by the gray-card or substitute-target method. When reading a substitute target, fill the viewfinder with it, but do not refocus the camera. Leave it focused at the camera-to-subject distance, since moving the lens forward to focus on the card can change the indicated exposure reading considerably.

In closeup photography, photomacrography and photomicrography, the BTL meter has a great advantage over conventional meters. No matter how close the focus, the BTL meter receives an accurate sample of the light that will reach the film during the exposure. The meter automatically indicates the increased exposures required at greater image magnifications, making exposure correction unnecessary.

For detailed instructions on using the BTL meters in the Leicaflex SL and the Leica M5, see the chapter, "Handling the Leica and the Leicaflex" by Rüdiger Krauth.

Spot meters

Spot meters also read the light through an optical system, so they are closely related to BTL meters, and share some of the same problems.

The spot meter's function is to let you make narrow-angle readings of selected parts of the subject without having to go right up to the subject. If a mile-high mountain in the distance is the brightest part of the scene, some spot meters will enable you to read it, while excluding its surroundings from the reading, from as far away as fifty miles. At a circus, you can get a reading of a spotlighted performer on a trapeze, or in the ring with the lions, without your meter "seeing" mostly dark background, which might lead you to overexpose if it were included in the reading. Zone-system photographers find spot meters useful for readings of different subject areas, taken from the camera position.

The spot meter's optical system helps you aim the meter accurately, and narrows its field of response; but the problem of flare remains. All lenses produce some flare due to the scattering of light inside or between lens elements. Some spot meters have minimal flare, while others may produce enough flare to cause significant exposure errors: camera flare and meter flare do not necessarily cancel each other out.

Bright subject areas cause no problems when measured for their own luminances, but flare due to their brilliance can distort readings of deep shadows or dark tones. In severe cases, the reading may be as much as two stops too high for these dark areas, leading to serious underexposure. Where extremes of contrast exist side by side, you may find it best to move in close enough to fill the whole viewing field of the meter—not just the narrow reading area—with the dark tone you are measuring.

How big is a spot? It is important to know this when you select or use a spot meter. A rule of thumb is that a one-degree meter at a distance of sixty feet will read a spot one foot in diameter, a two-degree meter will read a one-foot spot at thirty feet, and so on. Some so-called spot meters that read over angles of five degrees or more largely defeat their own purpose, although the meter with the narrowest reading angle is not necessarily the best choice.

Multi-purpose meters

Several meters now available attempt to perform more than one specialized function. Some successfully combine reflected-light and incident-light capability. A few even try to convert to spot or semi-spot reading. Such meters may fill more than one of your photographic needs and be a logical choice; but, in general, the meter designed for a single specialized purpose is likely to perform its function better than a multi-purpose meter with an adapter.

Many professionals who need to take various kinds of specialized readings solve the problem by using several meters, each for its own purpose—but even they sometimes run into situations where the right exposure can only be found by a combination of experience and bracketing (giving a series of graduated exposures, including some that are greater and some that are less than the estimated exposure.)

Which meter do you need?

The most common exposure problems and the metering approaches that solve them have been sketched here. If you know your problem, you should have no trouble choosing the appropriate metering method, and careful shopping and comparison will help you select the meter that best fills your needs. Only you can decide. The meter that most conveniently and consistently gives you good exposures is the right meter.

The more complex the light, the more important accurate metering is in achieving proper exposure. Photo of film animator Norman McLaren copyright 1969 by Bill Pierce

Exposing without a meter

For most of a century, our photographic forbears did well with no light meters at all. During much of that time, home-made sensitive emulsions were used, and they could not be rated for speed. Now things are much easier for the meterless photographer.

Most experienced photographers work mainly with one or two films that are well suited to their photography, and they get to know these films well. They know the light in which they usually work equally well. For such a photographer, the right exposure for a given condition often seems self-evident. If he reads the meter at all, it is to confirm what he already knows.

One way to develop this kind of exposure-awareness is to make a habit of estimating the exposure quickly in your mind before you read the meter. If you keep it up, you will soon find that under certain light conditions you are usually right. As you go on, you will be able to handle more and more situations by experience.

If you don't yet know that much, you can still read and follow the exposure suggestions for different lighting conditions and subjects that are given on the data sheet packed by the manufacturer with each roll of film.

Finally, here's a rule of thumb for using ASA ratings to estimate bright-sunlight exposure for unfamiliar films. No meter or calculator is needed.

$$\frac{1}{ASA} = \frac{1}{seconds} \quad \text{at } f/16$$

Thus, with ASA 400 film, the exposure for bright sunlight is 1/400 second at f/16. This will not necessarily be the optimum exposure, but the formula will keep you from being too far off. A little bracketing will usually help you do still better.

Developing and Printing

Bill Pierce

What you need

You want to do your own developing and printing. Good! You are going to need a darkroom. This can be a kitchen or a bathroom with the windows blocked off. But you will be happier, and will work better, if you have a place where you won't be interrupted and can be the master of your own schedule. In addition to a darkroom with running water and adequate ventilation, you will need:

(1) Two work surfaces, a "dry" one and a "wet" one. The dry one should be big enough to hold an enlarger, a box of photo paper, and a few other tools. Any sturdy table should do. The wet area will hold tanks and trays of chemicals. It should be far enough from the dry area so that chemicals will never be spilled or splashed on equipment like your enlarger. It will be more convenient to mix chemicals, wash negatives and prints, and clean up the wet area if this second table is actually a large, shallow sink. You can build it out of plywood, or you can buy a stainless-steel or plastic sink.
(2) Some small graduates (one 8-ounce and two 1-quart ones should do); a plastic pail that holds at least a gallon; a plastic stirring rod; a funnel; and some bottles, to measure, mix and store your processing chemicals. You will also need a can opener and some way to label your bottles. (White adhesive tape and a Magic Marker will do.)
(3) A developing tank and some reels.
(4) A photographic thermometer.
(5) An interval timer, or an electric clock with a large, legible second hand.
(6) A viscose sponge to wipe down your processed film.
(7) Some film clips (or clothespins) and a dust-free place where you can hang film to dry.
(8) Envelopes or sleeves for negative storage.
(9) A contact-printing frame or a heavy sheet of glass. This will let you "proof" an entire roll of film on a single sheet of photo paper.
(10) An enlarger.
(11) Four processing trays.
(12) A safelight.
(13) Chemicals and photo paper.
(14) Photographic blotters or other print-drying equipment.
(15) Last, but not least, a roll of paper towels.

Although they are luxuries, I seriously recommend the eventual acquisition of a print washer and a dry-mount press.

One intangible that you will also need is enough practice and experience to reduce darkroom procedures to a simple, *repeatable* routine. If you don't know what you did, you can't find out what you did wrong—or right. Knowing what you have done, and changing one thing at a time, you can evolve a system that delivers top-quality negatives and prints with a minimum of fuss.

You will make mistakes at first (everybody does), but you will make fewer mistakes if you practice any procedure a few times before you actually do it. You will be literally working in the dark; so have "a place for everything and everything in its place." When you have finished for the day, clean up. Chemicals have a sneaky way of getting into things, including other chemicals, and ruining them.

Developing film

Prepare bottles of developer, hypo (also called fixer), and hypo neutralizer from the dry chemicals or liquid concentrates you buy at the camera store. Mixing instructions will be on the packages.

If you are confused by the number of film developers on the market and don't know what to buy, the instruction sheet packed with the film probably recommends one or more suitable developers. Some instruction sheets contain what amounts to a short course in film developing. If the instruction sheet has no processing instructions, or if you can't decide which of the developers listed to use, try Kodak D-76.

More than any other formula, D-76 is accepted as a standard developer for 35mm and roll films. Ilford markets the same formula as Ilford ID-11. DuPont 6-D, Ferrania R-18, and Gevaert G.206 are the same for all practical purposes. GAF Hyfinol is similar. Other, more specialized products are often described by comparing their performance to that of D-76. While it is not the "best" developer in the world (no developer can be best for everything), it is a safe bet that you will get acceptable results from it. Once you have mastered D-76, you will have a basis for judging the performance of other developers.

Any of the rapid fixers (hypos) that are mixed from liquid concentrates are excellent for use with film.

They are convenient to prepare, and complete mixing instructions are on the package. Edwal Quick-Fix, Heico NH5, and Kodak Rapid Fixer and Kodafix are all established products.

GAF Quix, Heico Perma Wash, and Kodak Hypo Clearing Agent are all·"hypo neutralizers" or "washing aids" that have been on the market long enough for a number of independent sources to test them to their satisfaction. These washing aids not only shorten washing time, but do a much better job of removing hypo from film and from paper than a water wash by itself. (Insufficient washing can lead to staining and fading.) The GAF and Heico products are liquid concentrates. The Kodak Hypo Clearing Agent is a powder from which you can prepare either a concentrated stock solution or a working solution. Mixing instructions and directions for use are on all packages.

The instructions packed with your film suggest different developing times at different temperatures. Chemicals are more active at higher temperatures, and the same degree of development is accomplished in a shorter time. With luck, the temperature of your darkroom, and therefore the temperature of your chemicals, will fall within the range (usually 65°F to 75°F) given in the instruction sheet. The easiest way to stabilize the temperature of your chemicals is to work at room temperature. If your darkroom gets very hot or very cold, you may need an electric heater or an air conditioner. If you can't control the room temperature, you will have to control the temperature of your chemicals by placing the bottles in a container of water at the right temperature. While you are developing film, the tank will have to be in the water, too, to make sure the chemicals remain at the right temperature. Stainless steel tanks of the Kindermann or Nikor type transmit the temperature of the "water-jacket" to the chemicals more efficiently than hard rubber or plastic tanks.

Once the chemicals are set in the wet area and are at a usable temperature, we can load the film into the developing tank. I can add only a few thoughts to the directions that came with the tank. Unless you use one of the many kinds of daylight loading tanks, you will be working in the dark. Put the cartridges of exposed film in your pocket so you can find them with the lights out. (If you use factory-loaded Kodak cartridges, you will need a beer-can or bottle-cap opener to get at the film; put that in your pocket, too.) Don't stack the reels in front of you; put each one down on its own piece of table. Tall stacks come tumbling down in the dark. Even if you locate the scattered reels you may find they are too badly bent to work.

Whether your tank uses an apron or wire reels, practice the loading procedure several times with an expendable roll of film. Do it first with the light on, then with the lights off. And when you take twenty minutes to load that snaky length of film onto that tiny reel, when you think that you will never be able to do it quickly and efficiently, call the most experienced darkroom worker you know and ask him to tell you about the first time he loaded a tank.

Once the tank is loaded, the lid is on it, and the lights are turned on, the procedure is simple. You pour in the developer, start the timer, and "agitate" the tank to start the developer moving evenly over the surface of the film. Some tank lids are watertight; with them, you can start the developer moving by inverting the tank. Invert the tank about once per second for the first thirty seconds of development. Bang the bottom of the tank once or twice on the work surface to dislodge any air bubbles from the surface of the film. Some tanks can't be inverted; you agitate by sliding or rotating them, or by turning a knob that spins the reel. If you were to stop agitating after this initial effort, the results would be disastrous. The chemicals on the surface of the film would soon become exhausted from the effort of turning your film into negatives. Every thirty or sixty seconds you must agitate again to bring fresh developer to the film surface. Unless the developer instructions specifically state otherwise, agitate every thirty seconds during short development times up to six or seven minutes. For longer development times, agitate for ten seconds, once every minute.

Manufacturers' recommended development times for popular 35mm films in D-76 at 68°F (20°C)

Ilford Pan F	6 minutes
Ilford HP4	7½ minutes
Ilford FP4	6 minutes
Kodak Tri-X Pan	8 minutes
Kodak Plus-X Pan	6 minutes
Kodak Panatomic-X	7 minutes
Adox KB-14	6 minutes
Adox KB-17	5½ minutes

If the flow of fresh developer over the surface of the film is not even, uneven development results. This can be seen as weak, variegated tones in what should be a continuous-tone area, or as a build-up of density at the edges of the film, in a pattern that often corresponds to the flow of developer through the film's sprocket holes.

A few pointers: Always fill the tank with its full complement of reels. A single reel in a two-reel tank can piston back and forth and cause streaking. Fill the tank with just enough solution to cover the reels. The large air bubble that rushes through the spirals of film during inversion seems to be our friend. Invert the tank around an axis halfway up the tank. In other words, simply turn the tank upside down—don't wave it up and down in some ill-conceived ritual. Whatever you do, make sure you can repeat it exactly with the next roll of film—the same number of inversions at the same intervals. How much fresh developer you bring to the surface of the film affects its degree of development, something you will want to control because it has a decided effect on the contrast of your negatives and prints.

Once the recommended time of development is over, we pour out the developer and pour in several rinses of fresh water. Next, hypo is poured into the tank for two to four minutes. The rapid fixers work quickly. Avoid overfixing, which could degrade the image by bleaching it, and make proper washing difficult. With proper agitation, the film should be fixed in about twice the time it takes to clear the gray opalescence from the emulsion. (If you are using fresh rapid fixer, you can remove the tank lid and watch this clearing process after the film has been in the hypo for thirty seconds.) Once fixation is complete, you'll want to rinse the film in water and take a preliminary glance to make sure it "came out."

After fixing and rinsing, treat the film in a washing aid. Don't forget to agitate. While it is being treated, turn on the water and adjust the taps until the water is running at the same temperature as your processing chemicals. Pour out the washing aid, then place the tank under the faucet and wash the film. Empty the tank every two minutes to ensure efficient washing action. The instructions on the washing aid package will recommend treatment and washing times. Remember that these are the minimum times. A little more washing aid won't hurt, and a longer wash is definitely better.

While the film is washing, clean up the darkroom. I simplify clean-up procedures by throwing out all used chemicals except the hypo. Most of them could be used again, but the reliability and consistency you get from fresh chemicals is worth the slight expense.

When the film has washed, hang it up to dry. Wet the viscose sponge; then wring as much of the water from it as possible. (New viscose sponges must be rinsed thoroughly to remove any trace of sizing or loose particles; old viscose sponges should be checked to see if they have any grit embedded in them.) Slowly, and without excess pressure, wipe down both sides of the film. Make sure no drops of water or sponge particles remain on the film. Hang a clothespin or a film clip on the bottom of the roll to minimize curl while the film is drying. Any problem with water drops on the film surface can be eliminated by treating the film before drying in a solution of water and a photographic wetting agent such as Edwal Kwik-Wet or Kodak Photo-Flo. If this rinse is a solution of distilled water and wetting agent, you won't have to sponge the film. This eliminates any danger of accidentally scratching it. My experience indicates that a slightly more dilute solution of the wetting agent than the manufacturer recommends minimizes the possibility of the unwiped film drying with streaks on it.

The method we have just outlined is not the only way to develop film, but it keeps the equipment investment down. It is possible to use several tanks and lift the reels from solution to solution in the dark. This technique leads to more positive timing of the development by eliminating a pouring operation that takes fifteen to thirty seconds and leaves you unsure when to start the timer. If your developing times are short enough to make a fifteen- or thirty-second error significant, the multi-tank system is preferred. The film is developed in your standard tanks. You use no more developer than you need, and you don't feel bad about pouring it down the drain once its job is done. Standardized agitation procedures are maintained. But hypo and washing aid can be both used and stored in large tanks. These don't have to be expensive photo items. Plastic refrigerator containers, old battery cases, and pickling jars have been used with success.

Nor is it necessary to wash your film in a tank which has to be emptied every few minutes. Film washers (which look like topless plastic film tanks

with inputs at the base) connect to the faucet, push a turbulent mixture of water and air past the film, and do a better job than ordinary processing tanks.

Once the film has dried, cut each roll into strips for filing. These strips can be five to seven frames long, to fit the containers you use for filing. Many paper envelopes contain residual chemicals and glue that can, in time, attack and damage the negative image. It is more efficient to name the few containers that are safe than the many that are not. Cellulose acetate sleeves, available in many camera stores, are safe. Sleeved sheets of polyethylene that will hold seven six-frame strips are available by mail from Print File, Inc., Box 100, Schenectady, N.Y. 12304. They have the advantage of allowing you to make contact prints of a roll of film without removing it from the protective sleeves. File your negatives in a cool, dry place. Heat and humidity are enemies of negatives and prints.

If you feel that these are the precautions of an egomaniac and that your photography doesn't merit "archival" processing, let me point out that it is not future generations, but you, who will see your early images fade away. But the same precautions that protect these images during your lifetime will probably make them available as a visual document to generations to come.

Contact sheets

You can proof-print an entire roll of film on a single sheet of paper. A sheet of glass presses the strips of negatives in contact with a piece of photo paper, the sandwich is exposed to light, and the paper is processed. These postage-stamp images let you know what is worthy of enlargement, form the basis of a filing system that lets you find a specific picture without manhandling your negatives, and—in our case—they will be a good introduction to the printing process.

For photo paper, I suggest that you use 8½x11-inch, single-weight, glossy enlarging paper. 8½x11 because, any way you cut it, it's almost impossible to squeeze a full roll of 36 exposures neatly onto the more conventional 8x10 paper. Single-weight, as compared to the thicker double-weight, because you can file more "contacts" in the same space, and the thinner paper washes and dries more rapidly; glossy-surfaced, because any textured surface obscures detail in the tiny images; enlarging paper, because we are going to use our enlarger to expose the paper ("contact" paper, far less sensitive, has to be exposed to a much brighter light).

Typical paper choices for contact sheets would be DuPont's Velour Black R2 or Varilour R ("R" is DuPont's code for single-weight, glossy), and Kodak's Kodabromide F2 or Polycontrast F, single-weight ("F" means glossy in Kodakese). But talk to your photo dealer before you order. All the papers I have mentioned, and others, will do an excellent job, but it is important to standardize on one of them and become familiar with it. The combination of your experience and a good product is what produces results. 8½x11 is an odd size that your dealer may not carry in stock, so choose a paper from a manufacturer who will let him order relatively small quantities of odd-sized paper and will deliver them promptly. It won't do you any good to be forced to jump from brand to brand.

Because enlarging paper is sensitive only to blue or blue-green light and is much less sensitive than film, we no longer have to work in the dark. A "safe-light" can be anything from a red bulb to a special fixture that accepts a variety of colored filters, for use with a variety of light-sensitive materials. A safelight equipped with a Kodak OC or DuPont S55-X filter will be easier to work under than a red bulb, and is safe for all the black-and-white papers that you will use. In my darkroom, several economical, red-bulbed ceiling fixtures provide general illumination, but smaller, filtered units spotlight key work areas.

In the wet area you will need four trays of chemicals at the start. In the order of use, they are paper developer, stop bath, hypo, and water. When we start to make enlargements we will make some sophisticated distinctions between various enlarging papers, developers, and so on. These choices can create subtle, but meaningful, differences in such things as the print's image tone. For now, however, the logical paper developer is the one that the manufacturer of your paper recommends; it is guaranteed to give acceptable results. If your camera store doesn't know what developer that is (you can't open the box of paper in the room light to get at the instructions), try Kodak's Dektol. This is a proprietary version of D-72, their "universal Elon-hydroquinone paper developer." It is the paper world's equivalent of D-76. The mixing instructions on the can produce a "stock solution" that is diluted 1:2 for use (one part stock solution to two parts water).

Stop bath is a mild acid that stops development and prevents the carry-over of alkaline developer into the acid hypo, thus prolonging the hypo's life. It can be used with film, but isn't essential because the film base doesn't absorb much developer. The paper base is like a sponge, so the stop bath is necessary in printing. Stop bath is prepared by adding 1½ ounces of 28% acetic acid to each quart of water. *Never pour water into acetic acid. To avoid the danger of the chemical splattering, always add the acid to the water.* This is particularly important when preparing 28% acid by adding three parts of glacial (99%) acetic acid to eight parts of water.

Your paper hypo should be one of the types that you mix from a powder. Rapid fixers mixed from liquid concentrates work so quickly that it is difficult to control the process with a tray of prints. Too long a print-fixing time can make the prints difficult to wash and may bleach the delicate highlight values.

Trays should be slightly larger than the prints you intend to make. An "11x14"-inch tray is actually larger than 11x14 inches. It can handle 11x14 enlargements and will be more than adequate for 8½x11 contacts. Be sure there is enough solution in the trays to cover the paper quickly and evenly. If this doesn't happen in the developer, blotchy and unevenly developed prints will result. If the stop bath isn't given an opportunity to work effectively, stains may result. If the hypo isn't given a chance, stains may also result. When you pour the hypo into the tray be generous. Remember that at times there will be more than one print in that tray.

Room (and chemical) temperatures should be between 60°F and 80°F. It is even better if the temperature is between 65°F and 75°F. Some literature gives the impression that you can only work at 68°F. Nonsense. But there are optimum temperature ranges that give the best results. Developers consist of several chemicals working together as a team. Within a certain range of temperatures, each chemical contributes its share in proper proportion. Outside that range, it may lie down on the job. For example, we noted that Dektol is an Elon-hydroquinone developer. As the temperature drops, the hydroquinone becomes proportionally less active than the Elon. Even though you develop for a longer time to compensate for the slower chemical reaction at lower temperatures, there comes a point where the Dektol starts behaving like a low-contrast Elon

developer, rather than a normal Elon-hydroquinone developer. I've worked in makeshift darkrooms which dropped to the 50s in the winter. The temperature problem was solved by floating the developer tray in a tray of warm water. If your trays have flared sides so you can stack them for storage, you can float one 11x14 tray inside another. The solution is simple if you know it; the problem is damaging to print quality if you are unaware of it. If you normally develop your prints for two minutes when the developer is between 65° and 70°, try three minutes at 60°, 1½ minutes at 75°, and 1¼ minutes at 80°.

Hypo simply takes longer to do its job at lower temperatures, and that gives a number of little invisible nasties (which we will discuss later) time to soak into the paper. These nasties are invisible until they stain your print; so warm up your hypo if it drops below 60°F.

Excessively warm solutions and washing can lead to fogged paper, physically softened emulsions, and easily damaged prints. The ultimate is the emulsion which floats off the paper, leaving you with a gray slime that used to be your picture and an expensive piece of soggy writing paper. We point this out because the temperatures have been extreme in some makeshift darkrooms we have worked in. We recovered, but the pictures did not.

Back to contact printing: Turn your enlarger on, raise the lamphead and focus the lens until the projected light covers the baseboard. Our list of items earlier in this chapter included a sheet of glass. It should be comfortably larger than 8½x11 inches and heavy enough to defeat the natural curl of the negatives and hold them in tight contact with the photo paper. All four edges should be taped to avoid the danger of cutting yourself. Place the glass in the center of the baseboard and hinge the top edge temporarily to the baseboard with a piece of tape. With the room lights out and the enlarger lens set at f/5.6, swing the glass back from the baseboard, set a sheet of photo paper in the center of the baseboard (emulsion or shiny side up), lay the negative strips in neat rows on top of it (emulsion, or dull, side down), then swing the glass down on top of the package. There is an alternative to the glass. You can use a printing frame. It resembles a picture frame with a spring-loaded back. In this case, you open up the frame, put the negatives on the glass, put the

Glass, negatives, paper and light are all you need for contact printing

paper on the negatives, snap the back into position, and turn the whole frame over so the glass is on top. It takes more time, but the spring-loaded frame guarantees good contact between negative and paper, and sharp proofs.

Turn the enlarger on for sixteen seconds. Take the enlarging paper and slide it smoothly into the developer, edge first, in a single stroke. Agitate by rocking the tray gently for the full development time. Manufacturers usually recommend 1½ minutes development at 68°F for the papers we have mentioned. But often the blacks in a fine print benefit from longer development. Three to five minutes can be beneficial. This is seldom necessary for contact sheets, but it is valuable information to file away until you are making enlargements.

After development, drain the paper for about ten seconds, or until most of the developer has run from the paper back into the tray. Place it in the stop bath for about twenty seconds; stop-bath time is not critical. Drain the print, place it in the hypo, and agitate for two minutes before you turn the room lights on. *Make sure that the box of enlarging paper is closed.* The contact sheet will spend two more minutes in the hypo before you store it in the tray of water. (The instructions on the hypo package say five to ten minutes, but we are going to do something special. More on that later.)

If you are lucky, you have just made your first good contact print. But chances are that the proof in the hypo is too light or dark to show the pictures clearly. That's no good; the proof sheet should let you judge what is on the film well enough to choose the pictures you want to enlarge. If the proof sheet is too light, make a second one with the same negatives, giving it more exposure. If the proof is just a little light, try twenty-two seconds; if it is very light, thirty-two seconds. If it is too dark, give less exposure. If it's much too dark, expose the next contact print for eight seconds; if it's a little too dark, try eleven seconds. Adjust the exposure until you get a proof that clearly shows the details of your pictures.

A contact sheet provides same-size proof prints of the negatives on an entire roll. Standard 8x10-inch paper is fine, but many papers are available in a 8-1/2x11-inch size which accepts 36-exposure rolls without crowding

When you get good at judging images under a safelight, you will be able to save proofs with minor exposure errors by shortening or lengthening development time. Less time lightens the image; more darkens it. But development time also affects contrast and image tone, so this is not a technique to use for fine enlargements.

If you have written a file number on the negative sleeve, you can write that same number on the back of the contact sheet. If you use pencil, it doesn't matter whether you do it before or after the paper is processed. But you must write very lightly to avoid damaging the emulsion. You can also write the number, before printing, on the emulsion side of the paper with a red or black marking crayon. This blocks the light from the paper and produces a number that is part of the photographic image. It also fills your chemicals with little pieces of crayon. These don't harm the chemicals, and a build-up of particles in your developer will remind you not to overwork the solution. (I will squeeze twenty to twenty-five contact sheets through a quart of working developer, but I will only develop eight 8x10 enlargements in the same amount of solution.)

An alternative is to number the edge of the negatives with a drawing pen and India ink. These numbers appear automatically on the contact sheets. Make sure the ink is dry before you slip the film into sleeves, or it will smear into the picture area and ruin the negatives.

After three or four proofs have reached the storage tray of water, empty it and refill it with fresh water. If you don't, it will soon become a tray of very dilute hypo, and may bleach your prints.

When the printing session is over, it is time to treat the prints in a second, fresh tray of hypo. This is why we began by fixing our prints for only half the recommended time. Why two fixers? Because two-bath fixing guarantees proper fixation (essential for long-lasting prints), because it is economical, and because it is a good habit to have when you start making truly fine enlargements.

Hypo works by "dissolving" the unused silver salts in the paper emulsion that have not been converted into the silver print image. In the process, the hypo gets weaker and builds up an accumulation of dissolved salts. Because the first hypo has already removed most of those salts, a second hypo bath stays relatively fresh and can guarantee complete fixation.

A single bath in exhausted hypo soaks the paper fibers in a heavy accumulation of complex silver salts that are impossible to remove by washing (the invisible nasties we mentioned earlier). In two-bath fixing, we move the prints to the fresh, lightly-salted second bath before the salts in the first bath can work their way into the paper fibers.

"Rotate" the stack of prints through the second hypo for four minutes by moving the print on the bottom of the stack to the top, and continue to do this until the time is up. Then pour the hypo back in its bottle. Unlike diluted paper developer, it can be used again. The two-bath system increases its capacity. Kodak claims a capacity of 100 8x10 prints per gallon for most of its fixers, but two-bath fixing extends this capacity to 200 8x10s. Then the second hypo becomes the new first hypo, and a fresh bath becomes the new second hypo. This cycle can be repeated up to five times before both hypos are discarded. Then start again with two fresh hypos.

After the prints have had their second fixing, store them in a tray of water while you prepare a tray of "hypo neutralizer." Rinse the prints for five minutes in running water, then put them through the hypo neutralizer for the time the manufacturer suggests. Use the rotation system of agitation both for the rinse and for the neutralizer treatment. The prints are now ready to wash.

Kodak claims that single-weight prints treated in Kodak Hypo Clearing Agent will wash in ten minutes in water as cold as 35°F, if there are at least four complete changes of water during that time. They also state, " . . . the time of washing and the rate of water flow are both meaningless if the prints are not separated constantly so that water can reach every part of every print throughout the washing time." In other words, you are going to stand over that tray, rotating prints, for the full ten minutes. The figures just given are minimal: paper fibers, unlike film base, cling to hypo. A realistic minimum wash time, established by chemical tests, for archival double-weight prints, is forty minutes with the water at the optimum temperature for washing, 80°F. ("Archival" prints can be expected to last at least fifty years under good storage conditions.)

Rotating prints and emptying and filling a tray is boring work. Almost every serious darkroom worker eventually buys an automatic print washer. This can be as simple as a tray siphon, which simply moves

water in and out of a conventional processing tray, or as elaborate as a rotating drum washer not too far removed from machines you see in a laundromat. There is one catch: many automatic print washers don't do as good a job as hand rotation in a tray. Are the prints separated from each other? Any washer works for one print. Large prints that crowd the washer and are not free to move tend to stick together regardless of the turbulence in the washer. A large number of small prints will also cluster. A washer that does a good job of filling and emptying itself may still need you to separate the prints. Is the flow rate sufficient to ensure a complete change of water every five minutes? The washing times suggested by Kodak and other authorities are generally based on this assumption. A complete change takes longer than the time it takes for the washer to fill or empty. You can measure this time by putting a healthy dose of food coloring in the water and seeing how long it takes to clear. Obviously, the bigger the washer, the longer it takes. For example, a 20x24x6-inch tray, tested with a tray siphon, took twenty minutes for a complete change.

This is not to condemn automatic washers, but their abilities are more limited than many people suppose. A simple tray is more effective than is usually assumed. We belabor the point, not to frighten you, but to point out common, erroneous assumptions that may affect your photographs.

Here are your options. (1) Rotate prints in a tray of water, dumping and refilling it often. (2) Use a siphon or a commercial washer, but stick around and separate the prints by hand. To get a fast enough exchange rate for reasonable and efficient wash times, two small washers may beat a single big one. (3) Accept the fact that not all prints have to be washed to archival standards. But be aware that the blotters, the aprons on heated dryers, and other items that come in contact with these less-washed prints will, in time, pick up chemicals from them and contaminate more-thoroughly-washed prints that go through the same equipment. (4) I know of only one type of washer currently on the market that can be filled to capacity and left unattended. The East Street Gallery (723 State Street, Grinnell, Iowa 50112) makes print washers which hold each print in a separate washing compartment. These washers are available only from the manufacturer, a cooperative community that supports itself, in part, by producing them.

When I first started in photography, I dried my prints by hanging them from clothespins, then pressing them under weights. I now own an electric dryer. But, for the reasons just mentioned, I use it only to dry prints that have *not* been given an archival wash. The prints I care most about are still hung on clothespins to dry.

Some other drying methods are equally simple and effective. After prints have been drained, and excess moisture sponged from their surfaces, they can be dried between photo blotters or in a blotter roll. Drying can be speeded by transferring the prints to a second set of dry blotters after the first have absorbed much of the moisture. Changing blotters will give you flatter prints. (Avoid non-photographic blotters; they contain harmful chemicals.)

Prints can also be laid face-down on fiberglass screens. These could be window screens, but it is cheaper to buy the material and stretch it onto simple wooden frames. These screens absorb no moisture, so there is little chance that they will absorb contaminants. This must be regarded as the preferred system when we start making quality enlargements. Stacks of screens can dry an evening's worth of prints in a limited space. If you stack them with a few inches between the screens, a room with normal humidity and air circulation should present you with dry prints the following morning. This method takes much longer than an electric dryer, but you don't have to man the machinery while it is happening.

Some papers dry flatter than others. Your single-weight contact sheets will curl more than double-weight enlargements, but a moderate weight on a stack of the curliest should uncurl them again in twenty-four hours or less. A heated dry-mounting press will solve the problem in thirty seconds.

When speed is important, an electric dryer is essential, but there is a point of diminishing returns. If the dryer is too hot, the edges of the print will dry so much faster than the center that "fluting"—a print with a permanent wave—will result. Lowering the heat solves this problem, but the warm print still comes from the dryer with a definite curl. A few minutes in the open air may restore some moisture to the emulsion and let the print flatten out, but it may be necessary to treat the print in a flattening agent before drying. Such solutions contain glycerine or other moisture-holding agents, which are detrimental to the permanence of the print. Don't

use them with prints for which you want the maximum possible permanence.

Enlargers

Few people but yourself are going to examine your contact sheets. Your photography will be judged by your enlargements. It is worth your while to make good enlargements, to put your best foot forward visually, and to get a good look at your own work.

The first thing you need to make a good enlargement is a sense of what a good print looks like. For those of us who grew up on magazine reproductions and commercial photofinishing, an occasional visit to a museum or gallery that features fine photography may provide a more demanding standard.

The print is the product of a chain of equipment. If the enlarger is a weak link, your investment in a fine camera is for naught. An optical chain is weaker than its weakest link. Your enlarger must be built to the same high standards as your finest camera and lens. No wonder Leitz chooses to produce a series of enlargers to complement their cameras.

The Leitz Focomat Ic is an autofocus enlarger that accepts negatives to approximately 1-9/16 x 1-9/16 inches. Since few cameras produce 1-9/16-inch square negatives, the Ic is used mostly for 35mm negatives, but interchangeable negative carriers are available in sizes from 8x11mm to 4x4cm. The lamphouse condenser rests on top of the negative and flattens it against the masking carrier, holding the film in the focal plane of the enlarging lens, much as the pressure plate positions the film in a camera.

The enlarger head moves up and down at the end of a spring-balanced parallelogram, while a cam adjusts the lens so that the projected image is always sharp. The autofocal range is from two to ten diameters. If bigger enlargements are needed, the entire enlarger head and parallelogram can be raised on the enlarger's 32-inch upright column. The lens is then focused manually in its helical mount. The baseboard is 16x21 inches, but you can rotate the enlarger head around to the other side of the column and project onto the floor for even bigger enlargements. For those who often make extra-big enlargements, the Focomat Ic is also available in a model with a 20x25-inch baseboard and a 47-inch column.

The Focomat Ic is normally equipped with a 50mm f/4.5 Focotar enlarging lens. Lenses are corrected to

The Leitz Focomat Ic enlarger meets the highest standards for 35mm work

give optimum definition at specific working distances: the Focotar is designed to give its best performance at enlarging distances, not at the longer distances used in normal picture-taking. Special care is also taken to make sure that the projected image is sharp across a flat field (some high-speed camera lenses have a curved field that would produce unsharp images at the edges of a flat piece of photo paper). The autofocus cam on each Focomat is adjusted to the individual lens furnished with that enlarger.

For those who wish to hold down the initial price of their enlargers, adapters are available that will fit the bayonet-mount 50mm f/2.8 Elmar or the lens heads of the Dual Range or rigid-mount 50mm f/2 Summicrons to the Focomat Ic. It is wise, however, to close these camera lenses down several f-stops for the best print quality.

The Focomat IIc is equipped with two turret-mounted lenses (60mm Focotar f/4.5 and 100mm V-Elmar f/4.5), can handle negatives up to 2¼x3¼ inches in a masked glass carrier, and accepts a variety of accessories that equip it for reduction and copy work. It is a massive, impressive machine, ideally suited to the small-format photo lab that must handle

The Leitz Focomat IIc enlarger is a precision work-horse for 35mm and larger negatives in many professional studios and labs

a variety of assignments. It costs approximately twice as much as a Leica with standard lens (of course, the enlarger has two lenses), and has such luxury features as a miniature light box that slides out of the baseboard to aid in the examination of negatives.

Sliding one of the turreted lenses into position automatically engages the proper autofocus cam. Autofocus range with the 60mm lens is up to approximately 11 diameters; with the 100mm lens, to 5.7 diameters. Moving the enlarger head and parallelogram up the 31½-inch upright and focusing manually allows approximately 16- and 8.6-diameter enlargements, respectively, on the 21x26-inch baseboard. Bigger enlargements are possible with floor projection.

Both the Focomat Ic and IIc are available in models with a built-in filter drawer and an illuminated magnification indicator; these can make color printing much easier and pleasanter. Leitz easels, used to hold enlarging paper, have dovetail fittings that couple to a clamping device in the Focomat baseboards; the easel is free to move on the baseboard while you compose and crop the image, but the throw of a lever locks the easel in the desired position when you are ready to print. A wide variety of

accessories are available for all Focomats. They run the gamut from simple external filter holders for use with variable-contrast enlarging papers, to adjustable, tilting negative carriers and easel holders for perspective-correction work.

In essence an enlarger is an inside-out camera, with the light-sensitive material (the photo paper) on the outside and the subject (the negative) inside. It has to be built to the same high standards as a camera. In Leitz enlargers, particular care is taken to hold the negative flat and in the focal plane of the lens with either a flat-faced condenser or a full-glass carrier. The focusing and lens mounts are built to hold their alignment; there is no play between the negative stage and the lens stage. The enlarger housing is supported on a strong, carefully aligned upright, anchored to a heavy baseboard to ensure that the enlarging paper is parallel to the negative stage and that the projected image is distortion-free and sharp from edge to edge.

If you want a single enlarger that will not only handle your Leica negatives, but negatives larger than 2¼x3¼ inches, you will have to go outside the Leitz family of equipment. Fortunately other good enlargers are available; in evaluating them, remember to apply the same high standards that you apply to your cameras. Especially look for vibration-free construction and large, conveniently-placed controls.

Choosing an enlarging paper
A mind-boggling variety of enlarging papers is available. To learn to make good enlargements you must first make an intelligent choice of one paper and stick with it until you master it. The biggest choice is between "graded" paper and "variable-contrast" paper. To choose between them, we have to answer the question, "What is contrast?" We know that certain subjects are high in contrast (or have an extreme brightness range), and that others are low in contrast. A subject that is crosslit in sunlight, with bright highlight areas and deep shadows, would be contrasty. The same subject on an overcast day, with no significant areas of deep shadow or bright highlight, would be low in contrast. If we were to print both negatives on the same enlarging paper, the contrasty subject might yield a print with detailless pure white highlights and detailless pitch-black shadows. The low-contrast subject might yield a lackluster print that ran the tonal gamut from A to

B, from dark gray to light gray. Within reason, we want every print to have detail in the large dark and light areas and still have accent points of pure black and white. We can make a good print of the high-contrast subject (from a negative with a great density range) by printing it on a low-contrast paper. We can make a good print of the low-contrast subject (from a negative with a short density range) by printing it on a high-contrast paper. Normal negatives, not surprisingly, print on normal paper. It is a balancing operation: high on low equals normal; low on high equals normal; and normal on normal equals normal. Of course, we can use high- and low-contrast papers for special effects with normal negatives—a harsh effect on high-contrast paper, and a muted effect on low-contrast paper.

A graded paper, as the name implies, is available in different contrast grades. No. 2 and No. 3 are considered normal grades, with No. 3 a little more contrasty or "snappier" than No. 2. No.1 is considered a low-contrast paper; sometimes there is a No. 0 available. No. 4 is considered a high-contrast paper; No. 5 and even No. 6 are available. The higher the number, the higher the print contrast.

Variable-contrast papers have two emulsions, a high-contrast one and a low-contrast one, coated on the same paper. Each emulsion is sensitive to a different color of light. By producing different blends of the two colors with a set of filters, you can produce several "grades" of print contrast from one box of paper. Variable-contrast papers offer the economy of a single package of all-purpose paper as compared to three or four boxes of graded paper. Enlarging papers, like most photo-sensitive products, are organic materials that deteriorate in time. Who wants to get stuck with a little-used box of high- or low-contrast paper that is going to die on the shelf before we use it up?

But there is more to say about the difference between variable-contrast papers and graded papers, or no one would buy graded papers. No variable-contrast paper can produce contrast as high as some graded papers. For example, Kodak's Polycontrast (a variable-contrast paper), exposed through the No. 4 Polycontrast filter, is less contrasty than the No. 4 grade of Kodabromide. It is more like No. 3 Kodabromide. There is no No. 5 Polycontrast filter, but there is a No. 5 grade of Kodabromide.

The photographer who carries his Leica into a broad variety of situations is far more likely to produce a broad variety of negatives that go beyond the range of variable-contrast paper than the photographer who limits himself to one type of picture-taking situation. This is particularly true if the photographer works with "available light." Underexposure, whether accidental or enforced by a lack of adequate light, restricts the density range and contrast of the negative. Often these thin, underexposed negatives can be salvaged by printing them on No. 4, 5, or 6 graded paper.

Many photographers stock a large box of variable-contrast paper for most of their printing, and an envelope or two of a high-contrast graded paper for occasional use. If this is your route, remember to choose two papers that are similar in paper base, surface texture, and image tone, or your occasional high-contrast print will stand out like a sore thumb from the rest of your work. Accept the fact that two different papers may differ in printing speed, differ in response to different developers, developing times, and special techniques like toning or bleaching, differ in the way they dry, or differ in other ways that will lengthen the task of mastering your materials.

If you use a great deal of enlarging paper, there is no special economy in variable-contrast papers. There is convenience, but it is equally convenient to deal with graded papers that are more closely related to each other than a box of variable-contrast paper and an envelope of graded paper. There is one other important argument in favor of graded papers. Some enlargers are optically lower in contrast than others and require that you use more high-contrast papers. The two extremes of enlarger contrast are found in the pure condenser enlarger and the pure diffusion enlarger. Both are rare in darkrooms devoted to conventional black-and-white printing. Most small-camera photographers use modified condenser enlargers. The pure condenser unit is a high-contrast enlarger used in the graphic arts field. We lower its contrast by using an opal (frosted) bulb instead of a point light source. We may further lower it by backing that bulb with a broad diffuse reflector, by using a single plano-convex condenser instead of a double condenser, or by introducing diffusing materials into the illumination system. A simple double-condenser unit, like some of the popular Omega enlargers, is contrastier

than the single-condenser Focomat Ic, which has a lamphouse that doubles as a diffuse reflector.

Later in this chapter, we will see how we can adjust the inherent contrast of our films. We could boost the contrast of negatives destined for low-contrast enlargers, but the denser negative would show a slight increase in grain and a slight loss of definition. True, this is a fine point, but splitting enough hairs in the proper direction produces the top quality necessary in small negatives. A good negative that prints on No. 2 paper in a contrasty enlarger is still a good negative when it prints on No. 3 in a "softer" enlarger. But the equivalent of a No. 3 graded paper may be too close to the high-contrast limit of a variable-contrast paper. To have an adequate range of contrasts on both sides of our "normal," we may standardize on graded paper.

Having decided between variable and graded paper, we still have to choose a pleasing paper base, image-tone, and surface texture. Manufacturers make up sample books that let you examine these qualities first hand. Little sample books are given away or sold to consumers, and big sample books are bolted to photo store counters. Paper bases range from "old ivory" through cream-colored to neutral white. Some papers feature brightening agents that make their white "whiter than white." I stock one type of paper for the greater part of my work. I want this paper to be suitable to as broad a range of pictures as possible; therefore, I prefer a white paper, less specialized than any tinted base.

Image tone is a subtle thing in black-and-white photography. The subtle coloration of the "black" can occasionally enhance the picture. More often, a strong or inappropriate tone can ruin a picture. "Black" can be brownish-black (warm-toned), neutral, or bluish-black (cold-toned). Out of esthetic cowardice and an interest in universality, I recommend a neutral paper for most pictures—but people's opinions on what is neutral vary greatly. What manufacturers call "neutral" may have green or brown undertones. Those few enlarging papers designated "cold-toned" are seldom as bluish as warm-toned papers are brownish. If you agree with those oil painters who added purple to their blacks to make them deeper, and if, like me, you prefer a neutral tone, look at both the "neutral" and "cold-toned" papers in the manufacturers' sample books to find your own neutral paper.

Surfaces vary from smooth to highly textured. Smooth surfaces don't obscure fine detail by imposing an obvious pattern, nor do they introduce a pattern that conflicts esthetically with a specific image. It is not too easy to accept a picture of an all-star athlete printed on a paper whose surface imitates peach fuzz. On the other hand, it is not difficult to accept a picture of a peach (or an athlete) on a paper that has no pattern of its own. Therefore, I prefer a smooth paper surface.

Within that category there is still quite a range, from mirror-like glossy to smooth matte. Glossy paper, dried normally, presents a smooth, lustrous surface with no obvious grain or pattern. It is as universal as the paper in this book.

When the emulsion of a glossy paper is squeegeed in contact with a highly polished ferrotype tin, the mirror-like surface is transferred to the paper as it dries. This maximizes the tonal range of the paper and minimizes the loss of fine detail. As a result, it is a popular surface for contact sheets and pictures for reproduction. Because the surface shows fingerprints, and because light reflections on its surface can obscure the image, the ferrotyped print is less than universal. But in spite of its association with "drug-store prints," this mirror-like surface can impart an effect of brilliance and clarity that benefits some portfolio prints. You can enjoy the best of all possible worlds by using normally-dried, unferrotyped glossy paper as an all-purpose surface, and ferrotyping it when the need arises.

A variety of relatively textureless, non-glossy surfaces are available. Some are just a little less shiny or lustrous than the glossy surface; some are as "dead-matte" and non-reflective as the striking surface of a match box. This non-reflective quality can be useful to us. A wall-mounted print on glossy paper can pick up glare from the lights in the room. If we held that print in our hands, tilting the print could remove the glare. We can't do that with an exhibition print on the wall. To make it easy to see from all angles, we can print it on a less lustrous paper. Unfortunately, the same surface that diffuses the glare will weaken the maximum tonal depth of the blacks. The specular glare is traded for diffuse reflection that does not obscure the image locally. But, just as with "no-glare" picture glass, there is an over-all veil of diffuse reflection that lightens the dark tones of the print and lowers its apparent contrast.

Neutral-toned to cool-toned graded enlarging papers include Agfa Brovira, DuPont Velour Black, Eastman Kodak Kodabromide, GAF Jet, Ilford Ilfobrom, and Spiratone Enlarging Paper. Variable-contrast papers with similar image tone include DuPont Varigam, GAF VeeCee Rapid, and Kodak Polycontrast Rapid. DuPont Varilour, Kodak Polycontrast and Kodak Medalist are slightly warm-toned papers that can produce relatively neutral images with full development in such formulas as Acufine Incorporated's Printofine and Kodak's Dektol. All these papers are available on a white base and with a glossy surface. Each is also available in at least one matte surface; most come in a variety of surfaces.

While it is often wisest to use the paper developer that the manufacturer recommends for his product, that developer is not always easy to get. Stores that sell Brovira, Jet and Ilfobrom papers may not stock Neutrol, Vividol, and Bromophen developers. Kodak Dektol is often the most readily available, and it produces excellent results with all the above papers.

To a certain extent, developer can affect a paper's contrast and image tone. But this is much truer of its effect on warm-toned "portrait" papers than the papers that we have suggested. To produce a contrast that is in-between the grades, or to shift the image tone of neutral and cool-toned papers significantly, you will have to mix your own paper developer. That should wait until you are experienced in more routine darkroom procedures. When you are ready to deal with those subtle changes in the esthetics of the print, read *The Print* by Ansel Adams. Published by Morgan and Morgan, it is the classic work on fine photographic printing.

Enlarging

We have already dealt with several basic procedures of enlarging in making contact prints, but so many creative controls are available in enlarging that we now face the problem, "Which enlargement do I want to make from my negative?" Let us begin with a conventional print—one that looks as much like the subject as it can.

Clean the negative before you put it into the enlarger. It is easier to remove a few specks of dust from the negative now than to spend the time it takes later to "spot out" their enlarged brethren on the print. There are special cleaning cloths, cleaning sprays, liquid cleaners, anti-static brushes and blowers, to help you. All of them work well under normal conditons, but none of them are sufficient in a filthy darkroom. Two tips: Ground your enlarger by connecting one end of a wire to a metal part of the enlarger, and fastening the other end to a metallic part of the building, such as radiator or a water pipe; then it won't attract dust. And save that dust-raising sweeping for a final clean-up *after* the prints have been made.

Turn on the enlarger and study the projected image. What size print would you like? Would you like a small picture surrounded by broad borders that act as a neutral background? Would you like a big image that bleeds to the edge of the paper? (Don't be alarmed: in prints and in layouts, "bleed" just means there is no border; the picture goes all the way to the edge.) Would you like an image somewhere in between? The choice is yours, and this is the first of your creative controls. Would you like to crop the picture? Is there something at the edge of the frame that would be less distracting if you cut it off? Adjust the arms of the easel accordingly. But if you find yourself constantly cropping your prints, it's a sign that something is wrong with your seeing. Most cropping is done best with the viewfinder of the camera. This is a hard decision to make until you have enlarged many pictures. But stepping a little closer to the subject or using a longer lens may improve both your "seeing" and the technical quality of your pictures. One way to minimize grain and maximize definition is to use your entire negative.

Focus the image on the easel with the enlarger lens wide open. It is wise to use a "grain focuser" at this stage. This is an inexpensive accessory that magnifies your view of the projected image so you can focus on the grain of the image. The philosophy is simple: if you are trying to focus on a slightly unsharp image, it will be difficult; but the grain pattern is always sharp, so it is always a good indication of accurate enlarger focus. Before exposing the print, stop the lens down a stop or two. Most lenses perform better at these apertures than wide open.

Expose and develop your first enlargement. You can guess at the exposure the way we did with our contact sheets, or you can cut a sheet of enlarging paper into several smaller pieces and try a variety of test exposures on a key area. When the tones of a test strip look right, give the same exposure to a whole sheet of paper, and soon you will have an

A grain focuser insures maximum sharpness at any size of enlargement. Place it on the easel in the light path from the enlarger. Sight through the eyepiece, and adjust focus until the sandy, or salt-and-pepper grain pattern is crisp. Dense portions of a negative show more grain than clearer shadow areas

enlargement in the hypo tray. Even if you think it is an acceptable print, adjust the exposure and make two more prints—one a little lighter (less exposure) and one a little darker (more exposure). You may be surprised at the difference that a small exposure change can make in print quality. By exploring the potentials of your negative and asking yourself why you like one print better than another, you can come to grips with print quality and creative printing.

There is a chance that all three prints may look too soft or too hard. In that case, abandon your normal-contrast printing paper and reprint on a harder or softer paper. If the dark tones are weak and gray in a print where the lighter values are just right, the print is too soft and needs a contrastier paper. When the light tones are just right, but areas that show ample shadow detail in the negative show up as solid black in the print, the print is too hard and needs a lower-contrast paper. Even if your original prints look good, it is still wise to make softer and harder prints as a learning experience. Are they better or worse than the first prints? Perhaps they are simply differ-

ent. If so, does that difference matter esthetically? The map is not the territory and the print is not the subject, but most people react as if they were. The same words we use to describe the print (bright, luminous, dark, somber, soft, delicate, hard, harsh) are often used by the viewer to describe the subject.

Let me tell you three secrets. (1) I still return to this "multi-print" technique, and learn from it. (2) I'm not interested in making "atmospheric" prints; I just want to be as faithful as I can to the subject. But I rely heavily on the controls afforded by print exposure and paper contrast because I know more about my subject than a timer and a sheet of enlarging paper know. (3) When you produce a stack of prints from a single negative, most of them may be acceptable. But only one or two are likely to be good in their technical quality and good in their contribution to what you have to say about the subject.

After a while, you won't need to make a stack of prints from a given negative. You'll make one, and know that you and photography can do better. Then you will make a second print that heads in the right direction—a direction you are familiar with because you took the time to try all the directions when you were first learning. If you are lucky, the second print is it. If not, you'll fine-tune the results with a third sheet of paper. Usually you will be able to produce an excellent print without needing any of the special techniques we are about to discuss. The ability to make a good "straight" print is rare, and it is the basis for the correct use of more specialized techniques. The special procedures you will use to make a good print better are used by many photographers to make an initially poor print acceptable.

Dodging and burning

Dodging and burning are techniques to lighten and darken specific areas of a print. Dodging—giving less exposure to part of the image—is done by holding back some of the light falling on the photo paper with an appropriately shaped small piece of cardboard at the end of a wire. It is important to keep the "dodger" moving so that you do not see a well-defined silhouette of it in the final print. Burning is just the opposite—allowing extra light to strike part of the print through a hole in a cardboard. Advanced workers use a variety of personalized tools for burning and dodging, from pieces of putty at the end of a wire to their hands.

A simple dodging tool of wire and putty (which can be formed to any shape) is used to shadow portions of the image for less exposure during printing. Wire must be moved constantly to avoid a light line from its shadow on the print

The corrective uses of dodging and burning are obvious—lightening a shadow or darkening a highlight so that they reveal more detail. Less often used, but just as important, are the interpretive uses—suppressing unimportant things and emphasizing important things. For example, a bright object in the background of a picture may distract from the main subject. A discreet burn can tone it down, thus giving the main subject more prominence. Many photographers make a practice of burning down the edges of their prints to get a subtle spotlighting effect that holds the viewer's eye to the main subject. A subject with dark hair or a dark suit may sink into a dark background. Dodging either the subject or the background until the two merging tones are distinct and separate can give the print greater clarity and immediacy. In all cases, you are burning and dodging to rebalance the print so that what you think is important is enhanced. A camera "sees" in a limited way: a single eye blinks open for 1/125 of a second and eventually produces a dimensionally, tonally, and temporally limited abstraction without the benefit of four other senses and a culture. Does the camera see? Maybe. Does it perceive? Not at all. We help the camera along by pointing it in a chosen direction and clicking it at a chosen time. But the task of turning that two-dimensional abstraction into a visual equivalent of the subject we saw may take a little burning and dodging.

An important time out

A good negative, by definition, is one that produces a good print. When you have been printing for a while, you are in a position to evaluate your negatives. Remember what is said here, for these few words are the key to achieving top print quality with a minimum of time and effort. *Negative development affects negative contrast.* The great majority of your negatives should produce a fully detailed image when printed "straight" on your normal paper. If the range of the negative is beyond the tonal range of the paper and you must often turn to corrective burning and dodging, or to a soft paper that pins you at one end of your scale of choices, then your negatives are too contrasty and are being overdeveloped. Experiment with an initial reduction in film developing time of twenty percent. Then fine-tune your developing time until the majority of your negatives give a good unmanipulated print on your normal

The face is too dark on the right side

Dodging lightens the dark area for better visibility

paper. On the other hand, if you find yourself turning too often to a hard paper with its hair-trigger response to print exposure, its extreme sensitivity to burning and dodging, and its tendency to dramatize every scratch and dust mark on the negative, then you are underdeveloping. Try an initial increase of twenty-five percent in negative development. Remember that the manufacturer's recommended times are just recommendations. There are so many variables in a photographic system and in photographers' tastes that no manufacturer claims to do more than recommend a developing time that is a starting point for your experimentation.

The same goes for film exposure. If you aren't getting enough shadow detail in your negatives to produce a straight print that satisfies you, you are underexposing, and will have to set your meter at a lower film-speed rating. If this is an extreme change from the setting you have been using, it may increase the density of your negative enough to require a reduction in developing time. But if your exposures are so generous that you are consistently converting significant negative detail into blank white areas in your final prints, then you are overexposing. If a reduction in film exposure still gives you all the tones you want, you will enjoy the added benefits of finer grain and greater sharpness from the thinner negatives. The personalizing of exposure and development (sometimes it is unconscious,—"I give a little more exposure than the meter says, just to make sure") is what separates the "old pro" from the beginner. You have to print a great many pictures before you can identify a good negative.

This is so important, let's repeat it. *Film exposure controls shadow detail. Decreasing development decreases negative contrast; increasing negative development increases negative contrast.* Control these values until the great majority of your negatives are "good"—negatives that give a good straight print on your normal paper.

Top left:
The glaring countertop, mirror and wall need extra exposure through a hole in a large piece of cardboard or cupped hands. Extra light must not spill on properly-exposed portions of image

Bottom left:
Burning in "prints down" the glare to balance the print and shift attention from the place to the person

Print finishing

If a stack of unfinished prints reflected only on you, that would be your business. But we find that our subjects are dismissed along with our prints when those prints are blemished and dog-eared.

Spotting. Try as we may, we can seldom remove all the dust and physical blemishes from a negative. Under the high magnifications used in 35mm enlarging, the tiniest of these will show up on the print surface as white spots. Occasional hairline scratches show up as thin white lines. These imperfections are not merely distracting; they can convert a rich, full-dimensioned print into a piece of flat photo paper. Spotting dyes, such as Spotone, can be used to match the tone of the white spot to the gray of the surrounding photograph. Dyes have the advantage of producing little change in the reflectivity of the paper surface, but it may take several applications of full-strength dye to achieve a deep black. Some workers allow a little dye to dry on a non-porous surface such as glass, pick up this "concentrate" on the tip of a damp brush, and use it to darken spots surrounded by black. This is best done with small spots, as the thickened dye may produce a matte surface on an unferrotyped glossy print. Indeed, any large spot presents a problem because even normally applied dye may, in time, change color. Simply matching densities will camouflage a small spot, and minor variations in surface and color go undetected. Not so with larger spots; you may do better to reprint. It is possible to use relatively stable and permanent pigments to spot large areas, but these dry with a different surface than the lustrous print, so that both print and spotting have to be resurfaced with a lacquer or spray.

Whether applying dye or pigment, a damp, almost dry brush is easier to use than a very wet one. Repeated touches of the brush tip to build up a tone is a more controllable technique than attempting a match with one pass of the brush.

Mounting a print serves two purposes: (1) to protect it from the rigors of handling and exhibition; (2) to enhance it esthetically by providing a complementary background for the picture.

Many common adhesives contain chemical compounds that are bad for print permanence. Dry mounting is the safest, easiest, and most effective method of mounting prints. A sandwich of print, dry mount tissue, and mount board are briefly placed in

a press under heat and pressure. Adhesive in the tissue melts, bonding the print to the board. (In theory you can do this with a flatiron, but I have seen too many prints ruined and too many mounts undone with the first change in humidity to recommend this technique.) The press is also useful to flatten unmounted prints. My press enabled me to use my clothespin dryer effectively, saving me the price of an electric dryer until my photography was more than paying for itself.

Since the mount board becomes an inseparable part of the print, choose it with care. The laminations of cheap board may separate after relatively little handling or time, and the board may discolor. Anything less than such acid-free rag boards as Bainbridge Museum Board or Strathmore Drawing Board may contain compounds deleterious to print permanence. Lately, I have been mounting my prints on the finest paper available—photo paper. Properly fixed, archivally-washed photographic printing paper can be mounted back-to-back with a print. Not only does it offer top quality, but its curl exactly counters that of the print, so the mount is thin but flat. For this kind of counter-mounting, I print well within the dimensions of a given paper size. For example, the wide borders around an 8x10 print centered on 11x14 paper serve as a friendly background for the picture.

Whatever mount board you use, remember that it will form the background for your photograph. Fancy colors and textures are distracting. So are pretentious positions on the mount—a picture rammed into one corner or barely visible at the bottom edge of a giant mount. Your own taste will guide you through the many choices if you remember that *the function of the mount is to complement the picture,* not to call attention to itself.

A final note. These are the basic procedures, from film to the mounted print. In time, you will pick up many other darkroom techniques. But do not be impatient. Remember that none of the refinements are worth much unless they are supported by a mastery of the basics.

Good luck in your photography; that includes developing and printing as well as seeing and shooting. When you do them all, you can coordinate them for maximum control and the strongest, most beautiful and pertinent pictures.

Available-Light Photography

Bill Pierce

The secret of available-light photography—shooting when your exposure meter tells you to give up— is not a special developer, a super-film, or an exotic lens. It is a way of seeing.

We have all underexposed a picture by accident and then saved it in the darkroom by printing the thin negative on a contrastier-than-normal paper. As explained in the chapter on developing and printing, the degree of film development controls the contrast of the negative. All other things being equal, the more development, the contrastier the negative. It is perfectly possible to *under-expose film intentionally,* by setting our meter at a higher than-normal "effective index," boost contrast by extending the development, and produce an under-exposed negative that will print on normal paper. This is called "push processing." The visual result is not greatly different from the accidental underexposure that was printed on contrasty paper. There is less-than-normal shadow detail, bright highlights tend to block up, and graininess and contrast are increased. But if you learn to work within these limitations by previsualizing the results, you can make **effective pictures under difficult conditions.**

Accept the fact that your "pushed" pictures will have less shadow detail than normal, and much less than you can see with your eye. If a subjects's face is in shadow, wait until he turns toward the light before you shoot. Accept the fact that the increased contrast will make skin textures more pronounced. Use this effect to make dramatic character studies, rather than flattering portraits of vain women who wish to look younger. In other words, take enough pictures using this technique so that you can predict the results and not be defeated by them. This isn't difficult; you are already doing it to a lesser degree. Even normally processed film doesn't "see" the same way you do. It can't encompass the great range of brightness that the eye can easily discern. When you take a picture of somebody standing in front of a window, you no longer expect to capture full detail in both the backlit face and the sunlit outdoors. You impose on your vision the limitations of the camera and the film; you work within them; you begin to see like a camera. In many cases, this is a completely unconscious habit, one that has been acquired as you took more pictures. With experience you will be able to throw a new switch in your brain as easily as you can set a new film speed on your meter. As the

exposure index on the meter moves from 400 to 1200, your eyes will narrow, detail will drop out of the shadows, textures will be emphasized, and you will begin to see like a piece of pushed film.

How much push do you need? I'm not sure that merely doubling your film speed accomplishes anything, This is only the equivalent of speeding up your shutter-speed dial one notch. What can be shot at 1/60 second can usually be shot at 1/30, and what can be shot at 1/30 second can usually be shot at 1/15. Indeed, in a situation where such an adjustment is critical—for example, when you're using a telephoto lens that you can hand-hold for 1/60, but can seldom hold steady enough at 1/30—if your normal techniques give you negatives with full shadow detail, there is no reason not to underexpose one stop and print that negative on contrasty paper. By keeping your film development normal, you will be able to return to the normal rating, with its higher technical quality, when the subject moves to brighter light or you change to a shorter lens. If you find that this entire roll has been underexposed by one stop, you might want to set it aside to receive a slightly increased development. There are so many variables in metering, processing, printing, and personal taste, that it is impossible to say how much you should increase your development to compensate for a one-stop underexposure, but don't be surprised if it is as little as fifteen percent. A safety factor is programmed into ASA film speed ratings. On many frames, you may have exposed within this factor.

I don't feel that I am accomplishing anything truly useful by push processing until I uprate my films by almost two stops. I use an ASA 400 film for most of my shooting, and push it to 1200. Don't ask me why I use this rating instead of the insignificantly different and more logical two-stop push of 1600. In most cases, it would make no difference. But as experience has fine-tuned my metering, that is the setting I have arrived at. Experience will also fine-tune your results. You will make minor adjustments in your meter setting until you arrive at a speed that gives you an acceptable compromise between shadow detail and film speed. You will make minor adjustments in your film developing times until the great majority of your negatives give a pleasing tonality when printed on your normal paper. But, for your first experiments, I suggest that you extend your film development by thirty to fifty percent for a two-stop push.

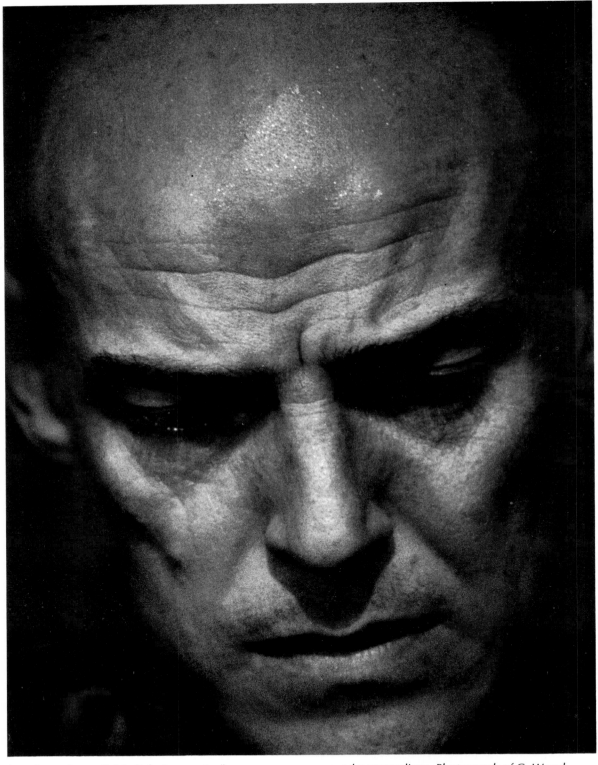

Low-intensity available light from a single source often requires development and printing that emphasize texture and underlying structure. Tight cropping adds drama, eliminates seriously under-exposed surroundings. Photograph of G. Wood copyright 1970 by Bill Pierce

Is it worthwhile to use a special developer to push-process film? If you don't do push processing, it is probably best to stick with extended developing times in your standard developer. Your intimate knowledge of its responses to a variety of processing conditions means more than the theoretical advantages of an occasionally-used developer that you have not mastered, and which may have deteriorated in long months of storage.

If, however, you do a great deal of push processing and can master a second developer, there are formulas that offer advantages. They provide a genuine increase in film speed when compared to standard metol-hydroquinone-borax developers like D-76 (although, technically, this is on the order of a fraction of a stop, rather than the two-stop increase you apply to the meter). Developing times are conveniently short, and the factors that affect graininess, definition, and tonality are balanced specifically for film exposed at elevated ratings. Some of the outstanding formulas are Acufine Incorporated's Acu-1, Acufine, and Diafine; Edwal FG7; Ethol UFG; Ilford Microphen; May and Baker Promicrol, and Paterson Acuspeed. Instructions that come with each developer suggest basic developing times to produce higher-than-normal effective film speeds.

I cannot emphasize enough the need for experience in successful available-light shooting. Once again, push-processed film has a different look—decreased shadow detail, highlights that block-up more quickly, and increased grain and contrast. Learn to compose your pictures so they do not depend on the information that is in the shadows. Use the higher contrast to create bold, graphic images that carry the information in the mid-tones and highlights.

As with any personalized darkroom procedure, it is wise to keep a notebook with suggestions on possible improvements. Typical entries might read, "Most negatives a little too contrasty; reduce development ten percent," or, "Can get away with even less shadow detail; try uprating film 2/3 stop." Within six months you will have evolved a system that allows you to successfully produce a certain type of photograph under conditions that many consider impossible.

You will also have learned when *not* to push. Harsh, contrasty scenes in which shadow detail is essential (many theater situations are like this) demand normal ratings for anything approaching a conventional interpretation. You will learn to resist the temptation to move to a higher and more convenient shutter speed or a smaller f-stop. You will learn other, less convenient, ways to shoot when your exposure meter tells you to give up.

Certainly the classic available-light technique is to use a slow shutter speed. Every camera club speaks in awe of a mythical figure, a past member, who could hand-hold longer and steadier exposures than any current mortal. Much of his success was probably due to the confidence this adoration gave him. It is impossible to squeeze off a successful slow-speed exposure if you are tense and worried. Like a good rifleman, exhale and relax. Steady yourself and your camera against any convenient support. Lean against walls or chair backs. Rest your elbows or the camera on the edge of a table. Both the Leica and the Leicaflex have gentle, smooth shutter releases that will help you trip the shutter without jarring the camera.

Oddly enough, your choice of lenses can help you hand-hold slow shutter speeds. Just as a wide-angle lens reduces the image size as compared to the image produced by a normal lens, it also reduces the visible effects of camera shake. A longer-than-normal lens, on the other hand, makes a camera movement more obvious. Other things being equal, you will probably be able to produce sharp wide-angle shots at a slower shutter speed than your normal-lens limit.

The tripod is the ultimate slow-speed aid. But when you depend on a large tripod, you sacrifice most of the convenience and flexibility of the small, hand-held camera. A few tripods are small enough to carry conveniently at the bottom of the gadget bag. I say "a few" because, while there are many small tripods on the market, most of them are really toys. Few are solid enough to hold a camera steady when it is equipped with a long lens and used without a cable release. If you go this route, be sure to buy a good small tripod; don't be surprised when it costs as much as a larger tripod.

Not a tripod in the conventional sense, but worth serious consideration, is the Leitz table-top tripod. Its legs are not adjustable; they are three pieces of cast metal that raise a tripod head and camera a scant four inches above the supporting surface. But they fold to a package that can fit in a jacket pocket, and are sturdy enough to support a large-view camera for

A tripod is a light stretcher—the longer exposures it makes possible let more light into the camera, and can save the shot when available light is dim

low-angle shots. I use the table-top tripod together with the Leitz ball-and-socket head. Set on a table or the floor, pressed against walls and lamp posts, even held against the ceiling, this emergency support has saved my neck more times than I care to remember. It is small enough to be conveniently packed or carried; I would not travel without it.

What about subject motion? I am constantly amazed at the way people hold still when something important is happening. An animated speaker pauses to emphasize a point, a playing child stops to stare at something that amazes him—and if a hand or some background element is blurred by movement, that only adds to the picture by showing the action that surrounds the moment. Indeed, I have become so fascinated by those things that are important enough to make the world stand still that I sometimes try to reverse the process, to create something important by telling everybody to hold still. Even when there is plenty of light, I will put a camera on a tripod and shoot portraits at one second. I am happy to report that something beautiful does happen to people when they hold still and aren't allowed to make their preconceived faces at the camera.

One factor that established the early miniature cameras as the champions of available light was the availability of high-speed lenses. This is still an im-

portant factor, but the high-speed lenses have retained their one disadvantage—no lens formulated for general picture taking is as good wide-open as it is when it is stopped down a little. To look at this phenomenon in a more positive way, all lenses are improved by a little stopping down. Nonetheless, there have been vast improvements in wide-open optical performance in the last decade. The newest 50mm f/1.4 Summilux delivers wide-open performance that is indistinguishable, in many cases, from its performance at f/2, and would present a serious challenge to early lenses at any large aperture. Still, high-speed lenses used at maximum aperture have personality traits that you should become familiar with. Sometimes there is no noticeable loss in performance except at the edges of the frame. In that case, simply keep the important subject near the center of the picture; after all, the foreground and background will be out of focus anyway. Some lenses show the greatest large-aperture loss of definition at close focusing distances. That's easy to avoid. Some lenses show a marked improvement when closed down only half a stop from wide open—hardly a serious loss of light. Others deliver an acceptable image under normal lighting conditions, but fall apart in high-flare situations. Come to grips with the wide-open performance of your lenses. Learn what they can do well and where they have problems. The only method I know to do this is to take a lot of pictures.

Some cameras are better than others for work by available light. The rangefinder camera will always surpass the single-lens reflex as an all-around available-light camera; Leitz makes one of each. For one thing, the viewing through a simple optical viewfinder will always be brighter and contrastier than a view that has passed through a lens and a viewing screen. The Leicaflex provides one of the brightest, most contrasty reflex viewing systems, but it cannot compete in this respect with the Leica. Since good seeing is a vital factor for good picture-taking, any advantage that a camera can provide in dim, low-contrast situations is important. Beyond this, the rangefinder consistently provides more accurate focusing than the reflex system with wide-angle and normal lenses used at high apertures that allow for little or no focusing error. The reasons are complex, but it is a no-contest situation: these normal and near-normal lenses are the workhorses of available-

light photography. In these focal lengths, we find both the fastest lenses and the lenses that permit us to shoot most safely at relatively slow shutter speeds.

Today's high-speed films deliver incredibly good quality together with speed that lets us shoot in previously impossible conditions. By the time this book is dog-eared and worn, films of even higher speed may deliver the same quality. But at any stage of the art there are always specialized films that are faster than the standard high-speed films, but offer lower image quality. At this writing, the king is a recording-and-surveillance film called Kodak 2485 Recording Pan. It has two slightly slower brothers—2475 and 2484. Kodak 2485 has a higher-than-normal red sensitivity that is useful in tungsten light, and a tough emulsion and Estar base that allow processing at high temperatures. This is an advantage when the developing times (with conventional developers) at the usual 68° or 70°F become very long. Processed in Kodak 857, it can be exposed at an effective index of 8,000.

When exposed at indexes of about 3,200, and given reduced time in 857—or processed in a standard high-speed formula, such as Acufine or UFG—it may deliver the tonality we normally associate with conventionally exposed and processed film. You will have to experiment. Even at the conservative 3,200 rating, its graininess is high and its definition is low, but the results are superior to those of film rated at 8,000, and are pictorially usable.

The 2485 film is available only in bulk rolls, but the slower Kodak Recording Film 2475 is available in factory-packed cassettes. When exposed at a rating of 1,600, the results remind me of those obtained with the first special-order rolls of a long-ago new film, then rated at the unprecedented speed of ASA 200; a few months later that film was introduced to the public as Kodak Tri-X. Moral: keep alert to new developments, and explore them.

Much of what used to be classified as available-light photography is now just plain photography. It used to be exceptional to take a picture indoors without flash. Today, using conventional ASA 400 film, we can take pictures indoors at moderate exposure settings in the neighborhood of 1/60 second at f/2.8. The film is processed and printed normally to yield high-quality enlargements. It follows that when we combine push processing with high-speed lenses and slow shutter speeds, we can photograph anything we can see. In recent weeks, I have photographed a night-time vigil outside a prison lit only by a few distant floodlights; a friend who was sharing dinner with me in one of those "intimate" restaurants that puts dark shades over its already-dim lights; and a night-time picnic illuminated only by one candle. I never doubted for a second that the pictures would come out. In the many situations that are better lit than these, you don't have to combine all the techniques, but can use the one that best suits your subject. In most cases, my own choice is to push-process. That way, I can use shutter speeds and f-stops that need less attention to the equipment and leave me free to concentrate on the subject. Push processing also enables me to use a greater range of lenses, including slow extreme-wide-angle lenses, and relatively slow long lenses that demand high shutter speeds for hand-held work. I am constantly amazed at how little quality is lost when today's films are pushed. The main losses are in the tonal scale. By previsualizing the loss in shadow detail and in the smooth, continuous transition of subtle tones that normally-processed film affords, a good photographer can produce images of a technical quality that is often superior to images made in a conventional manner by a photographer who has never taken the time to master his craft. When the subtle translation of a long scale of tones is necessary to the picture, normal processing, combined with slow shutter speeds and fast lenses, can produce pictures that rival larger-format work which can only be done in brighter light.

Some photographers are happy only when they are making problems for themselves. Available-light work has become so easy for us all that they can no longer amaze us with their gloomy black-and-whites. They have turned to shooting available-light pictures in color. The problems are greater here. The films are slower and the faster ones among them have far lower technical quality than their black-and-white counterparts. But, even here, the problems are not monumental.

The most important key to available-light color shooting is high-speed color film. Currently available are GAF T/100, with a speed of ASA 100 under tungsten light; GAF 200 and 500, with daylight ratings of ASA 200 and ASA 500 respectively; High Speed Ektachrome—Type B, with a tungsten rating of ASA 125, and High Speed Ektachrome—Daylight Type, at

Natural pauses in action make sharp pictures possible even at slow speeds; here, ⅛ sec. at f/2.8 with tripod-mounted Leica M3.
Photograph of Julian Bond copyright 1970 by Bill Pierce

ASA 160. All of these reversal films can be push-processed to higher ratings by the home processor or the custom lab. Eastman Kodak offers a 1-2/3-stop push service for their Ektachromes at a fee slightly higher than the normal manufacturer's processing price.

High-speed color-transparency films have less latitude than slow color films, and much less latitude than black-and-white films. When the film is push processed, that latitude is decreased further. Meter carefully and don't be surprised if experience and your metering techniques dictate that you set your meter at an exposure index different from the manufacturer's recommendation for the highest possible yield. More important, bracket. Take one exposure that matches the meter's suggestion, then take one

exposure opened up a stop, and one closed down a stop from the "normal" exposure. Not only will this guarantee an acceptable exposure, it may also provide an exciting, "non-standard" interpretation of the subject. It will certainly provide a constant education in metering techniques that will serve you well on those rare occasions when there isn't time to bracket. High-contrast scenes "eat up" more of the film's latitude than low-contrast ones, however, so it is particularly important to bracket when shooting them, even when you don't think you have time.

The color quality of light often falls outside those neat categories, "Daylight" and "Tungsten," that are printed on the film box. Neon lights, fluorescents, special-purpose tungsten lamps, vapor lamps, and normal lamps "bouncing" off colored surfaces provide enough wild color to satisfy the most experimental color photographer and make him throw away his trick filters. In most cases, people will accept unusual color renditions, expecially of unfamiliar scenes. But familiar colors, especially flesh

General light on audience was less intense than spot-
light on speaker, but a long exposure built up the
image as if more light were available; ½ sec. at f/1.4,
tripod.
Photograph copyright 1970 by Bill Pierce

tones, can present a problem. People just don't like other people who are blue, green or cyan, unless they are portraying a ghoul friend or corpse. They don't seem to mind if the flesh tones are a little warmer in color than normal. That distortion can be interpreted as a healthy, ruddy glow. In other words, any error is acceptable, as long as it's on the warm side; people demand the option of looking at the world through rose-colored glasses. To that end, I have several warming filters that I can let my camera look through. They are magentas and reds up to CC30 in strength, and an FLD fluorescent-correction filter for daylight film. Both the FLD and the CC30 magenta are used under fluorescent lights, which tend to turn people green in unfiltered color pictures. Instinct guides me in choosing between them;

when that deserts me, I use both—one at a time. These filters can overcorrect. As we pointed out, no one objects to the additional warmth in people, but don't show your subject next to an easily-recognized neutral-colored object that will be the first to show a color cast. I have a lovely picture of a young lady, taken under fluorescents, that is less convincing than it might be because she is standing next to a refrigerator that was turned from white to brilliant orange by the filter.

The other filters, the reds and the weaker magentas, are used in "people pictures" when I am not sure about the color quality of the light—anything from the lights in a sports arena to open shade on a porch surrounded by green foliage.

Our eyes can adapt to light of various color qualities, but color film cannot. Daylight film will record tungsten illumination as excessively yellow; tungsten film will record daylight as excessively blue; so light that is a mixture of two sources—for example, light falling on a face from both a tungsten desk lamp and

Direct light sources make the contrast range extreme in many available light situations. The solution is to expose fully for the general intensity, reduce development to keep the light source printable. Photograph copyright 1970 by Bill Pierce

a window—can drive the film up the wall. You must decide for yourself which film is likely to provide the most pleasing result. My experience indicates that daylight film seems to be the right choice for the majority of scenes, especially where people are involved. Once again, it's the old ruddy-glow rule-of-thumb. A little daylight creeping through a window can produce a disturbing blue imbalance on a face in a room lit primarily with tungsten lamps and photographed on tungsten film. A little tungsten can

Struggling with bright highlight-deep shadow situations makes us foget that a soft, general illumination is the most common available light. Sesame Street television characters, Gordon (Matt Robinson) and Muppet, Betty Lou
Photograph copyright 1970 by Bill Pierce

create as great an imbalance in a daylight situation, but this is not disturbing; it is a pleasant, warming glow.

Obviously, the high-speed-lens and slow-shutter-speed techniques that help us in black-and-white are equally important to the photographer shooting color film in dim-light situations. But the demands that high-speed color films make on high-speed lenses are somewhat different in color photography than in black-and-white. At present, high-speed color films are relatively grainy and low in definition, and more so when they are pushed. Optical resolving power means nothing to a film that can't record it. Lenses for color work should be of high optical contrast, and provide the clearest possible tonal distinctions in the details that the film can resolve. The lens should be free from flare that degrades the blacks of the film (already degraded by push processing), lowers tonal separation in the shadows, and diminishes color separation and saturation. When you are studying the personality of your high-speed

lenses, these are the factors to consider for color photography. Again, I know of no better way to deal with the problem than to learn by experience. You will be pleased to note that recent Leitz lenses are excellent in these departments.

One bright piece of news. Reversal films—and all the fastest color films are reversal films—have most of their latitude on the underexposure side; so when your exposure meter says "no," it really means "maybe." Overexposure ruins a slide by converting it to unredeemable clear cellulose acetate. A dark slide may present an interesting image as is, with rich highlight detail and strong colors. You can often save it by corrective duping, by bleaching, or by just moving the slide projector closer to the wall. If it is destined for reproduction, the engraver can make it lighter. Indeed, corrective duping on a conventional shooting film (high in contrast by duping-film standards) is much like printing a thin negative on No. 5 or No. 6 paper, and can compensate for as much as a two-stop underexposure; but a two-stop color overexposure is unredeemable once it has been returned from the processors.

Gene Smith says that available-light shooting is nothing more than working with any light that is available. In his midwife essay, he used kerosene lanterns: he had "flood" lanterns, "spot" lanterns, and "fill" lanterns. With that in mind, let me remind you that you can always turn on all the lights in the room, ask the subject to stand closer to the window, put photoflood bulbs into the existing fixtures, or, if worse comes to worst, use a flash. Don't create problems for yourself when it's more fun to take pictures.

Artificial Light

Bill Pierce

You must have light to take a picture, even with a Leica. When you run out of natural light and must provide your own, you often want a light that is as compact and easy to use as your camera—an "emergency" light you can pull from the bottom of your gadget bag.

Flash photography

Self-contained, battery-operated flashguns that slip into the accessory shoe on the camera offer compactness and freedom from external power sources. They use expendable one-shot flashbulbs or "fire" an electronic flashtube that is good for many thousands of shots. Both have advantages.

The flashbulb unit produces more light than an electronic flash unit of comparable size, and doesn't need the maintenance required by the rechargeable batteries and condensers of the electronic flash.

The advantages of electronic flash are simple: you don't have to buy, carry, and change bulbs. This is more than a long-term economy. It is almost imperative when using the flash at the end of a long extension or in combination with another unit. If you must run around changing bulbs for every shot, you may not have enough time left to take good pictures. A secondary advantage is the short duration of the electronic flash, which can "freeze" action when there is not enough existing light to produce an image while the shutter is open.

If your flash unit is mainly an emergency light, the relatively maintenance-free, compact flashbulb unit is a logical choice. If your unit is to be more than that, electronic flash is the answer.

Synchronization

With flash, we must synchronize the pulse of light with the time the camera shutter is open. In modern cameras, this is done by a switch built into the shutter mechanism.

At high shutter speeds, Leica and Leicaflex focal-plane shutters do not expose the entire picture area simultaneously. A moving slit travels across the film, exposing one edge of the frame to light 1/50 of a second before the other in the Leica and 1/100 of a second in the Leicaflex. If a flashbulb is to be used at higher speeds, it must have long enough duration to provide relatively constant illumination while the shutter slit is traveling, or one side of the picture will be darker than the other. Flashbulbs designated FP

(focal plane) provide long flash duration for even exposure at all shutter speeds. Unfortunately, FP bulbs are less compact than the flashcube, and AG (all-glass), and miniature M2 and M3 flashbulbs.

All of these bulbs and cubes may be synchronized at slow shutter speeds up to 1/30 second by connecting the flash unit to the synchronization contact marked with a lightning-bolt symbol. If you are willing to accept somewhat uneven illumination,

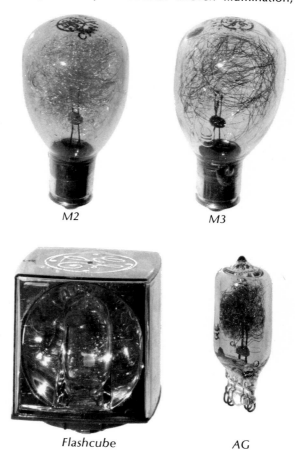

M2

M3

Flashcube

AG

these compact bulbs can also be used at higher speeds; with the M Leica, we have achieved pictorially acceptable results when flashcubes and AG bulbs were synchronized at speeds from 1/125 to 1/500 second. At these higher speeds, the flash unit is connected to the sync contact marked with a pictograph of a flashbulb. The Leicaflex, with its faster-

Flash on the camera gives flat frontal light, but frees photographer to shoot and move rapidly. Using proper f-stop for subject distance ensures proper exposure.
Photograph of Fr. Phillip Berrigan entering prison with Federal marshals copyright 1972 by Bill Pierce, courtesy TIME magazine

moving shutter, permits the use of these bulbs at all speeds, and provides quite even illumination. Of the miniature bulbs, the M3 has the longest flash duration, and can be used at all speeds with both M Leicas and Leicaflexes.

Electronic flash, with its brief duration—approximately 1/1000 second—cannot be synchronized at higher speeds than 1/50 second with the M Leicas, and 1/100 second with the Leicaflex (the highest speeds that expose the entire frame of film simultaneously).

The easiest way to use a flash unit is to mount it in the accessory shoe of the camera and fire away. True, the lighting is not at all like the light in which we

normally see our subject, but it does let us see them. With a minimum of fuss, we can capture an important moment. Those who sneer at this kind of photography should consider the happiness they get from a family snapshot album, and the information they get from their daily newspapers.

Guide numbers

The greater the distance between the light source and the subject, the less bright the light on the subject, and the larger the aperture required for proper exposure. The distance and the correct aperture are proportional: distance in feet multiplied by f-number for any specific flash-and-film combination produces a constant called the *guide number*. To find the right aperture for flash-on-the-camera work, simply divide the guide number by the flash-to-subject distance. For example, if the guide number is 110 and you are ten feet from the subject, the aperture to use is f/11. If you are five feet away, use f/22; at twenty feet, the aperture is f/5.5 (for practical pur-

poses, use f/5.6). Manufacturers of film, flashbulbs, and electronic flash units provide guide numbers on their instruction sheets. Some flashguns have calculator dials that perform the division for you. My own short cut is to write several distance-and-f-stop combinations on an adhesive label and stick it to the back of my camera.

Guide numbers, like much other information furnished by manufacturers, are initial recommendations. If your flash pictures are consistently underexposed (dark transparencies or thin negatives), use a lower guide number; if they are overexposed (washed-out transparencies, over-dense negatives), use a higher guide number. If the subject is unusually dark, or is in an open space that will not reflect additional light back onto the subject, open the lens one stop. If the subject is unusually light, or in a small, light-colored room that will reflect a great deal of additional light onto the subject, close down a stop.

If exposure calculations baffle you, or if you don't want to bother with them, you have two alternatives:

(1) A number of "automatic" electronic flash units are now available, with built-in photo-sensors that "read" the subject and "squelch" the flash when it has provided enough light for a predetermined f-stop.

(2) Flash meters, once rare and expensive, are now available with a variety of price tags and degrees of sophistication. Used in much the same way as conventional light meters, they respond to a pulse of light and hold their readings.

Single-flash lighting

Flash-on-the-camera is simple and effective, but its arbitrary and unnatural-looking lighting limits its uses. A number of alternative techniques will produce more natural effects with a single small unit. One of the simplest is to move the flash from its position on top of the camera. Many flash units have sync cords that can be unplugged and replaced with a longer cord. (Leitz supplies flash connecting cables in seven different lengths, from six inches to fifteen feet.) If your unit is going to be more than an "emergency light," the replaceable cord is a feature to look for. A two- to three-foot coil cord is compact enough to prevent fouling when the flash unit is used on the camera, but will stretch enough to let you hold the flash above and to one side of the sub-

Coiled cords to camera and power pack allow using flash off the camera to adjust direction of light

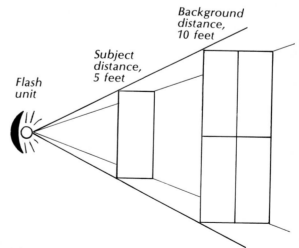

Why close objects receive more light than more distant ones: at twice the distance, the light spreads over four times as large an area: the inverse square law in action

Photograph of folk singer Major Wiley and friend used single flash unit well off to camera left. Photograph copyright 1970 by Bill Pierce

ject, producing modeling and shadows that may make the picture more interesting.

The same inverse square law that governs the speed of lenses affects the light from flash units and other small sources. *The intensity of the light is inversely proportional to the square of the lamp-to-subject distance.* In other words, if the subject is halfway between the light and the background, it will receive four times as much light as the background. That is why flash shots so often have burned-out white foregrounds and black, underexposed backgrounds. The farther the flash from the subject, the less the difference between flash-to-subject distance and flash-to-background distance. The light is more nearly uniform, and the picture looks more natural. Therefore, if you can shoot your flash pictures from relatively far away with a long lens, like the 90mm or the 135mm, and, at the same time, improve the modeling by holding your flash at arm's length, you can produce a very natural-seeming flash shot.

Another way to keep the flash at a distance is to use a ten- or fifteen-foot cord or extension instead of a coil cord. Place the flash at a considerable distance from the main subject. Now you are free to use

whatever lens and camera position will produce the best picture. You don't have to buy a light stand; a friend can hold the light in the proper position, or clamp accessories are available that let you fix the light to a doorjamb, bookcase, or what-have-you.

Single flash from any angle will still produce a picture with dark shadows, so be careful to shoot when the subject is facing the light, or at least when no pictorially important details will be lost in the shadows. Sometimes it is easy to previsualize the effect of the flash if you place the unit next to an existing incandescent lamp. Essentially, you are boosting the existing light, which is enough to see by, but not bright enough to produce a reasonable exposure. This is a common situation with the slower color films and the slowest black-and-white ones.

Bare-bulb flash

One way to "open up" dark shadows is to use bare-bulb flash. If you can conveniently remove the reflector from your flash unit (or fold it up, if it is a folding-fan reflector), the subject will be lit both by direct light and by light bounced from the surroundings. In a room with light walls that afford much reflected fill-light, the lighting from bare-bulb flash will approach natural light in appearance. Normally we can determine flash-off-the-camera exposure in the same way we determine it when the flash is on the camera—by guide number or by flash meter; but

Flash in reflector produces hard shadows, crisp highlights and details

Bare-bulb flash is a soft and general light. Reflections from surroundings fill shadows and lower contrast

bare-bulb exposure depends largely on the reflective power of the surroundings, so it is impossible to come up with a guide number that will give accurate exposure under all conditions. A rule of thumb for "average" rooms is to use two stops more exposure than the flash unit requires with its reflector. Dark-walled rooms and areas that have no reflecting surfaces convert the bare-bulb unit to nothing more than a wide-angle flash unit, and will require you to open up at least one stop more. Small, white-walled rooms let you close down a stop (that is, you give only one stop more exposure than you would with the reflector on the flash). Experience and the latitude inherent in modern negative films can ensure decent results without bracketing; but users of critical color-reversal films would do well to bracket their exposures or rely on a flash meter. Bare-bulb light is a blend of direct light and light reflected from the surroundings.

Bounce flash
An even more natural effect is achieved by using bounce light alone. The flash unit, with its reflector, is pointed at the ceiling or a wall. The only light that reaches the subject is the soft, diffused light reflected from the surface. It resembles the soft light we see

outdoors on an overcast day, or when a person stands near a window indoors. In effect, the broad expanse of ceiling or wall that we illuminate becomes the light source. The light is soft, wraps around the subject, and moves gently from highlight to shadow, but it is directional. If you light the ceiling directly above the subject's head, his eye sockets will be sunk in deep shadow. If you bounce from a wall to one side of your subject, you will produce the strong sidelight that is popular with fashion photographers. This is a created "natural" effect that you can control. If you slip the flash unit from the accessory shoe and use your left hand to point the unit above and behind you, the resulting pictures will have lighting similar to that produced by soft, overhead office fluorescent lights. By attaching a long sync cord or extension to your flash unit and using your judgment in placing the light, you can create lighting that ranges from a variety of conventional studio-portrait effects to dramatic, shadow-filled scenes.

The intensity of the light that falls on the subject depends largely on the surface from which the light bounces. If it is a light-colored surface, you can divide the distance from the light to the wall plus the distance from the wall to the subject into your con-

Flash bounced from ceiling and walls behind camera produces soft, natural illumination

Bounce flash from ceiling emphasizes tops of heads and shoulders, creates eye, nose, and chin shadows

Strong sidelight is created by bouncing flash from wall at right of subject. Photograph of Israeli actor Amnon Meskin

ventional guide number, then open up two stops more than this calculation indicates. The relatively low-contrast light puts little strain on the film's exposure latitude, and the broad reflecting surface against which the light is bounced provides a more uniform light from foreground to background than a small point-like source. An experienced "bouncer" develops a feel for various types of rooms. His experienced guess is often more accurate than a calculation based on guide numbers. "This is an f/4 room; f/2.8 for the far corner, and f/5.6 for anyone standing close to me." Short of a flash meter, normally the preferred technique, your own experience, when you have acquired some, is probably the best bounce-flash exposure guide. Bounce-light is such a valuable technique that we owe it to ourselves to get that experience.

If you are going to use bounce-light with color film, make sure that the light is bounced from a white or neutral-colored wall: if you bounce it from a colored wall, the light and the subject will pick up that color.

Bounce techniques use up a lot of light. Even with fast black-and-white films, it is common to use apertures on the order of f/4 with small, self-contained electronic flash units. Far from being a disadvantage, this allows the film to pick up some of the existing light, so that the light fixtures in the picture won't have that dead, overpowered look. Existing light can fill shadows or add interesting highlights to the flash exposure.

Flash fill

In some situations, the existing light can overpower the bounced-flash exposure. In such a case, why use flash at all? Because natural light is sometimes ugly and inappropriate. Our eyes have a technical advantage over film: we can see detail in bright highlights and in dark shadows that the film cannot record. Is it a requirement of honest photography to let important visible detail fall off into unprintable shadows on the film? Are beautiful people less beautiful because we freeze their images in that unfortunate fraction of a second when they pass under a harsh overhead light? Some of the finest "natural light" photography is done by placing a bounce light in a far corner to fill and soften the hard shadows cast by existing light. Some photographers do it by bouncing flash off their shirt fronts.

Direct sun is a high-contrast light which creates deep shadows

Flash lightens shadows, brings contrast into printable range

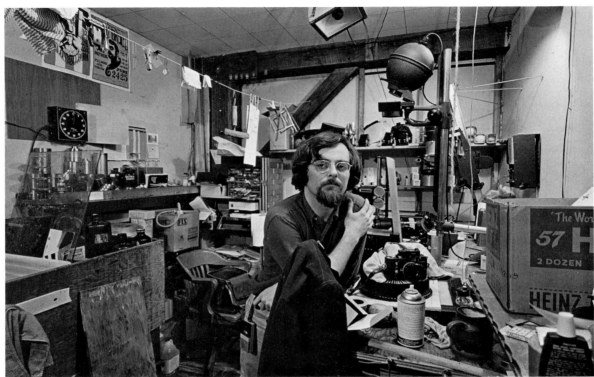

Self-portrait: the author in his darkroom. Flash off camera, at left, fills shadows from overhead sources, bounces from wall to raise overall illumination level

Even direct flash can be used to fill shadows if the existing light is strong enough. One of the harshest natural light sources is fortunately also one of the strongest—direct sunlight. An outdoor flash lets the subject face away from the sunlight that makes him squint, and lightens the deep shadows that would normally result. It does not eliminate them: that would destroy the sunlit effect. Sunlight is relatively constant the world over, once it is more than thirty degrees above the horizon. Any given flash has a constant output. Since we are dealing with two constants, we can establish a fixed ratio between sunlight and fill light by keeping the flash unit at a fixed distance from the subject. That distance can be used for all fill-in flash work with that unit in sunlight, regardless of what film is used. Since the effective output of a flash bulb is affected by shutter speed, one shutter speed should be used for all flash-fill

work in sunlight. Top speeds for electronic flash with the Leica M series and the Leicaflex are 1/50 and 1/100 second, respectively, so these are the speeds to use for electronic-flash fill light. Personal taste is the criterion for the best ratio of fill light to sunlight. Experiment to find the ratio you like best.

With the camera set for the appropriate exposure in bright sunlight, and a flashcube for fill light, the correct distance will be between two and eight feet, regardless of shutter speed. Closer than that, even the sunlight let in at 1/30 second will be overpowered by the flash; farther away than that, the flash does not fill in the shadows effectively. The entire test can be done with half a dozen frames of film. Even the brightest of the small blue flashbulbs will only shift the possible range four to five feet farther from the subject. Any self-contained electronic flash unit I have run across can be tested by taking pictures at distances between two and eleven feet. Regardless of the equipment you choose, this test is quick and simple.

You can also use direct flash to fill in the shadows

of interior shots, though the long exposures required to balance the existing light with the flash may make this technique unsuitable for photographing moving objects. The method is simple. Suppose you are photographing in a factory and want to make sure that a machine in the foreground is not obscured by shadows. Calculate the f-stop that the machine would require with flash exposure alone. If you are using a flashbulb, assume a shutter speed of 1/30 second or longer. If your guide-number calculation tells you that the proper f-stop is f/11, then read the existing light with a conventional light meter and find the shutter speed that would also require f/11. Say, for example, that the indicated exposure is one second at f/11. Then you use one second at f/16, with flash, to take the picture. (Half the light will come from the flash, and half from the existing light; since the correct stop for either light source alone is f/11, the correct stop for both together is f/16.)

Open flash

Believe it or not, you can make the single flash unit you keep in your gadget bag produce pictures that most photographers will assume were made with many lights and an elaborate setup. Long ago, before cameras had built-in synchronization, all flash pictures were taken with *open flash:* the shutter was opened, the bulb or flash powder was fired, and then the shutter was closed. We can use this technique to make one flash unit do the work of many. By keeping the shutter open, with the camera on a tripod, we can fire the unit once, walk to where the next light is needed, fire the unit again, and repeat the procedure until we have created the effect we want. Of course, we must do this when the existing light level is dim enough not to record on the film during the long period while the shutter is open. But, using this technique, we can "paint" an entire building with light for an exciting night-time architectural shot, do the same with a large interior, or work in a darkened studio to create still-life lighting that would normally require far more elaborate equipment.

Larger electronic flash units

Eventually, you may become so fascinated by lighting that you will want to move beyond the limitations of your "emergency light." Larger electronic flash units afford other advantages besides greater light output. Bigger battery packs, worn over the shoulder on a strap, allow for more flashes, and can permit more rapid recycling. Often they have more than one outlet and can accept several lamp heads for multiple-light work. (Separate flash units can also be fired synchronously with "slave-tube" photo cells.) The same is true of electronic flash units that use AC or "household" current instead of batteries. One great advantage of some AC units is a pilot or modeling lamp, an incandescent lamp, built into the lamphouse, that lets you see in advance the effect that the flash will have.

Incandescent light

Whether the lamp is photoflood or quartz, it is too big to keep in the bottom of your gadget bag, and you will always need an electrical outlet to use it. But incandescent light has one great advantage: you can see it. Since seeing is the name of the photographic game, anybody who is seriously interested in lighting will do well to begin with visible light.

To really understand flash-off-the-camera, bare-bulb and bounce-light, it is a good idea to backtrack and create these same effects with incandescent light. Indeed, each of these techniques is as valid with continuous light as it is with flash. It is possible to visualize the effect of a single light without actually seeing it, but only the most experienced photographers can previsualize the effect of multiple light sources. For complex lighting, it is almost imperative to start by using incandescent lights.

The main light

The success of most multiple-light setups depends on your skill in using the *main light.* The main, or key light is the primary source of illumination for the picture. It creates the shadows and the basic modeling in the scene. Other important lights are the *fill light,* which lightens the shadows and reduces the contrast of the overall scene; and *effect lights,* which create a sense of spatial separation in the two-dimensional photograph by lighting the background, or by rimming the subject with light. Outdoors, the sun is the main light, and diffuse light from the dome of the sky is the fill light. Effect lights are rare in nature, but anyone who watches old movies on television is familiar with such lights. When the gangster lights his cigarette, the match is

"Hard" light brings out texture, detail. Photograph of Fr. Daniel Berrigan 1972 by Bill Pierce, courtesy TIME magazine

the main light and the street lamp is the effect light. That bright halo of backlight around every ingenue's head is a somewhat overdone effect light.

There are two basic types of main light—hard and soft. The *hard light* is small in size; the *soft light* is large. Any small light source, like that tiny dot in our sky, the sun, produces sharp-edged shadows and small, contained specular highlights on most surfaces. Any large light source, such as a skylight or a large, nearby window, "wraps around" the subject to some extent, providing a smoothly gradual transition between shadow and highlight—a soft shadow edge. Specular highlights on most surfaces are broad and diffuse.

Hard lights, with their crisp highlights and shadows, render textures distinctly. If you want to show the dimples in a golf ball, use a hard light. Soft lights minimize texture; they are often used to de-

emphasize skin texture in portraiture. The small light source in a hard light facilitates efficient reflector design. With a good reflector, a hard light can deliver more usable light to the subject than a soft light of equal wattage. The small source allows the light to be controlled in other ways. A stage spotlight and a small floodlight are both hard lights. Because they are small sources, they produce sharp-edged shadows. A self-contained reflector flood (such as a *PAR* lamp) may cover a large area, but it casts a distinct shadow. Such a light can use *barn doors* (baffles hinged to the light) to limit its coverage. The lens in a stage spotlight can focus the small source on a small area, producing an intense spot of light.

The large, diffuse soft light is inherently inefficient and relatively uncontrollable. The soft-light used in the movie industry is simply a large, white reflecting surface in an open sheet-metal box, lit by bulbs concealed behind panels at the top and bottom of the

"Soft" light is as contrasty as "hard" light: note the black shadows. Photo copyright 1970 by Bill Pierce

box. No direct light reaches the subject. The light spreads over a large area, and cannot be barn-doored or focused effectively. The studio still photographer can achieve the same lighting effect by shining his hard light through large panels of diffusing material, or by bouncing a light from a large piece of white cardboard. One sophisticated approach is to bounce the light from the inside surface of a large, white umbrella—a collapsible, easily carried and mounted bounce surface. These indirect light sources are often considered low-contrast lights: this is not correct. The shadows they produce are just as dark as the shadows produced by hard lights, until the great amount of spill light from the soft units is reflected from light surroundings and begins to fill in the shadows. Used in a large room with dark walls, the soft light is just as contrasty as the hard light. The difference is in the edges of the shadows and the size and brilliance of the highlights.

Except for the possibility of rigging a bare bulb on a light stand, you will have to purchase your hard lights. They include reflector floods and spots (wide- and narrow-beam photoflood lamps with built-in reflectors as part of the "bulb"), photoflood bulbs that screw into metal reflectors, and a variety of high-efficiency quartz-halogen bulbs and fixtures, from wide-angle floods to narrow-beam spots.

You can buy soft-lights from companies that specialize in movie lighting equipment, but most still photographers prefer to bounce their hard lights from light-colored surfaces—walls, sheets of cardboard, and umbrellas—or to shine them through sheets of diffusing material—spun glass, matte acetate, or tracing paper. (Never put a hot lamp so close to a flammable diffusing material that it will burst into flame.)

The first lighting decision for a picture is, should the main light be hard or soft? Practical considerations such as portability, efficiency, and potential control may influence your choice, but generally you can decide on esthetic grounds. Do you want the hard, crisp light that mimics sunlight, or the soft, diffused light that mimics a skylight or the light of an overcast day? Do you want to emphasize texture or minimize it? Once you have chosen your main light, the next problem is where to place it.

Many formulas claim to dictate the "correct" main-light position for various subjects. Portraits, for example, are conventionally lit with the main light

Incandescent lights: flood lamp in aluminum reflector, self-contained reflector flood, quartz-halogen lamp in spotlight housing

The umbrella is a soft-light reflector; the source can be flash bulb, electronic flash, or a continuous-light source such as the quartz-halogen unit shown here

The quality of umbrella light is especially pleasing in portraits. Photograph of actor Richard Kiley copyright 1971 by Bill Pierce

placed 45 degrees to one side of the lens, and 45 degrees above it. Products are often photographed with the main light high above and somewhat behind the subject. All such formulas can be replaced by the use of common sense to fill the requirements dictated by your own taste. There is no reason not to place the main light in several different positions to see which you like best. Moving the light changes the placement of highlights and the placement and shape of shadows. The farther the light is above, below, or to either side of the lens axis, or from the main suface of the subject, the more large areas of the subject will fall into shadow. A broad face can be slimmed by throwing much of it into shadow with a strong sidelight; the thinness of another face can be played down by frontal lighting that strikes all the major planes of the face. The form of a product is often best defined by the strong top light, but if

you want to show textures or important details in the object, you will have to place your light accordingly. Watch the lighting, and move the light until you get the effect you want. If you must light a room or any large area, it is often best to mimic the existing illumination, rather than imposing an arbitrary and uncomfortable lighting on the subject. In all cases, the problem is solved by looking at the main light's effect and moving it until you are satisfied.

The fill light

The function of the fill light is to lighten shadows until the amount of detail you want to see is rendered properly. If you are not careful, this second light can introduce unwanted shadows of its own, an effect that can be minimized by using a soft light as close to the axis of the camera lens as possible.

Lighting ratios

The ratio between the brightness of the main and fill lights on the subject will dictate the amount and the relative lightness of the shadow detail seen in the

Lighting ratio of 2:1, at left, is easily within latitude of all films. 6:1 ratio, at right, is too great for color, fine for black-and-white

Light on background provides separation by increasing tonal differences between subject and surroundings

Actor Ernest Graves. Featureless black shadows lend drama. Photo copyright 1970 by Bill Pierce

picture. No hard-and-fast rule can dictate this ratio. Different films can record different brightness ranges. Some photographers favor a dramatic treatment with dark shadows, while others prefer an open and soft treatment. Others change their treatment from subject to subject.

It is wise to measure the lighting ratios that you use, jot them down in a notebook, and repeat them or change them as experience dictates. Lighting ratios can be measured with an incident-light meter. When the combined intensity of the main and fill lights is measured, the meter is held in the position that gives the maximum reading. Then the main light is turned off and the fill-light intensity is metered. If the main-plus-fill combination is one stop brighter than the fill light alone, the ratio is 2:1; if the combined lights are two stops brighter than the fill light alone, the ratio is 4:1, and so on. A reflected-light meter can be used to measure lighting ratios by monitoring the surface of a gray card lighted by the combination of main and fill lights and by the fill light alone. Since we are measuring a ratio, not determining exposure, you can use a white card if this makes your meter more responsive under dim-light conditions. A 3:1 ratio will almost always produce acceptable color results. Black-and-white films

seldom give trouble with ratios twice as high. In any case, let experience be your guide.

Separation

Photography is a two-dimensional medium. Under artificial light, subject and background may lose separation. After you have established the main and fill lights, close one eye and pretend you are a camera. You may have to add a light or two to regain the three-dimensional effect that we two-eyed creatures take for granted. Our relatively close main light falls off far more rapidly than a natural light source; the background may be artificially dark and lack detail, so our natural sense of modeling and depth is violated. The solution is obvious: throw an additional light on the background. If the background is two-dimensional, as it often is in portrait and studio work, you can place the lamp between the subject and the background. First, point it toward the camera (if the subject's shadow covers the camera, the camera will not "see" the lamp). Then turn the lamp around to light the background. In some studio situations, you may not have enough space to separate the main subject physically from the background, and the main and fill lights may cast disturbing multiple shadows on the background. The background light fulfills a second purpose in eliminating these shadows. If you use a background light on a three-dimensional surface, place the light

so it throws the background shadows in the same direction as the shadows from the main light. Nothing is more annoying than a conventionally lit figure with a shadow below the nose standing in front of a bookcase whose shadows move upward from the shelves.

Even when the background receives enough light to satisfy our natural sense of depth, there may be "tonal mergers" between the subject and the background. Natural backgrounds are seldom flat in tone, but artificial ones often are. If that flat tone matches a major tonal area in the main subject, such as a skin tone, you won't be able to see where the subject ends and the background begins in the final, two-dimensional print. In such a case, you can rim the subject with a light that draws a bright line around it, separating it from the background the way the black line an illustrator or cartoonist draws around his subject separates it from the background. This outlining is artificial and arbitrary. Such a light, usually high and behind the subject, is rare in nature: we must be careful not to make the technique too obvious.

Keep it simple

In general, good lighting is simple. Its success is already determined when we have positioned the main light. Often, nothing more is needed. The same techniques we use with a single "emergency" light can be used to increase the versatility of any main-light equipment, minimizing the practical problems and the esthetically displeasing artificialities that arise when we introduce additional lights. (We live under a single sun, and that single light source is embedded in our sense of what is "good and true.") Bare-bulb and bounce-light techniques in small rooms with light-colored reflecting surfaces can minimize the need for a fill light. With specific pictures, we can often accept the fact that the film will not record all the shadow detail that the eye can see, and we can previsualize the picture so it will be effective without shadow detail. If that isn't possible, we can add a soft fill light close to the lens axis. Camera angle, lens choice, and subject placement can go a long way to maintain our sense of depth and dimensionality in an artificial situation. If the fall-off from the light sources, or the flat tone of an arbitrary background make this impossible, we may have to add more lights to separate subject from back-

ground; but, in general, the simpler the lighting, the better.

Stretching the light

Most Leica and Leicaflex photographers use "available" light, but need some way to keep taking pictures when the light runs out. To that end, we have discussed "emergency" lights and other, more complex systems that stay available after the sun goes down. One piece of equipment that we have not discussed is the *light stretcher*.

This remarkable device lets you shoot pictures as long as you can see the subject. You can get it at most photo stores by asking for a tripod.

Even in dim natural light, a tripod enables you to work at the f-stops that optimize the performance of your lenses. You can stop down all the way, for maximum depth of field. You can use slow color films or ultra-fine-grain black-and-white films. You can use long lenses in indoor situations that defy the most skilled hand-holders. True, the shutter speeds will be slow enough to show considerable blur if the subject moves; but you'd be surprised how often the world stands still when something important happens. A politician stops in the middle of an animated speech. For a second, a child is lost in thought. Usually, when the action stops, it is because something important or beautiful is happening.

Color Films

Hubert C. Birnbaum

The world of color is a vast one for the user of the Leica or Leicaflex system, since a wider choice of films is available in 35mm, to suit nearly every conceivable need or personal taste, than exists for any other still-camera format. To make the most of this wealth of color materials, you must understand the basic differences between one type of film and another, and the applications to which each category of film is best suited. Once you learn the ground rules, you can improvise with reasonable assurance of producing satisfactory pictures even in unfamiliar conditions or when you wish to create nonstandard special effects.

Basically, color films are divided into two major groups: transparency or positive materials (also called reversal or slide films) in which the film exposed in the camera becomes, after processing, a finished picture to be viewed by projection or transillumination; and negative films, which are used to make positive color prints. As it happens, you can also make color prints and duplicate transparencies from a positive color transparency, and make positive transparencies or black-and-white prints from a color negative. Nonetheless, each type of material is at its best when used for its primary purpose.

Transparency films are further subdivided into types for use in daylight (or with electronic flash or blue flashbulbs), for use indoors with tungsten illumination, and special-purpose materials designed for false-color infrared photography, high-contrast photomicrography, underwater photography, and duplicating in still or cine photography. Color negative films, because of the controls affecting color rendition that are customarily applied during the printing stage, are generally, "universal" materials, that is, they are not so strictly bound to specific light sources as are most transparency films.

The reason that different film types are necessary for different light sources is simply that a piece of color film leaves the factory with inherent characteristics that provide plausible color rendition when exposed by light of a particular color quality. Unlike human vision, which manages to interpret colors properly under an extraordinary range of lighting conditions for reasons that are both physical and psychological, a general-purpose color film must be designed to provide familiar color rendition under fairly specific conditions. It cannot adapt itself automatically to conditions with which it was not meant to cope.

By convention, the color quality of light sources is described in terms of color temperature, which is expressed in Kelvin degrees (K). A useful oversimplification of the color temperature concept is to imagine that you are heating a dead-black iron poker over an extremely hot fire. When the poker reaches a moderate heat it will begin to glow orange, then yellow, then, eventually, when it has reached an extreme temperature, it will emit a pure blue-white light. A similar relationship exists between color temperature and the color of the light source it describes. The lower the color temperature, the more red and the less blue the light contains; the higher the color temperature designation, the less red and the more blue the light appears. Some examples of typical color temperatures are: household lightbulb, 2800 K; studio flood light, 3200 K; photoflood lamp, 3400 K; clear flashbulb, 3800-4000 K; noon sunlight, approximately 5500 K; overcast day, 7500 K; north skylight, 10,000 K or higher. As you can appreciate from your own experience, each light source mentioned looks bluer (or less red) than the preceding one, and more red (or less blue) than the next, and the lower color temperatures correlate with the redder sources while the higher ones describe bluer illuminants. (Interestingly, we tend to think of reddish colors of low temperature as looking "warm," and bluish colors of higher color temperature as looking "cool" or "cold.")

Daylight color films are generally balanced to provide good color results when exposed to light of approximately 5500 K, the specific figure varying according to what a given manufacturer thinks best. However, not all daylight qualifies as 5500 K. Early morning and late afternoon, when the sun is low in the sky, are typically "orange" times of day for color film. The redder quality of the light produces a quite noticeable over-all tint in transparencies made at these times. Conversely, just before sunrise and just after sunset, or when photographing in deep shade, the light takes on a distinct blue quality that will be much more apparent on film than it was to your eye. Although you can use color filters to reduce excess red or blue casts, you may find your photographs more attractive and the esthetic challenges of photography more enjoyable if you exploit the film's tendency to shift under these conditions for creative and interpretive effects. One of the real pleasures of color photography, in fact,

is to let the film show you something as you yourself generally do not see it.

Electronic flash units produce light with a color quality more or less similar to daylight, and the same is true of blue flashbulbs. Both light sources are therefore compatible with daylight-type color films, although, depending on the specific film/ flash combination, some minor "trimming" of color balance may be necessary, through use of a color filter, to attain the most pleasing balance in transparencies. With negative films, minor adjustments in color rendition are most easily handled in the darkroom.

Tungsten-balanced color films customarily produce good rendition with either 3200 K studio lamps or 3400 K photofloods. In the Kodak family, transparency films designated as Type B are optimized for 3200 K lights, and Kodachrome II, Type A, is intended for use with 3400 K photoflood illumination. The negative films, which are primarily intended for use with daylight, electronic flash, or blue flashbulbs, may be used with tungsten lights if appropriate filtration, recommended in the manufacturer's data sheet, is employed at the time of exposure. In this instance, the degree of filtration required to adapt the film to tungsten lighting is sufficient to warrant placing a filter over the lens, rather than attempting to make a substantial color correction in printing.

From the preceding discussions of color temperature and film designations, it should be apparent that the major practical difference between daylight and tungsten color films rests in their respective sensitivities to red and blue. Daylight film is balanced to achieve an essentially neutral color rendition when exposed to light that is rich in blue, but comparatively deficient in red. Therefore such film is made correspondingly less sensitive to blue and more sensitive to red. In the case of a tungsten film, which is exposed to light that is rich in red and comparatively weak in blue, the color bias is toward lower red sensitivity and greater blue sensitivity. This, incidentally, explains two of the commonest errors that afflict inexperienced or careless color photographers: over-all red casts in transparencies of tungsten-lighted subjects inadvertently made on daylight-type film, and over-all blue casts on outdoor subjects accidentally shot on tungsten-type material. Clearly, if you want your pictures to have

reasonably accurate color rendition, you must match the right film to the right lighting. On the other hand, you can also use your knowledge of how a particular film will shift colors with a nonrecommended light source to produce deliberate deviations from conventional rendition. Done with taste and discrimination, this can produce striking results.

One common light source, the fluorescent tube, poses an awkward problem with nearly all color films. Because certain colors are entirely absent from, or are at least quite deficient in, the light generated by fluorescent tubes, some degree of corrective filtration, and often a considerable amount, may be necessary to achieve an acceptable color balance. Typically, fluorescents cause color casts ranging from greenish yellow to blue-green, depending on the type of film and tube. Although film manufacturers generally provide filtration data for proper color with various types of fluorescent tubes (different types require different corrections), unless you know what kind predominate in the area where you're photographing, there's little you can do on a rational basis. If in doubt, use a daylight emulsion without a filter and hope for the best, or try a CC30 magenta color correction filter. You may not be completely right, but you may not be unbearably wrong, either. One film that seems to work surprisingly well with fluorescents with no filtration is GAF 500 Color Slide Film. It is a high-speed film (ASA 500), quite grainy, very contrasty, and not terribly sharp. But for reasons best known to God and GAF, it delivers quite good color rendition under fluorescent lighting. (Good, in this context, means less nasty-looking.)

Although it's best to match the proper film to the proper illumination, there are times when it is inconvenient or impractical to do so. In fact, unless most of your photographs are made under controlled conditions (in a studio or a scientific laboratory), the chances are that the majority of your exposures will occur with light sources that are at least slightly off the ideal balance point of your film. There is no need to become paranoid about it. By all means avoid gross color errors, and be careful about not mixing incompatible light sources when correct balance is important. However, if you're going to make available-light color slides with a high-speed Type B film, for example, you know that tungsten room lights have a color temperature about 400 K

lower than the film's balance point of 3200 K. You could, conceivably, obtain the appropriate bluish-light-balancing filter and use it over the camera lens to yield rather close, neutral color rendition. However, you would also lose about 2/3-stop speed because of the filter factor, at a time when you certainly don't want to lose speed. If you shoot without the filter, you don't sacrifice film speed, and the worst that happens is that you get a slightly more orange cast in the pictures; but this more often than not improves the effect because it telegraphs the impression of room lighting. The moral of the story is that if a minor discrepancy between lighting and film color balance will result in a color shift that is pleasant and acceptable, go ahead and shoot without a filter.

As a rule, in photographs in which people are prominent, viewers will accept considerable color deviation toward the oranges and reds before they find the distortion objectionable. However, most people quickly rebel when blue or green casts begin to affect skin-tone rendition. And most viewers will tolerate considerably more off-color results in pictures of unfamiliar objects than they will in photographs of objects of known color.

Periodically, photographic writers resurrect the quaint notion that you can make life easier for yourself by standardizing on one type of color film for all your shooting, preferably a tungsten emulsion. The idea is that you shoot it without a filter indoors under tungsten lights, and with the appropriate daylight conversion filter outdoors. This is such an attractive idea that it's a shame it isn't a very good one. The trouble is that even with a fine-quality conversion filter, your results in outdoor shooting will seldom be quite as good as they would have been if you had shot on daylight film. They won't be bad, mind you, just slightly different in some unfortunate direction. The color balance conversion that everyone admits makes no sense at all except in emergencies is filtering a daylight emulsion to adapt it to tungsten use. Although the color quality will probably be acceptable, the filter factor will require 1-2/3 to two full stops additional exposure when you can least afford it. (Opening up the lens by one f-stop doubles the amount of exposure; two stops represent a four-times increase; three stops, an eight-times increase, and so on.) For example, if you were shooting Ektachrome-X outdoors at its normal speed

of ASA 64, using it indoors with 3200 K lights would require an 80A conversion filter and a consequent reduction in effective film speed to the equivalent of ASA 16. It's too much of a beating to take unnecessarily. In general, it is senseless to use any filter unless it is absolutely essential to produce the photographic effect you want in the finished picture. Given the superb quality of Leitz lenses, it would be a shame to stick filters in front of them without good cause.

An important exception to the above objections to conversion filters arises when photographing distant scenes with long tele lenses. Even when working with long lenses of superb optical quality, distant scenes are frequently rendered overly blue and rather flat in contrast because the film is sensitive to scattered ultraviolet radiation. By shooting with a tungsten-type film, which requires a fairly orange conversion filter in daylight, you get a cleaner image because the conversion filter also acts as a rather strong UV haze filter, and its orange tint is effective in removing the excess blue.

At opposite ends of the exposure range, two areas of frustration lie in wait for the unwary color photographer. Both of them derive from the same basic cause: failure of the reciprocity law. Briefly, the law of reciprocity holds that a piece of film should respond identically to 100 units of light for one unit of time and to one unit of light for 100 units of time. In other words, a large quantity of light for a short period of time should affect a photosensitive emulsion the same as a small quantity of light for a long period of time, as long as the total accumulation of the light is the same in both cases. Unfortunately, life isn't that simple. When color films are exposed for unusually short or unusually long times, they respond abnormally, manifesting a loss of effective emulsion speed, and aberrant color shifts. For many color films, the points at which these shifts become noticeable are speeds of 1/1000 second or shorter, and 1/10 second or longer. Major color film manufacturers supply correction tables that indicate how much additional exposure and/or filtration should be applied at various exposure durations with the films they make. If you expect to do much work involving long exposures or exceptionally short ones, you can avoid some grief by obtaining correction tables in advance, and using the recommendations as a starting point for your own experimental

determination of reciprocity failure corrections you know will work well for your purposes. (You cannot take manufacturers' tables too literally, since they represent average data over a period of time, but not necessarily specific data for a given emulsion batch of film. Even the most carefully manufactured films do, in fact, vary slightly in speed, color balance, and reciprocity traits from one production run to the next. For average-use conditions, these deviations are seldom painfully noticeable.)

Aside from the critical characteristic of color balance, various films differ in the following practical respects: emulsion speed, sharpness, graininess, color rendition, contrast, and exposure latitude. A further consideration that may or may not matter to you is whether or not a film may be processed conveniently by the user, if at all.

First, let us consider exposure latitude. This is simply a socially acceptable way to say exposure error this side of disaster. If you have a very specific final picture in mind, you actually have no exposure latitude whatsoever to play with when using any transparency film, and perhaps 1½ stops of tolerable overexposure with negative films (but no useful tolerance for underexposure). If you're not terribly picky and you're shooting under forgiving conditions (soft, even light), you can get away with about a one-stop error, over- or underexposed, with the transparency films before you become an embarrassment to friends and family. In contrasty light, avoid overexposure like the plague. When photographing under familiar circumstances, if conditions permit, bracket your exposures in half-stop increments from one stop over the meter recommendation to two stops under, and pick the best frame later. This is a particularly useful approach when photographing sunsets. Nature abhors a vacuum and transparency films abhor exposure errors.

Emulsion speeds of general-purpose color films range from Kodachrome II, Daylight, at ASA 25, to GAF 500 Color Slide Film, at ASA 500. With the exception of Kodachrome-type films, which must be machine-processed, most transparency materials may be push-processed to obtain increased emulsion speed. When this is done, some increase in graininess, decrease in sharpness, and deterioration in color quality are to be expected. As a rule, pushing is confined to the high-speed color films, where it may make the difference between success-

ful or unsuccessful available-light work. When medium-speed films are pushed, it's usually a matter of attempting to compensate for an exposure error.

Sharpness and graininess in color films, as in black-and-white films, have a fairly predictable relationship to film speed: the higher the speed, the lower the sharpness, the greater the graininess. If you routinely project to fill a large screen in a small-to-moderate-size room, or if your transparencies are intended for photomechanical reproduction, it will work to your advantage in terms of final picture quality to use a slow, ultrasharp, fine-grain film whenever shooting conditions permit. If you project to more normal sizes and view from moderate distances, you will probably find even the high-speed emulsions perfectly satisfactory. Where color negative films are concerned, they all seem to be in about the same part of the ball park, with moderate emulsion speeds (ASA 80 to 100), moderate graininess, and mediocre sharpness. Color negative films, incidentally, don't take kindly to pushing.

Color rendition, too, relates to emulsion speed in most lines of film. As a rule, the slower films within a brand tend to be more saturated, and the faster ones somewhat less intense in color quality. As high-speed emulsions have improved over the past few years, however, these differences in saturation have tended to become less pronounced. Probably more noticeable than differences in rendition within a brand are the differences that exist among brands. If you photograph the same subject under uniform conditions on film from several different manufacturers, you will assuredly be rewarded with several different color renditions. If you are just beginning to shoot in color, you may wish to try various brands of film to see which firm leans toward a color rendition that suits your personal taste. With negative color films, the differences among the films themselves seem to be less important in determining how the finished print will look than the skill and personal preferences of the printer, and the characteristics of the color printing paper.

Where contrast is concerned, it is traditional that the faster color emulsions are usually less contrasty than the slower ones and, in general, color films are more contrasty than black-and-white materials. The second part of the statement still holds true, but there are enough exceptions to strain the first part. For example, Kodachrome-X, at ASA 64, is consider-

ably more contrasty than Kodachrome II, at ASA 25; and GAF 500 Color Slide Film is much more contrasty at ASA 500 than is GAF 64 Color Slide Film at ASA 64. If you need accurate information about contrast, shoot your own comparison tests with several different films and believe what you see; your experience will certainly be more current and applicable to your working methods than any published information. And whenever you notice consistent contrast changes in your work, make new tests.

To most amateur photographers the matter of color processing, who does it and how, is academic; the important thing is that it be done by someone else and done well. The professional photographer, however, is often vitally interested in processing his own color materials to save time (clients want finished pictures delivered the day before the shooting), to control quality more carefully than an outside laboratory might (not all independent labs produce consistent optimum quality), or to perform nonstandard processing for corrective or creative reasons. All commonly used color transparency and negative films, except for the Kodachromes and Kodachrome-type films, can be user-processed. However, because color processing chemicals are both expensive and short-lived, it is not economical to do it yourself unless you shoot enough film to exhaust, or nearly exhaust, the potential processing capacity of the chemicals before they deteriorate. Some of the possibilities opened up with nonstandard processing include: pushing emulsion speed; lowering emulsion speed and reducing contrast; and modifying color balance through adjustments in the chemistry. However you choose to have your films processed, make sure they are processed as soon after exposure as possible. Delays between exposure and processing can reduce picture quality by impairing both color balance and density.

Since the various color films on the market combine these basic characteristics in differing proportions, the question arises of how to choose the color film or films that will be best for you. The easiest choices, of course, are those involving special-purpose applications. If you need a false-color infrared-sensitive emulsion, you have a grand choice of one—Kodak Ektachrome Infrared Film. For an underwater film designed for oceanography, you pick GAF Blue Insensitive Color Slide Film. Need a high-contrast, extremely-high-resolution film for photomicrography? Then it's back to Kodak for KPCF SO-456, an Ektachrome-type ultrasharp emulsion, whose initials stand for Kodak Photomicrography Color Film. Choice is no problem when your needs will be served best by unique products. The fun begins, though, when you're trying to pick a general-purpose film.

Ideally, given ample time, patience, and funds, you could shoot comparison tests of all the available films, then pick whatever pleases you most in each category of film you expect to use. If this is not practical for you, you can narrow the field considerably by analyzing your requirements with an eye to film characteristics. For example, if most of your shooting involves outdoor subjects and scenery under fairly bright lighting conditions, you might standardize on a slow-speed, fine-grain, high-sharpness film that will allow you to make breathtakingly sharp transparencies. If you tend toward candid photography of fluid situations and also shoot at times when the light isn't particularly bright, you might find a medium-speed film just the ticket, offering adequate emulsion speed, fairly fine grain, and good sharpness. For photographing sporting events or other situations involving rapid motion, your best bet will be a high-speed film, since action-stopping shutter speeds and good depth of field will be more important than hair-splitting sharpness or invisible grain. Do you like to make color photographs in really dim available light? Then you may pick a high-speed film on the basis of its ability to withstand a one- or two-stop push gracefully, rather than because of its unpushed virtues. To be sure, you will find yourself making compromises, because it simply isn't possible in the current state of the art to make a color film that has only endearing qualities. To maximize one characteristic you may have to give up a bit in another area. Just make sure that the areas in which a film shines are the ones that matter most in terms of the way you want your finished pictures to look, and that the film's weaker aspects involve qualities that are of secondary importance in your pictures.

Finally, bear in mind that no color film is capable of providing 100-percent accurate color rendition. The important factors here are that color rendition should be pleasing, and that it should be sufficiently accurate for the intended purpose of the photo-

graphs. Since our human ability to remember color accurately is notoriously poor, it seems somehow unreasonable to demand more of a roll of film than we can accomplish ourselves. In any case, when it's a question of accuracy or attractiveness, attractiveness will usually win hands down. Despite the scientific underpinnings of color photography, in the long run its esthetic aspects prove to be the most rewarding areas of concern.

1
Kodachrome II, Daylight type; "available light" at night. Tungsten-type film could have been used instead, for a somewhat colder (bluer) color rendition, but the overall effect would be similar. The greenish background color is a reciprocity-failure effect due to prolonged exposure. This could have been corrected by filtration, but I did not consider it important. Under these conditions, even high-speed film would require a tripod. Slow film was therefore equally convenient, so I chose it for its sharpness and fine grain. Exposure not recorded, but approximately 15 to 30 seconds at f/5.6. (Under such conditions, bracket to be sure)

2
Kodachrome II, Daylight type; overcast daylight. Kodachrome and other relatively contrasty, saturated color films give brilliant results even when overcast reduces the contrast of the light. A mild warming filter could have reduced the blue cast of the light, but I preferred to do without the filter and retain the feeling of the day. I usually do. Exposure, 1/60 second at f/4

3
High Speed Ektachrome, Daylight type; fairly dim overhead light from surgical operating lamp (tungsten) mixed with fairly bright daylight (sunlight reflected from white walls). Fast color film was chosen both for speed and to preserve "real-life" feeling, even though situations were set up for the camera. Slower film would produce sharper, less grainy, more saturated pictures, but in my judgment, this would have made the pictures less convincing in spite of any technical advantages. 1/50 second between f/2.8 and f/4

4
High Speed Ektachrome, Daylight type; fluorescent light with some daylight from windows. I believe in simple solutions. The dim light required fast film, and daylight-type emulsion gave the least offensive color rendition under fluorescent lighting. No corrective filter was used, since film speed was more important than color accuracy for this job—a film-

strip on nurses' training. Daylight films work better than tungsten films under most types of fluorescent lights, at least for non-scientific photography. For scientific or technical work, I believe it makes more sense to change to a different light source than to try to adapt the film to fluorescent illumination by filtration

5
Kodachrome II Professional, Type A (photoflood); tungsten-lit store window at night. The film is balanced for 3400 K light, but the store lights were more like 2800 K, so the rendition was on the warm side, which was desired. Film was picked both for color balance and for sharpness and fine grain. About 15 seconds exposure between f/5.6 and f/8

6
High Speed Ektachrome, Type B. Exposing this film under the 3200 K studio floodlamps for which it is balanced produced a photograph with good color balance using no filter or other special handling. Exposure not recorded

Photographs by the author

1

6

True color photographers, who live color, see color and think color as well as using color film in their cameras, are rare. Ernst Haas is one of the few, as the pictures on the next twelve pages show

3

6

1 Rodeo contestant; ca. 1953
2 Ceremonial Indian Festival, Gallup, N.M.; 1968
3 Segovia, Spain; 1952
4 Glen Canyon, Arizona; 1963
5 Colorado River; 1971
6 Lake Huntington, Kenya; 1970
7 Lake Manyara, Kenya; 1970
8 Yosemite, California; 1967
9 Yosemite, California; 1967
10 Surtsey Island, near Iceland; 1964
11 New York; 1970
12 St. Thomas, Virgin Islands; 1970

Pictures 4, 6, 7, 9, 10, 11, 12 first appeared in *The Creation* by Ernst Haas, copyright© 1971 by Ernst Haas and The Viking Press

Comparison photograph, non-infrared color. Visual-ly matching natural and artificial leaves appear the same in a conventional color photograph made on Kodak Ektachrome film. Photo by Kodak Research Laboratories

Comparison photograph, infrared color. The artificial leaves appear as blue or cyan against the red rendering of the natural leaves. This principle is used in camouflage detection, detecting plant diseases, etc. Photo by Kodak Research Laboratories

Infrared Photography

Walter Clark

Photography is done mainly with visible light, used to depict—or distort—the visual environment. However, there are other radiations which cannot be seen, but can produce images on photographic materials. These include ultraviolet, infrared, x-rays, electrons and other radiations.

The infrared has special interest. Its waves are longer than those of visible light (hence its name, "infrared"—"below the red"), and they lie in wavelength between visual red and heat. It is convenient to think of the visual spectrum as lying between 400 and 700nm*. The spectrum which can be photographed directly includes the ultraviolet (radiation shorter than 400nm), and the infrared out to about 1300nm. Common infrared photography is done mainly in the region from 700 to 1000nm, and it is this wavelength region which gives infrared photography its special interest. The range beyond 1000nm is mainly the province of the spectrographer—the astronomer and the physicist; although by indirect photography, in which special sensors are used to provide indirectly photographs which can be studied, very long wavelengths have been recorded, with very important applications.

Infrared photography has been done since the nineteenth century, but it was not until the early 1930s that it could be applied and practiced with the ease of ordinary photography. It uses normal cameras, and most of the same light sources and the same processing as conventional photography. There are certain slight differences in practice; filters must be used to confine the exposure to the infrared, exposure meters cannot always be used in the normal manner, and the lens focus may have to be adjusted slightly.

Why infrared?

The "infrared effects" in photography can be applied over a wide range. They result from the fact that objects may reflect and transmit infrared in a manner different from their behavior to visible light. This will provide unusual pictorial effects, but it is of interest chiefly because it can give special information.

For instance, chlorophyll, which gives the green color to foliage and grass, is transparent to infrared, which is, however, reflected by the internal struc-

*nm—nanometers, formerly millimicrons (mμ), or A (Angstrom units: 1nm = 10A).

ture of the plant, so that in a black-and-white infrared photograph, leaves and grass appear white. There is almost no infrared in sky light, so that clear skies appear black and sun-reflecting clouds appear white, giving effective contrast. Water, unless polluted, absorbs infrared and will appear black, so that shorelines can easily be identified.

The atmosphere is usually hazy from dust, smoke and moisture particles, and this haze obscures the viewing of distant objects. However, while the haze tends to reflect (scatter) light of short wavelengths, thus giving the obscuring effect, it also tends to transmit the longer wavelengths. (This is a matter of the size of the haze particles, but applies to some extent in the spectral region we are discussing). Photography by infrared may therefore be used to penetrate haze, and this, coupled with the special reflecting properties of objects in the infrared, may give the impression of "seeing further." This effect has been used largely in long-distance photography over the land, and in high-altitude photography from aircraft and space vehicles.

Paints, dyes, varnishes, inks, oils and dirt layers may all transmit or absorb infrared. Building materials, soil, rocks, sand and pigments may have high infrared reflectivity, or strong absorption. Their tonal appearance in infrared photographs may be quite different from the way they look to the eye or in a normal photograph, and infrared photography may therefore be a significant means of study.

Requirements for infrared photography

The requirements are very simple, and are specially suited for 35mm photography. They are:

Infrared-sensitive film.

Light sources that emit infrared (most of them do).

Filters over the lens (or the light source) to pass only the infrared (for black-and-white photography, red or deep red filters; for color infrared film, a yellow filter is used).

The capability to adjust the focus to a somewhat nearer distance than that of the subject.

Exposure judgement by experience or by tables, rather than by the meter.

Infrared-sensitive films must be handled in total darkness.

Process them normally in total darkness.

(In case of fog, check everything!)

Film response to infrared

Panchromatic films respond to the ultraviolet, and through the visible spectrum—blue, green and red—because, in making the sensitive coatings, dyes have been added which absorb green and red light. (All photographic films naturally respond to ultraviolet, violet and some blue light.) The same principle is used in making films sensitive to the infrared. Special sensitizing dyes are added, their nature being determined by the spectral response required. A wide range of specially sensitized infrared films is made, but those used for general black-and-white infrared photography respond to the same spectral region as panchromatic film, and past it to beyond 900nm, with a peak response at about 850nm. They have very low sensitivity to green light.

A special color film is made for infrared effects involving false-color development. It uses a combination of infrared and color photography, but the infrared-responding layer in it has the same spectral response as normal black-and-white infrared film.

Infrared films are manufactured by various companies in different countries, but only Kodak films will be considered here. In the black-and-white field, other films may be comparable, but at present only Kodak makes the infrared color films.

For the 35mm camera, using 135 magazines, the films are:

Kodak High Speed Infrared Film (black-and-white, with variants in 16mm and 35mm long rolls, and in sheet film);
Kodak Ektachrome Infrared Film (color, with variants in 16mm and in 4x5-inch sheet film sizes).

The spectral response of Kodak High Speed Infrared Film is shown in Figure 1.

Kodak High Speed Infrared Film is coated on a dimensionally-stable .004-inch Estar (polyester) base. The light-protective leader that was used in the past is no longer attached, so *the film must be handled in total darkness from the time the film can is opened, when loading and unloading the camera, and for processing.*

Typical characteristic curves of the black-and-white film are shown in Figure 2.

The infrared-sensitive layer of Ektachrome Infrared color film responds to the same region in the

1

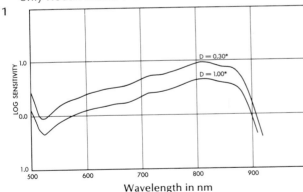

Spectral sensitivity* curves of Kodak High Speed Infrared Film, developed 10 minutes in D-76 at 68°F. (From Kodak Publication No. N-1, Medical Infrared Photography; reproduced by permission of the Eastman Kodak Company)

*Sensitivity is the reciprocal of exposure (ergs/cm²) required to produce specified density above the density of base plus fog.

2

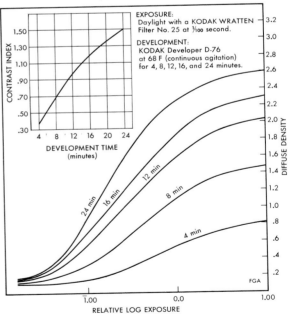

Characteristic curves of Kodak High Speed Infrared Film (from Kodak Publication No. N-17, Kodak Infrared Films; reproduced by permission of the Eastman Kodak Company)

infrared part of the spectrum as the black-and-white film—approximately 700 to 900nm.

Black-and-white exposure

Outdoor photography in daylight is almost as simple as conventional black-and-white photography. However, the ratio of infrared radiation to visible light in sunlight or daylight varies, so that only experience can indicate an approximate exposure value if a meter reading is taken.

For indoor exposures in tungsten lighting, it is possible to establish a more reliable meter setting, since the infrared content of this illumination is less subject to unknown changes than that of daylight.

The Eastman Kodak Company suggests the following film-speed settings on meters as starting points for exposure determination for Kodak High Speed Infrared Film under average conditions, using meters marked with ASA speeds or exposure indexes:

Exposure indexes for film given recommended development in undiluted Kodak D-76 (10 minutes at 68°F, with agitation for 5 seconds at 30-second intervals, using a small development tank).

Kodak Wratten Filters	Daylight	Tungsten
No. 25, 29, 70 or 89B	50	125
No. 87 or 88A	25	64
No. 87C	10	25
Without a filter	80	200

In bright sunlight, with a Wratten No. 25 red or a Leitz Red (dark) filter over the lens, an exposure of 1/125 second at f/11 may be used as a basis for shots of distant subjects. For nearby subjects—across the street rather than across the valley—the exposure may have to be as much as 1/30 second at f/11. The difference is due to reflected radiation from dust, moisture, etc., in the atmosphere.

Photoflood exposure table for Kodak High Speed Infrared Film (black-and-white), with Wratten No. 25 or No. 29 filter over camera lens, using two lamps (R2 reflector floods or No. 2 photofloods in 12-inch reflectors) at a 45-degree angle to the camera axis (copy lighting):

Lamp-to-subject distance (feet)	3	4½	6½
Lens opening at 1/30 second	f/11	f/8	f/5.6

Flash exposures for Kodak High Speed Infrared Film. Approximate lens settings are determined by dividing the guide number by the lamp-to-subject distance in feet:

Electronic flash guide numbers (Wratten No. 87 filter over lens):

Output of unit (BCPS or ECPS)	500	700	1000	1400	2000	2800	4000	5600
Guide number for trial exposure	40	45	55	65	80	95	110	130

Flashbulb guide numbers (Wratten No. 25, 29, 70 or 89B filter over lens: clear flashbulb, No. 6 in bowl-shaped polished reflector, or No. 26 in 3-inch reflector):

Focal-plane shutter speed	Guide number for trial exposure
1/30	300
1/60	210
1/125	150
1/250	105
1/500	75
1/1000	50
1/2000	35

Wratten Filters No. 25, 29 and 70 are all red filters; No. 89B is a red-and-infrared filter so dark that it is virtually opaque to the eye, as is the Leitz Infrared (dark) filter. Wratten Filters No. 87, 88A and 87C are visually-opaque infrared filters which admit infrared radiation of varying wavelength ranges. The 89B filter admits infrared wavelengths from 700 to 950nm, plus some visible red light of less than 700nm wavelength.

Cameras for infrared

Leica rangefinder cameras are excellent for infrared work in black-and-white and in color. A filter is normally used over the lens, which, for black-and-white infrared photography, should be focused on a slightly closer distance than that of the actual subject. (For color infrared work, the normal focusing procedure is used.) Exposure meters are not usually designed for infrared work, and will not be accurate unless they are specially calibrated.

The Leicaflex, with its through-the-lens viewing

and focusing, is not well suited for black-and-white infrared photography because of the very dark filters, some of them visually opaque, that are used. An auxiliary viewfinder of the right focal length can be used (these are made for the Leica M cameras, and will fit the accessory clip on the Leicaflex), or a tripod will serve for viewing and focusing with no filter, after which the appropriate filter can be put on for the exposure.

For color infrared work, using a yellow or orange filter, the Leicaflex can be used in the normal way.

Focusing

In black-and-white photography, the infrared focus may be different from the visual focus in the case of most lenses. Some earlier Leica lenses had an "R" setting for infrared engraved on the lens mount. The camera was first focused normally, and then the "R" mark was aligned with the indicated distance. This system has now been dropped. For the best definition, lenses should be used at the smallest convenient aperture; and for large apertures, if the lens has no special mark for infrared focusing, the focusing must be calibrated photographically. It is necessary to focus on a distance nearer than the one that is indicated visually, by increasing the lens-to-film distance. Focus normally and make a series of exposures, starting with the visual-focus setting, and then focusing for gradually shorter distances from one exposure to the next.

In the case of color infrared film, normal focusing can be used, since the visual-light component of the image predominates.

Infrared photographs, unless made with specially corrected lenses, will never be quite as sharp as conventional photographs.

If the lens has a stereo attachment in which conjugate images are side-by-side on a single 35mm frame, it is possible to make comparison photographs—so called "multiband" photographs—by using different filters, one over each light beam. To ensure equal exposure through both filters, they may have to be balanced by adding neutral density filters, which can be selected by experiment. This technique has proved very worthwhile in making 35mm photographs from the air, especially with infrared color film, for water-supply, pollution and other ecological studies. For instance, in water-resources investigations, the Kodak Wratten 61 and 16 filters have been used in this way with Kodak Ektachrome Infrared Film with great effect.

Sources of infrared

The natural source of infrared radiation is the sun, but all incandescent objects give off infrared.

The sources mainly used in infrared photography are those common to normal photography—sunlight and daylight; tungsten filament lamps, including ordinary household lamps, overvoltaged lamps of the photoflood type, 3200 K studio lamps, quartz halogen lamps, and, occasionally, heat therapeutic lamps; carbon arcs; xenon arcs; photoflash lamps and electronic flash lamps. In general, normal fluorescent lamps are not practicable for infrared photography, although they may be used for infrared-luminescence photography (discussed later in this chapter). For photography with Kodak Ektachrome Infrared Film, use daylight or electronic flash.

Most of the sources mentioned have good radiant emission in the spectral region of the near infrared (700-900nm), to which the common black-and-white and color infrared films are sensitized.

Flashbulbs coated with a deep-red infrared-transmitting varnish have been marketed: they are designated by the letter "R."

The arrangement of the lights in infrared photography is similar to that used in normal photography, but since special light-and-shade modeling is seldom required, a great deal of the work is done with lighting of the "copying" type, that is, with two lamps at 45 degrees to the lens axis, and at equal distance on both sides of the subject.

Filters

If black-and-white infrared film were exposed without a filter on the lens, the infrared response would be "swamped" by that of the red and blue, and specific infrared effects would not be seen to advantage. In order to ensure that these effects are clear, the blue, the green, and some of the red light should be filtered out, by red filters, or by darker infrared filters, which essentially exclude all visible light. The appropriate Kodak Wratten Filters, in order of increasing effectiveness, are Nos. 25 (red), 29 (red), 70 (deep red), 89B (red and infrared), 88A, 87 and 87C (visually-opaque infrared). The Leitz filters for black-and-white infrared photography are designated Red (dark) and Infrared (dark).

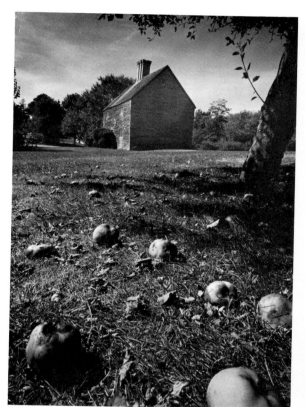

Comparison photograph, panchromatic film. The Olde House, Cutchogue, New York; Leica M4, 21mm Super Angulon; Kodak Plus-X Pan film, no filter; 1/60 second at f/22. Photo by Harvey Weber

Comparison photo, Kodak High Speed Infrared Film, Leitz Infrared (dark) filter; 1/60 second at f/22; developed in D-76. Note dark sky, light foliage. Photo by Harvey Weber

Forest Survey aerial photographs, panchromatic (left), and infrared (right). In the infrared photograph, stands of conifers stand out as black areas surrounded by the white rendering of deciduous trees; similarly, diseased hardwood trees are rendered in dark tones. Photos by Stephen H. Spurr, Fairchild Aerial Surveys. From Photography by Infrared *by Walter Clark, published by John Wiley & Sons, Inc.*

Golden Triangle, Pittsburgh. Leica M4, 21mm Super Angulon, Leitz Infrared (dark) filter; Kodak High Speed Infrared Film; 1/250 second at f/11. Note black water, white foliage and clouds. Photo by Harvey Weber

Infrared surveillance photograph taken in total darkness, using Kodak Wratten Filter No. 87 over a light source. Photo by Kodak Research Laboratories

Infrared Photograph of torso, showing subcutaneous veins. Reproduced, with permission, from Kodak Publication No. N-1, Medical Infrared Photography

Processing

The processing for black-and-white infrared film uses normal developer, stop bath and fix, but must be done in total darkness. Follow the instruction sheet that is furnished with the film.

Color infrared film

By 1940, much had been learned about infrared photography in black-and-white, and about color photography. It seemed that if the two could be combined, the valuable properties of each might have special value. The first idea was to use such a film for camouflage detection; natural foliage might be distinguished from painted materials designed to simulate it visually, using the different infrared reflectance of green foliage and green paint, and showing it up as a color difference in the picture.

A special film designed to fulfill this function was supplied in limited amounts to the military. Later it was developed into the present Kodak Ektachrome Infrared Film, which is available in 35mm cartridges, and has many interesting applications.

The structure and response of color reversal (positive) infrared film are shown below.

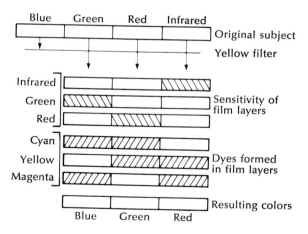

In black-and-white infrared photography, the effects show up as density differences. In color infrared, they appear as color differences—as "false" or "unreal" colors. This has the great advantage that the special characteristics of infrared can be detected readily by these color differences.

Kodak Ektachrome Infrared Film (in 35mm, it replaces Kodak Ektachrome Infrared Aero Film 8443, which was made specifically for aerial photography) is designed for outdoor use in daylight. This film, unlike black-and-white infrared film, can be loaded and unloaded in subdued light.

For indoor photography, the best light source is electronic flash. In all cases, to exclude blue light, the Wratten No. 12 (medium yellow or "minus blue") filter, or the Leitz Orange filter must be used. Due to problems of color balance, flashbulbs are not satisfactory (although false color effects will result), and if photoflood (3400 K) illumination must be used, special filter combinations are needed—for instance, the Wratten No. 12, plus a Kodak CC20 filter, plus a Corning Glass Filter C.S. No. 1-59 (3966). These filters must be selected by trial.

Color adjustment in the final picture can be made by using Kodak Color Compensating Filters (CC filters), as indicated in the instruction sheet that comes with the film. These adjustments may be important, especially in biomedical studies, to ensure the optimum rendition.

Color infrared film can be used in all situations where black-and-white infrared film is used, although for certain purposes, such as long-distance penetration of haze, the latter may be preferred. In general, however, the color film has much broader uses. Among them are:

Pictorial photography: special color effects.

Agriculture and forestry: detection of diseased trees and plants. The diseases may be seen as a cyan or other non-red color against the red background of healthy foliage. This might be seen photographically before it could be seen visually, and the diseased trees or plants could therefore be removed before the disease spreads.

In addition, stands of deciduous and softwood trees can be distinguished and the trees counted.

Water pollution studies: pollution can be shown up if there is a change in infrared reflectance in the polluted areas. For instance, algae growth under the surface may appear red against a dark blue-green background.

Medical photography: in the biomedical field, color infrared film shows promise for study of: the venous pattern, showing disturbances in the blood circulation, which may be related to tumors; to cirrhosis, to varicosities, thrombosis or diabetes; in dermatology; in opthalmology; in dentistry.

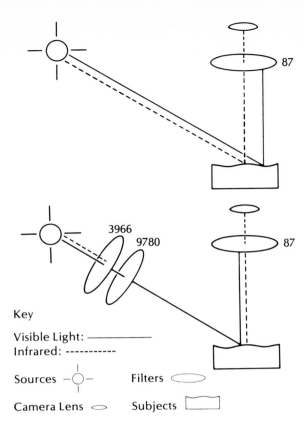

Key

Visible Light: ————————

Infrared: - - - - - - - - - -

Sources -○- Filters ⬭

Camera Lens ⬱ Subjects ⌣

Diagram showing the difference between setups for infrared-reflection photography (top) and infrared-luminescence photography (bottom). (Drawing from Kodak Publication No. N-1, reproduced by permission of the Eastman Kodak Company)

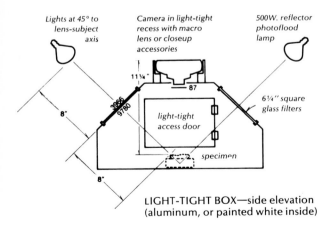

LIGHT-TIGHT BOX—side elevation (aluminum, or painted white inside)

Plan for an illumination box for infrared-luminescence photography. An exposure of 3 minutes at f/5.6 should be tried with Kodak High Speed Infrared Film. (Drawing from Kodak Publication No. N-1, reproduced by permission of the Eastman Kodak Company)

Infrared luminescence

In the same manner that exposure to ultraviolet radiation can induce fluorescence (the production of longer-wavelength visible light) in many materials —an effect which can be photographed and which is used to study paintings and altered documents, and in law-enforcement photography; so can exposure to blue-green light induce luminescence in infrared wavelengths with many materials. This luminescence can be photographed on infrared film.

The subjects are illuminated by blue-green light, with no infrared radiation, and are photographed by infrared luminescence only. They are irradiated with a light source covered with a blue-green filter, such as a 13-percent solution of copper sulfate, or so-called heat-absorbing filters which are blue-green in color. The filters must *not* transmit the infrared radiation to which the films respond. Glass filters which may be used in combination over the lamp are:

9780—Corning Glass Color Filter, C.S. No. 4-76, molded, 8mm (blue-green), and
3966—Corning Glass Color Filter (Aklo Type), C.S. No. H.R. 1-59, molded and tempered, 4mm (heat-absorbing).

The 3966 filter protects the 9780 glass from heat, and should be placed between the 9780 glass and the light source. Since these filters are not used in the optical system over the lens, they need not be flat-polished. The lamphouse plus filters, however, must not leak white light.

The infrared luminescence is photographed on black-and-white Kodak High Speed Infrared Film, using a filter over the camera lens which passes only infrared radiation; for example, the Kodak Wratten Filter No. 87 or the Leitz Infrared (dark) filter. The exposure for any particular subject must be determined by trial, but a good start will be obtained with an exposure of three minutes at f/5.6, using two 500-watt reflector photofloods at an angle of 45 degrees to each side, covered by the blue-green glass filters mentioned above, at a distance of eighteen inches from the subject, with the Wratten No. 87 filter on the lens.

Electronic flash can be used for infrared-luminescence photography, and color infrared film exposed in this manner can give striking results. (Only the

infrared-sensitive layer of the color film is affected, and the resulting image is red, but at least infrared-luminescent areas can be determined.)

The photography of infrared luminescence is an interesting field for study, and many worthwhile results have been obtained in the areas of botany, biology, medicine, mineral studies, palaeontology, the photography of questioned documents, museum and gallery studies, the study of paints and pigments, and forensic studies.

Photography in the dark

Black-and-white infrared photography can be used to take pictures in darkness (the subject , of course, must be irradiated by infrared). This technique has been used successfully for surveillance (photographing intruders, for example); for audience-reaction studies (to training films, audio-visual presentations and the like); for the study of human and animal behavior, and for pupillography. The light sources may be screened with an infrared filter such as the Wratten 87 or 87C, although, if they are pointed toward the person, a dull red glow may be seen. It is good practice, therefore, to direct the source of radiation toward the ceiling, so as to illuminate the subject by diffuse, indirect infrared rays. Using this infrared version of "bounce light," the "darkness" photograph may be made on infrared film without a filter over the lens, provided the subject is illuminated only by infrared radiation, with no visible light present in the environment. Visible light leaks must be carefully avoided in this work.

Special effects

Both black-and-white and color infrared photography can be used for special effects. In motion pictures and still pictures in black-and-white, infrared film is often used to simulate moonlight effects in photographs taken in daylight—light leaves and grass, black shadows, dark skies and dark water. If these effects are too intense when a red filter is used, they may be reduced by using a less efficient filter—for example, a yellow filter such as the Wratten No 12 or No. 15, or the Leitz Orange filter; or by adding some fill light to the shadows. Clouds should not be included in such a scene, for they will appear too bright for moonlight. People's faces are not rendered agreeably in infrared.

In still photography, very effective shots can be obtained with architectural subjects with side or back lighting that casts strong shadows; over water, especially if boats or light buildings are in the picture; and showing snow-clad mountains and cumulus clouds against the sky.

Dramatic landscape views may be taken in black-and-white infrared. Distant haze may be penetrated, sharpening up the horizon and distant hills, and subject contrasts may be exaggerated. Water and clear sky will appear dark, deciduous trees and grass will look pure white, and conifers will generally be dark.

Simulated night scenes are not obtained with infrared color, but extraordinarily effective false-color rendition can be produced; this is often unpredictable. Skies may be bluish in the photograph, and water purple or bluish; grass and foliage may be red or a variant, depending on the nature of the vegetation, its condition, and on the time of year; artificial green leaves may be blue or cyan; painted buildings may appear in false colors, depending on the way the paint absorbs or reflects infrared. A red barn or a brown weathered building may appear gray-green or blue, giving striking effects against a red record of green foliage. The photographer who likes to experiment will find a fruitful field here.

Worthwhile applications

Haze penetration and infrared reflectance of foliage have been mentioned. The special transmittance and reflectance of infrared as compared with visible light lead to other special applications, to which the Leica is well adapted, whether you are shooting from the air, on the ground, or in the studio. Among them are:

Environmental and ecological studies: as stated before, the detection and location of water pollution;

the detection of plant diseases;

the study of the effect of salt water on plant growth;

identification of trees and the counting of timber stands;

the determination of moisture on the ground;

the delineation of water lines;

the study and delineation of certain geological features, fossils and sediments.

Animal studies: counting and differentiation of livestock;

the study of the influence of animals on plant life;

animal behavior studies.

Archaeology: locating and identifying ancient earthworks;

the detection of crop and soil markings.

Copying by infrared photography: the photography of otherwise illegible documents—charred, aged, worn, obliterated, chemically-bleached, falsified, or palimpsests;

copying works of art, using infrared photography to supplement x-ray and ultraviolet photography and chemical analysis, for determining the authenticity of paintings, to examine and aid in restoring badly aged paintings, engravings, and photographs.

Law enforcement applications: many have been found in criminology, including:

the deciphering of erasures and forgeries; the study of charred or worn documents; the differentiation of inks, dyes, pigments, powder burns, cloth, hair, fibers, secret writing.

Photomicrography: infrared photomicrographs are made with conventional apparatus, using the 35mm camera and infrared film. In the medical, biological and palaeontological fields, useful results have been obtained as a result of increased penetration of preparations by the infrared radiation, showing improved structural differentiation in photomicrogaphs.

For black-and-white, the common light sources are used with red or infrared (visually opaque) filters.

For infrared color, pulsed xenon arcs and quartz-iodine lamps, used with the Wratten No.12 yellow filter or the Leitz Orange filter, have proved satisfactory.

Focusing may have to be done by calibrating the fine adjustment of the microscope.

Thermography: infrared film can be used to record temperature distribution at the surface of bodies, but is limited in practice to a range of about 250°C to 500°C—that of electrically-heated appliances, cooling ingots and castings, stoves, and internal-combustion engines. At lower temperatures, special infrared sensors are used.

Indirect photography by infrared: infrared photography can be done indirectly, by methods in which an effect—usually heat—is produced by infrared radiation in a non-photographic medium, giving visual patterns which can be photographed; for instance those of liquid crystals, of the evaporation of thin films of oil (used in thermography) and of the extinction of phosphorescence.

Indirect infrared photography may also be done by scanning with infrared-sensitive devices which can be made to give traces on cathode-ray tubes, or to modulate glow lamps, thus making visible records which can be photographed by normal techniques.

Medical: infrared photography is used widely in medical diagnosis:

to map venous patterns;

to reveal varicose conditions;

for the study of liver pathology;

for outlining some subcutaneous tumors;

in blood studies;

in ophthalmology;

in dermatology;

in dentistry;

in the photography of gross specimens.

Further reading on infrared photography

The following Kodak publications may be of interest to photographers using Kodak infrared films:

Medical Infrared Photography (No. N-1)
Kodak Data for Aerial Photography (M-29)
Kodak Filters for Scientific and Technical Uses (B-3)
Kodak Plates and Films for Science and Industry (P-9)
Basic Scientific Photography (N-9)
Photography Through the Microscope (P-2)
Applied Infrared Photography (M-28)
Photography from Lightplanes and Helicopters (M-5)

These data books are available from Morgan & Morgan, Inc., 400 Warburton Avenue, Hastings-on-Hudson, New York, 10706.

For a copy of the latest edition of the *Index to Kodak Information,* write to:

Department 412-L
Eastman Kodak Company
343 State Street
Rochester, New York 14650

Filters

Leslie Stroebel

Filters are not essential to photography in the sense that a camera, a lens, and film are necessary to make a photograph. Fortunately, many picture-making situations do not require, and are not improved by, the use of filters. Filters are invaluable, however, for the photographer who wants to control his images rather than have to accept the results that may otherwise be dictated by specific combinations of subject, illumination, and film. Filters enable the photographer to lighten or darken colors selectively, to alter the contrast between colors, to obtain more accurate tone reproduction, to change the color balance of color images, to decrease or increase the appearance of haze, to reveal otherwise invisible detail, to eliminate reflections, and to create a multitude of special effects. The uses of filters increase with the photographer's knowledge of them—not necessarily knowledge of specific filters (there are hundreds) or of applications to specific picture-making situations (there are thousands), but knowledge of a few basic principles and facts.

Color nomenclature

Hundreds of names are used to identify colors. In the advertising world, it is common to see new, exotic-sounding names applied to the same old colors in an effort to stimulate sales. Such practices create confusion and make it difficult to communicate clearly about colors. Fortunately, because of the trichromatic nature of both human vision and photographic color processes, we can systematize and simplify color nomenclature.

In vision, color perception orginates with the selective absorption of different regions of the color spectrum by three sets of light receptors in the retina, commonly referred to as the red-, green-, and blue-sensitive cones. All of the tremendous number of different colors that we see can be thought of simply as different combinations of red, green, and blue light. Some obvious examples: *yellow* equals red plus green; *magenta* equals red plus blue; *cyan* equals blue plus green; and *white* equals red plus green plus blue. Scanning the color spectrum from one end to the other involves gradual changes in the proportions of light absorbed by the red-, green-, and blue-sensitive cones in the eye.

Photographic color films and printing papers typically have three emulsion layers which are also selectively sensitive to red, green, and blue light.

After processing, the three emulsion layers contain cyan, magenta, and yellow dyes which absorb red, green, and blue light respectively. The amount of absorption of each color is controlled by the amount of the corresponding dye in an area, and all of the many colors that can be produced on a color photograph consist of different combinations of the three dyes. Thus, the colors that we are most concerned with are red, green, blue, cyan, magenta, and yellow. The interrelation among these colors can best be visualized by positioning them around a triangle as illustrated in Figure 1.

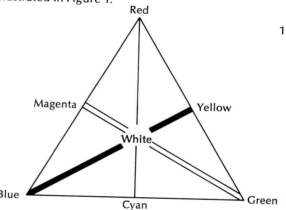

1

Red, green, and blue are called *additive primary colors* because red, green, and blue light can be added together to form white light; or, by varying the proportions, to form any color we can see. The colors formed by combining two primary colors—cyan, magenta, and yellow—are called *secondary colors*. A primary color (e.g., red) and the secondary color on the opposite side of the triangle (cyan) are called *complementary colors,* since lights of these colors can be combined to form white light. (Note that, whereas cyan, magenta, and yellow are secondary additive colors in terms of light, they are primary subtractive colors as applied to dyes in color photographs.)

Since photographic film can record shorter-wavelength radiation and longer-wavelength radiation than that included in the visible spectrum, such regions of the electromagnetic spectrum must also be identified. *Infrared* identifies a region of radiation of longer wavelength than red light, and *ultraviolet,* a region of radiation of shorter wavelength than blue light. It is not correct to refer to infrared and

ultraviolet as "colors," nor is such radiation "light," since it is not visible. On the short-wavelength side of the visible region, photographic film can also record x-ray and gamma-ray radiation beyond ultraviolet radiation.

Spectral sensitivity of film

To select a filter for a desired effect, we must know something about the color sensitivity of the film being used. Silver halide grains used in photographic emulsions are sensitive only to blue light plus the shorter-wavelength ultraviolet radiation. This limited color sensitivity is adequate for some types of photography, such as copying black-and-white originals, and making positive slides from black-and-white negatives. These blue-sensitive or "color-blind" films have no advantage over panchromatic films for tone reproduction, since filters can be used with panchromatic films to achieve the same effect, but for some work there are other reasons for preferring blue-sensitive film—the ability to use bright safelights when handling the film in the darkroom, and its lower cost.

Orthochromatic films, which are sensitive to green light as well as blue light and ultraviolet radiation, were popular for portraits in the past, but there is little demand for them today.

Panchromatic films are sensitive to the entire visible spectrum and to ultraviolet radiation. Most modern general-purpose black-and-white films are panchromatic. These films usually record subject colors as gray tones in the print that correspond sufficiently closely to the visual lightnesses of the original colors so that they look "natural" to the viewer. Various panchromatic films have different relative red and blue sensitivity, and the color quality of the illumination also affects the tonal reproduction of subject colors. In general, panchromatic films tend to record reds lighter in the print than they look under tungsten illumination, and to record blues too light in photographs taken in daylight.

Going beyond the visible spectrum, we do not need a special type of film to record ultraviolet radiation, since silver halides are inherently sensitive to short-wavelength radiation. Ultraviolet radiation from blue sky affects the tone reproduction of skies in photographs, making them lighter in the print or transparency, unless it is filtered out. The effect of this ultraviolet radiation would be greater, but much of it is absorbed by camera lenses, lens coatings, and gelatin in the film. To record only the ultraviolet radiation from a scene, we must filter out any longer-wavelength radiation, such as light, to which the film is sensitive. When photographing objects that fluoresce under ultraviolet radiation, the normal procedure is to filter out ultraviolet radiation reflected by the subject and record only the visible light.

To sensitize film to infrared radiation, manufacturers must add special sensitizing dyes. Infrared films are also sensitive to blue and ultraviolet wavelengths, so these must be filtered out if the image is to be formed entirely with infrared radiation. An infrared color film has useful sensitivity to infrared, green, and red radiation on three different emulsion layers. The film's inherent sensitivity to blue and ultraviolet radiation is nullified by using a filter over the camera lens that absorbs these wavelengths. This film produces false-color effects that can be used for a wide variety of scientific and technical applications.

Conventional color films are sensitive to the same visible spectrum as black-and-white panchromatic films, except that they record red, green, and blue light on three different emulsion layers to form cyan, magenta, and yellow dye images. A filter layer placed below the top blue-record emulsion layer prevents blue light from affecting the green-record and red-record emulsion layers. Unlike the human visual system, which can adapt to different qualities of illumination so that a white object is perceived as being white under either daylight or tungsten illumination, color films record differences in the color quality of illumination as objectively as they record differences in the color of objects. Therefore, color films are balanced for specific types of illumination, such as daylight and 3200 K tungsten light, but since it is impractical to make a different color film for every possible quality of illumination, it is often necessary to match the illumination to the film by using a filter over the camera lens.

Absorption and transmission of filters

Filters are useful in photography because they selectively absorb some of the radiation that would otherwise fall on the film, thereby producing a change in the tone reproduction. A major problem is how the filter manufacturer can specify to the photographer the nature of the absorption by a

specific filter. Unfortunately, no single method is satisfactory for all situations. Some of the methods are listed below.

(1) Identification of the color of the filter. A "yellow" filter, for example, appears yellow because it transmits the yellow component of white light.

(2) Identification of the color absorbed by a filter. A "minus-blue" filter, for example, absorbs blue light, and therefore appears yellow.

(3) Preparation of an absorption curve for the filter. Density or transmittance is plotted on the vertical axis, versus wavelength on the horizontal axis.

(4) Identification of the filter's color and its density to light of a complementary color. A CC50Y filter, for example, is a yellow filter that has a density of .50 to blue light.

(5) Presentation of photographs of a standard color chart, made with and without a filter, showing the extent to which the filter lightens and darkens selected colors.

(6) Designation of the mired shift value of a filter, which can be converted to the change produced by the filter in the color temperature of light from a given source.

(7) Identification of a specific use for a filter. An 85B filter, for example, is specified for use with a tungsten-type color film when it is exposed with daylight.

(8) Designation of the coordinates for a chromaticity diagram, such as the CIE chromaticity diagram.

Basic to the use of filters is an understanding of the concept of absorption and transmission, in terms of the additive primary and secondary colors—red, green, blue, cyan, magenta, and yellow. When white light—a mixture of red, green, and blue light—enters a red filter, red light is transmitted and the blue and green components are absorbed, as illustrated in Figure 2.

Similarly, a green filter transmits green light and absorbs red and blue light. A blue filter transmits blue, and absorbs red and green. Thus: a primary-color filter transmits light of its own color and absorbs light of the other two primary colors. Secondary-color filters transmit their own color, and the two primaries which make up that color. A

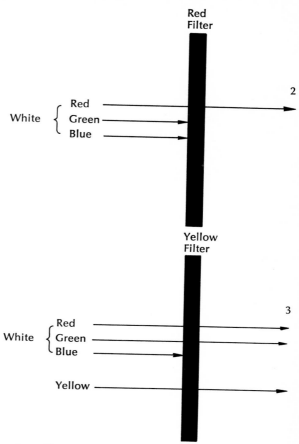

yellow filter, for example, transmits yellow, red and green, and absorbs blue, as shown in Figure 3.
These relationships are summarized below:

FILTER COLOR	COLORS TRANSMITTED LIGHTENS	COLORS ABSORBED
red	red	blue, green, cyan
green	green	red, blue, magenta
blue	blue	red, green, yellow
cyan	cyan, blue, green	red
magenta	magenta, red, blue	green
yellow	yellow, red, green	blue

The above discussion assumes that the filters are strongly colored and transmit either all or none of the light of a given color. But few filters approximate this situation. A more precise description of the action of filters is provided by absorption curves. The visible spectrum can be divided roughly into three sections: 400-500nm (blue), 500-600nm (green), and 600-700nm (red.).

4

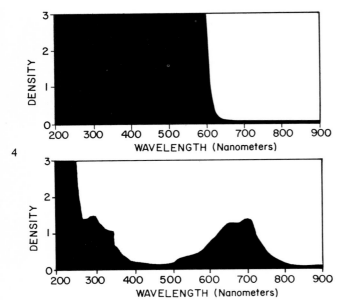

In Figure 4, the upper absorption curve is for a red filter that absorbs very little red light, but essentially all blue and green light. The lower curve is for a light blue filter; its absorption varies much more gradually by wavelength. Curves of this type are essential for certain kinds of technical and scientific photography. However, they do not take into consideration the quality of the illumination, the spectral sensitivity of the film, or the color characteristics of the subject.

Classification of filters

All filters absorb light or other radiant energy. To understand filters better, let us classify them on the basis of how they function or what they are used for.

Filters can be classified in three broad categories: (1) filters that absorb selectively according to color or wavelength form the largest class, commonly labeled *color filters* (though it includes colorless filters that absorb invisible radiation); (2) filters that absorb all colors similarly (they appear gray and are identified as *neutral density filters*); (3) filters that absorb selectively on the basis of the angle of polarization. When polarized light falls on such a filter, the transmittance can be altered by rotating the filter, identified as a *polarizing filter*. Polarizing filters are also neutral in color.

Because of the large number and variety of color filters, they are commonly assigned to subcate-

gories. A given filter may appear in more than one subcategory when it is used for different purposes. Some common subcategories of color filters are listed below.

(1) Contrast filters. Contrast filters either freely transmit or largely absorb light of selected colors, such as red, green, blue, cyan, magenta, and yellow. They are used in black-and-white photography to produce significant changes in tone reproduction. Some contrast filters are also used for color photography, for example, in making color-separation negatives. When used for this purpose, they may also be identified as tricolor filters, color separation filters, etc. (Some references use the term *contrast filter* for any filter that is used to alter the tone reproduction of color subject areas in black-and-white photographs. The term is meaningless when used this way, because it includes all color filters used in black-and-white photography, including correction filters.)

(2) Conversion filters. Conversion filters enable color films to be used with other types of illumination than the ones they were manufactured for, as when a tungsten-type film is used with daylight.

(3) Light-balancing filters. Light-balancing filters are similar to conversion filters, but produce smaller changes in the color quality of the illumination. They are used, for example, with color films to compensate for the change in color temperature of tungsten lamps with age.

(4) Correction filters. Although the differences between daylight and tungsten illumination are less important for black-and-white photography than for color, these differences do cause some colors to be recorded too light or too dark to appear natural. Correction filters modify the color quality of the light so that the tones in black-and-white photographs correspond more closely to the way the eye would see the relative lightnesses of the subject colors.

(5) Color-compensating filters. Color-compensating filters are produced in six hues (red, green, blue, cyan, magenta, and yellow), and in a variety of densities (from .025 to .50). Used extensively in color printing, they are also used on camera lenses to produce controlled changes in the color balance of color transparencies.

(6) *Ultraviolet filters.* Ultraviolet filters have high transmittance to ultraviolet radiation, but absorb essentially all light (visible radiation). They are used on camera lenses in types of technical and scientific photography for which it is desirable to form the image entirely with ultraviolet radiation.

(7) *Ultraviolet-absorbing filters.* Haze and barrier filters both have low transmittance of ultraviolet radiation, with variations in transmittance of blue. Haze filters are used mostly for distant outdoor scenes, photographed on either black-and-white or color film, to increase the contrast of distant objects. Barrier filters are used for fluorescence photography, to prevent reflected ultraviolet radiation from obscuring the fluorescent effect.

(8) *Infrared filters.* Infrared filters for black-and-white photography have high transmittance of infrared radiation and low transmittance of ultraviolet radiation and light. They are used for both outdoor and indoor photography where it is desirable to form the image mostly or entirely with infrared radiation. Infrared filters for color photography are yellow to absorb ultraviolet and blue radiation, permitting the formation of three images on different emulsion layers with infrared, green, and red radiation.

(9) *Viewing filters.* Two types of viewing filters have been used. One type transmits colors that correspond to the spectral sensitivity of the film being used, to show how various subject colors will be recorded in black-and-white photographs. The other type is used to judge the lighting on a scene. The eye can normally see detail over a much larger range of subject luminances than can be recorded in the photograph. Viewing the subject through a dense neutral filter reduces the light level nearer to the threshold of sensitivity and reduces the ability of the eye to adapt to local variations in luminance within the subject.

Predicting filter effects

It has been said that the only way of proving whether a piece of film has been exposed or not is to develop the film. Similarly, the best way of determining the effect of a given filter is to make photographs with and without the filter. Fortunately, however, there are methods for predicting filter effects which help us to select the best filter for a given situation. If we limit our photography to panchromatic black-and-white films and color films, simply looking at the scene through the filter works surprisingly well. This method assumes that you have an appropriate variety of filters available, that the film responds to colors in about the same way as your eye, and, in black-and-white photography, that you are able to concentrate on the lightness of the subject colors while disregarding their hues and their saturation.

Thus, in making a black-and-white photograph, if the subject appears to blend with the colored background, we can look through several filters to find one that will either lighten or darken the background to provide the desired tonal separation. This technique has also been used successfully in color printing: the first test print is examined through color-compensating filters to determine the change in filtration on the enlarger that is needed to improve the color balance. The same procedure can be used when exposing color film in the camera when the intention is to produce a mood or other expressive effect rather than a faithful reproduction of the scene. The visual inspection method is especially appropriate with polarizing filters, where the effect is varied by rotating the filter. Whether the polarizing filter is used to darken blue sky or to control glare reflections, the visual effect is a good indicator of the photographic effect, since the relationship is not affected by differences in spectral sensitivity between the eye and the film. It is only necessary to be sure that the polarizing filter is rotated in front of the camera lens to the position that produced the desired visual effect.

Another method for predicting the effect a filter will have on a photograph is based on understanding the basic action of a filter in absorbing and transmitting colors. Absorption curves show this action wavelength by wavelength with considerable precision, but it is more useful, for most black-and-white photography, to think in terms of the three primary colors—red, green, and blue—and the corresponding complementary colors—cyan, magenta, and yellow. Since a filter transmits its own color and absorbs others, it will lighten the tones that represent its own color and darken others in the print. A subject area having a color that is absorbed by a filter will be thinner on the negative and, therefore, darker on the print: thus, a red filter will lighten red

subject areas and darken blue and green. Since cyan contains blue and green, both of which are absorbed by a red filter, cyan subject areas will be darkened also. It may be less obvious that a red filter will tend to lighten both magenta and yellow subject colors. Since magenta contains red, which is transmitted by a red filter, and blue, which is absorbed, one might assume that the two effects would cancel each other, and that there would be no change. However, the filter transmits a larger proportion (half) of the light from the magenta subject area than the one-third it transmits from a neutral subject area that contains red, green, and blue, which will remain unchanged in density on the print. We need not go through this reasoning process every time we use a filter. Referring to the color triangle in Figure 5, a general rule is that a filter lightens its own color and the two adjacent colors, and darkens the others.

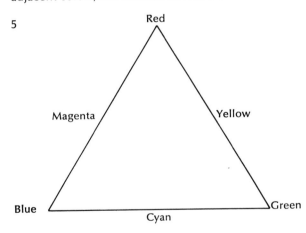

5

For example, a blue filter lightens blue, cyan, and magenta subject colors, and darkens yellow, green, and red. A yellow filter lightens yellow, green, and red, and darkens blue, cyan, and magenta.

Situations that involve invisible ultraviolet or infrared radiation do not lend themselves to either of the above methods for predicting filter effects. However, by examining a spectrogram for infrared film (Figure 6), and the absorption curve for a filter recommended for use with the film (Figure 7), it is easy to anticipate the photographic effect.

This film has sensitivity in the long-ultraviolet and blue region in addition to its sensitivity to infrared radiation, but since the filter transmits practically no

6

7

radiation in the ultraviolet-blue region, only infrared radiation can reach the film to form an image. Of course, we must also know whether the illumination on the scene contains infrared radiation. Most light used for conventional photography, including fluorescent lamps, flashbulbs, and electronic flash tubes, as well as daylight, contain enough infrared radiation for black-and-white infrared photography.

Similarly, we can predict the effects of using two different types of filters with a conventional panchromatic film which, as illustrated by the spectrogram in Figure 8, is sensitive to some ultraviolet radiation.

8

A filter having the absorption curve shown in Figure 9 will transmit long-wavelength ultraviolet radia-

9

tion freely but will absorb all of the light, so that the image will be formed entirely with ultraviolet radiation, whereas the filter represented in Figure 10 will absorb the ultraviolet radiation and transmit the light.

Applications

It is impossible to list all possible applications of filters to picture making. In the field of expressive photography, the applications are limited only by the photographer's imagination. But let us consider some common photographic problems that can be solved by using the proper filters.

To lighten or darken certain colors. The first experience many photographers have with filters results from a desire to control the tone of blue sky in outdoor photographs. Since the sky tends to be reproduced a little lighter on photographs than it appears to the eye, some darkening is necessary for a natural effect, and an exaggerated darkening is often more pleasing. Recalling that yellow is opposite blue on the color triangle, we can predict that a yellow filter will absorb blue and make it look darker in a black-and-white print. Light, medium, and deep yellow filters absorb increasing proportions of blue, and the amount that the sky is darkened increases in the same order; but even the most saturated yellow filter will not produce a black sky. So-called "blue" sky actually contains considerable green light, which is transmitted by yellow filters. Therefore, a red filter will darken the sky more than a deep yellow filter. The maximum effect is obtained by using infrared film with a filter that transmits only infrared radiation, of which there is very little in "blue" sky. Of course, it is also possible to lighten a blue sky to produce a stark effect, or to increase the contrast between the sky and a darker object, by using a blue or cyan filter.

Complications will obviously result if we try to darken the sky in color photographs with the above filters. Even in black-and-white photography, the yellow and red filters may produce undesirable tonal changes in other subject colors. If only a slight darkening is desired, a colorless or nearly-colorless ultraviolet-absorbing filter, such as the Leitz UVa filter or the Leitz Skylight filter, can be used (the coating on modern Leitz lenses has similar ultraviolet-absorbing characteristics to the UVa filter). A polarizing filter, however, will produce a considerable range of darkening effects simply by rotating the filter, and since it is neutral in color, it can be used for both black-and-white and color photography. Much of the light from blue sky is polarized, but the relative amount of polarized light does not depend entirely upon the saturation of the color of the sky. More darkening

can be obtained at right angles to the direction of the sunlight than when shooting generally toward or away from the sun. Another way to darken the sky without altering the foreground is the sky filter: a filter that is smoothly graded from clear on one side to colored on the other. Sky filters are usually yellow for black-and-white photography and blue for color photography. Such filters must be placed on the camera lens with the colored portion uppermost.

It is a mistake to assume that a given filter will always produce the same effect on the sky. A medium yellow filter may darken the sky more in one photograph than a red filter will in another. The blueness of the sky not only increases from the horizon to the zenith, but it also varies with the time of day, with atmospheric conditions, and with other factors. When the sky is completely overcast, even a red filter will have little or no effect on the sky tone.

Before we can decide whether to use a filter to lighten or darken certain subject colors in a black-and-white photograph, we must visualize how the colors will be reproduced without a filter. This ability can be developed by concentrating on the lightness qualities of the subject colors. For example, experienced photographers can predict when a red object and a blue background will blend together on the photograph, even though the hue contrast is vivid to the eye—and therefore they select a filter that will lighten one color and darken the other. Tonal separation between subject areas is often essential for successful photographs, but the change in mood produced by lightening or darkening selected subject colors with filters may be even more important. Because the perception of mood is subjective, the precise effect on the photograph is hard to predict, but a good preview can usually be obtained by looking at the subject through the filter.

Panchromatic black-and-white films do not match the human eye with respect to the reproduction of the lightness qualities of subject colors, either in daylight or in tungsten illumination. The discrepancy is subtle and usually not objectionable, but when the most natural effect is desired, a medium yellow correction filter should be used outdoors, to darken blues, and a yellowish-green correction filter should be used with tungsten illumination, to darken reds and blues.

To alter the appearance of haze. The appearance

of atmospheric haze is due to scattered radiation. Since short-wavelength radiation is scattered more than long-wavelength radiation, haze is rich in ultraviolet and blue. So the appearance of haze in photographs is controlled in much the same way that blue sky is darkened. Haze superimposes a uniform amount of light on the light from distant objects, reducing the contrast of the image. If the light from the haze is relatively intense, it can obscure the image completely. Haze tends to be more apparent in photographs than it is to the eye, and its appearance in pictures made on panchromatic film is reduced with increasing effectiveness by filters that range from light yellow to deep yellow to red. The maximum reduction is obtained by using infrared film and a filter that transmits only infrared radiation. Polarizing filters are not effective with haze. The appearance of haze can be increased for a mood or for pictorial effect by using a blue filter. With color films, haze control is limited to the use of colorless or nearly-colorless ultraviolet-absorbing filters for realistic effects, although haze can be reduced greatly with infrared color film, which also produces false-color effects.

To control reflections. Most glare reflections from non-metallic surfaces consist partly of polarized light. The proportion of glare light that is polarized varies with the angle at which the surface is viewed or photographed, reaching a maximum of nearly 100% at an angle between thirty and forty degrees to the surface, depending upon the material. Thus, a polarizing filter can often be used to eliminate or reduce glare reflections on the subject being photographed. At the optimum angle, the reflection can be reduced to any desired degree, or completely eliminated, by rotating the filter through ninety degrees. At other angles, the reflection may be reduced but not eliminated.

Glare reflections occasionally contribute to the effectiveness of photographs, but they often conceal desired details, take attention away from more important parts of the subject, and, in color photographs, desaturate subject colors. Even on subjects that do not have glossy surfaces, the increased color saturation gained by adding a polarizing filter is often significant.

When a subject can be illuminated with polarized light by placing a large polarizing filter in front of a studio lamp, glare reflections can be eliminated with a polarizing filter on the camera lens, regardless of the angle at which the surface is photographed or the nature of the reflecting material. This is especially useful when copying oil paintings or other surfaces that have a high sheen, where the camera must be aligned perpendicular to the surface.

To control exposure. Occasionally there are situations where the major problem is to reduce the amount of light that reaches the film. Ordinarily, the shutter and aperture provide more than enough control to obtain correctly exposed negatives and transparencies. A Leicaflex with a Summicron-R f/2 lens enables the photographer to alter the exposure over a range of 128,000 to 1, with shutter-and-aperture combinations that range from one second at f/2 to 1/2000 second at f/16. However, the photographer may want to use a larger aperture or a longer exposure time than is indicated for correct exposure, in order to obtain shallow depth of field or an intentionally blurred image of a moving object. In photographing a waterfall, for example, he may want to leave the shutter open for several seconds so the moving water will be recorded as a smooth blur, and at this exposure time, even the smallest aperture will overexpose the film. Neutral density filters, made in a wide range of densities, can be used in such situations to control exposure. If the correct exposure time at the selected f-number is 1/50 second in the example above, and the photographer wants to expose for 2 seconds, a filter that transmits 1/100 of the light is needed. The corresponding density is 2, the logarithm of 100.

Other examples of the use of neutral density filters to reduce exposure are: to pan the camera along with a moving object at a slow shutter speed, to produce a blurred background; to use a time exposure with a scene that includes moving people or other objects, to make them disappear in the photograph; to photograph a very bright object, such as a lamp filament; and to expose correctly a closeup photograph made with an electronic flash lamp that has no intensity control.

To alter color temperature. Color films manufactured for use with specific light sources can be used with other light sources by changing the color quality of the light that enters the camera with appropriate filters. Color films are made for three different color temperatures of illumination: 5500 K (photographic daylight), 3400 K (photoflood lamps),

and 3200 K (tungsten studio lamps). When all photographs on a roll of film will be exposed with one type of light source, it is normally best to use the corresponding type of film without a filter. Some photographers buy extra camera bodies so they can change from one film to another without having to remove an unfinished roll from the camera. Although negative color films permit color-balance correction at the printing step, it is usually advisable to use the same filters on the camera that are recommended for reversal color films. (See table, page 202.) Electronic flash and blue flashbulbs are usually treated the same as daylight, but it is a good idea to run a photographic test, since the color quality of such sources varies somewhat in practice.

The nomograph on the next page shows the recommended filters for a number of sources, including household-type tungsten lamps. The color temperatures listed are average values which, for critical work, should be checked with a color-temperature meter or by practical testing.

Fluorescent lamps present a special problem. Since their spectral-energy distribution curves do not closely resemble those of the standard source, the color temperature does not necessarily give an accurate indication of the photographic effect. However, experiments have been conducted to determine suitable filters for various types of fluorescent lamps. The table below gives recommended filters and exposure factors for Kodak color films:

In practice, it is often difficult to identify the type of fluorescent lamp used in an area without contacting the appropriate person on the building maintenance staff.

A number of factors can cause incorrect color balance in a transparency, even though the film and the light source are ostensibly matched; these include film variations and processing variations. One of the more predictable factors, which can therefore be corrected with appropriate filtration, is the change due to reciprocity-law failure with long exposure times. Most color films not specifically designed for long exposure times require filtration and exposure compensation for reciprocity-law failure when the indicated exposure time is one second or longer. The color shift is consistent for a given film, but varies between films. Filtration and exposure data should be obtained from the film manufacturer or determined by testing.

Special effects. In addition to their uses in producing realistic images, filters make possible a variety of special effects. Many photographers have discovered the beauty of the warm colors of sunset scenes photographed on daylight-type color film without a filter. Such scenes can often be enhanced by increasing the color saturation with a red or orange filter over the camera lens. Similarly, a blue filter can be used with a snow or water scene, a yellow filter for a hot summer day photograph, a magenta filter for a romantic effect, and so on. Subtle effects can be

Filters for fluorescent light

Type of fluorescent lamp	Type of Kodak color film		
	Daylight type	Type B and Type L	Type A
Daylight	40M + 30Y + 1 stop	No. 85B + 30M + 10Y + 1 stop	No. 85 + 30M + 10Y + 1 stop
White	20C + 30M + 1 stop	40M + 40Y + 1 stop	40M + 30Y + 1 stop
Warm White	40C + 40M + 1-1/3 stop	30M + 20Y + 1 stop	30M + 10Y + 1 stop
Warm White Deluxe	60C + 30M + 1-2/3 stop	10Y + 1/3 stop	no filter none
Cool White	30M + 2/3 stop	50M + 60Y + 1-1/3 stop	50M + 50Y +1-1/3 stop
Cool White Deluxe	30C + 20M + 1 stop	10M + 30Y + 2/3 stop	10M + 20Y + 2/3 stop

Note: increase exposure by amount shown in table.

Reproduced with permission from Kodak publication No. AB-1, Filters for Black-and-White and Color Pictures.

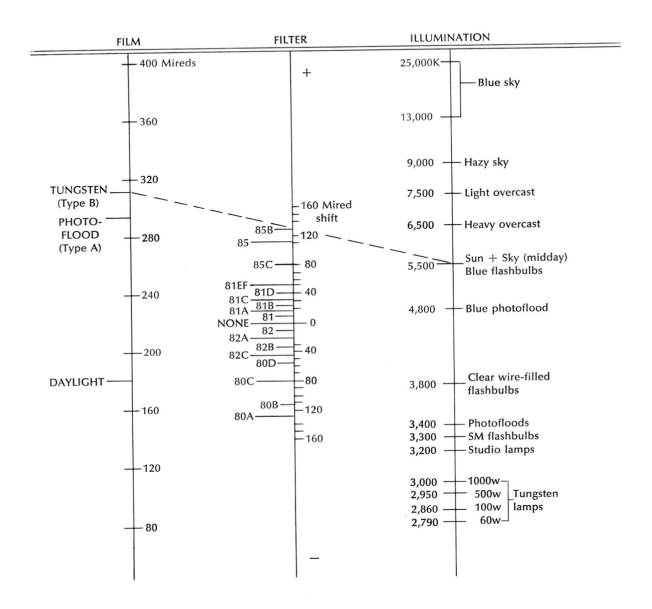

Figure 11.
Nomograph of filters to use for various combinations of color film and illumination. A straight line from the film on the left to the light source on the right identifies the appropriate filter in the center

obtained with the low-number color-compensating (CC) filters and light-balancing filters, and more dramatic effects can be obtained with high-number CC filters, conversion filters, and contrast filters. Although looking at a scene through a filter will assist in predicting its effect on the photograph, it should be noted that the visual effect gradually decreases with prolonged viewing due to color adaptation in the human visual system, which tends to compensate for changes in the color quality of light.

Other special effects in color include photographing through a mosaic of gelatin filters, so that different areas of the subject are colored differently in the picture; exposing through red, green, and blue tricolor filters in sequence, so that stationary objects receive the equivalent of white light exposure, while moving objects produce strongly colored image areas; and using gels of different colors over light sources for indoor photographs.

Invisible ultraviolet and infrared radiation can be utilized with appropriate films and filters to reveal detail that cannot normally be seen. Besides the numerous applications of filters and short- and long-wavelength radiation to photography for scientific, legal, medical, and other purposes, such combinations provide the pictorial photographer with a valuable means of producing unusual and exciting visual effects.

Adding filters. In most situations, a single filter can be used on a camera lens to achieve the desired effect, but some situations require combining two or more filters. Note, however, that certain filters cannot be used in combination because all the light that is transmitted by one filter is absorbed by the other. This is generally true of contrast filters; for example, efficient red and blue contrast filters will transmit essentially no light when superimposed.

Neutral density filters are manufactured in density increments of 0.10 up to a density of 1.0, and, from there up, in increments of 1.0. Thus, a density of 1.3 can be obtained by combining 1.0 and 0.30 filters. The *density* of the combination is the sum of the densities of the individual filters, but the *filter factor* of the combination is the product, not the sum, of the factors of the individual filters. For example, a 1.0 filter has a factor of 10 (the antilog of 1.0), and a 3.0 filter has a factor of 2. The factor for the combination is 10 x 2 =20, the antilog of 1.30. Neutral density filters can also be used together with color films—for ex-

ample, to equalize the filter factors of tricolor filters used in sequence for a multiple-exposure special effect, as described above.

Color-compensating filters of the same color are treated in the same way as neutral density filters. For example, a 20Y filter and a 30Y filter, combined, are equivalent to one 50Y filter (the actual densities are .20 + .30 = .50). It is also possible to produce the equivalent of red, green, and blue filters by combining corresponding pairs of cyan, magenta, and yellow filters; for example, 50Y plus 50M equals a 50R filter. Note that in this situation there is a change of hue, but not of density.

Two or more light-balancing or conversion filters can be combined to control color temperature, but the effect must be calculated in mired-shift values. For example an 81 filter (mired-shift value of 9) plus an 81A filter (mired-shift value of 18) equals one 81B filter (mired-shift value of 27).

The greatest advantage of combining neutral density, color-compensating, light-balancing, and conversion filters in this way is versatility. A greater variety of effects can be achieved than if we were limited to using single filters.

There is seldom any occasion to combine two polarizing filters on a camera lens, although they can be used as a variable neutral density filter (by rotating one of the filters) to photograph extremely bright objects. A polarizing filter can be combined with color filters, such as a red contrast filter, for example, to darken a blue sky more than either filter would alone. Two or more polarizing filters are required, one over the lens and one over each light source, to control reflections on metallic and non-metallic objects that are photographed at other than the optimum angle. Two polarizing filters are used in a different way for stress analysis in translucent or transparent materials. Here, the object is photographed on a light box, with one polarizing filter beneath the object, and the other above, usually on the camera lens, rotated at right angles to the first.

Variations in filter effects

Statements that overexposure can cancel the effect of a filter and underexposure can exaggerate the effect have occasionally appeared in print. Such statements should not be interpreted as meaning that the proportion of light of a given color that a filter absorbs changes with the exposure level. Tone

reproduction depends upon a number of factors. An unintentional change in one of these factors, such as contrast or overall density, when a filter is used, can make it difficult to evaluate the effect of the filter. For example, if a series of color slides are made with half-stop variations in exposure, all without a filter, the darker sky in the underexposed slides may give the impression that the sky has been darkened with a filter, even though the entire slide is darker than normal, not just the sky. Similarly, printing a black-and-white negative on different contrast grades of paper may result in the sky (or other colored area) being recorded as different tones, so that one print looks as though a filter had been used on the camera, but the other does not. To determine the effect of a filter, make comparison photographs with and without the filter. Include a gray scale in the scene so you can be sure the photographs match in density and contrast for neutral subject areas.

Physical types of filters

Most filters are made of gelatin, gelatin laminated between glass, and solid glass. Dyed gelatin filters are the least expensive, can be produced with a great variety of absorption characteristics, can be cut to any size or shape, and have little effect on image definition, but they are awkward to handle and are easily damaged. Laminating the dyed gelatin between glass provides protection, but at higher cost, and with a possible loss of definition due to slight deviations from flatness of the glass surfaces. Solid glass filters are the most durable of the three types, but are the most limited in their range of absorption characteristics. Leitz filters for black-and-white photography are solid glass, whereas the polarizing and color-photography filters are laminated.

Image definition

Under certain conditions filters can improve image definition, for example, by increasing image contrast between subject colors, or by reducing haze or glare. It is important, however, to recognize and guard against the possible image-degrading effects filters can have. Gelatin filters are generally considered superior to both types of glass filters with respect to definition. Because gelatin filters are thin, they tend to produce little change in the direction of rays of light. Gelatin filters are easily damaged, though, and dirt, scratches, and other imperfections can offset this optical advantage by causing excessive scattering of image-forming light. Relatively small variations in thickness of glass filters cause rays of light from an object point to be deviated differently, lowering image definition. The glass in the highest-quality filters is ground flat, with the same precision as a lens.

Glass filters can also produce a slight focus shift due to the thickness of the glass. This effect is usually negligible, but, since the shift can be as much as one-third of the thickness of the filter in closeup work, thin filters are preferable. (Leitz solid-glass filters are unusually thin, with an average thickness of .066 inch.) Compensation for focus shift is automatic when the image is focused through the filter with a single-lens reflex camera such as the Leicaflex. Another type of focus shift, related to the use of filters, but not caused by them, is due to the inability of photographic lenses to focus ultraviolet and infrared radiation in the same plane as visible radiation. Therefore, when using black-and-white infrared material, the lens-to-film distance should be increased slightly (by focusing on a slightly closer distance than the subject); and when exposing by ultraviolet radiation, the lens-to-film distance should be decreased slightly (by focusing on a slightly farther distance than the subject). It is also advisable to use the smallest possible aperture to increase depth of field and depth of focus.

Filters for various film-light source combinations

FILM	LIGHT SOURCE			
	Daylight (5500K)	Tungsten (3200K)	Photoflood (3400K)	Clear Flash (3800K)
Daylight	None	80A	80B (Leica Photoflood)	85C
Type A (Photoflood)	85 (Leica Type A)	82A	None	81C (Leica Flash)
Type B (Tungsten)	85B	None	81A	81EF

Getting the Most out of Black-and-White Film

Bill Pierce

The principles and procedures that enable you to get the best results with your black-and-white film are simple. With a little experimenting and intelligent evaluation of your day-to-day photography, you can soon have a standardized, repeatable metering and processing procedure that will not only optimize the technical quality of your pictures, but will let you use exposure and development to reinforce your own pictorial tastes.

The principles

(1) Expose your film properly. Exposure controls shadow detail. If you haven't given enough exposure to place the detail that is pictorially important to you on the film, no amount of development and no special-purpose developer will put it there. Indeed, the ASA system for determining film speeds deals with densities that represent shadow values in the negative because these densities are relatively unaffected by the degree of development.

(2) Develop your film properly. Just as exposure controls the shadow values, development controls the highlight detail. While shadow values stay relatively constant, the densities in the negative that represent highlights are increased when you develop longer. To say it in another way, you increase negative contrast by lengthening development and decrease contrast by shortening the film development. After a period of trial-and-error, you can arrive at a personal developing time that will allow you to print the great majority of your negatives on a single contrast grade of paper. These will be "straight" prints, with burning-in and dodging reserved as creative, rather than corrective, tools. "Softer," lower-contrast papers and "harder," higher-contrast papers will be reserved to compensate for unusually flat or harsh scenes, or to create effect.

The procedures

If exposure controls the shadow values, then our metering for exposure must take these shadow values into account. A "ritual wave" of the meter that measures only the average brightness of the scene (reflected-light metering), or the light falling on the scene (incident-light metering), is relatively useless if you are looking for consistent, photographer-controlled tonal interpretation. The picture will "come out," because a statistically determinable relationship between average light values and shadow values will produce acceptable results most of the time. But we are looking for better-than-acceptable results, and we will try to get them all the time.

There are a number of ways to stop playing the averages and start metering the shadows.

One of the simplest is to point a reflected-light meter at a shadow and base your exposure on this shadow reading. But when a single shadow is all that it measures, a meter calibrated to indicate proper exposure when it integrates or averages all the brightness values of an entire scene will suggest an exposure that would render that shadow an average or middle gray in the final picture. A picture with middle-gray shadows would be both weird-looking and overexposed. Unless we are after a very unusual effect, we want pictures with dark gray shadows. As a rule of thumb, if we meter a shadow directly, and expose two stops less than the meter recommends, we will produce the darkest gray tone that separates easily from the black values in the final print, and shows texture and detail clearly. An exposure decrease of only one stop from the meter's suggested exposure produces the bright, open shadow that might be desirable in a studio portrait or a product shot.

In theory, shadow metering is the best way to determine exposure for black-and-white negative film. It has, however, two disadvantages for the Leica photographer. First, using an exposure which produces a fixed shadow value in the negative, and then using a single, standardized development time for all your rolls of film will produce negatives with almost as much variety in their density ranges as the variety in brightness ranges in the original scenes. To print these greatly varied negatives, you would need enlarging papers with contrast grades from one to six. The shadow metering technique is easier for the view camera user, who can develop individual sheets of film for different times, altering their contrast and allowing them to print on a smaller selection of paper grades. Secondly, the Leica photographer who works with fast-moving subjects may not have time to make specific readings of shadow values. The shadow metering technique is easier for the photographer who works with relatively static subjects.

Leica photographers may find it easier to use metering techniques that simply bias the exposure in favor of the shadows. These techniques may not produce as much shadow detail as the pure shadow reading, but they will give more shadow detail than "ritual wave" metering, while they also allow films that have been given standardized development to print on a mid-range of paper grades. These intelligent compromises can also save you time.

One popular compromise technique is to take a reflected-light reading of the darkest important shadow and of the brightest important highlight, then use an exposure midway between these extremes. With a conventional reflected-light meter, you will have to take closeup readings of the shadows and highlights you consider important. Spot meters or selected-area meters such as the through-the-lens meters in the Leicaflex SL and the Leica M5 may let you take these readings from the camera position. But even then, it will take time to locate the areas you want to read, meter them, and calculate the "in-between" exposure.

A time-saving technique is to meter the palm of your hand, first as it faces toward the main light source for the picture, then as it is held in the shadow or turned away from the light. The palm of your hand is lighter than the middle-gray tone for which most meters are calibrated, so, for subjects of average tone, you will have to give one stop more exposure than the "in-between" meter indication for your hand. If the subject is unusually light in tone, use the "in-between" hand-reading exposure directly. If it is unusually dark in tone, compensate for this by giving four times the "in-between" hand-reading exposure. Even with all these second thoughts, you should be able to arrive at an effective exposure within twenty seconds.

A similar technique can be used with incident meters. The meter cell is first pointed toward the main light source for the picture; then the meter cell is turned away or shielded from the light to produce a shadow reading. You use a compromise exposure halfway between the two extremes.

What do you gain from these exposure techniques? Under low-contrast conditions, the exposure they give you is little different from the one you would get from the "ritual wave." Indeed, under shadowless conditions, the exposure these two techniques indicate would be similar to those you

have been getting with conventional reflected-light and incident-meter techniques. But in high-contrast situations with very dark shadows, these techniques that take the shadow areas into account result in exposures that are often one to two stops greater than a single average reading would recommend. If a ritual wave of the meter has been giving you good results in low-contrast situations, but short-changing the shadows in contrasty situations, you will want to use the same exposure index (ASA or DIN setting on the meter) with a two-reading system. If contrasty scenes have been satisfactory, but low-contrast scenes have produced denser negatives than you need for shadow detail, you can set your meter to a higher film-speed number. If every scene has been rendered properly at the exposures given by a ritual wave of the meter, you are probably one of those photographers who intuitively "opens up a little, just to be sure" when he sees a contrasty scene that demands fully detailed shadows. Keep your meter setting, but eliminate your guesswork with a metering technique that actually measures shadow values.

Shadow-biased two-reading systems are inappropriate for some scenes: (1) those in which the shadow detail is not important; (2) scenes with no shadows or dark values; and (3) contrasty scenes with shadows so dark and detailless that exposing for shadow detail would not only be a misinterpretation of the scene, but any attempt to do so would produce—with normal film development—a negative with blocked, unprintable highlights.

How do you meter these scenes? You expose for the important highlights and let the shadows, if any, go black. You can take a reflected-light reading of the highlight areas. Since you don't want to render these areas as a middle gray, you can open up the lens one stop to produce a lighter-than-middle gray that is suitable for a flesh tone, or you can open up two stops to produce a still lighter gray that will nevertheless hold clear detail when printed.

You can point the incident-light meter directly toward the main light (a contrasty situation always has a main light source). This minimum exposure will enhance tonal separation and definition in the light values and guarantee freedom from blocked highlights. If you want to pick up a little detail in some of the darker values, you can open up a stop

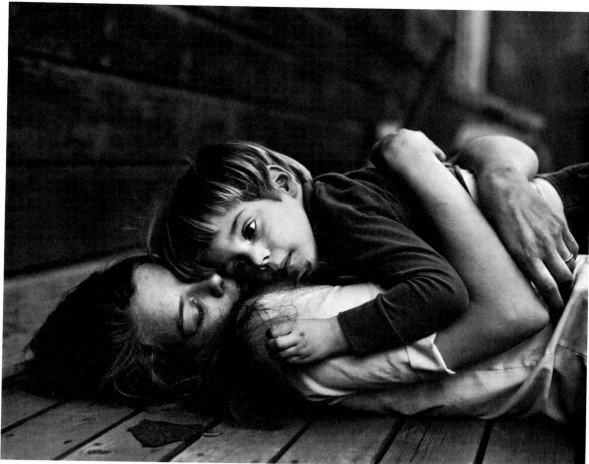

Full exposure, proper development permit beautiful prints on normal-grade paper, with rich detail in dark areas, lustrous texture in light areas. Photograph copyright 1970 by Bill Pierce

or two before most black-and-white films will show any sign of blocking up. But don't expect the film to capture the entire range of brightness that your eye can see in a very contrasty scene. Try to see like a camera and previsualize the scene with detailless, but dramatic shadows. (Squinting can help.) Compose your pictures accordingly, and don't let pictorially important detail fall into those shadows.

Processing

The two classic enemies of small-negative definition have always been overexposure and overdevelopment. By some standards, our shadow-biased exposures are generous. It is still possible to destroy the definition of a film by overexposing it, but you must go much farther than we are going to impair definition much in today's films, with their thinly-coated emulsion layers. As long as our development is such that we avoid excess highlight density in the negative, we are safe. Within reason, the more we hold that density down, the better the definition. Even conservative sources are turning to the point of view that a lower-contrast negative printed on a higher-contrast paper is more favorable than the alternative combination, and that we can get better sharpness from miniature negatives by working for a negative that prints

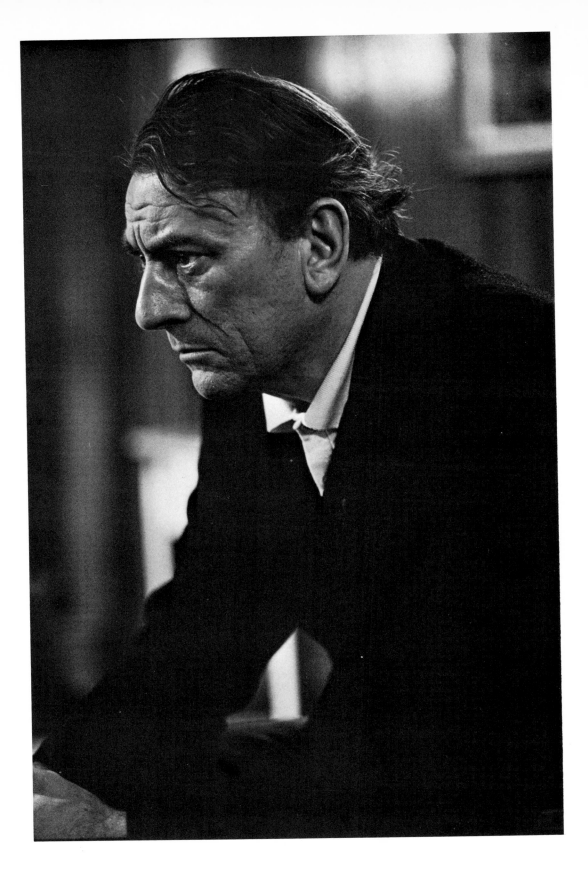

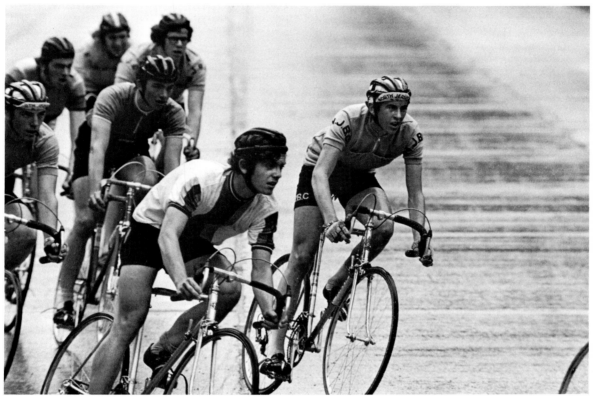

normally on grade three paper, rather than the conventional choice of grade two.

No one can tell you how long to develop your film. There are too many variables in the process that leads to the final print. But it does make sense to optimize definition by arriving at a personalized development time that will let the great majority of your negatives print on the slightly-contrasty number three paper. Not only is definition enhanced, but you are working from the midpoint of the contrast range. Softer-than-normal scenes can be printed on number four paper; harsh scenes, on number two. You will seldom, if ever, need number one paper. This is all to the good: while the dif-

Exposure for the most important area, the face, left dark areas underexposed. "Push" processing would have produced overly dense highlight accents and excessive grain. Instead, normal negative processing and high-contrast printing paper were used. Photograph copyright 1970 by Bill Pierce

A flat, or low-contrast situation: dim general light, rainy day, long-focal-length lens. Moderately extended development and a paper one grade above normal contrast solved the printing problem. Photograph copyright 1971 by Bill Pierce

ference in definition is subtle between negatives that require number two and number three paper, a negative with a density range that demands number one paper or its variable-contrast equivalent usually shows some loss of definition. Many printers feel that extremely low-contrast papers do not provide the rich blacks and clear shadow separation afforded by more normal papers. You may sometimes need to use the extremely high-contrast papers at the other end of the contrast range. The relatively low-contrast negative which normally prints on a grade three paper can drop even further down in contrast if there is serious lens flare or accidental under-exposure. There are times when such a

negative can not be rescued with number four paper. While number five or six will save the day, their minimal exposure latitude under the enlarger, the tendency of some extreme-contrast papers to show a different print tone from that of their softer brethren, and the higher visibility of dust and scratch marks on the negative in contrasty-paper prints make it unwise to standardize on a negative of such low contrast that these papers are used for more than emergencies.

Is all the detail you can see in your negatives clearly visible in your prints? This is the criterion by which you can determine how long to develop your film. As long as thermometers, water supplies, brands of paper, and personal taste vary from darkroom to darkroom, there is no simple test that can give the best possible development time for everyone's films. But evaluating your own negatives by printing them, keeping a notebook on the results, and gradually adjusting your development time until most of your negatives are producing excellent straight prints on a single grade of paper should lead you to an accurate personal development time within a few months. Since you are adjusting development time, not changing it radically, you don't have to lose a single picture in the process.

Every time you print a negative of a normal scene, make the first print a straight print on your standard paper. For the reasons already mentioned, I suggest a grade three paper. Print it for good highlight detail—nothing that is just a whisper below the white of the paper, but the kind of detail the viewer can see easily. Does all the shadow that is clearly seen in the negative show up on the print? If it is buried in the blacks of the paper, the negative has too great a density range, and you can improve the next negatives by shortening your film development time. If the clear areas of the film print gray instead of black under the same condition, the density range is too short, and you should increase your film development time. However, this situation may partly be produced by underexposure. Does the too-flat negative show all the shadow detail you wanted when you viewed the original scene? If it does, you are underdeveloping your film, not underexposing it. If the negative lacks shadow detail, increase your exposure (lower the film-speed setting on your meter) until you get all

the shadow detail you want. Then evaluate your negative contrast and adjust your development if you need to.

In general, contrasty scenes should print on a paper one contrast grade lower than your standard —number two instead of three—and flat scenes should print well on paper that is one grade contrastier—number four instead of number three. Keep notes on all the negatives you print. Over a period of several weeks you will see a pattern emerging: "Most of my negatives would have benefited from a little less development," or "Most of my negatives would have benefited from a little more development." Adjust your developing time by ten or fifteen percent and hold it there until you have printed and accumulated another stack of opinions. After a few months, you will find that any new changes you make are simply splitting hairs. You will have arrived at your personal optimum development time and the resulting negative quality that affords both high definition and the wealth of visual information in small areas of light and dark tone that can only come about when burning-in and dodging are reserved for creative, rather than corrective, effects.

By taking the time to work out your own best exposure and your own best development time for your favorite film you become a member of an exclusive club that doesn't have to be exclusive. The sharpness and the full tonal range from shadows to highlights that are mistakenly considered the province of larger-format work will show up in your 35mm work. A simple, standardized procedure will grant you these results consistently and with little effort.

Simple as it is, there is no other way to get optimum-quality results consistently than to understand the principles of exposure and development (that old chestnut, "Expose for the shadows and develop for the highlights"), and to take the time to work out the specifics in terms of your own photography.

Ultrasharp Black-and-White Photography with High Contrast Films

Jerry Katz and Sidney Fogel

Evolution toward quality

Throughout the history of modern photography, photographic workers have attempted to achieve a maximum degree of enlargement with a minimal loss in sharpness, coupled with relatively high film speeds and a large dynamic range — the film's capacity to reproduce in the negative a long scale of light-and-dark values in the subject.

Leica users traditionally demand equipment that is unexcelled in its imaging performance. They are typically acutely conscious of sharpness, image contrast, and all the highly subjective qualities related to the making of ultrasharp photographs.

The 1930s were marked by an explosion in the number of developer formulas published, usually accompanied by fantastic claims of fine or superfine grain. In the 1950s and '60s, faster, finer-grained films were made available. Thin-emulsion films such as Adox KB-14 made possible 35mm photography on a new level of fine grain and high resolution.

From a quantitative standpoint, the Leica photographer has found that if exposure and darkroom techniques are optimized, and high-resolution, fine-grain films such as Kodak Panatomic-X or Ilford Pan F are used, good-quality 30-diameter and 40-diameter enlargements can be achieved.

ASA speeds and exposure indexes

For clarity, we must distinguish between the terms, ASA film speed and exposure index.

ASA film speeds are standards established for the photographic industry by the former American Standards Association (now ANSI, the American National Standards Institute). The standard procedures for determining the ASA speed of a black-and-white film require the use of a particular developer formulation at a given temperature and pH.

American Standard pH 2.5—1960 specified the following developing solution:

ASA test developer

Air-free distilled water	500 milliliters
Monomethyl para-aminophenol sulfate (metol)	1.0 grams
Sodium sulfite (anhydrous)	25.0 grams
Hydroquinone	2.0 grams
Sodium carbonate (anhydrous)	3.0 grams
Potassium bromide	0.38 grams
Air-free distilled water to make	1000 milliliters

The pH of the developing solution is approximately 9.75 at 20°C. The temperature for development of test films is 20°C, with a tolerance of plus-or-minus one-half degree C. Other specified parameters include agitation, exposure time, light source, atmospheric temperature and humidity surrounding the sample film, development to a given *gamma* value (degree of contrast), and washing and drying methods.

Since photographers use neither the methods nor the developer formula specified by the ASA standard, they do not typically obtain comparable photographic results. Therefore they cannot consider the responsivity of their camera-film-developer-brain systems in terms of ASA speeds as determined in testing laboratories. Practical photographic situations include wide luminance differences within a single picture area, and wide variations in processing procedures — notably in temperature, the water used for solutions, and methods of agitation.

In practice, we adjust our luminance meters (popularly called reflected-light meters) to some film-speed value, such as 25, 32, 80 or 250, expose according to the meter reading, and then process. Using empirical methods, we then correct the ASA speed given by the manufacturer to a value that is consistent with our individual processes and needs. Thus we may find different photographers who use speeds of 20, 25, 32, 40 or 100 when exposing Panatomic-X, rated by Kodak at ASA 32. This empirically-determined film speed is termed *exposure index* (EI). (An EI number represents the same speed value as the same ASA number; thus EI 100 = ASA 100 for meter-setting purposes.)

Thin-emulsion high-contrast films

Microfilm materials that were initially designed for the high-contrast copying of documents and the printed page can also be processed to give continuous-tone images of unprecedented sharpness. The evolution of microfilms into similar films designed for pictorial use is now under way.

In April, 1959, Eastman Kodak marketed High Contrast Copy Film in the form of 100-foot rolls and 36-exposure cartridges of 35mm film. This material had previously been called Micro-File, and was distributed originally by Recordak.

Marilyn Levy published (Ref: *Phot. Sci. Eng.* 11, 46, 1967) a developer formula that could be used with Micro-File film for continuous-tone negative making.

By using Phenidone without the further addition of developing agents that produce super-additive effects, the contrast could be kept low while the toe speed—the film's sensitivity to low exposure levels —could be maintained. (Phenidone is a trade name used by Ilford for the developing agent, 1-phenyl-3-pyrazolidone. Its behavior resembles that of metol, but it can be used in much lower concentrations.)

Levy developer for High Contrast Copy Film

1-phenyl-3-pyrazolidone	1.5 grams
Sodium sulfite	30.0 grams
Water to make	1.0 liter

The availability of Kodak High Contrast Copy Film and similar 35mm microfilm materials, coupled with the publication of the Levy formula, established the initial conditions for the high-contrast-film, high-resolution, small-format wave of the 1970s. However, the Levy formula is relatively unstable, and produces variable results depending on the mixing techniques of individuals. Images produced on both High Contrast Copy Film 5069 and the H & W film using the Levy formula lack contrast. The Levy formula limits the range of densities that can be obtained. This formula is especially useful when overexposure has occurred.

In 1969, the H & W Company, of St. Johnsbury, Vermont, made available a packaged developer which, when used with Kodak High Contrast Copy Film 5069, yielded high-resolution, fine-grain negatives at an exposure index in the neighborhood of EI 25. However, the photographer was limited to a dynamic range of four to five stops. The extreme thinness of the emulsion, while making high resolution possible, resulted in a restricted range of densities.

In 1971, the H & W Company marketed an Agfa-Gevaert high-contrast fine-grain film, known in its microfilm applications as Copex Pan, under the name, H & W VTE Pan (VTE stands for *very thin emulsion*). When properly processed in H & W Control developer or the Levy formulation, this film produces ultra-sharp, fine-grained images having a range of five to six stops and an exposure index of 80. Delaware Photographic Products, of Buffalo and Rochester, N.Y., also manufactures an ultrasharp, fine-grain developer. Both the H & W developer and the Delaware Photographic Products developer produce high-quality images with broader density ranges than are obtainable with the Levy formula. The Delaware developer produces a slightly greater range of densities in the negative than the H & W developer, and achieves this range in 30 percent less processing time when used at 68°F.

Experimental results

The authors performed a development-time series, using the Anscomatic tank for processing. H & W VTE Pan film was chosen for sensitometry and for general-purpose photography because of its relatively high speed.

Utilizing a voltage-regulated Kodak 101 sensitometer, and processing in H & W Control developer, the following characteristic curves were obtained at a pH value of 10.50. (Figure 1).

The sensitometric strip from which the 14-minute curve was derived shows twelve or thirteen discernible steps. (Figure 2).

Photographers often ask, "Is it really possible to achieve high-quality results with good tonality using these films?" The photographs in this chapter were made by Jerry Katz with H & W VTE Pan and with Kodak High Contrast Copy Film 5069.

The films

Kodak High Contrast Copy Film 5069, processed in H & W Control developer or in the Delaware Photographic Products developer, yields excellent results at an exposure index in the neighborhood of EI 25. Slower than H & W VTE Pan, High Contrast Copy Film shows a slightly shorter density scale and a lower noise level than the H & W film.

Other films in the same class include Fuji H.R., and Ilford Micro Negative Pan (clear or white).

These films, used with high-quality camera optical systems, will enable many workers to engage in a new photographic experience. They can view their negatives in a microscope at magnifications ranging from 25x to 200x. At 25x the images will appear grainless, while only slight graininess is seen above 40x.

Before printing, it is useful to preview the negatives with a microscope: an inexpensive one will do. In almost every case, such previewing will locate interesting portions of landscapes or other subjects.

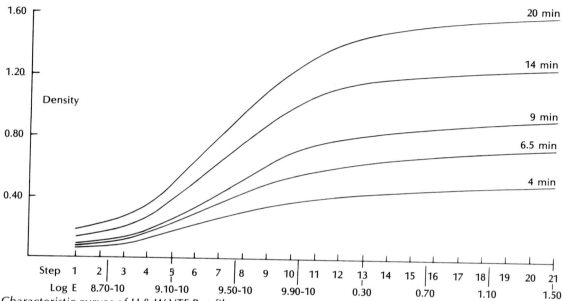

| Step | 1 | 2 | 3 | 4 | 5 | 6 | 7 | 8 | 9 | 10 | 11 | 12 | 13 | 14 | 15 | 16 | 17 | 18 | 19 | 20 | 21 |
| Log E | | 8.70-10 | | | 9.10-10 | | | 9.50-10 | | 9.90-10 | | | 0.30 | | | 0.70 | | | 1.10 | | 1.50 |

Characteristic curves of H & W VTE Pan film process-
ed in H & W Control developer (42ml stock
developer plus distilled water to make 32 ounces
working solution), for times of 4, 6½, 9, 14 and 20
minutes at 72°F, tank development. Kodak 101
sensitometer, Macbeth densitometer TD-404.
pH 10.50

Sensitometric strip representing 14-minute develop-
ment. More than twelve steps can be counted. The
H & W VTE Pan film was contact printed onto Kodak
Azo paper, grade 2. The print was developed one
minute in Kodak Dektol, diluted 1:2

Techniques for maximum sharpness

To achieve sharpness adequate for a high degree of enlargement (50x or more) with these films, use a tripod or a fast shutter speed, or both together, and focus with the utmost precision.

When using the Leicaflex with normal and shorter-focal-length lenses (50mm, 35mm, 28mm and 21mm) at large apertures and at distances of twenty-five to one hundred feet, a focusing series should be made. (After focusing as accurately as the eye permits, make an exposure at this focus, and others that are focused slightly closer and slightly farther, to compensate for errors too small for eye-judgment.)

Since longer lenses are easier to focus visually, they may not require a focusing series. However, these lenses will show any trace of camera movement more than shorter lenses will, so a tripod will be needed for optimum sharpness.

The rangefinder Leicas of the M series are ideally suited for photography with these films.

Maximum-sharpness checklist

For high degree of enlargement, your practice should conform to these specifications:

1. Camera cleaned, adjusted.
2. Tripod and/or high shutter speed.
3. Fresh film (H & W VTE Pan, Kodak High Contrast Copy Film 5069, Fuji H.R., or Ilford Micro Negative Pan).
4. Fresh developer. (Must be water-white; refrigerate concentrates; discard if discolored.)
5. A focusing series may be necessary when using single-lens reflex cameras with short-focal-length lenses.
6. Make an exposure series for each subject. Bracket in half-stop increments over a two-stop range (from one stop under to one stop over the exposure indicated by the meter), thus making five exposures per subject.
7. Shelter the camera from high wind.
8. Establish your own individual exposure index. For starting points, expose H & W VTE Pan at EI 80, and expose Kodak High Contrast Copy Film at EI 25.
9. To ensure repeatability, use distilled water for mixing the developer solution.
10. Wash and dry film in dust-free atmosphere.
11. Preview film with microscope (about 50x).
12. Use only first-rate camera optical systems and enlargers.
13. Process film to a gamma value in the neighborhood of 0.65 (see manufacturer's data).
14. Some concentrated developers show changes in pH and in contrast after a period of storage. Such variations will affect repeatability.

New films for new functions

In the past, photographers found that one negative size could not do all jobs. This is still true, but the new high-resolution films and techniques give the 35mm photographer an extended technical range and a new degree of freedom.

However, if you need a high-speed (EI 200 to 400) film with a wide dynamic range that can record a wide range of tones in a scene, and if you don't mind trading off this greater tonal range by accepting a corresponding graininess and loss of detail in enlargements above 40x, then H & W VTE and Kodak High Contrast Film are not what you want. If your work does not call for enlargements beyond 25x, or if you must work in dim light where you may have to underexpose by more than one-half stop, then thin-emulsion high-contrast films are not the best choice.

Historically, the 35mm photographer using such films as Plus-X, Tri-X, Panatomic-X and Ilford Pan F has generally thought in terms of 11x14-inch or smaller prints. If given the job of producing cropped prints in 16x20 or larger sizes, most would have reached for a larger-format camera. But today's photographer can carry a few rolls of the new high-resolution films, and can easily produce cropped, grainless 16x20 prints by following the checklist we have given here.

These films have created a new kind of photography: large, ultrasharp prints from 35mm negatives. This new photography combines the advantages of small, versatile, high-speed and high-precision cameras with the sharpness and fine texture and detail rendition that used to belong exclusively to large-format photography.

We predict that the 1970s will see continued breakthroughs in emulsion and processing technology, and that many new small-format cameras and ultrasharp films and developers will become part of the photographer's inventory.

George Eastman House. Leicaflex SL, 50mm Summi-cron-R; H & W VTE Pan; print from negative exposed at EI 64, based on camera-meter and 1-degree spot-meter median reading; exposure series, EI 40, 64, 80, 100. H & W Control developer; tank development, 13½ minutes at 72°F. Section below enlarged approx. 17x from same negative

Leicaflex, photographed with Leicaflex SL, 50mm Summicron-R; H & W VTE Pan; print from EI 80 negative; exposure series, EI 40, 64, 80, 100, 125. H & W Control developer; tank development, 13½ minutes at 72°F. 85x enlargement

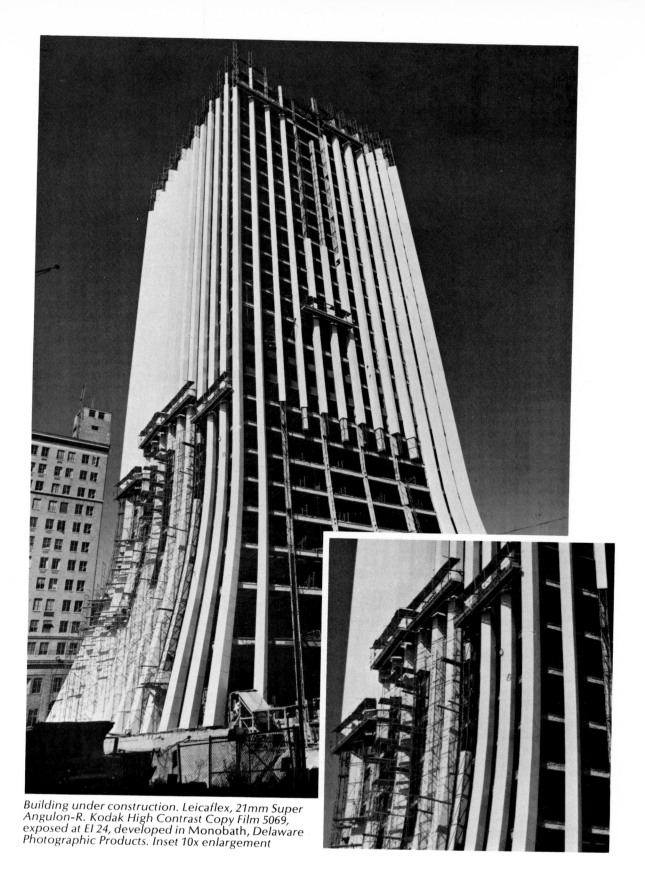

Building under construction. Leicaflex, 21mm Super Angulon-R. Kodak High Contrast Copy Film 5069, exposed at EI 24, developed in Monobath, Delaware Photographic Products. Inset 10x enlargement

Kodak Tower. Leicaflex, 21mm Super Angulon-R;
H & W VTE Pan; print from EI 64 negative, exposure
based on camera-meter and 1-degree spot-meter
shadow readings; exposure series, EI 40, 64, 80, 100,
125. H & W Control developer; tank development,
13½ minutes at 72°F. Approx. 10x enlargement

Enlarged section, Kodak Tower; same negative as
Print 3. Approx. 30x enlargement

Far left:
125x enlargement from Plus-X negative, exposed at EI 125 and tank developed in D-23 for 10 minutes at 68°F

Center:
125x enlargement from VTE Pan negative, exposed at EI 80 and processed in H & W Control developer for 13 minutes at 72°F in a modified Levy developer

Left:
125x enlargement from VTE Pan negative, exposed at EI 80 and processed in HC-3 developer, Dela-ware Photographic Products, Rochester, New York

an experimental

Right:
8x enlargement from section of H & W VTE Pan nega-tive exposed at EI 80 and developed 10 minutes at 68° in Delaware Photographic Products HC-5 developer

Far right:
Portion of same negative, enlarged 135x

*Exposure and development control—such as pro-
vided by the Zone System—permit a photographer
to shoot long-scale subjects and print them easily
and beautifully. Here, full exposure for shadow
detail was balanced by normal-minus-one develop-
ment to control the high value densities.
Photograph copyright 1969 by David Vestal*

The Zone System for 35mm Photography

Ansel Adams

INTRODUCTORY NOTE
W. L. Broecker

Ansel Adams' Zone System is fundamentally a way to measure and control variables in the photographic process to produce brilliant, full-range images on normal-contrast printing paper. The zone system deals with ranges of difference in the subject, the negative and the print. For convenience, these ranges are divided into scales of various numbers of steps. The best-known is the range of black-and-white print values divided into a ten-step gray scale. A negative has a corresponding scale of density values—different amounts of dark silver which control how much light can pass through various portions of the negative.

(Density is a scientific measurement expressed as a logarithm to the base 10. Most photographers find it clearer to think of density in terms of opacity, the light-stopping power of a given negative value, or transparency, the light-passing power of a negative value.)

The subject in front of the camera also has a range of values, called a luminance scale. The common, but less accurate, term for luminance is brightness; it is the amount of light reflected or emitted by the subject. Illumination is the intensity of the light that falls on the subject. It is a constant quantity at the moment a picture is made, but the luminances reaching the camera vary in intensity because high-value (light, bright) portions of the subject reflect more light than low-value (dark, or shadow) portions of the subject.

When the camera shutter opens to let light from the subject strike the film, it is the differences in subject luminance values that cause differences in film exposure, and therefore in negative densities upon development. These in turn cause the tonal differences in a print. Thus the subject, negative and print value scales are related by the common element of exposure.

To help visualize and control the exposure relationships, the zone system uses a scale of exposure zones as a kind of measuring and sorting device. To prevent confusion with f-numbers, shutter speeds, and other numbers, zones are identified by roman numerals: I, II, III, IV, etc.

A given exposure zone corresponds to a relative amount of subject luminance, negative opacity, and print reflectance. Each zone differs from the next by a standard factor of 2 or 1/2, just as f-stops do. For example, a value IV subject luminance is twice as bright as a value III luminance, and half as bright as a value V luminance. In the corresponding negative, the value IV density is proportionately greater than that of the value III density, and less than that of the value V density. In the print, these densities produce three adjacent shades on the gray scale: print values III, IV and V. Thus, the concept of a zone relates subject, negative and print values.

Zone system procedure consists of measuring the subject luminances accurately, visualizing how they should be translated into black-and-white print values, and controlling negative exposure and development to arrive at the desired, visualized print.

Because the print value scale commonly is divided into ten steps, the zone scale is often thought to be limited to a range from Zone 0 (the maximum black obtainable in a print) through Zone IX (pure white print paper with no darkened silver). However, neither the subject nor the negative is limited to a ten-step value scale. Subject luminances may extend into values X, XI, XII and even higher. The ideal solution to this photographic problem is to make a negative that fits the subject into the ten-value range of a normal-contrast-grade paper, no matter how great a range the subject may encompass.

The zone system approaches this problem by measuring the range between significant subject values and comparing that to the exposure scale of the negative. The significant subject values are the darkest area in which full texture and detail are desired in the print (a Zone II or III print value), and the brightest area in which texture and detail are desired (a Zone VII or VIII print value). The practical limits of the negative exposure scale are the lowest luminance which will produce printable detail (any lesser negative density will print as a dark gray, distinguishable from pure black, but without texture or detail) and the brightest luminance which will produce printable detail (any greater luminance will create so much negative density that the print paper will remain unexposed).

We are concerned here with printable image densities. The thickness of the film-base material and the slight chemical fog produced by development of unexposed emulsion combine to make up filmbase-plus-fog (fbf) density. When exposure builds up to the threshhold of film response—the point at which silver begins to be affected enough so that it will darken when developed—the first true image

density value, equivalent to a Zone 1 exposure, is reached. There is no texture or detail recorded, simply a discernible density. We take the amount of exposure required to produce Zone 1 density as one unit of exposure.

Twice as much exposure—two units, or a Zone II exposure—produces enough density to begin to print texture. The equivalent print value is the darkest gray-black in which any texture variation is visible. Twice as much exposure again—four units, a Zone III exposure—finally achieves a density and print value that record fully-visible dark area detail and texture.

The relationship between zones and units of exposure is shown in the Zone System Relationships chart on the next page.

Negative densities which represent low subject values (shadows, dark tones) are primarily the product of exposure. Development completes the job of darkening the exposed silver that represents the low values long before it is finished in the high values. But negative densities which represent high subject values are the product of exposure and the amount of development given. In most photography, it is not practical to change the intensity of the high subject values to control exposure. However, development can be changed to control high value negative densities and thus keep them in a printable relationship to the low value densities.

When the subject luminance range matches the negative exposure scale, a normal (N) amount of development (as established by tests) is indicated.

If the subject luminance range is greater—that is, if it encompasses more zones—than the limits of the negative exposure scale, high value densities can be limited by giving the negative less-than-normal development. This is called normal-minus development in the zone system, and its effect is to squeeze, or compact the subject values into a printable negative density scale. Development which compacts the scale by one zone is designated N-1 (N-minus-one); a two-zone compaction is N-2, and so on.

If the subject scale covers fewer zones than the negative can record, more-than-normal, or normal-plus development is indicated to expand the density scale so that print values will be fully separated and rich in tone. A one-zone expansion is designated N+1 (N-plus-one), a two-zone expansion, N+2, etc.

The tests by which 35mm photographers can

determine negative exposure scales and normal, plus-and-minus-developments are described by Ansel Adams in this chapter.

It is strongly recommended that the reader consult Book 2, The Negative, and Book 3, The Print, of Adams' Basic Photo Series, and Visualization Manual, by Minor White, for an extended explanation of the zone system approach and procedures. (All are published by Morgan & Morgan, Hastings-on-Hudson, N.Y.) A brief explanation here of how to read subject luminances in terms of exposure zones will help the reader follow the test procedures.

Reflected-light meters are calibrated to produce mid-range, middle-gray exposures. A meter cannot distinguish between a solid dark tone, a solid light tone, or a mixed pattern of lights and darks. The meter only receives a certain total luminance, and it produces a corresponding scale reading. In most meters a needle points to a number on a scale. The scale numbers may represent actual luminances in candles-per-square-foot (c/ft^2), or they may be an arbitrary series. In either case, when the arrow of the meter calculator dial is set to that scale reading, a series of f-stop-and-shutter-speed combinations is produced, representing appropriate exposure of a given film for whatever luminance the meter has read. The meter says, in effect: "For a single-tone subject of this luminance, expose the film at any one of these combinations in order to get a negative density that will print as a mid-range, value V gray." (The meter calibration assumes normal development.)

Although the meter calculates exposure for Zone V, the photographer may be interested in value II and value VII or VIII as the limits of significant detail in the print. To determine whether the subject is within these limits, he places a reading of a dark subject value on Zone III and then observes in which zone a high subject value reading falls. The method is explained on the next page.

(Note: The zone system was first designed for easy use with the calculator dials of the Weston Master exposure meter, but the following steps for 35mm photography are applicable to any meter that calculates a series of f-stop and shutter-speed combinations. Also consult the Zone System and Light Meters data at the end of this introduction.)

1. Select the darkest subject area in which you wish to see detail clearly in the print. Take a meter reading of this area and calculate the normal exposure for it. Write down the f-stop called for at any convenient shutter speed, say f/2 at 1/50; you will compare this with another reading (Steps 3 & 4).

2. The meter has calculated a Zone V exposure for the dark area, but if that area ought to be two values darker in the print—the equivalent of a Zone III exposure—it needs the equivalent of two stops less exposure. Change the meter calculator to produce this much reaction. In this way you place the exposure for that value on Zone III. For example, if the Zone V exposure for the dark subject value is f/2 at 1/50, the Zone III exposure is two stops less—f/4 at 150. (Use one of the Zone III f-stop, shutter-speed combinations when you take the picture.)

3. Select the brightest subject area in which you wish to see detail clearly in the print. Take a meter reading of this area and calculate the normal exposure. Note the f-stop called for at the same shutter speed you noted in Step 1, say f/16 is now at 1/50.

4. Count the number of full f-stops of difference between the original dark value exposure calculation (f/2, from Step 1) and the high value exposure (f/16, Step 3). The difference between f/2 and f/16 is six stops (f/2.8; f/4; f/5.6; f/8; f/11; f/16).

5. Starting from where you placed the low value (Zone III), count off one zone for each full f/stop of difference. The zone you reach at the end of counting is where the high value falls. In the example, six stops from Zone III brings you to Zone IX. (If f/2 = Zone III: f/2.8 = IV; f/4 = V; f/5.6 = VI; f/8 = VII; f/11 = VIII; f/16 = IX.)

The zone in which the high reading falls determines what development you should give the film to achieve printable negative densities. In 35mm photography, if the high value falls in Zone VII or VIII, you may develop the negative normally (except that if you read Caucasian skin tone as the high value, it should not fall above Zone VII). If the high value falls below Zone VII, you will need normal-plus development. If it falls above Zone VIII, you will need normal-minus development.

"Normal" development depends in part on the kind of enlarger used. Condenser (collimated-light) enlargers project a higher-contrast value scale from a given negative than diffused-light enlargers. Therefore, less development is required to achieve a "normal" contrast-range negative for a condenser enlarger than for a diffused-light enlarger.

Zone system relationships

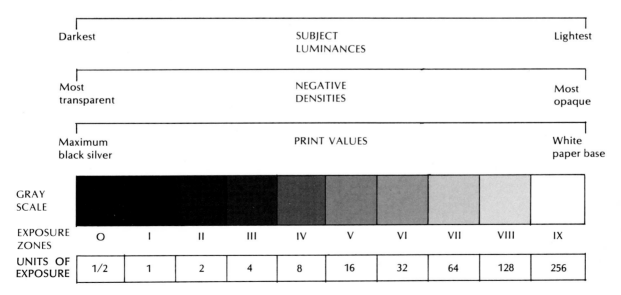

	SUBJECT LUMINANCES	
Darkest		Lightest

	NEGATIVE DENSITIES	
Most transparent		Most opaque

	PRINT VALUES	
Maximum black silver		White paper base

GRAY SCALE										
EXPOSURE ZONES	O	I	II	III	IV	V	VI	VII	VIII	IX
UNITS OF EXPOSURE	1/2	1	2	4	8	16	32	64	128	256

Zone descriptions

Low Values

0 Total black in print; no negative density except filmbase-plus-fog density.

I First step of print value above black; slight tonality, but no texture. Effective threshold of negative; first visible density above filmbase-plus-fog density.

II First print value and negative density sufficient to reveal some texture. Deep tonalities representing the darkest part of the image in which traces of detail are required.

III Low values showing adequate texture. Average dark subject materials.

Middle Values

IV Normal shadow value on Caucasian skin; average dark foliage in sun; dark stone; landscape shadow; etc.

V Middle gray; middle value of the exposure scale; 18% reflectance [as in the Kodak Neutral (gray) Test Card]; the "pivot" value from which changes are made. Clear north sky (as rendered by panchromatic film); dark skin; gray stone; average weathered wood. Negative density V is the "pivot" density for development time determinations, after effective film speed has been established by testing to determine Zone I exposure values with normal development.

VI Average Caucasian skin value in directional sun or artificial light, diffuse skylight, or very soft light; light stone; clear north sky on panchromatic film with light blue filter. Approximately 36% reflectance.

High Values

VII Light skin values; light gray objects; snow with acute sidelighting.

VIII Highest print values in which some texture is discernible; delicate values, but not blank whites.

IX Approaching pure white; glaring white surfaces; snow in flat sunlight; light sources in the picture; whites without texture. Represented in the print as the pure white of the paper base.
 Zone IX, or higher, represents little or no density of the print image, although negative density values can be anything higher than the optimum density for Zone VIII exposure.

Zone system development relationships

The arrows indicate the negative density value at which a subject value can be recorded when given the indicated development. For example, N-3 development, will record a subject value which produces a Zone XI exposure as a printable value Zone VIII negative density.
 Note that changes in development affect low values least, high values most.

Value range Development

Compaction (less-than-normal development)

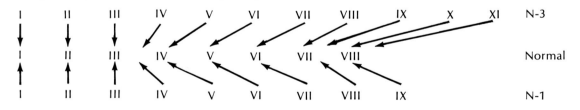

Expansion (more-than-normal development)

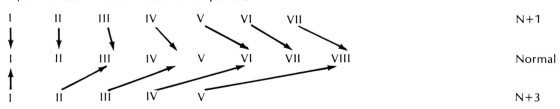

To determine the development indicated by a given subject value range, measure the range as described above, then consult this chart.

Place dark value reading on Zone III. Then:		
If high value falls on Zone:	the range of difference is:	To render the high value as a VII negative density, give this development:
IX	6 stops	N-2
VIII	5 stops	N-1
VII	4 stops	Normal
VI	3 stops	N+1

Zone system and light meters

Any reflected-light meter that gives scale readings of subject luminances and provides calculator scales or dials to determine f-stop, shutter-speed combinations can be used with the zone system. The Weston Master meters are particularly convenient to use because the markings on their indicator dials correspond to zones as follows:

DIAL	•	U	•	•	A	▼	C	•	0	•
ZONE	0	I	II	III	IV	V	VI	VII	VIII	IX

The scale on the Master IV meter provides luminance readings directly in candles-per-square-foot (c/ft²). The Master V scale uses a number series, 1-16; the corresponding c/ft² values are given in the next column.

It is useful to know the actual luminance values of the subject—and it is essential in order to follow the examples Ansel Adams gives in this chapter. The following method applies to any meter.

1. Set a typical ASA number on the meter, say ASA 125. Meter a subject luminance and set the reading on the meter calculator.

2. Look at the f-number on the calculator that is equal to the square root of the manufacturer's ASA rating of the film in use (f/11 for ASA 125; see table, next column).

3. The denominator (bottom half) of the shutter speed at that f-number is equal to the subject luminance in candles-per-square-foot.

 Examples

Film: ASA 64; square root of 64 is 8. If, after the luminance reading is set on the calculator, the speed at f/8 is 1/60 sec., the luminance is 60 c/ft².

Film: ASA 125; approximate square root: 11. After meter reading is set, calculator shows 1/100 at f/11. Therefore, the luminance is 100 c/ft².

Film: ASA 400; square root: 20. After reading, 1/2 sec. is at f/20. Luminance is 2 c/ft².

F-numbers as approximate square roots of ASA speeds

ASA	10	f/3.2	ASA	160	f/12.5
"	25	f/5	"	200	f/14
"	32	f/5.6	"	250	f/16
"	40	f/6.3	"	400	f/20
"	50	f/7	"	500	f/22
"	64	f/8	"	650	f/25
"	125	f/11	"	800	f/28
			"	4000	f/64

Weston light meter scale numbers

Master IV (reads directly in candles-per-square-foot)	Master V
0.05	1
0.1	2
0.2	3
0.4	4
0.8	5
1.6	6
3.2	7
6.5	8
13	9
25	10
50	11
100	12
200	13
400	14
800	15
1600	16

Note: The Zone Systemizer, invented by John Dowdell, is a calculator which determines all zone system relationships. When shadow and highlight luminances are set on the Systemizer, it shows: luminance ratio; zone range; zone placement and locations; effective film speed; f-stop, shutter-speed combinations; value shifts; and plus-and minus-developments. The Zone Systemizer, with complete instruction book, is available from Morgan & Morgan, Inc., Hastings-on-Hudson, N.Y. 10706.

The Zone System for 35mm Photography

Ansel Adams

The Zone System enables you to visualize the final picture *before* you make the exposure. Visualization is modified, of course, by the process used. When writing music for the violin, you don't think in terms of the qualities and scope of the pipe organ!

The zone system is merely a practical application of basic sensitometry; it can be thought of as a way of understanding how photographic materials respond to exposure and development. The zone system terminology now employed is described fully in recent editions of Book 2 of the Basic Photo Series, *The Negative,* by Ansel Adams (Morgan & Morgan, Hastings-on-Hudson, New York). In brief summary, the terminology and the photographic process are related in this way:

sualized before making the exposure, either on the basis of simulating "reality" or of making intentional departures from reality. You are *not* limited to making a literal translation of the subject, a "photometrical equivalent" in terms of scientific measurements; you can visualize any final image that your imagination and your technical mastery make possible. Visualization also includes the effects of camera position, the focal length of the lens, and your personal approach and orientation as a photographer.

Large-format photography with sheet film or film pack lets you make each photograph a separate technical and esthetic entity; but, of course, with 35mm film you cannot apply all the controls to indi-

SUBJECT VALUES	EXPOSURE VALUES	NEGATIVE VALUES	PRINT VALUES
Luminances in candles-per-square-foot (c/ft^2).	Placement of luminance values on the Exposure Zones.	Density values for the various Exposure Zones at various times of development.	Brilliancies: the reflective densities of various parts of the picture.

TECHNICAL PROCEDURES

ESTHETIC, INFORMATIONAL RELATIONSHIPS

The term *zone* is applied only to the exposure scale, which we divide into nine or more sections, each related to the next by a factor of 2x or 1/2x (geometric progression). This is the same progression that is found in the series of lens stops and the series of shutter speeds on modern shutters. The exposure relationships among zones, and their descriptions are given in the Introduction, page 226. The descriptions relate approximately to the normal and visual interpretation of the ten zones of the exposure scale (nine zones if we omit Zone 0). Frequently we will expose for high zones, but adjust the development time to reduce negative densities so they relate to the high value densities of the normal scale (that is, the negative densities produced by Zone VIII and IX exposures given normal development).

The informational and esthetic content of a photograph lies in the interpretation of *subject values* in terms of *print values*. This interpretation is vi-

vidual frames. In particular, when you use conventional 35mm color-transparency films you are confronted with relatively short exposure scales and a minimum of development control; you must adjust your visualization to such limitations.

With 35mm black-and-white film, where you process an entire roll in the same solution and for the same development time (unless you cut out sections of the roll), you must obviously make some compromises and adjustments. Using 35mm, you can limit the photographs on a single roll to subjects of similar luminance range; this enables you to give the optimum exposure and development for all the pictures. Changing to a different roll for subjects of a significantly different luminance range can be simplified by carrying two or more camera bodies. (The photojournalist Dan Weiner, an excellent technician, used to carry a "high-contrast subject" camera and a "low-contrast subject" camera on assignments, and develop accordingly.)

With the small negative you can *compact* the negative-contrast scale and obtain lower contrast by giving less-than-normal development time, or you can *expand* the scale, for higher contrast, by increasing development time. However, the latter will produce coarser grain, which can be objectionable in smooth, textureless areas such as skies. Graininess is sometimes an asset, however, in highly-textured areas of the picture, especially if the optical resolution is poor. You cannot increase negative contrast very much with the small negative; therefore you must think of using papers of higher-than-normal contrast. This becomes an important factor in your visualization of the final print and your choice of methods of achieving it.

The principle, "expose for the shadows and develop for the high values," remains valid. Exposing for the shadows means giving exposures that will place the low luminance values in dark areas of the subject within the exposure scale of the negative. Developing for the high values means giving the optimum development that will hold the bright areas of the subject within a practical negative-density range, so that you can make enlargements on normal-contrast papers (with some exceptions).

To begin, you visualize in terms of print values— you identify significant dark value areas and make "placements" on the exposure scale first in the shadow areas.

For example: a forest scene of dappled bright sunlight, shadowed and translucent leaves with bright sky peeping through, dark tree trunks, deep shadows, black earth and rocks. While this would be considered a "contrasty" subject, you *feel* an enveloping light—light-filled air throughout the scene. You might think of the dark areas of the tree trunks being, in the print, a dark gray of value III, so you "place" them on Zone III. You measure their luminance—perhaps it is 6.5 c/ft². When this is placed on Zone III, the luminance value of 25 c/ft² is on Zone V (the luminance doubles for each zone up the scale). The Zone V value is the basic exposure key.

Now you read the sunlight on the forest floor: 200 c/ft². This *must* fall on Zone VIII. (Start at the III value, double the luminance and count one zone; keep repeating the process —200 c/ft² falls at VIII.) With most films you could hold some feeling of texture at this zone. So, with an acceptable range of III through VIII, normal development is indicated.

But perhaps you want a greater sense of light, with dark subject areas a step lighter in the print. You can then place the dark tree trunks (6.5 c/ft²) on Zone IV. This represents 13 c/ft² on Zone V. The sunlighted grassy floor luminance, 200 c/ft², now falls on Zone IX, out of the range of negative densities that will print any detail or texture. Therefore, developing instructions would be normal-minus-one (N-1) because you want to establish a negative-density value of VIII for that subject value. (The Zone IV value would drop a little with the less-than-normal development, but not enough to effectively change the full range of negative-density values.)

Having placed the shadow value on the desired zone, any f-stop, shutter-speed combination thus produced can be used to make the exposure. The negative is then developed as indicated by the high value location (where it fell). The resultant print on normal-contrast paper should convey the "feeling of light" you visualized with this particular subject.

Conversely, you might have as your subject a highly-textured granite rock in shade: a low-contrast scene. Here you would visualize an expanded texture of the stone, a visual exaggeration of the subtle differences in its surface—an effect that Edward Weston might have termed "more than granite." You would then place the average values on Zone V and indicate more-than-normal development of N+1 to obtain an expansion of values in the print. You could manage this with a 35mm negative because of the "assist" of negative grain in intensifying textured subjects. Otherwise—with a smooth-surfaced subject, for example—you would develop normally and rely on a higher-contrast paper to give you the desired results. The important thing is, of course, that you *know* from the start what your final picture quality will be.

Another example: a street scene, with one side in sun and the other in shadow. The shadow side is about one-third of the picture area; it reads about 25 c/ft². You can place it on Zone IV. The sunny side of the street averages 400 c/ft², which falls on Zone VIII. This would call for a normal development time.

However, if the shaded area commanded the greater part of the picture area, you would place it on Zone V to ensure visibility and a fuller range of tones for everything within it. Then, definitely,

the development instructions would be for a one-zone compaction—N-1 development—because the luminance of the sunny side falls on Zone IX and it must be kept to a printable negative density. In this case, water-bath development (discussed below) might well be better than simply shortening the time enough for N-1 development.

These are only crude examples; no two subjects are really alike, no two interpretations are the same.

If you assume that skin in sunlight (the "flat" of the face at 45° to the sun) represents a Zone VI exposure value (and print value VI), you have a simple problem and can tolerate a one-to-four (1:4) shadow-to-sun relationship. This is a simple, "normal" situation. Checking values with your meter you can quickly determine that a "normal" exposure and "normal" development will give you a full-range, easily printable negative.

But don't be beguiled into thinking of picture values as simple luminance relationships. Your eye sees quite differently from the sensitive film. It is your problem to visualize what you see in terms of print values, and to manipulate your techniques so that you can induce the photographic process to "come through" with the concept: the experience you are seeing and visualizing.

Without this visualization you are working on a very chancy basis, trusting to all kinds of unpredictable manipulations in the darkroom to evoke some compelling photographic statement.

The actual measurement of the luminances, and the exposure and development of the negative are purely technical in character; both are dictated by the requirements of your visualization. The making of the print is an expressive as well as a technical process, a process of interpreting what you have secured in the negative and, hopefully, realizing or expanding your original visualization.

If you consider the negative as the equivalent of a musical score, the print is its performance. In other words, an optimum negative contains the necessary basic values that can be interpreted in terms of an expressive print. As with musical performances, the prints from such a negative can increase in perfection and expressive quality as you repeat them over a period of time. Creative photography is not an automatic process, it results from growth in sensitivity, vision, response, understanding, *along with* technical competence!

In order to use the zone system, it is necessary to make tests to find an effective, operational exposure value (ASA speed) to assign to a film when used with your meter, your camera and your lenses, and to determine exactly what normal, plus- and minus- development times are. My preparatory tests on 35mm are similar in principle to those for large-format film.

1. Select a smooth wall or card of medium-gray value, under consistent, even illumination without glare or random shadow. (The Kodak Neutral Test Card is a medium gray of 18% reflectance; it corresponds to a Zone V exposure and a print value V. The cards are sold in a set of four, which may be taped together from behind to form a large test area.) The luminance value can be around 8 c/ft². If it is higher, the exposures for the lowest zones will be very short (short shutter speeds tend to be the least accurate), so the use of a neutral-density (ND) filter is suggested. An 0.60 (4x) ND filter reduces exposure by the equivalent of two f-stops, and thus will permit low zone exposures at a mid-range shutter speed. It is better to retain the same shutter speed as much as possible throughout the tests and control exposure by changing lens stop and using the ND filter as required.

2. Be sure that your exposure meter is accurate. Remember, the results of the tests, in terms of usable, effective film speeds and development times, depend upon the performance of *your* equipment and may not be comparable to other equipment and procedures.

3. Select a film for the tests in 36-exposure lengths. For the first film speed test, each length can be cut into quarters after exposure to provide four test strips for processing. In subsequent full-scale tests, a length can be cut in half.

4. Aim your camera at the test surface and focus the lens at infinity (you do not want any texture in the test image, just a featureless area of tone that will record as an even negative density). At infinity, f-stops transmit light at full value. Use the *second* full f-stop in the range of apertures provided on your lens as a starting point in the tests. This will allow you to open up at least one stop for more exposure during the tests, as well as close down for less exposure. Be sure to use *full stops* (i.e., f/1, f/1.4, f/2, f/2.8, f/4, f/5.6, f/8, f/11, f/16, f/22, f/32). The widest marked opening on some lenses is a half- or third-

stop in the main series (stops such as f/1.2, f/3.5, f/4.5). Each stop in the main series transmits one-half as much light as the next larger stop, twice as much light as the next smaller stop. It is essential to make 1/2x and 2x exposure changes accurately and easily in the tests.

5. Determine the luminance of the test surface with your meter and place it on Zone I of the exposure scale. Use the ASA rating recommended by the film manufacturer. If the luminance value is 8 c/ft², when it is placed on Zone I, the chart would show the following:

I	II	III	IV	V
8	16	32	64	128

With an ASA 32 film, this provides an exposure of 1/125 sec. at f/5.6. (Actually it would be better to close the lens to f/11 in order to use 1/30 sec., as this speed will probably be quite accurate. Better still, use a 4x ND filter and make the exposure at 1/30 at f/5.6, or 1/15 at f/8.)

6. Give the exposure calculated in Step 5 by placing the luminance on Zone I (using the recommended ASA rating); say 1/30 at f/5.6. Then give the same exposure time at half-stop intervals for a total range one stop wider and one stop smaller than the first exposure. That is:

1st exposure	- f/5.6
2nd	- f/4
3rd	- halfway between f/4-f/5.6
4th	- f/5.6 again
5th	- halfway between f/5.6-f/8
6th	- f/8

Cover the lens and shoot off frames 7, 8, and 9 so they will be blank. Beginning with frame 10, repeat the above exposure series. Do this twice more. You will then have four groups of six test exposures, with three blank frames between the groups.

In the darkroom, remove the film from the cartridge, bring the ends together, and cut through the loop in the middle. Double each of the resulting lengths and cut them in half in a similar manner. The blank frames will give you leeway to cut without destroying an exposure. Identify the lengths by punching one, two, three or four holes in one end. You will develop one length in whatever developer

you have chosen for the test (begin with your usual developer). Save the other lengths in a lighttight container in case there are processing errors, or to use with other developers you may wish to test. *Develop at the recommended temperature (usually 68-70°F) for the recommended time; use your standard pattern of agitation.* Fix, wash and dry the film normally.

7. Examine the test length to determine which frame has a density just greater than the filmbase-plus-fog density of a blank frame. If you have access to a desitometer (many schools and professional studios have one), make readings to identify the frame that shows 0.10 density greater than filmbase-fog. If you cannot get density readings, make the following practical printing test.

Expose a piece of enlarging paper to white light and develop it to obtain a test patch of maximum black. Next, insert a blank frame of the test strip in the enlarger and find the *minimum* exposure that produces a black that matches the maximum black patch. Then give the same exposure to other pieces of paper through each of the frames on the test strip (mark each patch with the appropriate frame number for identification). When dry, compare these test patches with the filmbase-fog black patch and identify the first frame to print as a discernibly lighter shade of dark gray. Thus, you print filmbase-fog density as a 0 value, then determine which frame was exposed enough to produce a value I density.

8. If the f-stop used to produce the value I density was the same as the normal exposure calculation, the manufacturer's recommended ASA rating is proper for that film, and that development, with your equipment. If the f-stop was not the same, the degree of difference tells you how much you must change the ASA rating to arrive at an *effective* film speed—one full stop larger means half the ASA rating, one stop smaller means twice the rating. In terms of the test exposures with an ASA 32 film (Step 6):

Exposure at		Equivalent speed
f/4	=	ASA 16
f/4-f/5.6	=	ASA 25
f/5.6	=	ASA 32
f/5.6-f/8	=	ASA 50
f/8	=	ASA 64

9. The next test is to take the entire scale, from Zones I to IX, by giving a series of increasing exposures to the test card. Use the same film, but rate it at the *effective* ASA speed you have arrived at in the first test. Assuming that your lens stops down as far as f/22, a typical exposure series would be the following:

Zone	Filter	Aperture	Speed
I	4x ND	f/22	1/30
II	"	f/22	1/15
III	none	f/22	1/30
IV	"	f/16	"
V	"	f/11	"
VI	"	f/8	"
VII	"	f/5.6	"
VIII	"	f/4	"
IX	"	f/4	1/15

(If your lens closes only to f/16, then all stops must be one larger than shown in the series above.) Make four groups of this exposure series, two on each of two rolls of film, with blank frames between the groups. In the darkroom, fold them in half and cut them apart. Store three strips and develop one for the same, "normal" time that you used before (Step 6). Note the density obtained for Zone V, and print the frames on reference patches, using the same exposure to put filmbase-fog on Zone 0 as before (Step 7). I have found that optimum Density Value V in a 35mm negative is 0.55 to 0.65 above filmbase-fog for use in an average condenser enlarger, 0.65 to 0.75 for a diffused-light enlarger.

Assuming that you have a condenser-type enlarger, I suggest that you work first for a Density Value V of 0.6 above fbf. (If this value is higher in your first full strip, develop another strip at two-thirds the previous time. If the density is lower, increase the development time about one-third. It may require all the strips to arrive at the desired density, but if you come close, you can extrapolate the desired value with reasonably accurate results.

Keep careful notes! These first tests can be the "pivot" of many future trials. The final objective, however, is to determine the amount of development indicated for actual photography in terms of what *you* want to achieve in the general feeling of your work. These first tests will give you a "platform" from which to launch further tests with different films and developers.

10. Once you have determined your normal developing time, you can test for the developing times required to lower or raise the densities for an exposure effect equivalent to one zone difference. Normal-minus-one developing time would accomplish the following:

Exposure Zone	Development Normal	N-1
VII	VII	VI
VI	VI	V
V	V	IV

Lower values would be affected to a lesser extent than this. The effect on higher values depends on the basic density limits of the film used. Try about two-thirds development time for your first N-1 test, with the same exposure series (Step 9). Read densities, or match comparison print patches from this development with the results of normal development. If the Zone VI frame with N-1 development matches Zone V with normal development, your N-1 time is correct. Proceed by trial and/or extrapolation until you have a good density match of these frames, or of normal VI to N-1 density value V.

11. You can achieve a normal-minus-two effect by further reducing developing time to around half-normal. However this is not advised, because although it reduces the density of the middle and high values by the equivalent of two exposure zones, it may underdevelop the low values. Here, two different processing procedures can be helpful: two-solution development and alternate-water-bath development. In the two-solution process, the film is placed first in a solution of developing agents, then into a solution of activating agents to complete development. In water-bath development, the film is moved back and forth between a developing solution and plain water. Both processes not only control the high densities, but actually strengthen the low values, adding contrast and "body" to Zone I, II and III density values. They are discussed fully, with formulas, in Book 2, *The Negative*, of the Basic Photo Series, but some notes here may be helpful.

Two-solution development. Lately I have been using a more concentrated alkaline bath as the

second solution than is suggested in Book 2. It completes development action before the developer absorbed by the emulsion is diffused into the second solution. A sodium carbonate solution can be used. Also, developing film on reels poses a problem. When the negatives have adequate agitation in the developer, streaking and uneven development should not occur. But *do not* agitate in the second, alkaline bath, otherwise the developer will be diffused from the emulsion before it has time to act. Place the reel in a *quiet* second bath for about 15 seconds, then remove it—gently!—and reverse it (top for bottom) for the remainder of the time in the second bath. This will help to equalize the flow of the developer to the bottom edge of the film and equalize the density build-up in that area. If conditions permit, it is best to unroll the film, attach a clip to each end, and develop "by hand." Then place the film *flat* in the second bath and allow it to stand for the required thirty seconds *without* agitation.

Water-bath development. This process provides the most control. Its effect is based upon the exhaustion of the developer that is absorbed by the emulsion, without the need of further activation by an alkali solution. Any normal non-staining developer, such as FG-7 at 1:7 dilution, or HC-110 at dilution A, can be used. With most developers, one-minute immersion in the water is sufficient; by that time the retained developer should be exhausted. The first immersion in the developer should be for one minute, thereafter for fifteen to twenty seconds with constant agitation for developers of the HC-110 type. The number of alternate developer-water immersions must be determined by trial. Keep very careful notes on the exposure, especially on the location of high values. Reverse the reel for each water immersion to equalize solution flow over the surface of the film. The "flat" development method, as discussed above for the two-solution process, is preferable for uniform results.

Modern thin-emulsion films do not absorb sufficient solution to function well with water-bath or two-solution developers. Try high dilutions, such as *stock* HC-110 diluted 1:15, 1:32, etc. Development times will be longer than usual: agitate as usual for the first few minutes, then once every two or three minutes. Use a tank large enough so that the total amount of solution will contain plenty of developing

agent to adequately reduce the silver of the negative and develop the image.

12. An increased range of contrast can be achieved by normal-plus development. This can be planned to increase any normal density value to the equivalent of the next highest value. N+1 development would produce a one-density-value difference. However, with small negatives, longer-than-normal development time invites increased grain size, which can be very unpleasant in areas of consistent, textureless value, such as open sky. On the other hand, with a low-contrast, strongly-textured subject, negative grain can actually enhance the sense of texture and sharpness. The process to determine normal-plus developing times is the same—develop lengths of test exposures for specific times longer than normal and compare densities or print patches. When N+1 V density matches normal VI density, you have found the N+1 developing time.

13. No matter what development process you use, maintain all solutions, including wash water, within two or three degrees of optimum temperature. Accurate results depend especially upon a consistent agitation pattern. I agitate continuously for the first thirty seconds, thereafter for five seconds every thirty seconds.

If your rolls contain subjects of various contrast ranges, you should always expose and develop for normal-minus-one development. Then you can use printing papers of less-than-normal contrast with the more contrasty negatives, and papers of higher-than-normal contrast for the low-contrast negatives.

There has been great emphasis on increased film speeds, especially by some manufacturers of proprietary developers, and this deserves critical scrutiny. The fact remains that a film has a true, basic "speed," or response to light; it takes a certain minimum amount of light to get over the threshold of the film. Varying the amount of development may yield varying densities in relation to exposure, *but only within the exposure scale of the negative!* Only very slight enhancement of the lowest densities is possible by extended development.

To sum up: The zone system is a process of visualization, modified and controlled by esthetic and technical values. Always, it is your sensitivity to the subject and your creative intent that determines the decisions you make at every step.

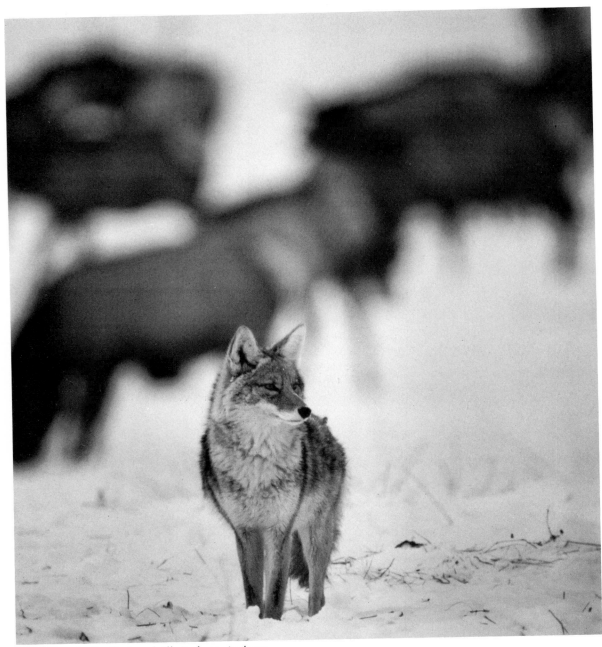

Coyote and elk, National Elk Refuge, Jackson Hole, Wyoming. Leitz 800mm f/6.3 Telyt-S. Handheld camera with lens barrel cradled in a beanbag on doorframe of the photographer's jeep. From a color transparency by Stan Wayman

Telephotography

Julius Behnke

Large images in distant shots

Telephoto lenses, the photographer's field glasses, belong in the outfits of all those who want to solve their photographic problems easily and efficiently. In the hands of a skilled photographer, a long lens is a creative tool; but even the beginner will find a telephoto lens indispensable when he cannot get close enough to his subject to photograph it successfully with a normal lens. The telephoto lens bridges great distances easily, so that a single object can be selected to fill the picture, making it seem close enough to touch. Such a photograph often has a special effectiveness, in keeping with the valid photographic motto, "Less is more."

The following table shows approximate image sizes for two objects (one 1.75 meters, or about 5 feet, 9 inches, about the height of a man; the other 4 meters, or about 13 feet, the length of a racing car) when photographed at a variety of distances with telephoto lenses of different focal lengths. The table indicates some of the possibilities and limitations of long lenses when they are used to obtain large images of distant subjects.

Table of approximate image sizes with long lenses

Focal length	Subject size	Image sizes in mm at various distances						
		5m	10m	25m	50m	100m	200m	300m
90mm	1.75m	32	16	6.4	3.2			
	4m		36	14.8	7.3	3.6		
135mm	1.75m	47	24	9.5	4.7	2.4		
	4m		54	21.6	10.8	5.4	2.7	
180mm	1.75m	63	32	12.6	6.3	3.2		
	4m		73	28.9	14.4	7.3	3.6	
280mm	1.75m		49	19.6	9.9	4.9	2.4	
	4m			44.8	22.4	11.2	5.6	3.6
400mm	1.75m		70	28	14	7	3.5	
	4m			64	32	16	8	5.4
560mm	1.75m			38	19	9.9	4.9	3.1
	4m				44.5	22.5	11.2	7.6
800mm	1.75m			56	28	14	7	4.7
	4m				64	32	16	10.7

The image sizes listed on this table were calculated with the following simple formula, which is approximate, and should not be used for precise calculations:

$$\frac{\text{Distance}}{\text{Focal length}} = \text{Scale}$$

$$\frac{\text{Object size}}{\text{Scale}} = \text{Image size.}$$

In practice, this formula is adequate because the deviation from the exact image size is negligible. But if the calculation must be precise, a different formula must be used:

$$\frac{\text{Image distance}}{\text{Object distance}} = \text{Scale}$$

$$\frac{\text{Object size}}{\text{Scale}} = \text{Image size.}$$

The smallest usable image size is approximately 3 millimeters, under ideal conditions, which include: high-resolution film (such as Kodak High Contrast Copy Film); high subject contrast, aided by side-lighting or backlight; a plain, uncluttered background that lets single subjects stand out; or subjects that fill a whole area, as in street scenes or landscape shots.

The table shows that under these conditions, the 560mm Telyt lens can make a usable (3.1mm) image of a man at a distance of about 300 meters, or about 1,000 feet. Since usable images range in size from 3mm to the full 36mm length of the Leica and Leicaflex format, we can see that long lenses at long distances offer a wealth of photographic possibilities.

Flattened perspective

Certain photographs show a strangely dramatic compressed perspective, in which the depth of objects in the pictures looks foreshortened. Distant objects seem relatively near and large, and objects of the same size at different distances appear only slightly different in image size.

Some other photographs, on the contrary, create an illusion of increased depth and distance.

We know from experience that long lenses were used for the compressed-perspective pictures, and wide-angle lenses for the expanded-perspective pictures. The reasons for these unusual renditions of

Only a portion of the negative was printed.
Leica M4, Visoflex III, Televit Rapid Focusing
Device, 560mm Telyt lens head. Kodak Plus-X Pan,
1/1000 sec., f/5.6. Photograph by Julius Behnke.

depth are less well known. Both impressions look strange to use because they differ from the familiar appearances of things as seen by the eye.

According to the laws of optics, the farther away an object is, the smaller it appears to the eye; however, the product of the virtual (apparent) size multiplied by the distance remains constant.

Our concept of perspective is based on these differences in virtual size at different object distances. Past experience of seeing known objects at various distances enables us to judge distances by perspective. Our depth perception is unconsciously conditioned by the optical laws of perspective that apply to normal vision. Even when a closer viewing distance is simulated by optical enlargement (which does not change the perspective), the mind automatically assumes the same degree of foreshortening in its interpretation of distances between near and far objects.

In a 5x enlargement of a picture of a building 100 meters away, with its far wall 125 meters away, the building will appear to be only twenty meters away, and its far wall will also seem to be only one fifth of its actual distance away—that is, it will look as if it is only twenty-five meters to the far wall. Thus our mental concept of "normal" perspective makes us accept an apparent depth of only five meters for the house, although it is actually twenty-five meters deep. We accept its apparent height and width as correct, and assume that the larger virtual size results from a closer viewing distance.

Contrary to a popular notion, this effect is not restricted to long focal lengths. Perspective depends strictly on the location of the camera in relation to the subject. The angle that the subject subtends is a decisive factor, as is the ratio of focal length to picture format. An 8x10-inch print at a normal viewing distance subtends an angle of forty to sixty degrees. A photograph will appear normal in perspective when the viewing angle of the taking lens is the same as the angle subtended by the picture as seen by the viewer. For the 24x36mm Leica format, this requires a normal focal length of 35mm to 50mm. An enlargement of a portion of a negative made by such a lens will already create the impression of a flat perspective; but it is easier and technically preferable to use a longer lens in the first place. For example, a 200mm lens creates the same perspective as a 4x to 6x enlargement of a portion of a normal-lens negative.

The photographer can use this flattened perspective for special compositional effects. Objects group-

Flattened perspective. 280mm f/4.8 Telyt. Photograph by R. Seck

ed at various distances are especially suited to this treatment: groups of people or animals, buildings, trees, or even groups of mountains. The apparent reduction of distances and the flattened perspective create a powerful effect. Compressed perspectives work well with subjects that have strong linear structures—highways, city streets, cultivated fields, rivers,

terraces, railroad tracks, and so on. It does not matter whether the lines are curved, straight, or zigzag. Extremely long lenses produce especially attractive effects with such subjects.

Telephoto lenses for M Leicas

M-Leica tele lenses that couple to the rangefinder include the 90mm f/2.8 Elmarit, the 90mm f/2 Summicron, the 90mm f/2.8 Tele-Elmarit, the 135mm f/4 Tele-Elmar and the 135mm f/2.8 Elmarit with Optical Viewing Unit. The bayonet mounts of all lenses from 35mm to 135mm in focal length will automatically actuate the proper luminous frames in the M4 and M5 range-viewfinders.

The lens heads of these telephoto lenses can be unscrewed from their rangefinder-coupled focusing mounts for use with other accessories, except in the case of the 90mm f/2.8 Tele-Elmarit.

Lenses with individual focusing mounts, designed for use with the Visoflex III reflex housing, include the 65mm f/3.5 Elmar, the 200mm f/4 Telyt, and the 280mm f/4.8 Telyt. They can all be removed from their focusing mounts for use on such devices as the Focusing Bellows II or the Televit Rapid Focusing Device.

Two lenses are made especially for use with the Televit device: the 400mm f/5.6 Telyt and the 560mm f/5.6 Telyt. The lens heads of the 280mm f/4.8 Telyt and the (discontinued) 400mm f/5 Telyt can be used on the Televit by means of Adapter No. 14,138.

Accessories for telephotography with M Leicas

The *Visoflex III* reflex housing adapts Leica M cameras to long telephoto lenses. Other accessories and adapters for the Visoflex III extend the M Leica's versatility into the photomacrographic range.

The Visoflex III reflex housing converts rangefinder M Leicas into single-lens reflex cameras.

An eye-level 4x magnifier, viewed horizontally, gives an upright, laterally correct view through the Visoflex; a straight 5x magnifier, viewed downward, gives an upright, laterally reversed view of the groundglass image. This choice of viewing magnifiers gives the photographer increased freedom in telephotography and closeup work.

The groundglass screen of the Visoflex III permits accurate focusing and parallax-free composition

throughout the entire working range, providing outstanding versatility both for pictorial work and for scientific and technical photography.

Focusing mounts for long lenses: the 200mm f/4 and older 280mm f/4.8 Telyt lenses have individual focusing mounts. Both can be used on the Visoflex III by means of Adapter No. 16,466, which has a tripod socket, and can be rotated through 90 degrees to change quickly between vertical and horizontal

formats. A different Adapter, No. 16,462, is required for the Visoflex III with the 90mm f/2 Summicron and the 135mm f/2.8 Elmarit. Universal Focusing Mount No. 16,464 adapts the lens heads of the 65mm f/3.5 Elmar, the 90mm f/2.8 Elmarit, and the 135mm f/4 Tele-Elmar to the Visoflex III.

The magnification and focusing ranges of all the above lenses can be extended further by the use of Extension Tubes No. 16,471, 16,474, and 14,020.

LEICA TELE LENSES FOR VISOFLEX II AND III

Lens	Angle of view	No. of elements	Filter size: Series	Smallest aperture	Focusing range	Smallest object field
90mm f/2.8 Elmarit lens head	27°	5	(E 39)	f/22	∞ -19'6''	3x4.7''
90mm f/2 Summicron	27°	6	(E 48)	f/16	∞ -3.5'	9.5x14.25''
135mm f/4 Tele-Elmar	18°	5	(E 39)	f/22	∞ -5'	8.75x13''
200mm f/4 Telyt	12°	4	(E 58)	f/22	∞ -10'	11.75x17.75''
280mm f/4.8 Telyt	8.5°	4	(E 58)	f/32	∞ -19'	18x27''
280mm f/4.8 Telyt lens head*	8.5°	4	(E 58)	f/32	∞ -7'3''	5.4x8.1''
400mm f/6.8 Telyt**	6°	2	VII	f/32	∞ -12'	6x9''
400mm f/5.6 Telyt lens head*	6°	2	VII	f/32	∞ -11'10''	6.4x9.6''
560mm f/6.8 Telyt**	4.5°	2	VII	f/32	∞ -21'	9x13.5''
560mm f/5.6 Telyt lens head*	4.5°	2	VII	f/32	∞ -23'8''	9.1x13.7''
800mm f/6.3 Telyt-S**	3°	3	VII	f/32	∞ -41'	12.6x18.9''

*Must be used with Televit Rapid Focusing Device No. 14,136 and Diaphragm Adapter No. 14,137, except fot the 280mm f/4.8 Telyt lens head, which requires only Bayonet Adapter No. 14,138.

**Not a telephoto, but a long focus lens.

The *Focusing Bellows II* for the Visoflex II and III reflex housings is more versatile than the Universal Focusing Mount No. 16,464 because it has a much greater focusing range without requiring additional extension tubes. This is especially useful with the longer telephoto lenses. The lens heads of the 90mm f/4 Elmar and the 90mm f/2.8 Elmarit have a focusing range from infinity to unit magnification (1:1) when used on the Bellows II. The 135mm lens heads have a range from infinity to a reproduction ratio of approximately 1:1.5 on the Bellows II.

The Bellows II has an exposure-factor scale and a magnification scale on the left side of its track; on the right side, a scale shows the lens extension in millimeters.

The Bellows II has two separate focusing controls. The upper knob moves the lens standard. The lower knob moves the whole assembly—camera, Visoflex,

LEICAFLEX TELE LENSES

	Angle of view	No. of elements	Filter size: Series	Smallest aperture	Focusing range	Smallest object field
90mm f/2 Summicron-R	27°	5	VII	f/16	∞ -28''	5.75x8.25''
90mm f/2.8 Elmarit-R	27°	5	VII	f/22	∞ -28''	5.75x8.25''
135mm f/2.8 Elmarit-R	18°	5	VII	f/22	∞ -5'	9.75x13.25''
180mm f/2.8 Elmarit-R	14°	5	VIII	f/16	∞ -6'8''	8.5x12.75''
250mm f/4 Telyt-R	10°	6	VIII	f/22	∞ -13'	14.5x21.7''
400mm f/5.6 Telyt lens head*	6°					
400mm f/6.8 Telyt-R**	6°	2	VII	f/32	∞ -12'	6.3x9.5''
560mm f/5.6 Telyt lens head*	4.5°					
560mm f/6.8 Telyt-R**	4.5°	2	VII	f/32	∞ -21'	9x13.5''
800mm f/6.3 Telyt-S "R"**	3°	3	VII	f/32	∞ -41'	12.6x18.9''

*Can only be used with Televit Pistol Grip Rapid Focusing Device No. 14,146, plus Diaphragm Adapter No. 14,137
**Long focus lenses, rather than telephotos

bellows and lens—on the tripod connection piece, permitting focusing with no change in magnification. The lower knob has a locking lever to prevent accidental changes in magnification.

Tele accessories for the Leicaflex SL

Telephoto lenses: the 90mm, 135mm and 180mm f/2.8 Elmarit-R lenses and the 250mm f/4 Telyt-R are outstanding for combining compactness and large aperture with excellent full-aperture performance, and good contrast and high resolution that are improved slightly by moderate stopping down.

The 90mm f/2 Summicron-R, also extremely compact, offers twice the speed of the Elmarit-R lenses. Like them, it has a fully-automatic aperture control and a built-in collapsible lens hood.

The 250mm f/4 Telyt-R is, at the time of writing, the longest Leicaflex lens with a fully automatic diaphragm.

The 400mm and 560mm f/6.8 Telyt lenses are not telephotos, technically, but long-focus lenses. They fit directly onto the Leicaflex SL. Their unique sliding focusing movement requires only a simple push-pull action when the focus lock button is depressed, making these lenses extraordinarily flexible and easy to use, as well as giving rise to their nickname, "the Trombones."

The *Televit-R Pistol Grip Rapid Focusing Device* was designed for use on the Leicaflex and Leicaflex SL with the following lens heads: the 280mm f/4.8 Telyt, the 400mm f/5.6 Telyt, and the 560mm f/5.6 Telyt. A quick-change bayonet adapter permits rapid changing of these lens heads on the Televit-R, which has both a fast-focusing and a fine-focusing provision. An adjustable shoulder stock and the pistol grip improve the steadiness of handheld exposures. The bayonet mount that connects the Televit-R to the camera rotates through 90 degrees for a quick change between horizontal and vertical formats. Two pre-selected distances can be set within the focusing range of the Televit-R: these can be used, for instance, to set the near and far focusing limits for a given lens-subject combination.

Adapter No. 14,127 permits certain Leica range-finder-camera lenses to be used on the Leicaflex SL. All Visoflex lenses can be used for closeup and tele-photo work with the Leicaflex SL; exposure can be determined using the camera meter with the lens diaphragm.

The *Focusing Bellows-R,* developed for the Leica-flex SL in conjuction with the 100mm f/4 Macro-Elmar lens, permits continuous focusing from infinity to unit magnification (1:1). The 100mm Macro-Elmar performs excellently throughout this range. The pre-

LONG-LENS USE OF ELPRO LENSES

Leicaflex Lens	ELPRO	Catalog number	Distance scale setting	Approx. Distance in inches		Field covered (inches)	Reproduction ratio	Depth of Field (inches)		
				Subject to film	Subject to ELPRO			f/8	f/11	f/16
90mm Elmarit-R f/2.8	VIIa	16,533		29-1/16	24-1/16	6-5/16x9-1/2	1:6.7	1-1/16	1-1/2	2-1/8
			28''	17-7/16	11-13/16	2-7/8x4-5/16	1:3.0	17/64	3/8	17/32
135mm Elmarit-R f/2.8	VIIb	16,534		59	53-1/4	9-5/16x14	1:9.9	2-1/4	3-1/8	4-1/2
			5'	33-1/2	27-3/16	4-1/4x6-3/8	1:4.5	17/32	23/32	1-1/16
	VIIa	16,533		29-13/16	24-1/16	4-1/4x6-3/8	1:4.5	17/32	23/32	1-1/16
			5'	23-1/8	16-13/16	2-5/8x3-15/16	1:2.8	7/32	5/16	7/16

set iris diaphragm of this lens is operated with a double cable release. The diaphragm is actuated by the coaxial knob that is also used for focusing with the rack-and-pinion focusing mechanism. The exposure factor caused by bellows extension is automatically taken into account when using the camera meter of the Leicaflex SL.

All standard Leicaflex lenses can be used for extreme closeups by connecting their bayonet mounts directly to the Bellows-R.

Closeup focusing without changing a given extension or magnification can be done with a mechanism in the base of the device. For extreme closeups, stop the lens well down for reasonable depth of field and good optical performance.

The *Divisible Extension Ring 14,158* can be used to increase the focusing range of 50mm, 90mm, 135mm and 180mm lenses.

Elpro Closeup Lenses are achromatic front lenses which extend the focusing range of Leicaflex lenses, while retaining the use of the fully automatic diaphragm. Elpro lenses improve the performance of Leicaflex lenses in the closeup range: the combination of camera lens and closeup lens is a fully corrected optical unit.

Elpros for use with long lenses include the Elpro VIIb, for the 90mm and 135mm f/2.8 Elmarit-R lenses, and the Elpro VIIa, for the 135mm f/2.8 Elmarit-R. (More detailed information on Elpro lenses will be found in the chapter, "Closeup Photography," by Norman Rothschild.)

Long lenses: general remarks

Long lenses have many uses in amateur and in professional and scientific photography. When long focal lengths are wanted for technical reasons, high optical quality is essential.

The maximum apertures of telephoto lenses vary widely according to their optical configuration. Large-aperture telephotos are significantly heavier and bulkier than other telephotos of the same focal length, but of smaller maximum aperture. The lens designer's task is to select the best combination of optical characteristics for a given photographic purpose. This approach is used in the development of new Leica and Leicaflex lenses, each created to meet the demands of practical professional use.

Long lenses are used at all distances, from closeups to extremely distant views.

Portraiture

90mm and 135mm lenses are useful for portrait photography because of their pleasant, natural-looking perspective, and because the longer distance from camera to subject helps to make the subject feel comfortable and relaxed, as well as providing the room necessary for good studio lighting in posed indoor portraits. The longer working distance is also convenient outdoors, especially when working with children, who must feel unencumbered and be free to move.

The choice of aperture depends on the situation and the desired result. For passport and general portrait photography, f/4 usually provides adequate speed and depth of field, but if the whole head must be sharp, f/8 or f/11 will be preferable. When working in dim light, or when a strong sharp-unsharp separation is wanted, the 90mm f/2 Summicron, or the 90mm or 135mm f/2.8 Elmarit-R can be used wide open with beautiful results.

Sports photography

Many sports subjects can only be photographed with distance-bridging telephoto lenses, which bring the action close, and render it with graphic power.

The flat perspective of a long lens makes people or objects look closer together than they really are, often creating an interesting effect in sports photographs.

The unavoidably shallow depth of field requires careful focusing on the principal subject; but sometimes even the experienced sports photographer cannot keep a fast-moving subject in focus. In such cases, the professional simply pre-focuses on a spot or a plane where his subject is expected to pass.

Fast-moving action requires short exposure times to maintain sharp images. Often the sense of motion is intensified by panning the camera along with the moving object, which will then be seen relatively sharp against a motion-blurred background. This lends the picture both clarity and drama.

Reportage

Because of the great and unpredictable variety of situations that a photojournalist must cope with, very high demands are made on the quality of lenses —especially under poor light conditions. High-aperture telephoto lenses are an important tool for the photoreporter.

The 90mm lens was used at a large aperture for its in-and-out-of-focus visual quality as well as for selective focus. Photograph by Charles Reynolds

A Leica with 90mm lens was used at moderate aperture for normal sharpness. Photograph by Charles Reynolds

Goal shot by Rolf Geiger. Leica with 400mm Telyt;
Kodak Plus-X Pan, f/8, 1/500 sec. Photo by
Erich Baumann

Leica M2, 400mm f/6.8 Telyt; Kodak Tri-X,
1/1000 sec. Photo by Bruno Walter, from the
Leica- Archiv, Wetzlar

Prefocusing where the subject will be. Leica M3, 400mm Telyt, Visoflex III; f/8, 1/1000 sec. Photograph by Volker Rauch, from the Leica-Archiv, Wetzlar

Panning to blur background while showing a fast-moving subject sharply. Leica IIIf, 135mm Hektor, f/5.6, 1/500 sec. Photo by T. C. March, from the Leica-Archiv, Wetzlar

Sculpture detail, monastery at Tomar, Portugal. Leica M3, 200mm Telyt, Visoflex I; f/8 at 1/30 second. Photo by Siegried Hartig, from the Leica-Archiv, Wetzlar

Theater and circus photography

Here, too, large-aperture telephoto lenses are important. The available-light situations in the theater and the circus require not only fast lenses, but lenses that have their best performance at large apertures. Used together with high-speed film, they enable the photographer to take good pictures under very difficult conditions. Precise focusing is especially important with high-aperture telephoto lenses.

Landscape photography

Telephoto landscapes can be very effective. By using the appropriate lens, scenic areas can be isolated from distracting surroundings and shown large in the photographs. Distant places seem deceptively close, and the scenery appears compressed. Mountains look higher, rocks seem steeper and valleys seem narrower than they really are. Streets in a hilly terrain seem closer together, and their slopes look steeper. Extremely long telephoto lenses yield a perspective that makes the background seem more enlarged than the foreground.

A large aperture can be used effectively with a telephoto lens for unusual landscape photographs. Precise focusing on the main subject in the background separates it strongly from the out-of-focus foreground, dramatically emphasizing the principal subject. Because of their high degree of correction, Leica and Leicaflex lenses are eminently suitable for this approach. The large apertures make it practical to use very short exposure times, which, in turn, permit hand-held photography.

In general, however, a good tripod is recommended, especially when the longer lenses, such as the 400mm and 560mm Telyts, are used, and when these lenses are stopped down for increased depth of field, making longer exposure times necessary.

Architectural photography

Architecture provides another field for long-lens photography. The greatest advantage of the telephoto lens in this application is the better perspective that is obtained in pictures of buildings of all kinds. With a wide-angle lens, you must move close to a building to fill the frame. This usually forces you to aim the camera upward, so that vertical lines converge in the picture, even if you want them to be parallel. The building appears to lean over backward. This effect is minimized by using lenses of long focal length, provided you can back away far enough to include as much of the subject as you need within the frame. Under favorable circumstances, convergence of vertical lines can be avoided altogether.

Telephoto lenses can also be used to advantage for "closeup" pictures of details, often located where they cannot be closely approached, so that a long lens is necessary to bridge the gap. Such enlarged details add much to the photographic coverage of architecture.

Other applications

In scientific photography, telephoto lenses are often the only tools that can solve certain problems—especially when small details must be recorded large from a distance.

The range of such applications is great, from scientific or technical photography in industry to the fine detail that must be recorded when photographing a surgical operation in the hospital.

In zoology, many pictures are only possible be-

cause of the telephoto lens. The applications range from scientific studies of animal habits to pictorial photographs of wildlife in the woods, the tundra, or the fields.

Long working distance
for "closeup" photography

The laws of optics involve certain fixed relationships between focal length, image distance, object distance, and the resulting scale of reproduction. These laws indicate that a desired image size on the film can be achieved with a lens of any of the various

Left: Iron work detail. Leica M3, 90mm Elmar; f/11 at 1/30 second. Photo by Werner Kohler, from the Leica-Archiv, Wetzlar

Below: Closeup photograph by R. Seck; Leicaflex with 100mm f/4 Macro-Elmar and Focusing Bellows-R; exposure by electronic flash at f/11

focal lengths: only the object distance—the distance from the lens to the subject—would vary. The object distance for a given image size in relation to subject size depends on the focal length of the lens used, and will be different for different focal lengths at any given scale of reproduction (or magnification). The image distance—the distance from the lens to the film—that is required for a given combination of focal length and scale of reproduction can be attained by using a helical focusing mount, a bellows, or extension rings or tubes.

In closeup photography, the open space between the subject and the lens is often an important factor. In practice, the particular assignment determines which lens should be selected. The photography of small animals and insects in their natural environments requires a special technique involving the use of long lenses. Tele lenses are practically mandatory for closeups of living creatures who are so sensitive that they cannot be photographed from closer than a certain minimum distance. With butterflies, for example, that distance can be one to two meters; so a long lens is necessary to get a large image. Pictures of young birds in their nests, or being fed by their parents, can only be made from considerable distance, often with camouflaged cameras operated by remote control or by electric eye.

Long lenses are important for botanical closeups. Whether the pictures are taken in a garden or in nature, distance must often be bridged because of obstacles, such as fences or streams, which prevent the photographer from coming close. Many flowers and plants are out of reach for the normal lens. Consider a lotus blossom in the middle of a pond: only the telephoto can reach far enough to make a frame-filling picture of it from the shore.

In technical photography, many subjects are best handled by using long lenses. A few such applications are: details of machines and apparatus; photographs of furnaces, reactors; studies of explosions; breakage test records; and motion studies in certain technical procedures.

Medical photography, too, usually requires long working spaces, and only long focal lengths make detailed views of the operation possible without interfering with the surgeons. The long lenses of the Leica and Leicaflex systems permit these distances, and are well suited to this purpose.

Techniques and problems in telephotography

Telephoto lenses isolate portions of the view in front of us. When photographed from the same distance, a given object is reproduced larger, and looks closer in the picture, as longer lenses are used.

For the best results, certain factors must be considered; among them, the maximum aperture, the focal length, and the optical design of the lens.

INCREASE OF WORKING DISTANCE WITH INCREASED FOCAL LENGTH

	50mm f/2 Summicron-R	100mm f/4 Macro-Elmar	180mm f/2.8 Elmarit-R
2:1 REDUCTION (FROM 48x72MM)			
Distance from lens:	121mm or 4-3/4 in.	265mm or 10-7/16 in.	580mm or 22-13/16 in.
From lens hood:	100mm or 3-15/16 in.	220mm or 8-5/8 in.	560mm or 22-1/16 in.
1:1 UNIT MAGNIFICATION			
Distance from lens:	66mm or 2-9/16 in.	160mm or 6-5/16 in.	400mm or 15-3/4 in.
From lens hood:	45mm or 1-3/4	115mm or 4-1/2 in.	380mm or 14-15/16 in.

A large aperture in a lens requires a large front element; and in some telephoto lenses, some of the elements are very thick, as well. To maintain these elements in precisely the required positions within the lens, the fabrication and assembly of the lens mount must also be extremely precise. This necessarily means added weight.

As we have seen, the image on the film is larger when the focal length of the lens is longer. At the same time, the relative displacement of moving objects within the image increases to the same degree. With long lenses, it is normal to use faster shutter speeds than with shorter lenses to prevent blurred images.

Another method, as we have also seen, is to use relatively slow shutter speeds—1/60th or 1/30th of a second instead of 1/500, for example—and pan the camera to follow a moving subject during the exposure. The subject is sharp, and the background is translated into streaks or blurs—the faster the movement or the slower the shutter, the longer the streaks, and the more difficult it is to keep the main subject sharp. This technique requires skill and practice, but gives very effective results.

Isolation by selective focus

When the lens is focused on a given object, not only that object will appear sharp; other objects, somewhat nearer and somewhat farther away than the distance focused on, will also be reproduced relatively sharply. This range in distance of acceptable sharpness is called depth of field.

Sharpness and depth of field in pictures are affected by the focal length of the lens, its aperture, the degree of optical correction of the lens, and the diameter of the circle of confusion that is considered acceptable.

The diameter of the acceptable circle of confusion in the negative or transparency depends on how much the picture is enlarged and on the viewing distance. At a given enlargement and viewing distance, the range of apparent sharpness in the photograph is limited by the aperture at which it was taken, and by the focal length of the camera lens. The larger the aperture, and the longer the lens, the shallower the depth of field.

The limited depth of field that results when large apertures and long lenses are used is sometimes a disadvantage, but it can be very useful when used with judgment. The separation of the principal subject from unimportant picture elements by selective focusing is an important compositional tool. The main object is shown very sharp, with very soft, unsharp surroundings. An uninteresting background or foreground sometimes becomes visually exciting when photographed out of focus. It may have a delicate softness, or be transformed into fantastic and powerful forms that add drama to the picture. Softly delineated blobs of color, or gray areas in black-and-white photographs, form a beautiful frame for the main object, and produce a compelling sense of depth.

Sometimes an unsharp background is a necessity. In botany, a sharply focused busy background can make the shape of a flower impossible to see clearly. Throwing the background area out of focus makes the specimen easy to see. It is often useful to add an artificial plain background by placing a card of subdued color or of contrasting tone behind the subject.

Leitz telephoto lenses are easy to focus on the goundglass because of the sharp, brilliant images they produce; nevertheless, it is important for the beginner to practice focusing until precision becomes automatic.

All Leica tele lenses for the Visoflex III, from 90mm to 800mm, and all Leicaflex lenses in the 90mm to 250mm range are excellent for this type of image isolation by selective focusing because of their sharpness at full aperture.

Keeping the camera steady

Steadiness is essential for good hand-held exposures. With a 90mm lens, it is usually enough to be careful to hold the camera still; but additional precautions should be taken when hand-holding 180mm or 200mm lenses. The arms should be propped against a firm support, or the body should lean against a tree or a wall to improve steadiness and prevent camera movement. For still longer lenses, such as the 400mm and 560mm Telyts, the detachable shoulder pod provides additional support and makes these lenses easier to handle.

For telephoto pictures of distant objects, a solid tripod is recommended. It must be free from vibration or wobble, or camera movement will impair the definition of the pictures. With extremely long lenses, it may be necessary to use a second tripod or other support under the lens as well.

Leica M2, 400mm f/5.6 Telyt; f/5.6, 1/500 sec.
Photograph by Julius Behnke

Leica M4, 560mm f/5.6 Telyt lens head on Televit with Visoflex III; Ilford Pan F, f/8, 1/250 sec. Photograph by Julius Behnke

Although a ball-and-socket tripod head is adequate for short lenses, a professional pan head of the motion-picture type is recommended for the longer lenses. The large camera-support surface of this type of tripod head assures firm, wobble-free support for the camera and lens.

The bellows device is normally used on a tripod. Its built-in fine-focusing rack permits a smooth movement of the entire assembly for extreme closeups.

Lens hoods

Because lens hoods are important in telephoto work, they are built into all Leica and Leicaflex telephoto lenses.

The lens hood prevents stray light, and frontal light from sources just outside the angle of coverage, from entering the lens. This improves the contrast of the image and eliminates unwanted internal reflections. The lens hood also protects the lens against rain and snow, making excellent photographs possible under unfavorable weather conditions.

Cleanliness

To obtain optimum contrast with a telephoto lens, the lens must be spotlessly clean. Fingerprints are especially damaging to lens performance, and dust specks on the lens also affect image contrast, especially in backlighted photographs. The photographic outfit should include a camel's hair brush and a soft lint-free cloth for lens cleaning.

Filters

With telephoto lenses, the use of color filters is limited to certain applications.

In black-and-white photography, we can influence the separation between objects of different colors by the judicious use of filters. Contrast is increased, yielding improved photographs, when telephoto lenses are used with filters for aerial or distant shots. Orange and red filters are most efficient in penetrating atmospheric haze, so they produce the greatest increase in contrast. The use of infrared films with appropriate filters provides striking results. (For detailed information, see the chapter, "Infrared Photography," by Dr. Walter Clark.)

In landscapes with large areas of green, a yellow-green filter will reproduce green forests, leaves and grass in lighter and more distinct tones of gray, adding a luminous quality to the pictures, especially in backlighted scenes.

In color photography, conversion filters are used to match the spectral characteristics of the illumination to the film.

Ultraviolet-absorbing filters were recommended in the past for color purity in daylight photography, but current Leica and Leicaflex lenses are equipped with UV-absorbing coating or a UV-absorbing cemented surface, so this is no longer necessary.

Polarizing filters are also available for long lenses, to reduce unwanted reflections or to darken skies without color change. (See the chapter, "Filters," by Leslie Stroebel.)

Fitting filters to lenses

Conventionally, filters are attached to the front of the lens. Such filters are available in screw mounts, or in the form of series filters, held in place by a retaining ring or by the lens hood.

However, in the 400mm and 560mm f/6.8 Telyt, and 800mm f/6.3 Telyt-S lenses, the filters are placed behind the lens in the mount, permitting the use of much smaller (Series VII) filters than would be needed for the front of these lenses. It is important to focus with these filters in place.

A dramatic, mysterious world can be discovered through closeup photography. Qualities, even personalities, never before noticed seize our attention and extend our visual understanding of reality. Photograph copyright 1972 by Louise Brauner

Closeup Photography

Norman Rothschild

"Amazing" is the word when your projection screen is filled with an image from the seldom-noticed microcosmos around us. "Necessary" is the word for closeup photography by professional, commercial and industrial photographers, doctors, dentists, scientists, engineers and researchers, investigators, and many, many others.

"Amazing" may apply to the results of closeup shooting, but it no longer applies to the techniques used with Leica and Leicaflex equipment. Leitz has taken the mystery and drudgery out of this important and rewarding field of photography. As early as 1936, when the first Reflex Housing (the Visoflex) was introduced, images life-size or larger were easily possible with Leica equipment. Today, whether you wish to get just a little closer than your lens normally allows, or so close that details the eye cannot usually see are revealed, a well-thought-out and optically sound piece of Leitz equipment is available to do the job.

There are two ways to get large images at very close distances with a 35mm camera. One is to change the focal length of the camera lens optically by adding a supplementary lens. The other is to move the camera lens farther away from the film than it normally is by inserting extension tubes or a bellows between the lens and the camera body. Specific Leitz accessories permit you to use either of these methods with all Leica M, Leicaflex and Leicaflex SL cameras.

Supplementary or "closeup" lenses are actually low-power magnifiers. Their use on the camera closely resembles the use of a magnifying glass with the human eye. Leitz *Elpro* lenses are excellent supplementaries especially designed for use with Leicaflex R lenses. An Elpro is screwed into the front of the camera lens in the same way as a filter. The combined focal length of Elpro-plus-camera-lens is shorter than that of the camera lens alone; this permits focusing much closer to the subject. In effect, the combination puts a short-focal-length lens on the focusing mount of a longer lens; in other words, it provides extra extension.

The same result is accomplished with extension tubes or bellows. To understand how these work, set your camera lens at infinity and look at it from above. Now slowly turn the focus ring until it reaches its closest distance setting. As you do so, you will see that the lens moves forward, away from the film. If

you could move the lens still farther, you could focus on ever closer objects—that is the principle of extensions.

Leitz extension tubes mount directly on the camera body, or on the Visoflex reflex viewing attachment. The lens then mounts on the tube. The tubes have various fixed lengths, but two or more can be combined for greater extension.

A bellows also mounts on the camera body or on the Visoflex and accepts Leitz lenses either directly or with adapters. A bellows extends and retracts along a guide track, providing continuously variable extension; thus it is far more flexible than fixed-length tubes. The Leitz Bellows II is for all M Leicas; the Bellows-R is for the Leicaflex and Leicaflex SL.

Most Leitz lenses are designed for optimum performance at normal distances, but many also perform excellently at closeup distance. In addition, Leitz manufactures some lenses especially designed to produce closeup and "macro" (life-size and larger) images. These include the Photar macro lenses in focal lengths from 12.5mm to 120mm; the 100mm Macro-Elmar f/4; the new 60mm Macro-Elmarit-R f/2.8; the 65mm Elmar f/3.5; and others. These lenses are discussed in more detail later, and in other chapters.

Closeup language

A word about closeup terminology will help you visualize the capabilities of the equipment and setups to be described. In closeup work, image size is often expressed as a *reproduction ratio*, or the relationship of image size to object size. Image size is always written first—image:object.

When the image on the film is smaller than the object, the image size is written as one, and the object size as the number of times it is bigger than the image. 1:10 means the object is ten times larger than the image on the film. Thus the image represents a *reduction* (a "minification") in size.

When the image and the object are the same size, the reproduction ratio is 1:1, or *life-size*.

When image size is larger than object size, the object is written as one, and the image size as the number of times that it is larger. Thus 5:1 is a *magnification* with the image five times larger than the object.

A reproduction ratio can also be expressed as a fraction or a decimal. For example:

1:10 = 1/10 = 0.1
1:1 = 1/1 = 1.0
5:1 = 5/1 = 5.0

The decimal form is often called the scale of reproduction, or simply the *scale*.

Occasionally the terms seem mixed, as in the phrase "0.5x magnification." This is in fact a reduced-size image, even though it is called a magnification. The clue is in the decimal figure—a decimal less than 1.0 is a reduction; a decimal greater than 1.0 is a magnification, no matter what other terms are added.

Broadly speaking, normal-range photography includes image sizes from 1:100 or more down to about 1:10. Closeup photography extends from about 1:10, through 1:1, into magnifications up to about 40:1. (See Photographic Scale chart.)

Photographic scale

```
         ┌─Closeup range─┐┌─Normal range──────→
1000+:1...40:1.....1:1.....1:10.....1:100
         ║        (life-size)
←─Micro──╨─Macro ┘
←─Magnification────┘└─ Reduction ────────────→
```

Larger-than-life photographs, up to about 40:1, have the name *photomacrography*, or "macro" work. Greater magnifications are possible with standard equipment, but it is easier to couple the camera to a microscope for *photomicrography*. The chapter "Photomacrography and Photomicrography" contains much specialized information about making pictures in these ranges.

Closeup equipment

A number of factors influence how you get closer than the normal focusing distance engraved on your camera lens. First of all, the equipment you choose and the accessories available depend on whether you are using a Leicaflex or a Leica.

Leicaflex and Leicaflex SL

By far the easiest approach to closeup shooting is to use the standard Leicaflex or the Leicaflex SL. In these single-lens reflex cameras the finder shows both focus and composition for a lens of any focal length, for any lens-plus-Elpro combination, or for any lens-plus-extension combination. Because viewing is through the lens, there is no problem of parallax, or difference in point of view between lens and finder.

The focusing screen of Leicaflexes shows almost exactly the same area that is seen in a mounted transparency. In negatives and unmounted transparencies, you get a bit more on the film than the finder shows. (Some of that is masked off by the negative carriers of certain enlargers.) In either case, you can frame the subject with precision.

Two additional Leicaflex SL features help greatly in closeup shooting. The first is selective through-the-lens light measurement, which ends the exposure recalculations usually needed in closeup work. No matter what lens or combination is used on the SL, the meter automatically indicates correct exposure. The small, selective area measured by the SL meter cell helps you read exposure for the small objects often encountered in closeup situations.

A second important feature is full-screen-area focusing and depth-of-field preview. These permit you to see subject-to-background relationships and make esthetic judgements. For example, you may wish to make the main subject stand out by keeping the background out of focus. Depth-of-field preview lets you see just how sharply the background is focused. Full-screen focusing lets you see the sharpness of the main subject even though it may not be located in the center of the picture area.

Some Leicaflex lenses have a respectable close-focusing capability built into them, so accessories may not be required for the closeup you want. For example, the normal 50mm Summicron-R f/2 focuses to 20 inches, the 35mm Elmarit-R f/2.8 to 12 inches, and the 21mm Super-Angulon-R f/4 to 8 inches. The new 60mm Macro-Elmarit-R f/2.8 focuses from infinity to a half-life-size image (1:2 ratio). An intermediate ring supplied with the lens extends the focusing range from 1:2 down to 1:1, or life-size images.

Elpro lenses

Getting closer than the minimum focusing distance of a Leicaflex lens is easiest with the help of Leitz Elpro supplementary lenses. These are two-element coated achromats. They do not interfere with the metering systems of the Leicaflex or the Leicaflex SL and require no recalculation of exposure.

Elpros are supplied in two sizes, VI and VII, and

two strengths, *a* and *b*. The Elpro VIa is weaker than the VIb; both were computed exclusively for use with the 50mm Summicron-R f/2, and fit the series VI filter threads of that lens. The VII Elpros fit the filter threads of the 90mm and 135mm Elmarit-R f/2.8 lenses. VIIa is stronger than VIIb and can be used on either lens. VIIb is intended only for use with the 135mm lens.

Table 1 at the end of this chapter shows the subject distances, field sizes and reproduction ratios of the various Elpro-plus-Leicaflex-lens combinations. Tables 2 and 3 also include data for Elpros used with other combinations.

The Elpro lenses are especially designed to maintain very good image definition when combined with Leicaflex lenses. That is not the case when the inexpensive, single-element supplementary lenses offered by several manufacturers are used. Although center definition may be acceptable at the maximum lens opening, for closeup work the Leicaflex lens should be set at f/8, f/11 or f/16. As the f-stop is made smaller, depth-of-field increases; this is particularly important because depth is so shallow in any case at close distances.

It is possible to combine two Elpros to obtain greater image magnification, but usually too much definition is sacrificed. When larger images than those obtainable with a single Elpro are desired, the preferred solution is to use extension rings and tubes, or the Leicaflex Focusing Bellows-R. Although they perform the same basic function, the extension rings and tubes are quite different in operation and capabilities from the bellows.

Extensions

The Leitz Divisible Extension Ring (Cat. No. 14,158) consists of two parts, ring-1 and ring-2, which are used together between the camera body and a Leicaflex lens. Additional extension for even larger images can be obtained by inserting one or two extension tubes (Cat. No. 14,135) between the rings. (See Fig.1.) Table 2 at the end of the chapter shows the reproduction ratios obtained with various combinations of the ring-and-tube set with 50mm, 90mm and 135mm Leicaflex lenses. The rings may also be used with 180mm and 250mm Leicaflex lenses, but for the best quality images, they are not recommended for use with focal lengths less than 50mm.

The current-model combination ring (No. 14,158)

1

Divisible Extension Ring.
Lens ring (top) and camera ring (bottom) are used together to extend Leicaflex 50mm, 90mm or 135mm lenses. Intermediate tube (center) may be inserted for additional extension

provides semi-automatic aperture coupling. The previous model (No. 14,134, discontinued) can be used on all Leicaflex and SL cameras, with or without intermediate tubes, but it does not provide aperture

coupling. When taking closeups with the new rings, first focus with the lens open to its maximum aperture; then preset the lens to the desired f-stop. To make an exposure, first press the release button on ring-1 that holds the lens; this closes the diaphragm to the preset f-stop. Then press the shutter release on the camera. To open the diaphragm again, simply turn the f-stop control to the maximum aperture; then preset for the next exposure. It is not necessary to open the lens each time, but only when you want to refocus or change the aperture setting.

The Leitz Double Cable Release (Cat. No. 16,494) makes the job even easier. It connects to the release on the extension ring and to the shutter release on the camera. The part of the cable release whose pin appears first when the cable control is pressed must be screwed into the extension ring; this ensures that the lens stops down before the camera mirror rises and the shutter operates. In use, you focus wide open, preset the f-stop, and press the button of the double cable release; then everything automatically happens in the proper sequence.

With the Leicaflex SL, you make exposure readings with the lens aperture closed to the desired f-stop. Simply turn the shutter speed control until the follow-pointer matches the meter needle.

The meter of the standard Leicaflex does not read through the lens. When the camera ring (ring-2) of the extension set is mounted on the Leicaflex, the follow-pointer of the meter is moved to the f/11 position for the film speed and shutter speed being used. If this corresponds to the meter needle position when the camera is held so the meter reads the closeup area, you may proceed; otherwise you must change shutter speed until the meter needle and follow pointer match—f/11 is almost invariably used for closeup work.

The exposure you arrive at by this method is for normal photography; the meter does not know that the lens has been extended for a closeup. You do know, however, and you must determine how much more exposure is required to compensate for the lens extension. The exposure factors given in Table 7 tell you how much to compensate for various reproduction ratios. (A factor of 2 requires a setting one f-stop wider or one shutter speed slower; a factor of 4 requires two f-stops or two shutter speeds more exposure. But stay at f/8, f/11 or f/16 for good closeup quality.)

Focusing Bellows-R

A deluxe system for closeup photography is embodied in the Leicaflex Focusing Bellows-R and the 100mm Macro-Elmar f/4 lens (see Fig. 2). This combination permits continuous focusing from infinity to an object-to-lens distance of 187mm (about 7-1/4 inches) for a same-size, or 1:1 image. The bellows may also be used with other automatic-diaphragm Leicaflex lenses from 35mm to 180mm. The maximum image magnification of almost 3:1 (three times life-size) is obtained by using the 50mm Summicron-R f/2 at full bellows extension with the lens set to its nearest focusing distance (0.5 meters; 20 inches).

The 100mm Macro-Elmar f/4 is especially corrected for closeup and macrophotography. It does not have its own focusing mount and is designed for use on a bellows. Elpro supplementaries may be added to several lenses on the bellows to increase their magnification. Table 3 at the end of the chapter gives data for various lenses on the Bellows-R.

The Bellows-R also accepts the complete range of Photar macro lenses. The 50mm f/2.8, 80mm and 120mm Photars require adapter ring No. 500,935 to fit the Bellows-R. The 50mm f/4, 25mm and 12.5mm Photars require adapters No. 542,151 and No. 500,935. Data for these lenses are included in the chapter "Photomacrography and Photomicrography."

A special feature of the Bellows-R is a scale bar on the lower left side of the bellows. The bar rotates to reveal four scales. Three of the scales give image magnification data for the 90mm Elmarit-R, the 100mm Macro-Elmar, and the 135mm Elmarit-R lenses. The fourth scale reads directly in millimeters, 0-100, for use with other lenses. Data in the instruction book and in the tables with this chapter let you determine exposure factors (for the standard Leicaflex) and reproduction ratios (for other lenses) from the scale readings.

The 90mm and 135mm Elmarit-R are lenses of telephoto design; their back focus is shorter than their focal length. Therefore more exposure compensation is required than most normal reproduction ratio tables indicate. Table 4 gives proper factors for these lenses.

In operation, focus the Leicaflex bellows with the lens aperture wide open. Push in the ring which surrounds the bellows focusing knob (lower left

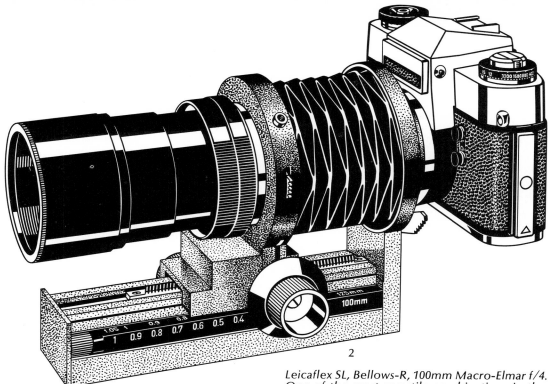

2

Leicaflex SL, Bellows-R, 100mm Macro-Elmar f/4. One of the most versatile combinations in the entire Leicaflex system: compact enough to carry anywhere, capable of photographing almost any closeup or macro situation

front) and hold it in to keep the diaphragm open; release the ring to permit the diaphragm to close to the preselected f-stop. To keep the diaphragm open for an extended period, push in the ring, then depress the aperture lock on the left side of the bellows lens standard. To release the lock and stop down, simply push in the aperture ring slightly and let it go.

To shoot subjects where the sequence of stopping down and releasing the shutter needs to follow rapidly, use the Double Cable Release. It connects to the camera shutter release and to the cable release socket on the left side of the bellows lens standard. The twin cable release is also useful for remote work, where touching the setup can cause unwanted vibration; for example when the camera and bellows are mounted on a tripod or copying stand. The cable release also allows you to step away from the camera a bit, for instance to get your shadow off the subject.

Two knobs adjust image size and focus. The left-hand knob moves the lens toward or away from the film. Use it to set the lens for any desired magnification, as shown on the appropriate bar scale. The right-hand knob controls a fine-focus rack on the bottom of the bellows unit. With the bellows on a tripod, use the right-hand knob to move the camera and lens toward or away from the subject without changing the lens-to-film distance. This allows you to focus the subject precisely without changing image size or exposure factor. It also allows you to get closer or farther away without moving the tripod.

To make vertical pictures, a release catch at the rear of the bellows lets you rotate the camera body without disturbing the rest of the setup.

Exposure metering in the Leicaflex SL is through the lens, with the aperture stopped down; no calculation is necessary. In the case of the standard Leicaflex, the bellows lens standard blocks the meter. You must take a closeup reading with the camera off the bellows, or use a hand-held meter such as one of the Leica meters or the Metrastar CdS meter. Be sure to apply the extension exposure factor for the magnification or extension you are using; see Table 4.

If you have a Focusing Bellows II for use with M Leicas, you can attach it to any Leicaflex with adapter No 14,127. The operation and metering are similar to those of the Bellows-R.

Closeups with Leica M cameras

Before describing the accessories that adapt Leica M cameras to closeup work, let me remind you that several Leitz normal and wide-angle lenses focus

quite close via the rangefinder. For example, the 50mm Dual-Range Summicron f/2 focuses to 19 inches and is equipped with a special viewing unit for close work. (This lens must be modified for use with the M5.) The Leitz 21mm, 28mm and 35mm lenses for M cameras focus as close as 2 feet-2 inches, depending on the M model in use. The newest version of the 50mm Summicron f/2 focuses to 28 inches without accessories.

To get closer with normal (50mm) lenses, Leitz provides a Close Focusing Device (Cat. No. 16,507). This is a bayonet-mounting extension lens mount with an attached optical unit which adapts the camera range-viewfinder for closeup focusing and framing. It accepts bayonet-mount collapsible 50mm lenses, and the screw-mount 50mm Elmar f/2.8. With the addition of adapter No. 16,508, it will accept the lens unit (unscrewed from the focusing mount) of the 50mm Rigid Summicron f/2. The close

focusing device provides a range from 2 feet-10-1/2 inches to 19 inches. This provides reproduction ratios from 1:15 (area covered: 14x21 inches) to 1:7.5 (area: 7x10-1/2 inches). The combination of 16,507 and 16,508 is designated Catalog No. 16,509.

The Auxiliary Reproduction Unit can be used to photograph small objects and to copy flat materials at ratios of 1:4, 1:6 and 1:9. It is discussed under *Tripods and Copying Stands,* below.

The greatest closeup versatility with a Leica M camera is obtained by converting it into a single-lens reflex. This is easily accomplished with the Visoflex III (or the earlier Visoflex II or IIa) reflex housing. Various adapters extend Leica lenses on the Visoflex for closeup work.

When Bellows II is used on the Visoflex (Fig. 3), the focusing range is extended from infinity to 1:1 with the lens unit of a 90mm Elmar or Elmarit lens. The lens heads of a number of long-focus 135mm

M Leica, Visoflex III, Bellows II, 90mm lens unit. An M Leica becomes a single-lens reflex with the Visoflex; the bellows adds closeup and macro capabilities

3

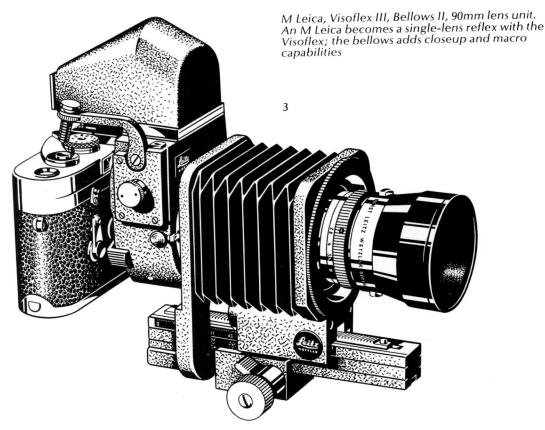

Leitz lenses provide a range from infinity to 1:4 when mounted on the bellows. Magnifications up to 5:1 are obtainable with other lenses, but without the capability of also focusing to infinity. Closeup data for various lenses with these accessories are given in Table 5 (Visoflex) and Table 6 (Bellows II).

The Focusing Bellows II has a revolving-locking collar which permits turning the Leica-plus-Visoflex for horizontal- or vertical-format pictures without moving the bellows. There are two focusing methods. A knob at the left focuses by changing the lens-to-film distance. A knob at the right moves the entire bellows-camera assembly as a unit. This allows obtaining sharp focus without changing the image scale, picture field, or exposure factor, as previously selected by setting the lens-to-film distance. Below the focusing track there are two engraved data scales. The one on the left shows reproduction ratios and exposure-increase factors for the 90mm Elmar or Elmarit lens heads. The scale on the right shows the actual extension in millimeters. It is used with a table to determine magnifications and exposure factors when using other lenses.

Reflex viewing is provided by the Visoflex: a mirror reflects the image onto a groundglass screen. The groundglass may be viewed from above with a vertical 5x magnifier; this is convenient for holding the camera at chest level, or for using it mounted on a copying stand, pointing downward. The image in the 5x magnifier is upright, but reversed right for left. A 4x Prism Magnifier is used for conventional, behind-the-camera viewing; it shows the image upright and correct from left to right.

With all M Leicas except the M5, exposure readings are best made using a hand-held light meter. Any compensation needed because of extra lens extension may be read or calculated from the scales on the bellows focusing-track, or from various tables, as at the end of this chapter. The calculator dial of the meter may also be used as a sliderule for this computation. (For details, see the chapter, "Light Meters and Metering," by James Forney.)

The Leica M5 permits closeup readings to be made through the lens. There is no need to recalculate exposures when this is done. To read the meter through the lens, the mirror of the Visoflex is temporarily raised. To take the picture, the mirror is reset, and the exposure made in the usual manner. The mirror control is on the right side of the Visoflex.

Tripods and copying stands

Some closeups at low magnification are easily possible with a hand-held camera, but for really sharp pictures you must have a sturdy tripod. It should be a heavy-duty type, with smooth and effortless movements. Leica equipment is relatively small, but don't be tempted to match its diminutiveness with a tiny, flimsy tripod. For work on a table or close to the ground, and in cramped quarters, a combination of the Leitz Table Tripod (Cat. No. 14,100; Fig. 4) and the Large Ball-and-Socket Tripod Head (No. 14,168) is useful. I prefer it to the usual pan-and-tilt heads supplied with most of today's tripods, as I find it easier to set for the exact angle I want.

4

Leitz Table Tripod.
This small, sturdy device folds for packing. Its usefulness is greatly increased by adding either the small or the large Leitz Ball-and-Socket Head

The Leica Auxiliary Reproduction Unit (Cat. No. 16,526; Fig. 5) is a set of copying adapters and distance gauges for use with bayonet-mount Leicas. It consists of four legs which telescope to marked lengths for three reproduction ratios—1:4, 1:6, 1:9. The legs screw into an extension collar (camera-lens adapter) for the desired ratio. Each collar accepts bayonet-mount collapsible 50mm lenses, and 50mm Elmar f/2.8 and collapsible Summicron lenses. With adapter No. 16,508 the collars also accept the lens units of the 50mm Rigid or Dual-Range Summicron lenses. The camera body attaches to one side of a collar, the lens to the other. (Older collars for this unit must be modified for use with the M5 Leica.) The lens focusing scale is set at infinity.

5

Auxiliary Reproduction Unit.
Interchangeable collars give fixed reproduction ratios; legs mark off area covered when extended to proper length

When screwed into the appropriate collar and extended to the marked length, the legs gauge the proper camera distance and their feet mark the corners of the area covered at each reproduction ratio. The stand is commonly used to support the camera pointing downward, for instance toward a page in a book. But the photographer can hand-hold the camera and use the legs to get the distance to, and framing around, a close subject. The area covered at each ratio is:

1:4; 4-1/8x5-3/4 inches
1:6; 5-3/4x8-1/4 inches
1:9; 8-1/4x11-5/8 inches.

The auxiliary reproduction unit is extremely useful when a simple setup for quick closeup work is desired; for example, in doctors' and dentists' offices, libraries, and similar locations.

[The Universal Copying Stand (Cat. No. 16,511) provided for reproduction ratios of 1:1, 1:1.5, 1:2 and 1:3. It was a small adjustable stand, with a groundglass-and-magnifier housing to check focus. It accepted any bayonet- or screw-mount Leica and any 50mm lens. Four extension tubes and changeable field masks provided the various coverages, including a 2x2-inch field for slide copying. This unit has been discontinued because its capabilities are covered so well by other, more versatile accessories.]

If you intend to copy flat material (photographs, pages in books, magazines or newspapers, etc.) up to 18x19-3/4 inches, then the Leica-Leicaflex Copying Stand (No. 16,707; Fig. 6) will prove very useful. It accepts all Leica and Leicaflex cameras, with or without bellows, extension tubes, Visoflex or other accessories. It holds the camera above and exactly parallel with the copy on the baseboard. A quick-release lever in the copying arm permits raising or lowering the camera assembly rapidly. Fine-focusing is provided by a friction-drive knob.

The Reprovit IIa (Cat. No. 16,789; Fig. 7) is a truly universal copying and closeup tool for use with M1, M2, M3, modified M4, and MD and MDa Leicas. Basically it is a 27-inch square baseboard, with a 56-inch tall column which supports and guides a specially designed camera-carrying arm. Four copy lights attached to the baseboard provide even illumination; they have baffles to prevent glare into the lens.

The counterweighted camera arm has a sliding focusing stage, a bellows, and an illuminated projector. The camera body mounts on the stage. When it is moved to one side, a groundglass takes its place over the bellows and lens. The groundglass is engraved with focusing and register lines. The projection light shines through the glass to project the engraved lines onto the baseboard or the copy. Coverage is changed by moving up or down until the illuminated area that represents the camera field takes in the copy. The image is focused by adjusting the bellows. A scale on the bellows shows reproduction ratios, baseboard-to-film-plane distances, and exposure-increase factors. This scale is for use with the 50mm Repro Focotar f/4.5 lens supplied with the outfit.

It is also possible to preset the lens-bellows assembly to a desired ratio and move the camera arm up or down until the projected image is precisely focused. Reproduction ratios can be determined by measuring the distance between lines in the projected image. These are spaced ten millimeters and one inch apart on the groundglass. If the spacing on the image is 5 inches, the ratio is 5:1.

With the projector uncoupled, a 5x magnifier

6

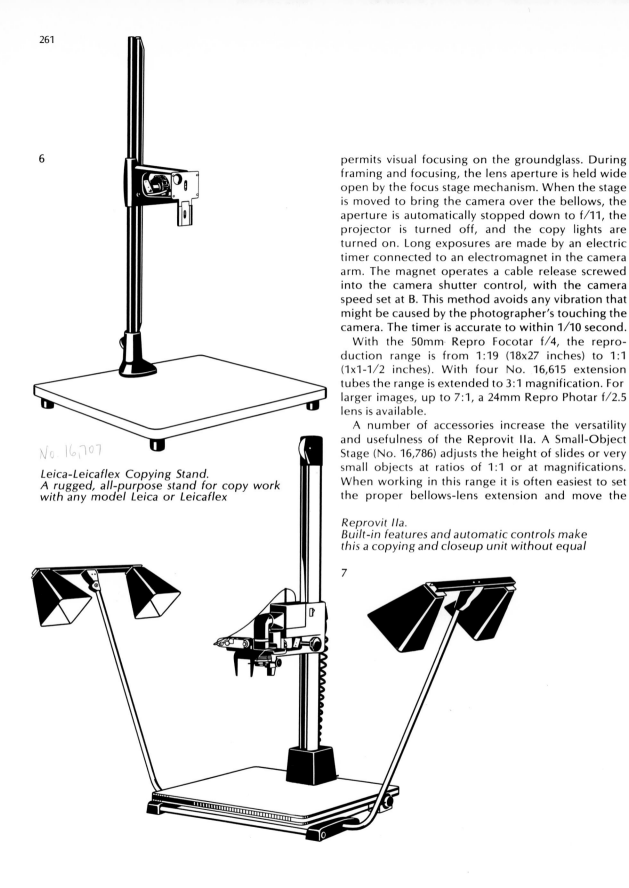

No. 16,707

Leica-Leicaflex Copying Stand.
A rugged, all-purpose stand for copy work
with any model Leica or Leicaflex

permits visual focusing on the groundglass. During framing and focusing, the lens aperture is held wide open by the focus stage mechanism. When the stage is moved to bring the camera over the bellows, the aperture is automatically stopped down to f/11, the projector is turned off, and the copy lights are turned on. Long exposures are made by an electric timer connected to an electromagnet in the camera arm. The magnet operates a cable release screwed into the camera shutter control, with the camera speed set at B. This method avoids any vibration that might be caused by the photographer's touching the camera. The timer is accurate to within 1/10 second.

With the 50mm Repro Focotar f/4, the reproduction range is from 1:19 (18x27 inches) to 1:1 (1x1-1/2 inches). With four No. 16,615 extension tubes the range is extended to 3:1 magnification. For larger images, up to 7:1, a 24mm Repro Photar f/2.5 lens is available.

A number of accessories increase the versatility and usefulness of the Reprovit IIa. A Small-Object Stage (No. 16,786) adjusts the height of slides or very small objects at ratios of 1:1 or at magnifications. When working in this range it is often easiest to set the proper bellows-lens extension and move the

Reprovit IIa.
Built-in features and automatic controls make
this a copying and closeup unit without equal

7

object into sharp focus. The small-object stage moves up and down exactly parallel to the baseboard and film plane.

Framing Box No. 16,761 (Fig. 8) holds books and other materials up to five inches thick pressed flat against a glass top so that all portions will lie in the same plane. It has a subject area 12x17 inches.

8

Framing Box.
Adjustable shelf height and clamping action solve the problem of making flat copies from thick books or wrinkled pages

Illuminating Box No. 16,773 (Fig. 9) can be used to illuminate x-ray films, slides and other materials from below, and to provide a lighted background for shadowless photography of small objects. The subject area is 16x17 inches; masking curtains for reducing the area to any size are attached.

9

Illuminating Box.
Shadowless lighting of small objects and slide illumination for copying are just two uses of this unit. Curtains mask down to desired area so stray light will not affect image contrast

Kapeka-Pol equipment (Cat. No. 98,789) consists of four polarizing filters for the Reprovit lamps and a 36mm-diameter polarizing filter for the lens. These make it possible to eliminate reflections from glossy-surfaced materials.

The Leitz Docuflex 35 is a specialized copy camera used on the Reprovit IIa (the Reprovit 35 is the same stand, but especially equipped for use only with the Docuflex camera). It holds up to 100 feet of perforated or unperforated 35mm film, which makes it valuable for quantity copying, filmstrip photography and microfilming. Five different formats can be set; thus the most economical format for a given size original may be chosen. Formats include microfilm standard frame (32x45mm) and half-frame (32x22.5mm), regular 35mm standard frame (24x36mm) and half-frame (18x24mm), and 16mm cinefilm (14x20mm). Object fields up to 45.5x63.5mm may be copied on the baseboard, and accessory extension tubes make magnifications to 1:1 possible. Other features include reflex focusing with a 4x magnifier; 70mm f/5 interchangeable lens; built-in tape measure; flash synchronization; shutter speeds of 1/4, 1/2, 1 second and intermediate click positions; vacuum suction of film during exposure; and motor drive.

Closeup technique

When you have made up your mind which piece of Leica or Leicaflex equipment meets your special needs, it's time to get down to some matters of photographic practice.

Closeup perspective and depth of field

Certain image magnifications may be obtained by using lenses of different focal lengths. It is possible, using the proper amount of extension in each case, to obtain a 1:1 image with either the 50mm Summicron-R f/2 or the 100mm Macro-Elmar f/4. Which is preferable? Your first impulse might be to use the 50mm lens, since you have been told that shorter focal length means greater depth of field. That does not hold true in closeup work. The determining factor is the image magnification, not the lens focal length.

Where magnification, f-stop used, and degree of sharpness desired (circle of confusion) are the same, the depth of field is the same regardless of the focal length of the lens. You get the same depth of field in a 1:1 image (or any other given ratio) whether you use a 50mm, 90mm, 100mm, 135mm or any other lens. And closeup depth of field extends half in front

of the plane of sharp focus and half behind (in contrast to about one-third in front, two-thirds behind at normal distances).

There is also a difference in perspective. With a shorter-focal-length lens, more objects will appear in the background, because of the wider angle of view, and the background object will appear smaller than with a longer lens at the same magnification. With the longer lens, background objects seem closer, and fewer of them appear in the field of view. This capability of the longer lenses to show less background than a short lens at any given magnification is of special value when working in a relatively confined space in which it is not feasible to use a large background. For example, a long lens permits use of a smaller white card or other background material. In outdoor work, the longer lens eliminates much of extraneous backgrounds.

Shorter lenses are helpful when background objects are close to the subject and cannot be moved or concealed. The short-focal-length perspective increases the apparent subject-to-background distance and makes the objects smaller; it seems to push them back so they do not crowd the main subject as much.

Certain important differences do depend on the lens focal length. For the same image magnification, lens-to-subject distance will be greater when using a long lens than when using a short lens. This makes it easier to place lighting units, adjust apertures, and make other settings. It is also easier to avoid casting shadows of yourself or the camera and lens on the subject, especially in outdoor shots.

Closeup extension

In planning setups or selecting equipment to take into the field, it is often useful to know how much extension—that is, how great a lens-to-film distance —will be needed for the image sizes you wish to make. A simple formula lets you determine the required extension for any magnification with any focal-length lens:

$$Ext = (m + 1) F$$

where m is the magnification, and F is the focal length of the lens. (It is easiest to use the magnification in decimal form; e.g., 1:5 = 1/5 = 0.2.) So, one plus the magnification, multiplied by focal length, equals the required extension for that magnification. If the focal length is in inches, the extension will be in inches; if in millimeters, the extension will be in millimeters. The distance is from the lens diaphragm to the film plane.

Exposures in closeup work

When using a Leicaflex SL or a Leica M5, with their through-the-lens metering systems, no exposure recalculation for extension is necessary. Additional exposure is measured directly for you by the metering system.

In all other closeup work using lens extensions, exposure data gleaned from a meter reading must be recalculated. There are two general approaches to this problem. The easiest—and the one that avoids arithmetic—is to follow the copious exposure compensation data given by Leitz for each of its closeup devices. Much of that data is included in the tables in this chapter. There is no need to pull out a slide-rule where Leitz has already done the figuring for you.

The second approach to closeup exposure compensation involves a simple formula. It is useful when tables are not at hand, or whenever some odd lens-and-extension combination is employed. The formula for the exposure increase factor is:

$$Factor = (m + 1)^2.$$

Simply add one to the magnification, then multiply that figure by itself. The result is how much you must increase normal exposure for that situation. For example, at a 3:1 ratio, $m = 3$. So, $3 + 1 = 4$, and exposure factor = $4 \times 4 = 16$. If the exposure for a normal-distance picture is f/11 at 1 second, the closeup exposure would be f/11 at 16 seconds. Opening up four f-stops would provide an equivalent increase, but closeup work requires f/8, f/11 or f/16 for good image quality. Therefore it is generally better to increase exposure time than change to a wide f-stop. Note that the exposure increase becomes significant only at ratios of 1:5 and larger. Additional information about closeup exposure is contained in the chapter, "Meters and Metering."

When you use filters you must also give some attention to exposure. After consulting the data supplied by Leitz on how to compensate for the closeup exposure, you must also allow for the light

absorbed by most filters. In the case of the Leicaflex and the Leica M5, it might seem that filter factors would be taken care of automatically. In certain non-critical work that may be the case. But Leica and Leicaflex users tend to be critical technically. Since the color sensitivity of a CdS cell does not correspond to that of films, certain film-and-filter combinations need additional correction. In black-and-white photography with Leitz filters, an extra half-stop exposure should be tried with the Yellow 1 filter, and one stop extra with the Yellow-Green, Orange and Polarizing filters. Factors or compensations for other types and makes of filters should be established on the basis of experiment. If in doubt, start by taking a through-the-lens meter reading without the filter, then apply the factor supplied by the filter and film makers. Once you have established a filter factor by experiment, you can simply divide the ASA rating of a film by the factor and use the new ASA setting on your meter. In any event, because of differences in color sensitivity, *do not* take a meter reading through a colored filter.

It is possible to read through neutral density filters for color or black-and-white photography, or through a polarizing filter for black-and-white (but not for color) photography—these filters are nearly colorless and will not affect meter response inaccurately. But it would be silly to try to take meter readings through deep infrared filters that are almost black, such as the Wratten 87C, 88A, etc.

Focusing

Much confusion about seeing properly in the viewfinder, especially that of a single-lens reflex, may be avoided by realizing that the focusing system of your eyes and that of the camera are two separate entities. In general, the rays of light emitted from a camera eyepiece are more or less parallel, or collimated—like rays coming from an object at infinity. This means that although the viewfinder image is physically close to your eye, it is *optically distant*, and your eye must function as if it were looking at a distant subject. Therefore, to see rangefinder and focusing-screen images critically, you need normal distance vision, or an eyeglass correction which enables you to see distant objects clearly. If you wear bifocals, the upper or distant-vision portion should generally be used when focusing a Leica or Leicaflex. If you have an eyesight problem, consult your opthamologist and optometrist for their recommendations. The Service Department of E. Leitz, Inc. can supply correction lenses for the eyepieces of M Leica, Leicaflex, and Visoflex equipment, but you must furnish the prescription for the eye you use for viewing.

No matter how well you see, the indiscriminate use of filters can degrade image sharpness. For example, say that you have just focused your Leicaflex or Visoflex on a closeup subject, without a filter. You did this because you didn't want the filter color to cut down your focusing light or distort your esthetic judgement of the subject. Now you place a filter on the lens. If you observe carefully, using a filter that is not too dense (so that there is enough light to see the image clearly), you will usually notice that the point on which you focused critically is no longer the sharpest point of the image, but that the emphasis has shifted elsewhere. This focus shift from a filter is not due to an optical defect, but is something that will happen any time you place a filter of appreciable thickness in front of a lens. In ordinary photography, the focus shift due to filters is generally negligible, especially where small f-stops compensate with extra depth of field. In closeup shooting, however, it is best to focus with the filter in place whenever possible. If the filter is too dense to let you see clearly, focus through a substitute, lighter-colored filter of the same make and thickness. Then use the darker filter to make the picture. Filters made by Leitz are as thin as possible, consistent with other required characteristics. Where much work is to be done at high magnifications with a great variety of filters, and focus shift must be kept to a minimum, the use of thin gelatin filters is recommended.

Focus shift due to filter thickness should not be confused with image degradation caused by defects in poorly-made filters. Leitz filters are checked for internal strains (which might shift some wavelengths of light) and are made as plane-parallel as cost permits. Since Leicaflex lenses can take series-sized filters of many brands not offered for sale by Leitz, the makers of your camera cannot take responsibility for them. The same holds true for filters adapted to other Leitz lenses. This does not mean that non-Leitz filters are necessarily poor in quality. Careful picture-taking experience can help you decide whether a given filter provides the definition you require.

Film and light

Limited depth of field and slow shutter speeds combine in closeup work to tempt you to use the fastest film available. Fast films today have far finer grain and higher resolving power than they used to, but that doesn't mean you should sacrifice the extra detail and sharpness so desirable in closeup photography. My advice is to use the slowest film that can do the job. Such films usually have the fine grain and high acutance needed to render the very fine detail we normally require in a closeup shot. Wherever possible, if you need to use a smaller f-stop or a higher shutter speed, try to raise the light level rather than change to a faster film.

Outdoors, the use of reflectors to cast more light into the shadows or to add overall light is recommended. Still another approach is to use flashbulbs or electronic flash. The ability of the Leicaflex to synchronize the latter at 1/100 sec. will be appreciated. No data on flash exposure can be given here, since this depends on the amount of light cast by your unit. Generally speaking, one or two of the portable units now popular will give plenty of light when used close to a subject. For totally even, shadowless illumination, there are various makes of ringlights—circular electronic flash tubes which fit around the front of a lens. The light from these may be too flat for black-and-white, but it can be fine for color work, where color differences provide needed separation between the various parts of the subject. Follow carefully the instructions supplied by the makers of ringlights or other flash units.

With conventional flash units, side lighting tends to emphasize texture. A single main light from one side may cast shadows that are too deep, and photograph devoid of detail when highlight exposure is correct. A second unit, farther from the subject than the main light and nearly in line with the lens, can be used to fill in the shadows. By using two identical units, lighting ratios and exposures can easily be figured. In color, the lighting ratio between highlight and shadows should not exceed 1:4 for transparencies for projection, nor 1:2 for transparencies that are to be copied, or negatives or transparencies that are to be color-printed. For a 1:4 ratio, the fill-in light should be twice as far from the subject as the main light. For a 1:2 ratio it should be about 1.6x as far away. An easy way to figure this is to use working distances equal to the numbers used for f-stops.

Thus: 22, 16, 11, 8, 5.6 (5-1/2), 4, 2.8 (3), and 2 inches. We know that f/11 is twice as fast as f/16. If we place the main light 11 inches from the subject and the second light 16 inches away, the latter will contribute only half as much light to the subject as the main light. To get 1/4 the amount of light, we would move the fill-in unit to 22 inches away.

Slide copying with Leica and Leicaflex

To copy color slides you must have equipment capable of making 1:1 or larger image sizes, a convenient slide holder, and a suitable light source.

A Leicaflex equipped with extension rings or the Bellows R, or an M Leica with Visoflex and Bellows II, provides the needed closeup capability. Except for certain non-Leitz equipment which I will discuss later, slide copying is best attempted with a camera mounted on a Leitz copying stand.

A convenient holder for 2x2 slides is the Small Object Stage (Cat. No. 16,786). It is suitable for use at magnifications of 1:1 or greater. The slide to be copied is placed in a recess in the stage and held firmly in place by a metal frame. Ultra-critical focusing, especially appreciated when working at ratios higher than 1:1, is accomplished by means of a threaded screw which raises or lowers the slide stage without having to disturb the camera-lens setup. This action is also useful when making pictures of small objects.

You will need a color-correct light source for slide copying. You can construct an illuminating box containing a suitable lamp. The nature of the light will depend on the kind of color film you use for making your copies. (Electronic flash is balanced for daylight-type film; tungsten lights should be chosen to match the color temperature of your film.) If you use electronic flash for the exposing light, include a weak tungsten lamp that can be switched off during the actual exposure, to give you light to focus by. The box should be large enough to hold the Small Object Stage, have an opal glass plate to diffuse the light, and be masked down to confine the light to the open area in the stage. It should also be large enough, with holes in the sides, to provide ventilation for any tungsten lamp employed.

An excellent unit that provides tungsten light for focusing and electronic flash for exposing is the Bowens Illumitran, available from franchised Leica dealers. Exposure is varied by raising or lowering an

Leicaflex SL
mounted on Bowens Illumitran

electronic flash tube within the unit. This changes light intensity, but does not change the flash duration or the color temperature of the light. (If flash duration were significantly changed, reciprocity failure of the film would cause color shifts.) As the exposing light is moved, so is the tungsten focusing light; thus the ratio of difference between the two lights remains the same at any intensity, and exposure can be figured by metering the focusing light and adjusting for the greater brilliance of the exposing light. A selenium-cell exposure meter is provided with the Illumitran to measure the overall density of the slide to be copied. By matching a needle on the face of the unit, good exposures may be obtained for a wide range of transparencies. Of course, variations from the measured exposure can be made for creative or interpretive purposes. Holders for 2x2 and 2-3/4x2-3/4-inch slide mounts are provided. A sliding tray under each holder provides space for correction filters. Since the color sensitivity of the selenium cell is similar to that of color film, exposure readings may generally be made successfully with the filters in place. (This is not the same problem as trying to read exposure with a CdS meter through a camera filter.) There is also a holder for 4x5-inch originals.

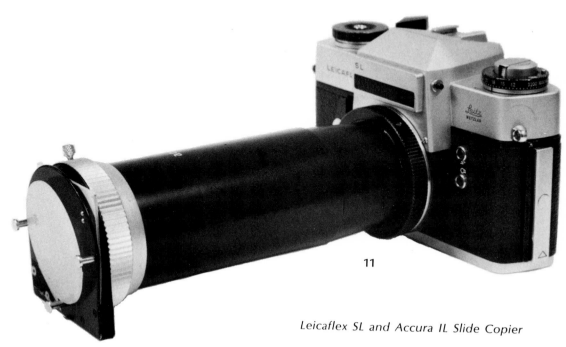

11

Leicaflex SL and Accura IL Slide Copier

The Illumitran has its own extension bellows, and Bowens supplies adapters for the Leicaflex and for Visoflexes of all vintages. If desired, the Leica or Leicaflex may be fitted with Leitz extensions and mounted on a Leitz stand over the illuminating portion of the unit. In this case, the bellows supplied by Bowens is not used.

For occasional work, a simple device such as the Accura IL Slide Copier may be fitted to a Leitz lens via a filter adapter ring and used in conjunction with Leica or Leicaflex extensions. The Accura copier has a holder for 2x2-inch slides which positions the slide at the correct distance from the lens. In addition, the duplicator is provided with an opal diffuser for an external light source, and a place to hold correction filters.

Of course, specialized equipment, such as the Reprovit IIa and the Docuflex 35, may be adapted for slide copying.

Making an accurately-matched duplicate color slide is anything but a "one shot" affair. Passable copies are fairly easy, but the intricacies involved in making a true duplicate are beyond the scope of this chapter. Your best bet is to consult the film manu-facturer's literature for help. Consider slide copying a creative adventure in which it is possible to correct faults, change colors, make multiple exposures through various filters, lighten and darken slides, and the like.

Generally speaking, any daylight-type film may be used with electronic flash. Tungsten-type color films required 3200K studio flood lights. An exception is Kodachrome II, Type A, which is balanced for use with 3400K photofloods. Most camera films tend to give color copies with increased contrast and an appearance of heightened color saturation. If this is undesirable, investigate the use of a special color duplicating film, such as those offered by GAF, Agfa-Gevaert and Kodak. The Kodak and GAF films are intended for exposure by tungsten light, the Agfa film by electronic flash. Any special instructions for exposure, basic filtration and processing of these films, as outlined in the manufacturer's data sheets, should be followed carefully.

Information on the Bowens Illumitran is available from E. Leitz, Inc. Information on the Accura I L Slide Duplicator and various other non-Leitz accessories, such as filter adapters, is available from your photo dealer, not from Leitz.

TABLE 1 ELPRO CLOSEUP LENSES*

LEICAFLEX lens	ELPRO	Lens distance setting	Approx. Distance				Area covered		Repro-duction ratio**
			Subject to film		Subject to ELPRO				
			mm	inches	mm	inches	mm	inches	
50mm SUMMICRON-R f/2	VIa	∞	50	19-11/16	41	16-1/16	184 x276	7-1/4 x10-7/8	1:7.7
		min.	31	12-1/8	21	8-1/4	91 x137	3-5/8 x5-7/16	1:3.8
	VIb	∞	30	11-7/8	21	8-3/16	94 x141	3-11/16 x5-9/16	1:3.9
		min.	24	9-1/2	14	5-9/16	62 x93	2-7/16 x3-11/16	1:2.6
90mm ELMARIT-R f/2.8	VIIa	∞	74	29-1/16	61	24-1/16	161 x241	6-5/16 x9-1/2	1:6.7
		min.	44	17-7/16	30	11-13/16	73 x109	2-7/8 x4-5/16	1:3.0
135mm ELMARIT-R f/2.8	VIIb	∞	150	59	135	53-1/4	237 x355	9-5/16 x14	1:9.9
		min.	85	33-1/2	68	27-3/16	107 x160	4-1/4 x6-3/8	1:4.5
	VIIa	∞	76	29-13/16	61	24-1/16	107 x160	4-1/4 x6-3/8	1:4.5
		min.	59	23-1/8	42	16-13/16	66 x99	2-5/8 x3-15/16	1:2.8

*For ELPRO + Extension Ring + Lens, see Table 2.
For ELPRO + Bellows-R, see Table 3.

**For Depth of Field and Exposure Compensation at a
given ratio, see Table 7.

Focusing data are given for ∞ and for minimum distance
engraved on Leicaflex lenses. All figures are rounded
off, therefore approximate.

TABLE 2 DIVISIBLE EXTENSION RING

Ring combinations*	ELPRO	Lens distance setting	Approx. Distance Subject to lens		Repro-duction ratio**
			mm	inches	
50mm SUMMICRON-R f/2					
(1) + (2)	—	∞	120	4-3/4	1:2
(1) + (2)	—	min.	97	3-3/4	1:1.6
(1) + T + (2)	—	∞	67	2-5/8	1:1
(1) + T + (2)	—	min.	61	2-3/8	1.1:1
(1) + (2)	VIa	∞	88	3-1/2	1:1.6
(1) + (2)	VIa	min.	73	2-7/8	1:1.5
(1) + (2)	VIb	∞	72	2-7/8	1:1.5
(1) + (2)	VIb	min.	62	2-5/8	1.1:1
(1) + T + (2)	VIa	∞	51	2	1.1:1
(1) + T + (2)	VIa	min.	46	1-7/8	1.2:1
(1) + T + (2)	VIb	∞	46	1-7/8	1.2:1
(1) + T + (2)	VIb	min.	41	1-5/8	1.4:1
90mm ELMARIT-R f/2.8					
(1) + (2)	—	∞	360	14-1/4	1:3.5
(1) + (2)	—	min.	238	9-3/8	1:2.2
(1) + T + (2)	—	∞	202	8	1:1.8
(1) + T + (2)	—	min.	166	6-1/2	1:1.6
(1) + (2)	VIIa	∞	225	8-7/8	1:2.3
(1) + (2)	VIIa	min.	166	6-1/2	1:1.6
(1) + T + (2)	VIIa	∞	148	5-3/4	1:1.4
(1) + T + (2)	VIIa	min.	125	4-7/8	1:1.1
135mm ELMARIT-R f/2.8					
(1) + (2)	—	∞	860	34	1:5.4
(1) + (2)	—	min.	600	23-1/2	1:3.3
(1) + T + (2)	—	∞	515	20-1/4	1:2.7
(1) + T + (2)	—	min.	430	16-7/8	1:2
(1) + (2)	VIIb	∞	535	21-1/8	1:3.3
(1) + (2)	VIIb	min.	416	16-3/8	1:2.3
(1) + T + (2)	VIIb	∞	375	14-3/4	1:2
(1) + T + (2)	VIIb	min.	325	12-3/4	1:1.6

*(1) = Lens ring, (2) = Camera ring of either 14,158 or 14,134. T = Intermediate extension tube 14,135.

**For Area covered, Depth of Field, and Exposure Compensation at a given ratio, see Table 7.

TABLE 3 BELLOWS-R

Leicaflex lens	ELPRO	Bellows exten-sion*	Distance Subject to lens		Repro-duction ratio**
			mm	inches	
50mm SUMMICRON-R f/2	—	min.	91	3-1/2	1:1.2
	—	max.	45	1-3/4	2.9:1
	VIa	min.	65	2-1/2	1:1.07
	VIa	max.	27	1-1/16	2.99:1
	VIb	min.	56	2-1/8	1.07:1
	VIb	max.	24	15/16	3.16:1
90mm ELMARIT-R f/2.8	—	min.	245	9-5/8	1:2.1
	—	max.	104	4-1/16	1.8:1
	VIIa	min.	172	6-5/8	1:1.56
	VIIa	max.	81	3-1/8	1.99:1
100mm MACRO-ELMAR f/4	—	min.	∞	∞	—
	—	max.	187	7-1/4	1:1
	VIIa	min.	611	23-1/2	1:6.04
	VIIa	max.	123	4-3/4	1.24:1
	VIIb	min.	1353	53-1/8	1:13.4
	VIIb	max.	138	5-3/8	1.10:1
135mm ELMARIT-R f/2.8	—	min.	593	23-5/16	1:3.2
	—	max.	273	10-5/8	1.2:1
	VIIa	min.	303	11-7/8	1:1.65
	VIIa	max.	188	7-5/16	1.65:1
	VIIb	min.	415	16-1/8	1:2.27
	VIIb	max.	225	8-3/4	1.37:1
180mm ELMARIT-R f/2.8	—	min.	980	38-5/8	1:4.4
	—	max.	406	15-3/4	1:1.1

*Min. = Bellows retracted, lens at ∞.
Max. = Bellows fully extended, lens at closest focusing distance.

**For Area covered and Depth of field at a given ratio, see Table 7.

TABLE 4 BELLOWS-R EXPOSURE COMPENSATION

Exposure increase required with Leicaflex lenses when meter reading is not through-the-lens, at bellows extensions as marked on scale bar.

90mm Lens		100mm Lens		135mm Lens	
Scale Marking	Exposure factor	Scale Marking	Exposure factor	Scale Marking	Exposure factor
1.5	7X	1.0	3.8X	1.05	7X
1.4	6.5X	0.9	3.5X	1.0	6.5X
1.3	6X	0.8	3X	0.9	6X
1.2	5.5X	0.7		0.8	5X
1.1	5X	0.6	2.5X	0.7	4.5X
1.0	4.5X	0.5		0.6	4X
0.9	4X	0.4	2X	0.5	3.5X
0.8	3.5X	0.3		0.4	2.5X
0.7	3X	0.2	1.5X	0.31	
0.6		0.1			
0.5	2.5X	0			

TABLE 5 CLOSEUPS WITH VISOFLEX II or III

Adapter (Cat. No.)	Lens (LU = lens unit only)	Minimum focusing distance	Reproduction ratio*
16,469	35mm lenses 50mm lenses	5-3/4'' 8-1/4''	1.4:1 1:1
16,462+ 16,474	LU 90mm Summicron f/2 LU 135mm Elmarit f/2.8	20-3/4'' 42''	1:3.7 1:5.5
16,464+ 16,471	65mm Elmar f/3.5 LU 90mm Elmar f/2.8 LU 135mm Tele-Elmar f/4	10-5/8'' 15-1/8'' 26''	1:1.2 1:2 1:2.5
16,464+ 16,471+ 16,472 (discon- tinued)	LU 135mm lenses, except Tele-Elmar	26''	1:2.5
16,469+ 16,466	125mm Hektor f/2.5 (non-current) 135mm lenses in short mount, except Tele-Elmar 200mm Telyt f/4	32-3/4'' 40-1/2'' 6' 6-3/4''	1:5 1:5.5 1:8
16,469	280mm Telyt f/4.8	12' 0''	1:11

* For Area covered, Depth of Field, and Exposure Compensation at a given ratio, see Table 7.

TABLE 6 CLOSEUPS WITH BELLOWS II
(on Visoflex II or III)

Adapter (Cat. No.)	Lens (LU = Lens unit only)	Focus Range Subj. -film distance inches	Reproduction ratio*
16,596	35mm bayonet-mount lenses	6-1/4 to 10	2.1:1 5:1
	50mm bayonet-mount lenses	8-1/4 to 11-3/8	1.4:1 3.2:1
16,558 (supplied with bellows)	65mm Elmar	∞ to 11	∞ 1.4:1
	LU 90mm Elmar or Elmarit	∞ to 14-1/4	∞ 1.1:1
	LU 135mm Tele-Elmar	∞ to 22-7/8	∞ 1:1.5
16,598	LU 90mm Summicron	40-1/4 to 14-1/8	1:9 1.2:1
16,558 (supplied with bellows) +16,472 (discon-tinued)	LU 135mm Elmar or Hektor	∞ to 22	∞ 1:1.4
16,598	LU 135mm Elmarit	110 to 22-1/4	1:18.5 1:1.32

*For Area covered, Depth of Field, and Exposure
Compensation at a given ratio, see Table 7.

TABLE 7 REPRODUCTION RATIO DATA

Repro-duction ratio	Exposure increase required	Area covered		Total Depth of Field*							
		mm	inches	mm				inches			
				f/5.6	f/8	f/11	f/16	f/5.6	f/8	f/11	f/16
1:20	1.1X	480 x 720	18.9 x 28.4	156.8	224.0	308.0	448.0	6.18	8.85	12.1	17.7
1:18	1.1X	432 x 648	17 x 25.5	127.7	182.4	250.8	364.8	5.05	7.17	9.94	14.4
1:17	1.1X	408 x 612	16.2 x 24.2	114.2	163.2	224.4	326.4	4.50	6.43	8.85	12.8
1:16	1.1X	384 x 576	15.1 x 22.6	101.6	145.1	199.5	290.1	4.02	5.72	7.90	11.4
1:15	1.1X	360 x 540	14.2 x 21.3	89.6	128.0	176.0	256.0	3.53	5.05	6.95	10.1
1:14	1.1X	336 x 504	13.2 x 19.8	78.4	112.0	154.0	224.0	3.09	4.41	6.08	8.84
1:13	1.2X	312 x 468	12.3 x 18.5	68.0	97.1	133.5	194.1	2.68	3.83	5.28	7.66
1:12	1.2X	288 x 432	11.3 x 16.9	58.2	83.2	114.4	166.4	2.30	3.28	4.50	6.55
1:11	1.2X	264 x 396	10.4 x 15.6	49.3	70.4	96.8	140.8	1.94	2.77	3.82	5.56
1:10	1.2X	240 x 360	9.45 x 14.2	41.1	58.7	80.7	117.3	1.62	2.32	3.18	4.62
1:9	1.2X	216 x 324	8.51 x 12.8	33.6	48.0	66.0	96.0	1.32	1.89	2.60	3.78
1:8	1.3X	192 x 288	7.56 x 11.3	26.9	38.4	52.8	76.8	1.06	1.51	2.08	3.03
1:7	1.3X	168 x 252	6.61 x 9.92	20.9	29.9	41.1	59.7	0.825	1.18	1.62	2.36
1:6	1.4X	144 x 216	5.66 x 8.51	15.7	22.4	30.8	44.8	0.620	0.885	1.21	1.77
1:5	1.4X	120 x 180	4.72 x 7.09	11.2	16.0	22.0	32.0	0.440	0.632	0.867	1.26
1:4	1.6X	96 x 144	3.78 x 5.66	7.5	10.7	14.7	21.3	0.296	0.422	0.580	0.840
1:3	1.8X	72 x 108	2.84 x 4.26	4.5	6.4	8.8	12.8	0.178	0.252	0.347	0.505
1:2	2.3X	48 x 72	1.89 x 2.84	2.2	3.2	4.4	6.4	0.087	0.126	0.173	0.252
1:1.5	2.8X	36 x 54	1.42 x 2.13	1.4	2.0	2.8	4.0	0.055	0.079	0.110	0.158
1:1.33	3.1X	32 x 48	1.26 x 1.89	1.2	1.7	2.3	3.3	0.047	0.067	0.091	0.134
1:1	4X	24 x 36	0.945 x 1.42	0.8	1.1	1.5	2.1	0.031	0.043	0.059	0.083
1.5:1	6X	16 x 24	0.630 x 0.945	0.41	0.59	0.81	1.19	0.016	0.023	0.032	0.047
2:1	9X	12 x 18	0.472 x 0.709	0.28	0.40	0.55	0.80	0.011	0.016	0.022	0.032
3:1	16X	8 x 12	0.314 x 0.472	0.17	0.24	0.33	0.47	0.007	0.010	0.013	0.018
4:1	25X	6 x 9	0.236 x 0.354	0.12	0.17	0.23	0.33	0.005	0.007	0.009	0.013
5:1	36X	4.8 x 7.2	0.189 x 0.284	0.09	0.13	0.18	0.26	0.004	0.005	0.007	0.010
6:1	49X	4.0 x 6.0	0.158 x 0.237	0.07	0.10	0.14	0.21	0.003	0.004	0.006	0.008
6.5:1	56X	3.7 x 5.5	0.145 x 0.217	0.07	0.09	0.13	0.19	0.003	0.004	0.005	0.007
7:1	64X	3.4 x 5.1	0.135 x 0.202	0.06	0.09	0.12	0.17	0.002	0.004	0.005	0.007
8:1	81X	3.0 x 4.5	0.118 x 0.177	0.05	0.08	0.10	0.15	0.002	0.003	0.004	0.006
9:1	100X	2.7 x 4.0	0.105 x 0.158	0.05	0.07	0.09	0.13	0.002	0.003	0.004	0.005
10:1	121X	2.4 x 3.6	0.094 x 0.142	0.04	0.06	0.08	0.12	0.001	0.002	0.003	0.005

*Circle of confusion 1/750 inch (1/30mm). Closeup
depth of field (1:10 ratio and closer) extends half in front,
half behind point focused on.

A vast moonscape? No, a small piece of metal photo-
graphed with the Leica. The lunar-like craters in this
photograph are actually defects in the coating of a
razor blade, revealed by incident-light photomicro-
graphy at a magnification in the print of 500x

Cross section of human eye
a. Photomacrograph; print magnification, 3x
b. Photomicrograph; print magnification, 100x

Photomacrography and Photomicrography

Renate Gieseler

Introduction

Photomacrography and photomicrography are photographic procedures for recording data in many fields of scientific research. They are also used as visual aids in teaching and for purposes of illustration. The kaleidoscope of structures and colors they make visible are fascinating to amateur and professional photographers alike. Leica and Leicaflex cameras are readily adaptable to microscopes and to photomacrographic equipment, and offer great versatility in these fields.

Photomacrography uses low magnifications, ranging approximately from 1:1 (1x) to 40:1 (40x), to record and examine relatively large areas such as large transparent cross sections in pathology.

Photomicrography reveals greater detail in areas through higher magnification and higher resolution. The magnification can be as high as 1000x to 1400x.

Principles

To understand the possibilities and limitations of both fields, we must consider some principles of optics.

Advancing from a conventional photographic lens to a photomacrographic setup, and then to a microscope, is easier than you might think. Their optical functions are closely related: all are image-forming systems. With image-forming systems, a given *object plane* (the location of the object that is being photographed) is always correlated to a definite *image plane* (the plane upon which the image is focused by the lens). The location and magnification of the image depend on the focal length of the lens called the *objective,* and on the distance from this lens to the object (*object distance*). The corresponding distance from the lens to its image is called the *image distance.* As a rule, the *reproduction ratio*—the re-

3-1 *Gross photography*

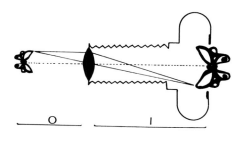

3-2 *Photomacrography*

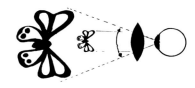

3-3 *Magnifier*

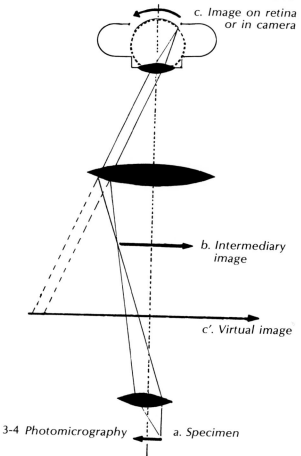

c. *Image on retina or in camera*

b. *Intermediary image*

c'. *Virtual image*

3-4 *Photomicrography*　　a. *Specimen*

duction or magnification of the image—is determined by the relation of the image distance to the object distance.

In general photography, the object distance is greater than the image distance, so the image is reduced in size (illustration 3-1). In photomacrography, we decrease the object distance to increase the image distance, thus obtaining higher magnification. Image distance can generally be increased further by using extension tubes or bellows between the camera body and the lens (Illustration 3-2). This can be done only within the limitations imposed by such factors as vibration, long exposure time and mechanical limitations, but the main limitation is in the lens itself. When the object distance approaches the focal length of the objective, the image plane moves to infinity, and, of course, cannot be recorded. However, the human eye sees an upright *virtual image* on the object side of the lens: this is the principle of every simple magnifier (Illustration 3-3). The limitation of a lens with respect to its magnification can be overcome using a two-step image-forming system called a microscope.

In advancing our requirements to this stage, we progress from photomacrography to photomicrography. The principle is simple. The first lens, called an *objective,* forms a magnified aerial image *(intermediary image)* of the specimen. This image is viewed through a magnifier, called the eyepiece, which magnifies the image for a second time, recording it on the focal plane of the eye (the retina) or on the focal plane of the camera—on the film (Illustration 3-4).

Magnification and resolution

In photomacrography, the reproduction ratio, or magnification, is directly related to the focal length of the lens. It can be determined by dividing the image distance, minus one focal length, by the focal length. For example: with a 1:1 reproduction ratio, the image distance is twice the focal length; with a 2x magnification, the image distance equals three times the focal length, and so on. (For detailed formulas, see the appendix at the end of this chapter.) An exact measurement of the magnification can be obtained by placing a scale in the subject area, and measuring the image of this scale against another scale on the groundglass. This method is often used in photomacrography.

In microscopy, two optical systems are involved. However, the *object distance,* also called the working distance, and the *image distance* are always fixed within the microscope system. Thus the microscope objective and the eyepiece each provide only one magnification, which can thus be marked on each lens. The total magnification can then be determined by multiplying the magnification of the objective by the magnification of the eyepiece (see appendix for more information).

It is not hard to obtain a magnified image. Although it may sound strange, magnification is less important than resolving power—the capacity of the lens to separate detail in the specimen—in photomacrography and photomicroscopy. Magnification is needed only to make the resolved detail visible to the eye or to the film.

The resolving power of a lens depends on the number of rays that pass through the lens from any point on the object and take part in forming the image; in other words, the larger the aperture, the higher the resolution. Ideally, the lens should collect and transmit every ray that comes from the object, but this is not possible. Due to the diffraction of light, a point on the object cannot be recorded as a point in the image, but only as a small disc. The size of this disc can be computed; following the theory of Sir George Airy, its radius is r = 1.22 wavelength x f-number. Two separate points are resolved when the distance (R) between them is R = wavelength x f-number. (The wavelength of the center of white light is 550 nanometers; see the chapter, "Photographic Optics," by Rudolf Kingslake.)

In general photography, especially when both near and distant objects are in the pictures, high resolution is necessary only when very big enlargements are required. Generally, great depth of field is essential, and the image will appear sharper when the lens is stopped down. Also, even the most highly corrected lenses have slight aberrations which can be reduced by closing the lens aperture down about two stops.

It does not work that way in photomacrography, where higher magnifications are used. As the magnification increases, finer and finer details should become visible, so the need for resolution increases in proportion to the magnification.

In photomicrography, the need for higher resolution is even greater. The resolution of a microscope

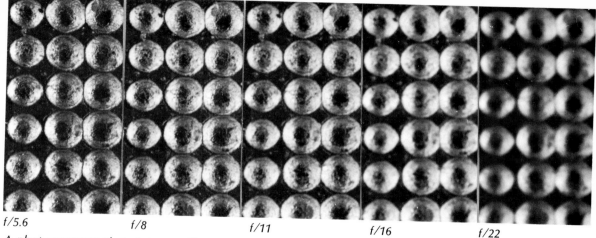

f/5.6 f/8 f/11 f/16 f/22

A photomacrograph (print magnification, 50x) of the surface of a printing block. Note the obvious loss of resolution as the lens is stopped down

is determined by the objective; the eyepiece serves only as a magnifier. The calculation of the resolving power of the objective is based on the angle of the lens opening and the refractive index of the medium between the objective and the specimen. This value is called the *numerical aperture* and is marked on each microscope objective. (For detailed information, see appendix.)

The separation of detail is calculated by dividing the wavelength by the numerical aperture of the objective. With a microscope using light (rather than electron) illumination, the highest resolution possible is slightly below 0.2 microns (see appendix).

According to the optical theory of a microscope, the best definition of the image is achieved when the total magnification of the photomicrograph is in the range from 500x to 1000x the numerical aperture of the objective. This range is called *useful magnification* (see appendix).

a. b.

For photomicrograph a. (left), a 10x objective, a numerical aperture of 0.25 and a 25x eyepiece were used. For photomicrograph b. (right), a 25x objective, a numerical aperture of 0.50 and a 10x eyepiece were used. The objective with the higher numerical aperture clearly provides higher resolution and more information.

PHOTOMACROGRAPHY

Photomacrography links closeup photography and photomicrography, but we must distinguish between *reflected-light* and *transmitted-light* photomacrography. The first is much like closeup photography; the second is more closely related to photomicrography.

Reflected-light photomacrography

Reflected-light photomacrography deals primarily with three-dimensional objects, and requires both high resolution and depth of field. It requires good lighting to obtain contrast and to keep the exposure time as short as possible.

We have seen that resolution and magnification are related. High magnifications are needed to make detail visible, but this can be achieved only with high resolution. In practice, the f-stop is opened as much as the quality of the lens permits. Resolution is better at larger apertures, but depth of field increases when the lens is stopped down.

Depth of field can also be increased by using lower magnification. The common belief that depth of field increases as focal length decreases is mistaken. From a given object distance, a shorter focal length gives lower magnification, and therefore more depth; but in images of equal magnification for which the same f-stop is used, the depth of field is the same regardless of focal length.

To avoid loss of resolution, it is generally preferable to select a view of the specimen which requires minimum depth of field, so that a large f-stop can be used. When neither resolution nor depth can be sacrificed, take two photomacrographs: one that shows the whole object, and a second that magnifies an area of special interest.

1:1 3:1 5:1 10:1 20:1

Specimen illuminated by transmitted light combined with incident light

a. b.

Microfossils. Photomacrograph a. = 20:1; photomacrograph b. = 50:1

The key to good photomacrography lies in finding an optimum balance between all these factors. This is necessarily different with each object, depending on its shape and the detail that is needed. The equipment used is much the same as that of closeup photography: the Leica with Visoflex and focusing attachment, or the Leicaflex with bellows, the Reprovit, and the copy stand. (For detailed information, see the chapter on closeup photography.)

Besides these attachments, Leitz offers a special photomacrographic stand, the Aristophot, which gives the Leica user the convenience and flexibility of long bellows extensions, up to 50cm, adjustable by a rack-and-pinion mechanism.

A set of special objectives, the Leitz Photars, covers a range of magnification from 1:1 up to 50:1.

A photographic lens can be corrected to eliminate aberrations most efficiently at only one exact subject distance. Most lenses are corrected for working distances at or near infinity, and do not give their best performance at very short subject-to-film distances. Therefore the Leitz Photar macro lenses are designed for closer subject distances. The Photars with longer focal lengths are designed for relatively low magnifications, and the short-focal-length Photars are for higher magnifications.

The 120mm f/5.6, 80mm f/4.5 and 50mm f/2.8 Photar lenses fit directly into the bellows support of the Aristophot.

The 50mm f/4, 25mm f/2.5 and 12.5mm f/1.9 Photars have a microscope thread and are used for photomacrography on a microscope stand. They can be adapted to the Aristophot by means of the intermediate ring No. 542,151.

All Photars can also be used on the Leicaflex Bellows-R with adapter ring No. 500,935, and on the Leica Bellows II with adapter ring No. 542,046.

The highest magnifications obtainable with the bellows attachments are:

Photar 120mm f/5.6 = 1:1.7
 " 80mm f/4.5 = 1.5:1
 " 50mm f/2.8 = 2.9:1
 " 50mm f/4 = 2.9:1
 " 25mm f/2.5 = 7.5:1
 " 12.5mm f/1.9 = 16:1

Photars of shorter focal lengths will be of more interest to the photographer using the bellows at-

tachments because of their extended magnification range.

The approximate reproduction ranges of the Photars on the Aristophot are:

Photar 120mm f/5.6 1:2 - 4:1
 " 80mm f/4 1:1 - 7:1
 " *50mm f/2.8 3:1 - 8:1
 " *50mm f/4 3:1 - 8:1
 " 25mm f/2.5 5.1 - 22:1
 " 12.5mm f/1.9 12:1 - 50:1

*It is almost impossible to make macro lenses of large aperture for use with a microscope thread; therefore two 50mm Photars are available. The f/2.8 one has a macro thread and fits directly onto the Aristophot. The 50mm f/4 Photar has a microscope thread and is used only on a microscope stand for photomacrography.

Photar macro lenses and adapter ring No. 542,151

The question of which focal length lens to use often arises. In general, lenses of longer focal lengths are preferable when the desired magnification permits. With longer lenses, a better perspective of the object can be obtained because of the longer object distance, which also makes it easier to light the object well.

Good lighting is extremely important in photomacrography. Special small light sources such as the Leitz Monla Lamp should be used. This lamp has a 30-watt tungsten bulb and a collector that varies the size of the light spot. A regulating transformer is used to vary the intensity of the light.

A ring illuminator which can be mounted on the stand is available for the Aristophot. It provides very even illumination.

Transmitted-light photomacrography

Transmitted-light photomacrography is used with thin specimens that are too large to examine under a microscope, such as lung or brain sections, or thin sections of rocks. These specimens require little depth of field; therefore the f-stop should be opened as far as the correction of the lens permits. Good contrast and crisp detail can be obtained only with a proper illumination system, using a condenser lens below the specimen. The objective should be located in the focal plane of the condenser to obtain even background illumination and optimum resolution. The object stage above the condenser should be focusable.

A special Leitz illuminating attachment, the Macro Dia Apparatus, can be attached to the Aristophot stand. The same lenses are used here as for reflected-light photomacrography. Each lens has a matching condenser. The light source, a low-voltage 30-watt lamp, projects light onto a 45-degree mirror, then into the condenser system. A regulating transformer —the same that is used with the Monla lamp—controls the intensity of the light.

A microscope stand can also be used for photomacrography. The binocular tube is replaced by a special low-power phototube with a bayonet mount that accepts the Leica with Visoflex. The macro lenses are screwed into the microscope nosepiece. The range of magnifications is limited, however, because of the fixed image distance.

Determining exposure in photomacrography

When photomacrography is being accomplished with a Leicaflex SL or a Leica M5, the camera's built-in light meter will give accurate exposure readings through whatever optical system is being employed.

When other Leica/Leicaflex models are used, a useful method for exact measurement of exposure time is illustrated at the right. The Leitz Microsix L meter, originally designed for photomicrography, can be used to obtain readings from the Visoflex. The meter has a flexible probe, which is positioned over the groundglass of the Visoflex. The meter has two sensitivity ranges, so it can give exact readings even when the light intensity is rather low. Of course, the meter has to be calibrated by means of test exposures or comparative readings for this particular application.

Aristophot stand with Macro Dia Apparatus

Taking reading from Visoflex with Microsix-L meter

Photomicrograph: Bromo Seltzer *crystals, melted and recrystallized between microslide and coverglass. Polarized light; magnification 20x*

Leicaflex SL, Universal Camera Attachment, and Dialux microscope

PHOTOMICROGRAPHY

Almost any microscope can be used for photomicrography, but the more sophisticated the microscope, the more convenient and flexible it is to use. For example, a built-in light source is easier to adjust than an attachable one, and vibrations can be avoided with a larger stand.

All microscopes have three optical components: the objective, the eyepiece and the condenser.

The objective is the most important component. Because of recent improvements in their correction, achromatic objectives are suitable for photomicrography, especially if used with a green filter for black-and-white photography. For color photography, apochromatic objectives are preferable. Flat-field objectives should be chosen when photomicrographs of highly plane specimens, such as thin tissue sections or flat metal surfaces, are required. For routine work, a microscopist selects his objective according to the technique he is using: strain-free ob-

jectives for polarized-light microscopy, incident-light objectives for metallographic work, etc.

The second imaging system, the eyepiece, magnifies the intermediary image so that the resolved detail becomes visible to the eye or is recorded on a photographic emulsion. The eyepiece also plays an important role in overall optical correction. The eyepieces selected should be those the manufacturer suggests for the specific objective you are using.

The third optical system, the condenser, provides proper illumination. To make full use of the objective's numerical aperture, the whole lens opening must be filled with light; this requires a lens system, the condenser, below the specimen, to direct light up through it.

The best resolution is obtained with the largest aperture, but contrast and depth of field increase when the aperture is smaller. To compromise between highest contrast and best resolution, an adjustable iris diaphragm is placed in the front focal plane of the condenser: it is called the *aperture diaphragm.* Its image can be seen in the rear focal plane of the objective by removing the eyepiece and looking into the microscope tube. The aperture diaphragm should be closed down until glare disappears. This usually occurs when the aperture diaphragm is closed one-third (center example, page 284). Stopping down too far loses detail.

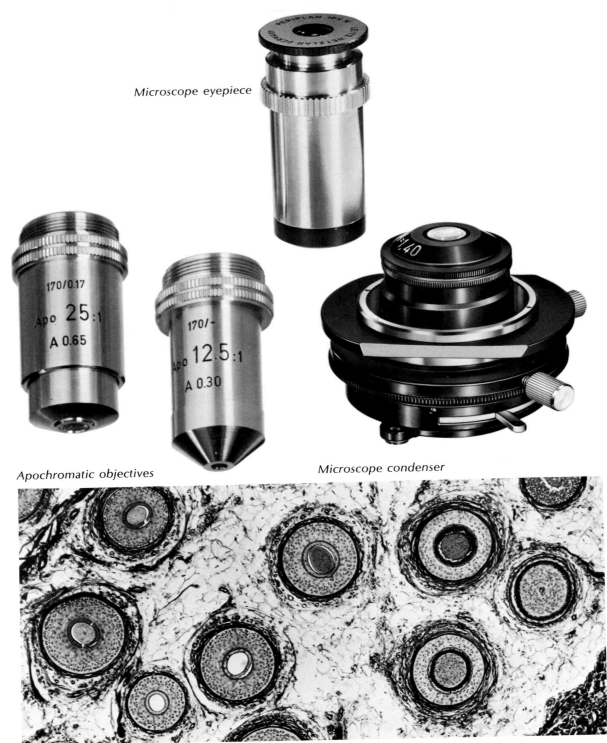

Microscope eyepiece

Apochromatic objectives

Microscope condenser

Cross section of human scalp, revealed in bright field microscopy. Print magnification, 75x

Dialux microscope with Universal Camera Attachment and Leica Mda

The better microscopes have a second diaphragm, the *field diaphragm,* built into the microscope stand. Its purpose is to exclude stray light that comes from illuminated areas outside the field of view. The field diaphragm is imaged by the condenser in the specimen plane.

The condenser system and these two diaphragms provide "Kohler illumination." Proper adjustment of the illumination system is essential for successful photomicrography, but is often overlooked. Loss of light, uneven illumination and a colored hue in the background result if the condenser is not accurately centered and focused.

Photomicrographic camera attachments

Besides aligning the microscope correctly, you must also use the proper camera attachment. The Leica and its 35mm format offer several advantages in photomicrography: the camera body is light, compact and handy; the camera can be used for other kinds of photography, such as closeup and macro work; it is easy to focus and operate, and many different kinds of film are available at low cost.

The microscope is designed to project an image to infinity. The best image quality is achieved only when the rays of light leaving the eyepiece are parallel to each other. Only then is the objective being used at the image distance for which it is calculated and corrected. The observer's eye, accommodated to infinity, then focuses the image onto the retina. In photomicrography, the human eye is replaced by a camera with its lens set at infinity, so that the optimum image distance is used.

The simplest way to take a photomicrograph would be to place a camera with its lens set at infinity above the microscope eyepiece. This method is limited because vignetting may occur. The problem is overcome by using special camera attachments which accept Leica and Leicaflex bodies.

The best known of these attachments is probably the Micro Ibso. It contains an eyepiece which is inserted into the microscope tube. A beam splitter, mounted above, allows the specimen to be brought into focus using a viewing telescope. A built-in leaf shutter is the next element, followed by a reduction lens which focuses the image onto the film plane. The Leica body is attached to the Micro Ibso by a screw or bayonet mount. To avoid vibration, the built-in leaf shutter is used while the focal-plane shutter of the Leica remains open.

The Kavar attachment is more compact and more sophisticated. The Leica body rests on vibration dampers, permitting the use of the focal-plane shutter without danger of vibration. A focusing telescope and a receptacle for the probe of the Micro-six-L CdS exposure meter are integral parts of the unit. The Kavar is simpler and faster to use than the Micro Ibso.

The latest design, the Universal Camera Attach-

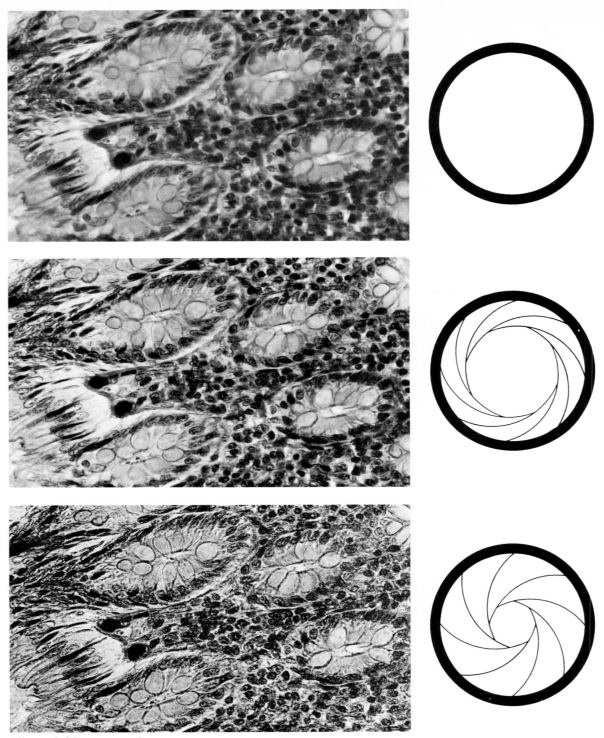

Effect of different condenser apertures.
(Top) Full aperture gives high resolution, low contrast
(Center) Intermediate aperture gives good resolution, moderate contrast
(Bottom) Small aperture gives poor resolution, high contrast

Micro-Ibso camera attachment

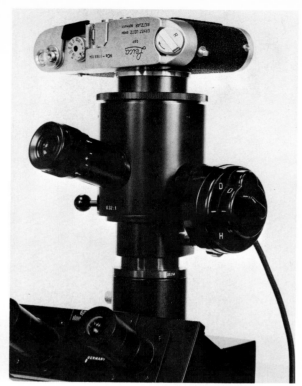

Kavar attachment with CdS meter probe

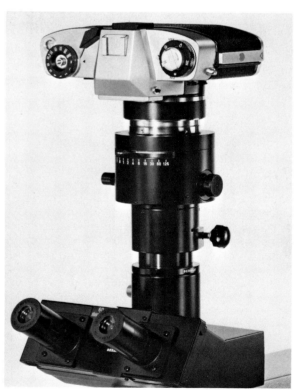

Universal Camera Attachment

ment, allows both Leica and Leicaflex cameras to be used. Specially designed adapters connect the camera to the basic unit. The built-in leaf shutter is shock mounted, and should be used instead of the focal-plane shutter. There is no focusing telescope: instead, the specimen is focused through the binocular tube. (However, this is only possible with a binocular tube which does not change focus with different settings of the interpupillary distance; all recently-developed Leitz microscopes have such binocular tubes.) Special eyepieces, one of which is equipped with a reticle that indicates the frame of the image, make photomicrography much more convenient.

Determining exposure time

Varying techniques for photomicrography require a wide range of exposure times, from fractions of a second to several minutes. For proper exposure of negatives and transparencies it is essential to use a light meter. The Microsix-L meter is highly sensitive, and its wide measuring range covers the exposure times that are likely to be needed in photomicrography. The Microsix-L probe can either be placed in the photo tube or binocular tube of the microscope, or attached to the Kavar or the Universal Camera Attachment. The built-in exposure meters of the Leicaflex SL and the Leica M5 can also be used,

Universal Camera Attachment
a. with Leica M4, Microsix-L meter and probe
b. with Leicaflex SL (built-in light meter)
c. with Leica M5 (built-in light meter)

although the sensitivity of the Microsix-L meter is higher.

Films and filters

The appropriate black-and-white film for photo-macrography and photomicrography is selected according to the contrast of the specimen. For subjects of moderate to high contrast, slow fine-grain films such as Kodak Panatomic-X and Ilford Pan F are generally satisfactory. Contrast can be varied in developing the films (the longer the development, the higher the resulting contrast). One-shot developers, used once and then discarded, are preferred for consistent results.

For low-contrast specimens such as chromosomes, high-contrast films such as Kodak High Contrast Copy Film or H & W Control VTE Pan (Agfa-Gevaert Copex Pan) may have to be used. These films should be developed in an ordinary film developer, and not, as is often recommended, in a high-contrast developer. (For example, the author exposes Kodak High Contrast Copy Film at exposure indexes from EI 6 to EI 25, depending on the filter used and on the need for reciprocity-failure compensation, and develops it in Ethol TEC developer, diluted 1:15, for seven minutes at 70 degrees Fahrenheit. H & W Control developer is often used for similar results.)

Contrast can also be varied by using light filters. A filter of a color complementary to that of the specimen increases contrast; a filter of the same color as the specimen decreases contrast.

Filters are also used to differentiate between two colors that might otherwise reproduce in the same tones. For example, a red filter made the red nuclei of salamander tissue (next page) appear lighter, while the blue-stained areas appear darker.

The choice of a color film depends on the type of light source. A low-voltage lamp with a regulating transformer, the most common light source, requires artificial-light (tungsten) color film. The color temperature of the light can be varied with the regulating transformer. (See appendix at the end of this chapter for the relationship between transformer setting and color temperature.) Xenon lamps require daylight color film, which may also be used with low-voltage lamps if the color is corrected with a conversion filter.

The new Kodak High Definition Ektachrome film 2483 and the Agfa film CT 18 fall into this range and can be recommended because of their high

Azan-stained tissue from salamander photographed with red filter (left), and without filter (right)

contrast and color saturation. With tungsten light sources, the transformer should be set to 3200° K (see appendix) and a conversion filter recommended by the microscope manufacturer should be used. Every Leitz microscope is supplied with a corresponding conversion filter.

Preparing the specimen

All your careful attention to equipment, procedure and detail will be ineffective if the specimen is not skillfully prepared. Here are some guidelines. Rock specimens must be sliced evenly, and must be as thin as possible. Metallurgical specimens should be flat and carefully etched. In transmitted-light microscopy, the specimen is a part of the optical system: therefore the mounting medium should have a refractive index and dispersion similar to that of glass. The thickness of the glass slide should be approximately 1.0mm and the thickness of the cover glass should be about 0.17mm. Cutting and staining procedures are also very important, and should be executed with care.

The series of photographs on the next page shows how the thickness of the section influences the photograph. These pictures show three kidney sections taken from the same specimen, but varying in thickness from 2 to 10 microns. They were stained in hematoxylin-eosin and photographed with a 40x apochromat objective.

Conclusion

Photomacrography and photomicrography are often considered difficult fields of photography, but Leica and Leicaflex cameras and accessories simplify the procedures and eliminate guesswork. This equipment is easy to use, yet performs with the precision that is needed for the most effective results. With carefully-prepared specimens, an accurately-aligned microscope, and a Leica or Leicaflex, you can take excellent photomacrographs and photomicrographs consistently, time after time.

Sections of different thickness cut from the same specimen: (Top) 2 microns (Center) 6 microns (Bottom) 10 microns

1. Microscope magnifications

Visual magnification:

M (visual) = M (objective) x M (eyepiece)

Photomicrographic magnification:
M (negative) = M (objective) x M (eyepiece) x camera factor

The *camera factor* is obtained by dividing the focal length of the camera attachment (mm) by 250mm, which is considered the normal viewing distance. The Leitz camera attachments have a factor of 1/3. Example: Magnification: objective, 20x; eyepiece, 10x

M (negative) = (20x) x (10x) x 1/3 = 66.7x

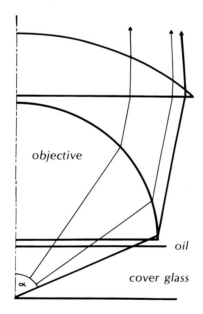

Numerical aperture:
The numerical aperture is the product of the size of half the aperture angle (sine \propto) and the refractive index (n) of the media between objective and specimen.

NA = n x sine \propto

For higher resolution, oil is used between specimen and lens. Since the refractive index of the oil (1.515) is higher than that of air (1.000) the numerical aperture will increase. The highest numerical aperture obtainable with a light microscope is 1.4.

2. Resolving power of a microscope objective

d = 1.22 NA
u = wavelength of light
NA = numerical aperture of objective
1.22 = a theoretical factor

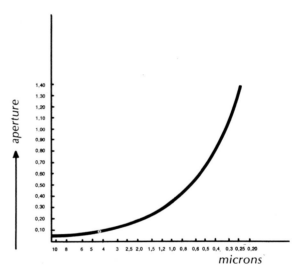

Relationship between resolving power for green light (λ = 550nm) and aperture

3. Useful microscope magnification

The final magnification on the print of a photomicrograph should be in the range of 500x NA to 1000x NA of the objective.
Example: Objective 40x, NA 0.65. The print magnification should be in the range of:

325 x (500 x 0.65) and
650 x (1000 x 0.65).

The eye is not able to resolve all detail of the microscope image below 500x NA. When the total magnification exceeds 1000x NA of the objective, the image is blown up without gaining additional information: this range is known as "empty magnification."

4. The relationships of different magnifications obtainable with the Aristophot macro lenses. (The lowest magnification with the Macro Dia Apparatus is 1:1)

Magnification	24mm x 36mm Approximate field size in mm	Macro lens focal length in mm
1:4	96 x 144	120
1:3	72 x 108	120
1:2	48 x 72	120
1:1	24 x 36	120 - 100
2:1	12 x 18	120 - 80
3:1	8 x 12	120 - 50
4:1	6 x 9	120 - 50
5:1	4.8 x 7.2	100 - 50
7.5:1	3.2 x 48	80 - 25
10:1	2.4 x 3.6	65 - 25
15:1	1.6 x 2.4	42 - 25
20:1	1.2 x 1.8	25
25:1	0.96 x 1.44	25
30:1	0.80 x 1.20	12.5
35:1	0.65 x 1.03	12.5
40:1	0.60 x 0.87	12.5

5. Transformer settings and color temperatures

The graphs illustrate the range of color temperature from approximately 2600°K - 3400°K covered by regulating the amperage of the lamp. Most tungsten-type color emulsions are balanced for color temperatures within this range.

6. Color temperature balances of films

Agfachrome CK 20	ASA 80	3100° Kelvin
Kodachrome IIA	ASA 32	3400° K
High-Speed Ekta-chrome, Type B	ASA 125	3200° K
Ektachrome, Type B	ASA 32	3200° K
GAF Anscochrome T/100	ASA 100	3200° K

Suggested further reading on microscopy

1. *How to Use a Microscope,* by W. G. Hartley; Natural History Press, Garden City, New York, 1964; English edition: English Universities Press, 1962
2. *Photomicrography,* by C.P. Shillaber; John Wiley and Sons, New York, 1944
3. *Applied and Experimental Microscopy,* by Steve D. Wilson; Burgess Publishing Company, Minneapolis, Minnesota, 1967
4. *Photomicrography,* by Dr. Roy M. Allen; D. van Nostrand, Princeton, New Jersey, 1958

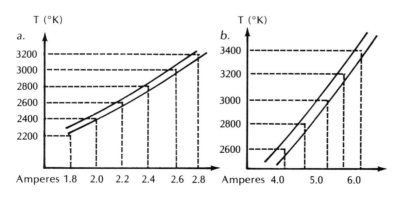
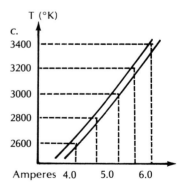

a. Color temperature curve of 6-volt, 15-watt low-voltage lamp: Dialux and Labolux microscope
b. Color temperature curve of 6-volt, 30-watt low-voltage lamp: Ortholux microscope, Monla Lamp, Macro Dia Apparatus
c. Color temperature curve of 12-volt, 60-watt low-voltage lamp: Orthoplan microscope

Motorized Shooting

Norman Goldberg

As one of the first, and certainly the most long-lived "system" cameras available, the Leica can trace its ability to be automated for rapid-sequence shooting back to the 'thirties. That's when a spring-wound motor was first made for it.

More modest in cost than the motor, was a remote release and winder which fastened to the camera and was operated from a distance by pulling on two strings. One string tripped the shutter, the other wound the film and shutter. Users were advised to use strings of two different colors to avoid confusion. They were also admonished to be sure the camera was secured to a sturdy tripod, since an over-enthusiastic tug on one of the strings could upset everything.

Surely individual users have come up with any number of ways of automating their Leicas over the years. The spring-wound motor of the 'thirties had a cable release socket on the bottom—there must have been many cases of extra clockwork or solenoids adapted to this motor to add remote control. But none of these features was adopted by Leitz as a standard catalog item.

The closest thing I have ever seen to a true remote-control Leica from the early days, was a Leica FF (the 250-exposure model made during the mid- and late 'thirties) with an electric motor drive on the bottom. As far as I could learn, only three or four are known to exist. Don't ask me about buying one, because I tried. The owner of the camera shop in Tokyo, where I saw it, was unwilling to part with it at any price. Evidently a few were made for use as aircraft wing-cameras, but large-scale production was never undertaken.

Leica users had to wait until the mid-1960s for an electric motor with remote control. This was the motor for the Leica M1, M2, MP, MD and M4. A few years later, a special version of the Leicaflex, called the Leicaflex SL/Mot, was made available with its own motor drive. It has evolved into a complete system, including a tandem arrangement which mounts two cameras side-by-side with cables connecting their motors together. Pressing the switch button on a special hand grip causes the two motors to fire alternately. I'll discuss the specific advantages this offers later.

First, let's talk about the general advantages of automating your camera. Any time or place which is hostile, or makes it inconvenient, uncomfortable, or inefficient to be close to the camera, calls for some means of remote control. Automation can also overcome human limitations which sometimes prevent us from getting the exact picture we want.

Few photographers can make consistently good pictures by manually operating their cameras as fast as one frame per second, nor can they honestly say that they are fully involved with the subject if they must concentrate on advancing the film and tripping the shutter as fast as possible without error. Automating the Leicaflex means equipping it for remote control and rapid firing, and this means *motorizing* the camera.

The specific applications of a motor drive must include sports as one of the most obvious. It is so obvious, many non-sports photographers think that it is the only application and dismiss the motor as something they don't need. But the same photographers may be very involved in spot news coverage or portraiture—two other fields in which a motorized camera can be of great advantage.

Before the best use of the motor can be realized, everyone must come to grips with the fact that, motor or not, the Leica or Leicaflex is a 36-exposure camera. Adding a motor can make this fact painfully clear unless the user learns the simple art of budgeting his film during shooting. At a firing rate of three to four frames per second, the film will be used up in less than twelve seconds if the switch is held down continuously. There are times when this is necessary and desirable, but for most purposes a short burst of two to four shots will do the job. The most successful users of motor-driven cameras often find that their best results come from touching off *single* shots as needed. But why use a motor for single shots?

The biggest reason is the motor's ability to free the photographer from the small, but nevertheless real distraction of advancing the film after each shot. He can maintain his grip on the camera and never disturb the position of his eye behind the viewfinder. This reduces the number of steps required for making pictures to simply viewing and touching the switch button. For those who have tried, there is no need to explain; for those who haven't, there is a beautiful experience waiting for you.

For portraits in a wide variety of situations, the spontaneity of the subject often can be captured best with the aid of a motor-driven camera, especially a

1

To get frame-filling portraits of a highly animated subject places severe demands on the photographer's ability to respond quickly enough to capture each fleeting expression. A motorized camera lets him concentrate on reacting to changes of mood. The contact strip shows the variety of expression in just over two seconds. Camera: motorized M2 with 90mm Elmarit f/2.8. Exposure: 1/125 sec. at f/5.6

subject who is animated and vivacious, like the girl in Photo 1.

Photographers whose assignments include covering celebrities know how elusive a dramatic look or an expressive gesture can be. Those who consistently produce the best pictures can testify to the benefits of using a motor-driven camera. A burst of frames as something important develops in effect "brackets" the moment, and greatly increases the chances of getting precisely the most telling expression.

Children, and child-like grownups, have the quality of racing through a dozen moods—with expressions to match—within a few seconds. Trying to capture this with a camera becomes much easier when you are free of all operations except tripping the shutter. A motor can give you that freedom.

The spontaneous-looking results of motorized portraiture suggest another use of the motor which may have been overlooked. During the infancy of 35mm, candid photography was one of its hallmarks. People thought a camera had to be a big box, and paid no attention to small devices. Today, people are so familiar with "miniature" cameras that it is difficult to make pictures unobserved. Bringing any small object up to your eye calls attention to you, and the glitter of a camera makes it worse.

Try this for your next candid shots of people. Use a motorized Leicaflex with a short remote control cord plugged into the motor. Rest the camera on a table, in your lap, or hang it over your shoulder. Preset focus using the distance scale on the lens, and aim the camera instinctively. Use a wide-angle lens because it offers greater depth of field than a normal lens at the same f-stop, and it covers a larger field so that aiming errors will be less of a problem. With some practice you can become quite good at this "shooting from the hip." I have discreetly photographed shy subjects with a motorized M2 hanging from my shoulder and a short length of release cable running down my sleeve. I set the 35mm Summicron so everything from six to fifteen feet will be in focus. When I see someone interesting, I simply turn sideways so the lens points in his direction, and press the switch in my hand. Try it sometime; the results are surprising.

This technique suggests using the camera for surveillance, and other applications in which it is desirable to make pictures without the subject's knowledge or approval. If the candid approach won't do because your presence would affect the situation, the answer may be remote control. Any event that can be made to close an electrical switch can be used to take its own picture. And that means that practically any situation you can think of is capable of triggering the Leicaflex SL/Mot.

There are transducers which convert sound, pressure, strain, light, moisture, temperature change —you name it—into an electrical impulse which can be used to energize a relay and fire your camera within a split-second of the event. Radio remote control even eliminates tell-tale connecting cords.

In many ways, surveillance and nature studies of animals in their natural habitat call for the same techniques. The camera must be housed in a container that protects it adequately and that blends into the surroundings. The location of the subject must be anticipated so the camera can be aimed and prefocused accurately. A suitable means must be chosen to cause the motor to respond to the subject's presence. And if the action will occur at night, suitable illumination—continuous, flash, or infrared—must be provided.

If the camera's noise will be a disturbing factor, some means of soundproofing the container is necessary. The need to have a clear, thin window for the lens to look through often makes soundproofing a problem, but surrounding the inside of the container with acoustical absorbing material is a great help in reducing motor-mirror-shutter noise.

The need for a subject-actuated tripping device will be eliminated if you can be in a position to observe the action and close the switch yourself. A difficult news photography situation is an excellent example of how this kind of remote control was used with great success.

A few years ago, some press photographers wanted to photograph the presidential inaugural parade from within the President's reviewing stand. The idea was to shoot from the stand with the President in the foreground of the shot, watching the parade pass by in the background. Secret Service authorities responsible for the President's safety would not permit anyone except the presidential party inside the specially-enclosed booth. The closest any member of the press could get was across the street, in the press booth.

2

A montage of eleven separate shots creates this step-
climbing sequence. The problem was to match foot
positions on each step. A motor provided rapid
enough film advance for the photographer to shoot
at the proper instant for each step. Camera:
motorized M2 with 35mm Summicron f/2.
Exposure: 1/250 sec. at f/11

The late Milt Freier, former Press and Technical Representative for E. Leitz, Inc., came up with a solution which yielded some memorable pictures. He obtained permission to install a motorized Leica and a tiny radio receiver, in a trim-looking white box inconspicuously fitted into the reviewing stand, behind the President. As the parade passed by, Milt watched through binoculars from the press booth. When he saw the President gesture to the crowd, he simply pressed the switch on a radio transmitter at his side; the receiver actuated the camera motor. The results were published worldwide the following day.

The same technique can be employed for a variety of situations. Radio control offers a certain freedom and fexibility over the simpler remote control cable that must be connected directly to the motor. Very compact, reliable radio units with an effective range of up to a quarter-mile can be purchased in most hobby shops for a reasonable price.

Another useful accessory for a motorized camera is an intervalometer. This is a device which can be adjusted to cause the camera to fire one or more shots at regular intervals. For time studies of an event such as a flower blooming or an insect hatching, it permits unattended photography with the regularity and patience only a clock has.

At the opposite end of the time spectrum are events too rapid for the eye to freeze. To think of the motorized Leica as a suitable instrument for the complete analysis of a problem with a high-speed machine is a bit foolish; there are high-speed motion-picture cameras designed to run film through at the rate of thousands of frames per second for that kind of work. But the analysis of certain high-speed events is possible with the motorized Leica or Leicaflex, as long as the speed of the event falls within the ability of the three-frames-per-second motor to make some sense out of it.

When Eadweard Muybridge made his monumental studies of human and animal movement about a hundred years ago, he set up as many as forty cameras in a row and tripped the shutters one after the other. Among the many things learned from his work was that analytical studies of human physical effort require a rate of about twenty frames per second. Given our three frames per second limit, there would seem to be little hope for making any serious motion studies.

In the illustration of the girl walking up the steps (Photo 2), the motorized Leica was fired at far below its maximum framing rate. If the camera had fired at three frames per second, there would not be the orderly left-right, left-right succession of the girl's feet on each step. Instead, there would be a hodgepodge of leg positions, some mid-stride, some just short of full-stride, and so on, because the three frames per second speed would not be synchronized with the subject's movements.

To make the picture, the camera with a 35mm Summicron was tripod-mounted and located so that the entire scene from the bottom to the top of the steps was included in the viewfinder. Then a short remote control cable was plugged into the motor, to free me to watch the movement carefully from alongside the camera. As the girl walked up the steps, I pushed the switch each time she took a step.

There are eleven figures in the picture, showing a different stage in the ascent of the steps. Eleven individual prints were made to get the eleven figures (one from each frame). The first one, with the girl at the bottom step, was a print of the whole negative. The remaining ten prints were of the girl only, and a small amount of background. The girl and just enough background detail to assure accurate alignment were carefully cut out of each one and cemented onto the first, full-negative print. The assembly was placed in a glass "sandwich" for copying onto a single negative. The result is the closest thing to a static "movie" that is possible on the printed page.

The same technique can be applied to any action which falls within the motor's three-frame speed capability, but that is not an absolute speed limit. Thanks to the special tandem device made for the Leicaflex SL/Mot system, this rate can effectively be doubled.

To show how much difference this can make, take a close look at the composite contact strip of the cheerleader doing a leap (Photo 3). The strip was made up from two different rolls of film, one out of each of the two tandem-mounted Leicaflex SL/Mots which fired alternately to make the pictures.

You can see that camera "A" missed the peak of action, while camera "B" captured it. They were both firing at the maximum framing rate, one after the other, so each had an equal chance of getting the peak moment; but there was no way to predict

3

Alternately-firing motorized cameras cover one second of action with twice the total number of frames as a single camera, and greatly increase the chances of capturing peak action. Cameras: two Leicaflex SL/Mots in tandem motor-drive cradle, each with 135mm Elmarit-R f/2.8. Exposure: 1/1000 sec. at f/8

B

A

B

A

B

A

Leicaflex SL/Mot
For operation, see Handling the Leica and Leicaflex,
pp. 70-72

exactly what instant that would be. At the combined framing rate of six-per-second, it seems that I couldn't miss getting the shot I wanted, yet the results you see here represent the best of six different tries. In all the others there was some imperfection—a wisp of hair in the wrong place, the toes not graceful enough, or something similar. That proved to me that even with the tandem arrangement, the element of luck is still a factor.

How much a factor this is can be appreciated by assuming that I had to shoot the job with only one camera. If it was camera "A", I might have had to shoot twelve or more takes. The model would have been quite tired by that time, and her pretty smile might have turned to one of grim determination. The pictures show that I could have gotten the shot with camera "B," but that is hindsight; who could have known which camera would be the right one?

For this kind of action, the photographer simply has to fire a continuous burst, hoping that the law of averages will favor him. If the event can be rehearsed or repeated, the chances are more in favor of the

photographer's timing the burst to coincide with the approximate peak of action. Learning to anticipate that peak is a mark of any successful action photographer, but having the advantage of a motorized camera makes capturing the dramatic moment much easier.

It must be mentioned that motor-driving any camera imposes certain demands on the camera mechanism that exceed those of normal, manual operation. Although both the Leica and the Leicaflex are extremely rugged instruments, using them with a motor drive for long periods is equivalent to compressing their operating time.

The life of shutter and wind mechanisms is rated in number of cycles of operation, not years. It is likely that a motor-driven camera in the hands of an active photographer will undergo a good many more cycles in a year than a manually-operated camera. Therefore, it makes good sense, to provide regular preventive maintenance for both camera and motor more frequently than for a manually-operated camera. For motorized cameras I would recommend a thorough checkup once every nine months.

Little Painted Desert north of Winslow, Arizona

Aerial Photography

William Garnett

All photographs by the author

In aerial work, as in any action photography, one should be so familiar with the equipment that it becomes an extension of thought rather than an obstacle course. Practice with an empty camera until you can operate every control quickly, smoothly and accurately without looking at it. This will help when you want to bracket exposures rapidly. Get used to the feel of the camera with lenses of different focal length on it. I find that I can hold the long lenses steadier by using the lens as a handle in my left hand.

The camera must be brought to the eye with precision on the first try. Hold it firmly against your forehead for solid control, and never let the camera or lens touch any part of the aircraft when you are shooting. Your body absorbs most of the vibration as long as the camera doesn't touch the plane.

Sit in the airplane before the flight and try camera angles: should the seat be higher or lower to make the best angles possible? Find a place within easy reach where you can keep your spare film and accessories. If there is no such place, carry a small gadget bag or wear a multi-pocketed jacket in which to keep the extras. Advance preparation can add much to your success in aerial photography.

Secure a good neckstrap to the camera. Remove or fasten down all long, loose ends of straps so they cannot blow around and get into the picture. I find it best not to use eveready cases on the cameras, for they greatly complicate reloading in the plane.

Professional aerial photographers usually carry three cameras with lenses of different focal lengths. Each camera body is clearly labeled with a code letter—A, B, and C. One can be very busy in the air, especially in turbulent air. It is better for the equipment to use several cameras instead of changing lenses on one camera, and you will work faster and get more pictures per flight.

When you load the camera, immediately stick a large tape label on top of it: if you are using more than one camera, include a letter to identify the camera, as well as a roll number for the film and a code for the type of film. For example, "A-12-FX" stands for "camera A, roll 12, Panatomic-X film." I use white pressure-sensitive tape like that used for freezer packages. It is useful, while flying, to see all this information at a glance. When you reload, pull the tape label off the camera and put it on the exposed film cartridge for positive identification.

The point is to keep all pertinent information together with the film until the pictures have been processed and are ready for filing.

The labels should identify the camera used as well as the roll number so that when you are traveling you can send the film to someone at home base for processing without losing track. Then if a camera malfunctions, you will know which pictures to reshoot and which camera to adjust or put aside until it can be repaired.

Lock the focus of all lenses on infinity (if they do not have built-in infinity locks) by taping the focusing ring to the lens barrel with pressure-sensitive tape. Avoid tape that gets soft or gummy in hot weather. (I use American Tape Company Freezer Packaging Tape, available in housewares stores.)

Be sure filters are fastened securely to lenses. Try to avoid sudden temperature changes, as they may cause moisture to condense on the lenses: keep your cameras away from heating outlets in the plane.

Filters for black-and-white photography

A light yellow filter is helpful in cutting haze. In areas of high humidity, an orange or red filter will give better contrast and penetration of haze that results from moisture in the air. The red filter, while it darkens the sky and cuts through some haze, will also greatly darken grass and green foliage. If these greens are predominant in the picture, even more exposure is needed than the filter factor calls for.

The comparative effects of different filters for black-and-white photography are easy to check. Simply hold each filter to your eye in turn, and notice what colors in the scene appear lighter or darker when seen through it. The effect on the film will be similar. As far as I know, the only thing that can capture an image through smoke is radar.

Aerial photographs of high mountains such as the Rockies will generally be too contrasty for normal printing if a red filter is used. At these altitudes, usually above ten thousand feet, the sky will be rendered black. For more normal rendering under these conditions, use only a very light yellow filter. Infrared film used with a deep red filter gives maximum distance penetration through moisture in the air, but it renders green foliage as white. A polarizing filter used with black-and-white panchromatic film can darken the rendering of the sky without causing green leaves to darken or appear white.

What focal length?

The lenses I use most range in focal length from 35mm to 135mm. At altitudes between 1,500 and 3,000 feet, the 35mm lens gives a broad, sweeping oblique view of the landscape. At the same altitudes, the 90mm or 135mm lens can pick out a detailed composition within the larger view covered by the 35mm lens.

While it is advantageous to be able to take all your photographs of a scene from the same altitude, a far more important reason to use lenses of different focal lengths is that they enable you to control perspective. The wide-angle lens lets you show the foreground in relationship to distant things, including the horizon and the sky; and it may exaggerate the apparent distance between foreground objects and the background. But if you want the distant mountains to look larger or closer, use a longer lens, such as the 90mm or the 135mm.

Exposure

The most useful shutter speed for fine-grain black-and-white films or the slower color films is 1/250 second, which will stop all normal motion. If you pan, swinging the camera with the movement of the image as you shoot, it will give you sharp pictures even at low altitudes. If the light permits, of course, the faster the shutter speed the better; but in smooth air I have made sharp photographs from as low as 1,500 feet at shutter speeds as slow as 1/60 second.

If you have a Leicaflex SL or a Leica M5, it is practical to use the built-in meter in the camera. If you are using filters, a meter reading taken with the filter in place will provide correct exposures under most conditions. For my own aerial photography, I prefer to use a hand-held reflected-light meter such as the Weston Master V.

Meter readings made from the same altitude and angle that will be used for the photographs are usually correct; but the same precautions that apply to light readings on the ground also apply in the air. Watch out for bright stray reflections that might affect the reading: these can come from parts of the plane, sun reflections on ponds or rivers, and so on. One exception to the normal reading is the usual high-altitude reading on hazy days: the glare of the sun on the haze tends to over-activate the meter, leading to underexposure. A good rule-of-thumb adjustment is to add exposure by opening the lens one-half stop to one stop for color reversal film, and one to one-and-one-half stops for black-and-white and color-negative films. (For color slides, slight underexposure is desirable. A hazy slide tends to have washed-out color, and the extra density from slight underexposure gives better color saturation.)

To zero in quickly on the exposure that works best for you, take careful notes on your first few flights. Because the intensity of the light changes abruptly with your angle of view, especially when the sun is low in the sky, it is a good idea to bracket exposures by one-half stop over and under.

When you fly over predominantly dark or predominantly light terrain, you must interpret the meter reading, and compensate for it in your exposure, just as you would on the ground.

Make your exposure readings from inside the plane. A meter will occasionally give false readings when subjected to the excessive pressure of the slipstream. Air pressure, vacuum, or wind pressure may affect the balance of the meter. Be sure you are clear of the window frame and avoid reading reflections from internal and external parts of the airplane.

Film

I recommend using fine-grain film, as air views always have many small details that could be lost in a coarse grain pattern. For color, I find that most publications prefer Kodachrome II to other films.

Aerial photography requires no special processing. The same standards used for photography on the ground apply: the brightness range of the subject—its contrast—dictates the development that is needed for black-and-white film.

Lighting

There are two ways to control the effects of light on your subject when shooting from the air. The first is to choose a time of day when the sun is at the best angle to reveal the subject's forms—usually when the sun is low in the sky. Deep-plowed farm furrows and low hills that look flat and smooth from the air on a summer noon will show in dramatic relief a few minutes after sunrise.

The second way to control the light is by choosing your angle of view. In the air, besides circling your subject to get front light, side light or back light, you can change your viewpoint from vertical to oblique to take full advantage of the subject's reflectance.

Clouds, Lancaster, California (red filter)

Petaluma River; red filter turns foreground foliage black, but does not penetrate city "smaze"; 35mm lens takes in both near foreground and far horizon

Sand dune, Death Valley; low sun

Strawberry farm, Salinas, California; men spreading plastic over plants

*Eroded ridge and smooth, grassy hills between Ojai
and Maricopa, California*

*Tractor plowing, Salinas, California; 90mm lens
from 1500 feet*

Briefing the pilot

In the pre-flight briefing, be sure to tell the pilot that you do not want him to do any forward slips, but rather to fly in a normal attitude at all times. A forward slip lets you drift toward your subject, but it also makes the wind come buffeting through the window at you, making your eyes water so it is hard to see through the viewfinder. The wind makes it difficult to hold the camera steady.

Impress upon the pilot that you expect safety first. Never relax safety regulations to get a picture. Tell your pilot that you want him to make a clearing turn before each picture position. This consists of flying S-turns to check for other air traffic in the area that may be out of sight above, below or behind, or hidden by the wing.

You may then want him to circle completely around your subject once, so you can study the best angles for perspective and lighting, and take meter readings for correct exposure. This first circle will also let you check whether you are too close to your subject or too far out for the lens you are using.

When you are all set for the picture, the pilot should make another clearing S-turn and repeat the circle at the same altitude and distance from your subject that you selected the last time around. If you follow this procedure you will have time to make camera adjustments and the pilot will know what to do while you are busy with the camera.

Keep circling to stay near your subject. If the pilot flies a straight line or turns away from the subject after every meter reading or picture, you can end up ten or fifteen miles away from your next exposure in the time it takes to change filters or write a note.

The best airspeed for most small planes while photographing is eighty to one hundred miles per hour. The pilot should select a throttle setting that gives a minimum of vibration and a slow airspeed, yet leaves him with good flight maneuverability.

Helicopters

Helicopters have the advantage that they can legally be flown lower and closer to people and buildings than any other aircraft. If very low-altitude photographs are to be made in populated areas, the helicopter is first choice. It can also hover in one place, so you can record changes of action on the surface, as in car and boat races. Hovering lets you shoot several exposures from the same viewpoint without flying in a large circle as you would have to in an airplane. This permits faster shooting when you are using both black-and-white and color film, or more than one focal length.

The disadvantages of helicopters are that small ones usually have short range, slow cruising speed and high rental fees; and that rotor blast and noise disturb subjects on the ground.

Airplanes

Small, single-engine, high-wing two-to-four-place airplanes are ideal for low-to-medium-altitude aerial photography. Their lower rental fees as compared with helicopters, together with a three-and-a-half- to five-hour range at cruising speeds from one hundred to two hundred miles per hour make it practical to cover several areas in one flight without refueling.

The high wing offers no obstruction to looking down, and acts as a sunshade for you and the camera, making it easier to see through the finder. The best planes for photography are those with large windows that can be opened in flight. The smaller Cessna models have windows hinged at the top. By removing one screw from a window control, the window can be fully opened in flight, and the air flow will hold it up against the bottom of the wing. Never shoot through the plastic windows or the windshield: this can cause distortion and a great loss of definition, and you are likely to get unwanted reflections. Some people like to have the whole door removed for unobstructed views. I prefer to open windows that can be closed between pictures to cut down the noise of the engine, the propeller and the wind. It's even more important to stop the cold blast of air while flying to and from the picture location: this can be chilly even in summer. The normal temperature drop is three degrees Fahrenheit for each thousand feet of altitude. It might be a pleasant 70 degrees at the airport, but at ten thousand feet you can be blasted by a forty-degree wind. I have made aerial photographs over the high desert of the Southwest with the outside air at twenty below zero. It is nice to be able to close the windows!

Most small high-wing planes have wing struts. The largest unobstructed angle of view is usually aft of the strut.

If you can shoot out the left side of the airplane,

South Carolina farms; 35mm lens

you will find it much easier to hold the camera. Shooting from the right side forces you to bend your right wrist back and makes it difficult to work the shutter release and the film-transport lever. Therefore try to use a dual-control plane in which you can sit in the left seat, with the pilot at the right. In many planes, only the left window opens.

Protect your hearing with ear plugs or by using cotton or tissue. This helps greatly and still lets you converse with the pilot.

Airlines

Reserve a window seat forward of the engines and not over the wing (aft of the engines, the exhaust gases blur your vision and your photographs). Sitting over the wing greatly restricts your view, and sun reflections on the wing often glare right into your lens and add extra reflections in the window. Sitting on the shady side of the plane will eliminate many problems caused by light glaring on haze in the air or by bright reflections in the windows; however, backlighting sometimes produces exciting

effects, so sit on the sunny side sometimes.

If possible, schedule your departure so you will be over the area you want to photograph when the sun is low for dramatic lighting.

Most airline windows are double panes of plastic with air space between them, which makes them especially prone to reflections, many of which originate with you. Light on your face, hands, clothes and camera is usually reflected in the window. You can often control these reflections by staying in the shade, and by wearing dark clothing or draping black cloth around your camera and hands. Sometimes you can get rid of reflections simply by holding the camera very close to the window; but to avoid vibration, be careful not to touch the window.

Some airlines place a polarizing filter in front of the window to reduce glare, much as sunglasses do; but a polarizing filter placed over two layers of plastic often causes bands of color like the colors of a rainbow. This type of filter on a window makes good photography almost impossible both in black-and-white and in color, as well as spoiling the natural

Housing project; Lakewood, California.
Low sun, almost on horizon

color of your view. Sometimes these filters can be snapped out of the window by flexing them slightly.

A newer type of light control in airline windows is a chemical in the window pane that darkens when exposed to bright light and becomes lighter again when the light diminishes. This system causes no uneven bands of color or density. Don't assume that your light meter has gone bad when you check exposures through this chemical filter. According to my recent tests, the filter reduces the intensity of bright sunlight that comes through the window to about one-fourth of its unfiltered brightness. The color rendition of photographs I have made through this filter is very good; exposure readings are made in the normal way.

If you fly a great deal, have your camera checked periodically for loose screws. Jets feel smoother than piston-engined aircraft, but the high-frequency vibrations of a jet plane sometimes work screws loose very quickly.

Identifying your pictures

If you keep notes on the actual take-off time, the time over points of interest as announced by the captain, and the landing time (or the ground speed), you can later compute the approximate place where you took each picture with the aid of a map. Sometimes enough features of the locale are shown on a map so you can identify them from your photograph.

Spot news. Fast-breaking events demand that a photographer get to the scene at a moment's notice to shoot the action in progress; a major fire may last long enough to give him the chance. Photo copyright by Gary Settle

Photojournalism

Arthur Rothstein

News photographs are reproduced mechanically by the printing press or by television to bring them to the public. The journalistic photograph is not an end in itself, but a means to an end—the public distribution of a skilled observer's visual report.

The reporter's camera does what no other news medium can do. It teaches a new way of seeing the commonplace, and shows the visible world in infinite and exact detail. It opens up new vistas and shows people and their environment with unequaled precision. It has a unique power to convince.

The men and women in photojournalism must be technically skilled in using cameras, lenses and lights. But these techniques are best used to gain more freedom, to simplify the mechanics of picture-taking so the photographer can concentrate on the subject, the idea and the event.

A writer uses words, phrases, sentences and paragraphs. The photojournalist uses news pictures, feature pictures, and picture sequences and stories—categories that often overlap.

The news photographer must be a good reporter and a skilled craftsman. He must train himself to see what is important in the events he records, so his pictures will show the news in human terms and will move the people who see them. His is a demanding profession.

He must be there when the news is happening.

He must be ready—emotionally, technically, and with the necessary background information to cover the news intelligently and with foresight as it happens. Few shots can be repeated; few deadlines can be delayed.

He must know when to take what pictures.

Anyone can learn to work a camera, and news sense can be sharpened by experience. But the great news photographer has one quality that cannot be taught: he is able to anticipate the unexpected and to react appropriately and instantly, so his picture is shot at the height of the unfolding event.

The news picture is usually a single picture that presents the visual essence of a news event, a news situation, or a news personality. It is used either alone or as part of a picture story. To get it, the photographer must be in the right place and act at the right time. Swiftness and alertness are the keys.

A feature photograph is usually a single picture showing a subject of enduring interest. It creates a mood, presents information, or records a timely topic, but it does not have to be related to a news event. Feature pictures often use elaborate technical effects and unusual compositions, but they can just as effectively be simple. The photojournalist on a feature assignment does not have the urgency or tension that go with spot-news work, but he has more time and opportunity to consider his subject and how he will approach it.

The feature photographer must select what is significant. Selectivity begins with a thorough knowledge of the subject and an analysis of its important elements. Composition is used to present a chosen aspect of the subject in the most dramatically effective way.

The picture sequence consists of more than one photograph dealing with the same subject. It is an amplification of the single picture, and is justified when it reveals significantly more than one good picture can.

The photo sequence is most effective when all the pictures show high points of revealing action. Motorized cameras are often used. The sequence must have continuity, and is usually produced by editing down from many exposures to the few that work together most effectively.

The picture story or *photo essay* is a planned and organized combination of news and feature pictures, and presents a detailed story of a significant event, personality, or aspect of life. It is the most complex type of work done by the photojournalist, requiring a knowledge of varied techniques, tact and persuasiveness, news sense, and the ability to direct people and their actions.

Modern newspapers and magazines use photographic stories in three main ways. The most common form combines pictures and words, with the emphasis on the pictures, arranged in continuity. The words are subordinate, and typically appear in the form of captions.

Another type of picture story uses no captions. Only a brief headline, or a headline followed by a block of text, is needed.

In a third form, the picture story is used to illustrate, clarify, and dramatize a written story, within which it appears. Surveys show that the photographic story often receives twice as much attention from readers as the text it accompanies.

A picture story idea may come from an editor, a staff photographer, a press agent, a free-lance writer or photographer, or, indeed, from anyone.

The photojournalist who wants to create picture stories will do well to travel, meet people, and in general, expose himself to stimulating experiences. He should read newspapers, magazines and books. Ideas result from finding new ways to consider and express old experience. The photographer should keep up with new photographic techniques, and he must be able to translate verbal ideas into visual terms.

Different publications have different approaches, so he must also be aware of the slant of the one for which he is working.

The photographer shooting a picture story must keep several points in mind. Every story gains so much from a good lead picture or "establishing shot" that combines several elements of the story in one dramatic, story-telling photograph, that this shot is virtually a necessity. If it does not appear spontaneously in the course of shooting the story, the best photojournalists are skilled at making it happen. They do not hesitate to contrive a picture to put across a truthful point, and they are right.

The pictures in the published story must flow in an unbroken continuity from a clear beginning to a logical end. To make this possible, the photographer must shoot a great many more pictures than are needed in the final layout. (On an average magazine assignment, a photojournalist shoots fifty to one hundred exposures for each picture that finally appears.)

While shooting, the photographer should be aware of the restrictions of page size and layout. The professional will not forget to provide a balance between horizontal and vertical photographs, and will shoot in a variety of size scales as he goes, by photographing from different distances or with different lenses. Many good pros shoot each situation several ways. This gives the art director and the editors a wide choice of usable pictures, so they can select the combinations that best communicate the story.

The photographic essay is the greatest challenge, and gives the photographer his greatest scope as a communicator. If photographs speak more powerfully than words, they reach their greatest meaning and influence in a well-made picture story. The camera penetrates the economic, social, psychological and physical levels of our lives, examines and reveals our woes and our accomplishments, and often influences our opinions and actions. The photojournalist and his editors bear a heavy responsibility for the social outcome of their work.

Editing your pictures

Picture editing is primarily subjective. Individual reactions to a photograph are based on preformed ideas, previous associations, backgrounds and prejudices.

The untrained eye is apt to see only the most obvious features of the photographs. In editing his work, the photographer must see more, and must present his pictures so the meanings behind them are made clear—often with the help of well-chosen words.

Just as a literary monthly has a different writing style from that of a tabloid daily, so the photographs that a publication uses have a characteristic style. An editor selects the pictures in a story partly for how well they fit the image of his publication. The photographer who wants his pictures published must be aware of this factor. (One reason magazines employ staff photographers is that they typically have a better appreciation of the publication's needs and approaches than most outsiders.)

Whether the photographer is a professional, selecting pictures for publication, or an amateur assembling a slide show for his neighbors, he must be able to discard and eliminate, to refine and distill from many pictures to the few that communicate most strongly when used together.

On assignment in Japan for LOOK magazine, staff photographer Paul Fusco took 20,880 color photographs. Eighteen of them appeared in the published story.

After processing, hundreds of boxes of 35mm transparencies were turned over to the photographer, who examined them all with a magnifier. He spread the slides out on a light table, box by box, like so many contact sheets, picking out the best pictures of each subject and eliminating the weaker ones.

In doing this, he reduced the number of pictures to about six thousand—less than one 36-exposure roll for each of the 180 situations he had photographed for the story.

Next, Fusco arranged the pictures by theme,

War, mankind's dominant news topic, has been reported in photographs since 1855. The physical destruction is easy to record, for it remains when the fighting has passed. But the more important story—and the most difficult to photograph—is what happens to human beings, the fighters and the innocent people in their path, while the fighting is going on.

One of the world's outstanding photojournalists, Kyoichi Sawada (shown here with Leicas), was killed while covering the war in Vietnam as a staff photographer for United Press International. The Pulitzer-Prize-winning picture above, and those on the following pages, reveal his approach to reporting war: to show its devastating effects on human beings

All photos © UPI

UPI Photos by Kyoichi Sawada

grouping related pictures together on the light table and making further eliminations, but still covering all 180 situations.

At this stage, he began to project his slides, editing as he went, and cut the story down to 400 pictures.

Now the editors and art directors for the story assembled to see these 400 pictures and to discuss the story and its presentation.

Finally, during the layout stage, the eighteen key pictures were chosen. The standards were highly critical, involving editorial content, artistic effect, color balance, and how well each picture fitted into the layout.

Obviously, it takes considerable skill, objectivity and experience to choose the right eighteen photographs from more than twenty thousand. When so much of the responsibility for the final choice is placed on the photographer who took the pictures, it is a high tribute to him. The fact is, all of the 20,880 pictures that Paul Fusco shot on this assignment were good enough to be printed.

Why did he take so many? He had to cover the story thoroughly, and he was aware of two old photographic axioms: "film is cheaper than shoe leather," and "a photographer does not have an eraser on his camera."

Photojournalism and the law

Every photojournalist should know the basic legal aspects of his rights to take pictures and the risks involved in their publication.

He must know where he can legally operate. The photographer's right to shoot anything public is guaranteed by most states in the Union and by the first amendment to the Constitution of the United States, which says that Congress shall make no law abridging the freedom of the press. This refers mainly to the publication of the photograph, but the right to photograph in a public place has never been abridged by a law or a court decision. No statute prohibits photography in places of public amusement, museums, hotels, railroad stations or cafes, but the managements of such establishments can make whatever regulations they believe necessary, and may exclude cameramen. It is always wise to get permission before taking photographs. In general, though, the press photographer may legally photograph any person, scene or occurrence that can be seen from a public place.

What may be photographed? This is a question of property and personality.

Any public building may be photographed, but photographing a privately-owned building such as a hotel or a sports arena may create difficulties. In a case involving Madison Square Garden and Universal Pictures, the motion picture company made a film about hockey, using Madison Square Garden as the film's locale without getting the consent of the Garden's management. The court decided that damages were to be paid to the Garden for the publication of pictures of its building and the use of its name and publicity.

The government forbids the photographing of money and securities, but this law is meant to prevent copies from being made and passed off as real money or securities. It is permissible to photograph money, stamps, securities and so on being passed from hand to hand, or on a table, or in any situation, as long as the picture cannot be used to make forgeries. Copy photography of money or securities is illegal.

The problem of photographing personalities is more complicated. A 1926 court decision established that a public man cannot claim the right of privacy, so a public office-holder or a candidate for public office, a statesman, an artist or an author cannot claim the right of privacy. Politicians, entertainers, sports figures and people who are involved in newsworthy crimes or accidents are in a position where the public's interest is so great as to override their personal interests where press photography is concerned. (If a court holds that this privilege has been abused, however, a photographer may be enjoined to desist from photographing even a celebrity.)

Who owns the photograph? The law says that whoever pays for it to be made owns it. The person who has the negative and the prints is not necessarily the legal owner of the photograph.

A staff photographer for a publication has no rights in the photographs he makes for it. If a publication hires a free-lance photographer to shoot an assignment, the publication owns the rights to the resulting pictures, unless the photographer restricts their sale. He can license the publication to use the picture for a special purpose, for one-time publication, or for a limited time.

Every photographer who makes a picture for himself is protected by the copyright statute. The

Spot news. When an event such as a gunshot attack on a Black Power headquarters ends before the photographer can get there, he faces the problem of showing clearly what happened. Here, the man's position clarifies the edge of the door, emphasizes its protective function, and dramatizes the bullet holes. Poster on wall adds information about the location. Photo copyright by Gary Settle

A feature topic has a long life: changing youth fashions and hairstyles have always attracted attention. These two feature pictures could be used singly (the signboard is self-explanatory, the hairdryer shot would be aided by a caption), or could form part of a larger picture story. Photos copyright by Gary Settle

Photo essay. A variety of images is essential to build an effective picture story. Here are just two aspects of big-city streets after dark. One picture shows locale and specific action, the other, mood. Photos copyright by Gary Settle

law recognizes that the real value in a photograph lies not in the cost of the materials used, but in the skill, intellectual labor and effort that made the photograph possible. The law automatically copyrights every privately-taken picture with no effort or act on the photographer's part. This common-law copyright applies from the time the picture is made until it is published.

As soon as a photojournalist lets his picture be published, he loses the protection of common-law copyright, and must obtain a statutory copyright if he wants the picture to be protected. Such a copyright is obtained by registering the picture with the Copyright Office in Washington, D.C. The copyright symbol must be affixed to the copyrighted photograph, together with the copyright-owner's name or initials. Forms for copyrighting photographs may be obtained free of charge from the Registrar of Copyrights, Library of Congress, Washington, D.C. 20540. A statutory copyright lasts twenty-eight years, and may be renewed for another twenty-eight years.

Even if the pictures are copyrighted, the photojournalist must be careful when selling them to a publication. Many magazines and newspapers like to obtain complete ownership and rights to a picture, including the right to sell it later and to syndicate it to other publications. The photographer should read the fine print of any letter or contract he signs to make sure that his rights in the photographs are not abrogated. The preferred procedure in selling a photograph is to license its use for a specific purpose only or during a limited time only.

Staff or free-lance?

Most photojournalists are affiliated with a given newspaper or magazine, either by contract or by employment as a member of the staff; but many published photographs come from free-lance photographers and from amateurs.

The amateur usually gets involved in photojournalism by chance: he may be the only person with a camera at an important news event. The amateur whose pictures are published under these circumstances is usually a capable photographer who appreciates the visual significance of the event and the need to get his pictures to a publication quickly.

As a professional, the free-lance photographer seldom works on speculation. He keeps in contact

with newspapers and magazines, either in person or through an agent. He sometimes submits story ideas to publications to see if they are interested: good ideas often result in good assignments. The successful free-lance photographer is typically versatile, highly skilled, and enterprising. He is ready to go anywhere, any time.

Agencies

One way to keep in touch with the market is to employ an agent. At present, the greatest market for photography is in New York City, so representation there is important for photographers who live and work elsewhere.

Picture agents are glad to see new work, and if it seems salable, the picture agency can contribute valuable suggestions. A good agency advises its photographers, contacts editors, and helps create assignments.

The agent's commission varies according to the services provided. Some agencies handle film processing, purchase supplies, and provide office space. Others limit themselves to keeping the photographer busy and selling his work.

New York City is not the only picture market. Major news agencies, magazines and newspapers have bureaus all over the world. The wise free-lance photographer will get acquainted with the bureau chiefs in his region, and will see to it that they appreciate his willingness and competence to carry out assignments with a good understanding of their publications' needs.

When a photograph or story has national or international news value, the local newspaper will usually recognize this and will arrange for its distribution.

The free-lance photographer who does not work through an agent should deal with publications on the basis of a clear understanding of their rates, policies and working conditions.

Materials and equipment

In all the arts, there is a definite relationship between the artist's equipment and his ability to express himself esthetically. Just as the violinist desires a Stradivarius and the painter wants brilliant, permanent pigments, so the photographer appreciates sensitive, consistent emulsions, highly-corrected lenses, and well-designed, versatile and durable cameras.

There is a definite relationship between a photo-

journalist's equipment and the style of his pictures. This stems not only from the physical nature of camera, lens and film, but from the way of working that the equipment imposes or permits.

Thus the large, tripod-bound view camera is slow to operate, but can produce large images of high technical quality with considerable modifications of perspective. But the view camera is essentially static—best suited to subjects that do not move.

News photography used to be dominated by the 4x5-inch hand camera, with relatively slow lenses which made flash necessary for most pictures. In recent years, the old-style press camera has been almost completely replaced by modern 35mm cameras such as the Leica and Leicaflex. Among the reasons for this change, the Leica and the Leicaflex can be used quickly, unobtrusively and quietly, they offer great mobility, and can cope with poor light conditions with little or no need for supplementary lighting. They carry a 36-exposure film load, and many rolls of film fit into a small case or in the photographer's pockets. The Leica photographer is ready to take more pictures more responsively under a far wider range of conditions.

A range of lenses, from 21mm to 800mm in focal length, and as fast as f/1.2 in aperture, permit many different approaches to an infinite variety of subjects, using a single, convenient camera system.

Wide-angle lenses offer great depth of field even at large apertures, and can take in a large group of people even when the photographer has little room to move back. These lenses can be used to create dramatic perspectives that lend an exciting sense of space.

Long tele lenses let the photographer reach out optically for "closeup" views of distant objects or events that cannot be approached physically.

High-speed, large-aperture lenses let the photographer shoot action pictures even in very dim light, and permit the isolation of a sharply-focused subject in an unsharp surrounding area, which often makes clear pictures possible even when the subject is confusing to the eye.

The photojournalist wants realism, so when he adds light to make an adequate exposure possible, he wants his lighting to be unobtrusive. He prefers, when he can, to use the light in the situation exactly the way he finds it. Fast lenses and fast film make this practical most of the time, but when they are not

enough, the most popular solution is to carry a small, portable electronic-flash unit, and to "bounce" the light from it off a wall or ceiling for soft, natural-looking illumination. As lenses and film become faster, the photojournalist's lighting equipment becomes smaller and less powerful.

There is a definite trend in photojournalism toward miniaturization of equipment. The photographer communicating news and ideas is more interested in content and expression than in quantity. The larger negative made by the old-time press camera no longer assures better picture quality. The small negative and the light, flexible, fast camera produce a more versatile and responsive approach to the subject matter. The 35mm photographer can deal better with a greater range of content.

When pictures are published, halftone reproduction causes a definite loss of picture quality, so today's photojournalist is correct in stressing the visual content of his pictures in preference to technical finesse. Yet the technical quality of the photographs improves continually, thanks to high-precision equipment and today's vastly-improved films.

But the photographer remains the main factor. His sensitivity, alertness, imagination, perception and initiative are what make the pictures good. The Leica and the Leicaflex are there to help him use his talents in the most telling way.

Personalities are always news; catching opposing political leaders in affable agreement is a rare achievement. Photo of President Nixon, Vice-President Agnew, Senator Humphrey copyright by Gary Settle

Photo by Will McBride

Portraiture

There is no one right way to make portraits, so we have assembled here some photographs and some statements by the photographers who took them. They tell what they can about some of the possible ways.

Will McBride

"There are much greater portrait photographers than I: Dick Avedon and Irving Penn, to name my heroes, and David Duncan.

"My own situation may give some insight into portraiture. I was always that lonely one standing in the high school corridors. Alone, watching others. Other people were the heroes, the groups clustered around them, the talkers and laughers. I could not even be one of the admirers. I stood alone and watched from a great distance, although, in reality, I was very near. It was to bridge this distance that, years later, I began to photograph those people far out there.

"And in taking their photographs, I confront them, become involved in them, reach out and touch them. It is the experience of touching them that is exciting. The picture, I am sorry to say, always appears dead in comparison to the experience. And yet the photographs reflect perfectly the kind of experience it has been.

"I try to make the experience as close and intense and provocative, as truthful and beautiful as possible. I like to spend a long time making a portrait. I spent two and a half years, off and on, making my portrait of Konrad Adenauer. I did a portrait of my wife, Barbara. It took ten years of work, incredibly intense, and full of all the love I could give it and her. I shot more than fifty thousand pictures.

"For my portraits are acts of love. I've never portrayed anyone I've disliked. This does not mean that I believe all portraits should be testaments of admiration. One student of mine doesn't bring out his camera until he sees a face he hates. And I think this is fine for him. But I think it is an exception.

"Portraiture started early in human culture. The desire to make images of those who were dying was strong, and images of Egyptian kings accompanied the dead into their graves. Remember, we all die.

"With Roman sculptures, portraits became very much like the 'real' person. The people are dead. The sculpture lives?

"All great painters made portraits, becoming more and more concerned with the individual person. Each painter had his style—that is, he instilled a certain amount of himself into his conception of other people. A Holbein portrait shows the person portrayed, but it is also a Holbein. Rembrandt painted portraits of hundreds of people, but they all have that deep melancholy and questioning that was Rembrandt's own. And on to the photographers. Penn's portrait of Colette remains a Penn. Avedon said of his own work that he suspected he was portraying himself in each face that appeared in his pictures.

"I am concerned with the unbelievable complicatedness of people—with the change that takes place in them in time. That is why my portraits are composed of many pictures. I don't believe that one picture tells more about the person than the other. I believe that together, they give some indication of what the person is like in his complexity as he makes his way through time.

"Portraits do not have exclusively to do with naked faces thrusting up out of shirt collars, and the landscape of this face and the grimaces of that face. A portrait is a likeness. It shows things about the person. It can be dirt under his fingernails, the stoop of his shoulders, his heavy bones. You can tell about a man by showing his naked body, or by showing his choice of clothes or women or house or car.

"Penn and Avedon do their portraits in short, intensive sittings. I understand they expend great emotion and energy doing their work. So do I, but I prefer to work over a long period of time, making photographic notations of the changes that come about."

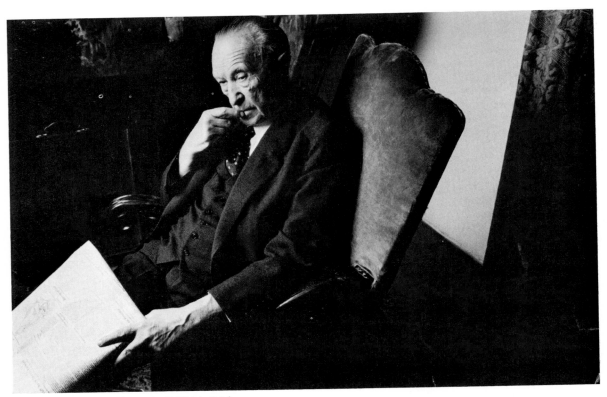

Konrad Adenauer. Photo by Will McBride

Photo by Will McBride

Photo by Will McBride

Photo by Will McBride

Photo by Will McBride

Barbara. Photo by Will McBride

Ralph Gibson

"I've always been impressed by the resonance of certain portraits—a distinct overtone inherent in the subject or the place where the photograph was made. The image singles out a particular moment in the person's life and calls out for attention and response. In this way, even the most ordinary person receives his due recognition and the act of making a portrait becomes an affirmation of one's life.

"This occurs with such intensity that long after the sitter has given up the ghost, his photographic image remains, as alive as the day it was made. In this way, a photograph can transcend time and memory, producing feelings that are available no other way.

"This also happens when the image communicates on more than one level. Consider a photograph of someone walking along the beach, seen from a distance. The image is composed of the waves, the sky, and the figure. Because it is small, it is the figure of no one in particular—a portrait of 'universal man.' As the camera moves in closer, we see more, until the face in the photograph is recognizable: 'That's Joe.' Now it has become a portrait of an individual man.

"A subtle threshold exists between universal and individual man. When a person is photographed passing through this threshold, the portrait includes his humanity, feelings, and identity, as well as his physical appearance. This is when a portrait really means something, and both the photographer and the person being photographed are quick to recognize its significance. Such moments are rare and elusive, but they certainly exist and can be photographed.

"The hand-held 35mm camera is perfectly balanced in this regard. A combination of velocity and documentary truth enables the making of a portrait to become an act of mutual discovery.

"People want to be seen and portrayed as they really are. We can hope that the days of the over-lit studio portrait are over, along with its exaggerated movie star effects. When approached in a natural way, in collaboration with the photographer, the person being photographed is far more willing to give of himself. This can only lead to a better photograph.

"But getting the sitter to reveal something means that the photographer must do the same. Good portraiture is a two-way proposition, and each must be willing to reach out. While this is not always easy to do, it can easily be seen in the results. The presence or absence of this kind of effort usually determines whether the portrait is really alive or just a rendering of the person's face.

"It's no secret that to make a good photograph, the photographer must have some feeling for what he's doing."

Photo by Ralph Gibson

Photo by Ralph Gibson

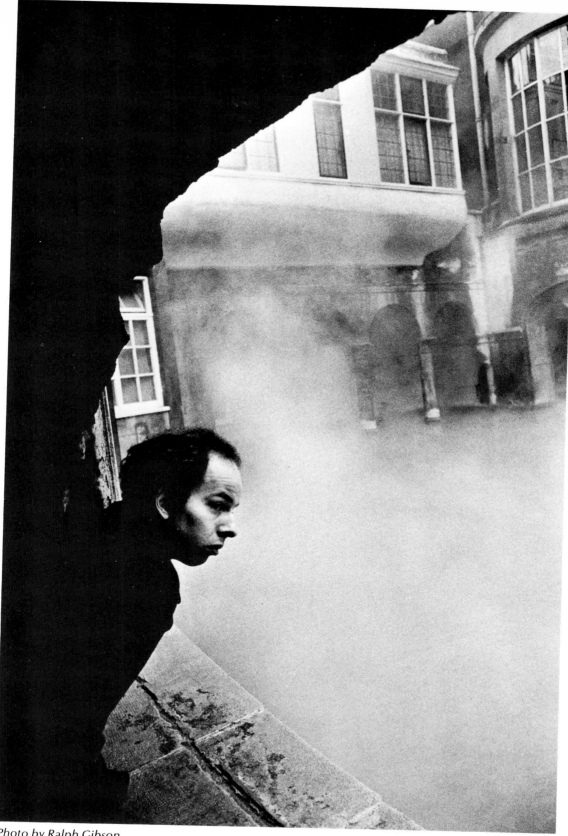

Photo by Ralph Gibson

Photo by Ralph Gibson

Eva Rubinstein

"When you take somebody's picture, you have to give something back.

"I avoid taking pictures for people's vanity. I can't do glamour shots of women, and can just about get away with it with men. But that isn't what I want to do.

"I'm not conscious of deciding on an attitude. I tend to work on an emotional base, not an intellectual one.

"I think the energy that goes into making a portrait is sexual. There's an emotional process going on between me and the subject. I sort of don't let the camera get in between.

"Type-casting doesn't work. There is a difference between deciding that someone is such-and-such a type and what actually happens.

"I used to use a gray paper background and lights, and it was all right, but I began to feel I was putting them all into a little cookie mold. Everything started to look alike.

"Then I tried to work in the places where people live. It's hard, at times. I try to find an area I can work in.

"Lighting? I can't work with flash and modeling lights—I have to see the light. I carry a couple of little 'Sun Guns,' and when there isn't enough light without them, I bounce one off a wall and the other off the ceiling. That gives me enough light for f/5.6 at 1/60, and the technical part is easy.

"A portrait session is a normal human intercourse situation, in concentrated form. You're getting acquainted. I've occasionally met people on the street or in the bus, photographed them, and become friends."

Duane Michals. Photo by Eva Rubinstein

Sylvester Stewart (Sly). Photo by Eva Rubinstein

Ikko and Keiko Narahara. Photo by Eva Rubinstein

Ralph Gibson. Photo by Eva Rubinstein

Dena

"Portrait photography involves a relationship between two people who may never have seen each other before. The photographer must be able to establish in a short time a situation which leads to maximum involvement on the part of the subject. The person who is being photographed must lower his defenses and feel comfortable enough to reveal himself and let go of the facade that he, like most of us, turns toward the world.

"There must be as many ways to accomplish this as there are photographers: no generally-valid formula exists. Only one thing is certain. A business-like, matter-of-fact situation will not yield good pictures.

"Personally, I am prepared to accept even a hostile attitude in preference to an indifferent one. In fact, I got one of my best pictures when the subject irately told me to go home and take care of my children, a suggestion I resisted, continuing to shoot.

"The portrait reflects both the subject and the photographer. There is no objective perception. Everything is filtered through the photographer's sensitivities and idiosyncrasies. This is why different photographers accentuate different aspects of the same individuals and produce entirely different portraits.

"The final portrait a photographer chooses from the many frames available is determined largely by his intuitive grasp of what is 'true' about the subject, and what are only passing expressions of little consequence."

Curtis Ether, painter. Photo by Dena

Photo by Dena

Curtis Ether, painter. Photo by Dena

Photo by Dena

David Douglas Duncan
"Get close. Then get closer."

Republican Delegate, 1968. Photo by David Douglas Duncan

Democratic Delegate, 1968. Photo by David Douglas Duncan

Democratic Delegate, 1968. Photo by David Douglas Duncan

Henri Cartier-Bresson

Cartier-Bresson did not tell us anything about these portraits or his approach to portraiture.

What do the pictures tell us?

That he is sensitive and respectful toward the people he photographs, though not overawed, and that he does not interfere with them while he works. Somehow, he makes it easy for them to be themselves. Then he presses the little button when they show themselves most clearly, humanly, and free from pretense. Nothing is forced.

Afterthought

All these photographers plainly know one thing that none of them have said here. Perhaps it seemed too obvious to mention.

You cannot get people to open up and reveal themselves to your camera by ordering them to "Relax!" This word is almost guaranteed to increase the tension of any photographic portrait situation. It's like asking, "Why are you so nervous?"

If you can persuade your subject to tell you about whatever interests him most, and if you really listen, there is a good chance that the camera will recede into unimportance and will no longer disturb him.

Alfred Stieglitz. Photo by Henri Cartier-Bresson

Colette. Photo by Henri Cartier-Bresson

Alexey Brodovitch. Photo by Henri Cartier-Bresson

Giacometti. Photo by Henri Cartier-Bresson

352

Meeting

The subtle charm of this composition comes from several confrontations: the face-to-face rapport between a contemporary American man and an ancient Mayan sculptured head sets the dynamics with a dimension of fantasy. For the empathy of the living man seems to bring to life the man of stone. The light open space between their profiles both separates and unites them. Around this magnetic center, an outer orbit circles from "Vivaldi" to lamp shade, and from upholstered chair to table, with a familiarity and warmth that lend credence to the reality of the meeting. *Photograph copyright 1972 by Margaret Cogswell*

Dynamics of Composition

Barbara Morgan

Today's life style around the world is attuned to motion and intercommunication—traffic, air flight, space exploration, as well as the complex flow of daily life for all of us. The photographer's awareness of dynamic movement and his ability to express it visually have come a long way from photography's head-clamp beginnings.

The Leica 35mm revolution started developments that now supply equipment to cope with almost any picture-making challenge. With such adequate equipment, the inspiring challenge now, as I see it, is for the photographer to develop greater ability in composition, to further express creative vision. This means the marriage of new technology and esthetics.

The machine age, urban life, and ecologically-threatened nature offer visual subject matter that urgently needs dynamic perception from the photographer. Such photographic interpretation requires a mastery of technical controls, linked with full esthetic structuring.

The photographer's visual intake from the world around him, and the way he transforms it with his mind's eye and camera lens into picture form, require a mastery of coordination. By *dynamics of composition* I do not mean merely virtuoso physical action, for that is only the most obvious factor. I am concerned here with the basic organization of any subject matter, moving or still, into coherent pictorial structure that delivers vital meaning and esthetic satisfaction. This can require the subtlest control of reciprocal internal organization.

In projecting clear human relationships, simple or complex, a sensitive counterplay of line and mass and ranges of light and dark might well suffice to "record the scene." But to symbolize meaning and feeling requires further interaction of human experience with esthetic vision and technical know-how, to produce the shot that will come through development and printing as a fully creative interpretation.

Working elements and principles

"Composition" is actually *co-position*; the placement of component parts in their dominant and sub-dominant roles. For a two-dimensional picture is something like a chess board, where each element has a role which influences every other element, but in which dominant action is a centering force.

The heart of a composition stems from *opposition* and *rhythmic vitality,* which can be variously ordered through *proportion, subordination, transition, symmetry* and *asymmetry,* all interpreted through lighting, natural and artificial.

OPPOSITION is often thought of as violence, but it could be lovers embracing—the unification of separates in harmonious opposition. The basic vitality of a composition comes from union of opposites—negative and positive—as does electricity! Differences of form and meaning enrich and stimulate—active-passive, male-female, dark-light, large-small, mass-space, Yin-Yang, serious-whimsical—the list of complementary pairs is endless.

While the unification of opposites is the crux of composition, RHYTHM is its life-giving connective force. Rhythm functions not only as linear rhythm, the most obvious manifestation, but in countless energy forms and serial progressions—mountains grouped in sculptural masses, flowing crowds of people. It can also be the rhythmical counterplay of geometric cubes or skyscrapers.

PROPORTION is the principle that controls the priorities of size and placement in structural dynamics. Relationships of large-to-small, dark-to-light, active-to-static and the like are a matter of proportioning forms and forces in the composition.

The principle of TRANSITION is the mediator and integrator that can link, contrast and harmonize picture elements.

SYMMETRY and ASYMMETRY play a crucial balancing role in composition. Often a predominantly rhythmical composition needs asymmetry to provide empty receiving space ("negative space") for a trajectory thrust.

In satellite-space photography, the contrast of the moving machine against the vast void into which it flies is an example of the asymmetry principle, using the trajectory and negative space in composition. Basically, it is the catalytic play of differences. Another example might oppose static mass against dispersed detail or against empty space. Opposition may thus involve forces visible within areas, or invisible forces, to which we respond by implication.

Though much of our life style today involves action and asymmetry, there are "moments of peace" which thrive on symmetry—such as a serene portrait.

Lighting is supremely important in composition, as well as in the technical creation of the photo-

graph; for the intensity and character of the light and the lighting affect the interaction of every working principle of the composition.

Even more obviously, lighting also affects and determines the structuring quality of such visual picture elements as line, mass, tone (light to dark, as variously illuminated), and color, if color is used. All photographs result from the interrelating of some or most of these elements, together with the moods and meanings they express.

Therefore the building of a two-dimensional photograph results from the structuring of *line, mass, texture* and *tone,* in black-and-white or in color, in relationships created by *opposition, rhythm, proportion, subordination, transition* and *symmetry* or *asymmetry*—all instigated and controlled by lighting.

So, regardless of theme, whether it is a technical photograph recording a space-flight rendezvous or a family snapshot of a kid hopping over a puddle, the photographer in either situation must deal with the composition of a gravity-defying mass moving into negative space. But obviously, because of the incredible variety of meanings and different emotional implications, the empathy that the photographer brings to the creative coordination of these elements has a great range of expressive differences. It is that personal sensitivity by which the photographer really "makes" the picture when he "takes" the picture.

Creative vision in photography

This brings us to the personal vision of the photographer who has mastered the technical skills and understands the working elements and principles of composition.

Two photographers shooting the same subject may be poles apart in interpretation.

Depending upon editorial slant, journalist photographers can give prestige to a public figure, or can minimize him by shooting him scratching his nose.

Shooting a ski-leap, one photographer might show a heroic, closeup leap, while the other might reduce the distant skier to a remote accent in a wide-angle snowy landscape. Another photographer might turn the leap into a clowning act by shooting before or after its climax.

To emphasize a figure's linear thrust, another composition might be backlit to show it in silhouette, while still another might emphasize tone and texture by diffuse front and side lighting. One cameraman might use fast film and a high shutter speed to "freeze" action, while another would use a slow shutter for blur.

The potentials for interpretation multiply in richness as the performance gamuts of cameras, lenses and films become endlessly varied, and as multimedia and other new exhibiting styles proliferate.

Expression through lighting

In addition to cameras and film, the great expressive control is lighting. One can interpret a form in a wide range, from sensuous and tactile to harsh and ominous. Through its centered stillness, a motionless form can convey a sense of quiet expansion into open space—much as Haiku poetry conveys implied meaning. Such poetic interpretation is far more difficult than taking straight photographs of gutsy athletes.

Observing the light

When you expect to photograph in a certain area, you can study angles of light throughout the day to find an optimum time when the light is not merely "available," but also *expressive,* to aid the compositional structure and bring out meaning. At a certain hour, sunlight may give oblique, supporting shadows, or place a luminous emphasis at the center of interest—the possiblities vary infinitely.

If natural light proves inadequate, one can plan for added artificial light and its placement: back, front or side lighting, or light from any combination of directions.

This preliminary survey of the lighting of a scene is not only for the technical control of lighting, but, more important, for the fuller absorption of the subject and your own attunement to it. The deeper you enter into the mood of your chosen subject matter, the more you discover refinements in camera vision and in the realization of your composition.

Two trees
Reaching, stretching, thrusting companions, these two create great visual depth and fill the volume of space with the energy of their growth and the force of their personalities. The radiating branches and the visual weight of the tree at the left start a wheeling movement, as if we were turning round and round while craning our necks to look upward. Photograph copyright 1960 by Barbara Morgan

Three buddies, Camp Treetops
"Three buddies" is an example of design supporting
the emotion of the photograph in its two motifs;
tentmate loyalty and whimsical monkey business.
 The embracing obliques of the tent, with the
vertical post, echo the arm-to-arm linkage of the
solidly standing boys and the playful mood that flows
from face to face. Photograph copyright 1948 by
Barbara Morgan

Boy and hamster, Camp Treetops
*Tenderness and touch in the boy's loving down-
gaze and the soft, furry closeness of the hamster's
body convey the essence of this photograph. The
rhythmical trajectory of the oval cheeks sings down,
then arches up over the hamster's back and the boy's
arching fingers, then completes the cycle in the
beadlike eye, in centered balance with the boy's
nose and eye. Photograph copyright 1948
by Barbara Morgan*

Willard Morgan descending into Canyon de Chelly
*This photograph was taken in 1928 with a Model A
Leica when we were exploring the flexibility of the
then-revolutionary Leica camera.*

*Going down into Canyon de Chelly, the geologi-
cal formation of the red sandstone walls seemed so
fluid that when I saw Willard entering the bottom
swirl, I composed him as a pivot of the rhythmical
motion of the dark-and-light stratified masses in
counterplay with the distant canyon walls.*
Photograph copyright 1928 by Barbara Morgan

Ice form, Tarrytown
*The serpentine center rhythm separates the light
and dark areas of this composition. It seems an
abstraction until the texture of ice crystals and the
leaf reflections in the contrasting dark water identify
the source of this finely-balanced visual fugue.*
Photograph copyright 1972 by William Swan

Anne
The delicate whimsy of this photograph is on two levels. The formal structure of the round table with clock and flowers conveys the factual world, while the little girl's eyes imply her world of imagination. The vertical-oblique lines of the floor unite the two themes structurally. Photograph copyright 1952 by David Vestal

Out to pasture, Camp Treetops
In the open pasture space, late evening shadows projecting from the fence, boys and horses become things in themselves, inspiring the boy to be a "galloping horse." The random mosaic of white stones, spotted ponies, white shirt and pants add another pattern of play which is anchored and accented by the distant white roof structure. Photograph copyright 1948 by Barbara Morgan

Lael
This composition uses three areas of tone; the darkness of the cape, the middle tone of the foliage, and the bright flowing hair in variations of linear sheen, together with the profile.

The foliage provides passive texture, while the cape functions as a dark support to the dynamic stream of hair which partly conceals and partly reveals the face with a subtle portrayal of personality.
Photograph copyright 1971 by Jennifer Morgan

Night garbage truck
A truck flows in wavelike striated lights and shadows. The radiant ball of light on the front bumper accents the compositional thrust of the truck. At the same time, it enters and connects the dark oblique mass, giving contrast to the otherwise total rhythmical flow. (One-second exposure while panning.)
Photograph copyright 1963 by David Vestal

Prelude to shooting

Study gesture while anticipating composition.

To sensitize yourself to the many facets of personality, always be watching. Watch not only overt action, but reflexes, passivity, and the repressed or hidden moods of all kinds of people in all kinds of situations. Try to learn what this body language, which photography constantly reinterprets, actually means. I find the human face and hands perhaps the most revealing: is the face open, warm, with eyes scanning easily; or tense, with the eyes fixed rigidly? Are the hands open, generous, caressing, or clenched, angry, dictatorial? Breathing rhythm indicates emotional rise and fall. The way people stand or walk shows the balance between action and inaction, and whether the person is "turned on" or "turned off." Watch the unpredictables—bursts of laughter, head-scratching, twitches. If you observe attentively, you can sense rapport differences with family, with friends, with lovers, colleagues, crowds, enemies, strangers, animals, machines, nature—with the whole environment.

Wherever I am, I watch, directly and also out of the corner of my eye, the rhythm, phasing and reflexes of people, places, machines, animals, fungus, insects, traffic, waves in water—everything, living or dead. I try to anticipate climactic action by watching cycles of preparation, expression and recovery. It might be a basketball player readying himself for the leap and toss of the ball, it might be the exchange of giggles between kids preparing a trick, it might be a bulldozer ready to scoop up a boulder, or a mother kissing her child goodnight. I absorb the flow of feeling and of visual structure so I can anticipate the crucial shooting instant intuitively, without thinking,

Urbanizing the suburbs
Our changing landscape is symbolized by weeds and distant trees giving up to telephone booth, air pump, tow truck and buildings, with "today's man" walking along with it. The horizontal highway and the vertical white post are supportive polarities for this counterplay. Photograph copyright 1971 by Barbara Morgan

Twig with bud
Circling light forms create an atmosphere of luminous flow and pulsation. The spring bud, horizontally emerging with its radiant sphere of light, brings climactic contrast. Photograph copyright 1968 by Helen Buttfield

while simultaneously coordinating the forms and forces into an interrelated whole. That is the goal of composition—with infinite variations. Watching the dispersed actions of a protest crowd, then seeing an introverted, meditative person, I imagine what framing will best convey these contrasted moods. Will a wide-angle lens work for the crowd? A 90mm lens for the contemplative person?

Developing a sense of action

Learn how to anticipate action, and also how to improvise within action as you walk in city streets—in a stream of moving people, faces coming, backs going. Pick a time of day, perhaps, when the sun-angle lights up faces and gives sculptural mass to bodies, skyscraper facades and traffic. You can stand near a doorway to read your light meter and determine the lens-and-shutter settings for optimum speed and depth of field.

Watch the overall rhythms of the come-and-go currents. Watch for accents or centering eruptions, like a cop lifting his nightstick, or a couple suddenly recognizing and hugging each other. Watch for dark-against-light form relationships that can unify and balance the moving army of people against, perhaps, a secondary stream of automobile traffic in the background.

In such a homogenized moving mass, the sensitivity of the photographer is expressed in the degree of accent within the flow.

Of course, this depends upon your purpose. Is your interpretation to be a straight documentary record, a protest demonstrating overpopulation, a portrayal of how a city planning project works or fails to work, or is it to be a personal, poetic reaction to what you see and feel?

Rapport with subjects

What will make it ring? For the interpretation of personality, empathy and mutual trust, which relaxes the subjects so they can be themselves, is all-important.

I find that if I breathe in the same rhythm as my subject, unconsciously, we build empathy and work harmoniously. There are so many facets to our personalities that we are often shocked when we see a contact proof sheet of portraits: "Is that me?" "No, that's me!" Absorbing the polarities of personality, as well as more obvious traits, before photographing,

brings greater depth to portraiture and aids more sensitive response to revealing gesture.

Today, kinesics and "body language" are fashionable in psychology and anthropology; but animals and so-called primitive people, since time immemorial, have had instant comprehension of gesture as a revelation of attraction and repulsion in personal contacts. Since photography, as a universal language, is increasingly used, this interpretation of feeling and attitude is now being studied intensively, notably through books by Edward Hall, Ray L. Birdwhistell, and Edmond Carpenter. Anthropologists are showing us how certain gestures and reactions take on different meanings from culture to culture.

World-traveling camera-users need to understand these semantic differences of gesture, for tourists often misinterpret motions and sign language in unfamiliar communities, and this can have unhappy consequences. Often no words are needed for good rapport with the subjects in such situations, just the exchange of confidence in a warm and knowing smile.

When I photographed children at Camp Treetops for my book, *Summer's Children,* I would not begin shooting or even carry a camera until I had circulated around as a "familiar object," as accepted as a goat or a rabbit would be, causing no apprehension or even curiosity.

The inconspicuousness of the Leica is one of its great assets, and the ease and flexibility of its use help the subjects and the photographer to interact spontaneously.

The sensuous beauty of the print

When the creative photographer has mastered composition, a further fulfillment lies in the fine craftsmanship of the final print itself.

The general public, absorbing photography chiefly through TV and newsprint, rarely experiences the sensuous beauty possible in a superbly printed photograph. Even if the pictures in these mass media are well composed, they still do not bring to the viewer the full potential of rich tonal relationships that the photographer can give to his own darkroom creations. A thoroughly fine print extends the photographer's eloquence and his integrity, carrying his expression to a new level of intensity and depth.

Fortunately, the new swing of collectors' interest and the awakening of the museums to the photograph as a 20th-century art medium have started a new appreciation of excellence in photographic printing. When a print is processed archivally, the toning not only increases its longevity, but also enriches and humanizes the entire picture, so that there is a sensuous, tactile, dynamic quality—tone to tone and form to form—in the completed composition. It can become "something to live with"—and to enjoy.

Contemporary
Leica
Photography

1

2

3

4

6

8

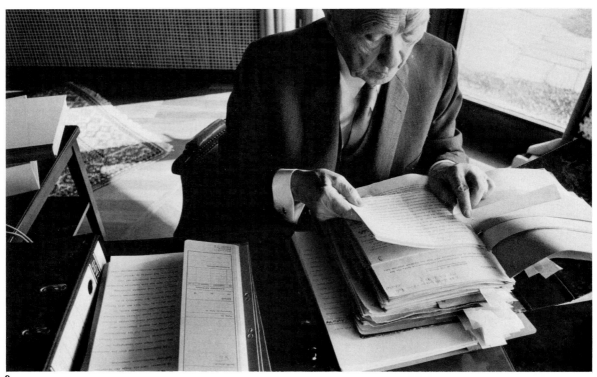

9

11

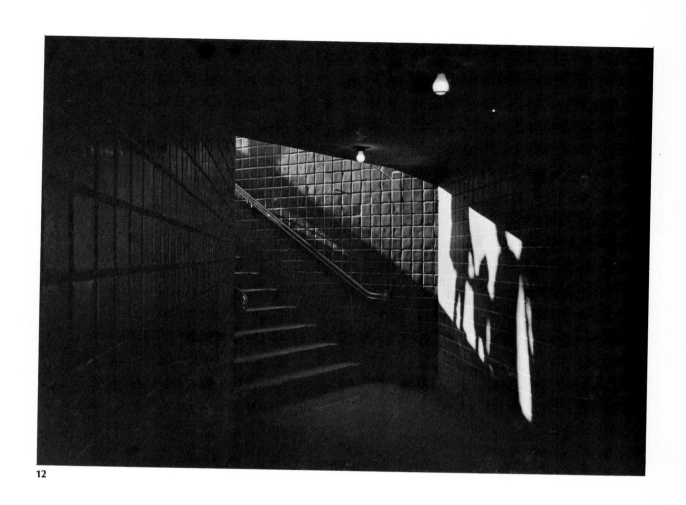

12

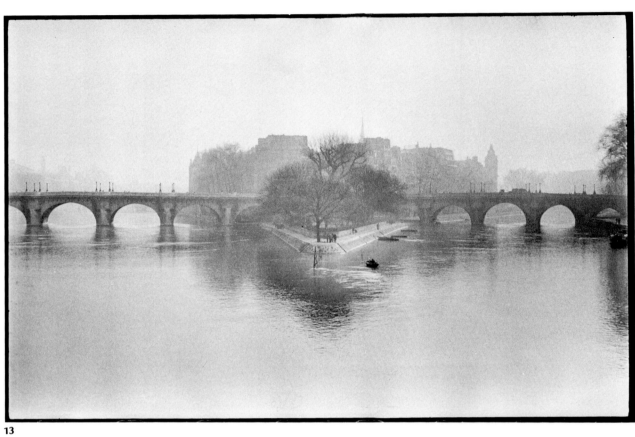

13

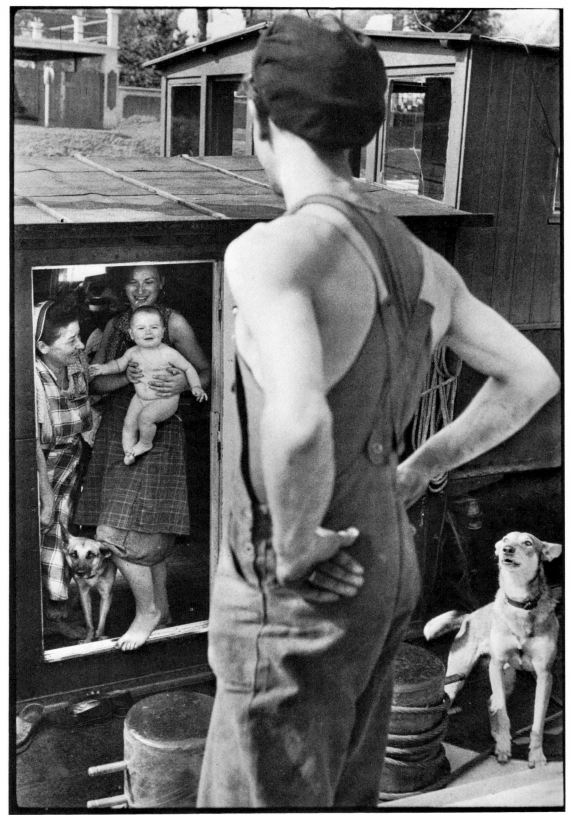

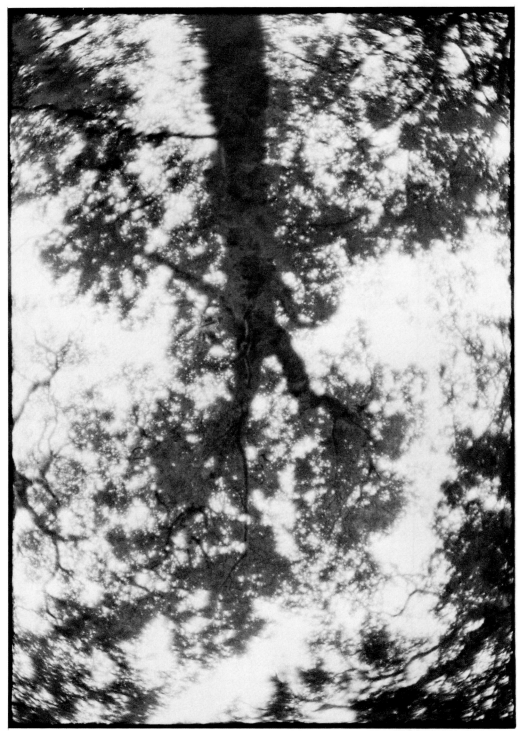

15

16

17

18

19

20

21

22

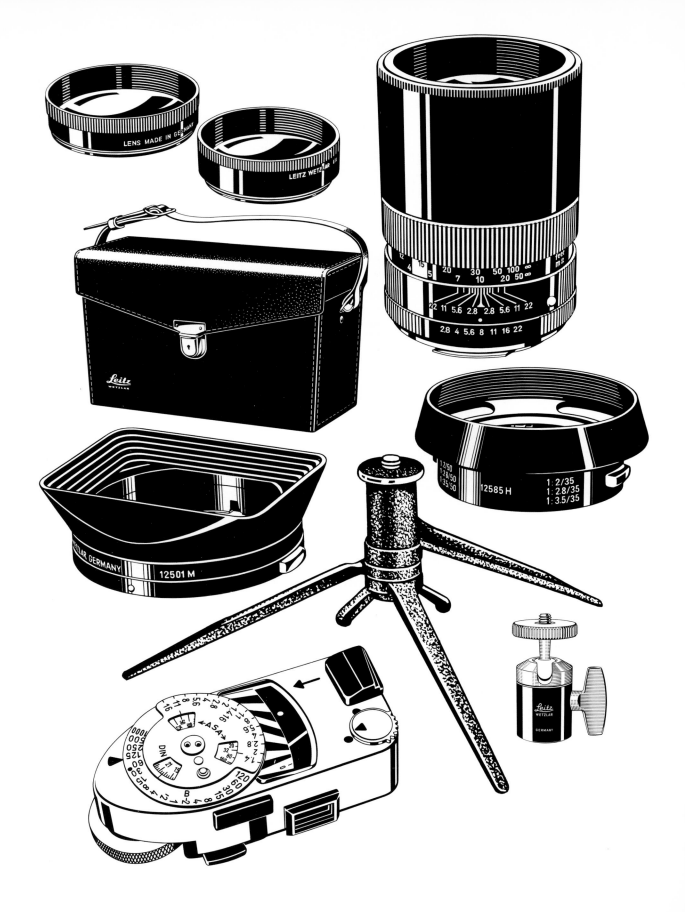

Adding to Your Outfit

Arthur Goldsmith

If there is any guide to acquiring picture-taking accessories, it is simply this: buy only what you really need, as the need arises. The logic behind this notion is obvious, but often disregarded. Rather than thoroughly mastering the essential photographic equipment, there is a temptation to accumulate gadgets for their own sake. That can be expensive, unhelpful, and counter-productive, distracting the photographer from his real concern—the creation of images.

The basic tools required for photography are not many. With the acquisition of relatively few accessories, you can extend the range of your own photography to all but the most specialized and sophisticated areas.

I am assuming that you have a Leica or Leicaflex body and a normal-focal-length lens, both in good working order. With that and some film, you are ready for photography. Before complicating a beautifully simple situation, let us examine every accessory from the hard-boiled viewpoint of, "What will it do for me?"

An adjustable-length neckstrap is the first item I would mention. You need it not only for carrying your camera, but also to help you brace it and hold it steady. A strap should be adjusted to fit the person using it: neither too long (or it will not permit you to exert sufficient tension on it with your hands when the camera is held in shooting position), nor too short (or you will feel cramped and awkward when you raise the camera to eye level). With a properly adjusted strap, you should be able to grasp the camera inside the strap and, by exerting a slight outward pressure with your wrists, pull the strap taut, "gluing" the camera more firmly to your face for steadier shooting.

A rubber shoulder pad to prevent the strap from slipping is desirable — most of the time you probably will prefer to carry your camera from the shoulder, rather than hung around the neck where it can bounce against your chest with every step. When wearing a coat or jacket, a useful variation is to sling the camera over your shoulder before putting on the jacket. The camera will then be concealed and protected by your arm. If the strap length is properly adjusted, you will be able to swing the camera up to your eye for shooting with just as satisfactory bracing as when the strap is around your neck, and then quickly drop it back again out of sight. I have found this "gunslinger" method particularly useful in candid photography.

Another simple but important accessory is a lens hood, which should be used for *all* your photography. A hood helps reduce flare: bright patches in the picture area caused by light reflections from inside the lens. It is especially valuable when shooting toward the light, as in backlighted scenes, or when photographing by available light in an interior with a number of visible light sources (unless, of course, you *want* flare for a visual effect). A hood also helps to improve both contrast and color saturation by cutting out stray light which otherwise might enter the lens, bounce off the various lens elements, and adversely affect image quality. Lens hoods are available in metal, or in "soft" models made from rubber, which fold back over the lens mount for convenience when not in use. In selecting a hood, be sure it is properly designed for the lens you are using. A hood that is too small in diameter or too long will cause vignetting—the cutting off of light from the corners of the picture.

If your camera is not equipped with a built-in exposure meter or an accessory clip-on type, a separate, off-camera meter should be high on your list of priorities. It is impossible to work precisely, and difficult to handle unfamiliar lighting situations, without one. There are many makes of photographic exposure meters on the market. The chapter,"Light Meters and Metering," by James Forney, thoroughly discusses meter characteristics, operation and use.

If you start out as a one-lens photographer, you will rather quickly want to extend your array of optics into both the telephoto and wide-angle ranges. Lenses, in my opinion, are true foundation-level additions to your scope as a photographer. They are not merely refinements, conveniences, or gimmicks; they profoundly alter the vision you apply as a photographer. The details of their optical specifications, and insights into the quality of vision they provide are given in other chapters. Here I will simply state the obvious: most photographers, after having lived with a normal-focal-length lens for a time, feel a strong urge to acquire something in the wide-angle (21mm to 35mm) range, and the medium telephoto (90mm to 135mm) range. Telephotos of 200mm to 800mm focal length are essential for specialized applications in sports, nature and astronomical photography. I urge you to explore the

remarkably different universes of seeing which lenses of different focal lengths can open up to you, but with the reminder that most of the generally recognized great photographs of all times, including our own, were made with a lens of normal focal length.

If you wish to delve into the world of extreme closeup photography, you will need special accessories. Essentially, you need a device to extend the minimum focusing distance of your lens. This may be an extension ring or tube, a bellows attachment, or a special closeup lens which alters the optical characteristics of your normal lens. All these accessories and their uses are discussed in detail in the chapters, "Closeup Photography" and "Photomacrography and Photomicography."

I haven't mentioned an individual camera case, of the so-called "eveready" kind, among the list of rock-bottom basic accessories, because it is of questionable value. Although it provides some protection to the camera, it also is a nuisance whenever you need to change film in a hurry. For that reason, many working photographers prefer to do without one. More important is a lens cap to cover the lens when the camera is not in use. That, and a carrying case, or "gadget bag," discussed later, should provide your equipment with adequate protection.

Two simple, inexpensive accessories can greatly extend the range of your photography by making it practical to take time exposures at night or under restricted light conditions. These are a tripod and a cable release. While a full-size, sturdy tripod is essential for studio use, on location you will probably be willing to sacrifice something in the way of size and weight for greater portability. A lightweight, collapsible tripod which fits into (or lashes onto) a gadget bag has many uses in the field. Obtain a well-constructed model with a head that allows you to tilt and swing the camera. Highly convenient, although not absolutely necessary, is a crank-operated elevating post which allows you to raise or lower the camera without adjusting the legs of the tripod. The cable release, of course, screws into the shutter-release button, and enables you to make "Time" or "Bulb" exposures without directly touching the camera and causing movement. If extremely careful, one can make vibration-free long exposures without a cable release, but that is doing things the unnecessarily hard way.

Filters are another kind of accessory which can have a direct effect on the quality and scope of your photography in color and black-and-white. In essence, a filter is an optical device which absorbs light from a certain portion of the spectrum and transmits the rest. Leitz filters of the most useful types are supplied in the durable and convenient form of dyed optical glass. They either screw directly into the threaded lens barrel, or are held in place by a retaining ring or a screw-in lens hood. In buying a filter, it is best to have your camera with you and to test things out to be sure the filter fits properly, the retaining ring is exactly right for the lens, and so on.

For color photography, the most universally useful type is a Skylight or a UVa correction filter. These reduce the amount of ultraviolet light commonly found in outdoor scenes with open skylight. Without some reduction, the ultraviolet radiation results in a bluish cast in color transparencies. The effect is subtle, but especially noticeable in skin tones in portraits taken in open shade. Although they are similar in purpose, the effects of the Skylight and UVa are not identical; the Skylight is slightly more pinkish in tone and is primarily intended for use with Eastman Kodak color materials. Follow the advice of the film manufacturer as to which type to use. No exposure increase is required for these filters, and because they result in a minimal color change, many photographers leave them on the lens for all outdoor shooting, color or black-and-white, as added protection for the lens.

Conversion filters are designed to alter the color quality of the light reaching the film so that you can use a color film with a light source for which it is not matched. That is, you can use a tungsten-type emulsion with daylight film, or a daylight emulsion with artificial light. Generally speaking, you'll do better if you can arrange things so that you don't need to use a conversion filter. Try to complete the roll of daylight color film in your camera before switching over to artificial-light photography, or vice versa. However, sometimes you may have no choice in the matter, and that is when a conversion filter becomes a necessary accessory. You can convert a tungsten or Type A emulsion to daylight use without severe loss of film speed, but the reverse is not true. For example, High Speed Ektachrome Type B film, used in daylight with the recommended 85B conversion fil-

ter, results in a tolerable drop in film speed from 125 to 80. But Kodachrome-X, a daylight type, drops from 64 to 20 when converted for photoflood shooting with an 80B conversion filter. Obviously, if you expect to do mixed shooting in daylight and artificial light, settle on a particular tungsten or Type A emulsion and add the appropriate conversion filter to your set of necessary accessories. The daylight-to-tungsten conversion is a last-ditch measure only.

A polarizing filter is another addition worth considering. One of its effects is to progressively darken blue sky for color photography as its setting is rotated through an arc of 180 degrees. Also, it reduces reflections from the surfaces of glass and water (but not metal).

As for filters for black-and-white photography, only a few are widely useful, and the most important of these is a medium Yellow-1 filter. This filter absorbs some blue light and helps to darken clear blue sky, making white clouds stand out more boldly. However, often a slight degree of underexposure can achieve a similar effect. I suggest that you experiment with a yellow filter for landscape and other outdoor work, and that you try using it without making any exposure adjustment for the "filter factor." With medium and light-colored filters, exposure compensation often virtually cancels the effect of the filter.

Neutral density filters are tinted gray in varying degrees of intensity. They cut off part of the light reaching the film without affecting the colors of the subject. Used with either color or black-and-white film, they can serve a number of helpful purposes. For instance, if you want to use a wide aperture to blur the background, or a slow shutter speed for motion blur, the high exposure indexes of many contemporary films used in broad daylight will require some reduction of the light intensity in order to achieve these effects. A 2x neutral density filter reduces exposure by the equivalent of one full f-stop; a 4x filter reduces it by the equivalent of two stops. Those two strengths should cover most situations you are likely to encounter.

For a further extension of the versatility of your photography, you should add a flash unit to your outfit. If you intend to do much flash photography, by all means acquire an electronic-flash unit. There are many different models, all becoming increasingly miniaturized and portable. For an absolute minimum

investment, and quite suitable for the available-light photographer who only rarely turns to supplementary illumination, there are many battery-capacitor (B-C) units which use flashbulbs. Obtain a unit which has a tilting reflector and head for convenience in making bounce-light pictures, and one with an extension cord long enough to hold it at arm's-length for better modeling and more interesting lighting when you do not want a stark flash-on-camera effect. Reliable B-C flash units are available in extremely compact, and quite inexpensive models which can easily fit into a pocket of your gadget bag. Small, high-intensity flashbulbs are readily available. Blue-tinted bulbs are universally useful. A "Flash" filter is required for the camera lens to use clear flashbulbs with Type A color film.

There is practically no end to the accessories you might add to your outfit as you progress in skill or move into areas of specialization, but what we have covered so far should take you a long way indeed. You will also need some kind of handy container in which to carry your camera and accessories. A good carrying case, or gadget bag—one which accommodates your personal choice of hardware—is of considerable importance for convenience and for protection. Fortunately, the choice is wide, and so is the price range. Leitz supplies various carrying cases with insert-dividers specifically designed to accommodate M Leicas or Leicaflexes and a wide variety of accessory equipment.

Among the non-photographic items you should include in an accessory kit are the following: a small screwdriver and a pair of pliers for various emergency on-the-spot repairs; a miniature flashlight with fresh batteries as an aid to setting exposure controls after dark (it can also illuminate the subject for focusing); a pocket-size package of tissues for cleaning lenses and equipment; and a small notebook and ballpoint pen for jotting down exposure data, locations, caption notes, interesting phone numbers, and other information.

All this brings us back to the beginning and the basic idea that each picture-taking accessory you add to your outfit ought to be truly functional. Unless you are involved in the status-seeking game of "see how much I own," you should ask the following question before you acquire a single additional accessory: "How will this help me take better pictures?"

Naples. Photograph by Dena

Travel Photography

Russ Kinne

Travel! The very word excites us, quickens the pulse and brings us more alive. It flashes mental images of exotic, exciting places. And pictures—pictures with impact; well-composed, beautiful. The kind you would be proud to bring back from your travels, but perhaps seldom do. Why not?

One reason may be that you let photography become a chore, even though you are armed with a modern Leica or Leicaflex SL with automation built into the camera. Photography may seem like a chore if you tackle a shot you are not equipped for, or if you are not confident that your results will be good. But those problems are easily overcome. A few well-selected accessories can make photography much simpler, and a little camera-handling practice before you leave for a trip is good success insurance. Travel photography *can* be easy, enjoyable, rewarding, and need take only a little of your time.

Pre-planning is the key to success. The basic rule for away-from-home shooting is: test everything before you leave — *especially* a brand-new, unfamiliar camera. Buy it a week or two before your trip starts, *shoot a test roll with it,* and have the film processed, to make sure that you can produce pictures with it. Then, and only then, consider taking it with you on your trip. Follow the same procedure with new lenses, accessories, a light meter, even a new tripod. Be sure you can use the item correctly, efficiently, and easily before taking it with you. Nothing spoils the pleasure of visiting new places and seeing new sights more than having your attention diverted by an unfamiliar mechanical or operational procedure, especially when a little practice could have prevented the problem.

Your choice of equipment is crucial for enjoyable, trouble-free picture-taking. Leica equipment is engineered for easy handling, smooth, precise operation, and durability. And this is important: a camera that is small enough to be carried easily will be at hand when you want it. If it is easy to operate, a joy to use and a source of pride to own, you will use it more and more.

As a Leica owner, you enjoy all the optical and mechanical advantages of 35mm photography. More and better lenses are available for your camera than for any other format. More different film emulsions are supplied in 35mm than in any other roll-film size, and with 36-exposure magazines you reload less often and your film supply fits into minimum space. Almost everywhere in the world that the word "camera" is known, you can find 35mm film. Finally, 35mm is the least expensive practical film size available.

When planning your trip, first consider additional lenses. It's a good idea to take a range of focal-lengths: normal, wide-angle, and telephoto or long-focus. Chances are they will all be needed during your trip, and they are small enough and light-weight enough to be easy to take along. For variety in your travel shots, a second lens, at least, can be classed as a must.

If your primary interest is in sweeping scenery, groups of people, interiors, or if you expect to do a lot of shooting in tight quarters, this second lens should be one of the Leitz wide-angles.

Among wide-angle lenses, those of 35mm focal length are usually one to two stops faster than the more extreme 28mm lenses. Ultra-wide 21mm lenses are still slower, and more expensive. If you think you will eventually want a 21mm lens, get a 35mm one now. If you have room for only one wide-angle lens in your arsenal, it's probably wisest to get a 28mm if most of your shooting will be in good light. Otherwise, choose the faster, slightly-less-wide-angle 35mm lens.

A long-focus or telephoto lens is very useful for portraiture or photographing people at a distance, with or without their awareness. It is also used for wildlife and nature subjects, for photographing skiiers, mountaineers, and other sports figures, and for producing striking "big sun" sunset shots. How long a lens is best for you? A 90mm or a 135mm lens is good for portraits, but too short for some other uses. The 180mm, 200mm and 280mm lenses are excellent for sports, candid portraits of shy people, and many wild bird and animal shots. If great distances will be involved, you may well want a Leitz lens of 400mm, 560mm or even one of the new 800mm lenses. Here you must carefully weigh the photographic situations you may encounter against the size and weight of the equipment you wish to carry.

The shorter-focal-length lenses often feature larger maximum apertures than the long lenses, and are better for dim light, but do not produce as large an image as the longer ones. On the other hand, they are easier to use. The longer the focal length, the larger the image, but the harder it is to hold the

Above: Majorca. Photograph by Dena
Left: Ireland. Photograph copyright
1971 by Joseph Portogallo

camera steady for a sharp picture. When you use a lens of twice or four times the "normal" focal length, increase the shutter speed proportionately. In terms of sharpness, a speed of 1/60th second with a 50mm normal lens is roughly equivalent to 1/125th with a 90mm lens, and 1/250th with a 180mm or 200mm lens. A rule of thumb for hand-holding long focal-length lenses is: make a fraction of one over the focal length (e.g., 1/180, 1/400, 1/560) and use a shutter speed at least that fast. Practice squeezing off "blanks" to develop a steady aim-and-fire technique. The rifle-firing routine, "breathe-aim-sight-(focus)-squeeze," is excellent for long lenses. Always squeeze the shutter release; don't punch or push it.

In an ideal set of lenses, you would have a normal lens, two different wide-angle lenses, and two tele-photos—and you would use them all to advantage. As a professional, I often carry six lenses, ranging from extreme wide-angle to 400mm telephoto, and have sometimes used them all in a single location within an hour's time. Most travelers don't get into things quite so deeply, but nothing can take the place of a second or third lens, and any serious photographer must eventually think along these lines.

A zoom lens, such as the 45-90mm Angenieux-R f/2.8 for the Leicaflex SL, is very tempting. It is convenient to use, but bulkier and heavier than most fixed-focal-length lenses in this range. Whether or not its convenience offsets these disadvantages for you is a question only you can answer.

A very useful accessory, especially for long-lens or slow-shutter-speed shots, is a tripod. You won't

want to carry something big and heavy, but the Leitz Tabletop Tripod with ball-and-socket head is ideal. It packs small and weighs little. The ball-and-socket head provides a pistol-like handle when screwed into the camera body. With the legs attached, it can be braced against your chest, against a wall, on a car top, on a table—anywhere—to give you the firm support that is essential for really sharp pictures under difficult conditions.

A lightweight full-length tripod which telescopes to about 12 inches is also helpful. With legs retracted it can be used like tabletop tripods. With legs extended it provides eye-level camera support. In crowded situations, the legs can be pulled together to act as a monopod.

When traveling, there's always a haunting whisper in the back of the mind that grows louder as we get farther from home. "Where can I get this camera fixed out here, if it should stop working?" As a Leica owner, the odds are in your favor, since your camera is known, sold and serviced the world over. You will have much less trouble getting service in Munich, Melbourne or Montevideo than if you were using a "Brand-X" model that is little known outside its country of origin.

If your camera is more than a year old, it's a good idea to have a factory-approved service center clean and check it before an important trip. In any case, your camera should have a good cleaning every two years to ensure trouble-free performance.

Another way to minimize repair problems is to buy another Leica or Leicaflex body, *of the same model as your first one*. Even if nothing ever breaks down, this is a very valuable piece of gear to have. With two cameras you can shoot the same subjects almost effortlessly in both black-and-white and color, or with indoor-type color film in one body and daylight-type film in the other. High-speed and regular color films, or color negative and color transparency films are other possibilities.

Next to a second lens, a second camera body is probably the most useful accessory you can have. It is helpful to keep your normal lens on one body and your telephoto or wide-angle—whichever you use most—on the other body, ready for immediate use. When both bodies are the same model, the controls and operating procedures are exactly the same; you can switch between them without hesitation. And if one camera is put out of action—through break-

down, fire, theft, being dropped or submerged—all your lenses and accessories will fit the other body. You can keep shooting until repair or replacement is possible. Professionals often carry three or four camera bodies, although that is hardly necessary for private photography.

Whether you have one camera or four, one lens or six, there is one "accessory" that you should investigate before going anywhere: an insurance policy designed to protect cameras. It is commonly called an "all-risk, world-wide floater," and if you can get one, it is foolish to travel without it. For a relatively low cost per year, your equipment is protected against virtually anything that can harm it. If you carry only a regular personal property insurance policy, usually only ten percent of the face value can be applied to cameras or jewelry. Because of the high incidence of camera loss and theft, many insurance companies are reluctant to issue separate camera insurance floaters unless they carry other policies for the same individual. It is best to deal with your regular insurance broker.

On any trip, take along all the film you'll need. Buying film as you go has several disadvantages. You must spend time finding a place to buy it. Film manufactured in your own country may be more expensive elsewhere because of import duties. You may be forced to settle for an unfamiliar film which may not be as good. And you could be sold film that has been poorly stored, or ruined by heat and humidity—something you can't know until your pictures come back from the processor looking terrible. And then it's too late to reshoot.

Before you leave, figure out roughly how much film you are likely to use. Be generous; you will almost always shoot more, not less, than you expect to. *Then take along double that amount.* If you don't use it all yourself, your companions may run short. Any unused rolls that you bring back will keep for a year or two in the refrigerator; you'll use them long before then.

Buying film before you go on a trip permits you to get a fresh stock of the exact type and loading you want. And even a month's supply doesn't take up much room in the suitcase. It's better to have plenty of fresh film on hand, than trust to luck and be sorry. Most countries frequented by tourists allow you to bring in an unlimited amount of film for personal use. But if you are going to a remote area,

*Ireland. Photograph copyright 1971
by Joseph Portogallo*

Above and left: Spain. Photographs copyright 1971 by Rick Winsor

check with that country's consulate for any customs limitations before you start.

What type of film should you take? Color slides, color prints and black-and-white prints can all be made from color negative film. The basic film—color or black-and-white, negative or reversal (slide film) —should be of moderate speed. As a rule of thumb, the slower the ASA or DIN rating, the better the technical quality of the pictures. But a few rolls of high-speed color, both daylight and indoor types, are good to have along. With your fast Leica lenses you can get pictures you couldn't possibly shoot otherwise. Folk dances on stage, native rites at dawn or sunset, indoor pictures of entertainers, churches, museums, and all sorts of dim-light situations can be photographed well and easily with the fast films and lenses.

Most manufacturers provide adequate protection in the original packaging, so carrying film in its own foil or other sealed container offers few problems before use. The most critical period in a film's life, especially in hot or damp climates, is after exposure and before processing. This period should be kept as short as possible. A week or less is ideal, but is not always possible. Carrying exposed rolls with you, waiting until you get home to process them, is *not* a good idea, unless you're on only a week's or ten-day trip. (But even carrying it with you is preferable to letting some unknown outfit process your film on location.)

Again, pre-planning helps. Before you leave, check with the film manufacturer to find out what processing facilities are available in your area of travel. You may be pleasantly surprised. For example, a traveler can have Kodak film processed *by Kodak* in Stuttgart, Germany; The Hague, Holland; Milan, Italy; Brussels, Belgium; Copenhagen, Madrid, London, Paris; and in Switzerland, Hong Kong, Japan, Singapore, Thailand, Australia, the Philippines, and India. Agfa films can be processed all over Europe, in the U.S.A., Hong Kong, India,

Paris. Photograph by Robert Doisneau

Greece. Photograph by Henri Cartier-Bresson

Japan, and many other places. These lists are by no means complete. Check before you leave home, and plan accordingly.

Another solution is to buy prepaid processing with the film and send the rolls back to a manufacturer's lab in your own country. Film manufactured in the U.S.A. can be sent in to a processing lab duty-free. Be sure the package is addressed to a processing facility, not to an individual, and mark it clearly: EXPOSED FILM FOR PROCESSING — U.S. MANUFACTURE. Put your home address as the return address and the finished pictures will be waiting for you when you return. The slight extra cost in postage is far outweighed by the convenience of this method.

In all cases, try to keep films, exposed or not, away from heat and humidity. The metal cans in which some film is packed are excellent for storage, but keep them cool and dry. Put the exposed rolls back into the cans, screw the lids on tightly, and mark them so you can tell unused from exposed rolls. They are usually better off in the hotel room than riding around in your car or camera bag, but don't put them where an overzealous maid will throw them out!

Before any trip outside the country, register your cameras, lenses and meter with U.S. Customs. If you have a ten-year-old camera this is not necessary, but any fairly new piece of gear may be eyed suspiciously by Customs men on return. If you claim you bought it here before you left, you may need proof. Take your camera and accessories to a Customs agent before you leave and get a registration form, good for three years, which will prove that you had the items in your possession before leaving the U.S.A. It's easy to do. Most international departure points have a Customs agent on duty twenty-four hours a day, and an extra fifteen minutes before leaving will allow for this step. If possible, get an extra copy of the validated registration form. Should you wish to send a camera home before your return, or if someone else brings it back for you, this copy will slide it through Customs without difficulty.

As for Customs abroad, honest tourists seldom have trouble crossing borders. Border guards realize that most people traveling for pleasure will spend money in each country they visit. Officials try not to delay tourists or interfere with their trips in any way. Just don't try to get away with anything illegal.

Customs men can smell a rat with incredible accuracy, so trying to smuggle some item across a border may cost you a day's delay, the inconvenience of having all your baggage unpacked and searched, and the expense of a fine.

There may be restrictions on what you are allowed to photograph. Such restrictions are few and usually apply only to military installations, works in museums, or the interiors of some holy places. Otherwise the world is open to your lens. Even in Eastern Europe and Russia you will be allowed to take pictures of almost everything you want. And you will be carefully and definitely told what things you *cannot* photograph. Anyone may be tempted to say to himself, "I'll bet I could do it, and no one would ever know," but if you are caught it could mean a delay of up to several *months* of personal confinement, great expense, and considerable inconvenience and embarrassment. All the film you have with you may be taken away and processed in whatever developer is at hand to determine what else you may have photographed illegally. After such treatment, you probably wouldn't want the film back even if it were returned. So when you are told, "NO," pay attention!

"Sneaking" pictures of people, places and things where photography *is* permitted, in order to get an unstilted, natural-looking picture, is quite another matter. In many parts of the world it is the only way to get any reasonable record of normal appearance or behavior. Long-focus or telephoto lenses, from 135mm to 200mm, can be used (with care) hand-held and will reach out to get closeups of people yards away.

One simple, effective method is to use a long cable-release on the shutter release of your camera. The camera hangs around your neck and the cable leads to your pocket or purse. With a little practice you can aim the camera fairly accurately this way: swing your body right or left for tracking, push your stomach out to tilt the camera up, or suck it in to tilt the camera down. If it won't come in far enough, bend over a little and pretend to be looking at something on the ground in front of you. Prefocus at a medium distance, and use a wide-angle (or at most a normal) lens to give you more margin for error. Practice in front of a mirror until you get the hang of it.

As a touring picture-taker, you may sometimes be

New Zealand. Photograph by Helen Buttfield

hounded by natives bent on separating you from as much money as possible. Everyone to his own course of action, but I never pay models unless I ask them to stop or start work, move, or otherwise cooperate in some way. Then it's worth being generous, and it will be very much appreciated.

It is very important to be sensitive to people who simply do not want their pictures taken. Overcoming a subject's shyness is one thing, but ignoring a taboo against making human images (as in Islamic countries) or exploiting someone against his will is quite another. Remember that you are a guest in any place outside your home, and your conduct affects how you and all who come after you will be received. A common fault among all travelers, photographers or not, is that they fail to read about the places they will visit to learn something of local customs and beliefs. Preliminary research will help you understand a great deal more about what you see and do, and is likely to alert you to picture opportunities that you would otherwise miss.

Whenever a traveler expects to encounter extremes of climate, he prepares special clothing, footgear, and so on. Photographic gear needs preparation, too. In the past, traveling in cold climates required that all oils and grease be removed from the camera and replaced with special low-temperature lubricants for "winterizing." Before a winterized camera could be used again at normal temperatures, the standard lubricants had to be put back in. Winterizing is still available for your Leica, but is not needed except for extremely cold conditions. Regular lubrication keeps your camera usable down to zero degrees Fahrenheit (-17.7°C) without special treatment.

Nevertheless, don't let your Leica get too cold if you can help it. Shutters can slow down unpredictably in extreme cold. Keep the camera inside your coat except when actually shooting. If it gets

*Spain. Photograph copyright 1971
by Mary Ellen Mark*

cold anyway, let it warm up *slowly* when you come back inside, otherwise water vapor will condense, "sweating" like an iced drink on a hot day. Condensation occurs *inside and out* of cameras, lenses and film cassettes; it can leave them soaking wet. When you come inside from wintry weather, put your camera (in its case or wrapped in a plastic bag) on the floor, in a vestibule, or someplace where it will still be cool but can warm up gradually. If you see "dewdrops" or a cloudy film of moisture begin to form on it, move it to a cooler place *immediately*.

If precautions are taken, you should have no trouble. I have successfully shot pictures at temperatures as low as minus 63°F (-39°C) on a trip that lasted over two months. My cameras went through many cold-warm cycles and worked perfectly.

Two special cold-weather operating cautions: don't breathe on your lenses—your breath will cause condensation—and advance and rewind film slowly.

Cold film is brittle; fast movement may break it or cause static flashes which will leave exposure marks in the picture area.

Exposure meters should be treated as carefully as cameras. Batteries and electronic circuits do strange things when they get cold, and metering accuracy will suffer unless care is taken.

Wandering photographers more often find themselves in warm places than in cold ones. Fortunately, high-temperature precautions are simpler and less urgent than those for low temperatures. In high heat or humidity, the film needs your attention more than the camera does; both film and equipment should be protected from extreme heat, but the film will suffer most and soonest.

Try to keep film below 75 or 80 degrees F. (24-27°C), and avoid humid storage conditions. Exposed rolls are the most vulnerable. Seal them in film cans with tight-fitting lids, or wrap them tightly in plastic; store them in the refrigerator when possible. Sealed rolls of fresh film can be stored there too, but let them warm up for an hour

*Spain. Photograph copyright 1971
by Mary Ellen Mark*

or more before opening them; otherwise moisture may condense on the film because of the cold-to-warm change. Film stored in a freezer should be allowed to warm up overnight before being opened.

Do not leave cameras and film in the glove compartment of a car, or in a camera bag or suitcase sitting in the sun. Automobile trunks are also bad; temperatures inside often soar to 120 or 140 degrees F. (49-60°C)! The floor of the back seat, out of the sun, seems to be the coolest part of the car, especially if the windows are open a bit to let the hottest air flow out. Light-colored containers for film and equipment absorb much less heat than dark ones, and insulated food-storage bags or boxes, such as those used for picnics, provide extra protection.

You can best protect cameras and film from heat and cold by keeping them with you as much as possible. Only then can you control what happens to

them. A Leica and its lenses will take considerable heat without damage, but no equipment is completely immune. Using your own shadow to keep equipment out of extreme heat will help.

On airliners, take the bag into the cabin with you; some baggage compartments are unpressurized and unheated; at jet-plane altitudes the outside air temperatures are far below freezing. Also, the more people who handle a piece of baggage, the greater the chance that it may disappear, be broken, or be tampered with somewhere along the line.

When moving through crowded places in your travels, keep your camera bag closed and fastened. Let it hang in front of your body, rather than behind on your hip. Hang cameras under your coat for protection and partial concealment. When you stop to shoot, put your camera bag at your feet, with one leg through the carrying strap; anyone snatching the bag will have to upset you before the bag will come free. Not many travelers have unpleasant

experiences, but crowds offer temptations and a few precautions are wise.

Occasionally you may meet an unusual photographic opportunity that you hesitate to grasp for fear that your camera will be damaged by dust or water. Boat trips, hurricanes, rainstorms, water sports, rodeos, sailing races, and blizzards all fall into this category. You need not miss these chances, nor damage your equipment. With five minutes' work you can be ready to shoot any or all of these subjects in relative safety.

Under dusty or wet conditions, the indispensable plastic bag will come to your rescue. Every traveler should carry an ample supply of two sizes; they fold flat and weigh almost nothing. Use a bag big enough to cover the camera. Screw a filter onto the lens, and tape the mouth of the bag tightly to the filter ring. (Note that regular cellulose tape is not waterproof; you'll do better with vinyl "electrician's tape.") The camera controls can all be worked through the bag, perhaps a bit clumsily, and you can see through the finder, althought things may look cloudy and make it hard to focus. If viewing is too difficult, focus by estimate, and aim-and-frame through the finder; or just sight across the center of the camera top.

In less severe conditions, slip the bag mouth-downward over the camera so you can reach up from the bottom to manipulate the camera controls from inside the bag. The lens can poke through a slit in the side of the bag, with the slit edges taped to a deep lens hood for protection. The pictures you get when beating the odds like this always seem to be especially pleasing. Any water, snow or dust will be stopped by the bag and you can shoot to your heart's content with a dry camera.

No two trips are the same, nor any two climates, two countries, two locations—nor any two photographers. One man's approach and methods may be far removed from another's. These techniques have all worked for me, but you may prefer to modify them or try entirely different approaches. Go to it, by all means! There's more than one good way to do most things. Just be aware of the hazards and take steps to avoid them. When traveling, you seldom get a second chance at a picture; so when in doubt, shoot first and wonder if it's possible later.

If you tell yourself, "There must be a way," you can usually find a way. Try it and find out.

Keeping Your Leica Out of the Repair Shop

Norman Goldberg

Armed with nothing more than your senses of touch, sight, hearing and smell, you can do a fairly good job of checking out the performance of your Leica or Leicaflex. You should do it at regular intervals: before a trip, when you return, in preparing for a shooting assignment, or when purchasing a used camera.

Some camera functions require special instruments to tell if they are working properly, but thanks to the consistency of Leitz products, many functions can be checked out with only the equipment nature has given you. Leicas within the same model group all sound, feel and look the same. These "family characteristics" make the job of maintaining them a lot easier than if there were gross differences from specimen to specimen.

The key to all the non-instrument checking you can perform is *correctness*. When your Leica is in proper working order, you will find this correctness in the way it *feels, sounds, looks*—even in the way it *smells*. When things are not right, certain telltale symptoms appear. An alert owner can detect them, and avoid unexpected camera failure later.

To begin, there is a Leica *feel*. It's that silky, even, solid feeling you get when you turn the focusing ring of a Leitz lens, the absence of gear rumble when you cock the shutter, or advance or rewind the film. It's a positive, smooth "click-feel" when certain controls lock into position, and the strain-free, secure operation of the baseplate and back latches. In short, it is a firm correctness to the feel of all the moving parts.

Gears that announce themselves by rumbling, or that feel uneven, are not functioning the way Leitz intended. This is quite easy to detect. Any deviation in the smoothness of movement when you turn the focusing control of your lenses is a sign something is wrong. Controls that stick and bind as you turn them, or that are supposed to click into place (like the lens f-stop control) but don't, are practically screaming, "Fix me, I'm sick!"

Learning the Leica feel is simple—just handle a Leica that you know is in good shape; yours should feel the same. This kind of check is valid for Leica accessories, too. From the humble cable release to the most elaborate equipment, any roughness, slipping or slack is simply not right.

The Leica *sound* can also serve as a guidepost to proper functioning. The Leica shutter represents the continuing evolution of one basic design. It was so good at its inception that almost every make of camera with a focal-plane shutter has made use of its principles. Fundamentally simple, the Leica shutter is one of the most uncluttered mechanisms around. Yet the precision necessary to achieve consistently accurate exposures is very demanding; it calls for the relatively few parts to be clean, properly lubricated, and free to interact with one another as intended. When all this is so, the Leica shutter produces a sound that can only be called—you guessed it—correct.

If you bear in mind the sequence of events that takes place when the Leica shutter is tripped, learning to listen for correctness will come easily. A well-studied run through the entire speed range of a properly working Leica is all you need to tune your ear. Basically, a first curtain speeds across the film aperture, followed closely by a second curtain. Both are braked at the end of their travel, so they cannot bounce back across the border of the film aperture. Certain shutter speeds have a sound all their own, and—depending on the Leica model in question—can serve as "pitch pipes" to indicate a properly working shutter. All but the older Leicas (black-dial IIIf and earlier) have 1/15 second. This speed is excellent for checking the audible correctness of your Leica. Here is the sequence of mechanical events.

1. When the shutter release is pushed, the first curtain speeds freely, right-to-left, across the film aperture and comes to a solid, positive halt about two millimeters past the aperture border nearest the film cassette.

2. Just before the first curtain completes its travel it unlatches the second curtain, which wants to begin its run across the film aperture but is retarded from doing so by a slow-speed gear train.

3. The force of the second curtain is applied against the gear train, causing it to spin rapidly. This creates a characteristic sound.

4. When the gear train's retarding action is overcome, the second curtain is free to run across the film aperture and come to a positive stop, slightly overlapping the first curtain.

5. The gear train—pushed through its retarding cycle by the second curtain—now restores itself by means of a return spring. This brings the gears back to their original positions. When all is well, the gears are quite free to spin and the return action is vigor-

ous enough to create a second distinctive sound—a kind of "echo" effect something like a steel ball, dropped on a metal plate, bouncing to a stop.

The actions described are the same for all speeds that employ the slow-speed gear train (1/30 down to 1 second), but there are differences. When the one-second speed is used, there is also an "anchor" which increases the retarding effectiveness of the gears. This anchor is comparable to the escapement in a watch movement, but because its back-and-forth rocking action is so fast, it buzzes instead of ticking.

On older Leicas (IIIg and earlier) the gear-train anchor is automatically disengaged upon completion of the second curtain's run. This frees the gears to rebound as described above. More recent Leicas do not disengage the anchor at the end of the shutter-curtain run, and the gears return to their starting positions under the load of the anchor. This generates a buzzing sound similar to the one heard while the shutter was operating, However, the gear train is now running under the vastly reduced power of its own return spring, not the second curtain's drive spring, and the result is a slower, quieter sound. It is one of the most telling of all the shutter sounds. The gear train is vital to speeds from 1/30 down to 1 second, so learn to listen for its correctness. If you hear any stuttering or hesitation on the return cycle of the slow-speed gear train, you can expect trouble soon with those speeds.

Listening to the 1/15-second speed has the advantage of letting you hear the gears run at high speed and rebound without the retarding effect of the anchor. Any wheezing or squeaking at this speed is a sure sign that the gear train—and most likely the entire camera—needs cleaning and lubrication. The value of also listening to the one-second speed is that the anchor slows the action enough so you can quite easily hear the full run of the gears.

If you are checking a Leicaflex, its sound will differ sharply from that of a Leica. Most noticeable will be the sound of the mirror, which will obscure the distinctive gear-train rebounding just described. The Leicaflex mirror movement is among the quietest in photography. This is due to the mass of the camera and the very original design of the mirror mechan-

Sense, and senses—touch, hearing, sight, smell— are all valuable in inspecting a Leica or Leicaflex

ism. The same force that is used to overcome the inertia of the mirror and swing it up is used to stop the upward movement in a manner free from shock. Coming down, the mirror has fresh spring tension applied. The same kind of arresting motion is used, but the forces are greater and the mirror must come to rest in an exact position. The result is that it makes slightly more noise coming down than going up. Nevertheless, all the sounds are characteristically solid, squeak-free and clean.

Shutter sounds are vital indicators, but they are not the only ones you should heed in your camera. Any grinding or rasping in a control indicates trouble. Tensioning the self-timer makes a distinctive ratcheting sound, not a rasping noise. Sand or grit of any kind, grinding between two metal parts, can quickly cause serious trouble. Focusing mounts, in particular, should be free of all rough sounds. Catching a lens with the sound of dirt in its focusing threads before the dirt has a chance to grind away at the threads can save you the cost of a new mount, so listen well.

The Leica *look* is another indicator of condition. Of course the overall design is clean, straightforward and handsome, but how does the camera look *now*? Is the fine workmanship and finish marred in any way? If so, how seriously? There should be no burred screw heads, no dents, bulges, or other signs of indifferent handling. There may be wear or scratches in the leather or plastic covering on the body; there may be fine scratches in the chrome or black finish; there may be rub marks where the camera consistently hits a coat button as it hangs around your neck. Such things show normal wear, and are not warning signs. But deep gouges or bent parts mean force was applied, and that could be serious. Not only is there visible damage to that part, but the force that caused it may have affected unseen parts inside the camera mechanism.

In checking a Leica or Leicaflex, you should visually inspect very closely the condition of screw heads and the appearance of the various chrome or black mounting rings. Leitz has minimized the number of screws accessible from outside, and often em-

A Leitz lens makes a convenient magnifier to search for minute clues to damage—such as chewed-up screw heads

ploys threaded rings to fasten external parts. These rings seldom have notches or flats to assist in turning them; they require special tools which grip firmly and evenly without marring. These rings help make the Leica tamper-proof. Any unauthorized attempts to take the camera apart will almost always deface these rings somewhat, so if you are looking at a used Leica, pay close attention to them. Bent or marred rings should make you hesitate to buy the camera.

The same holds true for screw heads. The few screws visible on the exterior of a Leica are well finished, and carefully tightened with screwdrivers that fit the slots as precisely as a key fits its lock. As a result, Leica body screws do not require any sealants to hold them in place. Leitz relies on precision fitting and on using the right size screwdriver to tighten each screw firmly. This is a matter of pride among those who assemble or repair Leicas, so a screw head which shows signs of abuse is often evidence of tampering. Chewed-up, burred slots or badly-scratched screws mean that someone has been using the wrong tool for the job, and using it badly. If he is that clumsy with simple external parts, there is no telling what damage he may have done to interior mechanisms.

I should qualify this by adding that many photographers carry a small tool kit and periodically tighten all the screws on their cameras—especially after a long jet flight, for the vibrations can cause screws to loosen. This practice is not without merit, but too often it is poorly done. The only screws which might loosen from prolonged vibration are the smaller, highly-finished, fine-pitch ones; the larger screws almost never loosen. The fine screws have narrow, shallow slots and require a screwdriver blade which fits them exactly, or they can be damaged. It is a simple matter to get a set of good-quality jeweler's screwdrivers and make sure the blade fits the slot perfectly. Then you can turn the screw until it seats firmly, without unnecessary force and without damage.

Continuing the visual check-out of a Leica or Leicaflex, the condition of the lens flange is revealing. Both the male ring on the lens mount and the female ring on the camera should be free from any sign of undue wear. It is normal to see some rub marks evenly distributed over the entire surfaces of mating parts on cameras and lenses that have had much use. It is abnormal to see scored lines, pits,

A simple cleaning kit goes a long way toward keeping your Leica or Leicaflex in top-notch condition

gouges, or signs of uneven wear. If such marks are visible on either the camera or the lens, it means trouble, for then the lenses will not seat correctly, although optimum results demand that they do so. Forcing a lens onto the body when some foreign substance is between the two is the most common cause of abnormal wear. The best preventive step is to make certain that both mating parts are clean.

The cams on the rear of Leitz lenses, whether for actuating the M-model rangefinder or the Leicaflex meter control, are finished with great precision. A sharp object can mar them badly enough to affect their accuracy. For this reason, never put the unprotected rear end of a lens against anything; always use a rear lens cap when the lens is off the camera.

You can see most damage to these cams with the unaided eye. A low-power magnifier will show smaller nicks and scratches, but from a practical standpoint, anything that small will not cause serious problems. Of course, you should have no trouble spotting a bent part anywhere on either camera or lens. But too often such things are not expected, so they are not looked for. A dent in a lens mount could mean that uneven pressure is being exerted on the

lens elements. This can lead to a chipped element if the lens is jarred. It can also mean that the centering of the lens elements—so vital to lens performance—is off.

The best way to examine a lens for scum or fog on the inner surfaces is to use a small flashlight. Hold the lens at normal reading distance and shine the light through the back side. Tip and rotate the lens slowly while you play the beam of light through the rear. This causes the light to glance off the various inner lens surfaces so you can easily see any cloudiness or other trouble. Only an authorized repairman can correct any conditions you see without damage to the lens.

The edges of lens elements are left unpolished and are painted black. If the paint chips or peels, flare can result. Worse than this, paint particles can lodge in the diaphragm leaves and jam them. The diaphragm leaves must be perfectly dry; you should see no grease or oil on them when you look into the lens. Open and close the diaphragm through the entire f-stop range several times and inspect this condition from both sides. Any lubricant on the leaves can catch and hold dirt; eventually it will thicken and create a surface tension too great to allow the leaves to move freely. When this happens, the blades will buckle when they are forced to move. This will permanently damage the diaphragm, and it

will have to be replaced. Even greater damage can occur if the blades arch far outward when they buckle, for they may rub against the adjacent lens elements. The inside elements of many Leitz lenses are soft-coated for greater efficiency in subduing reflections; buckled diaphragm leaves can scratch this coating.

Now a word to those of you who would stick your noses into a Leica. Do it! The telltale odor of mildew or fungus growth is hard to mistake. If you detect it in a used camera, it means trouble. Once started, mildew and fungus will not stop growing until the camera is completely cleaned and properly treated. Fungus has a healthy appetite for the soft glass used in lenses, and unless checked quickly, its growth will spread to all parts and make repairs very costly. Paint, glass, and shutter-curtain material are all fodder for fungus, so go ahead and sniff your Leica.

Preventive maintenance will lengthen your camera's life considerably. The very best advice is: *Keep it clean!* Although the Leica is one of the best-sealed cameras ever made, there still is the danger of foreign matter getting inside when changing lenses or film and causing a failure.

The Leicaflex, with its mirror mechanism exposed every time its lenses are removed, requires more care than the Leica. Like its rangefinder cousins, the camera becomes a miniature vault, well sealed against dirt as long as the lens is in place and the back and baseplate are secured. But when the camera is open, it is vulnerable. Film itself can be a source of foreign matter. Film chips have probably stopped more Leicas than any other cause. The normal film scrapings, or "dust," which accumulate after dozens of rolls have run through the camera, can work its way inside. There it can lodge in any number of places—obscuring a viewfinder, jamming a slow-speed or self-timer gear train, or causing a winding mechanism to operate roughly.

Much owner-applied preventive maintenance is just common sense. Keeping your Leica or Leica-flex clean is the best example of this. After all, you bring it up to your *face* each time you shoot, don't you? That should make you especially careful about what gets on it. The best way to ensure that your camera is kept clean is to put together an inexpensive cleaning kit. Here is all you need:

1. A small stiff-bristled brush. A paste brush will do.

2. A rubber ear syringe (the three-ounce size).
3. Cotton swabs on sticks, such as Q-Tips. (I prefer those with wooden sticks.)
4. Lens cleaning fluid (a one-ounce vial).
5. Lens tissue (but *not* the chemically-impregnated kind used for eyeglasses).
6. A camel's-hair brush. The ones which retract, lipstick-style, are best, for they stay cleanest.

Use the stiff-bristled brush to loosen and whisk off any accumulation of dirt or dust. The one rule here is never to use this brush on any lens surfaces—reserve it for metal camera parts, external and internal. The ear syringe becomes a hand-sized air compressor with which you blow off dust and dirt loosened by brushing. But a word of warning: be sure to direct the stream of air from the syringe so that dirt blows *away* from the camera. It is easy to be overzealous and blow dirt *into* camera crevices.

The cleaning of optical surfaces has always been a favorite topic of camera-club "experts." Here is what I recommend:

1. Gently whisk off any foreign matter from the surface with the clean camel's-hair brush. (Never touch the bristles with your fingers; skin oil or moisture will hold dirt in the brush, and may be spread onto the lens.)
2. Blow off the dust with a forceful puff of air from the ear syringe.
3. Dampen (don't saturate) a cotton swab with lens cleaning fluid, and very gently rub the lens surface with a small, circular swirling movement. The swirls should be equal to about half the diameter of the surface being cleaned. Start in one area of the surface and work your way gradually around, swirling gently as you go.
4. Use the same type of motion to dry the surface with a fresh swab. Remember: rub gently, don't scrub.

For large surfaces, the cotton swab is best used only to apply the cleaning fluid. Use lens tissue to dry the surface. Roll the tissue into a cigarette-sized cylinder and tear it in two. The resulting fuzzy ends become the business ends to dry the lens. Discard all swabs and tissue, once used; they may have picked up abrasive matter which could scratch the lens if used again.

Some waste materials can be used to clean camera body parts. The wood stick of a cotton swab can be broken at an angle to form a slender probe, useful to clean out narrow crevices. If the pressure plate of the camera needs cleaning, a wad of lens tissue lightly dampened with lens cleaning fluid will remove most scum. Be sure to dry the pressure plate well with fresh tissue.

Once again: Make no attempt whatsoever to clean the inner elements of any lens. You will surely damage the interior soft-coating. Worse than that, you may disturb the critical spacing of lens elements, vital to optimum image quality. Only qualified optical specialists should venture into the sacred interior of a lens.

For the Leica or Leicaflex user planning a trip to an area where severe climatic conditions are expected, here are some points to remember. Leicas chosen at random from a distributor's stock of new cameras have been tested by an independent laboratory and found to function satisfactorily at temperatures ranging from -4°F to +120°F (-20° to +49°C). In general, hot climates are less of a worry than cold ones.

The biggest problems likely to be encountered in hot climates are dust in desert conditions, or fungus and mildew in tropical conditions. In either case, the best procedure is to provide airtight storage containers for your Leica equipment when it is not in use. Surplus ammunition boxes, while heavy, do the job very well and can be bought quite reasonably.

A generous supply of plastic bags, especially those with a zip-shut closure, will help keep your equipment protected from the elements. Be sure to have everything checked by an authorized Leitz repair station before and after a long, hard trip.

As for arctic cold, it comes as a surprise to most people that the *film*, rather than the camera, is most prone to damage at extremely low temperatures. Sprocket holes tear and film breaks much more easily when cold than at normal temperatures. It is important to wind and rewind the film slowly and evenly to avoid both static marks and tears or breaks. Keeping the Leica or Leicaflex inside a partially-open parka will let some of your body heat warm the camera—enough so the film will remain pliable, but not so much that the lens will fog when the cold camera is returned to the parka after a shot. A few hardy souls I know have the frigid task of photo-graphing football games in northern Wisconsin. They use pocket-sized hand warmers, the same kind that hunters and ice-fishermen use. They carry a couple in their pockets for their hands. Other warmers, hung around the neck, form a warm "nest" for cameras held against the chest. Parkas are half-unzipped, with the cameras poking out. When action calls for a picture, the camera is raised to the eye, then returned to the warm nest. They tell me it works fine.

Equipment that must withstand prolonged periods of truly arctic conditions can be specially prepared. This involves removing all lubricants that would thicken too much in extreme cold. In some cases, special low-temperature lubricants can be used in place of normal ones, but many high-speed bearings in the shutter require that all "wet" lubricants be completely removed and replaced, either with a dry lubricant such as graphite or with none at all. That, of course, is a job for a repairman.

Precautions must be taken when the Leica or Leicaflex is brought inside from the cold. In extreme cases, lens elements may fracture from a too-abrupt temperature change. More common is "sweating," which occurs the moment a cold camera or lens is exposed to moist, warm air. Here again, a surplus ammunition box will come in handy. It can serve as an acclimatizing chamber for the camera, allowing it to reach room temperature gradually. Keep the box out in the cold until you are ready to come in, then put your equipment in the box, close the cover, and bring it in. After a suitable time, you can remove the equipment from the box and blot up any slight moisture from the small amount of sweating it might have done. A more thorough drying-out in front of the gentle heat of an oven will not hurt if you proceed slowly. Wrapping the camera in hot, *dry* towels is even better. It is moisture in the surrounding warm environment that condenses on cold surfaces.

All told, your Leica or Leicaflex is truly one of the toughest cameras ever made. It demands only a minimum of special care beyond what you would give any high-grade piece of equipment. The rest is plain common sense.

Made in Canada— by Leitz

Harvey V. Fondiller

Set into a plaque on the cornerstone of the Ernst Leitz Canada plant at Midland, Ontario, is an age-worn brick. The plaque says: "This stone is from the oldest building of the Leitz Works in Wetzlar, Germany." It also bears the dates, 1849-1952, and the legend *"Fern der Heimat dies Werk entstand/ Schirm es Gott mit seiner Hand."* (Far from the homeland this plant stands/May God protect it with His hand.)

Established in 1952, Leitz Canada Ltd. , is the parent company's only plant outside Germany. Originally a small assembly and optics production facility, it is now capable of designing and producing the most complex Leitz products.

Midland, 90 miles north of Toronto, was selected as a factory site because of its favorable environment for optical manufacturing, its pleasant surroundings, and its proximity to transportation facilities. The town's name, incidentally, has the same number of letters as *Wetzlar*—a factor originally considered in engraving lenses (today, however, Midland products are engraved "Leitz Canada").

Assembly of Canadian Leica cameras and lenses began in a 7,500-square-foot curling rink. Within two years, the plant had expanded to 20,000 square feet and, in 1955, equipment for the design and development of lenses was installed. In 1957, the ten-thousandth Canadian-built Leica lens was produced, and two years later the plant had assembled its ten-thousandth Leica camera.

By 1962, there were 42,000 square feet of plant space and 160 employees. A decade later, the factory occupied 55,000 square feet and had 250 employees, about equally divided among Wetzlar-trained craftsmen, non-Leitz-trained Europeans, and native Canadians. In a factory tour, one is likely to find a Canadian trainee positioning sheet metal under a power punch, a European-born craftsman adjusting a lens-grinding machine, and a Leitz-trained technician inserting lens elements in their metal mounts.

Leitz Canada has manufactured a variety of products, including:

the 90mm f/2 Summicron lens (starting in 1957);
the 35mm f/2 Summicron (design and production, starting in 1958);
the 35mm f/1.4 Summilux, one of the fastest wide-angle lenses (design and production, 1960);

the 280mm f/4.8 telephoto for the Visoflex II (design and production); and
special cameras and equipment designed according to government specifications.

The production of certain lenses, such as the 200mm f/4 Telyt and the 125mm f/2.5 Hektor, which were designed and developed at Wetzlar, has been shared between the German and Canadian plants. Leitz Canada is now basically a design and manufacturing operation, though a limited number of Leicas for special applications are assembled for distribution to non-European markets.

Leitz Canada fabricates all mechanical components used in its products, except those for Leica cameras. The factory's equipment includes not only conventional machine tools, but specialized devices for complex operations that require unusually close tolerances. Precision is paramount. Every employee is trained to check his work carefully, and each department has its own inspection section. Gauges are calibrated with instruments that can measure to an accuracy of 100 millimicrons (.000004 inch).

Lens designers at Midland are aided by an on-site IBM 1130 computer, used in conjunction with a Control Data 6600 on a time-sharing basis, which facilitates and speeds the most complex optical calculations. An EROS IV Optical Transfer Function Analyzer—the first such installation in North America—helps physicists and engineers to venture into that area between science and art that is the optical scientist's domain.

After the formula for a proposed lens has been developed, a prototype is made. It is then tested and, in the case of a Leica or Leicaflex lens, submitted to Wetzlar for further testing. If the lens is approved, production begins at the Midland plant, which has facilities to manufacture everything from large Schlieren optics to small micro-recording lenses.

Besides producing lenses and cameras under the name, *Leitz,* the factory designs and manufactures commercial and military optical products under the brand name, *Elcan.* The line includes a low-power laser, 16mm motion-picture instrumentation cameras, and various types of sights and rangefinders. Elcan lenses are available for microfilm systems, integrated- and printed-circuit manufacture, ultraviolet and infrared applications, aerial and instru-

mentation cameras, electro-optical systems, enlarging, and underwater photography. One of Elcan's most unusual products is a 90mm f/1 lens —the world's fastest lens of its focal length.

The first lens designed solely for underwater photography was developed by Leitz Canada in 1961. Its front element, a concentric lens, is designed for use in direct contact with seawater. Another product for use in the ocean's depths is the 21mm f/4 Elcan Internal Immersion Lens for Submersibles. The problems involved in its design were formidable. Deep-sea photography typically requires cameras to be mounted either on rigs that are lowered to the depths or on the outside of submersibles. In either case, the number of exposures per dive is limited by the film capacity of the camera system; therefore it was desirable to develop a water-corrected lens system that would permit the camera to be used inside a submersible craft. This could be achieved by replacing the viewing ports with domes similar to those in existing underwater lens systems. Another possible approach was to develop a system that would permit the use of existing plano-parallel windows, be fully seawater corrected, and still retain a wide field of view.

Optical designers at Leitz Canada decided to develop a lens system that would require no change in the conventional portholes of undersea vessels. A lens system with an external entrance pupil was selected so that wide-angle photographic coverage would not interfere with visual observation. This kept the lens diameter small and maintained the maximum field of view for the operator. To achieve the required correction and angular coverage, the optic was designed as an immersion lens, in which the space between the inner surface of the viewing port and the front surface of the lens is filled with a liquid having similar optical properties to those of the seawater environment outside.

The optical components of Leitz lenses usually begin as glass blanks, or occasionally as glass blocks. After grinding and polishing, they are assembled in a metal mount that has passed through a series of rigorously-inspected operations which include metal plating, anodizing, etching, spray painting, and engraving. On completion, the lens is examined for mechanical accuracy and for precise rangefinder coupling, and is tested both on an optical bench and on a camera. Negatives of a high-resolution subject, exposed on thin-emulsion film at several focusing distances, are evaluated microscopically and then filed at Midland as a permanent record of lens performance.

How do lenses marked *Leitz Canada* compare with those marked *Leitz Wetzlar?* The answer is simple. Their quality is identical. Any two lenses of the same formula match perfectly in appearance and performance. Although some of the materials used in Midland-made lenses come from Canada, the grinding and polishing are done on machines similar to those used in Wetzlar, using the same high-precision techniques.

For generations, the sap of the Canadian balsam fir has been used to cement lens elements because of its refractive index—almost identical with that of optical glass—and because of its virtually complete transparency. At Midland, Ontario, Canada balsam and other native raw materials mesh with traditional old-world craftsmanship and modern computer technology to produce photographic equipment of surpassing excellence. Its users can be secure in the knowledge that this equipment is as good as any that human hands can create.

How the Leica Changed Photography

Jacob Deschin

The scene is the Los Angeles Art Museum one Sunday morning in 1928. Barbara and Willard Morgan are photographing Chinese sculpture with a 5x7 view camera. Suddenly they become aware of a young man, possibly a German student, watching them intently, "around his neck a little gadget." Willard is more than merely curious.

"What is that you're wearing?" he asks. "The Leica Model A camera that uses 35mm film," the young man replies, briefly explaining its salient points as Willard presses questions.

The next morning Willard is at the Leitz store in Los Angeles, asking to see a Leica camera. "What can a photographer do with a tiny camera like that?" the clerk inquires. He has microscopes, binoculars, other specialized equipment, but no Leica; there is some literature. Willard takes it home, reads it avidly and rushes off a letter to E. Leitz in New York: "... If you will send me two Leica cameras with all accessories and lenses plus some film and the developing equipment, I will guarantee to go to the Southwest, photograph its dramatic features, such as the cliff ruins, Rainbow Bridge, Indian ceremonials, and so on, and then write articles and illustrate them with photographs taken with these cameras."

It is a wild chance — but it works. Two days before the Morgans are to leave on their annual summer vacation to travel, paint, and shoot pictures, comes "this marvelous big package with everything Willard asked for."

He uses the cameras as promised, writes text to go with the pictures, and gets both published. The Leitz people in New York and Wetzlar are pleased and, two years later, in 1930, while on another vacation, the Morgans are tracked down by a telegraph messenger who bears an offer from E. Leitz of a job as publicist for the Leica in the United States. Willard accepts on the spot, the Morgans pack hurriedly and are off to New York. The big push to get the Leica — and 35mm photography — on its way in this country begins.

Meanwhile, in Paris, André Kertész, the Hungarian magazine photographer, who has been using small cameras for years and has been rapidly building a reputation for his warmly human portrayal of the passing scene, learns about the Leica and immediately buys one. The year is 1928. He has had an exhibition the year before and all Montparnasse is buzzing with excitement. Imitations soon follow.

"The Leica was for me," Kertész told me recently. "I had always used a small camera because my style demanded the freedom of movement it gave me. But my previous cameras, which used small glass plates, were limited. The Leica was far more versatile. I could move around and people didn't know I was shooting. What had been difficult with my former cameras was done easily with the Leica. While my colleagues, who were using large cameras, were still setting up, I was already shooting.

"At first, there was difficulty with the 35mm. The magazines didn't like it, even in 1937, when I came to New York and Willard Morgan introduced me to Wilson Hicks on the chance there was a job for me at *Life*. Hicks asked me, 'What camera do you use?' I said, very proudly, 'the Leica,' and he frowned: 'The Leica is no camera, you should be using a Speed Graphic.'"

Because the Leica still was a curiosity, in America as well as abroad, and editors refused to consider it as anything more than a toy, incapable of doing professional work, Kertész used the Leica without telling the editors; after all, he says, they only saw the prints anyway.

In Germany, where the Leica first came on the market in 1925, Dr. Paul Wolff, a successful industrial photographer, began to champion the camera after winning one in 1926 in an international photographic competition. Drawing on his technical background and his skill with larger cameras, Wolff became the leading exponent of the Leica in his country and was very influential among American 35mm devotees who read him in translation.

In his zeal to demonstrate the Leica's versatility, as well as his own many interests, Wolff chose subject matter ranging from insects to industry, including landscapes, flowers, children, and, of course, pretty girls, anticipating in many of his subjects today's immense preoccupation with travel photography. His pictures were pleasant, nicely composed, and often commercially oriented. Unlike Kertész, Wolff made little impact on the development of 35mm photography as an expressive medium but the general public loved his work.

Through his writings and lectures and several illustrated books, especially *My First Ten Years with the Leica,* Wolff became internationally known, promoting the cause of 35mm photography at a time when it sorely needed a friend, an expert and a

missionary who could perform as well as preach, and who proved, time and again, the Leica's value as a serious camera.

When color film was introduced, Dr. Wolff turned to it with his characteristic enthusiasm and zest for experiment. His work contributed much to the growth of public interest in 35mm color shooting.

Dr. Wolff studied medicine and practiced it for a time; when this proved unremunerative, he returned to photography, his first preference, and stayed with it until his death in 1951.

It was largely through the pioneering efforts of such knowledgeable individuals as Dr. Wolff and other experts in Germany and the United States that 35mm photography eventually reached its present high level of technical excellence, control and practicability. Within a few years after its appearance, the Leica won the respect and devotion of both working photographers and amateurs, as well as those artists who saw in it a handy note-taker for paintings to be worked up at leisure. Meanwhile, other artists used the Leica for photography as an art medium in its own right.

Information gained in 35mm research in the fields of camera design, film emulsions, and processing soon began to benefit large-camera photography as well, and to bring general improvement in the quality of sensitized materials, across the board.

The precision of design and construction that are necessarily inherent in the manufacture of 35mm equipment gradually spread to the larger formats, and their manufacturers began to adopt 35mm standards of exactness and low tolerance, as well as styling.

But for the first few years it was touch and go whether the 35mm could survive its drawbacks at that early stage of development—graininess, poor image quality and, therefore, relatively poor enlargeability. To many, 35mm photography seemed to be a passing fad. Apart from the technical aspects, there was the matter of the man behind the camera. At the time, few saw the ultimate value of the 35mm camera as a personal instrument of incalculable potential, hence much of the work turned out with the early miniatures reached little higher than snapshot level.

In a 1939 survey of available cameras, Willard Morgan listed twenty-eight 35mm cameras in a field of more than 150 "miniature" cameras ranging in format up to 2¼ x 3¼ inches. (The term "miniature" so fascinated the public in those years and was so attractive commercially, that it was profitable to lump 35s together with rollfilm cameras under the general category of "miniature," ignoring the obvious fact that the rollfilm sizes, from 127 to 120, hardly shared the technical problems peculiar to the 35mm.) Rollfilm cameras, mostly of the folding bellows type, dominated the field at the time of that survey, but the 35mm, rather than being on the wane, as it was reported to be, was making steady advances. Ten years later, I was able to report in my New York Times photography column a marked bias toward the miniature. Arthur Rothstein, then technical director of photography at Look magazine, said at the time that he saw photographers beginning to use 35mm more and "in a maturer way than a decade ago, as they become more conscious of its potentialities for picture-making in a realistic manner."

Another source referred to the 35mm "revival" as the "second cycle of candid photography" (the word, "candid," was used interchangeably with "miniature"). At Life, where Kertész had been turned away a dozen years before because he used a Leica, the use of 35mm was steadily on the increase, due mostly to the results achieved by such masters as Leonard McCombe, W. Eugene Smith, and Alfred Eisenstaedt.

Willoughby's, the "largest camera store in the world," reported that 35mm black-and-white film was still being used a great deal by the rank-and-file amateur but that "the advanced amateur has graduated to the 2¼ x 2¼ size."

Augustus Wolfman, then editor of The Photo Dealer and a technical authority, today a photographic writer and consultant, in commenting at mid-century on the report of his magazine's survey, which listed about thirty 35mm cameras as against about half that many twin-lens reflex cameras, saw a definite trend toward the smaller camera.

"The miniature camera," he said, "has the advantage over other types, in that it gives the photographer great freedom in photographic expression. The limiting factor has been the resolution of the film emulsion (its ability to render fine detail). As emulsions have improved, the smaller camera and ordinary care in processing will aid greatly in bringing 35mm black-and-white back into general favor again."

There developed the practice of using two cameras, one (often the twin-lens) for black-and-white, and the 35mm for color. Today, most amateurs shoot 35mm color, often exclusive of black-and-white.

The advent of the Leica and the other miniatures that followed it in the 1930s was a powerful shot in the arm for the photographic industry. "It gave a new flavor to the field," the late Joseph G. Dombroff, president of Willoughby's, told me. "It was a kind of contagion. Everybody was talking candid and it seemed that nearly everybody was doing it. There was a kind of magic in the word. Before the miniature came along, people seemed to be afraid of photography, as if it were something too difficult to understand. The miniature changed all that. And when color and flash came along they helped to complete the conversion; they were new, exciting and simple things to do.

"Without the miniature, photography would never have made the strides we have seen. It has greatly widened the field, helped immeasurably in creating interest in photography and attracted hosts of hobbyists and some professionals."

Many professionals and users of photography remained skeptical for years. " . . . the only reason I can imagine why Mr. Nast (Condé Nast) didn't ask Henri Cartier-Bresson to work for him is that Cartier-Bresson habitually used, not a studio camera at all, but a 35mm Leica, which to *Vogue's* accredited photographers was firmly forbidden," Horst writes in *Salute to the Thirties* (Viking). "How we envied him!"

Exploitation of the miniature in many directions, some of them previously impossible, moved parallel with increasing perfection of the medium as a craft. Striving zealously for optimum negative quality, one class of photographers exposed cassette after cassette, carefully processing the film under controlled conditions, in hot pursuit of grainless negatives of uniform quality. They were called the "negative makers"—the technical hobbyists more interested in processing than in pictures.

One of the best known and most successful, so far as achievement in 35mm progress was concerned, was Harold Harvey, the Baltimore chemist whose Panthermic 777 Developer is still used widely in spite of the many other good fine-grain developers on the market today.

Harvey was a member of the fabled Circle of Confusion, named after the optical term relating to sharpness, a rather exclusive group of serious amateurs and professionals who met informally and periodically for dinner to exchange ideas and information on their common interest and to report on personal experiences with some practical phase of miniature camera work.

Along with Harvey, the group included such notables of the time as Willard Morgan, Henry Lester, Richard Simon, Dudley Lee, Konrad Kramer, H. W. Zieler, Manuel Komroff, and some thirty others.

The Circle was revived a few years ago with Komroff, an ardent Leica buff, as guiding light. At one of its monthly dinner-meetings, member Nat Resnick, professor of art at Long Island University, describing the early days, recalled how members would bring a new camera, a new film, paper, or other product, pass the things around and talk. Anybody who wanted to experiment with the materials could have all the film and paper he needed.

On one occasion, Harvey brought "the first big mural," made possible by the excellent performance of his Panthermic 777 developer. Another time, Jim Leonard demonstrated how he made rigs to photograph the tiniest insects by making long cardboard extension tubes and putting "a lens here and a camera there."

One evening Komroff said, "I want to show you what we worked out in Harold Harvey's lab. We took a 35mm negative and we blew it up to 11x14—look, there's no grain. Then we took a fraction of that negative and we blew that up to 11x14. See, no grain." "Albert Boni," Resnick continued, "sitting there at the table, said, 'You guys are all whacky; you're going just the other way.' We said, 'What do you mean, going the other way?' He said, 'Never mind, never mind.' Afterward, we learned that on his way home he got an idea and out of that idea he has built a ten-million-dollar business which today is known as Readex Microprint, where he has taken large things and made them small." The most recent result of that discovery is, of course, Boni's monumental achievement of reducing the thirteen volumes of the *Oxford English Dictionary* to the two-volume *Compact Edition of the Oxford English Dictionary* (1971), with type so tiny that it must be read with a magnifier (supplied with the set).

The Circle men were special, but in their curiosity

about the latest miniature cameras, accessories, materials, and techniques, they were not really far removed from the average amateur caught up in the Leica madness of the early-to-mid 1930s. I was one myself, having been hooked for sure by candid-camera fever. I bought my first Leica in the deep depression, trading my 4x5 Graflex for it and adding fifty dollars. It was the best move I ever made, even though it seemed like an extravagance at the time, **for much that has happened to me since is directly traceable to that bold purchase. It put me in the** middle of the action, for the Leica and 35 looked like winners to me. I wrote enthusiastic pieces for *Scientific American* on the "revolutionary" new medium of miniature photography, and soon afterward started a column for that monthly that lasted for seven years, until the war took me to Wright Field.

We miniature camera enthusiasts were "the new breed." With a Leica in the hand, nothing seemed impossible, so we shot in situations and under conditions undreamed of with the larger cameras. Candids were especially tantalizing, and the less adequate the light the better; the greater the obstacles (we actually sought them), the more challenging the prospect. We carried the camera everywhere and shot the most unlikely subject matter, just to see if the picture would "come out." I remember being especially turned on by night candids taken by the light of store windows, street lamps, bonfires, even by the light of a match or candle held close to the face.

By day as by night, candids were irresistible. You moved unobtrusively in a situation and shot secretively, not so much because you were afraid of being caught at it as that you wanted the natural, unposed gesture and expression you got when the subject was unaware of your camera. Besides, it was more fun that way. A much-used device was the angle viewfinder (you looked one way and shot the other). To steady the camera at the slow shutter speeds required by dim light and low film speed, you propped yourself against a building or lamp post, or rested the camera on a ledge or a table. In the theater we pushed our luck by exposing at 1/5th or 1/10th with the f/2 lens wide open, steadying the camera by bracing one's back against the seat, or by using such devices as the "chain pod," a short tube with a chain attached. You mounted the camera

on the tube and dropped the chain, then stepped on the chain and, gripping the camera, pulled it taut for a steady grip.

Soon after the appearance of the Leica came a flood of accessories, and it was thought at the time that the ingenuity, usefulness and range of these picture-taking aids were largely responsible for the continuing success of the miniature camera. Just when it seemed that everything had been invented that could possibly be used, along came new goodies for which uses were soon found, and which, in fact, extended the capabilities of the 35mm photographer.

This diversity of means available to the Leica photographer eventually spread; taking a cue from Wetzlar and elsewhere, the manufacturers of large cameras began to introduce accessory devices for their cameras, too.

Miniature photography imposed the necessity of enlarging the small negatives and brought on a host of enlargers and related items. While extending the miniature worker's interest in his hobby or vocation, these introduced new problems, not the least of which were domestic ones. As kitchens and bathrooms were commandeered for photography, one heard of crises that endangered family relations. One that has come down to our own time is the situation of the dedicated photographer who, printing far into the night and into early morning (to print all or most of the thirty-six negatives was as tempting as it was time-consuming) so strained his wife's patience and understanding that either tempers became ruffled, or the wife's submission turned her into a "darkroom widow." Some noted women photographers started that way—"joining them" when they couldn't "beat them."

The coming of 35mm Kodachrome in 1935 heralded a new era for the Leica and other miniatures — the age of Color Photography for Everyone had arrived. Now, except for the lower film speed (1/60 second at f/6.3 in bright daylight), one **could shoot 35mm color film as easily as black-and-**white. Anscochrome, which could be processed by the user rather than having to be sent to Eastman Kodak in Rochester, as was the case with Kodachrome, came a bit later. Other color films, domestic and foreign, followed in succeeding years and color-negative film for direct color prints hit the market. With the appearance of color enlarging paper, Kodak's Type C, the means of making color

enlargements directly from the color negative widened the color market further.

The possibilities of amateur color photography, I believe, were first pointed out in book form in 1938, in Anton F. Baumann's, *The Leica Book in Color,* published in Germany by Knorr & Hirth of Munich, and distributed in English translation in the United States. It included seventy-two full-color reproductions, "made by direct transfer from the color positive of 24x36mm to the halftone plate without retouching," according to the publisher.

Color was immediately popular and grew rapidly in favor, but black-and-white continued to be used as well, the more affluent amateurs carrying two cameras, one for color, the other for black-and-white film. The professionals often did the same, shooting assignments in both media simultaneously to give the client a choice.

Today, color is preferred by amateurs and snapshooters, who use more color film than black-and-white, and color reproduction in periodicals and books is used increasingly, although the relatively high reproduction cost continues to be a limiting factor. The photographic galleries and museums that show photographs still tend to avoid color, preferring black-and-white as the medium more suited to photographic achievement on the level of fine art. Aspects of this attitude include such questions as color permanence, excessive "realism," and garishness, as well as individual bias on the part of some museum authorities.

In a series of interviews on whether black-and-white photography was doomed, which I did for a 1947 issue of the short-lived *Photography* quarterly under the title, "The Future of Color," the result was a kind of yes-and-no consensus. We are still not sure, but my guess is that both media will continue side by side for a very long time. Color is still not an easy medium for amateur or pro, color know-how is still not easily acquired, printing and reproduction costs are still out of reach for most photographers and many publications. In addition, many photographers eschew color simply because they don't care for the results, or because they prefer black-and-white.

What is generally called the "35mm approach" really began before the camera itself appeared. André Kertész says he used the "Leica manipulation" long before he knew about the camera and bought one. When he began using it, it was as if it had been waiting for him all along; he was ready for it. He knew what he wanted to do, but had been slowed down by the limitations of the early small glass-plate cameras. The Leica freed him to move undeterred at his own pace, and with more technical control at his fingertips than he had ever had in the early days.

Kertész himself, a photographic personality with a distinctive, innovative style of his own, significantly influenced other photographers and gave them a point of view on which to build their own. Among these was Henri Cartier-Bresson, who as a boy in knee pants visited Kertész's first one-man show in Paris in 1927, and who later declared, "We all owe something to Kertész." Another was Brassai, who said, "It is daily life which is the great event, the true 'reality' . . ." He got his initial orientation in the miniature-camera way from watching Kertész take pictures at night.

Later, Cartier-Bresson and W. Eugene Smith (perhaps *Life's* most renowned, gifted and humane photographer), among others, became mentors for **a whole generation of upcoming young photographers, many of whom, imbued with similar attitudes** toward the world around them, have followed their own instincts and produced pictures on the same level, but along individual lines.

If one were asked to name one of today's most influential photographers, Henri Cartier-Bresson would certainly be a reasonable choice. One of the Leica's most devoted practitioners, he told me in an interview that a photographer must have a point of view, **be a disciplined person, responding instinctively and purposefully to meaningful subject matter.** He is a moralist, he said, with a sincere belief in the dignity of the human being and his potential and aspirations.

Everyone is a creative person, an artist, to some degree, he said: "A taxicab driver writing a love letter to his girl friend is exercising the creative urge."

Composition, he continued, is a matter of reproducing the shape of the subject, of fitting the elements into a geometric arrangement, of seeing the subject as it appears "in time, in space, emotionally."

Nothing is too trite to claim a photographer's attention, he believes. All life is grist for the photographer's mill. "We are taking pictures here and

now: we have to touch earth." The photographer's role is that of a commentator on the human situation in his time, expressing himself in terms of the world in which he lives.

The power of one photographer's influence on other photographers is forcefully indicated also in Robert Frank's 35mm still work. A near-legend in his own time, although still relatively young, Frank impresses his young listeners with such statements as, "Whatever I photograph is part of a process of living ... In doing *The Americans,* I think it was pure intuition; I looked at America and I felt something about it and I came back and I have these photographs ... When I try to sell them to magazine editors they tell me they aren't for the public because the average man, the man in Iowa, for example, wouldn't understand, and I say this is not true; he would understand."

The late Ben Shahn, painter and one-time photographer in Roy Stryker's Farm Security Administration group, said of the F.S.A. pictures, "We tried to present the ordinary in an extraordinary manner ... The camera people ought to photograph the obvious. It's never been done. What the photographer can do that the painter can't is to arrest that split second of action in a guy stepping into a bus, or eating at a lunch counter."

On another occasion, Shahn said that he was given the Leica by his brother in payment of a bet, and that he learned photography from Walker Evans, with whom he shared a flat in New York City. He said, "These weren't just photographs to me; in a real sense they were the raw materials of painting. Photographs give those details of forms that you think you'll remember but don't ... details that I like to put in my paintings."

I believe that the miniature's greatest impact has been in the area of the interpretive photo-reporter who came in with the advent of the small camera. This influence is aptly expressed in the phrase, "extension of the eye"; that is, one "sees" via the camera with the directness, the adaptability and the spontaneity of the human eye itself. Cartier-Bresson recognized the concept and introduced the phrase in his modern classic of photographic literature, *The Decisive Moment.*

Two of the miniature's most famous working photographers, Tom McAvoy and Peter Stackpole, both members of *Life's* original staff of four photographers, made photographic history with the 35mm camera. McAvoy, standing in a group of press photographers waiting for President Roosevelt to finish signing the mail on his desk so they could take a posed shot, decided to leave the pack and shoot informally, a role for which the 35mm is peculiarly suited. While his photographic colleagues stood about, McAvoy was busy taking snapshots of the President. The series, published in *Life,* showed the chief executive as a normal human being tidying up his desk for guests, unlike the posed portrait that all the other publications used. The 35mm had won a scoop from right under the noses of a host of Speed Graphics.

Peter Stackpole, who later became a specialist in underwater photography, first won notice with his 35mm coverage of the Golden Gate Bridge under construction between San Francisco and Oakland, California. His dramatic shots from very high vantage points are breathtakingly beautiful and have become classics in photojournalism.

Almost every application of photography has been affected by the 35mm approach, and for the better. Aside from photojournalism, its chief beneficiary, portraiture has undergone a great change from the static to the natural and expressive. The interpretive documentation of social history has been a valuable field for the miniature, implementing our understanding of the world we live in. Fashion, child photography, industrial illustration, experimentation, along with such fields as research, science and medical photography, all have been 35mm targets.

After the introduction of the Leica, the whole range of photography was freshened up for a new, more spontaneous and stimulating look at people, events and things. As a result, whenever a 35mm photographer with imagination and skill was behind the camera, the world looked better, or at least clearer, and was made more understandable.

Pioneer
Leica Photography

André Kertész—Paris, 1928. One of the first photographs Kertész took with his new Leica:" I had seen pictures like this all around me. Now I could take them"

Paris. André Kertész

Paris, 1934. André Kertész

Paris, 1928 André Kertész

Paris, 1929. André Kertész

Paris. André Kertész

Henri Cartier-Bresson—*Berlin in the late 1920s.
The young Cartier-Bresson, fresh from studying
painting with André Lhote, and influenced in his
photography by Kertész and Atget, traveled and
photographed with the eagerness of a hunter—as,
more than forty years later, he still does*

Paris, late 1920s. Henri Cartier-Bresson

At the coronation of George VI, London, 1937. Henri Cartier-Bresson

Valencia. Henri Cartier-Bresson

Dr. Paul Wolff—*Dr. Wolff, the ambassador of the Leica, went everywhere and photographed everything, or so it seemed, and his books went far to popularize the Leica and 35mm photography*

Naples. Dr. Paul Wolff

Alfred Eisenstaedt—*Eisenstaedt was a photo-
journalist in Europe for some years before he joined
Life in 1936. This self-portrait was taken in St. Moritz
in 1932*

Peter Stackpole—*Peter Stackpole's photographs of the building of the San Francisco-Oakland Bay bridge were started in 1934, when he was 21. Before that, he had photographed without pay for a Hearst paper and was fired for using his first Leica on the job. "I guess all this makes me a pioneer"*

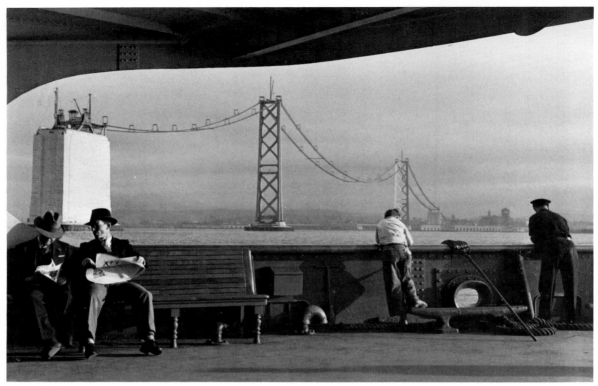

From the ferry. Peter Stackpole

Boarding the elevator. Peter Stackpole

After work. Peter Stackpole

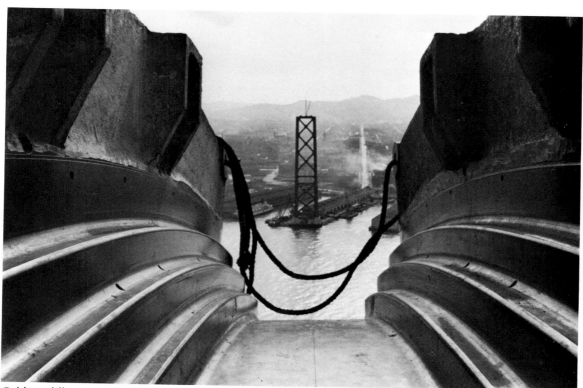

Cable saddle. Peter Stackpole

FSA—Arthur Rothstein—*The Farm Security Adminis-
tration's photography project, headed by Roy
Stryker, produced a great many photographs that
have lived beyond their original aim of recording
American farm life in the depression of the 1930s.
The FSA established a new way of photographing and
thinking about photography. Arthur Rothstein,
among others, made good use of his Leica*

Arthur Rothstein, FSA

Filing data and identification marking
on back of catalog print

Feed store. Arthur Rothstein, FSA

Vermont. Arthur Rothstein, FSA

Arthur Rothstein, FSA

Arthur Rothstein, FSA

FSA—Ben Shahn—*The painter, Ben Shahn, is said to have been propelled into photography by his friend, Walker Evans. He found himself traveling around the country with a Leica for the FSA, to his own surprise. Many strong pictures resulted*

Relief line, Urbana, Ohio, 1938

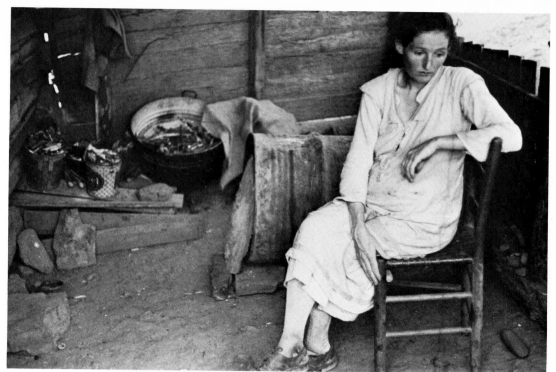

Tenant farm woman, Ozark mountains, 1935
Smithland, Kentucky

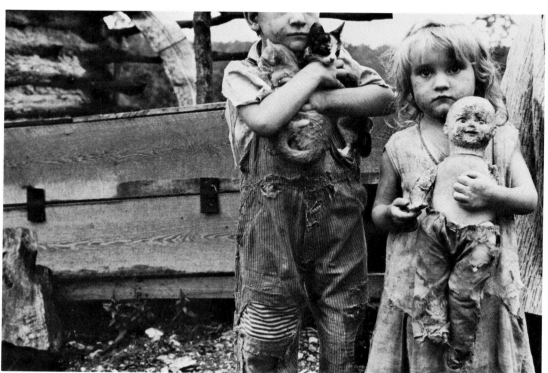

Ozark mountaineer's children, Arkansas, 1935.
Ben Shahn, FSA

Shahn photographs reproduced from the
collection of the Library of Congress

Barbara and Willard Morgan—*Willard Morgan was excited by the possibilities of the Leica as few people have been since. His wife, Barbara, then primarily a painter, got her start in photography by helping Willard out in their first Leica trips to the American Southwest*

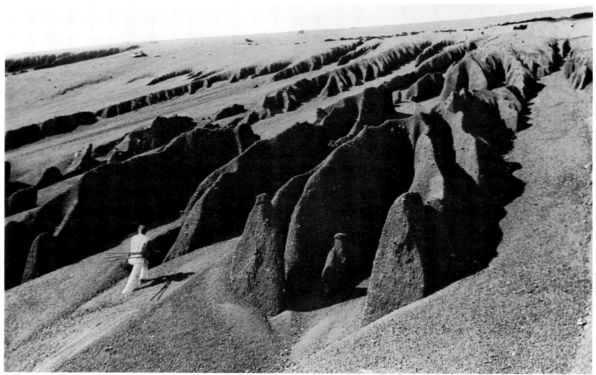

Willard Morgan climbing lava formations, Mono Lake, California, 1929. Barbara Morgan

Eagle dance, Gallup, New Mexico, 1929. Willard D. Morgan

Willard Morgan with Leica, Rito de los Frijoles,
Bandelier National Monument, New Mexico, 1928. Barbara Morgan

The Morgan car, "Packrat," Southwest desert, 1928.
Willard D. Morgan

Willard Morgan with Model A Leica on Rainbow
Bridge, 1928. Barbara Morgan

A Leica collector in his study; this impressive
collection is in England

The Leica:
A Collector's Perspective

Alfred C. Clarke and Rolf Fricke

While most readers of this manual may think of Leica cameras as picture-taking devices, a growing number regards them as objects worth collecting for their own sake, as one might collect fine sculpture or classic coins. These people use the Leica to make photographs, but their major interest lies in the systematic analysis of historic changes in this intriguing artifact from its inception to the present day. Leica loyalty now encompasses an allegiance based on the intrinsic qualities of the camera itself. Perhaps the essence of this viewpoint is reflected in one collector's comment: "Even if the Leica did not take good pictures, its existence would still be justified."

Although interest in Leica history is relatively new, collecting as a serious activity of man has a long history. The first things primitive man collected were probably food and other objects related to survival. One of the early roots of formal collecting can be traced to religious customs. Many early paintings, for example, contained sacred meanings and formed a part of religious beliefs and practices. It is not surprising that such objects were highly regarded in most societies and appeared early on the list of things to be preserved with care. Works of art were passed on from generation to generation. Those that contained rare stones and precious metals often served as a medium of exchange. Such items were also associated with power, and sometimes served as symbols of a nation's credit.

Other collecting traditions started with superbly-crafted objects presented to the king at the New Year feast. The palace soon contained what might be termed a "collection of modern art," but as one king succeeded another, these collections began to include ancient as well as contemporary pieces. Eventually, cherished articles outgrew the temple and the royal vault and were accumulated by the wealthy. There is also evidence which suggests that smooth objects were accumulated more often than those with rough surfaces, and that small items were collected before large ones. In some societies where families moved frequently in search of new hunting areas, a man collected only what he could carry. Eskimo sculpture, for example, is relatively small.

As long as the technology of a society remained simple, the variety of collectible items could not be great. As technology developed, the number of collectibles grew. Today, in a highly industrialized society such as the United States, the variety of items that are collected is almost unlimited. An examination of almost any current periodical devoted to collecting will reveal interests ranging from antique cars, steam engines, and hand-made trunks, to barbed wire, telegraph insulators, and paperweights. In fact, the number of magazines and journals published for collectors has skyrocketed during the past few years; they have become collectors' items themselves. The reasons for this impressive increase in collecting activity include higher levels of education, more leisure time, and higher income levels; all serve to aid the connoisseur's taste.

A further explanation for present-day collecting comes from the anthropologist's notebook. Modern man is still basically a hunter, but he no longer needs to hunt for sheer physical survival. He cannot satisfy his deep-seated urge to hunt in the same way as his primitive ancestors. However, just as early man found the search for game exciting and satisfying, so modern man still craves this kind of experience. While trophies of the hunt in the old sense are difficult to come by today, much of modern collecting satisfies this age-old urge. This may also explain why collectors often say that the search for a difficult item is one of the most intriguing features of collecting. The authors know collectors who admit that hunting for a hard-to-find article is more satisfying than possessing it after it has been found. An anthropologist would also add that skill at hunting was a basis for status and prestige in the tribe. In today's society, a man's position in the community is closely associated with his work; but in an urban-industrial world, occupational role-differences often become blurred. The possession of prized objects—and skill in collecting them—may represent a modern counterpart of the hunt, and may serve to indicate status in an increasingly complex society.

Granting this background of collecting activity, what explains the interest in collecting historic models of the Leica? What is there about this particular camera that accounts for the special way it is regarded? There is no simple answer. Ask those who collect the Leica why they do so, and their replies will vary widely. But there also will be a pattern to their responses. Most are interested in the development of the Leica system of photography. Some are interested in charting only part of the evolutionary process, such as pre-World-War-II cameras and lenses; other collectors seek a broader range of

models and accessories. Almost invariably they will refer to some characteristic of the Leica itself — the superb craftsmanship, the degree of precision, the velvet smoothness of operation, the difficult-to-describe "feel," or the esthetic aspects of the Leica. These qualities, in varying combinations, may form a basis for what some writers have termed the "Leica mystique." The important point is that the Leica has a truly impressive list of unique attributes: this camera stands alone. A brief overview of these features may provide insight into why this particular camera is so highly regarded among collectors.

The Leica is the oldest 35mm camera in production today. While not the first camera to use 35mm film, the Leica more than any other camera started the movement toward 35mm photography. No camera has been copied by as many other manufacturers: almost every major country has produced some version of the Leica design. No other miniature camera introduced more innovations than the first commercially-produced Leica; innovations that were incorporated in subsequent 35mm cameras. Perhaps the essential soundness of the original design is best illustrated by the fact that for its first thirty years—from the Model A to the IIIg—no basic change was deemed necessary in the Leica form or mechanism. The first major innovation occurred in 1954 with the introduction of the M-3; even then the new built-in features closely resembled those of earlier models.

The Leica was the first camera to have its own formal collecting society, and it probably has been collected more consistently and systematically than any other photographic item. No other camera has had as many clubs and organizations named after it, or had as many journals, magazines and technical bulletins devoted to it. No other camera has been advertised and described in as many languages as the Leica. No camera has been — or is — subjected to as many demanding tests during manufacture.

Regarding the meticulous attention to quality and precision, the Leica is built by a company that is basically devoted to manufacturing fine microscopes; thus even the first Leicas were built to standards hitherto unknown in the field of camera construction. Indeed, some enthusiasts think of the Leica as a kind of photographic jewelry and, in a sense, it has served in this capacity. Over the years, various models have been presented to kings, presi-

dents, scientists, and others recognized for their accomplishments. In short, no other camera or precision instrument in history has received such universal recognition as the Leica.

However, such attention has exacted a penalty. The steadily rising prices of high valued items represent an increasingly frustrating dilemma for many Leica collectors. Currently, this is a topic of great concern in almost all collecting circles, with issues that are not easily resolved — especially in an affluent society with generally spiralling costs. When collectors begin to pay many times the previous value of an item, prices accelerate quickly. Early model Leicas have been escalated all out of proportion to their value of only a few years ago. Collecting organizations are increasingly aware of this problem and codes of ethical behavior are being written, with sanctions against those who violate agreed-upon codes of conduct.

The hunting grounds

We have likened the hobby of collecting objects to man's interest in the hunt. Let us now explore the hunting grounds. This is where much of the Leica collector's skill comes into play, because he learns early in the game that much-sought-after items do turn up in unlikely places. The skill, then, is to make them surface, to smoke them out, and to stalk them patiently until he can at last admire his latest acquisition with that passion peculiar to collectors.

The most direct way to start a collection is to purchase the items new. This ensures truly mint conditions, but it is also expensive, at least until the item has been discontinued long enough for a degree of rarity to manifest itself. The next source is the used-camera counter in the photo store This used to be a favorite treasure trove for the knowledgeable collector. Used cameras cost considerably less than new ones, and one could usually find the desired model. Even though the dealer had the inevitable blue-book to help him set a basic price, one could still bargain with such arguments as degree of use, age, "it's only for the glove compartment of the car," and similar ploys. The dramatic upsurge in the popularity of collecting has affected this source, however. So many collectors are scouring camera stores in their neighborhoods and in other towns they visit, that a collectible item seldom remains longer than a day before it is snapped up by an eagle-eyed connois-

seur. The inevitable result is an increase in prices, and the appearance of speculators, some of whom prey upon impatient collectors. Fortunately, they are counterbalanced by quite a few new businesses that specialize in vintage photographic apparatus. These businesses frequently operate from private homes and publish subscription lists of their offerings. As soon as such a list arrives, a collector eagerly scours the pages for any wanted item. If he finds one, he must decide how badly he wants it — should he write, telegraph, or telephone? He knows that many other collectors have just received the same list. If he is to savor that peculiar pleasure of acquiring a new item for his collection he must act quickly. Since Leica items have become scarce, prompt action is essential.

Perseverance and patience are important for the serious Leica collector. He watches the classified ads in newspapers, he attends antique sales, and he is quite willing to accompany his wife when she wants to browse in an antique shop. All of this is happily worthwhile when that elusive OOFRE* or VORSA** is found in one of these unlikely places. Alertness pays off: a Leica IIId was recently bought at the photo counter of a large drugstore, at a very reasonable price.

The hunt becomes more interesting when the odds are better, and such is the case with pawnshops, notably those in large cities. For a while, the crowded, earthy hockshops on lower Third Avenue in New York were a fertile field for determined collectors. One of the authors will never forget the excitement of finding his first Leica Model A in just such a store, for $35. The price was high for that time, but he was so intrigued with the fascinating mechanism that he could not resist. (On the same occasion he met another collector, who also was reticent about revealing his hobby, because it was considered eccentric in those days.) Pawnshops now have recognized the bonanza in old cameras, and prices have risen sharply, sometimes exceeding those of the used items in regular camera shops. But the Leica mystique exerts a strange influence upon its devotees, whose optimism and determination seem unquenchable.

Today, the serious Leica collector has become more sophisticated. He carefully checks smaller

*Remote Release and Shutter Winder
**"Stereoly" Attachment for stereo photography

cities, and he lets all his friends and relatives know about his interest in Leica equipment. He joins other societies with the object of swapping for Leica items with collectors of other types of photographic apparatus. Most such general collectors would rather exchange cameras and accessories than sell them for cash. The astute Leica collector prepares himself by picking up collectible non-Leica items whenever an attractive opportunity arises. Many times we have offered cameras or accessories whose value exceeded that of the Leica item that we wanted, just to pry it loose from the general collector.

But to collect Leica material intelligently, one must know his subject thoroughly. Basic information is gleaned from old catalogs, which are valuable research sources for proper descriptions, code names, catalog numbers and — especially — dates. You have probably guessed that these catalogs themselves are now collectors items. An excellent source of information is the specialized camera society. As mentioned earlier, the Leica was the first to have its own specific collectors' organization. This topic is so important that it merits a closer look.

Leica societies

Before the Second World War, there were numerous Leica clubs in the United States, in Europe, and in Japan. Early photographic magazines had regular columns on club activities. The purpose of these clubs was to foster photography itself, which was greatly enhanced by the versatility and precision of the Leica. A few of these clubs are still active today, notably the Leica Club of Panama. In the sixties, a new type of society emerged — the collectors' or historical society. First came the general photographic collecting societies, such as the Antique Photographic Society, Rochester, N.Y., founded in 1965. Shortly thereafter, the first specialized Leica collectors' society appeared. The general collectors' clubs were local at first, but Leica Collectors International started right off in 1967 with a modest, but nationwide, membership. It was the first society of this type to be formed, and now there are similar societies in Great Britain, Italy and Japan (but strangely not in Germany).

At the 1970 annual meeting, the members of Leica Collectors International voted to change the name to Leica Historical Society of America, partly because the new name denoted a growing interest in histori-

cal matters as well as in the camera itself, and partly because it formed a friendly bond with societies of the same name in other countries. The membership consists of physicians, college professors, engineers, contractors, businessmen, and many others. A definite camaraderie bonds people from such diverse backgrounds, transcending even national boundaries. An English collector once told us about his unhappiness with so much Leica material (German) being taken out of England by foreign collectors! There is a lively swapping among members, who help one another by keeping an eye open for items that a friend needs. Members are encouraged to write articles on any aspect of Leica lore in which they have developed a good background, and these articles are published in the Society's journal, the "Viewfinder", which is issued quarterly every year. The contents have been remarkably substantial, obviously the result of thorough research in a labor of love. The Viewfinder publishes advertisements for nonmembers as well, hoping to bring as much Leica material into circulation as possible.

Types of collectors

The types of Leica collectors are as fascinating as their diverse backgrounds. Some collectors are adamant about having everything in mint condition, as if the items had just left the factory. This provides an extremely elegant display, but it slows the rate of acquisition. Others have very different attitudes. We can look at the types of collectors in three categories: 1) motivation for collecting; 2) style of collecting; 3) attitudes toward collecting.

Motivation. Some do not knowingly begin collecting Leica items, but simply never part with obsolete items, largely because they are intrigued by innovative mechanisms, smooth-working parts and miniature design. Gradually, a fascinating accumulation of cameras and accessories takes shape, all with the common denominator "Leitz." Unintentionally, this Leica owner is on his way to becoming a collector. Like other collectors, he finds moral support in the specialized societies mentioned earlier. It is interesting and revealing to learn the motivations of other collectors. Many have a love for fine mechanical precision, together with the age-old fascination with miniature versions of larger objects. At Leitz, these two qualities emerged naturally as a result of the

company's solid experience in designing and manufacturing microscopes.

Some collectors select the Leica because it represents the elite in cameras; it is sophisticated; it has status. Others choose it because of historical considerations: while not the first 35mm camera commercially available, it was nevertheless the first *successful* such camera, whose basic design was retained through numerous model changes. Still other collectors desire to combine a hobby with an investment, but most collectors shun the materialistic approach in favor of an interest in the social, national, and personal events that shaped Leica history. These aspects are described in Theo Kisselbach's chapter, "Oskar Barnack and the Development of the Leica."

Styles of collecting are just as colorful as the motivations behind them. Many collectors store their items in cardboard boxes, cabinets, or chests of drawers, because space does not permit a proper display. Occasionally they open their boxes and enjoy the collection, only to wrap it up again, lovingly and carefully. There are Leica collectors who have installed floor-to-ceiling shelves and arranged their Leicas in chronological order in transparent cases, so they can enjoy them every day, show them to visitors, and perform occasional maintenance.

Some individuals collect only Leica cameras as such, with only one lens for each camera. Some collect only screwmount cameras; still others collect only prewar cameras. Some collect everything that carries the name "Leitz." There are specialists in Leica literature, a complex subject in itself. There is the mint collector, mentioned earlier; there is the glutton or accumulator who seeks satisfaction in numbers ("How many cameras do you have?"). One collector specializes in Leicas that belonged to outstanding personalities; another wants everything in usable condition—and uses it! Still another collector has become very knowledgeable about minute variations of Leica M cameras. A tremendous variety of individual styles is held together by the unifying name Leitz. Each collection closely reflects the personal interests of the owner.

Attitudes toward collecting. This criterion yields a kaleidoscope of types in Leica collectors. Most Leica enthusiasts are gregarious and friendly, but some are

secretive, and never say what they have or how they acquired it. One of the authors knows of such a collector in his community. He never leaves his name or address, nor does he agree to meet with other Leica collectors. In contrast, there are the joiners, who belong to every known collectors' club and who attend all the meetings. There are compulsive swappers, who seem to derive more pleasure from acquiring new items than from prolonged owner- ship. Regardless of varying attitudes toward collect- ing, they all share an almost fanatical loyalty to the Leica. They are devoted to preserving its vintage accessories, to studying the personalities that in- fluenced its development, and to recording even minute changes that have occurred in Leitz photo- graphic equipment. (For descriptions of some of the more important cameras that belong in a serious Leica collection, see the first chapter.)

In summary, what a strange mystique we have. If anyone knew exactly how to create such an aura for a given product he would find many eager custo- mers for his talent. Certainly a by-product of the Leitz camera phenomenon is the enormous array of literature about the Leica and about photography with the Leica, written by persons who were not under contract to Leitz—they were simply genuine enthusiasts. Many books, magazines, manuals and guides have been devoted entirely to the Leica, and there are always Leica articles in conventional photo magazines.

To begin a collection today, one should first read about Leica history, then talk with some Leica col- lectors. It is now virtually impossible to hope for a complete Leica collection because there are so many collectors among whom the limited quantities of sur- viving items can be distributed. However, if one carefully selects a small segment within the Leica sys- tem, there is a good chance to assemble a significant collection. And if that reaches a gratifying degree of completeness, the area can be broadened, or a sec- ond collection started to complement the first one.

If we have succeeded in imbuing the reader with a germ of interest in Leica collecting, we are most happy, for it is a fascinating and exciting pursuit. We sincerely wish you good luck, patience, perserver- ance, time, an understanding family, and—oh, yes— the necessary funds. You'll need them all!

PARTIAL BIBLIOGRAPHY OF LEICA LITERATURE

These are key sources for learning about Leica development; many are collectors' items themselves.

Barleben, Karl A., Jr.
Travel Photography with the Miniature Camera
Canton, Ohio: Fomo, 1934
The Leica Data Book
Canton, Ohio: Fomo, 1933

Baumann, Anton F.
The Leica Book in Color
Munchen: Knorr & Hirth, 1938

Berg, A.
Ernst Leitz Optisches Werk
Wetzlar, 1949

Buxbaum, Edwin Clarence
Pictorial Photography with the Miniature Camera
Canton, Ohio: Fomo, 1934

Cash, J. Allan
Photography with a Leica
London: Fountain Press, 1949

Cyprian, T., and Stalony-Dobranski, Wisczorek, Z.
Leica W Polsce
Warsaw, 1936

West, Levon
How to Use Your Candid Camera, by Ivan Dmitri (pseud.)
New York: Studio Publications, 1936

Emanuel, Walter Daniel
Leica Guide; How to Work the Leica and How to Work with the Leica, 7th revised American ed.
Hollywood-by-the-Sea, Fla.: Transatlantic Arts, 1952
Como Trabaja la Leica y Como Trabajar con la Leica
Barcelona: Verl. Omega S.A., 1948

Emmermann, Curt
Photographieren mit der Leica
Halle (Saale): W. Knapp, 1930
Leica-Technik
Halle (Saale): W. Knapp, 1944

Johnson, Philip
The World of the Leica, with Some Notes on Leica Technique
London: Fountain Press, 1950

Karfeld, Kurt Peter, Ed.
My Leica and I; Leica Amateurs Show their Pictures
Berlin: Photokino-Verlag H. Elsner K.-G., 1937
(Translation of *Leica in aller Welt*)
Leica Book in Color
New York: B. Westermann, 1938

Kimura, Ihei
Japan Through a Leica; 100 Glimpses: Sceneries,
Life and Art
Tokyo: The Sanseido Co., 1939

Kisselbach, Theo
Kleines Leica-Buch
Seebruck: Heering Verlag, 1952
Kleinfilm-Foto; Hefte für Kleinfilmphotographie
und Projektion
Berlin, 1931
Leica-Brevier für das Jahr 1949
Wetzlar: Photographia Co., 1949
Le Leicaiste, Revue du Petit Format 24x36
Paris, 108 Boulevard Hausmann; first issued in
1934 as *La Revue Leica* and changed to present
name in 1938; not publ. 1939-1950
Leica Photography
New York: E. Leitz; issued from 1932; first
editor, Augustus Wolfman
Leica Fotografie (bi-monthly)
Frankfurt a.M.: Umschau-Verlag, Ed. Heinrich
Stockler
Leica Information Bulletin (discontinued 1940)
New York, April 1, 1940
Leica News and Technique
London: E. Leitz Instruments, Ltd.
*Close-up and Photomicrography with the
Leica Camera*
New York, 1952
Leica Photo Annual
New York: Galleon Press, 1936 Ed., H. M. Lester

Morgan, Willard D.
The Leica in Science
Canton, Ohio: Fomo, 1935

—and Barleben, K. A.
Developing, Printing, and Enlarging Leica Pictures
Canton, Ohio: Fomo, 1935

—and Lester, Henry
The Leica Manual
New York: Morgan and Lester, 14 editions since 1935

Natkin, Marcel
La Photographie sur Petit Format: Le Leica
Paris: M. Servant, 1933

Person, Alfred
*Bildmässige Leica-Photos durch Tontrennung nach
dem Person-Verfahren*
[Germany] 1935

Pestalozzi, Rudolph
A Leica Amateur's Picture Book
British Periodicals, 1936

Stenger, Erich
Die Geschichte der Kleinbildkamera bis zur Leica
Frankfurt a.M.: Umschau-Verlag, 1949

Stockler, Heinrich, Ed.
Die Leica in Beruf und Wissenschaft
Frankfurt a.M.: Breidenstein, 1941 und 1942

Vith, Fritz
Leica Handbuch
Wetzlar: Technisch-pädagogischer Verlag, Scharfes
Druckereien , 1932

— and Gornert, Paul
Die Leica-Praxis in der Tasche
Wetzlar: Techn. padag. Verlag., 1952

Wolff, Paul
Meine Erfahrungen mit der Leica
Frankfurt a.M.: H. Bechhold, 1934
My First Ten Years with the Leica
New York: B. Westermann Co., Inc., 1935
*Skikamerad Toni; Winterfahrten um Garmisch-Par-
tenkirchen Hochgebirgserfahrungen mit der Leica*
Frankfurt a.M.: H. Bechhold, 1936
Sonne über See und Strand; Ferienfahrten mit der
Leica; Ein Oskar-Barnack- Gedächtnisbuch
Frankfurt a.M.: H. Bechhold, 1936
Arbeit!
Berlin: Volk und Reich Verlag G.M.b.H.; Frankfurt
a. M.: H. Bechhold, 1937
Dr. Paul Wolff's Leica Sport Shots; more than 150
action photographs of the 11th Olympic games
(Berlin, 1936)
New York: W. Morrow & Co., 1937
Meine Erfahrungen mit der Leica;
Frankfurt a. M.: Breidenstein Verlagsgesellschaft,
1939 (not the same text and photographs which
appeared under this title in 1934)

The Scholar's Use of the Leica

Beaumont Newhall

For the scientific, historical, or literary research worker, the Leica or Leicaflex provides a means of quickly making exact and inexpensive records of written and pictorial material. Documents can be photographed in their entirety at distant libraries on field trips and read months later in the scholar's study with perfect assurance that not a word has been misspelled, not an *i* left undotted, not a *t* uncrossed. Every student can possess a picture library as resource material and for the illustration of his writing. Instead of typing copies of sections of books, the researcher with a Leica can quickly have a direct record of the printed words. Handwriting on unique documents, owned by institutions on opposite sides of the earth, can be compared in needle-sharp enlargements. Notes, drafts, manuscripts laboriously prepared, can be duplicated on film for preservation against loss or destruction. Work in progress can be photographed and mailed for a few cents to colleagues all over the world for their study and criticism.

Research with a 35mm camera is far superior to using electrophotographic copying machines. The camera can be taken anywhere; it can copy materials that may not be moved from storage or exhibition, or that are too large for a machine; it can provide black-and-white or full-color records; it can use special films to investigate important materials on location. The 35mm negative reduces storage space requirements and makes it possible to carry vast amounts of research material in a briefcase. Printed materials can be read directly from the negative with a simple magnifier, or any number of copies of any size can be made in a darkroom anywhere in the world. The researcher carrying his own camera is freed from the delay of waiting to use a machine in a crowded library, or the days usually required for a library's own photoduplication service to fill his order. There is no match for the portability and convenience, the versatility, and the economy of the 35mm camera as a research tool.

Most photography in scholarly research falls into one of three general classes, and each demands a special technique. *Class 1* comprises single pages, individual letters, or short articles that the researcher encounters in the course of his reading and would like to record in the quickest way for future reference. With a Leica, these can be photographed at his desk or at the library table with no more equipment than a fixed-focus closeup device such as the Leitz Auxiliary Reproduction Unit. With a Leicaflex, the same thing can be accomplished with an Elpro supplementary lens screwed into the filter threads of one of the camera's usual lenses. Provided that they are to be used as notes, not true facsimiles of the quality of the original, the negatives can be made by the normal illumination in the work place.

Class 2 includes whole books, large collections of letters, photographs, lengthy manuscripts, and other materials requiring a large number of exposures at one time. This kind of work demands a vertical support for the camera so that once camera position and focus are set, the material may be changed rapidly and efficiently. The Leica-Leicaflex Copying Stand is ideal for such photography.

Class 3 calls for making facsimile reproductions for faithful illustrations to accompany the scholar's writing. Equipment which provides groundglass viewing is required—the Visoflex for M Leicas, the regular viewing system of the Leicaflex. Careful lighting of the subject is also required.

Although these classes overlap, you will find it helpful to keep them in mind. It might seem ideal to make every photograph so good that it could be used for both reproduction and study. This, however, means taking complete equipment everywhere, and it adds needlessly to the time consumed in photographing. As will be seen, it is much more difficult to make a facsimile than to make a memorandum record. The difference between Class 3 and the first two classes is the difference between a scholar's final, polished manuscript and his notes, which, although accurate, detailed, and valuable to him, are not intended for publication.

Equipment for copying

The equipment for hasty notetaking is simple: a Leica and the Auxiliary Reproduction Unit, or a Leicaflex and one or two Elpro supplementary lenses, and a light meter. The built-in meters of the M5 and the Leicaflex SL take care of the last requirement. This equipment makes it possible to copy material up to full letter-page size (about 8-1/2 x 11 inches) on a single frame. Larger material may be recorded in several exposures which overlap the area being photographed. In any case, you do not need to move from your work location.

The coverage and use of the Auxiliary Reproduction Unit and the Elpro lenses are discussed in detail in Norman Rothschild's chapter, "Closeup Photography." Since most research copy work is a kind of closeup photography, it is recommended that you consult that chapter carefully, not only for equipment data, but for information about closeup exposure and related matters.

Note that the Auxiliary Reproduction Unit supports M-model Leicas firmly on four legs at exactly the correct distance above the material. A convenient, easily-packed support for a Leicaflex is the Leitz Tabletop Tripod fitted with the large ball-and-socket head. Material may be propped up at a slant and the camera aligned with it by means of the tripod head and the through-the-lens viewing. Some kind of support and a cable release are necessary where low light levels require exposures longer than 1/25 second.

The results of simple notetaking photography will not, of course, compare with work done with more care, but every letter will be distinct and every detail visible. With this technique I photographed, in less than an hour, right in the stacks of a Boston library, every reference to daguerreotypists in New England directories from 1840 to 1861. I made prints for my files from the negatives, stapling together those which overlapped, just as aerial photographs are combined into mosaics. Then I wrote a card for each name to add to a directory of daguerreotypists. The negatives themselves were filed by towns and automatically formed a geographical index. To have transferred this data by hand in the library would have involved several days' living expenses and doing the copying twice—once for the biographical and once for the geographical file. And photographing with the Leica actually took less time than writing out orders for conventional photoduplication!

For this type of work, done under almost any kind of lighting, moderate-speed panchromatic film is best. Exposure is less critical than with the slower, high-contrast films recommended for facsimile copying of printed material.

To keep track of exposures, as each document is photographed, record it in a small (about 3x5-inch) notebook. Every sixth frame, photograph the notebook list of the preceding five exposures. After processing, cut the film into strips of six frames for filing in negative envelopes. The frame with the notebook data insures that each strip has source identification. For reference, identify each strip with a number, each frame with a letter, and enter this code alongside the document listing in the notebook. Later, when you want to refer to a document, consult the

notebook. The code 56C , for instance, would tell you that frame 3 (letter C) of strip No. 56 has the material you want. The negatives can be read directly with a high-power magnifier, such as a linen tester, or by projection, if reference to them is too infrequent to warrant making prints.

The most efficient way to photograph entire books, collections of documents and the other materials grouped in Class 2 is to support the camera over them. The Leica-Leicaflex Copying Stand consists of an upright post on which a carrying arm for the camera can be fixed at any point. Coarse and fine adjustments allow the camera to be positioned with great precision. If you are using a Leicaflex, you can readily fill the frame in exact focus simply by viewing the image on the groundglass. If you use a Leica, it is convenient to choose an area approximately the size of the majority of your documents, say 9x12 inches, and rule a rectangle on the baseboard centered under the lens. To determine the center, hang a plumb bob from a string through the center of a cardboard disk inserted like a filter in front of the lens. Use a small level to check that the camera back and the baseboard are parallel. Rule the rectangle into one-inch squares, or fill it with ready-ruled paper. The exact height of the camera, and the type of supplementary lens or the length of the extension needed to bring the rectangle into exact focus, can be determined from the tables following the chapter, "Closeup Photography."

For the greater part of your work there will be no need to change focus. You will seldom encounter documents larger than 9x12 inches. If you do, you can refocus the Leica or you can photograph the document in sections. Smaller materials will be recorded with entirely satisfactory detail even though they may occupy only a portion of the negative. By framing the nine-inch width of the rectangle precisely in the one-inch width of the negative frame, you record material at a 9x reduction on the film. When prints are required from any negative, by setting the enlarger for a 9x magnification you will get prints the same size as the original. You will save time doing research and in the darkroom by adopting the single-area, fixed-focus approach. Using a standard degree of reduction eliminates troublesome calculations of exposure compensation for the lens extension, and focus is always exact. In the darkroom, the printing exposure will always be the same,

provided that you expose and develop your negatives consistently.

In photographing objects of various thicknesses—books of different lengths, for example—or as you work through a thick volume, the pages you are copying will be different distances from the lens. Groundglass Visoflex or Leicaflex viewing permits quick focus adjustment. Otherwise the book must be raised every few pages to keep the work at the plane of sharp focus, or the camera height must be adjusted to the new subject distance. The fine adjustment on the copy stand makes it easy to raise or lower the camera a short distance with great precision; a collapsible ruler is handy for checking the lens-to-subject distance when changes are made. Again, the tables with the chapter, "Closeup Photography," will help you to quickly figure corrections for major differences.

If you anticipate a great deal of book copying, the Reprovit IIa will speed up the work. Focusing is accomplished by projecting an illuminated target on the page of the book, which is itself held in a clamping box. The Reprovit is completely self-contained, with its own lighting. However, it is not a portable unit. It must be set up in a single location and the material to be copied brought to it.

Films of Class 2 material, containing many exposures of the same or closely related documents, are best kept uncut in rolls so that consecutive pages can be scanned quickly in a reader or with a magnifier. Use the first exposure of each roll to record an identification number, written on scrap paper with a crayon or marker. Use bold figures several inches high—big enough to be visible in the negative to the naked eye.

If you load your own cassettes with bulk film, the edge numbers may not start from 1 on each roll. This makes it essential to assign a roll number to be used in conjunction with whatever edge numbers do appear. Then simple notations such as 17/29 and 30/29 distinguish clearly between frame 29 on roll No. 17 and frame 29 on roll No. 30.

Books up to a large octavo size (about 7x11-inch page size) are best photographed two facing pages at a time to save time and film. Take care to place the book so that the pages will be recorded in consecutive order. With the top of the camera facing you, and the take-up spool at the *left,* have the book upside down as you look at it. Otherwise the film

1

Book copying. With top of camera toward you, film travels right to left. To photograph pages in sequence, book must be upside-down, as at (B)

strip will record the pages in the order 2,1...4,3...6,5... as shown in Fig. 1.

To support and level the book while it is being photographed, you may find an assortment of small wedges and thin strips of wood helpful. You can persuade pages to lie flat by encircling the outer margins and the cover of the book with rubber bands, but a more efficient device is a weighted tape such as medieval scribes used to hold parchment in place. Tie a weight, such as a heavy fishline sinker, to one end of a two-foot length of cloth tape; clip the other end of the tape to the book cover. Let the weighted end hang down over the table edge so the tape holds the outer margin of the page flat (Fig. 2). To turn the page, simply lift the tape.

2

Page holder. Weighted cloth tape holds outer margin flat

A stiff card, larger than page size, is also helpful to overcome curvature in thick or tightly-stitched

books. Insert it under the page being copied, so that the page will lie flat (Fig. 3). The camera back and page surface must be parallel to each other. If necessary, the weighted tape can be used to hold the outer page edge. To increase the contrast of the dark type against the white paper, use the white card if there is no printing on the other side of the page. Otherwise, use a black card to minimize any bleedthrough.

3

Avoiding curvature. Tightly-sewn books may curve severely into gutter (A). Stiff card under page being copied provides flat surface (B)

If you are photographing in a well-lighted room, you do not need special illumination for making study records. Medium-speed panchromatic film, developed for fifty-percent more than recommended time to increase contrast, gives negatives of printed material that are ideal for viewing by projection. Prints from them on high-contrast paper are somewhat gray, but perfectly readable.

However, for illustration purposes, where high fidelity is essential, this technique is not satisfactory. In such cases, individual attention must be given to each exposure. For linework (type, handwriting, woodcuts, engravings, etc.) use a high-contrast film such as Kodak High Contrast Copy Film 5069. Such films have the advantage that they yield negatives that are black-and-white with essentially no middle tones, and the disadvantage that their latitude is so narrow that errors of exposure will cause highly unacceptable results.

To get the best possible copies with this material, you will need as little image reduction as possible. Refocus the camera for each variation in the size of originals so that you use the maximum amount of

Careful choice of film and filter can eliminate stains and discoloration in old paper, parchment, fabric, etc. Strong sidelight here reveals the texture of leather and the incised quality of the writing. True facsimiles of handwriting are often important in authenticating documents and may give clues to the character, age or health of the writer

negative area. Although it is possible to do this by calculation, the use of a Visoflex or a Leicaflex is recommended.

Careful lighting is necessary to make the illumination uniform over the entire field, for any unevenness will be grossly exaggerated by the high-contrast film. Direct at least two, and preferably four, reflector lamps at the material. Adjust them until a light meter shows the same reading on every part of the field. Pay special attention to balancing the four corners with one another and with the intensity at the center of the field. Use an incident-type light meter, or make a reflected reading from a neutral-gray card that fills the camera field. The illumination need not be intense, for long exposures are perfectly feasible in copy work so long as the camera is firmly supported and you use a cable release.

The light meter will give an indication of the correct exposure, but the character of the document must be taken into account. Paper yellowed with time takes a longer exposure than the coated paper of a book published yesterday. Newsprint absorbs light in deceptive quantities. No general exposure factors can be given, because the character of the illumination is another variable. The solution is the old adage: "Trial and error teaches, tells." Collect sample documents of all classes you intend to photograph. Make five exposures of each,

changing one-half-stop each time—keep a record of each variation, of course. A session with the enlarger will quickly show you which stop is optimum for each class of material. For material with linework and continuous-tone copy on the same page, make tests with high-contrast and normal panchromatic emulsions to see which is the best compromise for the mixed situation.

Documents are often on colored paper, or on paper that is severely yellowed or stained. To photograph them so they will appear black on white, the basic solution is to use a filter of the same color, but greater saturation, as the color you want to eliminate. Leitz filters are more than satisfactory for many situations; other problems can be solved with gelatin filters which are inexpensive and may be easily cut to any required size. They are commonly slipped into cardboard rims and can be fitted to the lens with clip-on holders.

For negatives of continuous-tone material—halftone illustrations in books, lithographs, photographic prints, daguerreotypes, ambrotypes, tintypes

dimensions, était complété par un dessinateur, puis gravé par Chrétien lui-même sur une plaque de fer-blanc ou de cuivre.

Chrétien opéra d'abord à Versailles, puis, en raison de la faveur qui s'attachait à ses portraits, il vint se fixer à Paris en 1788. Il s'était adjoint un peintre en miniatures, Quenedey [1], qui travailla d'abord avec lui, puis

G.-L. CHRÉTIEN
Musicien du Roi
Inventeur du physionotrace
(Gravé par lui-même en 1792)

Mᵐᵉ L.-A.-P. CHRÉTIEN
(Portrait gravé par son mari en 1793)

—use low-speed panchromatic films. To obtain positive black-and-white slides for projection, a film such as Kodak Direct Positive Pan may be used, or any of several panchromatic negative films may be reversal-processed.

Daguerreotypes present no problem if you remember that they are literally pictures on mirrors of highly-polished silver. The silver plate forms the shadows, a whitish amalgam of mercury forms the highlights. When the bare silver reflects a dark field, the shadows appear dark and the image looks positive. However, stray reflections of equipment are often a problem. The solution is a baffle of black cardboard which provides the required dark field and masks off the camera and shiny metal parts. Cut a hole in the center for the lens to look through, and clamp the card to the camera stand during exposure. Daguerreotypes are deceptively low in contrast and require a fifty-percent increase in developing time, so do not take them on the same film with material that requires normal development.

Ambrotypes and tintypes have collodion emulsions with grayish-white light tones. Copy them as if they were normal continuous-tone images, using a panchromatic emulsion. Note that the ambrotype is really a kind of negative on glass; when backed with black it appears positive. Often it is possible to replace the original backing with a more

Combined line and continuous-tone materials present no challenge if a few tests are made beforehand. This book page was photographed with a low-speed panchromatic film (Kodak Panatomic-X) and existing light. (Illustrations of Gille-Louis Chretien, inventor of the Physionotrace, a pre-photographic method of making miniature portraits, and his wife)

intense black for greater contrast. It is also possible to use the glass plate as a negative for contact-printing or enlarging. Some experimentation to find a suitable grade of printing paper contrast will be required.

Faded photographs that have become pale yellow and have lost highlight detail from exposure to pollutants in the atmosphere yield excellent copy negatives on the high-contrast film generally intended for linework. Alternatively, a blue filter with panchromatic film restores contrast to faded, yellowed images.

Music historians have found 35mm photography an excellent way to reproduce complex musical scores from ancient handwritten originals speedily and without error. In the old days, the student of music would have to sit for hours and hours in libraries and archives in order to copy by hand a few musical pieces. Only the most well-to-do could afford a professional copyist. In any case, when later

Daguerreotypes are beautiful, full-range images on a polished silver surface. The silver must reflect a dark field to make the image appear positive. When possible, removing cover glass will eliminate stray reflections. Style of frame, details of case (requiring a second photo) often help in approximate dating. (Daguerreotype of his wife by Alexander Hesler, ca. 1850; collection, International Museum of Photography, Rochester)

Copying photographs in collections or exhibitions requires panchromatic film, even lighting. Copy negative must be fully-exposed to record dark-area detail, slightly flat in contrast to ensure printable light-area detail; proper paper grade will restore brilliance in copy print. Even faded, discolored photos can yield excellent copies; see text. (Original photograph by Paul Outerbridge, 1922; collection, Museum of Modern Art)

consulting the copy, he could never be sure whether what he was studying was exact, or whether it contained unwitting errors of transcription. Photography not only eliminates mistakes, it gives historians hundreds more hours for research and investigation. And it serves a far more important function. The impact of modern pollution on ancient inks and papers has been disastrous. Photography offers the only means of preserving what is still intact of thousands and thousands of deteriorating documents in all fields of study.

Color

Many researchers, particularly art historians, require records in full color. The Leica or Leicaflex is ideal for this purpose, because color transparencies are most economically made on 35mm film. The procedures do not differ from the use of black-and-white films, except that matching the type of illumination to the film emulsion is critical. It should be pointed out that it is impossible to compare a transparency with a painting; the quality of transmitted light is quite different from that of reflected light. A point-by-point matching of a color slide and a painted canvas is therefore not possible. The best approach is to photograph the painting as an object, rather than as an image, lighting it so that the impasto of the paint is visible in relief, and including the frame. The same holds true of all art works and artifacts. The scholar must realize that he can obtain an equivalent, but never an absolute duplicate in color.

In many museums the Leica has become an indispensable tool for the cataloger. It is often impossible to describe a work of art, a natural-history specimen, or a relic of the past by words alone; photographs mounted on catalog cards provide positive identification. Furthermore, such a pictorial inventory puts on record the condition of the specimens at the time they were received. For this work it is wise to group the material roughly into categories. Photograph flat objects of less than two feet in their largest dimension with the camera mounted above them, on a copying stand. Large pictures can be

placed on an easel, with the Leica on a tripod. Illuminate them evenly. Pieces of sculpture, miscellaneous objects, and other three-dimensional specimens usually appear to advantage with one strong light placed fairly high and at about 45° from the camera axis, and a weaker light to fill in the shadows. Careful placement of lights is not necessary for identification photographs, but it is essential for those pictures to be used for publication and study. The background should be continuous and undistracting. Large rolls of paper can provide an unbroken background from the floor or table top up onto the wall behind the subject. Various shades or colors can be used to provide clear contrast with all edges of the subject. It is a good plan to include in the picture a scale marked in inches and centimeters.

While contact prints from 35mm negatives are adequate for identification, slight enlargements are preferable, especially if there are important small details to be seen. An illustrated catalog of prints large enough to be studied without a magnifier saves needless handling of originals. For example, in a museum without an illustrated catalog and with a large collection of posters stored in numbered tubes, the curator would have to spend hours carefully unrolling each poster to make selections for an exhibition. By referring to the catalog cards, he can accomplish this task in much less time with no danger to the originals.

The negatives of inaccessible materials should themselves be cataloged. For other materials, it may be more practical to make some identification prints and discard the negative, if the originals are available to be rephotographed should the need arise. The deciding factor is the amount of time that bookkeeping consumes. The photography itself is the simplest part of the process.

Material that is lent by a museum, a library or a researcher can be photographed with a Leica in less time than a written record can be made. Illustrations submitted with a manuscript, books on loan, entire exhibitions, can be quickly photographed with the camera in a simple fixed-focus setup. The negative will serve as a record, and often as a substitute for the material while it is on loan.

The private collector will find the Leica as valuable as the public institution. No matter what you collect, an illustrated catalog will add to the value of your collection. And with the Leica anybody can become a collector. Most libraries and museums will allow photographs to be taken of objects in their collections when the intent is serious study; often they will provide a place for you to work. But it is not always necessary to go far afield. Every family has photographs of the last hundred years tucked away in bureau drawers, or tied up in bundles in the attic, garage or basement. With the Leica these can be copied to a uniform size and duplicated so that every member of the family can have a set.

In his book, *The Pencil of Nature* , in 1844, William Henry Fox Talbot, inventor of the negative-positive process, showed that photography could be used to catalog libraries, record collections, provide facsimiles of manuscripts, woodcuts and engravings, document sculpture and architecture. In 1889, Peter Henry Emerson also set down in his *Naturalistic Photography* some of the things that "this cool young goddess, born of science and art" might accomplish. "She twits the librarian," he said, "with the ever increasing deluge of books, and hints laughingly they must one day come to her, for she will show them how to keep a library in a tea caddy." With the development of the 35mm camera it has all come true.

Audio-Visuals
with Leitz Equipment

Ernest Pittaro

A variety of audio-visual material can be made with Leitz cameras with convenience and dependability. The most obvious are slides and filmstrips, but classroom charts, flashcards, pass-arounds, overhead projectuals and short motion pictures can also be prepared easily. Live-action photographs, printed matter, original artwork, model settings, specimens, charts and lettering can all be used as sources of material.

Basic procedures

Whatever medium the producer of audio-visual aids wants to use, the work finally comes down to using the camera as a copying unit. The accuracy of construction in the Leica and Leicaflex make them ideal choices for careful alignment of visual images and undistorted, parallax-free recording of sharp detail in the most critical setups. Copying can be handled with ease using a Leica M camera and the Visoflex attachment, or a Leicaflex, which provides direct viewing through the lens. In either case, a bellows and extension tubes may be necessary to focus at sufficiently close range. These accessories and their use are discussed fully in the chapter, "Closeup Photography."

One of the most important precautions to be taken in all copy work is to make certain that the camera, copy stand and copy are free of vibration. The use of the camera's self-timer will help in this regard, so that once the cable release is tripped, the camera will have time to settle down before the actual exposure is made. Be aware of vibration from external sources such as heavy traffic, or machinery in adjoining building space. Sometimes such nuisances can be avoided by doing the photographic work at night.

Lighting

Absolutely even illumination across the copy area is the second fundamental of good copy work. The smaller the area, the easier the task. For anything up to approximately 9x12 inches, two lights are adequate, one on either side of the copyboard. The lamps should be far enough away so that their coverage areas blend evenly. The angle of the lamps as related to the lens axis can vary from thirty to sixty degrees. The surface texture of the copy will influence lamp placement somewhat, for the more horizontally light skims across the subject, the more surface irregularities are thrown into relief and cast shadows. Forty-five degrees is optimum for most copy; if the lamps are closer to the lens axis, the chance of picking up glare, or the lamps' reflection, is much greater. Another precaution is to conceal the camera from the copyboard with a black card which contains a hole for the lens to look through. The card will prevent highlights on camera parts, or bright surfaces such as the photographer's hand, from being picked up by the glass that is commonly used to hold the copy flat.

Evenness of lighting can be checked by taking incident-light meter readings at the four corners and the center of the copy area, or by photographing a white card as copy on high-contrast film. When developed, the film will exaggerate any unevenness in the illumination and adjustments can be made. (Reflected-light readings from an 18% reflectance gray card are the equivalent of incident-light readings.)

For copy areas larger than 9x12 inches, better lighting is achieved by using four lamps, one at each corner, aimed diagonally across the copy. Whether a two-light or a four-light setup is used, each lamp should be directed at the opposite, not nearest, edge or corner. If the illumination is too bright at the edges, pull the lamps farther from the copy area. This will reduce the overall intensity somewhat, but it also will even out the intensity over the entire area.

Film

Color. Kodachrome II film is an excellent choice for transparencies to be used as slides, or as originals of low- and medium-contrast subjects which are to be used for further copies. Kodachrome II comes as close to a grainless color film as anything known at the present time, and the contrast characteristics provide excellent images. If your copy setup is equipped with 3200K lamps, Kodachrome II Professional, Type A, with a No. 82A filter (ASA 32) will give good results. Using the same film with photoflood lamps requires no filter and permits an ASA 40 rating as an exposure guide. In copying transparencies by transmitted light, Type A films can be used with the sources mentioned above; electronic flash illumination will allow the use of Kodachrome II Daylight Film (ASA 25) without a filter.

In recopying transparencies, color correction (CC)

filters may be used to compensate for variations in color balance. Density variations must be compensated for by increasing or decreasing the exposure. Extension tubes or bellows are usually required for 1:1 slide copying. Extension requires extra exposure, and this factor must be considered when taking the picture.

Black-and-white. A medium-speed panchromatic film will give good copies of continuous-tone material such as photographs, but may be too fast for some work—f/11 at a mid-range shutter speed is best for most copying. Slower films, such as Kodak Panatomic-X (ASA 32) have very fine grain and an excellent scale for copying. For line copy (black-and-white drawings, woodcuts, etc.), Kodak High Contrast Copy Film (ASA 64) is by far the best choice for 35mm work.

For general copying and duplication, these films will give excellent results, but your own experimentation with other films will allow a variety of applications for different kinds of work.

Some black-and-white films can be reversal-processed to provide positive transparencies. The Kodak Direct Positive Developing Outfit contains the chemicals and instructions for processing Kodak Direct Positive Panchromatic Film 5246 and Panatomic-X film. Slides can also be obtained by copying black-and-white prints on color slide film. Exposure, and color balance of light and film must be controlled carefully to avoid unwanted color cast.

Lettering

One problem that seems especially difficult for many people is the inclusion of professional-looking lettering in their visuals. Fortunately, there are some very handy materials to aid the individual who needs captions and titles.

Art supply houses stock lettering templates and guides, and a variety of rub-on or self-adhesive type faces, which are easy to handle and produce clean, neat captions. Stencils and cutout letters are also available, but unless used with skill they usually look amateurish. Hand lettering is difficult to produce on an occasional basis; it should be done by a professional artist. Hot stamping, using printers' type and pigment tissue, gives excellent results, but requires a special heated press.

Captions can either be put directly onto the artwork, or onto clear sheet acetate (.005-inch thick is standard) which can be laid over the copy when it is photographed. Legibility against the visual background is very important, and often it is necessary to lay a solid background for the lettering across or below the picture. This of course restricts the meaningful part of the picture to a smaller area in the frame.

Titles can also be made by shooting background pictures first, then double-exposing white letters on a jet-black background over the pictures. This "burn in" technique is widely used professionally, but you must be able to align the frames exactly for the two exposures.

Whatever the application, lettering should be readable without difficulty from any part of the audience. Generally, limit a caption that appears over background visual material to one line of five words. Limit non-pictorial written material to twenty or twenty-five words or bits of data, set in five lines. Use all capital letters, if possible, in a bold type face and in a color that contrasts well with all background material. Letter height should be no less than one-tenth the height of the copy area; spacing between lines should be at least one letter height. Leave ample margins at top, bottom and sides.

Slides

One of the most versatile tools for the teacher is the slide. Sequences may be changed, lectures may be adapted to various audiences or brought up to date, simply by rearranging, adding or subtracting slides. Accompanying information may be supplied by a live narrator, a recording, or a supplementary sheet. Slides can be a final product, or a preliminary step in the production of filmstrips. Slide sequences can be edited on a light box, with no additional equipment. Many different Leitz projectors (see list at end of this chapter) are available to be used alone or in pairs, with or without sound, so presentations can be made in a most attractive way. The ease of making slides makes them very popular with teachers who wish to supplement their courses with original materials unavailable from commercial sources.

In producing slides, the first thing to consider is the proportion of the frame. The Leica format of 24x36mm—an aspect ratio of 2:3—makes it possible to photograph a subject in a horizontal or vertical layout. In recent years, the use of vertical format slides has been diminishing, perhaps because the public has become accustomed to the horizontal

format of television screens and wide-screen motion pictures. However, the choice depends upon the subject matter and the manner in which the finished slide is to be used. Projection screens are usually square to allow for either format.

Subjects must be pleasingly composed within the 2:3 rectangle, and this aspect ratio is particularly important in preparing artwork, charts and printed matter. Care must be taken to ensure that the material being photographed is compatible with the frame size. If necessary, borders or backgrounds must be extended so that the camera can frame the information material well within the usable area of the slide.

Transparencies to be used for direct projection can be mounted in various ways. Most common is the cardboard mount in which transparencies come from the processor, ready for use. The film itself is lacquered to protect the image from fingerprints. As the cardboard frame is thicker than the film it encloses, there is little likelihood of abrasion except through extremely careless handling. There is ample room on cardboard mounts to write numbers or other identification. The slides are lightweight, can be stored compactly, and can be shown in any projector, manual or automatic. Under normal conditions, cardboard mounts have proven to be practical and convenient when slide use is restricted to one or two individuals.

However, when the slides are used a great deal or are handled by a large number of people—slides that circulate from a library, for instance—a sturdier, more protective mounting is essential. The following items, available from E. Leitz, Inc., will solve any slide mounting problem:

Perdia plastic mounts, without glass, for unmounted transparencies.

Perrot-Color metal-and-glass mounts, standard thickness or ultra-thin, for unmounted transparencies.

Per-O-Slide metal-and-glass mounts which go over standard cardboard mounts.

These mounts are available for 24x36mm transparencies, with either standard, or anti-Newton-ring treated glass. Perrot-Color mounts are also available with masks, or in alternate sizes, for transparencies in other formats: Tessina (14x21mm); single-frame 35mm (18x24mm); Instamatic (28x28mm); Superslide (38x38mm); 2¼-inch square (6x6 cm); "Ideal"

(54x70mm). Accessories include film and mount trimmers, rapid fasteners to seal the metal mounts, and self-adhesive labels.

Leitz also supplies glass plates, silvered masks, and silver-finish Mylar tape for traditional slide mounting. This method of binding is rapidly giving way to the superior, and quicker, metal-and-glass mounts.

Filmstrips

One of the most widely-used visual aids in classrooms today is the filmstrip—a length of 35mm film with a series of consecutive still pictures which is advanced through a projector one frame at a time. While slides can be used as separate entities, and their sequence rearranged at will, the filmstrip pictures must be used in the prearranged order. This ensures a uniform presentation no matter who is using the strip. Filmstrips are comparatively inexpensive, and their compactness stores a great deal of information in a minimum of space.

The frame size in a filmstrip is 17x22.5mm, a little less than half of a standard slide frame. Copy is prepared so it can be placed in a masking template that divides the standard copy area in two (see Fig. 3, p.471). Thus the camera photographs two frames at a time. This provides forty frames on a twenty-exposure roll, seventy-two frames on a thirty-six-exposure roll. However, to allow protection at the film ends, standard filmstrips use only thirty-eight or seventy frames of visual material.

Care must be taken to properly orient the film so that all material will appear proper end up and in correct order. It is wise to label the template (outside the portion seen by the camera) to coordinate with the direction in which the camera moves the film—left to right in all Leica cameras. (In the chapter, "The Scholar's Use of the Leica," Figure 1 and the accompanying discussion explain how to ensure proper orientation and sequence of material.)

Color filmstrips are easily made with standard transparency (slide) films; processing provides a positive image. Black-and-white films must either be reversal-processed, or the artwork and titles must be prepared with reversed tonality so that the negative image will appear positive. For example, copy with black letters on a white background will appear white-on-black in a negative image and be perfectly usable for projection. In fact, this tonality is to be preferred, because a white screen dazzles the audi-

ence's eyes and makes it difficult to read dark letters. (It also shows dirt and dust on the film as large black specks.) When shooting reverse-tone copy, be sure to use a white template so that the picture edges will be masked in black. And keep all white surfaces clean. Black specks on the copy or template will become pinholes of white light when the negative image is projected.

As with slides, captions for filmstrips should be brief and to the point, using as few words as possible to convey the meaning to the audience. One- and two-line captions are best. Remember that each line of written material reduces the picture area.

Overhead projectuals

These large transparencies (about 8x10 inches) are relative newcomers to the audio-visual field. They are held in cardboard frames and shown with a special projector which consists of a horizontal light box with a stage illuminated from below upon which the transparencies are laid. Above the stage, a front surface mirror and lens direct the light to a conventional projection screen. The projected image is quite brilliant, and allows the use of overhead projection in ordinary roomlight without substantially impairing the quality of the image.

There are many advantages in the use of these projectuals. The stage is open on all sides so that the operator can point things out on the transparency with a pencil or pointer. He can even write or draw on them with a china-marking crayon while they are being projected. Components may be flipped into or out of the image in the form of overlays tape-hinged to the basic transparency. Two-dimensional models with moving parts manipulated by the operator can appear to move or grow on the screen. For example, a graph will seem to draw itself as an opaque overlay is slowly pulled off to one side, revealing the transparency below. It is also possible to use special-pattern polarized tapes which are applied directly to the transparency. By fitting a motor-driven polarizing disk in the light path, repetitive motion is created on the screen. It can be used to show flow along a given path, or call attention to a particular element.

Transparencies can be made on colored materials, or the clear acetate can be hand-colored in a variety of ways. Diazo-process colored foils can be added for various effects. A number of films (such as Kodak Autopositive, Ektalith and Verifax materials) are available for making overhead projectuals of line and half-tone dot material. Conventional films can be used to make transparencies of continuous-tone copy. And clear acetate can be used for hand-drawn and taped or paste-up visuals. The range is great, and the methods are simple.

Other visual aids

Large photographic prints of drawings, charts, lettering and photographs can be used in a variety of sizes for display to an entire group. Small prints can be used as pass-arounds. Flashcards and other instant-recognition materials can be duplicated in any number by simple photographic printing methods. The production of such materials involves no more than basic photo and darkroom techniques.

Motion pictures

The use of motion pictures in audio-visual work is an entire field in itself. The range extends from brief, single-concept movies made by an individual teacher for a particular class, to full-scale professional productions designed for wide audiences. The production of movies is beyond the scope of this chapter, but special mention must be made of the Leicina Super RT 1 camera.

Leicina Super RT 1. A motion picture camera that can handle any film-making project with completely professional results

This Super-8 film camera has a range of features and quality of construction unmatched by other equipment. Its major features include:

Diagonals through the corners of a given rectangle provide guides for layouts in the same proportion at any larger or smaller scale

8-64mm f/1.9 zoom lens with two zoom speeds. Through-the-lens viewing throughout operation. Automatic exposure control with manual override. Single-frame operation and speeds of 9, 18, 25 and 54 frames-per-second.

Backwind up to 80 frames for superimpositions and dissolves.

Single-frame counter.

Split-image rangefinder for focusing.

Two pulse rates for fully-synchronized sound recording.

An electronic control unit for remote control, time-lapse and interval photography for up to 12 days, time exposures up to 5 minutes, flash synchronization with single-frame photography, and tape recorder synchronization.

These are full-professional film-making capabilities. They make the Leicina Super RT-1 an outstanding choice for any kind of audio-visual production.

Whichever medium is chosen, there are certain basic considerations common to the preparation of all visual materials.

Proportion

The first consideration is that of aspect ratio, the relationship of height to width in the frame. The standard slide frame has a 2:3 ratio; a filmstrip frame is close to a 3:4 ratio. Overhead projectuals have various formats, of which 3.75:5 (7-1/2x10-inch picture area) is most common.

Laying out material is aided by the kind of guide shown in Figure 2. On graph paper, draw a rectangle any size in the desired aspect ratio. Connect opposite corners with diagonals that extend to the edges of the paper. Any other rectangle whose corners fall on the diagonals will have the same aspect ratio. Thus it is possible to lay out large or small materials in a properly-proportioned area.

To prepare final copy, templates of the type shown in Figure 3 will define the copy area precisely. A standard overall size of 10x12 inches is easy to work with and to file. Note that the camera field is larger than the safe copy area, to allow for variations in slide mounts, projector gates and screen sizes. It is essential to keep these inner borders clean on final material so that fingerprints and smudges will not be photographed.

Exact-size templates are essential when preparing final copy for slides (top) or filmstrips (bottom). A similar template is laid over filmstrip copy when shooting to divide the standard 35mm frame in two

A great deal of material today is prepared for use both in classrooms and on television. Such material must be in a horizontal format to conform to the television screen. The TV aspect ratio is 3:4. Copy must be kept at least one inch inside the copy areas marked in Figure 3 (but using the same camera field) to allow for the misadjustment of picture size common on most sets.

Production details

A little careful planning and some extra trouble in preparation and shooting will provide excellent pictures. It is wise to take a number of shots of a given subject to give yourself latitude in arranging the presentational sequence. Different viewpoints, different focal-length lenses, and bracketed exposures will ensure a good series of pictures from which to choose.

You must especially use a discerning eye in the choice of background and subject matter. If live-action pictures are being taken in a classroom, is the wall behind the subject free of peeling paint or cracks in the plaster? Are you sure that your light sources are not causing ugly reflections in windows, glass door panels, or shiny paint? Is furniture scuffed or dirty? Can something better be substituted? Can furniture be moved from its usual location to show things more clearly? Is the subject wearing clothing that will photograph well? Is it well-pressed? Are the fingernails in that closeup clean? It may seem needless to mention some of these things, but in point of fact, such details frequently escape attention until they appear in the finished photographs.

Whether flash or flood illumination is used, the placement of the light sources must be handled with care to avoid bad shadows and reflections. Everything within range of the camera should be adequately lighted to balance well in the picture. Backgrounds, in particular, must not fall off into murkiness. Lights should be placed so as to appear logical in source. People in the picture should be brought far enough away from the background to achieve good separation. Shadows should be softened with fill light so that they do not become distracting patterns.

In photographing small objects and table-top setups, the same considerations apply. Backgrounds must be chosen to set off the principal subject well. Depth of field, which is quite shallow in closeup

work, can be turned to advantage by having the subject in sharp focus, while the background falls off into soft focus, creating a pleasing dimensional effect.

Regardless of the subject matter, preplan as much as possible in terms of pictorial content, composition, and sequence. Remember that a few extra shots can give you the greatest freedom in building a presentation.

Presentation methods

The use of large display visuals, pass-arounds, flashcards, and the like is dictated by the size and nature of the material itself. Slides, motion pictures and overhead projectuals, too, define somewhat the manner in which they may be presented. But a great range of approaches is possible.

•Some presentations are automatic; they play continuously as the audience moves by. Permanent displays often use this technique. Other material is prepared for an individual to present to himself. Cassette tape recordings and self-contained film cartridges are typical examples. But by far the most common presentation is by an instructor or lecturer who controls the projector and the accompanying sound.

A wide range of Leitz slide projectors is available to meet any presentational need. Their features are summarized at the end of this chapter. While live narration may be suitable for some presentations, combined tape-and-slide presentations are coming into common use. Leitz distributes the Philips N2209 AV cassette tape recorder for use with Pradovit-Color slide projectors. The recorder can be used to record and play back any kind of sound track or narration desired for the presentation. The accessory Philips LFD 3442 slide synchronizer records silent pulses on a track of the tape. When the projector and recorder are interconnected with this unit, the slides change automatically in exact synchronization with the sound as the tape plays.

Multiple screen presentations

Multi-screen techniques of projection can make very effective presentations of properly prepared 35mm slides. Original photography must be planned with an overview of the finished screen effects—superimpositions, overlaps, rapid changes, composite pictures, etc. A rough storyboard—an outline

sequence of sketches—can be of great help in developing ideas and in guiding the execution of the photography so that all the images will fit together smoothly.

The multi-screen idea implies the use of two or more projectors, usually coordinated by a control mechanism to cue the various machines and maintain synchronism with a sound accompaniment. Leitz supplies a multiple projection system control unit (Cat. No. 98,761) for alternate projection with two Pradovit-Color 250 Autofocus projectors. Banks of projectors with similar controls can be arranged to put four, six, eight or more images on the screen simultaneously or in desired sequences and arrangements.

When two projectors are aimed at the same screen area, their pictures will be superimposed. But if one picture is faded out while the other is being faded in, a dissolve from the first picture to the second is created. Various devices are marketed to accomplish this automatically, or it can be done manually with a voltage control in the line to each projector, or an accessory iris diaphragm attached to each lens.

Related slides can be dissolved very effectively to create a kind of motion effect. For example, if the picture dissolves from a person frowning to the same person smiling, it appears that we have seen him change expression. Of course, all such closely related shots must be framed to match in the camera, and the projectors must be aimed to frame exactly the same screen area. Most multiple projection setups provide for the projectors to be bolted or otherwise fastened firmly in position so that effects may be made with precision.

The effectiveness of multiple screen presentation is something that can be controlled from the earliest planning stages, but it requires great imagination to visualize the final screen effect at that stage. Very effective shows can be produced with as few as three projectors, or as many as twenty. It all depends on the goals of the photographer.

Leitz projectors and accessories

Pradovit-TA
24V, 150W lamp, 110-130 or 220-240VAC operation. Uses same slide magazines as Pradovit-Color projectors. Motorized forward and reverse slide changing for all 35mm slides; also manual operation and single-slide projection.

Pradix
110V, 150W lamp. Manual operation; accepts all 2x2-inch slide mounts. Extremely compact and portable, greatest simplicity of operation of all Leitz projectors. Socket in base for tripod-mounting. Accessory filmstrip carrier.

Pradovit-Color
Models: 150; 150 Auto-Focus; 250; 250 Auto-Focus.
All models have 3-30 sec. adjustable automatic timer, heat filter, remote control, 110-240VAC operation; all use 30-, 36- or 50-slide magazines for 2x2-inch mounted slides.
"150" models have 24V, 150W halogen lamp.
"250" models have 24V, 250W halogen lamp.
A continuous-cycling mechanism may be ordered in any model, or installed by Leitz in existing models. It is not possible to convert a "150" to a "250", or a manual-focus to an auto-focus projector.
Accessories include:
Multiple projection system control unit for two Pradovit-Color 250 Auto-Focus projectors.
Multiple outlets for tape recorder synchronization.
Light pointer.
Adapter brackets to accept Prado-Universal projector attachments including filmstrip carrier and micro-projection attachments.

Prado-Universal Professional
Models: 35; 2-1/4.
By far the most precise and versatile Leitz projectors, with special accessories. The first choice for audio-visual work.
The "35" is for 2x2-inch slide mounts; the "2-1/4" for larger transparencies. Both models have a 24V, 250W blower-cooled lamp, 100-240VAC operation, and a basic manual slide changer.
Accessories include:
Semi-automatic changer which accepts Pradovit 30-, 36- or 50-slide magazines ("35" model).
Filmstrip carrier for showing 18x24mm frames ("35" model).
Micro-projection attachment.
Vertical micro-projection attachment.
Both attachments permit projection of microscope slides and images of living organisms. Both have 4/0.12, 10/0.25 and 25/0.50 objectives, and 4x Huygens projection eyepiece.

Pradovit TA Projector

Pradovit-Color 250 Projector

Prado-Universal 35 Professional Projector

Pradix Projector

Screen Size and Projection Distance

PROJECTION DISTANCES IN FEET	TRANSPARENCIES 24x36mm											TRANSPARENCIES 2¼ x 2¼″ or 2¾ x 2¾″ (effective size 54 x 54 mm)				
	35	50	85	90	100	120	150	175	200	250	300	150	175	200	250	300
7′	6′7″	4′9″														
10′	9′10″	7′1″	4′	3′9″	3′5″							3′5″				
13′	13′1″	9′2″	5′3″	5′1″	4′7″	3′11″						4′7″	4′1″	3′5″		
16′		11′6″	6′7″	6′6″	5′11″	4′11″	3′11″					5′9″	5′1″	4′3″	3′5″	
20′		13′9″	8′2″	7′8″	7′1″	5′11″	4′7″	4′3″				7′1″	6′1″	5′3″	4′1″	3′7″
23′			9′4″	9′	8′3″	6′11″	5′5″	4′9″				8′2″	7′1″	6′1″	4′9″	4′1″
26′			10′8″	10′4″	9′4″	7′8″	6′3″	5′5″	4′7″			9′4″	8′	6′11″	5′7″	4′9″
30′			12′3″	11′6″	10′6″	8′10″	7′1″	6′1″	5′3″			10′6″	9′2″	7′10″	6′3″	5′3″
33′			13′6″	12′10″	11′8″	9′10″	7′10″	6′11″	5′9″	4′7″		11′8″	10′2″	8′8″	6′11″	5′11″
36′					12′11″	10′10″	8′6″	7′5″	6′5″	5′1″		12′11″	11′4″	9′6″	7′7″	6′7″
39′				14′1″	11′10″	9′4″	8′2″	6′11″	5′7″	4′7″	14′1″	12′4″	10′6″	8′4″	7′1″	
43′						12′10″	10′2″	8′10″	7′7″	6′1″	4′11″		13′1″	11′6″	9′	7′9″
46′						13′9″	11′	9′6″	8′2″	6′7″	5′5″		14′1″	12′4″	9′10″	8′2″
49′							11′8″	9′10″	8′8″	7′1″	5′9″			13′1″	10′6″	8′10″
52′							12′2″	10′8″	9′4″	7′5″	6′1″			14′1″	11′2″	9′6″
56′								11′6″	9′10″	7′10″	6′7″				11′10″	10′
59′								12′4″	10′6″	8′4″	6′11″				12′8″	10′8″
62′								13′1″	11′2″	8′10″	7′3″				13′3″	11′4″
66′								13′9″	11′10″	9′4″	7′9″				14′1″	11′10″
69′									12′4″	9′10″	8′					12′4″
72′									12′10″	10′4″	8′4″					13′
82′									14′9″	11′10″	9′6″					14′9″
98′										14′1″	11′6″					
115′											13′5″					

Figures give the longer screen image side. Corresponding square projection screens should be allow for horizontal and vertical pictures of the 24 x 36 mm frame

Picture Filing and Storage

W. L. Broecker

A vast amount of attention is paid to technical, craft and esthetic considerations in photography, but a central problem is often ignored: what to do with the negatives, proof prints, finished prints and transparencies that modern photographic methods make it so easy to produce in great numbers.

After exposing just ten rolls of 35mm film, a photographer can have up to 360 separate images which must be identified and organized so that he can work with them efficiently. The more enthusiastic a photographer is about his subject, the more rapidly he generates images of it, and the sooner the sheer number is beyond control. What can be done to organize all those images so that they can be located and used when needed and yet be protected from damage when not in use?

For any situation in which a large number of items must be organized and kept ready for use, whether they be photographs, books, tools, or the stock of a store, there must be a comprehensive system telling *what* is available and *where* it is located. An essential part of such a system is safe physical storage, organized to ensure that each item is kept in its designated place and easily brought out when required (and just as easily returned when no longer needed).

A professional, from sheer business necessity, is more likely to recognize the need for organization than an amateur, but many professionals labor with poorly thought-out, patchwork systems that restrict their efficiency and income. The amateur often dismisses the idea of filing his pictures systematically because of the work he imagines it involves. Few amateurs realize how much more pleasure they can get from their photographs if they can deal with them easily and efficiently. Fewer still realize that good organization makes it feasible to exploit a growing body of personal work for professional purposes.

A filing and storage system may be photographer-oriented or searcher-oriented. The first is basic: it helps the photographer find his own pictures when he wants them. The second helps others to locate pictures of a desired subject from the work of a single photographer or many photographers, as in a picture library or stock picture agency.

The individual photographer must begin with a system that meets his immediate working needs. Although needs vary in detail for a photojournalist, a portrait photographer, a product-and-illustration photographer, a scientific researcher, and a family-and-holiday amateur, all require a system that provides well-organized storage and protection.

The simplest system

Basically, negatives or originals are filed by number. Prints or other copies are used for inspection. They are related by file number to the originals but may also be indexed, cross-referenced, handled and marked on without damage to the originals. The following features make up a minimum system:

1. Negatives and transparencies are assigned basic identification numbers (roll and frame numbers).
2. Transparencies are filed by number. A written list catalogs the transparencies.
3. Negatives are printed on contact sheets, one roll to a sheet. The negatives are then filed by roll number.
4. The contact sheets make up a catalog of the collection. All notes are written on the backs of the sheets. They are filed by roll number.
5. A separate written list provides whatever cross-references are desired.

Such a system will meet the needs of many non-professional photographers. It is easy to put into use, even with a backlog of many uncataloged rolls, for it requires little more work than making the usual contact sheet. However it is too limited for a photographer with a great diversity of picture subjects, a busy professional who sells his work, a library or a picture agency. The remainder of this chapter tells how and why to expand the system to meet more complex and diverse needs. It also describes how to number, catalog, store and protect photographic images adequately, no matter what filing system is used.

Overall system considerations

A collection with a large and growing number of discrete items requires that every item have unique *identification*. Every item in the collection must be marked so that it cannot be mistaken for any other, as when several adjacent frames on a roll of film are of the same subject with only slight variations in the photography.

It must also be possible to add an infinite number of items, perhaps of great diversity, to the collection

without in any way confusing or violating the scheme of identification.

Once items are identified, they or their contents require classification and indexing, storage and retrieval.

Classification and indexing make up the broad task called *cataloging*. The scope of a catalog depends on the individual photographer's needs. The catalog: (1) groups items into meaningful categories, (2) shows or describes the content of each item, and (3) gives the specific identification of the item, which in turn tells where it is stored.

Storage provides a safe, accessible physical location for each item, and separates reference copies from irreplaceable master negatives, prints and transparencies. All items are placed methodically so they can be found quickly and easily. The identification system is the link that makes it easy to go from the catalog descriptions to the item itself.

Retrieval is the process of finding the description, identification number and location of a desired item in the catalog and of bringing it out of storage for use. The ease or difficulty of retrieval depends on the efficiency and flexibility of the overall organizational scheme and on *the care with which the system is maintained.*

Overview of the system

A brief overview will reveal its simple but practical organization, and show how the various parts of the system are related.

1. Every original or master piece of material is assigned a unique, concise identification number. Originals are stored in sequence according to these numbers.
2. A catalog of reference copies (such as sample prints or contact sheets) or written descriptions is organized by subject-matter classification into categories. Each copy bears the same identification number as its original. The number may be expanded with additional coded information to assist in retrieving the original. Each catalog copy is also marked with its file category, and, if necessary, with the photographer's name.
3. Additional copies for distribution, exhibition, sale, etc., are also marked with the identification numbers. They are stored separately from the catalog copies and originals and, depending on

the scope and use of the system, may be organized by categories, by identification numbers, or both.
4. A master log records every number assigned. It may also include technical data, caption notes, subject cross-referencing, order and sales records and other information; or these may be recorded in separate indexes.

Building the system

IDENTIFICATION—*roll and frame*

In an efficient picture-handling system, every original—negative, transparency or print—must be individually identified. All copies, whether photo prints, copy negatives, duplicate transparencies, photostats, electrophotographic or printed reproductions, must bear the same identification as the original from which they were made. Assigning a meaningful code number to each image condenses a great deal of information into a few characters and is the most concise means of identification.

The edge numbers preprinted on most modern 35mm films identify individual frames and thus give sequence data; but they are the same from roll to roll, so a distinguishing roll number should also be assigned. The value of the roll number is greatly increased if it encodes the date the film was exposed. The first two digits designate the year, the third digit (and fourth as required) designates the month within that year (see Box 1). The digits are followed by a dash and the number of the roll within that month (roll numbers begin again from each month). A slant bar and the frame number follow the roll number. Thus, 725-13/22 identifies frame 22 of the 13th roll exposed in May, 1972.

1: Basic Identification Numbering				
72	5	—	13	22
Year	Month		Roll	Frame

If it is important to note the day of the month on which a film was exposed, photographers should record it in the master log; adding digits for this purpose makes the roll number unwieldy. For photographers who give a job number to every assignment and prefer to use the same number to identify the films and prints, it is only necessary to add digits to distinguish the various rolls or sheets of film exposed. If the photographer wishes to include his personal

(i.e., non-assignment) pictures in the total system, he should assign them similar job numbers.

IDENTIFICATION—*film type and size*
A photographer who works exclusively with a single kind and size of film needs only the identification data described above. However, when negatives of various sizes are made, or when both color and black-and-white materials are used, it is useful to indicate the kind and size of the original on all copies. While a master or original is easily identifiable as a 35mm black-and-white negative, or a 4x5-inch color transparency, a file of reference prints that are all in the same format (all 8x10-inch prints, for example) should indicate the format of the originals. This is important for retrieval, since originals are most efficiently stored according to size and kind of film—color and black-and-white stored separately, negatives separated from transparencies, and originals grouped according to size.

A type and size designation on the copies indicates the proper location of the original. Further, type and size identification may make qualitative decisions possible without disturbing the original material in storage. Certain publishers, for instance, insist on large-format rather than 35mm color transparencies when the quality of printed reproduction is paramount; an exhibition director may require an 8x10-inch original negative to prepare a photomural; a color transparency may meet a need but a color negative may not. Type and size designators immediately tell anyone examining the collection whether or not the original meets such specifications.

Image type and size are coded by a combined letter-and-number designator. The major distinctions among originals are black-and-white or color, negative or transparency; these are coded B, P, C, CN (see Box 2). Further type distinctions which affect the visual character of the image are applicable only to specialized collections; most photographers will not need them.

Designators *D* and *G* have special uses. *D* follows any other designator to indicate that the item referred to is a duplicate transparency or a copy negative (i.e., a negative from a master positive image). *G* follows any other designator to indicate that the image is on a glass plate rather than on the usual celluloid or plastic film base.

These film type letters refer to visible, functional differences among films, rather than to emulsion names such as Plus-X, Isopan-IFF, etc. (If such information is wanted, the emulsion used for a particular image should be recorded in the master log. Most manufacturers imprint a trade name on the edge of the film.) The code letters showing film type may change from language to language according to the words used for the various types of film. The principle of choosing letters with mnemonic value (e.g., initials of key words) should be followed, whatever the language.

Size designators (see Box 3) relate to some dimension of the image, given here in inches. Photographers using the metric system or specialized film sizes can easily devise an equivalent code.

3: Film Size Designation

16	16mm film	57	5x7 inches
22	2x2-inch "super slide"	81	8x10 inches
23	2¼x3¼ inches (6x9 cm)		
24	2¼x2¼ square (6x6 cm)		
32	35mm, half-frame image		
34	3¼x4¼ inches		
35	35mm, standard double-frame image		
45	4x5 inches		

2: Film Type Designation

	Basic		Additional
B	Black-white negative	BR	B/W infrared negative
P	B/W positive transparency	CR	Color infrared negative
C	Color positive transparency	O	B/W orthochromatic negative
CN	Color negative	X	X-ray image
G	Glass plate	H	Holographic image
D	Duplicate transparency, or copy negative		

IDENTIFICATION—*other information*

In any collection which encompasses the work of more than one person, the *name of the photographer* should also be coded in the identification number. A catalog print probably will have the photographer's name stamped or written on it, but a negative, a transparency or a cross-reference listing needs more concise notation. The photographer's name is coded by one or two of his initials immediately before the year digits. For example, the fifth rolls taken in November, 1971 by Smith, James Jones and Richard Jones are differentiated S7111-5, JJ7111-5, and RJ7111-5, respectively. This procedure facilitates a usual practice in agencies and libraries: the catalog prints of all photographers are intermingled according to subject categories, but the original negatives and transparencies are filed separately under the name of each photographer. Notations and comprehensive identification numbers on the prints make it easy to secure specific negatives from an individual's file. The number on the negative must also include the photographer's code to ensure that it is returned to the proper file after use.

Box 4 illustrates the construction of a typical comprehensive image identification number. Note that while the entire number goes on prints and copies, only part of the number need be written on the original; and the frame number is preprinted by the manufacturer in most cases. (Since the number in Box 4 specifies a duplicate, the original was either a positive transparency or a color negative.)

MEANING	NUMBER	USE
	4: Image Identification Number	
		On all prints or copies
		On original film
	CND35 / RJ / 7112 / 10/14	
	Film type and size / Photographer / Year and month / Roll and frame	
	Color neg; duplicate; 35mm / Richard Jones / 1971; December / 10th roll; frame 14	

IDENTIFICATION—*marking films and prints*

Original material and all prints and copies should bear the proper identification numbers; the sooner they are marked, the less danger that some images will escape the system or be misnumbered. Ideally, negatives are marked before contact sheets are made, transparencies as soon as they are received from the processor. Small transparencies are marked on their cardboard mounts until remounted, then the number is marked on a label on the new mount. Negatives are marked in the clear film borders, or numbers are scratched into opaque borders.

All negatives are marked on the base, not the emulsion side, so that ink will take properly and letters and figures will read correctly in contact prints. The ink must be deposited evenly with a medium or fine pen point so it will print legibly. An opaque waterproof acetate (or "celluloid") ink must be used; art supply stores carry such inks. Regular drawing ("India") ink is waterproof on paper, but readily washes off film base. This makes it unsuitable for film that is likely to be rewashed or cleaned with a liquid at some later time.

35mm negatives are usually cut into strips of convenient length for contact printing and storage. Each strip from a given roll must receive the same roll number (Figure 1). On 35mm film the roll number is marked in the spaces between sprocket holes. Roll films often have very narrow side margins but provide more space between frames; the number should be marked in the space that will give the most legibility. Markings must be kept away from the edge of the image if the photographer expects to print the full image area with a surrounding black line.

Manufacturers' frame numbers must be checked for clarity and those obscured by processing variations re-marked in ink. (Such variations result when film processed on reels is not developed, or not cleared in fixing, where the edges touch the reel.)

Prints should be marked on the back with roll and frame numbers before the print is developed. Other parts of the identification number (film type and size, photographer) can be marked at this time or added later. Marking at the time of printing reduces the chance of error in matching print and negative and eliminates additional handling of the negative. The less negatives are handled, the better, and even cleaning can cause scratches.

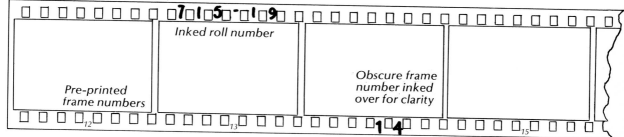

35mm negative marking
All strips from a single film receive same roll number

Prints should be marked lightly with pencil, on the back, before processing. Heavy pressure is almost certain to damage the print. The ink in ballpoint pens, the fluid in pencil-like felt-nibbed instruments (e.g., "Pentel") and the materials of china-marking pencils tend to come off the print during processing and afterward, and may stain other prints.

When prints are dry, the identification number is completed and filing classifications and storage notations added. It is useful to mark the number in a consistent location on the back of the print, usually the upper right-hand corner. Contact prints will automatically bear the basic identification number as it was marked on the negative. This should be copied and other markings added as required.

Self-adhesive labels and the adhesives used for other kinds of labels contain chemicals that will stain prints; many will release gases during storage that can attack photographic images; some adhesives will ooze from under the edges of the label to be transferred to the face of adjacent prints. Obviously all such materials should be avoided.

Procedures for marking transparencies are slightly different (Figure 2). Classification and filing data are marked, together with the identification number, on the mounts of small transparencies. Because the borders of transparencies are opaque, rather than clear, the identification number may be scratched into the emulsion in the border. Classification data and the number should be marked on the protective sleeve with suitable acetate ink. The sleeve must be pulled off the transparency during marking so any pressure or possible penetration of the pen point through the sleeve cannot injure the film.

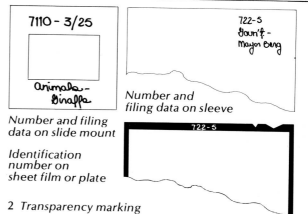

*Number and filing
data on slide mount*

*Number and
filing data on sleeve*

*Identification
number on
sheet film or plate*

2 Transparency marking

Some sheet film holders leave very narrow unexposed film margins; in such cases many photographers prefer to mark only on the protective sleeve or envelope. This practice has the drawback of providing no certain way to identify the film once it is removed from the sleeve.

Cataloging

After pictures have been marked for identification, they are ready to be classified and placed in the catalog. Although it can consist only of index cards with written descriptions (like a conventional library card file), the most useful picture catalog contains actual prints — it is more informative to see the picture itself than to read a description. The recognition of a known picture is positive and pictures can be scanned or searched faster than words. Black-and-white and color prints may be intermingled in the same files or kept in separate files organized in parallel fashion. Because transparencies are unique and especially fragile, it is best to minimize their handling by using a card file or notebook to catalog their content.

Each catalog is divided into categories and sub-categories describing the subject matter or content of the pictures. Categories are established according to the range of the collection, and subcategories are established as needed. For instance, *Animals* will serve while there are only a few pictures of each of various species. When a significant number of pictures of *Bears,* or *Giraffes,* or *Zebras* is accumulated, those subcategories are established under the general heading *Animals* and the corresponding pictures are refiled and listed there.

Some pictures relate to more than one category and require visual or written cross-references. The most versatile catalog files each item under every significant category to which it belongs. For example, a picture of a girl with a raincoat and umbrella in the rain by the Leaning Tower of Pisa might be filed by her name under *People* and also under *Italy-Pisa, Fashion, Rain, Girls,* and *Architecture.*

The picture is first marked and filed under its primary category; then additional prints are marked and filed in each of the other categories (or a "See also. . ." card or sheet, listing the primary category and the picture identification number, can be inserted in the other categories). Extensive cross-referencing is valuable for a large collection open to outsiders, such as researchers, who variously may need pictures for advertisements, textbooks, exhibitions, calendars, news reports and other purposes. On the other hand, the cross-referencing in a catalog of one photographer's work, for his own use, can be quite limited. Two criteria determine the extent of cross-referencing: (1) the scope of the collection and its range of use [is it: (a) one photographer's work for personal use, (b) one photographer's work for his own commercial and personal use, (c) one or more photographers' work for use by others?]; (2) the amount of work required to keep cataloging and indexing up to date. An adequate range of categories and thoughtful assignment of pictures to primary categories will limit the need for multiple references.

CATALOGING—*establishing categories*
The categories should be specific and limited in number. A preliminary list, prepared by marking down the terms that describe the content of each picture to be included, is revised by eliminating duplications and adding other terms as new categories become necessary. This list, arranged in alphabetical order, helps in filing as well as retrieving pictures. In classifying new pictures, it serves as a reminder of the categories already available. It is essential to keep the list up to date.

Two sample category lists are shown here. They may be used as guides in starting a catalog adapted to the reader's own needs. The first is for the collection of a single non-professional photographer. The other is a portion of a list for a picture collection from many sources, organized for general research use — the kind of list with which a picture library might begin. The categories refer to pictorial content, rather than technique, so they can include non-photographic images as well — drawings, lithographs, illustrations from publications, and the like.

Individual photographer's catalog list
Basic categories covering pictures taken by most non-professional photographers.

PEOPLE (by name, or by subcategories, as below)
 Family & Relatives (probably including pets)
 Friends
 Miscellaneous (groups, strangers, foreign faces, etc.)
PLACES (by place names and general subcategories)
 Home
 City
 Country
 Mountains
 Lake—Seashore
 General Nature & Scenic
 Miscellaneous (Architecture, etc.)
ACTIVITIES
 Hobby (or photographer's area of special interest; this may be a major category in itself)
 Sports
 Vacations & Holidays
 Public Events (Parades, etc.)
 Family Events (Weddings, Graduations, etc.)
 Miscellaneous
MISCELLANEOUS
 Experiments; Special Techniques
 Studies (Still Life; Nude; etc.)
 All other items not clearly belonging in other categories

Picture library master list

A master list reveals the scope and emphasis of a collection. The sample included here is for a large collection of *contemporary* photographs; historical material, when included, is most often cataloged under the name, place, event or era to which it refers. Categories (in capital letters) contain the pictures; cross-references (in caps and lower case) suggest where to look for a desired kind of picture and where to file new material.

ACCIDENTS—see also: Disasters
AERIAL—Air-to-air; Air-to-ground
AGRICULTURE—see also: Rural
Aircraft—see: Aviation
ANIMALS (by common name of species)
ARCHITECTURE—see also: Construction
ARCTIC & ANTARCTIC
Armed Forces—see: Military
ART—see also: Statues & Monuments; Crafts - Folk Art
Athletes, Athletics—see: Sports
ASTRONOMY
AUTOMOBILES—see also: Industry; Sports (Racing)
AVIATION & AIRCRAFT
Balloons—see: Aviation; Entertainment; Festivals
Banners—see: Flags
Bars—see: Hotels & Restaurants
. .
SCENIC VIEWS—Spring; Summer; Autumn; Winter
SCIENCE & RESEARCH—Activities; People; Scientific Images
Sculpture & Sculptors—see: Art
Shops & Stores—see: Business
SIGNS, BILLBOARDS & POSTERS—see also: Art; Communications
Snow & Winter—see: Arctic; Nature; Scenic-Winter; Sports
Social Services—see: Public Services
SPACE—see also: Astronomy; Military; Science
SPORTS & RECREATION
Strikes—see: Riots & Disorder; Laborers
Telephones—see: Communications
Television—see: Communications; Entertainment
TOYS & GAMES—see also: Crafts & Hobbies
Trades & Tradesmen—see: Business; Laborers; Industry

Trees—see: Flowers; Nature
Twins—see: Children; People
Ultraviolet—see: Science
Undertakers—see: Death
Underwater—see: Water
WAR—see also: Military; Government
WATER—Lakes; Oceans; Seas—see also: Rivers & Waterways
WEATHER—see also: Diasters—Natural
WEDDINGS—see also: Religion—Ceremonies
Whales, Whaling—see: Fish
. . . etc.

The content of most pictures falls into one of five very general classes: *People, Places, Activities and Events, Things,* and *Miscellaneous* (e.g., non-representational and experimental images). Such broad categories make it easy to classify and file pictures, *but hard to find them later.* Without more specific categories, it is necessary to look through all *Activities* pictures to find a desired picture of skiing, or through all *People* pictures to find a particular portrait. Using a greater number of more specific categories reduces this problem and increases the usefulness of the catalog.

CATALOGING—*marking*
Catalog classifications are marked in ink or pencil on the backs of prints used in the files. File transparencies are marked on their sleeves or mounts. However, if a card or notebook catalog is used to protect transparencies from unnecessary handling, idenfication-number marking is sufficient on the transparency; in the catalog, the number is simply written on a card or sheet in each relevant category.

Markings must be legible and permanent, and prints should be marked in a consistent manner. Writing all data in the upper right-hand corner, with the catalog category above the identification number, makes it easy to spot a large stack of face-down prints quickly. Waterproof drawing ink is excellent for catalog prints.

Duplicate prints that are stored separately need only the picture identification number, as the master log gives their catalog classifications. Wherever categories are listed, it is best to use actual category names rather than a code. It is far easier to look for and refile pictures if everyone using the system understands the data immediately.

CATALOGING—*other information*

Print and transparency catalogs should indicate only picture content to keep them simple and compact. Other data can be recorded in a *master log* composed of file cards of notebook sheets; each master log card correlates all the necessary information about its particular picture. The cards are arranged in sequence according to picture identification numbers marked at the top on both sides.

On the face of the card, the number is followed by all catalog categories that contain copies of the picture. Below that, notes identify the subject, date, location and anything else pertinent to the situation shown (such information grows more valuable as the years pass, and it is essential for writing accurate captions if the picture is published). The card may also record technical data such as film emulsion, how the picture was taken and processed, and equipment used. An elaborate log might even include a small print of the picture pasted on the card. (An extra proof sheet of each roll, made when the film is first contact-printed, can be cut up for this purpose.)

The back of the card lists printing data, use of the picture, orders, sales publication, etc. Some photographers make printing notes (paper grade, exposure, burning and dodging, development, toning) for every picture. This is a waste of time. Only out-of-the-ordinary procedures are worth noting—such things as special techniques for printing difficult negatives or basic filter pack data for color prints. Such notes are commonly written on the outer paper envelopes often used for negative storage: a poor idea because of the dangers most such envelopes pose for negatives (see *Storage—materials,* below), and modern plastic sleeves lack space for note-making. The master-log card solves such problems.

Other indexes and records may be required, depending upon the activities of a photographer, a studio or a picture library. Busy freelance photographers and libraries will need a *circulation file* that records which pictures have been loaned out, to whom, when, and when returned. A busy studio or commercial photographer will keep a separate record of orders and sales to facilitate billing and accounting. Technical photographers may index their pictures according to the related research or experiments; doctors may file them by name of the patient. Cross-references can be confined to written indexes, eliminating the need for duplicate file prints. The more elaborate the cross-referencing and the larger the number of separate indexes, the more clerical work required to keep the system up to date and operating accurately. Comprehensive simplicity should be the keynote.

Storage

Good storage facilities not only provide protection for prints, negatives and transparencies, they maintain the organization and usability of the collection as well. The physical requirements of good storage include proper preparation of the pictures, use of safe materials, and maintenance of safe storage conditions.

Because photographic materials are fragile, storage must first provide overall physical protection by separating copies used for reference and inspection from the irreplaceable materials: negatives, master prints, transparencies. The storage facilities must also provide individual protection for each item, suitable for the materials used and the handling methods they dictate.

STORAGE—*materials and conditions*

The principal causes of image deterioration have been known at least since 1855, when the Fading Committee of the Photographic Society of London published a report of their investigations. It is incredible but true that today most materials and conditions available for photographic storage are still contaminated with one or more injurious elements.

The dangers of various inks and of adhesive labels have already been pointed out. There are many additional dangers. Paper envelopes, even most of the kraft paper and glassine envelopes sold specifically for photographic purposes, contain acids and sulfur compounds and are assembled with glues that absorb moisture. The material of most cardboard folders and boxes contains damaging chemicals. An exception is the Permalife line of acid-free paper envelopes and other containers made for archival storage by the Hollinger Corporation, 3810 South Four Mile Run Drive, Arlington, Virginia 22206. Many white papers and non-photographic blotters are bleached with sodium thiosulfate or related compounds—exactly what washing must remove from films and prints. Wood containers, the glues and varnishes used for them, and almost all paints may release compounds that can attack photograph-

ic images. Photographs should never be stored in freshly-painted shelves. Probably the safest paints are those that use an epoxy base. Varnishes that use synthetic resins are generally preferable to those with natural resins, which tend to give off harmful by-products. Moisture, high humidity and heat not only affect films and prints themselves, they also increase the action of any contaminants present in other materials and in the atmosphere.

Paper clips, staples, envelope clasps and similar items will crimp, crease and gouge prints. Many metal fasteners will rust over the years and stain prints. All such fasteners should be avoided; they should be removed from pictures and envelopes immediately whenever they are encountered. Rubber bands may be even worse, since they cause both physical and chemical damage.

In the face of all this, storage problems may seem insurmountable; that is not the case. Negatives and unmounted transparencies can be stored safely in cellulose acetate sleeves or envelopes. Various styles and sizes of sleeves and compartmented storage sheets are manufactured by Print File, Inc., Box 100, Schenectady, New York 12304 and by the Nega-File Co., Furlong, Pennsylvania 18925. It is preferable not to use the style of sheet that accordion-folds into a cardboard outer jacket; the plastic sheet may be chemically safe but often the cardboard is not. Filled sleeves or envelopes may be kept in covered boxes or drawers made of hard plastic (dark-colored or opaque for color materials), stainless steel, aluminum, or metal coated with baked enamel or epoxy paint. Unfinished wood and ordinary cardboard containers must not be used for anything more than short-term storage. It is difficult to know what plastic boxes are safe: polystyrenes are probably chemically preferable to most others.

Small mounted transparencies can be stored in notebook-size sheets of rigid plastic which hold twenty 35mm or twelve 2¼-inch square images. The sheets should be kept in chemically safe boxes, not in notebooks. There is a danger of condensation in the tight-fitting pockets of soft plastic slide sheets. Mounted transparencies may also be stored standing upright in suitable metal or plastic boxes or drawers. The Kimac Company, Old Greenwich, Connecticut, manufactures individual plastic protectors which slip over standard cardboard slide mounts. While such materials protect the film from damage in handling, they do not eliminate the cardboard mounts, which may not be entirely safe (the adhesives used may dry out and let go, or if such mounts are stored in high humidity, they may be attacked by fungus growths which also can attack the emulsion). Transparencies are best protected cemented to glass. Next best are mounts of glass-and-plastic or glass-and-metal, with foil (not paper) masks. The common glass-and-tape method of slide binding does not provide sufficient ventilation to ensure that moisture will not be trapped and condense on the film.

Prints should be stored lying flat in cellulose acetate bags, acid-free paper envelopes, or boxes of safe material. The one exception in print storage is that of reference prints in the catalog. Those prints will receive so much handling under such a variety of conditions that they must be considered expendable; therefore, chemical and physical precautions necessary for archival storage may be relaxed in favor of the convenience gained by storing them in file folders, large envelopes or notebooks.

Virtually all cements and adhesives, except some dry-mounting tissues, and almost all mounting boards, except special acid-free boards, contain contaminants. Therefore, prints should be stored unmounted. When it is necessary for any reason to mount prints that are to be stored, it is preferable to dry-mount them on any of a number of acid-free mount boards. The Hollinger Corporation, mentioned above, makes a museum board especially for the permanent storage of photographs and documents. This cream-colored material is intended to be esthetically pleasing. For fine prints that need whiter mounts, the 100-percent-rag boards made by Strathmore and comparable paper makers are suitable, as is Bainbridge Museum Board. A barrier layer of unexposed photographic print paper—thoroughly fixed, neutralized and washed—may be dry-mounted between the print and the mount board.

All color films and papers must be stored with extra care because their emulsions are more susceptible to damage from gases, moisture, heat, fungus growths and light than are black-and-white emulsions. Color films are also inherently unstable. No manufacturer will guarantee the permanence of images on color film, for all the dyes are subject to color shifts and fading. Kodak's Kodachrome II is generally considered the most stable color film;

others have varying degress of permanence, and certain duplicating film images have relatively short lives even when kept in complete darkness.

All photographic images are best stored in moderate conditions: below 40% relative humidity and 75°F (24°C) temperature. Packets of dessicant such as silica-gel can be placed in containers when the air is too moist. Humidifiers or other devices must be used when extremely dry conditions occur, for instance in steam-heated rooms. Photographic images should never be stored where chemicals are also kept; fumes may cause rapid damage.

Storage problems often result from poor preparation of the items being stored. Many photographers fail to remove processing chemicals from the prints and films themselves, causing images to deteriorate even though stored in the safest materials and environment.

The best a photographer can do in preparing color materials is to follow the manufacturer's instructions exactly. The manufacturer's processing will normally maintain higher standards than that of the mass processors who service drug stores and other film pick-up depots. Poor processing practices tend to cause color shifts, mottling, or streaking in the image.

Black-and-white processing is simpler for the photographer to control. The essential points of processing for permanence are as follows:

1. Process less film or fewer prints in a given amount of solution than the manufacturer recommends.

2. Use fresh developer, stop bath, and—especially—fresh fixer.

3. Fix for the recommended time, with continuous agitation; do not overfix; use two fixing baths for prints.

4. Use a hypo-neutralizing washing aid or a hypo-eliminator.

5. Give prints protective toning with selenium or gold chloride solutions.

6. Wash for longer times than the manufacturer recommends. Agitate prints frequently during the wash, or use a washer that does this automatically.

7. Use hypo and washing tests frequently to check on the effectiveness of procedures.

8. Make sure drying devices and materials—especially blotters—are uncontaminated.

Photographers using stabilization processors must be very careful. Stabilized prints are loaded with chemicals that will contaminate everything they touch. Image transfer, staining, and sticking to adjacent materials are some of the problems that may result from storing stabilization prints. If possible, stabilized prints should receive the same fixing-neutralizing-washing treatment as conventional prints; this will make them safe. Otherwise they must at all times be separated completely from permanent prints and negatives—an almost impossible requirement.

STORAGE—*organization*

The basis of storage organization is *separation:* catalog prints, extra copies, master prints, negatives and transparencies are all stored separately from one another.

Catalog prints may be kept in notebooks, file folders, or envelopes arranged alphabetically by category. When the prints or contact sheets are all the same size, loose-leaf binders are neat and convenient. Large file folders or envelopes are better for handling mixed print sizes and ensure that, when several people are using the collection, one researcher does not tie up categories in which he is not interested.

Extra prints, arranged either by identification number or by major categories, are stored in suitable boxes. Master prints require especially safe separate storage.

Positive transparencies are stored in plastic sheets or suitable file boxes, arranged by identification number for an individual's own collection, or by category for examination by others.

Color negatives are stored separately from black-and-white negatives, with each group—arranged by identification number—in plastic sleeves or sheets that are kept in protective containers.

This scheme of organization provides maximum protection by ensuring that no material receives unnecessary handling, and it preserves organization by grouping materials according to their function. It is the final step in creating an efficient, safe and productive picture filing system.

An Introduction to Color Printing

Bob Nadler

There is no mystery to color printing. It is not especially complicated or difficult. It doesn't require a large investment in elaborate darkroom equipment, or demand that the color printer maintain absolutely precise control over the temperature of his chemicals or the time of his operations.

Almost all the knowledge that color printing requires that black-and-white printing does not is an understanding of how six colors interrelate. Once you have these relationships clear in your mind, and understand how three of the six are used to construct any other color, the mechanical manipulations of color printing are relatively simple.

All present-day color films and color-printing papers employ three layers of emulsion, each sensitive to one of the photographic *additive primary colors*—red, green or blue.

Each additive primary color has its exact opposite in a *subtractive primary color*. The opposite of any primary color is called its *complementary* color. The complementary of red is cyan; green's complementary is magenta; blue's complementary is yellow.

It may be helpful to point out that the red, green and yellow referred to are the familiar traffic-light colors. Blue, in its photographic context, is close to what many of us think of as purple. Cyan is very close to what we normally think of as blue. Only an interior decorator can describe magenta; it may help to think of it as a mixture of red and "photographic blue," since that is exactly what it is.

If you are wondering how these specific colors came to be used, you are not alone; so are some of the world's most renowned scientists. Exactly how the eye functions in seeing (or perceiving) color is far from perfectly understood. However, it is known empirically that any color, including white, can be made visible to the human eye by blending red, green and blue light. It works.

Let us establish the several color relationships necessary to an understanding of color printing, and illustrate their use:

PRIMARY COLORS

Additive		Subtractive
Red	complementary of	Cyan
Green	complementary of	Magenta
Blue	complementary of	Yellow

Blue-sensitive emulsion layer	1a
Yellow-dyed gelatin layer	
Green-sensitive emulsion layer	
Clear gelatin layer	
Red-sensitive emulsion layer	
Film base	
Anti-halation layer	

Typical color-negative film construction

Red-sensitive emulsion layer	1b
Clear gelatin layer	
Green-sensitive emulsion layer	
Clear gelatin layer	
Blue-sensitive emulsion layer	
Paper base	

Typical color-paper construction

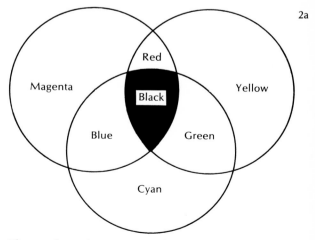

Three subtractive primary color filters viewed over a single light source

2b

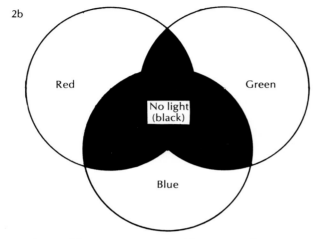

Three additive primary color filters viewed over a single light source

COLOR COMBINATIONS

Additive Primary plus Additive Primary			Subtractive Primary plus Subtractive Primary
	Red	=	Magenta + Yellow
Red	+ Blue	=	Magenta
	Blue	=	Magenta + Cyan
Blue	+ Green	=	Cyan
	Green	=	Cyan + Yellow
Green	+ Red	=	Yellow

NEUTRAL DENSITIES (shades of gray through black)

Complementary Colors

Red	+ Cyan	=	Neutral Density
Green	+ Magenta	=	Neutral Density
Blue	+ Yellow	=	Neutral Density

Three Subtractive Primary Colors

Yellow + Magenta + Cyan	=	Neutral Density

Two Additive Primary Colors*

Red	+ Green	=	Neutral Density
Red	+ Blue	=	Neutral Density
Blue	+ Green	=	Neutral Density

2c

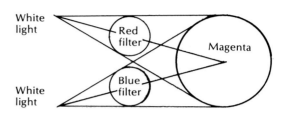

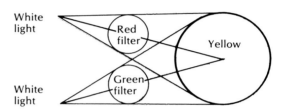

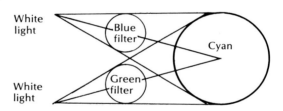

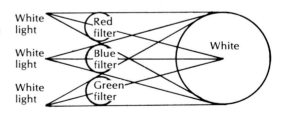

White light projected from separate sources through additive primary filters

* Red, blue and green light from three separate sources (three projectors), combined in equal amounts at the same point on the same plane, will yield white light. Neutral density is obtained when light from a single source passes through any two different filters of these colors in succession. (See figures 2B and 2C.)

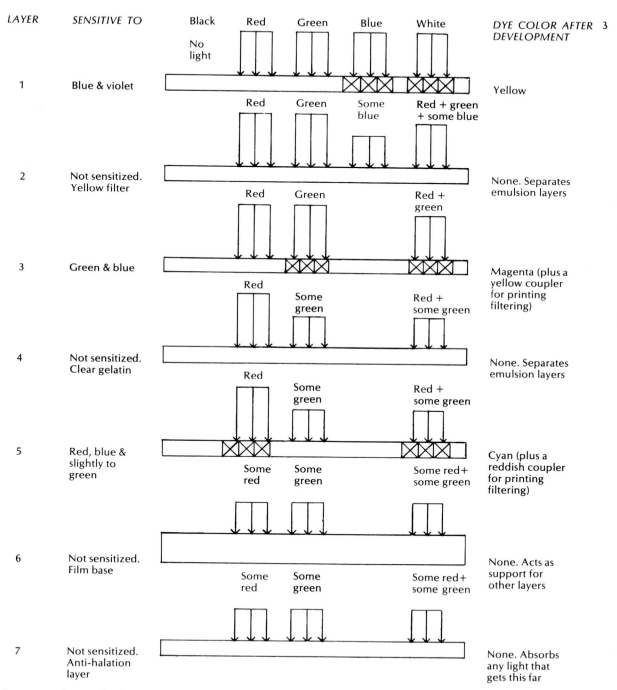

LAYER	SENSITIVE TO		DYE COLOR AFTER DEVELOPMENT
1	Blue & violet		Yellow
2	Not sensitized. Yellow filter		None. Separates emulsion layers
3	Green & blue		Magenta (plus a yellow coupler for printing filtering)
4	Not sensitized. Clear gelatin		None. Separates emulsion layers
5	Red, blue & slightly to green		Cyan (plus a reddish coupler for printing filtering)
6	Not sensitized. Film base		None. Acts as support for other layers
7	Not sensitized. Anti-halation layer		None. Absorbs any light that gets this far

Exposure of typical color-negative film to light reflected from a black, red, green, blue and white object

To understand how these color relationships are manipulated to make a color print, let us begin with the generation of a color negative. Figure 3 represents a greatly magnified cross section of a piece of tri-pack color-negative film which is being exposed in a camera focused on a board fence. Each board shown in the picture is a different color: from left to right, black, red, green, blue and white.

After the light passes through the lens, the first layer of film that it strikes is an emulsion containing silver salts sensitive to blue and violet light. Where this emulsion is struck by the light coming from the blue-painted board, the silver salts are affected, and the intensity of the blue light is diminished as its energy is consumed in the photochemical reaction that begins to reduce the silver salts in this layer to metallic silver. Note that this emulsion layer also reacts where light from the white board strikes it. White light, containing equal parts of red, green and blue light, will have its blue component diminished as it affects this emulsion layer. Since this emulsion is not sensitive to red and green light, it will not change where light from the red and green boards strikes it. Obviously, there will also be no effect in the area of emulsion under the focused image of the black board, since black is not a color, but the absence of light.

Layer number two is gelatin containing a yellow dye: it is simply a yellow filter. Yellow, being complementary to blue, effectively eliminates any blue light that remains after passing through the first blue-sensitive emulsion layer. Complementary colors, you will recall, yield neutral density—shades of gray through black—when combined. It is necessary to eliminate all remaining blue light because the emulsion in layer number three is both blue- and green-sensitive, but no blue image is desired in this layer. The red and green light pass through the yellow filter that is layer two without being changed.

Layer number three now records the image of the green board and of the green component of the white board. In doing so it reduces the intensity of the green light that passes through it and goes on to layer four. The red light passes through layer three undiminishd.

Layer number four is clear gelatin, used to separate layer three from layer five. It has no effect on the light that passes through it.

Layer number five is an emulsion sensitive to red and blue light, and, very slightly, to green. All the blue light in the image has already been either absorbed or filtered, and most of the green light has been absorbed, so only the image of the red board and of the red component of the white board are recorded in this layer.

Layer six is the transparent plastic film base that serves as a support for all the other layers.

Layer seven is an anti-halation coating which absorbs any excess light that has come this far, preventing this light from being reflected back up through the layers of emulsion and causing multiple images to be recorded.

If you have referred to Figure 3 while reading the above, you will have noticed the column at the right, headed "Dye color after development." This column shows the color of the dye deposited in each layer of emulsion during development.

The deposition of dyes in the emulsion layers is a horrendously complicated chemical process during which substances called couplers, which are incorporated in each layer of the film's emulsion, combine selectively with oxidation products from the action of the developer on the exposed silver salts. The amount of dye so deposited is directly proportional to the amount of exposure received by the emulsion. The couplers not only ensure that dye of the correct color is deposited in the appropriate emulsion layer; they also form the printing mask that gives color negatives their characteristic orange color. (I'll discuss this masking later in this chapter.) Once the dye is deposited, all metallic silver and silver salts are removed by bleaching and fixing.

A glance at Figure 3 will show you that in emulsion layer number one, which records the blue image, yellow dye is formed by development. Yellow is complementary to blue—for this is a negative that we are making. Similarly, magenta, green's complementary, is deposited in green-sensitive layer three; and cyan, the complementary of red, is deposited in red-sensitive layer five.

Now that we have an exposed and developed color negative, we can place it in an enlarger and print it on a sheet of color-printing paper. Figure 4 represents our negative of the multi-colored fence, placed emulsion-side down in an enlarger, and a sheet of color-printing paper below it in position to be printed. At the bottom of Figure 4 is a plan view of the paper as it will look after development.

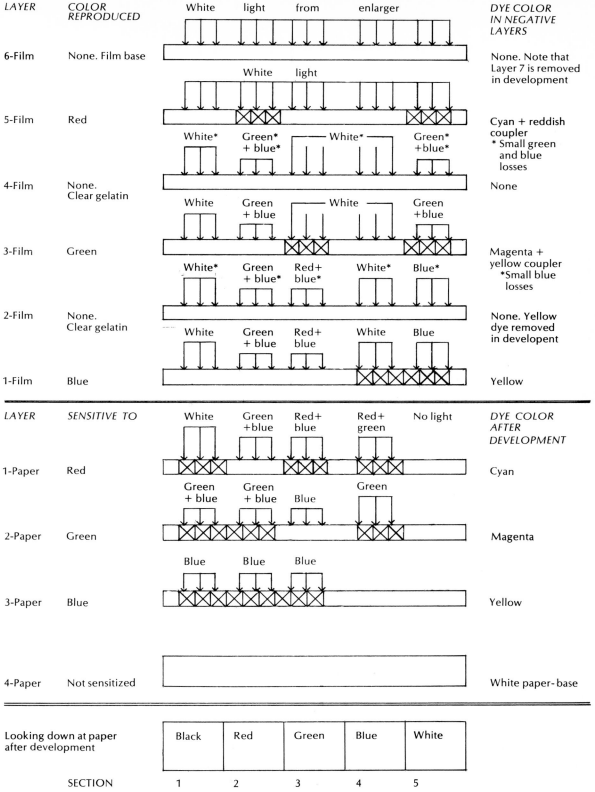

Exposure of color-printing paper to white light passing through a color negative

The topmost film layer illustrated is number six, the film base. (Layer seven, the anti-halation coating, has been removed during development.) White light from the enlarger lamp is shown falling on the film base; since the base is clear, the light passes through layer six unchanged.

Film layer five is now a dye layer, containing two sections of cyan dye which will control the reproduction of the color red on the printing paper. As the white light passes through these cyan dye deposits, its red component is filtered out, since cyan is red's complementary color, leaving only the green and blue components to pass through to film layer four. (For now, ignore the asterisks shown below layer five. We will return to them later.)

Film layer four is clear gelatin and does not affect the light.

Film layer three controls the reproduction of the color green in the print. It contains two magenta dye sections which remove the green component from light passing through them.

Now let's look at the light that falls on layer two. The first three arrows at the left (section 1) represent white light, because this light has not passed through any dye deposits up to this point. The next three arrows (section 2) are labeled green+blue, because the white light these arrows represented at the start has now passed through the cyan dye in film layer five. The next three arrows (section 3) are shown as red+blue, because their originally white light has passed through the magenta dye in film layer three. The next three arrows (section 4) represent white light which has not yet passed through any dye. The last three arrows on the right (section 5) are labeled blue, because the white light from which they originated has passed through cyan dye in layer five (where the red component was lost), and through magenta dye in film layer three (where the green component was lost).

Layer two is the gelatin which contained yellow dye before development. It is now clear and colorless; all the yellow dye was removed in development, so the light that reaches layer one is not changed by layer two.

Film layer one controls the reproduction of blue in the print. It contains two adjacent sections of yellow dye, which remove the blue component from the light that passes through them. The light which leaves film layer one now passes through the lens of the enlarger onto the printing paper.

The printing paper has three layers of silver-salt emulsion*, each sensitive only to one of the additive primary colors.

The first emulsion layer on the printing paper is sensitive to red light. Where light with a red component strikes this layer, the silver salts begin to be reduced to metallic silver. The red latent image is recorded, while the intensity of the red component of the light is diminished as its energy is consumed in the photochemical reaction.

Paper layer two records the latent image of any green light that strikes it, while diminishing the intensity of the green light. This effect is shown in sections one, two and four of paper layer two. Because all the red light has been absorbed by paper layer one, and all the green light has been absorbed by paper layer two, only blue light now remains to fall on paper layer three.

Paper layer three records a latent image of the blue component in sections one, two and three.

The development process for color-printing paper is essentially the same as for color-negative film. Cyan dye is deposited where the latent image of red is formed; magenta dye is deposited where the latent image of blue is formed. The white of the paper base, layer four, is not affected by development.

The bottom part of Figure 4 represents the developed print. It must be understood that the developed print is viewed by white light that first passes through the three dye layers, then is reflected by the white paper base and passes through the dye layers again to the eye. With this in mind, let's look at the developed print of the multi-colored fence.

In section one, at the left, light enters and passes through dyes of the three subtractive primary colors, cyan, magenta and yellow. You will recall that three subtractive primaries form neutral density; therefore, no light will reach the paper base in this section and none will be reflected back toward the eye. Section one will appear black.

In section two, the light passes through magenta and yellow dye layers, then is reflected back through these layers to the eye. Yellow and magenta combine to make red, so section two appears red.

* There are also two thin layers of clear gelatin which separate paper emulsion layers one and two and two and three. They have been left out of Figure 4 for the sake of clarity.

In section three, the light passes twice through yellow and cyan layers before reaching the eye, so this section appears green.

In section four, light passes twice through cyan and magenta dye before being seen as blue.

In section five, at the right, no light at all fell on this part of the paper during the print exposure, so no latent image was formed and no dyes were deposited. Therefore the light that reaches the eye from this section of the developed print is reflected unfiltered from the white paper base: it appears white. Now, before we go on to the chemistry and hardware, let's go back to those asterisks in Figure 4. You will notice that I have indicated small losses of blue and green light from all the light-component arrows that have passed through film layer five, the cyan dye layer. These losses are caused by the deliberate use of a coupler that remains in this layer after development, coloring the layer red wherever no cyan dye is formed. The film manufacturers do this to compensate for unwanted green and blue absorption by the cyan dye.

Small blue losses caused by magenta dye are compensated for in the same manner by adding a coupler to film layer three which colors this layer yellow wherever no magenta dye is formed in development. Therefore there is a slight blue loss from all light that passes through film layer three. The combination of these red and yellow masks gives color negatives their overall orange appearance.

Now let us consider what you will need—besides an understanding of the process—before you can begin to make color prints.

First you need a color negative. There are three ways to get one. You can buy a standard negative (an excellent idea, to which we will return). You can shoot color-negative film and have it developed by a lab—also a good idea. You can shoot color-negative film and develop it yourself. While it may appeal to the purist in you, this last course is not the wisest, in my opinion. Developing color-negative film is not difficult for anyone familiar with processing black-and-white film, but the economy and accurate control that make occasional processing of black-and-white film worthwhile do not apply to occasional color film processing. The best color negative for printing is one which has been properly exposed and developed in accordance with the manufacturer's instructions. The familiar black-and-

white option of choosing one or another of the many developers available for a certain effect is not open to you in color film development. There are several color-film developers on the market, but they are all designed to do the same job—to produce a normal negative that will print easily and will render color and contrast as close to those of the original scene as possible. Economy will depend on how much film you process. There are not many circumstances in which you can process your own color negatives at a lower cost than a commercial laboratory's normal charge for the same service.

The best reasons for developing your own color negatives are experimentation and convenience. There is just no way to get a roll of film developed between one and three AM on Sunday morning unless you do it yourself.

If you find yourself in such predicaments, or wish to experiment, Eastman Kodak produces Process C-22 solutions. C-22 chemicals come in kits as small as one pint per solution, and are also available in several sizes as individual components—developer, stop bath, hardener, fixer and bleach. Process C-22 requires that you keep your temperatures at 75°F (plus or minus ½ degree) for 14 to 18 minutes, which may pose some problems for those without automatic temperature controls on your darkroom sinks. However, this is not an impossible requirement, even where there is no running water. The entire C-22 process takes 53 minutes.

KMS Industries produce a readily-available color-film developer under the trade name Unicolor. It is packaged in kits consisting of film developer, stop bath, blix (bleach combined with fixer) and film stabilizer. All of Unicolor's chemicals are packaged in liquid form, which simplifies mixing. Here, too, you must keep the temperatures at 75°F, plus or minus ½ degree, for fourteen minutes. The whole process takes thirty-one minutes.

Processing color-negative film with either of these chemistries requires no equipment not already owned by those who process their own black-and-white photographs, with the possible exception of an accurate thermometer that can be read to ½ degree F. Instructions for use are packed with both kits; and, in the case of the Kodak process, they are published in the *Kodak Color Dataguide*. This excellent publication is almost a prerequisite for color printing, partly because it supplies you with a stand-

ard CPS 35mm color negative and a color print made from it. These come in each copy. There is more to the *Kodak Color Dataguide* than that, though; I will refer to it further in this chapter.

Assuming that you now have a suitable color negative, let's see what else you will need.

You can make color prints with any enlarger that can produce acceptable black-and-white prints. All but the oldest and the cheapest enlarging lenses are color-corrected. If yours is not, you will have to get a new one. (If in doubt, print and hope for the best. Your lens will probably turn out to be adequate.) I hasten to add that life will be simpler if your enlarger has a filter drawer between the light source and the negative, as do the Leitz Focomat Ic and IIc Color Enlargers.

If your enlarger only accepts filters which are placed between the lens and the easel, several possibilities remain open to you.

You may be able to get a conversion kit which will let you place acetate filters between the light source and the negative: several manufacturers offer them.

Another alternative is open to those who can afford a large investment in color-printing hardware. Simmon Omega, Beseler and Durst all make dichroic-filter color-conversion heads for several models of their enlargers. With the Beselers and Omegas, no acetate filters are needed. The Durst, however, will sometimes require their use.

The dichroic (two-color) conversion head replaces the enlarger's usual light source with a special tungsten bulb or bulbs and a diffusion illumination system. The bulbs feature a dichroic coating on their parabolic reflectors. The dichroic coatings on both bulbs and filters function as narrow-pass light filters—that is, they transmit only a narrow portion of the electromagnetic spectrum. All other frequencies are efficiently reflected or absorbed. In addition to dichroic filters, the conversion heads of these enlargers also contain a cooling fan or a chimney to which a hose from such a fan can be attached.

The dichroic filters, which take the place of acetate CP or CC filters, are arranged in the head so that they can be dialed into position from the outside of the machine. This conveniently provides accurate, spectrally clean filtration, ranging, in the case of the Omega, from 0M/0Y/0C through 150M/150Y/150C. These units, however, are expensive.

You can use subtractive filtration with the filters below the lens. If "color-compensating" (CC) filters made of gelatin, rather than acetate "color-printing" (CP) filters are used, they must be kept scrupulously clean and free from scratches. (I do not recommend this: the use of CC filters below the lens limits the number of filters you can use at once).

You can use the additive-filtration printing method. You need only three filters for this, typically Kodak Wratten Filters No. 25 and No. 98 and No. 99—red, blue and green. You can also buy these filters mounted in a wheel that is designed to clamp onto the barrel of almost any enlarging lens. This device, called the Uniwheel, is made by the Unicolor Company. The additive or tricolor printing method is simple and economical: I recommend it for use with enlargers that do not accept filters between the lamp and the negative.

Most of what follows concerns subtractive filtering techniques; but in the end everything will tie back in so it can be applied to tricolor printing as well.

I have discussed several kinds of color-printing filters, but, if you recall Figure 4, none were shown. Only white light was shown coming from the enlarger lamp, passing through the dye layers of the negative and being filtered in the process, then falling on the printing paper to expose it correctly for a latent image of the board fence we photographed in Figure 3. If only life were that simple!

But the light from a tungsten enlarger lamp is yellow, not white. (Cold-light heads for enlargers emit light of several possible colors: therefore *avoid cold-light enlargers for color printing.*) The glass in the enlarger's optical system may add its own color to the light. The exposure or development of the color negative you print may be less perfect than was assumed in Figures 3 and 4. You must therefore filter the light from your enlarger to correct for all these things. You must also correct because almost every box of color-printing paper has somewhat different printing characteristics, both in relative overall speed and in relative color sensitivity.

Two filters will remain in the enlarger regardless of whatever other filters may be put in the filter pack. These are a CP2B to remove ultraviolet radiation, and a heat-absorbing glass to decrease infrared radiation. The CP2B may be placed anywhere in a filter pack. The heat-absorbing glass is best placed between the light source and the rest of the pack.

In addition, you will need the following basic

minimum selection of subtractive filters, one each: CP05M, CP05Y, CP05C-2; CP10M, CP10Y, CP10C-2; CP20M, CP20Y, CP20C-2. Two each: CP40M, CP40Y, CP40C-2. Additional magenta (M), yellow (Y), and cyan (C-2) filters may be acquired if needed, as may CP red (R) filters; but the basic filters listed should suffice for most printing. The values 05 through 40 in the filter designations refer to color densities: an 05Y is a very pale yellow; a 40Y is much deeper.

These acetate filters may be bought in sheets of various sizes. Select the size closest to that of your filter drawer (larger, not smaller) and cut the sheets to fit with a razor blade. Filters can be added to one another to get the desired degree of color correction; thus two 20Y filters used together are equivalent in color filtration to a 40Y. Less light will be transmitted through the two 20Y filters, however, than through one 40Y, because the light must pass through more reflecting surfaces.

Now let's look at the rest of the hardware and chemicals you will need for color printing. I have assumed that the reader is already printing in black-and-white, and has all the necessary equipment for it, including a really dark darkroom. If you also have an accurate thermometer that can be read to ½ degree Fahrenheit, you need no further equipment if you wish to process your color prints in trays. I do not recommend tray processing, but it can be done with complete success. My reasons for not recommending it are that trays require a considerable amount of developer to be used at once, even when only a few prints are made, so that all the developer you use is partially depleted, and contaminated by exposure to air, hands, and printing paper (canoes and drums solve this problem); also, trays require that you work in total darkness or by the light of a Wratten Series 10 (or equivalent) safelight for a period of two to nine minutes, depending on the chemistry you are using.

The canoe, a type of tray bent so that its center is lower than its ends, overcomes the problem of contamination, but still requires you to work in darkness or by safelight for the same length of time as tray processing. The canoe has the virtue of using only enough chemicals at a time for a single print, but the disadvantage that you can only process one print at a time. (Trays can be used to process several prints at once by interleaving agitation.)

Frankly, though, I don't recommend canoes

either. I recommend that you buy an additional piece of equipment. If cost is not an important factor, and you plan to do much color printing, I suggest that you buy a motorized drum or tube processor. Both Kodak and Unicolor produce several models, as do other firms. If you don't plan to do enough color printing to justify spending several hundred dollars, I suggest a manual drum processor. The cost is low, and these devices overcome my objections to both trays and canoes. They produce prints of excellent quality and good uniformity with very little effort and good economy of chemistry, and they are used in normal room light. Among the many manufacturers of manual drums are Unicolor and FR. Drums process several prints at once if desired.

The drum processor, either manual or motorized, an accurate thermometer, and the printing filters are the only additional pieces of hardware you need to add to your darkroom for color printing.

You will, of course, need color-printing paper and chemicals. Most suppliers offer excellent products, but for the sake of consistency you will eventually want to settle on one among them.

To simplify this chapter, I will recommend printing papers sold under the Agfa, Unicolor, or Rapid Access labels. These papers are all similar in that they can be judged for proper color balance while still wet, and in the relative toughness of their emulsions when wet. I will also recommend Unicolor or Rapid Access chemicals for easy mixing and use, rapid processing and wide availability. Agfa color-printing chemicals are not as easy to find. Kodak's chemistry is used with their Ektacolor Professional paper (formerly called Type C). Full information on Kodak color materials will be found in the *Kodak Color Dataguide.*

If you are a first-time color printer, you must now prepare to face a double trauma—calibrating the paper and making a color print.

It is not absolutely necessary to begin with calibrated paper, but sooner or later you will tire of printing by chance and you will start calibrating. Sooner is better than later: therefore I suggest that you make your first color print as part of the calibration procedure.

Some manufacturers print a recommended filter pack or pack correction on their color paper boxes. At best, these instructions are general, because each enlarger and each set of filters is somewhat different.

Paper calibration is a trial-and-error procedure used with each new batch of color paper to find the *exact* filter pack that will give you a perfect standard print each time you expose a standard negative at a standard magnification, a standard f-stop, and for a standard length of time, and then process the print in a standard manner. A first-time color printer may need twenty or more tries to come up with anything close to a perfect print; an experienced printer can usually do it in two or three tries.

I have mentioned the *Kodak Color Dataguide* as an aid, but it is really almost a necessity. To make a standard print you need a standard negative. After you become familiar enough with color printing to know what kind of standard negative you need, the best source is your own camera. Before then, it is simpler to use the CPS standard 35mm negative in the little white envelope bound into the Dataguide.

Put the standard negative in your enlarger and set the height to get a magnification of 9x in the focused image on the easel. Set the lens aperture at f/8, and the enlarger timer at 15 seconds. Insert a filter pack consisting of a heat-absorbing glass, a CP2B, a CP20M and a CP40Y. Expose a sheet of the paper to be calibrated, and develop it according to the instructions for the chemistry and the color-printing processor you are using.

Note: These obviously are *general* instructions only. It is impossible to give an exposure time or filter pack that will be correct for every enlarger or every emulsion batch of color printing paper.

A word of advice: in color paper development, CONSISTENCY is all-important—much more important than accuracy. The papers and chemistries I have recommended can tolerate a wide range of temperatures, kinds of agitation, and processing times, but they require consistency. Consistent voltage to your enlarger is also essential. If it varies by 3% or more, you should have a regulator to hold the fluctuation to ± 1%, or you will never get consistent results in balancing your filter pack.

Just because so much flexibility is built into the materials you work with, you must act like a machine: DO EVERYTHING EXACTLY THE SAME WAY EVERY TIME. Even if you begin your color-printing career by making mistakes, make them consistently—until you catch your errors. Work out a definite routine for every step of the process, THEN FOLLOW THE SAME ROUTINE EVERY TIME YOU PRINT.

Simple and clear instructions come with the chemistries and the processors I have recommended. There is no need to go over them here. However, I must say two things about manual drums that are generally not said in the manufacturers' instructions. The first is this: if you use the type of drum that must be rolled on a solid surface (for example, the Unidrum), make sure that the surface you roll it on is *not* hard and smooth. A typewriter pad is ideal. The reason is that the drum will slip on hard, smooth surfaces instead of rolling. This causes uneven development. My second piece of advice is to roll manual drums at twice the normal rate for the first ten seconds of development and of bleach-fix (blix). (Your normal rate is the one you find you are comfortable with.) This initial rapid rolling will ensure quick and even distribution of the developer and the blix over the entire surface of the paper.

When you have made your first try at a print of the standard CPS negative, compare it (wet or dry) to the standard print that Kodak provided along with the negative in the Dataguide. You need to determine whether your print has the same color balance, and whether it has the same density.

The best way to appreciate these relationships is to refer to a "ring-around"—samples of normally-possible deviations arranged around a standard sample. An excellent ring-around is in Kodak Professional Data Book No. E-66, *Printing Color Negatives*. This interesting and inexpensive publication, which has several color illustrations, is very useful to the color printer.

The density (overexposure, underexposure or correct exposure) can be judged in the same way you judge it in black-and-white printing. Color balance is another matter. If you use the ring-around, you will find that it shows results from about two stops under- to two stops overexposure centrally in a vertical display. Examples of imbalance in each of the six primary colors, in filter-value increments of 10, 20 and 40, are arranged like the spokes of a wheel around a "perfect" print at the hub. Compare your print to the ring-around and try to see which color is off. With luck, you will be off in only one primary color, but there are times when just one wrong color can't explain the result you have obtained.

You can also use viewing filters to identify the color imbalance. A set of six (one each of the primary colors, in a value of 10) comes in the *Kodak Color*

| | | | | NEGATIVE FILE NUMBER—CPS 35mm std. | | | | | | 5 |
Date	Frame	Magnifi-cation	f/stop	Time Sec.	Magenta	Yellow	Cyan	Computer number	Paper cal.	Remarks
5/2/71	N.A.	9X	8	15	20	40	00	0.21	?	Calibrating emulsion # 6604-498-71. About ½ stop over.
5/2/71	N.A.	9X	8	9	20	40	00	0.21	?	Density OK. Balance about 20 over in red.
5/2/71	N.A.	9X	8	13	40	60	00	0.36	?	Density slightly under. Balance slightly blue.
5/2/71	N.A.	9X	8	16	40	55	00	0.40	16S/40M/ 55Y (CPS)	Right on.

Typical color printing data sheet

Color-balance correction chart

Dataguide. Additional filters in these and other values may be purchased. These are standard CC filters: the Dataguide explains how to use them and provides a computer for making corrections to the pack, based on your findings when you examine the print with the viewing filters.

To find which color in a print is out of balance, using viewing filters, simply look at the print through filters of the six primary colors. Flick the filters quickly in and out of sight between your eye and the print until you find a color which makes the print look "right" in the middle tones—especially the grays. (If there are no grays, use flesh tones.) The problem color in your print is the complementary of the color of the viewing filter that corrects the problem. Thus if a yellow viewing filter makes your print look right, the print has too much blue.

The filters must be flicked in and out of sight quickly to prevent your eyes from adjusting to the filter and making every color you try look "right." The eye adapts all too readily.

If the density of your print shows that it was more than one stop over- or underexposed, it's wise to make a second print with more nearly correct exposure before you evaluate the color balance or make corrections to the filter pack. It is always much easier to judge color balance in a print of normal density than in a very light or dark one.

Figures 5 and 6 illustrate what you may expect when you calibrate a new supply of paper. Figure 5 is a type of data sheet which I believe every color printer should use. You may feel that it's a colossal waste of time to record data for every exposure—until you want to reprint a negative some months after the first printing, or until the first time you forget how long your last exposure was. Then you will begin to appreciate darkroom records. If you run off a few dozen sheets of this form on an office duplicator, you will find that filling in the data takes almost no time and helps you organize your work.

Figure 6 is all you should need to correct your filter packs intelligently instead of by trial and error.

Section I shows the dye layers of a piece of color-printing paper after development. The first three boxes on the left, one in each dye layer, are solidly filled in to represent complete dye saturation. In other words, the emulsion layers these boxes stand for contain all the dye that can be formed in them.

Section II is a view of the surface of the paper as seen from above, after development. It shows the area that corresponds to the first three boxes in Section I as black (formed as seen in Fig. 4).

The next three boxes in Section I are crosshatched to show less-than-complete dye saturation. Because the three layers are equal in their degree of dye saturation, Section II shows that the area of the print that corresponds to these boxes will appear gray.

In each of the next six vertical columns of three boxes in Section I, one or more boxes are crosshatched to show greater dye-saturation, and one or more boxes are shaded lightly to show less dye-saturation.

You must understand that when there is more dye in the cyan layer than in either the magenta layer or the yellow layer, the resulting color imbalance will be cyan: an area that we know should look gray will have a decided cyan appearance. This situation is shown in the third set of boxes from the left in sections I and II—the area labeled "cyanish gray."

Similarly, equally-weak cyan and yellow layers combined with a strong magenta layer will give magenta-ish gray (fourth boxes).

Equally-weak cyan and magenta layers over a stronger yellow layer will give yellowish gray (fifth boxes).

Equally-strong magenta and yellow layers under a weak cyan layer gives reddish gray (sixth boxes).

Equally-strong cyan and yellow layers sandwiching a weak magenta layer will give greenish gray (seventh boxes).

Equally-strong cyan and magenta layers over a weaker yellow layer will give bluish gray (eighth boxes).

Lastly, when there is no dye in any layer, the result will appear white (ninth boxes).

For each of the balance problems just described, Section III of Figure 6 shows what correction to make in the filter pack. If a gray area in the print you are evaluating has a cyan cast, Section III shows that this can be corrected either by subtracting magenta and yellow from the pack, or by adding cyan to it. (It is preferable to subtract the yellow and magenta.) Subtracting yellow and magenta allows more blue and green light to strike the printing paper, causing more yellow and magenta dye to be deposited during development, and bringing the layers back into dye-saturation balance so the gray color will be reproduced accurately.

When making filter-pack corrections, *never have all three subtractive primary colors in the pack at the same time.* This does not change the color balance, but simply adds neutral density, causing print density to drop, or requiring increased exposure in printing.

Figure 5, a data sheet for calibrating a hypothetical box of paper, may help to illustrate the use of Figure 6. Note that the first line of data entries is the suggested starting point for calibrating paper for a standard CPS negative. All data on this line have already been given until you reach the column headed "Computer Number." The first entry here is the number 0.21, which was obtained from the tabular listing titled "Computer Numbers and Factors for Kodak CC and CP Filters" in the *Kodak Color Dataguide.* In this table, every filter value in every color is assigned a computer number. To use it, find the computer number *for each filter in the pack* (except the CP2B and the heat-absorbing glass) in the table, and add them all together to get the computer number for the whole pack.

For our first attempt at calibration, we used 20M and 40Y. The computer number for the 40Y is 0.05, and for the 20M it is 0.16. Added together, these give 0.21, which is entered on the data sheet. The computer number for the pack is used with the Color Printing Computer in the *Kodak Color Dataguide,* which enables the color printer to calculate new exposure times after changing the filter pack, the magnification, or the lens opening.

Under "Remarks," I have indicated that the print obtained with the initial pack and settings was about one-half-stop overexposed. By using the printing calculator according to the instructions published with it, I determined that a new exposure time of nine seconds instead of fifteen would decrease the print density about ½ stop if everything else was held constant. "Remarks" for the second print show that the new print exposure gave correct density, and that the color balance was judged to be about 20 over in red. A look at Figure 6 shows that a print that is too red needs either a stronger cyan dye layer or weaker magenta and yellow dye layers. If we had cyan filters in the pack, we would decrease their value by twenty to bring the balance into line. Since there are no cyan filters to subtract, we add 20M and 20Y (which are equal to 20R) to the pack to weaken the magenta and yellow dye layers. Of course, add-

ing this filter value requires a longer print exposure time: this is confirmed by the new computer number for a 40M, 60Y pack, which is 0.36. The Color Printing Computer indicates a new exposure time of 13 seconds for this number.

"Remarks" for the third exposure show that the print was slightly underexposed and slightly too blue. The solution is simple—remove the smallest possible value of yellow filter from the pack, find the new computer number, compute the new exposure time, and add about ten percent to it, using the color printer's version of Kentucky windage. It is interesting that although the total value of the yellow filters in the pack has decreased, the computer number goes up, not down. This is because, while you can make 60Y with two filters (40Y plus 20Y), it takes three to make a 55Y (a 40Y, computer number 0.05; a 10Y, computer number 0.04; and an 05Y, computer number 0.04). Figure 5 shows that the fourth and final calibration print, made with the 40M, 55Y pack at 9x, and exposed at f/8 for 16 seconds, was perfect: therefore "16S/40M/55Y (CPS)" is entered in the "Paper Calibration" column and marked on the box of paper.

The paper calibration column is extremely useful when you want to reprint a negative some time after the first printing, using paper from a new emulsion batch with a different calibration.

For example, suppose that your records show that you printed a negative with an 05M, 20Y pack on paper with a calibration of 13S/35M/50Y (CPS), and you now want to print the same negative on paper with a calibration of 15S/50M/60Y (CPS). It is easy to see that this negative prints properly with 30R less than the CPS calibration. Subtract 30R from the new paper's calibration to get a 20M, 30Y pack to use with the new paper for this negative.

If you do most of your shooting outdoors with Kodacolor-X film, you may find yourself printing with packs that contain cyan and yellow. It is a good idea to calibrate your paper for the film you print most often. When changing a CPS-calibrated pack to print Kodacolor-X, first remove enough red to give you a balanced print. If you remove all the red from the pack and the print still looks cyan, add cyan to the pack. Be sure to differentiate between the appearance of cyan and blue. The remedy for a blue appearance, of course, is to subtract yellow, as shown in Figure 6.

Let's assume you have calibrated your paper and made several successful prints. For general printing, I recommend that you avoid elaborate computers, comparators and gimmicks of all kinds, and simply rely on a contact sheet of the negatives you wish to print, plus the negative you have used to calibrate your paper. Print the contact sheet with the same enlarger settings, printing time, and filter pack you used for your "perfect" calibration print. This gives you a contact sheet in which the standard negative is always perfectly balanced, regardless of the balance of the other negatives. Now the picture to be printed can be compared to the standard print on the contact sheet, and its density and balance can be estimated fairly accurately by eye-judgement.

With experience, you will usually be able to estimate your starting pack about as accurately by this contact-sheet method as by using most of the color analyzers that are available.

After recommending tri-color printing (using three separate exposures—one each through a red, green and blue filter) for those whose enlargers only accept filters below the lens, I mentioned that I would get back to this method.

It should be clear that Figure 6 applies to tri-color printing as well as to filter-pack printing. In practice, where Figure 6 calls for the addition of any of the additive primaries—red, green, or blue—you simply increase the time of exposure that you give through that filter. Where Figure 6 calls for subtracting any of the additive primaries, reduce the time you expose the print through that filter. It is difficult to recommend any starting exposure times for the beginning of the calibration because of the wide divergence of different printing equipment.

The tri-color printer who buys the Uniwheel, a tri-color filter wheel marketed by Unicolor, will acquire a device called a Uniguide, which is included in the purchase price. The Uniguide is a simple tri-color extinction meter which, used according to instructions, will give you reasonably accurate starting print-exposure times to use with each of the three additive primary filters.

If other filters are used, you may have to expose several sheets of paper to arrive at a set of reasonable exposure times, and, from there, to get a balanced and well-exposed print. But once that is done, and the steps of the procedure carefully recorded, it should be simpler and quicker each time thereafter.

My recommendation that you work from a contact sheet which includes a standard negative applies to this printing method as well.

Contrast can be increased or decreased in color printing by using masks, which are made by exposing any of several types of masking film through the negative that is to be masked. After being developed and dried, the masks are then bound in registration with the original negative and the sandwich is printed to achieve the desired result.

It is also quite easy to make black-and-white prints from color negatives. If ordinary printing paper is used, the tones of prints from color negatives will often be unacceptable. This is because bromide papers are primarily blue-sensitive, and do not respond to light of other colors. Some printing papers are made with panchromatic emulsions specifically to render accurate tones in printing color negatives. One such paper is Kodak Panalure. Instructions for using Panalure are available from Kodak.

It is also possible to make color prints directly from positive color transparencies by reversal. Kodak, Agfa, Ciba and others have such processes available. In my opinion, however, these processes are not appropriate for the small-quantity printer. For those who are interested, Kodak markets Ektachrome Paper and Type R chemistry. (3½ gallons is the smallest quantity sold.) Details of the process are given in the *Kodak Color Dataguide*.

Otherwise, slides may be copied on a color-internegative film (such as Kodak's 6008), then printed from the internegative. This can be done by the printer, using any slide-copying device, or can be done by the film manufacturer or a commercial lab. You can make internegatives fairly successfully on ordinary camera negative film, but shifts in color balance and contrast can usually be expected when this type of film is used.

The materials and processes described in this chapter are covered in much greater detail in the manufacturers' literature, and in the *Photo-Lab-Index*, published by Morgan & Morgan, Inc.

The best advice about color printing I ever got came after I had read enough to be convinced that color printing was just too demanding to bother with. I was advised to go into the darkroom, forget all that I had read, and make every mistake in the book, *but print*. I did. I enjoyed it. Eventually, I learned. I think you will, too.

Camera Optics

Rudolf Kingslake

A camera is an optical instrument, and therefore a serious photographer should be familiar with the optical principles involved in its construction and operation. Optics can be very technical, especially in aberration theory and lens design, but many aspects of the subject are simple enough for a non-technical photographer to understand. A knowledge of these will help you make better pictures.

In preparing to take pictures you must consider the following: (a) whether they will be in color or in black and white, and for slides or for prints; (b) the limits of the scene to be recorded; (c) the perspective; (d) the point of accurate focus in the subject, and the desired depth of field; (e) the possible need for a short exposure time to "stop" subject or camera motion, for the use of flash, or for long enough exposure when the light is dim.

At least six degrees of freedom are available to you, which you must deliberately establish before you take a picture. They are: (1) choice of film and filter; (2) location of camera in relation to the subject, and whether a tripod is needed; (3) selection of lens; (4) lens focus setting; (5) lens aperture setting (f-stop); (6) shutter speed setting, and whether flash is necessary.

When using a reflex camera, such as the Leicaflex SL, with through-the-lens metering, most of the above conditions are met automatically. The area of the scene that is to be recorded, the perspective, the plane of best focus and the depth of field are all directly visible in the reflex finder. The illumination that will reach the film is indicated by the meter, even with very near objects, allowing the photographer to set either the shutter speed or the lens aperture at will and then adjust the other for correct exposure.

Since every change in the camera affects almost every aspect of the finished picture, taking a good photograph is not a simple matter. Indeed, the photographer's skill can be judged by his ability to weigh one factor against another to secure the picture he wants. For instance, the *perspective* of the picture depends not only on camera position relative to the subject, but also on the choice of lens and the manner of viewing the final picture. The *depth of field* depends on the object distance, the lens aperture and focal length in relation to object distance, and the position from which the final picture is viewed. The *exposure* depends on the object's luminance (the measurable intensity of the light reflected from its surfaces), the object's motion, the film speed, the relative aperture (f-number) of the lens, and, if it is very close, the distance of the object. A short-focus lens has relatively great depth of field, but it must be used with care if unnatural-looking perspective is to be avoided, especially at close working distances and when tilting the camera up or down. A long lens has relatively shallow depth of field at any given working distance, unless stopped down to a small aperture, which may require a long exposure. In this case, image motion due to movement of the subject or the camera may become a serious problem.

It is impossible to anticipate all possible cases, but in this chapter we shall consider various aspects of the final photograph and how they can be affected by lens selection and by changes in the lens and camera controls.

Viewing the photographs

At first the Leica was used solely to produce 24x36mm black-and-white negatives, all or part of which were enlarged to make paper prints of various sizes. Some workers also made positive transparencies from these negatives, for projection, especially for lecture purposes. These were either in the standard 3¼x4-inch size or the newer 2x2-inch size.

Since the introduction of 35mm color film in 1935, cameras such as the Leica have been used more and more to make color slides. Here the film that is exposed in the camera is reversed in processing to produce a positive slide, and masked down to about 23x35mm in mounting. The resulting transparency is viewed without further alteration, by projection on a screen, or through a magnifying lens in a viewer. Usually there is no cropping. Hence, in taking color transparencies, you must use great care in aiming the camera and determining the precise limits of the scene in the viewfinder. You must avoid any unwanted tilt of the camera, since in a color slide it cannot be corrected later.

Color negatives which are to be enlarged offer the same possibilities for cropping and for limited correction of perspective in the printing process as black-and-white negatives: nevertheless, for optimum image quality, it is still best to photograph as accurately as you can. In either case, the point of sharp focus cannot be shifted nor the overall sharpness or definition be improved in the final version.

Symbols used in this chapter

A number of symbols are used in the optical formulae that follow. For clarity, they are identified here:

A Aperture diameter of a lens: the entrance-pupil diameter.

B Luminance ("measurable brightness") of an object in candelas per unit area.

c Circle of confusion, indistinguishable from a point, in the focused object plane.

c' Circle of confusion, indistinguishable from a point, in the film plane.

D_1 Depth of field, from the focused plane to the nearest limit of depth.

D_2 Depth of field, from the focused plane to the most distant limit of depth.

E Illuminance at an image.

E_ϕ Illuminance in the image at a point corresponding to a field angle ϕ.

e' Distance of the exit pupil from the posterior focus of a lens.

F Focal point of a lens.

f Focal length.

h Image height above the lens axis.

K A constant.

k Transmittance factor of a lens.

L_1 Distance from lens to the nearest limit of the depth of field.

L_2 Distance from lens to the furthest limit of the depth of field.

m Magnification, or scale of reproduction; the ratio of image size to object size.

m_e Magnification of an enlarger or projector.

m_p Pupil magnification; diameter of exit pupil divided by diameter of entrance pupil.

N_1 N_2 Nodal points (principal points) of a lens.

p, p' Object and image distances measured from the respective principal points of a lens.

s Focus-scale setting of a lens.

t Length of extension tube.

V Viewing distance; distance of an observer from a print or a projection screen.

x, x' Object distance and image distance measured from the respective focal points of a lens.

y, y' Semidiameter of the entrance and exit pupils of a lens.

ϕ Field angle, measured outward from the lens axis.

θ Semiangle of the cone of rays from a lens to the axial image point.

π A constant (π = 3.14).

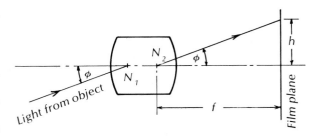

Fig. 1
Relation between field angle ϕ, image height h, *and focal length* f

The focal length of a lens

The most obvious and important property of a lens is its focal length. Leica and Leicaflex lenses currently range from 21mm (⅞-inch) to 800mm (32 inches) in focal length, thus offering a wide range of image sizes on the film.

When a camera is focused on a very distant object, the image is formed in the principal focal plane of the lens, and the size of the image on the film is directly proportional to the focal length of the lens. A 200mm lens will form twice as large an image of the moon, for example, as a lens of 100mm focal length.

We can express this property in precise mathematical terms by the formula: $h = f \tan \emptyset$. Here \emptyset is the angular position of a point in the scene, measured outwards from the lens axis (Fig. 1), h is the height of the image of that point on the film, also measured outwards from the lens axis, and f is the focal length of the lens.

The points N_1 and N_2 on this diagram are known as the *nodal points* of the lens, through which an oblique ray enters and leaves at the same slope. The focal length, f, of the lens is evidently equal to the distance from the second nodal point, N_2, to the focal plane.

The above relationship between object size and image size can be written $f = h/\tan \phi$, an expression which forms the basis of the current ANSI (American National Standards Institute) definition of focal length.

The size of the Leica negative is 24x36mm; hence

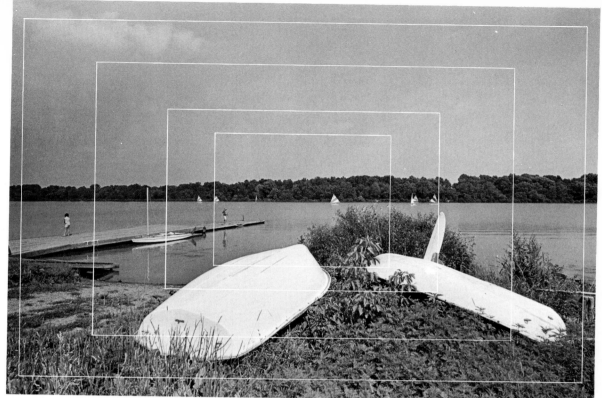

Fig. 2
The fields of view covered by lenses of different focal lengths (21mm, 35mm, 50mm, 90mm); also see Fig. 5

the maximum value of h to the corner of the film area is $\sqrt{12^2 + 18^2} = 21.6$mm. The relation between the focal length of the lens and the angular dimensions of the scene is given in Table I at the end of this chapter, and illustrated in Figure 2.

The size of the image of a near object is related only indirectly to the focal length of the lens. The mathematical expression for the scale of reproduction—that is, the magnification m or the ratio of the size of the image to that of the object—is $m = x'/f$ (Equation 1). In this formula, x' is the longitudinal distance from the focal plane of the lens to the plane of the image of the near object. It is the distance the lens must be moved forward from the infinity setting to focus on the near object.

An alternative formula is stated:

$$\text{scale of reproduction} = \frac{\text{focal length}}{\text{object distance} - \text{focal length}}.$$

For example, here are scales of reproduction for two lenses, of 100mm and 200mm focal length, at an object distance of 400mm:

$$\text{scale with 100mm lens} = \frac{100}{400 - 100} = 1/3$$

$$\text{scale with 200mm lens} = \frac{200}{400 - 200} = 1$$

ratio of focal lengths = 100mm:200mm = 1:2
ratio of image sizes = 1/3:1 = 1:3

Clearly, image size is not directly proportional to focal length when the object distance is short.

Perspective

Most photographs are two-dimensional representations of three-dimensional scenes. The relation of one part of the picture to other parts—the perspective—is established once the camera position has been chosen. Objects that are close to the camera appear large, while distant objects look relatively small (Fig. 3). Of course, if all the objects are at substantially the same distance from the camera, perspective is not a problem, and the camera may be placed at any distance from the scene that the photographer prefers.

The perspective of a scene is intimately related to the composition, and a skilled photographer will select his camera position with care to get the exact picture he has in mind. A study of the scene through the viewfinder is essential. If the area to be photographed is small and the camera is distant, either a

Fig. 3
Near objects appear large, while distant objects appear small. Photograph by George Krause

long-focus lens may be used, or only a portion of the negative is used, requiring great enlargment in printing, with consequent loss of definition (sharpness of detail). When color slides are being made, it is generally not practical to mask off part of the picture area; therefore the camera must be moved closer to the subject if a suitable long-focus lens is not available.

At the opposite end of the scale, if a wide area of the scene is to be included in the picture, then a short-focus lens that covers a wide angular field must be used, or the camera must be moved away from the subject until the whole scene fits into the picture area.

Because changing the camera position changes the appearance of the scene—the perspective—obviously much more can be done when several lenses of different focal lengths are available. One advantage of the 35mm film size pioneered in still photography by the Leica is that the normal focal length is only 50mm (two inches), so that even a four-times increase in focal length brings us only to 200mm (eight inches)—still not a very long lens. In the days when 4x5 inches was a much-used negative

size, the normal focal length was 6-1/2 inches; a four-times-normal lens has a 25-inch focal length—a heavy, unwieldy, expensive giant.

Center of perspective

A camera provides a means to record a scene exactly as it appears to the photographer standing with his eye at the viewfinder. The center of perspective of the scene, of course, is at the camera lens itself. The position of the camera therefore determines the relationship between the angular positions of the various objects in the scene and the linear positions of the images of those objects on the film.

The picture, as finally presented to the viewer, is only a true reproduction of the original scene when the observer's eye is placed at the center of perspective of the reproduction; namely, in that position at which picture details subtend the same angles at his eye as the corresponding original objects subtended at the camera. This concept is illustrated in Figure 4, which shows a color slide being projected on a screen and viewed by an observer from the center of perspective. The half-angle ϕ represents the same half-angle ϕ of the original scene (as listed for various lenses in Table I).

In the simple case of a color slide taken with a 50mm lens and projected with a 100mm lens, the

Fig. 4
The center of perspective of a projected picture

center of perspective of the projected images is midway between the projector and the screen. Table II, at the end of the chapter, shows the correct "true-perspective" distance of the observer from the screen for color slides made with a variety of different camera lenses; these distances are expressed as so many multiples of the long dimension of the projected image. Since the long dimension of a mounted color slide is about 35mm, the number in the right-hand column is merely the focal length of the lens divided by 35.

To avoid perspective distortion and to see the picture as it appeared to the photographer, it is clear that a wide-angle scene photographed with a 21mm or 28mm lens must be viewed from very close indeed, whereas a shot made with a long telephoto lens should theoretically be viewed from a great distance. But in a sense, this requirement for faithful reproduction of a scene defeats the purpose of using a variety of lenses, because if we use a long lens to magnify a scene and then look at the picture from a great distance, the object will look just as small to us as it did to the photographer, and we lose the advantage of the long lens. In practice, we generally view all pictures from about the same distance, regardless of these perspective considerations

Perspective distortion

When we view a picture from any position other than the center of perspective, we see some perspective distortion. If we view the picture from too far away, near objects appear disproportionately large; if we view it from too near, distant objects look abnormally large. In recent years, the use of long lenses to obtain dramatically weak perspective has become a popular technique—we are familiar with the large sun or moon with small-looking mountains, buildings, people, trees, automobiles and the like included in the foreground of the picture.

The perspective distortions caused by a wide-angle lens when the picture is viewed from too far away are very noticeable, so wide-angle lenses must be used with care. In Figure 5, a scene is shown as photographed with three different lenses. If we cannot accommodate our eyes to a very close center of perspective, we may use a magnifier lens with a focal length equal to the desired viewing distance. The increase in realism that results from using the correct viewing distance is remarkable.

A camera with a wide-angle lens must not be tilted up or down, but held accurately horizontal when taking the picture, unless drastic "keystone" distortion is wanted (Figure 6). This effect is generally less emphatic with longer lenses because they cover a narrower field. On the other hand, a wide-angle lens will often enable us to photograph a tall building without having to tilt the camera, thus avoiding any convergence of vertical lines; this would be impossible from the same viewpoint with a normal lens.

Another type of perspective distortion caused by a wide-angle lens may be called "elliptical" distortion, since spheres tend to be rendered as spheroids toward the outer part of the field. This is evident in the photograph reproduced in Figure 7. The reason for this type of distortion is shown in Figure 8: here the flat circles *aa, bb,* would be reproduced on the film as circles *a'a', b'b',* but the spheres *ss* project as an ellipse *s's'* in the camera. The long axis of the ellipse is radial to the picture; the tangential dimension remains as for the flat circle, resulting in an elliptical image of a spherical object.

Focusing a camera

The object in front of a lens and its image formed by the lens are said to be conjugates, and in a well-corrected lens with a flat field, the conjugate of the film plane is a plane perpendicular to the lens axis in the object space, as shown in Figure 9. The distance p of the object from the first principal plane of the lens, and the distance p' of the image from the second principal plane, are related by:

$$\frac{1}{p'} + \frac{1}{p} = \frac{1}{f}$$

(Equation 2) where f is the focal length. The "principal planes" of a lens are a pair of conjugate planes, such that an object situated in one of those planes is

135mm lens

Fig. 5
Scenes
photographed
with
different lenses

50mm lens

400mm lens

imaged at unit magnification (1x) in the other. The axial points of the principal planes are the "principal points" or nodal points of the lens. Equation 2 shows that the image of a very distant object falls at the focal point, since $p' = f$ when $p = \infty$.

In most lenses, the two principal planes are located close together near the middle of the lens, but there are many exceptions, especially in telephoto and reversed-telephoto ("retrofocus") lenses; one should never blindly assume that the principal planes are necessarily near the middle of the lens barrel.

The above equation can also be used to compute the focusing scale for a lens, but a much simpler formula relates the distances of object and image from the front and rear focal points: $xx' = f^2$. For any given distance x of the object from the front focus of

Fig. 6
"Keystone" distortion due to upward-tilted camera

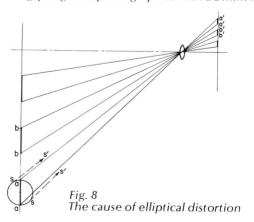

Fig. 7
Ping-pong balls photographed with a 21mm lens

Fig. 8
The cause of elliptical distortion

the lens, the corresponding distance x' of the image from the rear focus is given by: $x' = f^2/x$. Clearly, if x is infinite, indicating a very distant object, x' will be zero and the image will fall at the focal plane. For any object distance p engraved on the focus scale of the lens barrel, which is generally the distance of the object from the front principal plane, the corresponding x is equal to $(p - f)$, and the focusing movement from the infinity position will be:

$$x' = f^2/(p-f).$$

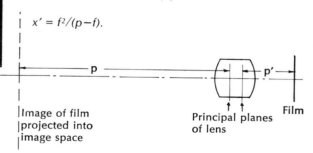

Image of film projected into image space

Principal planes of lens

Film

Fig. 9
The conjugate distances of a camera lens

Extension tubes

The focusing movement of most camera lenses is limited by practical mechanical considerations to a maximum of a little over ¾ inch. This is more than sufficient to enable a 50mm lens, for example, to be focused down to an object distance of 20 inches. But with long-focus lenses, the range of focusable object distances becomes quite limited. For example, these

are the actual nearest focusing distances of current long-focus Leica lenses, as published by Leitz:

Focal length (mm)	Nearest object distance (meters and feet)		
200	3 meters	9.4 feet	(on Visoflex)
280	3.5	11.4	(on Visoflex)
280	2	6.5	(on Televit
400	3.6	11.5	mount)
560	6.6	18.5	
800	12.5	41.0	

One way to increase the close-focusing capacity of lenses is to insert an extension tube between the lens and the camera, or to mount the lens on a bellows. Extension tubes for the Leica come in several lengths, from 11mm to 90mm. (Their use is explained in the chapter, "Closeup Photography," by Norman Rothschild.) When an extension tube is used, the distance scale on the lens is no longer correct; each distance mark now corresponds to a much closer object distance. We can use the above formulae to determine the range of object distances that can be focused when using a given extension tube, or we can determine what lens setting must be used to focus on objects at a given distance.

If the length of the extension tube is t, the object distance is p, and the focus-scale reading is s, then, as we have seen, the distance of the image from the focal plane of the lens is $f^2/(p-f)$. The extension tube accounts for an amount t of this, leaving an amount $x' = f^2/(p - f) - t$ to be absorbed by the focusing mechanism. This focusing movement corresponds to a scale reading in the object space of $s = (f^2/x') + f$. Combining these two equations gives the following expressions for p and s:

$$p = f \left(\frac{sf + t\,(s-f)}{f^2 + t\,(s-f)} \right) \qquad \text{(Eq. 3) and}$$

$$s = f \left(\frac{pf - t\,(p-f)}{f^2 - t\,(p-f)} \right) \qquad \text{(Eq. 4)}$$

As an example, suppose we are using a 400mm (16-inch) lens with a 30mm (1.18-inch) extension tube. If the focusing motion of the 400mm lens is from 25 feet to ∞ , a distance of $x' = f^2/(p-f) = 16^2/284 = 0.9$ inch; then, with the extension tube in place and the lens set at infinity focus, the actual object distance is:

$$p = f \left(\frac{f + t}{t} \right) = 16 \left(\frac{17.18}{1.18} \right) = 233 \text{ inches} = 19.4 \text{ feet.}$$

When the focusing scale reads s = 25 feet = 300 inches, the shortest focusing distance for this lens, the true object distance is found by Equation 3 to be:

$$p = f \left(\frac{(300 \times 16) + (1.18 \times 284)}{(16 \times 16) + (1.18 \times 284)} \right) = 138.9 \text{ in.} = 11.6 \text{ ft.}$$

Thus the focusing range of this lens with the 30mm extension tube in place is from 11.6 to 19.4 feet. We cannot focus on any object in the blind area lying between 25 feet (without the tube) and 19.4 feet (with the tube). For objects within this range, a shorter extension tube would have to be used.

A different calculation using Equation 4 is employed to discover the focus-scale setting that will correspond to a given object distance—say p = 15 feet = 180 inches—using this same lens and extension tube. For this object, the lens scale must be set at:

$$s = f \left(\frac{(180 \times 16) - (1.18 \times 164)}{(16 \times 16) - (1.18 \times 164)} \right) = 688 \text{ in.} = 57.3 \text{ ft.}$$

One of the many advantages of a reflex camera is that we do not need to use the focusing scale of a long telephoto lens of this kind, either with or without an extension tube, because we can simply focus the image on the viewfinder screen by eye.

The f-number of a lens

The size of the aperture of a lens affects both the depth of field and the illumination that falls on the film. It was a long time before a standard method of designating lens apertures was established, no doubt because both depth of field and brightness could readily be judged by looking at the image on the groundglass screen. Today all lens apertures are marked by the so-called f-number, the ratio of the focal length of the lens to the diameter of the largest entering parallel beam of light that can pass through it.

The beam is assumed to be circular, although iris diaphragms with as few as three leaves have occasionally been used (the automatic exposure controls in small movie cameras form non-circular apertures which may even, in extreme cases, be H-shaped).

When we look into the front of a lens we do not see the iris diaphragm itself but the entrance pupil—

an image of the iris formed by the part of the optical system that lies between the iris and the eye. Generally, this portion of the lens magnifies the iris, but in lenses of the reversed-telephoto type, the entrance pupil may be smaller than the iris. The designations, *iris* and *pupil* of a lens, are obviously analogous to the iris and pupil of the eye.

When we look into the rear of a lens we see another image of the iris, the exit pupil. In a symmetrical lens, the two pupils are exactly the same size, but in all other systems one pupil may be considerably larger than the other. The pupil magnification is the ratio of the diameter of the exit pupil to that of the entrance pupil. The f-number of a lens is the ratio of the focal length to the diameter of the entrance pupil.

Depth of field

The human eye is not a perfect instrument; because of such factors as lens aberrations, the granular structure of the retina and diffraction at the rim of the pupil, the eye has limited resolving power and cannot distinguish between a point and a very small circle of light. Experiments show that the ultimate resolving power of the eye under the most favorable conditions is about one minute of arc. Thus, we can just distinguish two black lines on a brightly-illuminated white ground (the space between the lines being equal to their width) if the total width of one line and one space is about 1/3400 of the distance of the object from the eye.

It should be realized that *seeing* a thing is not the same as *resolving* it. We can see bright stars that subtend only a fraction of a second of arc, but we cannot see their discs and we cannot resolve or distinguish between two stars that are separated by an angle less than about one minute of arc.

Likewise, experiments show that the eye cannot distinguish between a perfect point and a small circle of light if the diameter of the circle is less than the resolving power of the eye. However, our eyes quickly become less sensitive if the illumination is reduced, and we also have a great ability to detect and interpret details in a picture, even if they are not sharply imaged. In depth-of-field calculations, we therefore generally assume that the eye can just distinguish between a true point and a circle having a diameter equal to about 1/1000 of the distance of the object from the eye, representing an angular subtense of 3.4 minutes of arc.

The fact that the eye cannot distinguish between a point and a very small disc of light leads to the concept of *depth of field*. This is the range of distances in the object space within which all objects appear acceptably in focus to the final observer. Within this range, object points are imaged as tiny *circles of confusion*, too small to be distinguishable from perfect points.

We have stated that the average observer can recognize a disc of light if it subtends an angle greater than 1 to 1000 at his eye. This assumption enables us to determine the size of the acceptable circle of confusion in the final print or projected image. When we know the degree of enlargement in the print or on the screen, we can translate this circle of confusion back to the film, and hence out into the object space in front of the camera, to determine the depth of field.

To calculate the exact depth of field numerically in any particular case, we must know the observer's distance from the picture, V; the enlarger or projector magnification, m_e, and the scale of reproduction in the camera, m. Knowing these, the diameter of the circle of confusion on the film is $c' = V/1000m_e$, and the diameter of the circle of confusion in the original object plane is $mV/1000m_e$, which we will call c.

To determine the depth of field on the basis of this circle of confusion c, refer to Figure 10.

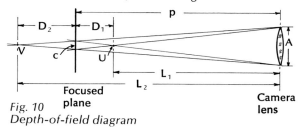

Fig. 10 Depth-of-field diagram

The aperture of the lens (entrance pupil) is A, and the lines in Figure 10 that join the edge of the circle of confusion to the rim of the lens aperture cross at U and V. Similar triangles show that the depths of field are respectively:

$$D_1 = \frac{cp}{A + c} \quad \text{(near) and}$$

$$D_2 = \frac{cp}{A - c} \quad \text{(far)}$$

$$\left. \right\rbrace \text{(Eq. 5)}$$

To see how these formulae work, let us suppose that the observer is sitting eight feet from a screen, viewing a color picture projected from a 1 x 1.5-inch (i.e., standard 35mm) slide. The image on the screen is five feet (60 inches) wide. Then V = 8 feet = 96 inches; and m_e = 60 inches/1.5 inches = 40x. Therefore, the circle of confusion on the film is: c' + $V/1000m_e$ = 96/(1000)x(40) = 0.0024 inch.

If the camera had a 50mm (2-inch) lens, then $f = 2$. And if the distance of the object from the camera was 20 feet, then p = 20x12 = 240 inches. The circle of confusion in the object plane is: $c = c'p/f$ = (0.0024)x(240)/2 = 0.29 inch.

Thus, the observer watching the picture will be unable to distinguish between a sharply-focused point and a circle 0.29-inch in diameter in the original object plane, which was 20 feet from the camera.

To calculate the depth of field, we need to know one more quantity—the diameter A of the entrance pupil of the camera lens. If our 50mm (2-inch) lens was used at $f/2$, then $A = 1$ inch, and the depth of field becomes

(near) $D_1 = \dfrac{.29 \times 240}{1.29}$ = 53.9 inches = 4.5 feet;

(far) $D_2 = \dfrac{.29 \times 240}{0.71}$ = 98.0 inches = 8.2 feet.

Therefore everything between 15.5 feet and 28.2 feet from the camera will appear to be in focus to the observer watching the screen. If he moves closer to the screen, or further from it, the depth will be reduced or increased accordingly.

It is clear that many factors are involved in computing depth of field. Over the years it has become customary to simplify the problem by adopting a standard value for c', the acceptable circle of confusion on the film. Many tests have shown that a reasonable value for c' is 1/30mm or 1/750 inch. That value has been adopted in all Leica depth-of-field tables and is used for the depth-of-field scales engraved on the lens barrels.

This circle of confusion is at the just-observable limit for an observer whose distance from the screen is equal to the long dimension of the projected image. Depth of field varies according to the position of the observer; thus, depth-of-field scales and calculations are somewhat indefinite at best.

For convenience in calculations, we can substitute $c = c'p/f$ in the depth equations (Eq. 5), giving:

$$D_1 = \frac{c'p^2}{Af + pc'} \quad \text{(near depth) and}$$

$$D_2 = \frac{c'p^2}{Af - pc'} \quad \text{(far depth)} \qquad \text{(Eq. 6)}$$

The limits of the depth-of-field range therefore become:

$$L_1 = p - D_1 = \frac{Apf}{Af + pc'} \quad \text{(near limit) and}$$

$$L_2 = p - D_2 = \frac{Apf}{Af - pc'} \quad \text{(far limit)} \qquad \text{(Eq. 7)}$$

For many purposes it is more convenient to add up the D_1 and D_2 expressions to obtain the total depth of field. If we do this to the formulae in Equation 6, we obtain:

$$D_1 + D_2 = \frac{2c'p^2Af}{(Af)^2 - (c'p)^2} \qquad \text{(Eq. 8)}$$

For objects that are fairly close to the camera, we shall make only a small error by neglecting $(c'p)^2$ in the denominator, in which case the total depth becomes:

$$D_1 + D_2 = \frac{2c'p^2}{Af} = \frac{2c'p^2 \ (f\text{-}number)}{f^2} \text{ approx. (Eq. 9)}$$

Hence, assuming an acceptable circle of confusion c' in the film, the depth of field of a lens for fairly close objects is proportional to the f-number, and inversely proportional to the square of the focal length, other things being equal.

It is worth noting that f/p is approximately equal to the scale of reproduction in the image, m. In terms of the scale of reproduction, the last expression can be written:

$$D_1 + D_2 = \frac{2c' \ (f\text{-}number)}{m^2} \text{ approx.} \qquad \text{(Eq. 10)}$$

Equation 10 tells us that if we have two cameras side by side, one with a 28mm lens and the other

with a 135mm lens both set at the same f-number, the depths of field will be in the ratio of $(135/28)^2$, or 23 to 1. Of course, the details in the 28mm picture will be very small compared with those in the 135mm picture. Equation 10 tells us that if the camera with the 135mm lens were moved back far enough so the picture details became the same size in both cameras, the depths of field would be identical, because depth depends only on scale of reproduction and f-number. If the objects are quite distant, however, these simplified formulae are no longer valid, and we must then use the accurate Equations 6, 7 and 8.

Another special case arises if an object is photographed by two cameras side by side with lenses of different focal length, and the negatives enlarged by different amounts so that the principal subject appears at the same size in each print. How will the depths of field differ in this case?

Substituting $c' - V/1000m_e$ in Equation 9 gives:

$$\text{total depth} = \frac{2c'p^2}{Af} = \frac{2Vp^2}{1000m_e Af} \text{ approximately.}$$

Since the principal subject is to appear the same size in each print, the respective enlargements must be inversely proportional to the focal lengths of the cameras lenses, or $m_e = K/f$ where K is a constant. Hence:

$$\text{total depth} = \frac{2Vp^2}{1000KA} \text{ approximately.}$$

Here V and K are fixed quantities, so the depth of field in each print will depend only on the distance p of the object from the camera and the diameter A of the lens aperture. Thus, two cameras placed side by side will show the same depth in the final prints if one has a focal length of 2 inches at f/2 and the other a focal length of 4 inches at f/4, the film from the first camera being enlarged twice as much in printing as the second film to make the principal subject appear the same size in each print. The lens aperture, A, is, of course, one inch in each case (Figure 11). It follows that if the same f-number is used with both lenses, the depth of field of the 2-inch lens will be twice that of the 4-inch lens.

These calculations assume that the lenses on the camera and the enlarger or projector are perfect and free from aberrations. In reality, even the best lenses,

Taken with 50mm lens at f/2

Taken with 135mm lens at f/5.3

Fig. 11
Depth of field is the same when two cameras with lenses of different focal length are used side by side at lens apertures of the same diameter (in this case, 25mm), and the principal subject is enlarged to the same size in both pictures

especially those of high aperture, possess some small residuals of aberrations, so the actual depth of field is often greater than is given by these formulae, especially in the near direction. Furthermore, since we can tolerate more blurring of close objects simply because they appear larger in the picture, the near and far depths are generally more nearly equal than our formulae indicate.

The presence of aberrations, especially spherical, does increase depth of focus, and hence depth of field as well. The reason is that rays from the rim of the aperture of a spherically aberrant lens come to a focus at a different distance from the lens than rays from the center, so that there will be an image of sorts all the way from the marginal focus to the axial focus, although at no point will the image be clean and sharp. Incidentally, this explains why simple lenses can be used on box cameras with no focusing mechanism; a well-corrected lens could not be used this way because it would have too little depth of focus.

Hyperfocal distance

If we wish to secure the greatest possible depth of field when the scene includes objects at a very great distance, we focus the lens so that the f-number indicator on the "far" side of the depth-of-field scale lies opposite the infinity mark. The scale pointer then indicates the *hyperfocal distance*. The near end of the depth range is one-half the hyperfocal distance, as shown by the f-number indicator at that side of the scale. You can readily check this by studying the depth-of-field scale on a Leica lens; see Figure 12.

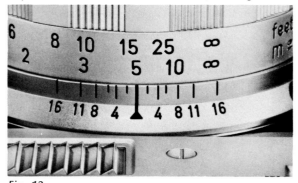

Fig. 12
The depth-of-field scale on a lens barrel. Indicator is at hyperfocal distance for f/16: 5 meters. Depth of field extends from approx. 2.6 meters to ∞

An expression for the hyperfocal distance may be found by referring to Equation 7, which gives the far limit of depth as:

$$L = \frac{Apf}{Af - pc'}$$

For L to be equal to infinity, the denominator must be zero, in which case $Af = pc'$, whence:

$$\text{Hyperfocal distance} = p = \frac{Af}{c'} = \frac{f^2}{c' \times f\text{-number}}$$

A few examples may be of interest. It is assumed that the lenses are all used at f/5:

Focal length (mm)	Hyperfocal distance (feet)
28	15
50	48
135	350
400	3100

With a 50mm lens at f/5, for instance, the depth of field will extend from infinity to half the hyperfocal distance, or 24 feet, provided the camera is focused at the hyperfocal distance, namely, 48 feet. Depth of field falls off at an alarming rate when long-focus lenses are used at relatively large apertures. At f/5, a 400mm lens focused at the hyperfocal distance of 3100 feet has a near depth limit of 1550 feet.

Depth of focus and depth-of-field scales

Because of the existence on the film of an acceptable circle of confusion, c', which the viewer will consider equivalent in the picture to a sharp point of light, there is a certain small longitudinal *depth of focus* inside the camera, within which all images will be

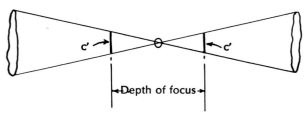

Fig. 13
Depth-of-focus diagram

acceptably sharp. In Figure 13 the sloping lines represent the boundaries of the cone of rays that converge to a point focus at 0. The beam expands to a diameter c' at a distance either way from 0 equal to the f-number of the lens multiplied by c'. Hence:

depth of focus = ± c'xf-number (Equation 11)

Since the two ends of the depth-of-focus range are the images of the depth-of-field limits in the object space, we can place limit marks that correspond to the limits of the depth of field on each side of the index pointer on the focusing scale of the lens (Figure 12). These marks are spaced at the depth-of-focus limits given by Equation 11, taking into account the pitch of the focusing screw of the lens.

Diffraction blurring

Another property of a lens—diffraction blurring of the image—depends primarily on the linear aperture of the lens and is also affected by the distance of the object. Fortunately, this effect can usually be disregarded, since it is not generally noticeable if the lens aperture is larger than about one millimeter in diameter. *Diffraction* is the name given to the slight bending suffered by light rays as they pass the edge of the lens diaphragm; the magnitude of the bending is inversely proportional to the diameter of the aperture.

Theory shows that the image of a point formed by even a perfect lens will not be a point, but a tiny circle of light with a diameter about equal to the f-number expressed in microns (a micron is 1/1000 of a millimeter). The effective diameter of the image of a point formed by a lens at f/11 is therefore 11 microns, or 0.011mm. This is a very small diameter indeed, but it may become significant when projected out into object space, where it becomes the *object-space f-number* expressed in microns. The object-space f-number is the object distance divided by the diameter of the lens aperture. Thus a lens with a linear aperture of 1.0mm, when focused on an object 50 feet away, will image an object point as if it were a circle of 15.2mm (0.60 inch) diameter in the object plane. In this case, no detail smaller than 15.2mm can possibly be recorded. Fortunately, very few lens diaphragms can be stopped down to an aperture as small as one millimeter (the only such Leica lens is the 21mm Super Angulon).

Image-brightness theory

If we use a reflex camera in which the light is metered through the lens (such as the Leicaflex SL), the illumination that falls on the lens from a given object is measured directly, and no calculations or adjustments are required. But with other cameras, where the luminance (brightness) of the subject is measured by an external photometer, we must know the relationship between the object luminance and the illumination on the film to determine the correct exposure time.

Our calculations will be based on the fundamental formula for image illuminations: $E = kB\sin^2\theta$, (Equation 12), where E is the illumination on the film k is the lens transmittance (usually close to 1.0), B is the luminance (measurable reflected brightness) of the object, and θ is the semiangle of the cone of rays leaving the exit pupil of the lens and proceeding to the axial point of the image (Figure 14).

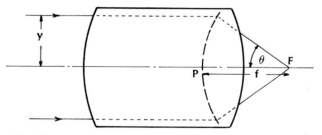

Fig. 14
The rear principal plane of a lens is really a sphere centered about the focus. Hence $\sin\theta = yf$

If B is measured in foot-lamberts, then E will be in foot-candles. If B is measured in candelas-per-square-foot (a unit commonly used in exposure meters), then a factor π must be added to the right-hand side of this formula because there are π times as many foot-lamberts in a given luminance as there are candelas-per-square-foot.

The important relationship given in Equation 12 underlies all calculations of image illumination, whether in a camera, a projector, or in the eye itself. The exit pupil of the camera lens determines the size of the angle θ, and hence controls the illumination falling on the film, and, ultimately, the exposure time.

We must now investigate the relationship between the angle θ and the f-number of a lens. It is

shown below that when the object is very distant, the f-number is equal to $1/2sin\theta$. Hence the illumination E on the film is related to the object luminance B by:

$$E = kBsin^2\theta = \frac{kB}{4(f\text{-}number)^2}$$ (Equation 13)

Furthermore, if the object is close, say at a distance less than ten times the focal length, we must multiply the exposure time by a correction factor that depends on the image magnification m and the pupil magnification m_p:

$$correction\ factor = \left(1 + \frac{m}{m_p}\right)^2$$

The image magnification m is approximately equal to f/p, the ratio of the focal length to the object distance. The pupil magnification, m_p, is the ratio of the diameter of the exit pupil to that of the entrance pupil; it may be estimated with sufficient precision by looking first into the rear of the lens and then into the front.

Equation 13

It can readily be shown that when the object is very distant, the second principal plane is really part of a sphere centered about the focal point (Figure 14), and hence $sin\ \theta = y/f$. But the f-number is the ratio of the focal length to the diameter of the entrance pupil; or f-number = $f/2y$. Hence:

$$sin\theta = \frac{1}{2(f\text{-}number)}$$

Substituting this into Equation 12 gives Equation 13 directly.

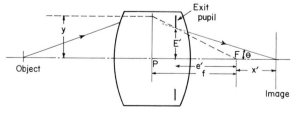

Fig. 15
Correction factor for exposure on a near object

To derive the near-object correction, we refer to Figure 15 and make use of the fact that, for any

image, the magnification is equal to x'/f, where x' is the distance from the principal focal point of the lens to the image (see Equation 1). From this figure we can see that $x' = mf$ and $e' = m_pf$.
To find the lens aperture for a distant object we project the exit pupil back onto the second principal plane by a line drawn from the focus, giving $y'/y = e'/f$. The true f-number of the lens is $f/2y$ as usual. Hence, for a near object:

$$sin\theta = \frac{y'}{e'+x'} = \frac{ye'}{f(e'+x')} = \frac{ym_pf}{f^2(m_p+m)}$$

The effective f-number of the lens for the near object is therefore:

$$Effective\ f\text{-}number = \frac{1}{2\ sin\ \theta} = \frac{f(m_p+m)}{2\ ym_p}$$

$$= (true\ f\text{-}number)\ \frac{(m_p+m)}{m_p}$$

The image illumination is:

$$E = \frac{kB}{4(effective\ f\text{-}number)^2}$$

$$= \frac{kB}{4(f\text{-}number)^2\ (1+m/m_p)^2}$$

The illumination on the film is therefore less by the factor $(1+m/m_p)^2$ and consequently the exposure time must be increased by this same factor when photographing a close object. As stated before, the use of a reflex camera with through-the-lens metering makes this correction unnecessary, as the meter reads directly the illumination that reaches the film, rather than the object luminance.

Film speed, and the exposure equation
During World War II the American Standards Association (ASA) developed a measure of film speed defined by the following "exposure equation":

Exposure
time in seconds $= \dfrac{(f\text{-}number)^2}{Bx(ASA\ film\ speed).}$ (Equation 14)

The exposure time is the least exposure that will give a satisfactory negative when the lens has the stated f-number, and the object luminance is B candelas per square foot. If B is measured in foot-lamberts, the time must be multiplied by π. For a close object, we must not forget to multiply the calculated exposure time by the factor $(1 + m/m_p)^2$.

As an example, if the object luminance measured

by a meter is 200 candelas per square foot, the ASA film speed is 64, and the lens aperture is f/5.6, Equation 14 tells us that the exposure time should be $(5.6)^2/(200 \times 64) = 1/400$ second.

Vignetting and the cos⁴ law

At their maximum apertures, all camera lenses tend to "vignette," or trim the light beams that proceed to the corners of the film frame, to a greater or lesser extent, depending on the construction of the lens. Telephoto lenses often exhibit no vignetting because of their narrow field angle. Normal lenses of large relative aperture tend to vignette considerably when fully open; but when the lens is stopped down, the vignetting is much reduced or even eliminated, as shown in the diagram in Figure. 16.

Fig. 16
The paths of axial and oblique light beams through a lens, indicating the cause of vignetting

Wide-angle lenses would ordinarily vignette considerably, except that the designer generally reduces the effect by making the front and rear apertures of the lens much larger than the axial beam diameter. However, even if the lens mounting permits the passage of an oblique beam as large as the axial beam, thus giving no vignetting whatever, the corner illumination will still be less than the central illumination by about the fourth power of the cosine of the field angle measured from the lens axis, or $E_\phi = E \cos^4\phi$

The value of this function at the corner of the field for lenses of different focal lengths is given at the end of this chapter in Table IV. Fortunately, wide-angle lenses, which would normally suffer most from the cos⁴ law, are now generally of the reversed-telephoto type. This form is chosen for its long back-focus clearance, necessary in such single-lens reflex cameras as the Leicaflex SL to provide space for the viewing-and-focusing mirror. In reversed-telephoto lenses, the large front negative component tends to enlarge the entrance pupil at high angles from the axis, thus admitting more oblique illumination and partially compensating for the cos⁴ law.

The usual result of the reduced corner illumination caused by vignetting and the cos⁴ law is that the corners of the picture are somewhat darkened. However, the eye is a very poor photometer, and we are normally totally unconscious of a gradual lowering of the illumination from the center to the corners of a picture by as much as 50 percent, which is all that vignetting and cos⁴ losses amount to in most cases.

Other factors that affect definition

The definition in a photograph is often affected more by camera or subject motion during exposure than by lens aberrations, diffraction, focusing errors, depth-of-field limitations, and so on. If the camera is not held absolutely still while the shutter is open, a noticeable blurring and loss of definition will occur. The use of a rigid tripod may lead to a surprising improvement in definition over that of a hand-held camera. Since objectionable camera movement is of an angular nature, the effect is proportional to the focal length of the lens. Thus a photographer can afford to be relatively casual when using a wide-angle lens, but he must be extremely careful to hold the camera still when using a telephoto.

Sharpness of definition is also affected by the cleanliness of the lens. A thumb print may cause a greater loss of sharpness than a residue of spherical aberration. This applies also to lenses on enlargers and projectors. If the lens surfaces are dirty, they should be cleaned carefully with soap and water applied sparingly with a soft brush, then wiped gently with a clean soft cloth or lens tissue. If dirt has found its way inside the lens, the latter should be returned to the manufacturer for cleaning.

In the early 1900s there was a furor about small bubbles in optical glass. These were then unavoidable, but did little harm, as their total area was only a minute fraction of the lens aperture. Today bubbles are extremely rare, and even if some tiny bubbles are visible in a lens they may be ignored.

The effects of scattered light and ghost images due

to internal reflections plagued photographers in the past. These are unlikely to give trouble today, as the surfaces of modern lenses are coated with a film of low-refractive-index material to reduce surface reflections to a negligible level. Also, the insides of lens mounts are blackened and baffled to prevent scattered light from reaching the film. Of course, if the sun or another bright light source is in or very near the field of view, the photographer can expect to see some signs of ghosts or diaphragm images in the picture, but these tend to be quite faint when modern coated lenses are used.

Types of lens construction

All lenses suffer from at least some of the numerous optical aberrations such as spherical aberration, coma, astigmatism and field curvature. Each aberration produces its characteristic type of image blur, or, in the case of distortion, a variation of magnification across the field. Every property of a lens varies with the wavelength (color) of the light, leading to the chromatic aberrations and to chromatic variations of all the other aberrations.

This array of image defects requires careful selection of the various lens elements and the kinds of optical glass from which they are made, so that the various aberrations can be balanced out and reduced to a negligible magnitude. The design of a fine lens is immensely time-consuming and tedious, often requiring weeks, months, or even years of laborious calculations. These were performed by logarithms until about 1926, when electric desk calculators appeared. Since about 1960 this work has increasingly been done by using electronic computers. Since computers can perform in seconds calculations that would take weeks or months by hand, it is now possible to design much better lenses with higher apertures than ever before; no human designer could possibly make the enormous number of calculations required.

The design of a lens is only the beginning. The mounting must be designed and built with extreme care to ensure that the anticipated performance is indeed realized. A trifling error in lens thickness or spacing, or in the refractive index of a glass, or in the centering of one lens element relative to all the others, will quickly undo the designer's efforts and render the lens useless.

Many different lenses of various types of construc-

tion have been designed and made for Leica and Leicaflex cameras. A brief summary according to the type of construction follows.

Fig. 17
Simple achromat: 560mm f/5.6 Telyt

Simple achromats

A cemented doublet telescope objective gives excellent definition over a semi-field of 2° or 3°; therefore this simple system can be used in lenses of 400mm or longer focal length for a 35mm camera. The length of the tube from lens to film is, of couse, equal to the focal length. However, the lens is very light in weight and gives excellent definition at apertures of f/5.6 or smaller.

Fig. 18
Modified triplet: 50mm f/3.5 and f/2.8 Elmar

Fig. 19
Modified triplet: 135mm f/2.8 Elmarit

Fig. 20
Double-Gauss: 50mm f/1.2 Noctilux

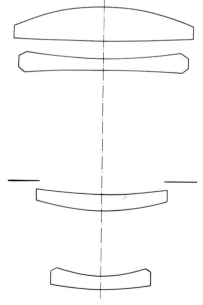

Fig. 21a
Telephoto: 200mm f/4 Telyt

Modified triplets

The first lenses used widely on the Leica were modified triplets, one or more of the three components being a cemented doublet. They were sold under the names Elmar and Hektor from 1925 to about 1960, in a variety of focal lengths, with a maximum aperture of f/3.5. The more recent f/2.8 forms were made possible by the introduction of high-index lanthanum glasses during and after World War II.

A more recent form of modified triplet consists of one or two thin front positive elements, a thick meniscus-shaped negative component, and, after the stop, a final thin positive element. This type has been used in some modern Leica lenses, including the 135mm f/2.8 Elmarit, the 135mm f/4 Tele-Elmar, and the 180mm f/2.8 Elmarit-R for the Leicaflex.

Double-Gauss types

In 1933, Leitz introduced the 50mm f/2 Summar, a six-element lens of the so-called double-Gauss type, still considered the best form for high-aperture lenses. It was reasonably symmetrical on both sides of the central diaphragm, each half containing a thin positive element outside and a thick meniscus

Fig. 21b
High-speed telephoto: 90mm f/2.8 Tele-Elmarit

Fig. 22a
Wide-angle lens: 28mm f/2.8 Elmarit

negative component inside. Many modifications of this basic form which followed all received names starting with "Summ-" —Summitar, Summilux and Summicron, for example. In some cases, additional thin meniscus elements have been incorporated close to the central diaphragm to improve definition and reduce the aberration residuals. The aperture of these lenses has varied between f/1.4 and f/3.5, depending on focal length. The latest in the series is the 50mm f/1.2 Noctilux, which has only six elements, two of its lens surfaces being aspheric.

Telephoto lenses

The essence of a telephoto lens is that, at the infinity focus, the distance from the front lens surface to the film plane is less than the focal length, so the lens is compact. This is generally achieved by using a positive front component, widely separated from a negative rear component, as in the early Telyt lenses dating from 1933. This form of construction, though desirable for its compactness, presents many design problems. As a result, telephoto lenses are seldom made with an aperture greater than about f/4, and then only in long focal lengths which cover a narrow angular field. The modern Telyt designs comprise an

air-spaced front component, which gives the desired compactness, and an air-spaced rear component of substantially zero power. An exception is the recent 90mm Tele-Elmarit, a true telephoto of high aperture (f/2.8) and wide angular coverage (\pm 13 degrees).

Wide-angle lenses

The first 28mm Leica lens was the f/6.3 Hektor of 1935, a five-element modified triplet type. This was replaced by a greatly improved six-element f/5.6 Summaron in 1956, and finally in 1966 by the much more elaborate f/2.8 Elmarit, which has no less than nine elements; the large front and rear negative meniscus components help to equalize the illumination over the picture area.

In 1958 this same general type of construction was employed in the nine-element 21mm Super Angulon lens, which covers a 90-degree field. The aperture of f/4 was raised to f/3.4 in 1963, using one less element, by rearranging the internal construction of the objective.

Lenses for the Leicaflex

The use of a mirror between the lens and the film in a single-lens reflex camera requires every lens for

Fig. 22b
21mm f/3.4 Super Angulon

Fig. 23b
50mm f/2 Summicron-R

Fig. 23a
35mm f/2.8 Elmarit-R

the camera to have a long back-focus clearance, no matter what its focal length. This presents no problem in long focal lengths, but it makes the design of short-focus and wide-angle lenses extremely difficult. A series of five "R" (for reflex) lenses was introduced by Leitz in 1964 when the Leicaflex was announced. They are:

> 35mm f/2.8 Elmarit-R (seven elements, reversed-telephoto type),
> 50mm f/2 Summicron-R (six elements, double-Gauss type),
> 90mm f/2.8 Elmarit-R (five elements, double-Gauss type),
> 135mm f/2.8 Elmarit-R (five elements, modified-triplet type),
> 180mm f/2.8 Elmarit-R (five elements, modified-triplet type).

In 1968 a new 21mm f/4 Super Angulon-R, of an extreme reversed-telephoto type with no less than ten elements, was added to the line. Its reversed-telephoto construction comprises a large negative component in front and a small positive component in the rear, which not only gives a long back-focus clearance, but also yields reduced aberration residuals at high aperture over a wide angular field.

Reversed telephoto lenses are physically large, but

Fig. 23c
90mm f/2.8 Elmarit-R

Fig. 23e
180mm f/2.8 Elmarit-R

Fig. 23d
135mm f/2.8 Elmarit-R

this is not important with the short focal lengths used on a 35mm reflex camera.

In 1969 the list of Leicaflex lenses was augmented by the addition of an Angenieux zoom lens that provides a continuous range of focal lengths from 45mm to 90mm at f/2.8

In the period from 1970 to 1972, the following new Leicaflex lenses were announced:

28mm f/2.8	Elmarit-R (reversed telephoto),
35mm f/2	Summicron-R (reversed telephoto),
35mm f/4	PA-Curtagon-R (with displacement of the lens as far as 7mm up, down or to either side of the optical axis for perspective control; reversed telephoto),
50mm f/1.4	Summilux-R (Gauss),
60mm f/2.8	Macro-Elmarit-R (permits up to 1:2 reproduction ratio without extension tube: a special extension tube supplied with the lens extends the reproduction range to 1:1),
90mm f/2	Summicron-R (modified triplet),
250mm f/4	Telyt-R (telephoto).

Fig. 24
21mm f/4 Super Angulon-R

Fig. 26
28mm f/2.8 Elmarit-R

Fig. 25
45-90mm f/2.8 Angenieux zoom lens for Leicaflex

Fig. 27
35mm f/2 Summicron-R

Fig. 28
35mm f/4 PA-Curtagon-R

Fig. 30
60mm f/2.8 Macro-Elmarit-R

Fig. 29
50mm f/1.4 Summilux-R

Fig. 31
90mm f/2 Summicron-R

Fig. 32
250mm f/4 Telyt-R

Table II

Focal length of camera lens in mm	Distance of center of perspective from screen, expressed as multiples of the long dimension of the projected image
21	0.6
28	0.8
35	1.0
50	1.4
90	2.5
135	3.8
200	5.6
400	11.1

Table III

Type of definition	Assumed size of the circle of confusion, c′
1/1250 inch = 1/50mm	For very sharp enlargements
1/750 inch = 1/30mm	For average good definition
1/400 inch = 1/16mm	For everyday snapshots

Table I

Focal length of lens in mm	Semi-angular dimensions of picture	Semi-diagonal of field
21	30° x 40°	46°
28	23° x 33°	38°
35	19° x 27°	32°
50	13.5° x 20°	23°
65	10.5° x 15.5°	18°
85	8° x 12°	14°
90	7.5° x 11.5°	13.5°
105	6.5° x 10°	11.5°
125	5.5° x 8°	10°
135	5° x 7.5°	9°
180	3.8° x 5.7°	6.8°
200	3.4° x 5.1°	6.1°
280	2.4° x 3.7°	4.4°
400	1.7° x 2.6°	2.2°

Table IV

Focal length of lens in mm	21	28	35	50	90	135	200	280	400
Maximum value of ϕ	46°	38°	32°	23°	14°	9°	6°	4½°	3°
$\cos^4 \phi$.23	.38	.52	.72	.89	.95	.98	.99	.99

Index

ERRATA

 The tests conducted and results discussed in the chapter "Ultrasharp Black-and-White Photography with High-Contrast Films" were accomplished in 1971 and utilized products available during that period.
 Page 210: Second column; disregard lines 5 through 8.
 Page 219: Center caption should read: ". . . and processed in a modified Levy developer . . ." Left caption should read: ". . . and processed in HC-3, an experimental developer . . ."